A Tokyo Anthology

Edited by Sumie Jones
and Charles Shirō Inouye

A Tokyo Anthology

LITERATURE FROM JAPAN'S
MODERN METROPOLIS, 1850–1920

UNIVERSITY OF HAWAI'I PRESS

HONOLULU

© 2017 UNIVERSITY OF HAWAI'I PRESS

22 21 20 19 18 17 6 5 4 3 2 1

Library of Congress Cataloging-in-Publication Data

Names: Jones, Sumie, editor. | Inouye, Charles Shirō, editor.
Title: A Tokyo anthology : literature from Japan's modern metropolis,
1850–1920 / edited by Sumie Jones and Charles Shirō Inouye.
Description: Honolulu : University of Hawai'i Press, [2017] | Includes
bibliographical references and index.
Identifiers: LCCN 2016039442| ISBN 9780824855895 (cloth ; alk. paper) |
ISBN 9780824855901 (pbk. ; alk. paper)
Subjects: LCSH: Japanese literature—Meiji period, 1868–1912—Translations
into English. | Japanese literature—Taishō period,
1912-1926—Translations into English.
Classification: LCC PL726.6 .T63 2017 | DDC 895.6/080042—dc23
LC record available at https://lccn.loc.gov/2016039442

Publication of this book has been assisted by grants from the following organizations:

THE SUNTORY FOUNDATION

Text design and composition by Julie Matsuo-Chun, with display type in
Gabriola Regular and Akzidenz Grotesk and text type in Arno Pro.

Contents

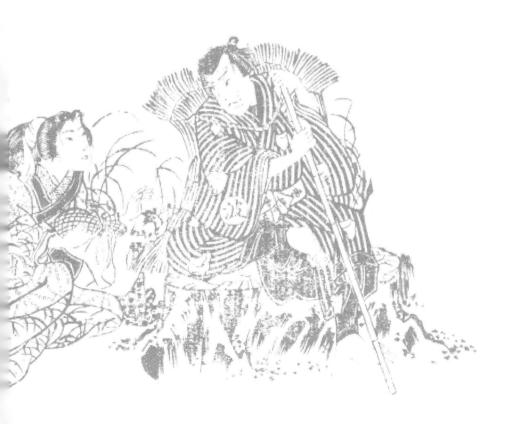

Preface

While Edo, the seat of the Tokugawa shogunate, had been designed and built largely from scratch, Tokyo was an invention superimposed on the already developed metropolis. This fact is emblematic of the nature of the city. The merging of and conflicts between two different stages of modernization not only characterized the city's life and culture but also stimulated the growth of a unique literary milieu.

This volume follows *An Edo Anthology: Literature from Japan's Mega-City, 1750–1850* (University of Hawai'i Press, 2013), which introduced the popular urban literature of Edo before it became Tokyo, and another volume is currently under preparation, tentatively entitled *A Kamigata Anthology: Literature from Japan's Metropolitan Centers, 1600–1750*. All three anthologies aim at providing an experience akin to that of the original reader by re-creating the tone and style of the original texts in these English versions, as well as maintaining their formats, particularly when the narratives are embedded in pictures. We provide a detailed introduction to each volume, describing the social and political context that impacted the creators and readers of the time. An introduction to each text places works in the context of real life and literary history, while the Notes for the Reader and the Source Texts sections provide information for the further appreciation of the works, enabling us to do without footnotes, which could interfere with the flow of the translations. Instead of chronological or genre organization, the arrangement of the contents reflects larger topics and themes

found in the literature as well as in the lives of people of the time. This arrangement allows readers to focus less on literary historical development and more on issues that concerned Meiji writers as they merged old traditions and new trends.

A Tokyo Anthology tells the story of a modern urban literature, which, like the physical structure of Tokyo itself, was influenced by Western Enlightenment but also rose out of the innovations of earlier popular culture. This literature also reveals the economic, political, and military turmoil of the time as well as Meiji writers' responses to the reality of their day. Beginning with oral and dramatic performances, this volume follows traditional forms as they transform into prose fiction and then mature into the modern novel, thanks to the trends of realism and the colloquial writing movement. The native Japanese tradition was inclined toward lyricism, but new trends and forms arose in response to the introduction of Western Romantic poetry. The contents of this volume also reflect the Meiji period's dynamic shift from the oral and pictocentric to the written and logocentric, although essential elements of spoken-ness, lyricism, and pictocentrism were carried over to these new forms of prose writing.

Although this volume highlights the novel as the epitome of modernity, it can only represent the genre in short selections. Similarly, drama here takes the form of selections from plays. In addition, since the aspects of performance and production cannot be represented on paper, we have chosen to select only one scene from a single kabuki play, which most conspicuously dramatizes the conflicts between Edo and Meiji, and Japan and the West. In presenting poetry, this volume does not attempt at being comprehensive in terms of the many forms that survived from earlier periods and those that emerged anew, but it illustrates the variety of imagination and expression according to the topical interests of the period. At the same time, the volume emphasizes new forms of orality by including works of staged storytelling and protest songs. It also testifies to the lingering force of ocularity in Meiji culture in spite of the modern spread of logocentrism. Woodblock-printed graphic novels coexisted alongside movable-type books; and journals were often adorned by innovative modernist designs.

A Tokyo Anthology features the use of original first-edition materials. Many works of Meiji-period literature were first serialized in newspapers or journals, of which legible copies are not always extant, making our search for the best versions of these first editions complex. Unlike their Edo counterparts, which consisted of handwritten woodblock-printed pages, Meiji books largely used letterpress printing, which affected the relationship between the picture and the written text. Because of the stylistic,

orthographic, and other complexities of Meiji literature, our translators had to be equipped not only with a broad knowledge of the period but also with the literary talent required to accommodate the wide variety of Meiji writing. The planning committee and advisers emphasized these requirements, making sure to mix distinguished scholar-translators with up-and-coming ones. The Source Texts section lists the original publications as well as their modern editions. For rare books, we list at least one owner of a copy (with the date of publication).

All of the translations are original and have not been previously published as they appear here. Most are the first translations of these works into English, with a few exceptions. For works that were previously partially translated into English, we chose different episodes or chapters to represent here.

This is the case for works such as Kanagaki Robun's *Things Heard around a Pot of Beef*, of which a different episode has been published in Donald Keene's *Modern Japanese Literature* (1956), and Shunkintei Ryūō's *The Bad Girl Prefers Black and Yellow Plaid*, of which Jones has previously translated different episodes from the same work in her *The Shirokoya Scandal* (2010). An earlier translation, although partial, of Kawakami Otojirō's "Oppekepe Rap" is included in Joseph L. Anderson's *Enter a Samurai: Kawakami Otojirō and Japanese Theatre in the West, Vol. 1* (2011). Earlier versions of Laurel R. Rodd's translations of Yosano Akiko poems have been published, but the translations in this volume have been further refined for their inclusion. The collection is so popular that many selections have been put into English, most conspicuously in Sanford Goldstein and Seishi Shinoda's *Tangled Hair: Selected Tanka from Midaregami* (1971).

The selections from Matsubara Iwagorō's work that appear in this volume also appear in an earlier complete translation of *In Darkest Tokyo: Sketches of Humble Life in the Capital of Japan* (1897), dating from the period of the original's publication. Similarly, two much earlier complete translations of Tokutomi Roka's *The Cuckoo* exist in the forms of *Nami-ko, a Realistic Novel* (Tokutomi, Kenjirō, Sakae Shioya, and Edwin Francis Edgett, 1904) and *The Heart of Nami-san (Hototogisu) A Story of War, Intrigue and Love* (Tokutomi, Kenjirō and Isaac Goldberg, 1918). Parts of the selection in the present volume have been quoted in Ito's *An Age of Melodrama: Family, Gender, and Social Hierarchy in the Turn-of-the-Century Japanese Novel* (2008). The episode "Hilltop" from Nagai Kafū's *Tales of America* is included in a complete translation by Mitsuko Iriye, *American Stories* (2000). Natsume Sōseki's *Short Pieces from Long Spring Days* was translated previously by Sammy Tsunematsu in his *Spring Miscellany and London Essays* (2002).

The idea for *A Tokyo Anthology* emerged from a group of scholars who had conducted, for a few decades, a group study of Edo-period literature under the leadership of Howard Hibbett. The project began to take shape in 2003, when a planning committee, consisting of Rebecca Copeland, Charles Shirō Inouye, Sumie Jones, and John Treat, met with advisers Howard Hibbett and Shinji Nobuhiro in Bloomington, Indiana. Robert Campbell and Adam Kabat also took part in the discussion through conference calls. While we, the coeditors, continued to receive advice from the planning committee, Edward Fowler also provided us with invaluable suggestions regarding the choice of texts.

As with the previous volume, the team worked according to a naturally formed pattern: a translator would pose a question to Jones, who would provide an answer unless assistance was needed in looking up materials in Japan or for gathering contextual information, sometimes turning to Nobuhiro for an answer. He, in turn, occasionally consulted other experts such as Hideyuki Iwata and Kurata Yoshihiro. Coeditor Inouye, chiefly responsible for the translations' readability in English, occasionally made use of Hibbett's editorial wisdom. In general, while Jones checked each translation for errors in sense and nuance against the original, Inouye went over each draft for further improvements, although their roles were not so clearly divided in their discussions with the translator. Each translator took part in debates with the coeditors, advisers, and occasional consultants, and she or he was the one who had the last word in interpreting the text. In most cases, the translator authored the introduction to her or his individual work.

We are grateful to the Toshiba International Foundation and the National Endowment for the Humanities not only for the generous funding we received over the years, but also for their patient encouragement. We thank the anonymous readers of our manuscript for their dedication and valuable insights to the project. We also thank Indiana University for supplementing the funding from the foundations with a Bridge Grant through the Office of the Vice Provost and a New Frontiers Grant through the Office of the Vice President for Research. We are indebted to the university's Institute for Advanced Study, which functioned as headquarters for the project. We are also grateful to the university's East Asian Studies Center, which supported our project by sponsoring various related events. Our special thanks go to Kenji Watanabe and Rikkyo University's Institute for Japanese Studies for the opportunity given to Howard Hibbett and the two of us to meet with prospective translators residing in Tokyo. We also thank Yasunori Tan-o for his guidance in our search for pictorial materials as well as our research at Waseda University. We are grateful for the expert help of curators and librarians who have responded to our numerous questions and

requests throughout the years: Wen-Ling Liu of the East Asian Collection of Indiana University's Herman B Wells Library; Yukiko Hasegawa, Megumi Shiraishi, and Kaori Fujii of the Archives of Meiji Newspapers and Journals of the University of Tokyo; and Hisayuki Ishimatsu, Toshie Marra, and Deborah Rudolf of the C.V. Starr East Asian Library of the University of California, Berkeley. We are also indebted to Kayoko Toda, Taeko Kita, and Fumiya Sohda, staff members of the National Institute of Japanese Literature, for their similarly supportive service over the years. Needless to say, we are grateful to all of the museums and libraries that offered us images from their holdings and permissions to reprint them. Their names are listed separately. We acknowledge the goodwill of Nicole Hayward for her skillful graphic design work and Laura Driussi for her expert copyediting of the camera-ready pages for the picture books included in the volume. This anthology would not have been possible without the inspiration and encouragement of many of our colleagues in our field of study and the dedicated help of thirteen assistants at Indiana University with whom both of us have worked closely over the years. We thank Pamela Kelley in guiding us and seeing to the publication of this volume.

It has been our pleasure to work with all the members of this team, whose ideas and labor have made this volume far better than it would have otherwise been.

Sumie Jones
Charles Shirō Inouye

Introduction

THE CONSTRUCTION OF JAPAN'S MODERNITY
AND THE GROWTH OF A NEW LITERATURE

SUMIE JONES AND CHARLES SHIRŌ INOUYE

THE INVENTION OF A MODERN STATE

This anthology presents the literature of the Meiji period (1868–1912), in its fitful transition between Japan's early and high modern eras. The so-called Meiji Restoration is conventionally portrayed as a sudden and clear break from the centuries-old power structure of the Tokugawa shogunate as it gave way to the emergence of a new emperor and his deliberative parliament. This impression of a sudden break arises from events that shook Japan at this time: Commodore Matthew Perry, backed by black ships and cannons, forcing Japan to open its ports to the rest of the world (1853–1854), the emperor's establishment of himself as national ruler upon possession of the shogun's castle (1868), and the declaration of a new constitution (1889) that entirely changed the country's political structure. Despite these monumental changes, however, the simplistic image of a sudden and clean shift precipitated by any of these events does not adequately describe the Meiji period, which was, in fact, a discursive and continuous period of modernization. Within the turbulence of the era, notions of modernity, nation, and individuality haphazardly developed against a backdrop of wars and political struggles that pitted old against new, central against local, and governors against the governed.

The literature of the period reflects the complexity of its historical context, where changes in government and society inspired new interpretations

of earlier models and new definitions of literature. After the fall of the Tokugawa regime, the ongoing struggle between classical writing and new colloquial styles, between traditional poetic forms and new prose genres, and between woodblock and movable-type printing—in short, between early modernity and late modernity—accelerated dramatically. The government itself encouraged the reception of newly imported Western literatures as part of its policy of "Enlightenment," and Tokyo artists considered literary issues with the same confrontational passion that propelled violent military clashes and political negotiations.

While the Meiji period was defined by invention and adaptation, literature of the Edo period, particularly the popular genres of the seventeenth century, should be acknowledged for its own modern features. Emphasizing visuality and performance, writers and illustrators collaborated to work against the authority of the dominant high literary forms of Japanese and Chinese classical writing. The development of new printing techniques coeval with this collaborative creativity ensured that these projects would spread widely. As the Edo gave way to the Meiji, collaborative composition gave way to individual authorship. Those who were working against classical Japanese and Chinese models turned to sources further afield. In particular, the genre of the novel in Japan was nurtured by the desire to imitate Western realism, for example, but all Japanese literary forms, including poetry, continued to adapt aspects of Western genres. The pursuit of Western realism in the novel ultimately produced texts that dissociated themselves from the earlier collaborative tradition of text and illustration, establishing a more narrowly defined form of realistic fiction for some decades to come. In short, the literary history of Meiji Japan traces a movement from the visual, performative, and lyrical to the sound-oriented, mimetic or realistic written word, as the modern novel took form in fits and starts.

COMPLEXITIES AND CONTRADICTIONS

The Meiji Restoration of 1868 put an end to the Edo period (1600–1868), marking a shift of power from the Tokugawa shogunate to an imperial reign supported by an elected national diet. Since Japan's emperor had historically been a ceremonial figurehead under the governance of the military *bakufu*, the shift also meant an active imperial role for the first time since the twelfth century. The Tokugawa clan's shogunate had smartly managed to stay in power for 268 years through its Neo-Confucian system of social and bureaucratic structures and through strict legal and tax systems. Following its defeat of competing forces, the shogunate enhanced its control through

various isolationist policies that barred overseas travel and severely restricted the entry of foreigners. This control extended downward through its own governmental structures; for example, daimyo were required to leave their families in Edo when away from the capital, thus ensuring loyalty, as families were more or less held hostage in the capital. By the early nineteenth century, however, the shogunate was showing signs of weakness in both its economic and legislative policies. A series of natural disasters, the arrival of ships from various Western nations, and the news of the first Chinese Opium War (beginning in 1839) further destabilized a shogunate weakened by factors both internal and external. The monolithic structure of the shogunate itself began to crack under the pressure: the shogun's bureaucracy, various daimyo domains, and the imperial nobility argued with each other about whether or not to open Japan's ports to foreign nations.

Adding to these internal and external pressures, rebellious groups of samurai from anti-Tokugawa domains in western Honshū and Kyushu, with the support of some factions among the nobility, asserted the need to make the emperor Japan's legitimate and visible leader. The power struggle, then, was nominally between Japan's 121st emperor, Kōmei (reigned 1846–1868), and Tokugawa Yoshinobu, guardian/adviser for Shogun Ieshige and later the fifteenth shogun for the last year of Tokugawa rule (1867–1868). In fact, the struggle involved complex divisions among samurai and imperial noblemen. Daimyo were divided by degrees of loyalty to the shogun, while imperial nobility adopted various schemes for cooperating with the existing powers of the shogun or with the rising factions supporting the emperor. The latter group included poverty-stricken and frustrated noblemen such as Sanjō Sanetomi (1837–1891) and Iwakura Tomomi (1825–1883), both of whom became leaders of post-Restoration Japan.

Compared with the revolutionary "imperial camp," the shogun's faction was more inclined to take a long view of Japan's future status among other nations. This was largely due to the compositional differences within each group. While the shogunate opened Japan's chief ports to foreign ships and moved toward signing trade treaties with those who came calling, the "imperial camp," chiefly composed of discontented leaders and soldiers from Satsuma, Chōshū, and other antishogunal domains, protested by pronouncing a two-pronged ideology to "uphold the emperor and expel the foreigners." It took only a decade of hostilities before the last shogun, Yoshinobu, handed over his sovereignty and vacated the Edo castle for the emperor. Edo was renamed Tokyo, meaning "the Eastern Capital," as a nod to Kyoto, the traditional imperial city in the western part of Japan.

The actual shift of power was neither smooth nor quick. Even after the Restoration in 1868, battles in the name of "protecting the imperial city," a

slogan used by both sides during the early 1860s, continued. The coup d'état by five antishogun domains, which included Satsuma, Chōshū, and Tosa, wreaked havoc in Kyoto and Edo, spreading its violence to other regions as the leaders declared themselves the "Imperial Army" and labeled supporters of the shogunate "rebels." After taking power, this "army" not only failed to assuage the losing side with any sort of magnanimity, but also left Yoshinobu out of the newly formed government entirely. The belittlement of the shogun infuriated some of his powerful *hatamoto,* the shogun's bureaucratic retainers, and other daimyo-class samurai, who formed a "Justice Revelation Army" (Shōgitai) to "protect the shogun's safety and dignity." Because of its members' high status, this army was well funded and influential, so that by the time the shogun retreated to Mito, the domain of his origin, the band had expanded to several thousand soldiers. Only by tightly focusing its limited military resources and by allowing certain brutal mass killings did the Imperial Army manage to completely defeat the Justice Revelation Army. In the midst of these raging battles, common citizens who weren't victimized by the violence tended to behave as optimistic spectators of the vying factions. For example, the Justice Revelation Army members, handsome sons of rich samurai known for dressing themselves in attractive uniforms, drew admiring cheers from women who lined the streets to watch them pass. Popular stories, songs, and pictures treated them as beautiful and tragic heroes.

As the Imperial Army advanced on Tokyo and then on to the northern parts of Japan, various domains engaged them in battle. "The Year of the Dragon War" (1868–1869) was partially memorialized in a song, "Prince, Prince" (Miyasama, Miyasama), probably the first ditty that became nationally popular in Japan. The piece was adapted from a marching song composed by a samurai in the Tosa faction of the Imperial Army, the rhythm of which served as a measure of control over the chaotic diversity of the army's soldiers. The first lines of the song ask, "Prince, Prince, what flutters / Just ahead of your horse?" addressing Prince Arisugawa Taruhito (1835–1895), who was the general of the antishogun army. The following two lines, "It's the Emperor's banner / Calling us to beat his enemies," propagate the army's legitimacy in its campaign against the shogun's power. The song acquired a longer life and broader appeal as the first lines were adapted in the "Miyasama" chorus for the entrance of the emperor in Gilbert and Sullivan's comic opera *The Mikado* (1885).

The final important battle of this transitional phase pit the belligerent Imperial Army against the Aizu Domain, which, out of unchanged loyalty to the shogun, fought back against the unfair appellation of "the emperor's enemies." The Imperial Army greatly outnumbered troops from Aizu, utilizing

large numbers of the country's jobless to swell the size of its ranks. The samurai army on Aizu's side was left to fend off the aggression on their own, since peasants in the domain had no stake in maintaining the status quo. The domain's "White Tiger Troop" (Byakkotai) consisted of teenage boys from the samurai class who fought to the death. Even women joined their efforts, killing themselves once their defeat was certain. Edoites in the new capital were critical of the unreasonable and brutal ways in which the anti-shogunal forces gained power: the popular idiom "whoever wins becomes the official army" pointed an ironic finger at the rebels' tendency to claim justice for the winning side regardless of its legitimacy. Aizu Domain's defeat on September 22, 1868, marked the end of the shogun's rule.

An edict in 1871 established a new system of prefectures according to which all daimyo "returned" their domains to the emperor. The majority lost their hereditary authority and were reappointed as governors. Their income was set at 10 percent of tax revenues, and their former retainers were now officers for the prefecture, appointed and paid by the central government. Under the banner of "all classes are equal," the government not only announced a military draft system in 1873 but also abolished the samurai class and banned the ownership of arms. This move was an attempt to assuage the central government's distrust of former daimyo who, it was feared, might maintain power over the populations of their former domains. Having accrued debt to fight the wars of transition, the new government was hindered in its ability to reward the daimyo-turned-governors and their followers as it had promised, however. And another war broke out as disgruntled former daimyo and nearly the entire samurai class rose against the government that had driven Japan into poverty, inflation, and, finally, incurable deflation.

Discontented samurai were not the only destabilizing force facing the new government. Internal ideological conflicts also plagued the prime movers of the Restoration. Saigō Takamori (1828–1877), from Satsuma Domain, who had been among the chief strategists against the shogunate, was disappointed by the Restoration when it failed to realize his ideals. His disappointment was shared by the former daimyo of Satsuma, one of the most powerful domains in advancing the Restoration, but Saigō did not turn to any military or political measures. Instead, he returned home to establish a number of schools aimed at educating young men in his former domain. These institutions also allowed him to gather followers under his wing, all with the long-term goal of training them to improve Japan's future. The schools actively invited foreign instructors and adapted a variety of Western practices to achieve the sort of enlightenment that Saigō had envisioned. In the propagation of an alternative model, the schools constituted not only a

political threat to the government, but also a military one, as Satsuma Domain was still immensely wealthy. The government, eager to squelch any dissidence from such schools, launched attacks and carried out assassinations. The national army, led by Prince Arisugawa, ultimately defeated Saigō's forces in the Satsuma region and continued to pursue the troops, who scattered to all parts of Japan. The end of this "Southwest War" put a stop to revolts against the Meiji government, giving it an opportunity to gain control over the whole nation. The old-fashioned commoners in downtown Tokyo, who were not at all comfortable with the Meiji Restoration, identified with Saigō's frustration with the leaders' failure to realize the ideals of equality and human rights. His status as a tragic hero continues to this day, as admiring visitors flock to his bronze statue at the Ueno Park in Tokyo.

ENCOUNTERING THE WORLD ANEW

Finally in control, the Meiji national government could now pursue its Enlightenment project, which included its own modeling of Japan after important Western countries. Although it is true that Japan's ports had remained closed to those leading nations for centuries, Japan had not exactly been an isolated country. The nation had a long history of exposure to foreign visitors—beginning with prehistoric associations with the Asian continent. The importation of Buddhism and Confucianism through China and Korea during and after the sixth century further strengthened these ties, providing Japanese culture with religious and intellectual foundations that would last for centuries. By the time of the Mongolian attacks on Japan's southwest coasts in 1274 and 1281, the country was well woven into an inter-Asian network of communication and diplomacy. During the mid-sixteenth century, Jesuit leaders and traders from Spain and Portugal visited and resided in Japan, promoting commerce as well as spreading Catholicism. The leading warlord of the day, Oda Nobunaga (1534–1582), encouraged the foreigners at first, not only because he admired the charm of Christian culture but also because their presence held strategic significance for trade and for military activities. Most significantly, the muzzle-loading rifles that turned the tide of battle in his favor were purchased from the Christians.

Despite Nobunaga's partiality, however, his successor, Toyotomi Hideyoshi (1537–1598), banned Christianity on the basis of its loyalty to a higher power. After Tokugawa Ieyasu (1543–1616) established himself as the nation's actual ruler, the ban against Christianity became even stricter. As mentioned, the shogunate also enforced various "isolation policies" that limited entry to the Chinese, Koreans, and the Dutch (who seemed less evangelical than the Iberian Catholics), and made them reside on a man-

made island in Nagasaki Bay. Despite these restrictions, the Netherlands' privileged access to Japan was the envy of other European countries, which now fiercely vied with one another to trade with and colonize Asian lands. Their ships entered Japan's ports repeatedly but were met each time with tightly closed doors.

The United States finally succeeded in bringing an end to the country's diplomatic isolation. In 1853, the looming presence in Edo Bay of four American steam-powered "black ships" led by Commodore Matthew Perry (1794–1858) compelled the reluctant shogunate to begin negotiations with foreign countries. In 1858, trade agreements were signed with the United States, England, France, the Netherlands, and Russia, permitting the ships of these nations to enter a small number of designated ports. Once opened to foreign trade, Japan's fear of becoming a colony of another power spurred the Meiji government to create a nation sufficiently strong and modern to deal with Western powers. Japan was compelled to undergo political, industrial, economic, and cultural revolutions within a matter of decades.

This is not to say that modernization was made possible only through Western influence. The idea that the Edo period was entirely feudalistic and behind the times is a misconception, as is the assumption that the new Meiji government invented Japanese modernity from scratch. Tokugawa rule of Japan had been a curious mixture of old and new. In spite of a rigid Neo-Confucian system of ethics at its core and its dependency on a rice-based economy, a modern bureaucracy had encouraged the growth of capitalism and consumerism, and had engaged in city planning to develop water systems and a network of freeways.

The city of Yokohama was key to Japan's efforts to improve its economy and security. Its port was the largest and most crucial entry point into Japan, connected to Tokyo by rail. The exportation of silk, tea, and ceramics became all the more important, resulting in the construction of a number of large factories throughout Japan. For example, the Tomioka Silk Mill, established by the government in 1872 in Gunma Prefecture north of Tokyo, showcased Japan's commitment both to mechanizing manufacturing processes and to constructing Western-style buildings. Popular ukiyo-e prints glorified the modernity of such industries and architectural developments by portraying women in the latest Western fashions, operating state-of-the-art machines. A UNESCO world heritage site since 2014, the Gunma factory stands as a monument to Meiji architecture and industrialization and to the worldwide popularity of Japanese silk. Yokohama's modern landscape, built in part with revenue from Tomioka silk, had become dotted with newspaper and publishing offices, banks, and other institutions. In short, before

Tokyo was made over into a model Meiji metropolis, Yokohama was Japan's first Westernized city.

During the Edo period, many established religions and superstitious beliefs persisted among the peoples of the growing city despite these external signs of modernization. Shinto, a conglomeration of local animistic practices, remained the basis for all ceremonies related to the ruling powers, as it had throughout Japan's history. Buddhism, however, gained influence through the patronage of the shogun's family, overwhelming Shinto's political role. It reduced the Shinto belief system to legends and precepts that survived in the form of folktales and festivals, although certain ancient rites were reserved for the shogunate's interactions with the emperor. Notwithstanding its diminished status as a religion, Shinto, with its assignation of divine authority to the emperor, came to play a chief role in the formation of nationalism. The so-called Native Studies that had developed during the eighteenth century in opposition to Confucian studies began to produce theories of "Japaneseness," which were later revived to support the nation's colonialist agenda.

Both Shinto and Christianity were newly discovered parts of Meiji modernity. This second wave of Christian influence was Protestant rather than Catholic. With its emphasis on equality and personal ethics, Protestantism represented both an ideal level of enlightenment and a new understanding of the world. Churches were constructed with assistance from foreign missionaries, and the teachings spread. But Meiji-period Christianity was largely embraced as a philosophy by progressive elites.

In the case of Itagaki Taisuke (1837–1919) and other Tosa leaders, their interest in Christianity came as an attempt to strengthen their position in relation to the two other major groups—the Satsuma and Chōshū clans—that had led the Restoration. They engaged with Christian philosophy, though not always with its theology, in their attempts to determine the shape of Japanese democracy. Their marriage of Christian values and traditional Japanese social beliefs positioned itself against class discrimination and promoted ideals of liberty, equality, and early human rights that would eventually merge with the milder democratic persuasions of other early Meiji factions.

As for Shinto, the influence of nativist theories encouraged awareness of Japan as a nation. What had been limited to ceremony and folklore in the Edo period became the basis for strong nationalist policies and an ideology of ethnic superiority. The "cult of the Emperor" emerged as an imperialist ideology in the 1890s and reached its apex during World War II, when Japan's leaders emphasized the emperor's "divine" status as the symbolic father of the nation, as well as Japan's role in "saving" Asia from unwanted

foreign influences. The Yasukuni Shrine, founded in 1869 to commemorate those who had died in the battles leading to the Meiji Restoration, later came to honor the spirits of fallen soldiers from World War II as well. Controversy erupted in 1978 when the souls of leading war criminals were admitted to the shrine after having been previously excluded. Visits decreased, and Asian countries came to view Yasukuni as a symbol of Japan's aggression during the war.

PERFORMING MODERNITY IN TOKYO

The reconfiguration of state religion was only a part of what became a nationalist march toward a Japanese modernity. The ubiquitous phrase *bunmei-kaika*—literally, the "blooming of civilization"—was a translation of the English term "Enlightenment" by Fukuzawa Yukichi (1835–1901), who became the mastermind for the national movement. Promoting the importance of the English language and American democracy over European models, he famously adapted Abraham Lincoln's message of emancipation, saying, "Heaven makes no man above another; heaven makes no man below another." As the Meiji modernization moved forward, Japan's attention shifted from the Dutch to the English model.

Although Fukuzawa's ideas were based on a perceived need to develop science and industry, the government pursued an aggressive policy of "catching up with the West" in all aspects of society. Itō Hirobumi (1841–1909), the first prime minister, represented the flamboyant side of the official Enlightenment movement. In addition to his adoption of Western styles and tastes, Itō also created a policy of emulating Western countries in their development of modern technologies as well as in their creation of imperialist agendas. He was in office during the Sino-Japanese War (1894–1895), when Japan first ventured onto the world stage as a conquering power. The 1905 victory of the Russo-Japanese War gave Japan the impression that it had finally succeeded in becoming equal to Western world powers.

While intellectual leaders subscribed to the government's ideology in terms of nation and empire building, common citizens viewed the Enlightenment more through the lens of changing fashions in cuisine, architecture, and attire. New forms of public schools, universities, hospitals, and factories were quickly founded as Tokyo became a model of and stage for Japan's modernization. Banks, department stores, and theaters, along with judicial courts, police stations, prisons, fire departments, and post offices had all existed in different forms during the Edo period, but they became newly systematized and housed in modern edifices. New architectural designs accompanied modern conveniences: steam trains departed from the new

brick Shinbashi Station headed for Yokohama; streets in the area, particularly after the Ginza fire in 1872, were lined with similar red brick buildings and gaslights; and horse-drawn coaches carrying men and women in Western attire moved gracefully through this modern landscape. The Deer Cry Pavilion, a luxurious, government-built space in which upper-class Japanese mingled with their Western counterparts, was the foremost stage for Japan's performance of modernity. During its peak in the mid-1880s, native Japanese men and women who dressed in what they hoped were the latest Victorian fashions escorted distinguished foreign guests to Western-style dinners, dances, and concerts.

Those uneasy with or critical of Japan's modernization often found easy targets in the city's Western-styled spaces. While the spectacle of the Deer Cry Pavilion was glorified in Meiji-style ukiyo-e prints, Western cartoonists such as Georges Bigot (1860–1927) satirized these elements of the Meiji program. In addition to satire, anti-Itō factions criticized easy submission to Western culture, pointing out the failure of the entire Deer Cry Pavilion project to produce any tangible results that might advance Japan's diplomatic relations. In short, the nation's infrastructure had seen no long-term results from the latest frenetic push toward modernity. Unlike the modernization of European countries, which naturally developed from internal motivations over time, the Meiji Enlightenment resulted instead from a pressure to urgently emulate external Western models, as novelist Natsume Sōseki (1867–1916) observed in his famous lecture, "The Civilization of Modern-Day Japan" (Gendai Nihon no Kaika, 1911).

With the newborn government's ideology of modernization and its project of nation building, Tokyo was superimposed on the already mature capital of Edo. Edo had been a highly developed metropolis, the largest in the world by the mid-eighteenth century. It also was in the peculiar position of having been ruled directly by the shogun, rather resembling the status of Washington, DC, among American cities. Given this unique status, Edo had served as a model for all aspects of society and culture. Tokyo, on the other hand, would not easily become a convincing capital for its residents due to the new governing structure: the emperor was from the remote city of Kyoto and his government consisted of former samurai and others from domains far away. Bureaucratically speaking, the new system took the form of a parliamentary monarchy, supported by ministries, with the entire nation organized into prefectures that replaced daimyo domains.

The centrally important and experimentally new metropolis of Tokyo harbored, on the one hand, an institutionalized incentive toward Western-style modernity and, on the other, persistent Edo traditions and a longing for the familiar old landscape that underlay the superimposed veneer of the new.

Trueborn Edoites, suddenly turned Tokyoites, were resentful of the invasion of "country bumpkins," victorious samurai from Satsuma and Chōshū who had risen through the new bureaucracy and by way of military service. The majority of downtown shopkeepers and traders conducted their businesses in the old-fashioned manner, and many people still wore traditional attire and hairstyles. The Edo-born Tokyoites tended to be pro-shogun, enjoying the battle spectacles and stories about their "rebellious" heroes. At the same time, they were also fascinated by the customs and attire of the newly arrived foreigners, who were elaborately depicted in ukiyo-e prints. Western cuisine had already begun to spread among the seventeenth-century elite: parties in Nagasaki had catered to Dutch tastes, and the last shogun had enjoyed the pleasures of French cuisine. After the Meiji Restoration, this culinary trend spread to the general populace, with two of the more prominent examples of popularized Western cuisine being *hayashi raisu* and corned beef, or *kondō bīfu*. *Hayashi raisu* was the name for thinly sliced beef sautéed in butter with onions and mushrooms and served over rice, recalling beef hash (possibly the root of *hayashi*). A more popular theory of the name's origin held that it was invented by a certain Mr. Hayashi. Similarly, *kondō bīfu* was believed to have been the invention of a certain Mr. Kondō.

Class divisions determined the extent to which Western culture was adapted and modified within the Meiji cityscape as it evolved toward modernity. Edo's demographic divisions between samurai and commoners split the city geographically into an uptown (*yamanote*)—populated with educated public servants, successful corporate workers, scholars, and other intellectuals—and a downtown (*shitamachi*), which was home to the majority of common citizens as well as smaller businesses. The "enlightened" population of Tokyo's uptown favored Western clothing and Victorian hairstyles, while old-fashioned citizens of downtown enjoyed the spectacle of new styles but loathed to part with their topknots and Japanese clothes. Christian churches were fashionable among the educated, but old temples and shrines continued to flourish, particularly through elaborate and frequent festivals. As the contents of this anthology demonstrate, the literature and arts of the Meiji period embraced these conflicting elements of old and new and were engaged in the process by which the Japanese public became conscious of their place in history and their identity as a modern citizenry.

DISCONTENT AND THE RISE OF POLITICAL PARTIES

New governmental forms required a reshuffling of political and social strata. The appellations of shogun, daimyo, *hatamoto* (the shogun's own retainers); and bureaucratic positions, such as grand councilor and magistrate, became

obsolete with the fall of the shogunate. At the same time, the old nobility under the emperor, whose authority had been chiefly ceremonial for centuries, had to be incorporated into the new class system. Political authority and financial power replaced the preeminence of heritage and the maintenance of the status quo. A system of peerage imitating European models was established in 1869 and continued until 1947. The ranks within the new system were doled out to former imperial nobility, daimyo, and honorees who had performed extraordinary service to the nation. In 1884, a law established titles equivalent to duke, marquis, count, viscount, and baron, which added a flavor of Western prestige to the upper strata of Japanese society. Those who had rebelled against the shogun's rule and won battles to bring about the imperial "restoration" naturally took leading positions in the government and also in society as newly minted members of the nobility. This barred some of the former powers, particularly the shogun and his direct retainers, from the full benefits of the modern system. As a result, the old leadership and its faithful followers were split from the new classes who enjoyed both wealth and political power. New developments in industry intensified this division, as the importation of steam engines, machines, and the idea of the assembly line encouraged mass production, preventing workers from owning the means of production and separating them from the newly risen class of capitalists.

Meiji society promoted social acumen and education as means to climb the ladder of social rank and to amass a fortune. Aspiring young men aimed for jobs in the various new bureaucracies or success in business ventures. Some great merchants from the Edo period did well by becoming modern investors who exported silk, tea, and chinaware and imported engines, weapons, and other machinery. Through the success of banks, factories, and trading companies, some of those merchant clans eventually grew into immensely rich combines (*zaibatsu*), which controlled Japan's economy and industry for nearly a century until they were dismantled after World War II. With the outbreak of war on the Korean Peninsula and a retrenchment of the liberalizing policies of the American occupation, these combines were allowed to revive themselves, founding the financial, industrial, and commercial organizations that continue to thrive today.

Outside the capital, the most shocking of all the Meiji reforms was the 1871 elimination of the old domains in favor of newly defined prefectures. The daimyo lost their vast holdings, and the majority of *hatamoto*, by fault of their direct connection to the old regime, were naturally excluded from important positions in the new government. Having no daimyo or *hatamoto* to keep them in their employ, the majority of samurai lost their sources of income. Disgruntled daimyo formed political groups with the educated

classes, demanding that the Satsuma-centered government establish a new constitution, open a national parliament, sanction freedom of speech, and amend unfair trade agreements with foreign countries. The so-called Liberty and Civil Rights movement began as a response to the abolition of domains and continued until 1890, when the Imperial Assembly was finally established. In addition to the politically and economically disaffected, affluent farmers also joined the movement to oppose heavy taxation by the new government. The government responded by tightening its unforgiving control, spurring militant groups on to violent incidents and skirmishes. Ultimately, these protest groups coalesced into political parties.

One of the strongest opponents to the government of Prime Minister Itō Hirobumi was Itagaki Taisuke. Founder of Japan's first political party, the Liberty Party, Itagaki criticized the ruling system, especially the peerage, and demanded that the emperor open a national diet meeting. He ultimately succeeded in becoming the home minister within the cabinet of Ōkuma Shigenobu (1838–1922), ensuring a national platform for his Liberty Movement. Following the French model, he emphasized people's sovereignty over the emperor's authority, finding support not only from Tokyo's intellectuals but also from the frustrated rural population. With Ōkuma, Itagaki later founded the Constitutionalist Party, Japan's first party to form a cabinet. A samurai from Saga in the south and instructor of Dutch at the domain's school, Ōkuma proposed the basic principles of democracy and argued against Itō's idea of a Korean invasion. He ultimately replaced Itō as prime minister. Inspired by the New Testament and America's Declaration of Independence, Ōkuma developed a mild liberalism, and his pro-emperor stance and knowledge of foreign languages helped him build a brilliant political career.

Yamagata Aritomo (1838–1922), a low-ranking samurai from Chōshū, represented the right wing among political leaders. Having led the Imperial Army in its battles against the shogunate, Yamagata had ascended the military ranks throughout the Meiji period. Often called "the founder of Japan's military clique," his political success included two appointments as prime minister, during which he severely suppressed political liberalism. Between them, Yamagata and Ōkuma represented the two strains of thought that dominated Japanese politics throughout the era: a militant nationalism, on the one hand, and a liberalizing democracy on the other.

Among the intellectuals, the rebellious extreme was Kōtoku Shūsui (1871–1911), an anarchist thinker and journalist. Having studied Jean Jacques Rousseau through his master Nakae Chōmin (1847–1901), he wrote a political protest play as well as essays for the *Liberty News* (*Jiyū Shinbun*) and for *Morning News for All* (*Manchōhō*), Tokyo's best-selling newspaper

founded by author Kuroiwa Ruikō (1862–1920). Kōtoku decried warlike
nationalism in his book *Imperialism: The Monster of the Twentieth Century*
(*Nijusseiki no Kaibutsu Teikokushugi,* 1901) and formed Japan's first Socialist
Party. He was executed in 1910 after becoming embroiled in a case of con-
spiracy against the nobility. Ōsugi Sakae (1885–1923), anarchist, journalist,
and activist, scandalized the nation not only because of his extremist actions
but also because of his relationships with women, most significantly with
feminist critic Itō Noe (1895–1923), who shaped his thought and career. He
was repeatedly arrested for organizing antiwar protests and was ultimately
murdered along with Noe and their young nephew by a military police
squad. These liberal and rebellious leaders turned a spotlight on the darker
side of glitteringly modern Tokyo.

THE DARK SIDE OF THE ENLIGHTENMENT

The Meiji government demonstrated its Enlightenment by showcasing
Tokyo's model streets such as Shinbashi and Ginza, and its public facilities
such as the Deer Cry Pavilion guesthouse. But modernization was spotty,
and other parts of the city were left to suffer. Less-educated inhabitants
from the days of the shogun and jobless former samurai, who might be called
the *nouveaux pauvres,* desperately lacked any sense of a stable future for them-
selves or for the nation. A vast disparity between rich and poor consigned
the latter to the lower and darker parts of Tokyo, hidden behind the lumi-
nous Enlightenment facade. A large number of jobless samurai joined those
laborers and traders who were pushed to the periphery by highly developed
industrial technologies. Moreover, military conflicts surrounding the power
shift from the shogun to the emperor had left the new government in debt;
and internal conflicts, coupled with wars against China and Russia, caused
national finances to worsen. Returned troops found themselves without com-
pensation or jobs, further swelling the ranks of the downtrodden. An increas-
ingly large number of the unemployed and homeless occupied Tokyo's worst
slums, as depicted in the nonsentimental and detailed reportage by Matsub-
ara Iwagorō (1866–1935), *In Darkest Tokyo** (*Saiankoku no Tokyo,* 1892–
1893). (Asterisks indicate works included in the anthology.)

Tokyo's newly impoverished joined old Edo's underbelly of "village
people" (*burakumin*). Traditionally categorized as "nonhuman," these people
engaged in professions considered either sinful by popular Buddhist beliefs
or perceived as generally unsanitary, working as butchers, tanners, under-
takers, and trash collectors. More importantly, fortune-tellers and mediums
as well as street performers, including magicians and animal tamers, inhab-
ited these villages. In short, both the perception of social unfitness and a repu-

tation for psychic and miraculous abilities separated this group from conventional society. The suspicion that these communities harbored illegal immigrants and criminals only added to their isolation. This long history of prejudice established the notion that these people constituted a race; in fact, the modern term "village people" officially replaces all other prejudicial appellations for them.

The Meiji government, based on a more democratic principle of parliamentary representation, did assign citizenship equally to all Japanese. This in itself, however, did not solve the problem for the victims of discrimination: the designation "new citizens" clearly distinguished them from everyone else. Even the intellectuals of the time were not free from this prejudice, though a few novelists made sympathetic efforts to represent the suffering of the peripheralized. Oguri Fūyō (1875–1926) launched his career with the short story "Makeup before Bed" (Neoshiroi, 1896), a sensitive study of the psychology of a woman and her brother, both "villagers," who are driven to an incestuous relationship. Shimazaki Tōson's (1872–1943) novel The Broken Commandment (Hakai, 1906) was the first to depict the struggle of a member of this group and his identity as a "new citizen." While village people became objects of well-intended observation by educated writers, they themselves remained voiceless.

Disease also cast its dark shadow from old Edo onto Meiji Tokyo. Syphilis and tuberculosis had spread among Edo's poor and the diseases continued to afflict those who populated the less reputable regions of Tokyo. Both ailments, thanks to the development of modern science, came to be understood as serious, though treatable, communicable diseases. While syphilis and other venereal diseases were either ignored or treated comically in Edo literature, Meiji authors such as Iwano Hōmei (1873–1920) and Nagai Kafū (1879–1959) dealt with them as part of the sinister reality faced by their main characters. Under the influence of Western literature, tuberculosis, while being stigmatized in Meiji society, was elevated in literature to the level of a romantic condition. The Cuckoo* (Hototogisu, 1898) by Tokutomi Roka (1868–1927) presents a heroine infected by the disease, her illness igniting the novel's familial conflict and evoking the reader's sympathy. While tuberculosis was romanticized using Western literary models, leprosy (Hansen's Disease) received divided responses. Popular religions considered the disease a sign of karmic retribution, while new medical science regarded it as a treatable disease. The illustrated novel Takahashi Oden, Devil Woman* (Takahashi Oden Yasha Monogatari, 1879) by Kanagaki Robun (1829–1894) proudly announced the establishment of a public Hospital for the Cure of Leprosy, indicating that enlightened institutions of the time had targeted the ailment for public improvement. As a final note, not all Meiji-era discussions

of disease focused on those inflicting Tokyo's poorer populations: "nerves" (*shinkei*) was a modern disease often found among the educated. A number of novelists, including Natsume Sōseki, suffered from this condition, which was taken as a sign of a modern sensibility and a keen sensitivity toward the world. San'yūtei Enchō (1839–1900) demonstrates his modernity by the use of the word "nerves" in the title of this staged story, *A True View of Kasane Precipice** (Shinkei Kasanegafuchi, performed 1873). *Shinkei*, a homophone for "true view" and "nerves," playfully suggests both the "true view" of the magical forces that caused serial crimes and also the "nerves" that imagine such forces.

Meiji writers familiarized themselves with the peripheralized and the diseased, also exploring the darker side of human psychology. The unflinching realism of Iwano Hōmei exposed a previously concealed side of intellectual life, depicting autobiographical protagonists who enacted and reacted to the issues of poverty, fraudulence, venereal disease, as well as racial and gender discrimination. Hōmei wove together a voluminous cycle of prose fiction that treats these modern issues. For example, his short story "Back to Back" (Senaka-Awase, 1910) describes the murder of a small, mentally disabled child by young parents who are exhausted from caring for her. Because the narrator takes the same ethically detached stance as the protagonist, sympathy is neither shown nor expected. In this way, the psychological demons of the intellectual class show the interior landscape of modernity to be even darker than the exterior one described in the slums of Iwagorō's work.

Crime—theft, robbery, rape, murder, extortion, and all types of fraudulence—was rampant during the Meiji period. The push to modernize Tokyo exacerbated the national economic crisis and its impact on the poor of the city. The government's incentive for modern capitalism and the new banking system paved the way for venture businesses, often open to manipulation by underhanded schemes. Crime narratives were a natural product of the social climate of the time, and works in this genre took advantage of the themes and rhetoric of earlier storytelling. Under similarly frustrating political conditions, late Edo citizens had wallowed in representations of murder, theft, extortion, and other vile crimes, but due to the Edo law banning the depiction of contemporary events, the thugs glorified on stage or in print were imagined or placed in historical time periods. The Edo genre of "combined volumes" (*gōkan*) intiated by Shikitei Sanba and Utagawa Toyokuni I featured the criminal lives of fictional antiheroes and survived far into the Meiji period. Thanks to a new law, Meiji crime narratives were largely based on the lives of real felons and drawn from contemporary newspapers. Meiji authors exaggerated the Edo models by glorifying dashingly colorful felons, including real-life mob bosses, genius con men, and femmes

fatales. Perhaps the sense of hopelessness that pervaded the oppressed classes drove them to the momentary satisfaction of identifying with larger-than-life rogues who dared to stand up against the system by breaking the law.

Popular stage productions competed with these salacious texts by borrowing and inventing bad-guy characters. The late-Edo playwright Tsuruya Nanboku IV (1755–1829) created crooks on a monstrous scale, some with magical powers and others with seductive charm, making his stage red with blood. Nanboku's brutality found a match in the dramatist Kawatake Mokuami (1816–1893), whose late-Edo taste for crime helped him thrive in Tokyo's entertainment world. His plays featured gorgeous hustlers—male, female, and sometimes transgender. In a similar way, Edo-style one-man oral performances of "human-interest stories" (*ninjōbanashi*) featured felons drawn from Edo kabuki and prose fiction, as well as town gossip. *Rat Boy** (published version 1913), narrated by Shōrin Hakuen II (1832–1905), featured the myth of an Edo thief that remained popular among the masses.

The outlaws in these narratives were largely based on contemporary figures and actual news items, and the stories often combined fictional plots set in Edo with modern police and judicial methods. They appeared alongside nonfiction reporting in local newspapers, which comingled fiction, contemporary news, and ongoing scandals. Popular performances and pictorial representations exaggerating cruelty, violence, and social enmity. Blatantly anti-intellectual and politically frustrated audiences demanded gruesome details, necessitating longer narratives either on stage or in print. They demanded pictorial representations with sadistically gaudy colors, which had become widely available through cheap imports from China. Ukiyo-e pictures began to encourage illustrated serialized stories in newspapers. Long narratives of this period began to develop a novelistic plot structure, a symptom of the Meiji audience's desire not only to follow the causes and effects of a crime but also to reach a satisfying conclusion in which justice is enforced and wrongdoers are punished. Instead of the old Confucian principle of "encourage virtue and punish vice," Meiji fiction highlighted the intelligence and authority of law and evidence and testimony-based judgments.

MONSTERS AND THE SURREAL IN DOWNTOWN ARTS

The same socioeconomic context that encouraged the popularity of bloody violence also spurred the exploration of the weird as a theme in the arts. By borrowing from Edo models and, at the same time, departing from them, stories of the weird joined crime fiction as popular fare in Tokyo. At the beginning of the Edo period, the medieval belief in supernatural powers inspired new literary forms that would eventually be developed into full-blown

representations of ghosts and monsters during the mid-Edo period, when well-known supernatural beings would be featured in elaborate pictorial and verbal forms. In the downtown Edoite imagination, all regions outside the city limits were populated with sorrowful ghosts, vengeful spirits, the *tengu* (mountain goblins who abducted children), the *kappa* (a mischievous water spirit with webbed feet and hands), the *tanuki* (a shape-shifting raccoon dog), and the fox (which could also take on various forms). Representations of ghosts and monsters in text and image, as well as onstage, were new creations that did not necessarily derive from earlier folktales. They belonged to what some modern scholars call the "folkloresque." However, it is important to note that although these spooky entities, or *yōkai*, were often newly imagined, they also lived alongside humans, so that people's daily reality included en-counters with the inexplicable, following traditional Edoite beliefs in the supernatural.

This fascination with frightening ogres and unexplainable manifesta-tions of Edo popular culture remained very much alive among downtown Tokyoites. Plays by Nanboku and novels by Kyokutei Bakin (1767–1848) merged themes of crime and magic by pursuing stories of curses, revenge, and punishment that featured grand criminals as well as *yōkai*. During the Meiji period, the merged themes and images were pursued particularly by human-interest storytellers and by ukiyo-e artists. Kawanabe Kyōsai (1831–1889) created what might be the most visually imaginative creatures of the period. He, like many others, took advantage of these themes, which al-lowed for new types of visuality and theatricality; and this coming together of creative exploration and popular demand translated into marketability for not just artists, but also for their publishers and producers. Partly because of nostalgia for "good old Edo" and partly from a long-cultivated taste for the mysterious and unreal, downtown Tokyoites created a subculture that was counter to the Enlightenment. Meiji taste favored stories of crime and the supernatural in newspapers and books. Even reportage such as that col-lected in "Monsters! Monsters! Read All about It!"* featured the appearance of *tanuki* and other folkloric creatures in the urban environs of Tokyo, pre-senting objective journalism in a tongue-in-cheek tone.

Countering the allure of the extraordinary in literature, the rationalist discourse of the Meiji period condemned portrayals of the supernatural as the yet "unenlightened" part of Tokyo's culture. While not completely de-nying the existence of the mysterious, Meiji intellectuals tried to distance their narratives from what they considered "base superstition." Inoue Enryō (1858–1919), a Buddhist philosopher, founder of a university, and the ac-knowledged "father of *yōkai* studies," was the first to intellectualize the magi-cal and weird by establishing a scientific taxonomy of ghosts and monsters

as metaphors for various psychological disorders. He proposed approaching the supernatural from the perspectives of physics, chemistry, biology, and so on, and emphasized the psychological cause of the supernatural. Under his influence, the "enlightened" population came to attribute the appearance of weird beings as symptoms of "nerves."

Toward the end of the Meiji period and coming after Inoue, Yanagita Kunio (1875–1962) took the opposite approach to tales of the eerie and weird, becoming the founder of folklore studies in Japan. A poet-turned-bureaucrat, Yanagita continued his literary activities as a critic and essayist. Writing for the *Asahi* newspaper's editorial column, he collected and published stories from various regions of Japan. His first collection, *The Tales of Tōno* (*Tōno Monogatari*, 1910), attracted much attention among literary writers and critics. The transmission of authentic oral narratives was viewed as an anthropological project, and thus appropriate for the quickly developing age of realism. Yanagita's stories supposedly conveyed voices directly from the country, as it were, and his writing style was considered compellingly simple and ingenuous. Yanagita's several collections and essays were closely followed by Orikuchi Shinobu (1887–1953) and other students, who together formed the original body of folklore studies in Japan. Unlike Inoue's, Yanagita's writings inspired the literary writers of the period, many of whom expressed a fondness for the uncanny and grotesque. Authors like Sōseki, Kafū, and Tanizaki could utilize such stories to create a body of literature that counteracted dominant trends toward mimesis and logocentrism. These three authors, like many others, were proficient enough in European languages to find resonances with the gothic works of Charlotte Brontë and Mary Shelley. The combination of Japanese folklore with gothic fiction created a uniquely surrealist mode of Japanese writing. The eeriness of folklore and the mire of romantic desire crystallized in the works of Izumi Kyōka (1873–1939). Beginning with his novella *The Holy Man of Mount Kōya* (*Kōya Hijiri*, 1900) and followed by his plays, such as *The Castle Tower* (*Tenshu Monogatari*, 1918), much of his corpus features imagery framed with the erotic and aesthetic senses. The short story "Messenger from the Sea"* (Umi no Shisha, 1909), describing a jellyfish, is a prime example of Kyōka's aesthetic sensuality, which draws the reader's attention not to any sharply articulated social point but to the surrealistic beauty of the image itself as it shifts and changes in appearance.

The romantic use of the weird belonged to Meiji highbrow literature, which influenced writers like Tanizaki, but popular interest in the criminal and the weird has survived and even blossomed in today's media culture. Manga comics by Mizuki Shigeru (1922–2015) have featured newly invented *yōkai,* and are so popular that they have turned into films, such as *The Great*

Yōkai War (*Yōkai Daisensō,* 2005). The anime filmmaker Miyazaki Hayao (1941–) has become a media star internationally because of his master-pieces, including *Nausicaä of the Valley of the Wind* (*Kaze no Tani no Nau-shika,* 1984), *Princess Mononoke* (*Mononoke Hime,* 1995), and *Spirited Away* (*Sen to Chihiro no Kamikakushi,* 2001), which not only present uniquely de-signed *yōkai,* but also explore questions of the environment and the future of the human race by way of the supernatural. In narrative fiction, Kyogoku Natsuhiko (1963–) reinvents folktales and crime stories by pursuing the psychological interiority of his characters. His books, such as *The Summer of the Ubume* (*Ubume no Natsu,* 1994) and *The Wicked and the Damned: A Hun-dred Tales of Karma* (*Kōsetsu Hyaku Monogatari,* 2003), have been translated into English. In our century, the folkloresque has reached its peak.

EDUCATION FOR THE NATION

Under the Tokugawa regime, nobility, clergy, and samurai took advantage of a well-developed educational system, chiefly based on classical Chinese and Japanese philosophy, history, and literature. Official academies under the auspices of the daimyo rulers vied with one another in educating the younger generations of samurai families within their domains. The shogu-nate sponsored the Shōheikō School for the Confucian education of younger members of *hatamoto* and other samurai families. In addition, individual scholars ran private academies where their followers, including members of the merchant class, gathered to learn. These scholars taught Neo-Confucianism, Japanese nativism, and Dutch Studies, as well as specific forms of classical poetry and art. Commoners were eager to better their stations, and boys and girls had access to elementary education through small-scale schools taught by low-ranking or jobless samurai. In addition, tutors for song, dance, and calligraphy prospered as commoners sought to improve their lot and broaden their enjoyment of life. Literacy among Edo citizens was already admirably high, sufficient to support numerous publishers as well as countless lending libraries throughout the period. By the eighteenth century, literacy rates in Edo were among the highest in the world.

In 1880, the new Meiji government passed laws to unify education throughout Japan, taking models from European countries. The new system transformed old facilities, such as temples and private academies for samurai and common citizens, into new venues for this national project. The regimen of the early Meiji system aimed at a unified and Tokyo-centered training of the young. The Ministry of Education announced a new system that divided Japan into eight university districts, over two hundred middle school dis-

tricts, and about fifty thousand primary school districts. Primary schools (ages six to thirteen) and middle schools (ages fourteen to nineteen) taught traditional skills such as calligraphy and music along with geography, physics, and other such modern subjects. High schools, rather on the level of our colleges today, added specialized subjects like chemistry, geometry, and economics. Of course, resistance to the national systemization of education did occur, particularly in rural areas where families and villages were accustomed to educating children according to their own and their community's needs and principles.

Similar to our graduate schools, academically specialized universities came into being in 1878, when the national University of Tokyo (called Tokyo Imperial University from 1886 until 1945) was established. The University of Kyoto followed. The chief national universities focused on training young Japanese men in medical sciences, languages, and Japanese and European humanities in the spirit of "catching up with the West." Historically, foreign dignitaries studied at these universities, returning home to become kings, prime ministers, and other national leaders, which probably helped facilitate Japan's diplomatic relations with other countries and promote its nationalistic causes. In fact, the university system itself supported Japan's colonialist project: an Imperial University of Seoul and another of Taiwan were established when Japan occupied those countries.

Girls' schools and women's colleges were a modern phenomenon. Government incentives during the first few decades of the period helped to establish girls' schools on the primary- and middle-school levels. These schools emphasized practical subjects such as household management, sewing, and reading as well as "womanly" arts such as etiquette, instrumental music, tea ceremony, and flower arrangement. Upper-scale schools for girls between the ages of four and eighteen focused primarily on mathematics, calligraphy, geography, history, and the English language. A Girls' Peerage School was established by the government in 1885 as a version of the all-male Peerage School earlier established in 1847. These national schools represented the language and culture of Kyoto-based imperial traditions and, as such, became a pinnacle of high culture. Normal schools provided the training needed for teachers in newly established primary and secondary schools. Tokyo Normal School for Women (founded in 1874) was a women's version of Tokyo Normal School, which went on to establish similar schools in various regions of Japan. Tokyo Superior Normal School for Women (established in 1890) became one of the leading national schools for teachers and, later, a women's university. These schools would later nurture women writers as well as leaders in women's movements.

THE CONTRIBUTION OF FOREIGN TEACHERS

As soon as negotiations regarding the 1854 signing of the Treaty of Amity and Commerce between Japan and the United States began, the colonial intentions of the United States, among other Western nations, became readily apparent. In the end, the treaty that the shogunate was compelled to sign was as unequal as the one signed between Britain and China. The shogunate's only path was to ask for an amendment of the treaty by challenging the premise that Japan was so barbaric and weak that it required the protection and guidance of the United States. For that purpose, Japan urgently sought to learn about the West in order to appear as modern and rigorous as the leading nations of the world. As a result, in 1860 the shogunate sent a select number of samurai and intellectuals to the United States and Europe aboard the *Kanrinmaru,* a steam-powered battleship owned by the shogunate, as it accompanied the USS *Powhatan,* which carried Japan's first official mission to the United States.

The shogunate's purpose in sponsoring the mission was not to rectify the imbalance in the treaty through direct contact with the West. Rather, it was to give many prominent leaders in Japan's society a chance to directly observe and experience Western countries. The journey, an effort to learn about Western modernization, contributed immensely to the foundation of the Meiji project for progress. The mission's leader was Katsu Kaishū (1823–1899), a samurai specialist on Dutch studies and military science, who was in charge of the shogun's navy at the time. The same delegation also included the aforementioned Fukuzawa Yukichi, who later became the strongest theorist and proponent for Westernization under the Meiji government. Another member of the mission was Nakahama Manjirō (1827–1898), alias John Mung, today commonly known as "John Manjirō," thanks to the biographical novel by Ibuse Masuji (1898–1993). After being shipwrecked as a teenager and educated in the United States, Manjirō had returned to Japan and served the Satsuma and Tosa domains until the shogunate appointed him teacher of English and shipbuilding. On the *Kanrinmaru,* he became an interpreter for the Japanese delegation and, upon his return, was appointed a professor of English at what became the University of Tokyo.

As part of the government's agenda of enriching and strengthening the country through military and industrial development, a great number of foreigners were invited either by the government or by the private sector, generally for very high salaries. During the first two decades of the Meiji period, approximately ten thousand technicians, scholars, and teachers came from the United States, England, France, Germany, China, and other countries, fostering Japan's modernization in education, law, industry, science,

and the arts. Christianity, banned during the Edo period, now returned to Japan along with these foreign teachers and consultants. Christian churches thrived, but the Protestant faith, tied to the ideals of rationality and equality, was understood, as already noted, more as a philosophy than as a religion. Although it cast a strong influence on Japan's intellectual leadership, it did not gather large numbers of converts from the masses.

Two notable foreigners shed light on the connection between the importation of Enlightenment sciences and the spread of Christianity in Japan. James Curtis Hepburn (1815–1911), a Christian missionary and physician, famously amputated the gangrenous leg of kabuki star Sawamura Tanosuke III (1845–1878). Hepburn's fame as a surgeon was such that in Kanagaki Robun's fictional account of the "poison woman" Takahashi Oden, the heroine takes her leprous husband to Yokohama, hoping for consultation with Hepburn. The chemist and botanist William Smith Clark (1826–1886), on the other hand, came to Japan as a specialist in agricultural education in order to help establish the Sapporo Agricultural School (now Hokkaido University). Although he stayed in Japan for only nine months, he became legendary because of the advice he gave to his students. "Boys, be ambitious!" became a national slogan for progress, and was expressive of the Christian zeal that turned some of his students into Japan's greatest Protestant leaders. Among his former students were Uchimura Kanzō (1861–1930) and Nitobe Inazō (1862–1933), each of whom studied in the United States and later returned as educators to lead Christian congregations in Japan.

Among the visiting foreigners were several who stimulated the development of the arts. The Italian Edoardo Chiossone (1833–1898), who was initially brought to Japan as a lithographer to design banknotes, stayed to teach lithography classes and founded the Toppan Printing Company, which still exists as a premier printer of artistic reproductions. Josiah Conder (1852–1910), a British architect who came as a professor of industry, designed Tokyo's most famous Western Enlightenment buildings, including the Deer Cry Pavilion and St. Nicholai's Cathedral. Ernest Francisco Fenollosa (1853–1908), an American art historian who taught at the University of Tokyo, had a tremendous influence on the development of philosophy, aesthetics, and art history in Japan. He and his student Okakura Tenshin (1862–1913) worked to establish what later became the Tokyo Institute of Fine Arts. In 1890, he returned to head the East Asian department at the Boston Museum of Fine Arts, which still holds his considerable collection of Japanese art.

Several other prominent figures played roles both as professors in the newly established universities and as writers who popularized Japanese culture in their native languages. Patrick Lafcadio Hearn (1850–1904), a

Greek-born American journalist, came to Japan in 1890, married a Japanese woman, and changed his name to Koizumi Yakumo. He taught at the Imperial University of Tokyo and Waseda University and is still remembered as the author of gothic tales and essays about Japan's landscape and customs. Basil Hall Chamberlain (1850–1935), a British linguist who taught at the Imperial University of Tokyo in 1886, stayed for thirty-nine years and trained prominent Japanese linguists. He also translated Japanese myths and haiku into English and wrote guidebooks and glossaries on Japan.

Some of the most important figures both within and outside Japan cast a strong influence on contemporary artistic trends in Europe. Pierre Loti (1850–1923), a navy officer and famous travel writer, stayed in Nagasaki for only two months, but the novel resulting from his experience, *Madame Chrysanthème* (1887), became immensely popular in Europe. He was the first to portray the lasting stereotype of the exotic Japanese woman, which became a symbol for Japan as a beautiful and helpless Other. The novel, with its chauvinistic and orientalist overtones, had considerable influence on the rise of French Japonism. Puccini's *Madama Butterfly* shared the same image of a beautiful Japanese woman, and is evidence of the popularity of the motif in the West's perception of Japan. Georges Ferdinand Bigot, a French illustrator and cartoonist, came to Japan in 1882 to teach at the army officers' school. His satirical sketches and prints on Japan, some of which are included in this volume, inspired a genre of highly political cartoons by his Japanese counterparts.

JAPANESE EXPLORATION ABROAD

Another and more elaborate attempt at exposing the Japanese to Western civilization was the Iwakura Mission. Led by Iwakura Tomomi (1825–1883), a former imperial nobleman from Kyoto and the first minister of foreign affairs under the Meiji government, the mission was headed by five government leaders from the powerful Satsuma-Chōshū faction. Accompanying these noblemen were many former retainers of the shogun acting as secretaries and interpreters, on whose technical knowledge and English proficiency the success of the mission depended. For the cause of educating women, five girls were appointed to travel with them. Their voyage took them to San Francisco, and then across the American continent to visit Washington, DC, crossing the Atlantic to visit England, France, Belgium, the Netherlands, Germany, Russia, and other countries. On their way back, their travels concluded with visits to Asian colonies under European control, arousing a national ambition of becoming "equal to" Western countries in all possible ways.

Nakae Chōmin (1847–1901), a samurai from the Tosa Domain, left the Iwakura Mission to stay in Paris and Lyon. The translator of Rousseau's *Of the Social Contract* (1762), he taught principles of civil rights and became the founder of liberal-minded newspapers, publishing houses, and the School of French Studies. As founder of the Liberty Party, he also took part in the establishment of the Constitutional Liberty Party in 1891. He was considered the "Rousseau of the Orient" and was the teacher of Kōtoku Shūsui, the greatest political rebel of the period.

The five girls in the mission later became important leaders of feminism in Japan, particularly Tsuda Umeko (1864–1929), daughter of a former shogunate samurai. Only nine years old when she joined the mission, she was informally adopted by an American family so that she could attend school in the United States. After her return to Japan, she taught English briefly before studying biology at Bryn Mawr College. In 1900, she established the Women's English College, now Tsuda University, which promised women of all social backgrounds the same education offered to the nobility.

Although the Iwakura Mission may have been unsuccessful in negotiating a favorable amendment to the Treaty of Amity and Commerce, it did provide opportunities to individual Japanese citizens to directly encounter the West. Noguchi Yonejirō (1875–1947), better known by his pen name Yone Noguchi, studied at Stanford University. He published poems in English and, upon his return, became a professor of English literature at his alma mater, Keio University. As a result of his lecture tour to Oxford University, he became friends with George Bernard Shaw, H. G. Wells, and others. In 1919, he went on to lecture in the United States. Although he was recognized as a poet in Japanese as well, his works were more widely read and acclaimed in English.

Another such scholar was Okakura Kakuzō (1863–1913), commonly known as "Tenshin." He associated with foreigners in the port city of Yokohama and trained at the language school established by James Curtis Hepburn. On the strength of his knowledge of English, he was hired as an assistant to Ernest Francisco Fenollosa and accompanied him to the United States and Europe. William Sturgis Bigelow (1850–1926), an American physician turned collector of Japanese art, was part of Fenollosa's circle and helped establish the Tokyo School of Fine Arts. At Bigelow's invitation, Okakura took a position as director of the Japanese division at the Boston Museum of Fine Arts. Earlier active in theater and literature, with broad connections among artists in Japan and abroad, Okakura wrote mostly in English on Japanese and Asian thought. *The Book of Tea* (published in New York in 1906) was his most famous work. Politically, he was a dedicated proponent of pan-Asianism, unlike his close associates in literature and the arts.

Although Western oil painting had been studied by the Japanese since the eighteenth century, it was not until the Meiji period that a large number of artists rode the tide of Enlightenment and ventured to go to Europe to study its techniques. Kuroda Seiki (1866–1924), a samurai from Satsuma who became a viscount under the Meiji system, studied in Paris between 1884 and 1893 to become one of the pioneers of impressionism in Japan. His portrait of the heroine of Tokutomi Roka's *The Cuckoo** is included in this volume. The artists who studied in France or Italy inspired Japonism among European impressionists such as Vincent Van Gogh and Claude Monet. They returned to develop modern genres in oil and watercolors, adapting European techniques to both Western and Japanese themes. It was they who graced newly founded literary journals with illustrations and cover designs. The most conspicuous was Fujita Tsuguharu (1886–1968), also called Léonard Foujita, a painter and sculptor, who attained fame worldwide for the marble-like skin he created on canvas. His work in France earned him a Légion d'Honneur.

Among literary writers who studied abroad, the most well known were Mori Ōgai (1862–1922) and Natsume Sōseki, both sent by the government. Ōgai spent time in Leipzig and Dresden, where he joined high society and studied bacteriology with Robert Koch in Berlin. Upon his return to Japan, he became a leader in medical science, but his chief achievement in life was literary. As a major romantic poet and novelist, he drew upon his experiences in Europe for his fiction writing, before turning to Japanese historical fiction later in life. He gained literary fame with the novel *The Dancer* (*Maihime*, 1890), which depicts, in the classical prose style, his love affair with a German dancing girl. His historical novels are written in a colloquially modern yet rhetorically high style, full of Chinese-based vocabulary. They reflect Ōgai's modern interpretation of Japan's past, including conflicts between individual desire and the ethical principles of society. Detachment characterizes the description in his best-known work in this category, *The Abe Clan* (*Abe Ichizoku*, 1913), in which suicides and mutual killings within a failing clan are depicted in the style of a historical record.

Sōseki's sojourn in London was not characterized by the same glittering experience Ōgai enjoyed in Europe. He was disappointed by the university's methods of teaching and took a private tutor for reading British literature. Although his poetry and diary testify to his fluency in English, Sōseki was acutely aware that, as a Japanese man, he did not belong among the impressively attired English gentlemen who surrounded him, leading to the development of a marked inferiority complex that would later be reflected in his work. Upon his return to Japan, Sōseki began to teach English literature at the University of Tokyo, succeeding Lafcadio Hearn, but soon found

his students and colleagues equally inadequate. His disdain for the state of Japanese education led him to decline a literary doctorate from the Meiji government, an honor which Ōgai gladly accepted with appropriate pomp and ceremony. After leaving the university, Sōseki found steady employment as the first serial fiction staff writer for the *Asahi Shinbun*, a position that revolutionized the role of newspapers in the development of new literary writing. All of his novels, from *I Am a Cat* (*Wagahai wa Neko dearu*, 1905) and *The Three-Cornered World* (*Kusamakura*, 1906) to *Kokoro* (1914) and the unfinished *Light and Dark* (*Meian*, 1916), were published serially in the paper. His writing style is characterized by highly creative rhetorical figures, through which he explored the dark side of modern individuality. Throughout his works, including *Short Pieces from Long Spring Days** (*Eijitsu Shōhin*, 1909), Sōseki's relaxed descriptions of the real and mysterious explored themes such as egoism and the suffering that results from the difficulties of love, family, and friendship. He was also the first theoretical and comparative critic of modern literature, as seen in "A Theory of Literature" (Bungakuron, 1907) and "A Critical Study of Literature" (Bungaku Hyōron, 1909). Ōgai and Sōseki, then, represent two opposite responses to Western people and civilization. While Ōgai's ostentation and exhibitionism illustrated the spectacle of Japan's modernization, Sōseki's stay in London brought him misery, as he became lost in isolation and fraught with anxieties of Japanese inferiority. While Ōgai embraced self-exoticism as a social tool, Sōseki was oppressed by his own sense of Otherness.

NEW WOMEN FOR THE NEW AGE

The reshuffling of classes and the ever-changing educational system created a new linguistic topography in Tokyo. During the Edo period, spoken language was divided into regional, class, and professional dialects but, within each group, there was no fundamental difference between the speech patterns of men and women. In contrast, gender differences emerged in the dialect of the samurai class as men developed something of an official samurai speech style consistent with their formalized code of conduct. Among downtown Tokyoites, commoners' speech survived the Meiji Restoration, while the official samurai style provided the foundation for what became modern educated male speech. With the development of private schools, which were attended by the sons and daughters of nobility, public officials, and affluent businessmen, differing speech styles for each sex gradually arose. Affecting childlike innocence and an attitude of superiority, those who sought to rise in social standing quickly adopted the utterances of upper-class

schoolgirls and schoolboys. This speech spread to form the core of the uptown Tokyoite language, which came to be featured in dialogues in the newly cultivated novels of the time. A dialect specific to girls' schools, with its specialized jargon, cast a strong influence on the formation of modern urban women's speech, continuing even to this day.

This gender separation through language was primarily inspired by newly adopted Western notions of the independence of the soul from the body, which came to have many repercussions. The Japanese conception of human relations had not traditionally separated spirit and body, so no demarcation had been drawn between love and erotic desire. While the downtown folk maintained the old Edo tradition in which love was understood as both sentimental and sexual, Christianity and Western Romanticism prioritized the soul over the body, and the enlightened uptown culture valorized romantic love as separate from sexual pursuit. Influenced by European Romantic and Victorian arts, Japanese culture, particularly among the elite, imitated these Western models and thus began to ascribe value to women's virginity and feminine propriety. Despite all the talk about the equality of citizens in the country, all positions in the political and bureaucratic systems, whether national or local, excluded women. Graduating from a women's normal school to become a teacher afforded women one of the era's few career options. Indeed, business and other professional fields accommodated women much less than had been the case during the Edo period. Marriage in the Meiji period offered the two most conspicuous options for women to exert political influence in Japan. The wives of high-ranking officials or of successful businessmen and those women who conveyed their views as radical speechmakers, often with the open support of their spouses and male friends who were leftist leaders, were able to establish a notable presence in the Japanese media of their time.

Ambitious young men of all social classes fully benefitted from the higher education made available by the Meiji democracy. Rising from their various beginning points, they could become government officials, politicians, diplomats, and bankers. The most motivated among them would venture into newly created sectors of business and industry such as railroads, electricity, mining, and international trade. The most successful professionals in these careers joined the ranks of the nobility and, in their display of power and wealth, formed the most envied part of uptown Tokyo. Under this Enlightenment project, literature and the arts suddenly became essential activities for the highly educated. Literature, which had previously been considered only a leisurely hobby or a commercial endeavor in the Edo period, became a respected art form that drew young men from all regions of Japan to Tokyo in pursuit of higher education and potential writing careers.

Up to the end of the Edo period, marriage was arranged between families among the samurai and, sometimes, affluent merchants. For the majority of commoners, however, social and erotic encounters turned easily into matrimony. The new concept of marriage that spread in the uptown society differed from the traditional custom in two primary ways. First, uptown Tokyoites theoretically rejected the old notion of "family," which perceived marriage as just one link in a vertical structure honoring not only the senior family members but also the ancestors. This structure had traditionally ensured passing on what has been acquired to the descending generations. Second, proponents of liberty and equality came to view marriage as a monogamous union of equal rights between a man and a woman. This ideal was introduced and propagated chiefly by Fukuzawa Yukichi under the influence of Puritan American practices. This new Enlightenment concept of "home" (*katei*), consisting of the male-female couple and their children, was in opposition to the traditional "house" (*ie*), or multigenerational family. The idealized image of a modern home was widespread among the educated elite but was still far from the reality of Tokutomi Roka's *The Cuckoo*,* in which the modern discourse of "home" clashes with the traditional one of "house," leading to a tragic conclusion.

Generally, the gap between the romantic ideal and persisting practice bred double standards: while the wife was required to be monogamous, the husband continued to enjoy the freedom of sexual promiscuity. Men had access to the flourishing sex industry, chiefly focused in Yoshiwara and other "pleasure quarters," which remained havens for a great variety of social activities, including artistic gatherings and impromptu theatrical performances. High-ranking men, most particularly Prime Minister Itō Hirobumi himself, were central fixtures not only of the diet and congressional buildings but also of hotels, restaurants, and brothels in districts like Yoshiwara. The satirical song "Oppekepe"* (1889), performed by Kawakami Otojirō (1864–1911), attacks the sexual conduct of high officials and the rich, exposing their infidelity as a sign of the corruption that was undermining the promise of Meiji Enlightenment.

Educated women likewise protested the hypocrisy and double standards. They were exposed to the same Western models as men but focused their attention on women's roles within Japan's emerging modernity. They compared their rights with men's and highlighted obvious limitations on their opportunities for actual freedom. Public speeches by women were a new phenomenon, and early feminist speakers drew both passionate female followers and intellectual male sympathizers while garnering fierce criticism from the conservative public as well as from members of Prime Minister Itō's legislature. Nakajima Shōen, née Kishida Toshiko (1863–1901),

emerged as a teenage feminist orator in 1882 and was arrested the following year for speaking against the unfair treatment of girls by their families. She famously spoke to women in her essay series, *To My Fellow Sisters** (1884), and later addressed male readers on the subject of gender relationships and family. Her marriage to Nakajima Nobuyuki (1846–1899), a former Tosa samurai who became a soldier in the Chōshū army and eventually a member of the Meiji government, demonstrated a strong ideological tie between Tosa-based principles of liberty and early Japanese feminism. Fukuda Hideko (1865–1927), admirer of Shōen and follower of Itagaki's Liberty and Civil Rights Movement, emerged as a militant activist and speaker. Her extremism and vociferous dissent first caused her expulsion from a Bible study group led by Uchimura Kanzō, a celebrated Christian writer and antiestablishment critic, and later resulted in her imprisonment.

WOMEN'S ACTIVISM AND WRITING

Despite the opposition many feminists faced during the Meiji area, the idea of women writers was not foreign to the Japanese tradition. In the Heian Court (794–1185), well-educated women left behind gothic romances and piercingly perceptive essays written in courtly Japanese, *The Tale of Genji* and *The Pillow Book* foremost among them. During the Middle Ages, the number of women writers decreased, and their efforts were largely confined to poetry. During the Edo period, the shift of readership to commoners tended to place women among consumers rather than producers. To be sure, women continued to write poetry, sing ballads, and keep records of their personal lives, but the second efflorescence of women writers did not occur until the privileges of the few began to become the privileges of many.

One of the first to make her mark was the short-lived though prodigiously talented Higuchi Ichiyō (1872–1896). Her lyrical yet analytically insightful stories about the poor and marginalized people of Tokyo were written in a number of styles, suggesting the newness of the project to which she so bravely gave herself: mixing classical and colloquial Japanese in order to tell her stories about common life. Drawing from her reading of Lady Murasaki and Ihara Saikaku (1642–1693), she was both a romantic and a realist, and readers continue to appreciate her lovingly crafted documentation of the mores of her age. Although she was not a militant feminist, Ichiyō's criticism of the established system was conveyed through irony, as was the case with Lady Murasaki.

More obviously feminist was Yosano Akiko (1878–1942), poet and critic, who simultaneously impressed and scandalized Japan's reading public

with her poetic collection *Tangled Hair** (1901). Openly erotic and affirming of physical desire, her poems paid narcissistic attention to her own body, inspiring a new awareness of the sexual self as well as the possibilities of "free love." Wife of Yosano Tekkan (1873–1935), the charismatic man who founded and managed the influential journal *The Morning Star* (*Myōjō*, 1900), Akiko was a prolific contributor to the journal and became an influential force in the movement to revitalize classical poetic forms. Unsympathetic with the growing militarism of her day, she famously wrote a poetic response to the Russo-Japanese War. "Brother, Do Not Die!" (Kimi Shinu Koto Nakare, 1904) openly attacked the government and the emperor for their willingness to sacrifice the lives of Japan's youth for questionable political causes. Over her long career she continued to be an outspoken critic, an influential educator, and the mother of thirteen children, eleven of whom survived to adulthood. Another notably strong voice belonged to Tamura Toshiko (1884–1945), a disciple of the novelist Kōda Rohan. Turning from acting to writing popular novels, she later contributed to progressive journals. She gave voice to modern women's anxieties about the pursuit of erotic desire. Her colorful love life and experience abroad, which began in 1910, made her conspicuous even among the rebellious group of women of her time.

With their progressive politics and daring private lives, these women laid the groundwork for "New Women," an appellation for members of the women's movements that surrounded the journal *Bluestocking* (*Seitō*, 1911–1916). The New Association for Women (Shin Fujin Kyōkai), the first political organization by and for women, was founded by Hiratsuka Raichō (1886–1971), leading writer for *Bluestocking,* and Ichikawa Fusae (1893–1981), the first successful woman politician, along with other giants of Japanese feminism. The organization was short lived (1919–1922) but made a strong impact on women's consciousness through groups that formed after its demise. Demanding equal opportunities for women to exercise their abilities professionally, the organization was responsible for winning an amendment to laws that prohibited women's participation in political parties and activities.

Women Erudites (*Jogaku Zasshi*), established in 1885 and published until 1904, was the first full-fledged journal for women. Its founder was Iwamoto Yoshiharu (1863–1942), a sympathizer with women's rights, vice principal of a girls' school, the editor of a few Christian publications, and, finally, husband of Wakamatsu Shizuko (1864–1896), feminist essayist, novelist, and translator. *Women Erudites* provided a much-needed space for women and men to debate political and social issues. Wakamatsu was the journal's most

prolific contributor, but romantic poet and critic Kitamura Tōkoku (1868–1894), poet and novelist Shimazaki Tōson, Izumi Kyōka, and many other male writers of the time also wrote for the publication.

Women founded and edited the journals that would ultimately provide space for their voices. *Bluestocking* offered women an arena for discussing such controversial topics as prostitution, abortion, women's professions, women's literature, and women's suffrage. Its participants included such illustrious figures of the period as Yosano Akiko, Tamura Toshiko, Mori Shigeko (1880–1936, novelist and wife of Ōgai), Hiratsuka Raichō, Kamichika Ichiko (activist and politician, 1888–1981), Iwano Kiyoko (activist, politician, and Hōmei's wife), and Itō Noe. Contributors also included male sympathizers, such as Yosano Tekkan, Iwano Hōmei, and Abe Jirō (critic and philosopher, 1883–1959). The daring sexual lives of the journal's contributors and their political dissension resulted in censorship and soon spelled the end of the journal. Despite its short life span, however, the journal, as a hotbed of early feminism in Japan, influenced the development of feminist thought for decades. Women's political activities, including the publishing of journals, resonated with larger political movements led by men. Within these groups, women and men had close ties with one another as lovers, spouses, and siblings, and often shared a common fate, whether imprisonment, death, or fame.

Typically free of the activism of journals like *Women Erudites* and *Bluestocking,* women's monthly magazines that targeted a broader female readership also emerged toward the end of the Meiji period and later. *Women's Pictorial Magazine* (*Fujin Gahō*), a monthly journal with ample pictures and photographs that featured stories and advice on family life, fashion, food, and travel, was founded in 1905 and is still being published today. Responding to the demand of aspiring women readers, *Ladies Pictorial Journal* (*Shukujo Gahō,* 1912–1923) featured the lives of upper-class women, particularly of the imperial family and their relatives. *The Housewife's Companion* (*Shufu no Tomo*) was founded in 1917 and still flourishes as a practical magazine devoted to women's daily lives and self-help. *Women's Debates* (*Fujin Kōron*) grew out of a special issue of the monthly journal *Essential Debates* (*Chūō Kōron,* 1887–) featuring contributions from fifteen women writers. First published as an independent journal in 1916 and still occupying a firmly established position in the market, *Women's Debates* separated itself from the other women's journals of the time by having fewer pictures and more content concerning intellectual and social issues. In this sense, although not as polemically leftist, it is an offspring of *Women Erudites* and other earlier journals for women.

KABUKI AND THE DOWNTOWN ARTS

In the Meiji era, men and, in greater numbers, women played important roles in voicing modern concerns. These writers, female and male, who were politically engaged proponents of new literature, belonged to the uptown part of literary production. The downtown arts, on the other hand, remained influenced by Edo popular genres, where men took the lead as the inheritors of the predominantly male tradition. Genres of Edo fiction and poetry remained strongly influential, but the most conspicuous of these traditional arts was theater, which included kabuki plays and oral storytelling performances. Although kabuki was supposedly invented by a woman during the seventeenth century, it soon became unlawful to allow women to perform on stage. Following a subsequent ban on the use of young men in the role of women as well, kabuki developed a corps of trained *onnagata,* or grown men who took women's parts. *Onnagata* soon came to draw in not only the spectators but also artists who depicted kabuki as one of the chief attractions of theater. *Onnagata*'s fandom was mix-gendered. Pictorial evidence shows that a large part of the audience was comprised of women, but men monopolized production, from playwriting to acting to backstage help.

As the chief entertainment for the urban populace since the seventeenth century, kabuki was widely spread both within the city and without. Theaters began to establish themselves in major metropolitan centers like Kyoto and Osaka. In the shogun-controlled Edo territories, however, local or "small" theaters had been banned, and kabuki performances had been restricted to specific, government-sanctioned "large theaters." Before the Meiji government's ban on politically charged performances, the city's theatrical landscape finally approached that of other Japanese cities, supplying affordable entertainment to downtown audiences. The "small-theater" kabuki troupes chose their themes and plots according to downtown tastes, adapting plays written for the "large-theater" kabuki. Some of these "small theaters" still operate today in Tokyo.

Outside of the city, rural kabuki probably predated the earliest urban kabuki performances. This can perhaps be attributed to religious rites initially, but kabuki soon expanded to cover other forms of theatrical representation. These theaters present professional performances on a regular basis in present-day Japan. A notable example is the Ekin Festival, presented for a few days annually during the summer in Kochi Prefecture on the island of Shikoku. The color inserts in this volume include an example of a two-panel screen that served as a flashy advertisement for a rural kabuki production based on the legend of Kasane, a woman who avenges her murder by her husband's hand from beyond the grave. More intellectual efforts in modernizing

kabuki, however, were to be borne by the playwrights, actors, and produc-
ers of "large-theater" kabuki.

Kawatake Mokuami, the leading playwright of the time, attempted to
Westernize his work by adapting foreign plays for Japanese audiences. His
*Money Is All That Matters in This World** (*Ningen Banji Kane no Yo no Naka*,
1879) is a largely faithful adaptation of Sir Edward Bulwer Lytton's play
Money (1840), set in Japan and including characters whose names echo the
original sounds of the English. The plot is smoothly embedded in kabuki, as
the playwright finds a comfortable parallel between Victorian morality and
the sentiment-based ethics of popular Confucianism. Like most of his works
on contemporary life, what Mokuami called "Western-style kabuki" fea-
tures natural spoken language instead of the poetic seven-five syllable style
often found in his earlier plays. Mokuami also complemented his use of
more colloquial dialogue with more traditional Edo forms of kabuki acting,
as is easily seen in his use of *mie* poses, traditional affected tableaux actors
strike to show power or emotion.

The Meiji government's encouragement of depictions of contemporary
events and historical facts led to Mokuami's style of factual realism, as he
came to master the art of recreating contemporary news stories for the stage.
His *Spencer the Balloon Man and Asakusa's High Tower* (*Fūsennori Uwasa no
Takadono Spencer,* 1891) was a smash hit. The play combined a reenactment
of Englishman Percival Spencer's balloon flight in Ueno Park with an en-
counter between the popular storyteller San'yūtei Enchō and his delin-
quent estranged son as they find themselves together among the spectators
on the top floor of the famed octagonal twelve-story skyscraper in Asakusa.
The lead actor, Kikugorō V (1844–1903), even gave his opening speech as
Spencer in English. It was the time for foreign acrobats, magicians, and cir-
cus troupes to make a scene in downtown Tokyo. Kikugorō was quick to
draw from the spectacle these performances created as well as the topical
matters treated in these performances. In 1869, he played an Italian horse
rider named Giovanni, or "Joani" in Japanese, in a play entitled *The Echoing
Sound of the Circus Whip* (*Oto ni Kiku Kyokuba no Kawamuchi*), which re-
created on stage an equestrian show popular at the time. An illustration of
his performance as the balloonist Percival G. Spencer from England can be
found in this volume.

In many of his works, Mokuami presented a broad range of themes and
characters, Edo and contemporary, which helped him remain the favorite of
Meiji audiences. However, in spite of his adaptation of Western themes, his
modernized kabuki was disdained by the advocates of kabuki reform, who
found his popularity itself to be a symptom of Japan's backwardness. For the
reformists, the more enlightened work of Morita Kan'ya XII (1846–1897),

actor-entrepreneur, better fit the bill. Kan'ya, the first modern theatrical producer-manager in Japan, aimed at producing kabuki that was "presentable to the emperor and foreign guests," raising its status from mere downtown entertainment to a national institution. His new Shintomiza Theater, built near the district for foreign residents, was Western in style, appropriately imitating the nationalism of Napoleon III's glorious Paris Opera House. Dismissing the age-old system of hiring actors and negotiating with prospective sponsors for each production, he turned Shintomiza into a stock-financed corporation, removing the pressure of constant fund-raising and loans. He was also a talented public-relations man. Ulysses S. Grant's (1822–1885) attendance at Kan'ya's theater was widely heralded as evidence of Japan's successful Westernization. Kan'ya's vision was very much influenced by Fukuchi Gen'ichirō, better known by his pen name Ōchi (1841–1906), a former shogunal retainer and multilingual interpreter who became a journalist, author, and politician. Having been a member of the Iwakura Mission, he became one of the leaders of the kabuki reform movement of the 1870s. Besides modernizing facilities and management, Kan'ya attempted to raise the respectability of kabuki by addressing the concerns of educated audiences and adopting a more realistic style.

In kabuki, songs and their musical accompaniment remained traditional. In fact, music during the Edo period meant stage-derived songs presented with instruments such as the shamisen, the flute, and the drum. Those genres of songs that remained popular during the Meiji period descended from *jōruri*, dramatic narrative chanting inclined toward epic, and *nagauta*, similarly dramatic chanting but with a penchant for lyric. Both originated from puppet theater and kabuki, where acting was to embody the narrative lines and songs presented by the chanters with shamisen, drums, and flutes. Those two main genres had bred newer ones during the late Edo period such as *tokiwazu*, *tomimoto*, *kiyomoto*, and *ogiebushi*. *Meriyasu* grew out of space fillers in kabuki scenes, and *shinnai*, melancholic songs about tragic love, developed independently from theater through the activities of party entertainers and door-to-door performers. Meiji citizens, high and low, not only continued to appreciate songs of this time but also learned to perform them.

The uptown population of the city, backed up by the government's policies, favored European music. Some ukiyo-e pictures show scenes in which Japanese men and women play European instruments. Social events at Deer Cry Pavilion and at political leaders' mansions often included chamber music performances to which people danced. Well-bred young women were depicted in pictures and fiction playing the piano or the violin. To spread the enlightened music nationally, the government established a music research

center, which became the Tokyo Institute of Music in 1887 and was later incorporated into the Tokyo Institute of Fine Arts. Instructors were invited from Europe and the United States. To further the education of children, the government published the first edition of *Songs for Primary School Children* (*Shōgaku Shōka Shū*) in 1881, which introduced many famous tunes from folk songs and other simple music from the West.

It was songs, and their popularity, that Kawakami Otojirō took advantage of in voicing his political ideology, thereby changing the landscape of Japan's theatrical encounter with the West. A samurai from the south who, soon after the Meiji Reform, became a political activist, journalist, politician, performer, and entrepreneur, Otojirō studied with Fukuzawa Yukichi as his live-in student and worked his way through Keio University, eventually becoming a member of the Liberty Party under Itagaki Taisuke's leadership. He minced no words in attacking the government in his speeches and newspaper articles, provoking repeated arrests. In 1887, when the government intensified its oppression of the Liberty and Civil Rights Movement, Otojirō founded an itinerant theater group consisting of students and amateur activists—many being young men from disgruntled samurai families—to travel around the country.

During the antigovernmental chaos, a group of satirical songs called "Oppekepe," probably originating in Osaka, became part of the urban street scene. As mentioned earlier, Otojirō's version of these street songs, first performed in 1889, harshly criticized both the government's and the people's failure to realize the ideal of Freedom and Civil Rights. Full of puns and propelled by a raplike rhythm, the song was such a hit that it was included in every performance by his student theater group. But his first real success in Tokyo, and the subsequent citywide popularity of his "Oppekepe,"* started with the production of his political play, *A True Record of Mr. Itagaki's Misfortune* (*Itagaki-kun Sōnan Jikki*, 1888) depicting an assassination attempt on Itagaki and highlighting his defiant response, "Itagaki may die, but liberty will not." Otojirō's success continued as his patriotism soon drove him to more mainstream nationalism. In response to the Sino-Japanese War, he invented the so-called war plays, including *Kawakami Otojirō's Reports from the Front* (*Kawakami Otojirō Senchi Kenbun Nikki*, 1894), the popularity of which justified the appearance of the troupe on the kabuki stage, much to the disdain of trained kabuki stars.

Otojirō was also the first to introduce Japanese theater to the United States and Europe. In 1889, his troupe, although limited in training, dared to present both classics and popular modern pieces of kabuki in the chief cities of the United States and, during the following year, at the Paris International Expo. The fact that Otojirō's wife, Sadayakko, was a famously talented

dancer and a beautiful geisha helped to impress audiences who had little exposure to Japanese culture. Upon the troupe's return to Tokyo, they presented loose adaptations of the masterpieces of Shakespeare. The productions of those adapted plays led to the formation of what is called New Wave theater (*shinpa*), independent from kabuki. Thus Otojirō combined uptown intellectualism with downtown theatricality, leading Japan's performing arts to a truly modern and intercultural stage. Since Sadayakko assumed the role of heroine in some of the plays, this inclusion of a female actor also distinguished Otojirō's theater from traditional, all-male kabuki. It was in this new genre that the unfinished *Gold Demon* (*Konjiki Yasha*, serialized 1897–1902) by Ozaki Kōyō (1868–1903), *The Cuckoo** by Tokutomi Roka, *At Yushima Shrine** (*Yushima Mōde*, 1899) by Izumi Kyōka, and other best-selling novels were presented on stage. New Wave theater is still part of major entertainment in Japan's cities.

PERFORMING THE NEWS

During the Edo period, attending kabuki meant leaving home before dawn in order to reach the theater in time for the all-day performance. This logistical requirement made kabuki a very special affair. Simpler, easier-to-attend entertainment consisted of one-man narratives in the categories of *kōdan*— long series of religious sermons, moralizing lectures, and recitations of history and classics—along with *rakugo*, or short humorous narratives. More than kabuki, these staged narratives performed the news of the day. During the Edo period, such performances began as entertainment in private houses and pleasure districts, but came to occupy small theaters (*yose*) that emerged to house them, along with magic acts, songs, and other brief forms of entertainment. After the Meiji Restoration, *kōdan* expanded to include the narration of news stories, the shogunal ban on portraying current events having been lifted. As the audience came to demand longer stories, a new genre called "human-interest stories" (*ninjōbanashi*) emerged, often reflecting the audience's taste for the criminal and the monstrous. As the genre was a specialty of *rakugo* narrators, the stories were dominated by dialogues and presented in a colloquial style as in *rakugo*, but with the complexity and length of *kōdan* narratives. The Tokyoites' fascination with these stories was so intense that they became increasingly elaborate, stretching into many hour-long installments.

The acclaimed narrators of *kōdan* and human-interest stories offered models for a developing trend toward colloquial writing that was taken up by novelists and the intellectual elite. Shōrin Hakuen II, a *kōdan* narrator, was hired to narrate newspapers aloud at a newly established reading room

on the premises of the Sensōji Temple in Asakusa. His *Rat Boy** (*Nezumi Kozō*) features the notorious thief Jirokichi (1797–1832), who specialized in burgling samurai mansions. Meiji audiences shared the Edoites' taste for crime stories, and Rat Boy became their hero in the form of a merciful bandit who victimized only the rich—an obvious expression of a growing class-consciousness. In style, Hakuen's narration constitutes an intersection between *kōdan* and human-interest stories.

Shunkintei Ryūō (1835–1897), a *rakugo* narrator, made a success of his human-interest stories through his crisp and polished Edo-style of speaking and his gossipy attention to detail. He not only sought realistic representations of document-based facts, but also pursued the psychology of an extensive cast of characters. His *The Bad Girl Prefers Black and Yellow Plaid** (*Adamusume Konomi no Hachijō,* performed much earlier but printed as a series in 1889) features the gambler Shinzaburō, nicknamed "Shinza the Hairdresser," whose iniquity sets in motion a series of felonies. Ryūō's contemporary Mokuami turned this character into a star villain, adapting this part of the narrative into his kabuki play *Dew Drops on Nostalgic Black and Yellow Plaid* (*Tsuyu Kosode Mukashi Hachijō,* 1873), popularly called *Shinza the Hairdresser* (*Kamiyui Shinza*), which is still performed today. Some of Ryūō's orally delivered stories, including *The Bad Girl,* were transcribed in shorthand during his performances and published serially in newspapers.

San'yūtei Enchō, another narrator of serialized stories, began his career during the Edo period but quickly and successfully adapted to Meiji urban culture, adding modern subjects, creating his own stories, and devising stagy presentations. Because they appealed to educated audiences and expressed cultivated ties with politicians and intellectuals, many of Enchō's human-interest stories were taken down by stenographers who used the playwright's popularity to market their own craft. Enchō's *The Peony Lantern: A Ghost Story* (*Kaidan Botandōrō,* 1884), transcribed by stenographers Sakai Shōzō (1856–1924) and Wakabayashi Kanzō (1857–1938), was the first to be published in a printed journal. *A True View of Kasane Precipice,* mentioned earlier, is one of the best-known and the longest series performed by Enchō. The novelty of recording oral performances through stenography went hand in hand with Enchō's own strategy of modernizing materials and performance techniques.

Stenographers set down colloquial speech as they heard it, radically changing the appearance of Japanese prose in print. Although all of these performers of human-interest stories deserve mention in the development of a modern colloquial-style writing, Enchō was the most prolific, and his work was the most frequently printed. This explains why Tsubouchi Shōyō (1859–1935) and others later pointed to his work as a model for the creation

of a new, more sound-oriented literary language. Edo literature had already offered models for realistic colloquial writing styles. For example, the comic novels of Shikitei Sanba (1778–1822) chiefly consisted of dialogues that illustrated the speech styles of downtown men and women. Sentimental novels by Tamenaga Shunsui (1790–1843) were written in a style very close to the colloquial, even in the narrative parts. As mentioned earlier, Mokuami's plays presented numerous models of modern conversational style. However, Tsubouchi and others tended to deny the value of Edo writing, not acknowledging Meiji literature's debt to its predecessors.

It is hard to pinpoint one single performer or writer as a model for what became the modern colloquial style. Adaptations among various media were frequent both in Edo and Tokyo: a ukiyo-e print might inspire a kabuki play, a newspaper item could be represented as a human-interest story, as a kabuki play, or even as a multivolume storybook. In this process, the lines between speech and writing styles became blended and more relaxed. With each new step toward the creation of a standardized, colloquial yet authoritative style, uptown and downtown writing styles merged.

FROM JOURNALISM TO STORYTELLING

During the Edo period, growing foreign trade and a dramatically changing political scene stimulated an increase in literacy among commoners. Anxious to learn about the latest social scandals and political developments, the reading public came to require broader public news sources. Under shogunal censorship, writers and artists attempted to circumvent the law by camouflaging their political commentary with nonsense, fantasy, and didacticism. Kabuki plays, for instance, were usually set in a historical period that thinly disguised the scandalously contemporary nature of their themes and characters. By contrast, orally delivered sermons and lectures (kōdan) tended to feature outlawed muckraking content, since the law was less stringent for nonprint materials. Once written, however, any material could put the author and publisher in danger. Baba Bunkō (1718–1758), a popular speaker of the eighteenth century, was executed for selling copies of his reports of a political scandal. Genres of fiction, particularly picture books called "yellow covers" (kibyōshi), which depicted contemporary life, often with satire, and illustrated narratives called "combined volumes" (gōkan), were relatively more successful in warding off censors by choosing historical settings and masqueraded as mindless comedy or trashy gossip. They also escaped criticism by employing a facile "encourage virtue, punish vice" (kanzen chōaku) moralism based on Confucianism that allowed their narratives to be gratuitously bloody so long as the characters got their just desserts. Needless to say,

censors often overlooked unpublished work, such as satirical graffiti written on walls, scandals reported by town criers, and, of course, human-interest stories delivered on stage. As discussed earlier, crime stories of the Meiji period demonstrated a sense of justice, more in the form of law and police work, rather than Confucian morality.

In 1872, a fire that destroyed the larger part of the Ginza district of Tokyo indirectly spurred the emergence of newspapers. The government took the opportunity to rebuild that part of Tokyo into a superscale model of a Westernized city, and newspaper companies were among the first businesses to move into the new brick buildings that proved to be off-putting to other potential business tenants. In this way, the center of newspaper publishing moved from Yokohama to Tokyo, making this district the most enlightened part of Tokyo. At first, the Meiji government was no better than the previous ruling structure in allowing popular representations of current events. All newspapers were initially banned, although the government took matters in a different direction by establishing a new law that required governmental permission to publish and distribute. To comply with the requirements of the government-sponsored Enlightenment projects, journalism came to report on new developments in industry and economy, emphasizing scientific facts. *The Japan Times* (established in 1897) and other English-language newspapers were meant not only as showcases of Enlightenment for foreigners in Japan but also as a way for the Japanese to foster an image of Japan as an international player. At the same time, in response to popular demands for the sexual, weird, and scandalous, newspapers had to rely on the themes and forms of Edo print culture, including serialized, highly illustrated narratives.

Separate purposes divided newspapers into two categories. "Big newspapers," including *The Tokyo Daily* (*Tokyo Nichinichi Shinbun*, 1872–1943, which merged into the current *Mainichi Daily*), *The Dawn Herald* (*Akebono Shinbun*, 1875–1882), and *News of the Nation* (*Chōya Shinbun*, 1874–1911), emphasized political news stories, debates and editorials, and contributions by notable intellectuals, usually written in a formal style with many Chinese characters. A progovernment stance kept *The Tokyo Daily* safe and flourishing, while the subversive tone of some entries in the other two papers often jeopardized their survival.

"Small newspapers" were physically smaller and aimed to reach a wider readership. Newspapers such as *The Town Crier* (*Yomiuri Shinbun*, founded in 1875 and now known as *Yomiuri*, the world's largest newspaper), *Tokyo News Illustrated* (*Tokyo E-iri Shinbun*, founded in 1875), *Easy Reading News* (*Kanayomi Shinbun*, founded in 1876), and *The Morning Sun News* (*Asahi Shinbun*, founded in 1879 and now Japan's second-largest newspaper)

provided news in the colloquial style. Each used the "easy-to-read" Japanese script and included illustrations and glosses for Chinese characters. Eventually, "big" and "small" newspapers converged, as they came to share topics and readers. Intellectuals' engagement with both types was not limited to their contributions as writers: thinkers of the day also presented to groups and led readings and discussions with the less educated, as seen in one of the episodes of Robun's *Things Heard around a Pot of Beef** (*Ushiya Zōdan Aguranabe*, 1872).

Once-popular Edo writings were found unfit for the new Meiji age, the same seasoned authors and artists who had been producing them found jobs with "small newspapers" as staff and contributors. They provided the readers with illustrated, serialized stories, as well as with talk-of-the-town gossip about the famous and infamous. Responding to the readers' thirst for details, these authors-turned-journalists made their reportage as descriptive and dramatic as possible, thus blurring the line between journalistic prose and narrative fiction. Reportage on *tanuki*, foxes, and other animals in those newspapers, for example, verged on the short story. Unlike these popular news stories about the weird, which remained rather short, news stories on criminals flourished as lengthy series and later as independent books. Robun began his *Takahashi Oden** as a news story and included documents from the actual felon's trial, but then developed the judicial procedure reports into a serialized narrative. Other prime examples of newspaper entries that were turned into serialized novels are *The Nautical Story of Omatsu the Street Singer* (*Torioi Omatsu Kaijō Shinwa*, 1877–1878) by Kubota Hikosaku (1846?– 1898) and *Nightstorm Okinu and Phantasmic Flowers* (*Yoarashi Okinu Hana no Adayume*, 1878) by Okamoto Kisen (1853–1882). These stories combine the factual realism of journalistic reports with episodic cliffhangers and fantastic flights of imagination, paving the way for the melodramatic fiction that has become central to contemporary popular culture.

The birth of newspapers was a direct consequence of the new technologies that made possible the economical use of movable lead type. Invented in China, movable-type printing was first used in the eighth century for printing Buddhist sutras, but was soon abandoned in favor of hand copying and, later, woodblock printing. The technology came to Japan from Korea and Portugal toward the end of the sixteenth century. After a few decades of use, it was abandoned in favor of woodblock printing, but was then reimported in the Meiji period, especially when rolled paper from Europe made high-volume printing with movable-type presses possible. For readers accustomed to the plasticity of Edo woodblock printing, however, the absence of calligraphic artistry in the machine-made typeface meant the loss of an inimitable part of the physical act of reading. Luckily for them,

Japanese newspapers maintained old methods alongside the new. Woodblock printing was found to be both much faster than setting type and easier for constructing a layout with pictures. Early newspapers would print the text in movable type but use woodblocks for illustrations to be inserted later. The daily demand to report and publish the news resulted in new production methods; some newspaper pages were patchworks of set type and woodblock. For a short season, lithographs replaced woodblock-created images, but even these were quickly abandoned with the invention of offset printing, a photographic process that more easily incorporated both image and text on the same, mechanically produced page.

The ultimate merging of newspaper storytelling and the novel can be seen in the 1907 appointment of Natsume Sōseki as full-time staff novelist at the *Asahi Shinbun*. This newspaper was an early example of a "small newspaper" that characterized itself by its attempt to enlighten the common masses. Sōseki's appointment, which came with an extraordinarily high salary, established modern-style fiction writing as a profitable profession. All of his novels were first published in this same form. The *Town Crier* hired Ozaki Kōyō, the success of whose *Gold Demon* increased the paper's subscriptions. Roka's *The Cuckoo** and other popular hits were also originally newspaper serials. This tradition of serializing novels in chief daily newspapers, with an illustration for each installment, continues today. It is interesting to note that, according to "small newspaper" practice, the Chinese characters in Sōseki's writings were copiously glossed with Japanese pronunciation keys. This was one way by which highbrow writing spread to the masses. By this stage in the late Meiji period, early modern and late modern, uptown and downtown, and written and spoken seemed to have merged at the edges.

EDITORIAL JOURNALS AND THE SPREAD OF ENLIGHTENMENT

Journalism during the Edo period, whether in the form of *kōdan* or graffiti scribbled on walls or flyers distributed by town criers, rampantly attacked failures of the government. Toward the end of the period, *Japan Punch,** a cartoon magazine, was published by Charles Wirgman (1832–1891), a cartoonist and special correspondent of the *Illustrated London News,* as a kind of Japanese version of the British *Punch. Japan Punch,* published monthly from 1862 to 1887 in Yokohama, was meant for residents of the city's foreigners' settlement. The journal's parody and satire of Japan's government, first the shogun's and then the emperor's, were highlighted by Wirgman's own cartoons as well as by the photography of Felice Beato (1832–1909). Wirgman also realistically depicted the battles that marked the transition from the Tokugawa shogunate to the Meiji government. For the benefit of

French speakers in Yokohama, Georges Bigot founded the satirical journal *Tobaé* (Cartoon) in 1887, which also lampooned Japan's authorities, superficial Westernization, and militant nationalism. Bigot also contributed to *Japan Punch* and other publications.

With the same critical intentions and employing similar styles, the Japanese created their own pictorial journals to reach a broader audience. *The Weird News Circular* (Marumaru Chinbun, 1877–1907)* featured journalist Miyatake Gaikotsu (1867–1955), artists Kobayashi Kiyochika (1847–1915), Georges Bigot, and others. While the periodical attracted a large number of subscribers, the government repeatedly responded to its satirical stance with fines and jail sentences for its staff members. Ukiyo-e artist Kawanabe Kyōsai adapted the model of political satire from *Japan Punch* when he collaborated with journalist Kanagaki Robun to create the short-lived publication *An Illustrated Ja-pun* (*E-Shinbun Nipponchi*, founded 1874),* whose name combines "Punch" with *Nippon* (Japan). Kyōsai was first trained in the elite Kanō school of painting and then received tutelage from the ukiyo-e artist Katsushika Hokusai (1760–1849). The combination resulted in a uniquely realistic and comical style. The monsters that populated his work were a cross between Hokusai's manga and the cartoons of *Japan Punch*. A sampling of these various publications are represented here as "Catfish, Prostitutes, and Politicians: Satirical Cartoons."*

Just as picture-oriented "small newspapers" became more like "big newspapers" by filling the pages with a higher ratio of words to pictures, cartoon-filled magazines also gave way to a more word-oriented presentations. In this sense, Meiji journals were an even more modern invention than their newspaper counterparts. While repurposing Edo's well-established tradition of satire and cartooning, the newer journals used the medium to create an arena for ideological and intellectual discourse, expressing opinions across the full political spectrum. A few journals, like early English-language newspapers, aimed at communicating with foreign readers as well as preparing Japanese readers for participation in international dialogue. In conjunction with the publication of *The Japan Times,* the dictionary publishers of Kenkyusha founded the journal *The Rising Generation* (*Eigo Seinen*, 1898–2009), designed to help the Japanese learn English. It featured articles about Anglo-American literature as well as reports on academia abroad, reviews of foreign books, and translation exercises. The journal remains a status symbol for teachers and students of English and linguistics even now.

In the realm of opinion journals, *Central Debates* (*Chūokōron*, 1887–) was dedicated to the exchange of public opinion and highlighted the stories and essays of distinguished novelists. Founded on the democratic principle of inclusive dialogue, the journal was occasionally targeted for attack by

right-wing nationalists. *Central Debates* also remains in print today and currently represents pro-American traditionalism. By contrast, *The Japanese* (*Nihonjin*, founded in 1888 and renamed *Japan and the Japanese, Nihon oyobi Nihonjin*, in 1902) provided a sounding board for right-wing nationalists who opposed the government's policies. Japan's first monthly journal of general interest, *Citizens' Friend* (*Kokumin no Tomo*, 1887–1898), under the leadership of Tokutomi Sohō (1863–1957), argued against militarism and elite control over industrial production. Whether for or against wars with China (1895) and Russia (1904–1905), even these more politically oriented publications invariably had a literature section that introduced their readers to the latest story or novel. Journals dedicated to literature also emerged: *The New Novel* (*Shin Shōsetsu*) focused its attention on the novel, and Yosano Tekkan's *The Morning Star*, the chief vehicle for the poetry of the day, also functioned as an incubator for future prose writers. Some journals even espoused the idea that social activism and literary expression were one and the same. As mentioned, the feminist *Bluestocking*, which began publication in the last full year of the Meiji era (1911), epitomized this viewpoint and served as a platform for politically minded novelists.

Larger Meiji publishing houses grew by fielding a number of journals, and each new acquisition was designed to appeal to a different subculture of readers. For instance, Hakubunkan Publishing House, founded in 1887 and patriotically named after the statesman Itō Hirobumi (Hakubun being an alternate reading of Hirobumi), published a wide variety of journals. Their first general-interest journal, *Treatises by Japan's Experts* (*Nihon Taika Ronshū*), contained a miscellany of writings, including Ozaki Kōyō's very popular *Gold Demon*. Riding this wave of success, Hakubunkan went on to expand its offerings in 1895 with the inauguration of three additional journals: the politically oriented *Sun* (*Taiyō*), the literarily focused *Literary Club* (*Bungei Kurabu*), and *Youth's World* (*Shōnen Sekai*, 1895–1933). Eventually, the company added a number of other more specialized journals that tapped into the enthusiasm of a growing market for the printed word, including *Detective Novels* (*Tantei Shōsetsu*), a journal that showcased the hyperlogical fiction of authors like Kuroiwa Ruikō, who had gained success for drawing on the gothic origins of the detective story. His short stories "Electricity"* (Denki, 1890) and "Wedlock"* (Kon'in, 1890) feature modern-day relationships and surprising turns of plot in realistic and contemporary settings.

Heroic legends about the battles of the Meiji Restoration, combined with the government's militarist agenda that eventually led to the Sino-Japanese War, inspired journals such as *Youth's World*, which capitalized upon and furthered patriotism among the young. In addition to the works of editor Iwaya Sazanami (1870–1933), the journal featured those by many other

leading writers of the time, including Tayama Katai (1872–1930) and Izumi Kyōka. The literary journal that most consciously targeted young female readers was *A Girl's Friend* (*Shōjo no Tomo*, 1908–1955), which high-lighted romantic art, fashion, and literary and theatrical arts, often including translations. It featured leading artists such as Nakahara Jun'ichi (1913–1988) and Nakanishi Toshio (1900–1948), as well as authors such as Yoshiya Nobuko (1896–1973) and the Nobel laureate Kawabata Yasunari (1899–1972). The journal encouraged a pseudo-leftist mode by publishing reader submissions as well as by allowing the use of boyish language. The military ultimately put pressure on the journal, finding Nakahara's portrayal of young women degenerate and unhealthy, eventually leading to the journal's closing.

LITERARY JOURNALS: RICH SOIL FOR THE NOVEL

A readership eventually emerged that demanded journals devoted solely to literature and the arts. One such journal was the short-lived but influential *Literary World* (*Bungakukai*, 1893–1898), which included writings by Higuchi Ichiyō, Kitamura Tōkoku, Shimazaki Tōson, and Tayama Katai. Many of the contributors were Protestant Christians who first wrote for *Women Erudites* but wished to expand their writings beyond that publication in order to promote Christian ethics-based education for women. The *New Tide* (*Shinchō*, 1904–) was the first monthly journal dedicated to highbrow prose narrative, embracing a wide range of respected authors at every stage of its history. Instead of being led by a creative writer who acted as chief editor, the *New Tide* nurtured professional editors. It remains one of the strongest literary journals in Japan today. *White Birch* (*Shirakaba*, 1910–1923), on the other hand, barely survived the Meiji period, but remained important as a bridge between European and Japanese arts. Founded by Mushanokōji Saneatsu (1885–1976) and other young writers from the upper classes, the journal emphasized individualism and liberalism, influencing intellectuals of the World War I era.

As the preceding discussion implies, modern Japanese literature was nurtured through groups of like-minded people who started their own common-interest journals. For instance, *Rubbish Literature* (*Garakuta Bunko*, 1885–1889) became a private publication for the Schoolmate Society (Ken'yūsha, 1885–1903), led by Ozaki Kōyō, Yamada Bimyō (1868–1910), and others who studied at the high school that later became the University of Tokyo. Reminiscent of leisure publications by educated sophisticates of the Edo period, the journal featured Edo aesthetics and a casual format that included prose fiction, essays, poetry in Chinese and Japanese, and even *rakugo*

narratives. Although only privately available for much of its short life, the journal holds literary historical importance: the contributors included Izumi Kyōka, Tokuda Shūsei (1871–1943), and other authors who led various literary movements after the group disintegrated upon Kōyō's death. Eventually regarded as an early form of a literary journal, issues were reprinted in 1927. A few decades would pass before the arrival of a highly developed and all-embracing monthly journal. *Seasons of Literary Art* (*Bungei Shunjū,* 1923–) was the first, forging a new genre of journal by focusing on literature while also covering a range of political and social topics. By featuring photographs of contemporary events and extensive book reviews on current publications, *Seasons of Literary Art* offered a model for commercially successful general-interest journals.

Literary movements were often centered on certain university groups. *Waseda Literature* (*Waseda Bungaku,* founded 1891), the oldest and most authoritative of these journals, was led by its founding editor, Shimamura Hōgetsu (1871–1918) and promoted Japan's own brand of naturalism. Waseda University's rival, Keio University, created its own literary journal, *Mita Literature* (*Mita Bungaku,* founded 1910), which was headed by the novelist Nagai Kafū and reflected his own taste for romanticism and decadence. Both journals are still published today. The intellectuals who were active in the propagation of university journals contributed greatly to the development of "the literary world" (*bundan*)—a term that came to mean the group of writers, publishers, and critics who had formed into a loosely organized subculture that constantly commented upon each others' work and contributed to the abovementioned journals. By way of journal publication, these collaborative and overlapping efforts eventually elevated the novel to the top tier of Meiji culture.

NEW FORMS OF POETRY

While prose seemed to better reflect modern attempts to rationally organize life in an age of discovery, Meiji literature had to contend with poetry, which still remained the dominant form of high literature throughout the Edo and Meiji periods. From a long and rich tradition of both classical Japanese and Chinese poetry, Meiji poets were blessed with models of form, rhythm, and imagery. At the same time, this heritage was also perceived as a burden. As the need to account for a quickly expanding modern world became increasingly obvious, the limitations of existing poetic forms and practices also became clear. With the modern attempt to incorporate everything into the broad organizing reach of reason, there occurred a shift from lyricism to description, so that all things—the high and the low, the ethereal

and the mundane—were made into details of an expanded reality. Of course, this impulse to widen the range of classical poetic forms had earlier resulted in the creation of various popular alternatives: *kyōka* (mad *waka*), *haikai no renga* (linked verse), *senryū* (comic haiku), and so on. Still, as the trend of realism strengthened during the Meiji period, one reaction to traditional forms was to reject them entirely.

An anthology entitled *Selected Poems in the New Form* (*Shintaishishō*, 1882), edited by an eclectic group of university professors—whose fields ranged from philosophy to biology to English—condemned Chinese poetry, *waka*, haiku, and also their comical versions (*kyōshi, kyōka,* and *senryū*) as inadequate for expressing modern thought and reality. The anthology's intention was to reform Japanese poetry by incorporating the extended descriptive style they found in models of Western poetry. Their preference is evidenced by the number of translations that appear in this anthology, fourteen compared with only five original Japanese compositions. While the group faced strong opposition, it won followers who were attracted to the new poetry's plain diction, expanded subject matter, and complexity of thought. The new form was actually not very innovative in the sense that it still maintained lines of five and seven syllables. However, the collection did introduce new poetic elements such as stanza breaks, rhyme, and refrains; and, more importantly, it spurred a reevaluation of what constituted appropriate poetic form and content. The anthology encouraged more translations from Western poetry and stimulated the writing of *shintaishi,* or "new form" poetry, which became the go-to format for a number of important Meiji poets, such as Mori Ōgai, Yosano Tekkan, and Iwano Hōmei, among others.

Traditional forms survived the anthology's attack but did not escape reform. Masaoka Shiki (1867–1902) was a poet and critic who reinvented *waka* and haiku (five-seven-five syllables) by subjecting these long-established forms to his innovative theories and practices. While working on the staff of the newspaper *Nippon,* he published "Talks on Haiku from the Otter's Den" (Dassai Sho'oku Haiwa, 1893), which advocated haiku reform, and "A Letter to Waka Poets" (Utayomi ni Atauru Sho, 1898), which called for liberation from the stale practices of Edo-period *waka*. He criticized the artificiality of the long authoritative anthology *Poems Old and New* (*Kokinshū,* tenth century) and gave preference to the ancient classic *Myriad Leaves* (*Man'yōshū,* eighth century) for its primitive expression of sincere sentiments. He led the Negishi Waka Society, which engaged such poets as Itō Sachio (1864–1913), Nagatsuka Takashi (1879–1915), and Saitō Mokichi (1882–1953), who later formed Japan's most authoritative poetic journal of the day, *The Yew Tree* (*Araragi,* 1908). The Yew Tree School of poetry

promoted realistic depictions of life as subjectively experienced through the senses, dismissing the conventions of classical poetic diction as trite. Its members also encouraged intellectual and analytical interpretations of poetry. This school remained a dominant force in modern poetry and poetry criticism for decades, closing its doors in 1997.

Shiki also became involved with the journal *The Morning Star,* which, under the leadership of Yosano Tekkan, was immensely influential in the development of new-form poetry as well as in the expansion of *waka* and haiku. Its general emphases were romanticism and aestheticism. Through the sensational success of Yosano Akiko, who combined erotic images of the female body with the classical *waka* form, the journal attracted and influenced many talented poets who created new forms and pushed at existing boundaries. Ishikawa Takuboku (1886–1902), one of the chief contributors to the journal, wrote *waka* in a simple colloquial language, drawing the reader's attention to the poverty and sadness of his own life. In this sense, his poetry is similar to the prose fiction of the Japanese naturalists. Takuboku's verses still garner a sentimental response from his readers as they engage with the image of the weeping poet who died young.

After *The Morning Star* ceased publication, Tekkan and Ōgai established another journal, *The Pleiades* (*Subaru,* 1909–1913), as a more focused effort to promote romanticism. Takuboku became editor, and Kitahara Hakushū (1885–1942) contributed regularly. The journal's rebellious stance was represented by its publication of Ōgai's confessional fiction "Vita Sexualis" (Vita Sekushuarisu, 1909). As a piece based on the author's sexual experiences, its publication resulted in the journal's censorship at the hands of the government. The same year witnessed *The Pleiades'* publication of Hakushū's *Heretics* (*Jashūmon,* 1909), a cycle of poems violating religious and ethical taboos in favor of aesthetic exoticism. Hakushū brought together a colloquial style with traditional seven-five rhythms and used a mix of religious, classical, and foreign images to provoke the reader's appreciation of the sadistic beauty and lyricism of his verses.

Journals of poetry and poetry criticism came to occupy a leading role in periodical publications, expanding their subject territory as well as their authority in the general literary world. Concurrent with the publication of *The Morning Star, The Pleiades,* and *The Yew Tree, Cuckoo* (*Hototogisu,* 1897–) was founded as a haiku journal by Shiki. Upon his death, Takahama Kyoshi (1874–1959) assumed leadership of the journal. It came to include prose fiction, such as Sōseki's *I Am a Cat* and *Typhoon* (*Nowaki,* 1907), haiku by Iida Dakotsu (1885–1962) and Sugita Hisajo (1890–1946), and various essays and critiques of poetry.

A romantic movement within Meiji poetry was intensified by poet and theorist Kitamura Tōkoku, who uniquely combined leftist politics and activism with romanticism. For instance, his "Poem of the Prisoner" (Soshū no Shi, 1889) voices his political protest, while adopting the metaphor of brutal imprisonment to represent separation from passionate love. He wrote free verse in a classical style, but his vocabulary was contemporary and politically charged. In his prose writings, he focused on literary criticism as well as on theories of romantic love. In his essay "Pessimist Poets and Women"* (Ensei Shika to Josei, 1892), he advocates passionate love as a prerequisite for life. Under the influence of Byron, Coleridge, and other romantic poets, he argued for an inseparable tie between aestheticism and spiritual love. His suicide at a young age ensured his lasting image as a tragic practitioner of romantic ideals.

Inspired by the Byronic Tōkoku, Shimazaki Tōson emerged with his Collection of Young Greens (Wakanashū, 1897) and became the most successful romantic poet of the period. He too wrote in the classical style, making full use of the beauty of its vocabulary, imagery, and sound. At the same time, he invented a new form of dialogue in his four-verse exchanges between different poetic voices, including voices of women and nature. In his book of later poetry and essays, Collection of Fallen Plum Blossoms (Rakubaishū, 1901), he stayed with seven-five and five-seven schemes in literary language. He focused less on romantic love and expanded on the topics of landscape, farming, and travel. The inclusion of prose in this book anticipated his move from poetry to fiction for the major part of his career.

Ueda Bin (1874–1916) also found inspiration from European poetry, but looked to a later period than that of Byron and Coleridge. In The Morning Star he published translations of poetry by Charles Baudelaire, Stéphane Mallarmé, Paul Verlaine, Robert Browning, and others. His approach to translation was in opposition to the earlier Selected Poems in the New Form, which he criticized harshly. He used both literary and colloquial styles but often maintained the seven-five rhythm, particularly for sonnets, in which he preserved the fourteen-line structure of the original. His book The Sound of the Tide (Kaichō'on, 1905) was the first successful collection of translated poetry. The work became something of a textbook for French Symbolist poetry, which had a lasting influence on new-form Meiji poets such as Tōson, Hōmei, Susukida Kyūkin (1877–1945), and Kanbara Ariake (1876–1952).

Translation also played a role in how Ariake became the chief torchbearer of the Symbolist movement. He translated part of Edward Fitzgerald's The Rubaiyat of Omar Khayyam as well as the poetry of Dante Gabriel Rossetti. His chief poetic collections, Spring Bird Poems (Shunchōshū, 1905)

and *Ariake's Poems* (*Ariakeshū,* 1908), illustrate his rejection of both traditional conventions and the unruly freedom of modern poetry. He revitalized the role of form in poetry by inventing new rhythms such as eight-six and four-two, enforcing them by the regularity of consistent stanza lengths.

Hakushū, Tōson, Ariake, and a few others of the time brought the new-form poetry to its height by broadening the range of styles and forms to accommodate Western images of love, pleasure, and nature, as evident in this volume's "Maidens, Stars, and Dreams: Poems by Shimazaki Tōson and Kanbara Ariake."* Both romanticism and poetic inventions, however, were overshadowed by the emergence of prose genres, whose own trends, especially realism, allowed for more freedom of involvement in current social and ethical realms. Paradoxically, while realism in prose and the newly innovated *waka* and haiku offered a language with which to explore issues of modernity, the issues explored through "modern" new-form poetry were limited to aesthetic principles and the nature of poetry. These concerns, while important to the writers, did not speak to a wider audience, whose taste for realism was cultivated by prose fiction. It is telling that, following the early modern example of Ihara Saikaku, many successful poets such as Tōson and Hōmei shifted their careers from poetry to naturalist fiction. New developments in poetry notwithstanding, the Meiji era was clearly an age of prosaic interests and accessible language, as reflected in the imbalance of prose and poetry in this anthology.

THE BUSINESS OF LITERATURE

Although contemporary cultural attitudes and markets supported the rise of naturalist prose, writers' social ambitions also drove the development of Meiji literature. Thanks to the nationalized education system, the younger generation, graduating from colleges and technical schools, stepped into the world with grandiose ambitions to serve their country and improve the world. As they envisioned their identity in relation to national causes, these young generations were attracted to careers in public service and business entrepreneurship, career paths in which they could exercise authority and make money while also being useful to the nation. These hordes of new intellectuals flooded into Tokyo, but many had trouble securing employment worthy of their education. Many authors turned to writing after they could not find jobs in business or government, and what started as merely a way to pay the bills led to the development of serious literary theories and deep commitments to Japan's emerging literary modernity.

Unlike Edo's popular authors, who claimed to write only as a pastime or as a means to gain income, these educated Meiji-era Tokyo writers took

their role more seriously. They engaged in polemics regarding all aspects of human life and society, from love and marriage to freedom and equality. Heated debates about the politics of the time, the future of the nation, one's place in the system, and similar topics were not only the purview of the new writing class but also the subject of caricature and comment, as seen in *Things Heard around a Pot of Beef** in which the author Kanagaki Robun portrays a horse and an ox engaging in just such an argument. The influence of Rousseau as well as literary writers such as Fyodor Dostoevsky, Maxim Gorky, and Henrik Ibsen further inspired the Japanese to explore issues of religion, politics, and society in new ways. Attempts were made to understand literature in terms of issues and beliefs: manifestos were copiously published to forward the causes of one literary "–ism" or another. As shown in the translations included in this volume and notwithstanding the Meiji preference for prose, a great variety of Meiji literary forms and styles resulted from the polemics and conflicts between the old and new and uptown and downtown.

Of course, writers' commitment to their profession did not necessarily translate into material wealth. Many writers lived in dire poverty, struggling to make ends meet. Lucky ones found financial support as private live-in secretaries or employees of newspapers and journals, unlucky ones merely sponged off of each other. Iwano Hōmei, for example, pressed by the need for income to support his family and lovers, tried his hand at various business ventures: a tenant house, a lumber company, and a fishing enterprise, to name a few. Futabatei Shimei (1864–1909) wished to go into business or diplomatic service and learned Russian as a useful tool for either career. Not finding an appropriate path to either, he found poverty an incentive to write and translate literature. There were, of course, best-selling writers such as Ozaki Kōyō who were affluent enough to support many disciples, including Izumi Kyōka and Tokuda Shūsei. Later, Natsume Sōseki and others made fame and fortune by serializing their works in newspapers. In fact, Sōseki was extremely affluent in terms of salaries he drew as a lecturer at what would become Waseda University and later at Tokyo Imperial University, and when he was hired as a staff writer for the *Asahi Shinbun,* his monthly salary was two hundred yen when highly ranked school instructors would earn only ten to twenty yen a month. This inspired other leading newspapers to hire distinguished novelists in a similar manner and contributed to the growing importance of daily serialized novels as a new form for extended composition. Needless to say, the varying levels of economic success among writers contributed to the wide range of human experience they featured in their works.

"WRITE IT LIKE YOU SAY IT!": COLLOQUIALISM AND THE NOVEL

The development of modern literature went hand in hand with the creation of a colloquial writing style. Traditional Japanese prose had distinguished between narrative and dialogue, using different styles of language for each. While dialogue reflected the spoken language of the time, the narrative portion always honored the literary, that is, classical, rhythm and diction. Western prose did not make the same distinction, which the Japanese considered a sign of modernity. Moving in the same direction, Japanese writers raised the rallying cry "Write it like you say it!" (*genbun'itchi!*) and endeavored to invent a narrative style to express their own experience of modern life realistically.

To establish an objective third-person narrative voice, Japanese writers had to make certain grammatical and syntactical choices to approximate spoken language while still maintaining an impersonal style. Sentence endings became an important source of debate. The two options that came to the fore were *da* and *de aru,* which were used in public oratory and informal male speech, or *desu* and *masu,* which indicated polite conversation and were used by Enchō and other verbal performers. While both styles appeared in experimental narratives, ultimately the *da* and *de aru* of public oratory won the day.

The first Japanese theorist and practitioner of colloquial writing was Futabatei Shimei. He was encouraged by his mentor, Tsubouchi Shōyō, to take Enchō's storytelling as a model. Shimei resisted any such established style, however, and stayed close to his own personal speech patterns. Although his first works in literary criticism were written, like Shōyō's, in the classical style, his creative writing was experimental. *The Drifting Cloud* (*Ukigumo,* 1887–1889), generally acknowledged to be Japan's first novel in the colloquial style, was written in an informal tone that echoed the style of university students' conversations at that time, studded with both Chinese idioms and downtown colloquialisms. Shimei's novels featured not only the speech patterns of male intellectuals but also those of outspoken, educated women as well as female students.

In *The Drifting Cloud,* Shimei created a protagonist that would become prototypical, particularly in Natsume Sōseki's later fiction: Bunzō, a university graduate and a poor fit for his bureaucratic job, is alienated from his family and friends due to his disregard for societal norms. He is a victim of the gap that lies between modern individualism and traditional social values, but is not aware of it. Full of authorial interjections resembling those found in Edo *gesaku,* or "playful composition," a comical and witty genre of prose writing, Shimei's sentences generally end with *da,* which was later es-

tablished as the standard form for novel writing. Shimei's experiment goes much further in his late essays "The Origins of My Colloquial Style"* (Yo ga Genbun Itchi no Yurai, 1906) and "Confessions of Half a Lifetime"* (Yo ga Hansei no Zange, 1908), which give the impression that he is talking casually to an interviewer. The same style was used in his last novel, *Mediocrity* (*Heibon,* serialized 1907), an intimate first-person confessional. Interestingly, in his translations of Turgenev's "The Tryst" (Aibiki, 1888) and "A Chance Encounter" (Meguriai, 1889), Shimei's narrative style is very like what we find in the modern fiction that was to come. The conversational tone had to be played down because he closely followed the realistic third-person narration of Russian writing. It was not so much Western literatures themselves that inspired the modernization of Japanese prose fiction but rather the act of translating them that finally gave Japanese writers a model for novel writing.

Women writers had the upper hand in writing in the colloquial style. In the tenth century court and among the clergy, women were trained to write their private letters and journals in contemporary spoken language, while men, discouraged from recording their private lives, were kept to standards of classical Chinese. In view of the fact that women traditionally had a way to write about their private thoughts in their own language, it is not surprising that Wakamatsu Shizuko's "My Grandmother's Cottage"* (Omukō no Hanare, 1889) emerged early during the Meiji period. The short story was published in *Women Erudites* only a year after *The Drifting Cloud.* This short story showcases not only a thoroughly colloquial style but also a first-person narrative voice, prefiguring the popularity of the "I-novel" form. It depicts the private, mundane lives of women with an acute social sensibility; in short, Wakamatsu represents the early consummation of naturalism in the female voice.

By and large, intellectuals of every stripe subscribed to the "write it like you say it" philosophy. The value of the movement, however, lay not only in the accomplishments of its subscribers but also in the ways that the struggle to develop greater creative expressional models added richness to Japanese writing. Some writers experimented with more formal styles in depicting life in the new era. For example, Mantei Ōga (1818–1890) was one of the old-school Edo citizens who insisted on the use of the Edo *gesaku* style that verged on scholarly Chinese. His *Toad Fed Up with Modernity** (*Kinsei Akire-kaeru,* 1874) features a style dense with literary allusions and wordplay, voicing indignation over the loss of traditional values. Narushima Ryūhoku (1837–1884) and Kōda Rohan similarly remained faithful to the masculine tradition of writing in Chinese, even though it represented "the old" in an age of "the new." Higuchi Ichiyō, who identified femininity

as the core of the classical writing style, portrayed the petty dramas of im-poverished downtown life in a highly polished and ornate style reminiscent of courtly literature. The contrast between her perceptive realism and her lyrical style subverted the conventions of classical Japanese and formed a fresh new mode of expression for modern life. Mori Ōgai, too, applied the classical poetic style to both his own romantic compositions and his trans-lations of works by Goethe, Schiller, and Hans Christian Andersen. Ōgai's *The Dancer* has an elegant classical style, using poetic rhythm in addition to ornate imagery to enhance the romantic effect of its depiction of tragic love. As he shifted to writing historical novels and short stories, Ōgai created a modern colloquial writing style praised for its precision and clarity. In short, he invented a realistically objective style that is quite separate from the nat-uralist I-novel.

Another dissident to the colloquial trend was Ozaki Kōyō, who ap-pealed to a lingering taste for popular Edo fiction, particularly for the work of Ihara Saikaku. He and his followers in the Schoolmate Society, although they made sympathetic efforts in trying out the colloquial style, continued to take advantage of the rhythmical charm of the old style. For storylines, Kōyō made use of newspaper entries on contemporary events. Inspiration for his successful novel *Three Wives* (*Sannin-zuma*, 1892), for instance, came from a gossipy news item about a rich man's funeral attended by his wives and mistresses. Kōyō fully fictionalized the story by imagining a competi-tive interplay among the women such as seen in the sentimental novels of Tamenaga Shunsui (1790–1843), who remained a favorite among readers of popular fiction during the Meiji period. Kōyō's "A Woodcutter Falls in Love"* (Koi no Yamagatsu, 1890) is an example of his Saikaku-esque liter-ary style. The minute attention he pays to the description of manners and clothing for men and women of different classes marks him as a virtuoso of Edo-style "books of manners" (*sharebon*). In his novels, Kōyō used the so-called mixed writing style, with both literary and colloquial elements. Using a high-blown poetic narrative style that intensified sentimentality and pas-sion, Kōyō laid the groundwork for the melodramatic turn that modern Japanese media was to take.

Subscribers to naturalism were fascinated by Émile Zola's revelation of the predestined darkness of human nature and Gustave Flaubert's explora-tion of the grip of desire on human life. Shimazaki Tōson's *The Broken Com-mandment* was naturalistic in the sense that it dealt with the question of biological heritage, social conventions, and an individual's attempt to rec-oncile himself with these conflicting demands. It was Tayama Katai, however, who compelled the Japanese brand of naturalism to diverge from French con-

ceptions of the genre. His declaration, "Raw Depiction"* (Rokostunaru Byōsha, 1904), advocated plain and bold descriptions of human reality by denouncing the literary art of his immediate predecessors such as Koyō, Shōyō, and Ōgai as conceited and ornate. "In the Next Room"* (Rinshitsu, 1907) further emphasizes the importance of plain description through an "I" narrator who witnesses the excruciating pain and eventual death of a lodger in a cheap inn. The scene is chiefly relayed via the sounds this narrator can hear—the dying man's screams and pleas mixed with the footsteps, conversations, and prayers of others. The unadorned physical description of a narrator overhearing what's going on in the next room, complemented by an artlessly plain style in a first-person, colloquial voice with the *desu/masu* endings, adds a corporeal reality to the narration that was missing in Tōson's work. Japan's naturalist impulses had been guided most persuasively by the influence of Rousseau and Dostoyevsky, who favored the confessional form, but Katai turned it into an almost nonfictional admission of the author's own human weakness. *The Quilt* (*Futon*, 1907), which describes the author's repressed sexual desire for a female student, turned into an emblem of the movement in Japan's literary history. This novel established a new trend in literature, as readers were encouraged to expect elements of autobiography in fiction and writers felt an obligation to confess their secrets for the sake of realism.

Iwano Hōmei, another prominent naturalist, separated himself from Katai's brand of I-novel partly by writing in the third-person but also by more blatantly associating the protagonist with the author himself. His phenomenology of human senses is demonstrated in his novella "Rich Boy"* (Bonchi, 1913), which highlights an individual's isolation by juxtaposing the protagonist's pain with his companions' personal inability to understand it. Unlike in Katai's "In the Next Room," pain in Hōmei's story is narrated in detailed descriptions of the protagonist's feelings, which the reader only encounters from a comfortable emotional distance, much like the characters who surround the protagonist. In addition, Hōmei's writing style here, plain but precise and polished, not only separates him from Katai's crude naturalism but also marks a triumph of the colloquial trend. In the self-debasing representation of the author-narrator, the emphasis on social and sexual desires, and the creation of lifelike speech styles, Hōmei's writings represent a newer and more decadent brand of Shimei's "subjective" realism. As illustrated in his body of work, Hōmei lived his life for the sake of fiction and wrote fiction to find direction in his life. Testing his theory about the relationship between life and art, he pushed naturalism to an extreme— actually breaking out of the boundaries of its Japanese version.

(ANTI)NATURALISM AND THE MODERN JAPANESE NOVEL

Although naturalism played a large role in the formation of the colloquial style and continued to have a strong hold on its proponents, it took a number of antinaturalists to push the style to its full potential. Ōgai and Sōseki, both of whom first subscribed to romanticism and later edged toward psychological realism, became the giants of Japan's modern literature. Both studied in Europe by governmental appointment, both held university positions, and both operated as cultural leaders of modern Japan. Together, they pointed their contemporaries to a broader range of literary writing, but it was Sōseki, in his stylistic experimentations and realistic depictions of individuals struggling with the challenges of modernity, who consummated the form of the modern novel as an artistic expression.

Sōseki owed much to Shimei's experiments with realism. Shimei developed the type Sōseki would later call a "high-class idler" (*kōtōyūmin*), a highly educated young man who is jobless and generally useless to society, whose own concerns about his modernity and individuality preclude any kind of success, either economic or social. His inertia inevitably brings about internalization, which opens up a space for the author to explore psychological depths and philosophical quandaries. Bunzō in Shimei's *The Drifting Cloud* and the narrator Furuya in his *Mediocrity* belong to this type, and the novels in which they appear chiefly concern themselves with the narrator's reading of these characters and with how the characters read each other. Shimei made the first declaration of realism in the prologue to the third part of *The Drifting Cloud*, claiming his novel was about "totally unremarkable people and the similarly unremarkable experiences they go through." Sōseki's *Kokoro* (serialized in 1914) features Sensei, a protagonist with a background eerily similar to Bunzō's. Sōseki makes the ethical issue of human relations far more complex in *Kokoro*, however, as Sensei blames himself for human egoism and epitomizes the struggle of the Meiji individual. The colloquial style, so cleverly explored by Shimei, fully matured in Sōseki's novels, reaching a high level of modern artistry.

By the end of the Meiji period, the question of Enlightenment was more or less settled ideologically and no longer the predominant issue. In fact, the crystallization of Enlightenment ideals and projects led to a stagnation of economic, ideological, and political discourses. In response to the loss of purpose and optimism toward the project of nation building, the anarchist Left rose up and harnessed the general dissatisfaction of the intellectual class. Ishikawa Takuboku saw a dead end for both the nation and the individual in the repressive and static atmosphere of Meiji Japan, as he wrote in his essay "The Impasse of Our Age"* (Jidai Heisoku no Genjō, 1913). The

angry young man accused naturalism, along with all other "isms" in litera-
ture, of being an inadequate tool for combatting this stagnation.

Naturalists should be acknowledged for trying out what became the
standard novelistic writing style, which was perfected by Sōseki and Ōgai.
While naturalism also left a powerful legacy, especially through the endur-
ance of the I-novel, naturalism per se fell out of fashion, and Sōseki's more
subtle realism became the dominant model. Among those who departed
from the naturalist movement was Nagai Kafū (1879–1959), who studied
at Kalamazoo College in Michigan and worked as a bank employee in New
York and Paris. His *Tales of America* (*Amerika Monogatari*, 1908) is a collec-
tion of short stories partly in praise of great American cities such as New
York and Chicago but darkened by the gritty realities of life for the Japanese
immigrants and tourists as found in America's port towns and in the agrar-
ian countryside. As an authorial persona, Kafū does not involve himself in
the action but instead listens to stories told by expatriates. The internal nar-
rator of "Hilltop"* (Oka no Ue), one of the stories included in *Tales of Amer-
ica*, tells of his desolate marriage based on his own mistaken judgment. *Tales
of France* (*Furansu Monogatari*, 1909) contains stories and essays about Kafū's
own experiences in Lyon and Paris. The book was censored because of his
criticism of the superficiality of Meiji modernity as compared to that of
France. Upon returning to Japan, he started writing about Tokyo's down-
town life, reviving the romantic nostalgia of his works abroad. Having re-
jected all political and economic authorities, he longed only for the dark
and damp part of Tokyo inhabited by day laborers and prostitutes, which he
portrayed in his later works, such as *Rivalry* (*Udekurabe*, 1916).

Akutagawa Ryūnosuke (1892–1927) went beyond the realism of both
Sōseki and Ōgai. A particularly talented short story writer, he wrote pas-
tiches of classical Chinese and Japanese works retold with psychological
twists, revealing the absurdity of human nature. The film *Rashomon* (1950), a
Cannes award winner that was directed by Kurosawa Akira (1910–1998), is
based on two short stories by Akutagawa, one demonstrating the unreli-
ability of any narrative point of view and the other exposing the cruelty of a
degenerate world. The prestigious Akutagawa Prize, given to the best new
writers, was established in 1935 by the Bungei Shunju Publishing Company
and continues to add star writers to the literary elite even now.

Tanizaki Jun'ichirō (1886–1965) shared Kafū's taste for eroticism and
Edo literature but often put his stories against a backdrop of ancient and me-
dieval courtly literature. Tanizaki believed in simple and direct sentences, in
keeping with the original intent of realism. His technical manipulation of
narrative form took the colloquial style to a new level as he pursued the
theme of sensual pleasure. At the very end of the Meiji period, he made his

debut with declarations against naturalism and for decadence and aestheticism. Among his early works, *The Tattooer* (*Shisei*, 1911) and *Terror* (*Kyōfu*, 1913) demonstrate his loyalty to the "art for art's sake" principle and his attention to dark sensory details. Tanizaki's hedonism developed into an extraordinary adoration for mothers and women, either elegantly remote or passionately cruel. His short story "The Jester"* (Hōkan, 1911) maintains his characteristic style as it tells of the descent of a rich young man who becomes a denizen of the pleasure quarters because of his masochistic love of being laughed at by the woman he admires. His novel *The Idiot's Love* (*Chijin no Ai*, 1923) featured a protagonist-narrator that is a precursor to Nabokov's Humbert Humbert (*Lolita*, 1955) in his obsessive devotion to a young woman who pays attention neither to his needs nor to social propriety. This novel established the Tanizaki hero, a man who finds ultimate pleasure in being enslaved by sexual and aesthetic desires.

Tanizaki began writing during the late Meiji period, but his concerns fell beyond the scope of the "Meiji project." Coming of age at a time when the Enlightenment was giving way to greater interest in a broader personal culture, Tanizaki freely experimented with all possible genres. His chief works include *Whirlpool* (*Manji*, 1928), an erotic confessional narrative in the Osaka dialect by a suicide survivor; *The Tales of Shunkin* (*Shunkin Shō*, 1933), a complex narrative combining interviews, diaries, and faulty narrators; and *The Key* (*Kagi*, 1956), consisting of a husband's and wife's diaries, written with the awareness that each is reading the other's. He is also known for his modern translation of the entire *Tale of Genji* (1939), censored during World War II. His works have been made into plays, television dramas, and films, and he came to be celebrated with the appellation of "Ōtanizaki" (The Great Tanizaki). Combining classical courtly style and recalling themes of the Edo period, Tanizaki used his sensibility as a writer to redirect the innovations of Meiji literature to a modernism in which vying forms of "truthful representation" merge.

In sum, Meiji literature was very much centered on the city of Tokyo in all its aspects, in keeping with the government's use of the city as a model for its Enlightenment project. The city's new culture was overlaid upon an already well-developed Edo, the shogun's capital. Accordingly, Tokyo's urban literature was built on a variety of Edo-period innovations as further enriched by turn-of-the-century authors who crossed the borders of genres and styles, mingling image and text, classical and modern, uptown and downtown, and East and West. Conflicting notions of literature—classical

rhetoric or colloquialism, lyricism or realism, and romanticism or naturalism—stimulated the modernization of Japanese letters. As we show in this anthology, the Japanese finally came to a form of prose writing in which the problems of modernity—the rise of the individual, the tasks of nation building, and the inclusion of formerly peripheralized genders and classes—found voice.

Meiji literature is still alive and well in the twenty-first century. Many of the titles mentioned here remain paperback best sellers in Japan. From April to September 2014, the *Asahi Shinbun* commemorated the work of Natsume Sōseki by running the novel *Kokoro* in its original, illustrated, and serialized form of 110 weekday installments. Along with each installment, the paper ran selected pieces of news from one hundred years ago and introductory essays on the historical and social context of the novel. In response to readers' demand, the newspaper ran a similar series of the original form of *Sanshirō* (serialized 1908), which prompted a continuation of the series with the daily publication of *And Then* (*Sorekara,* serialized 1909). The long-running festivities indicate both the close connection between Japan's newspapers and the modern novel and the value of what Meiji literature invented, nurtured, and passed on to today's readers. These commemorative publications also show us how the modern novel grew in parallel with the development of the fictive modern nation-state—each imagined at the outset and then made to seem real, believable, and, in the end, inevitable.

Notes for the Reader

1. Uses of Japanese terms are kept to a minimum except for those that are commonly used in English. Certain interesting expressions and widely used terminologies are introduced in parentheses following English equivalents throughout the volume.

2. Japanese names, including pen names, are given in the Japanese order, with the family name first. The popular writers of the period are generally called not by their family names but by their given names or that part of their pen names, as in "Sōseki" for "Natsume Sōseki" and "Kafū" for "Nagai Kafū." Exceptionally, Tanizaki Jun'ichirō is customarily referred to by his family name, "Tanizaki," as is the case with many more modern writers. Among women authors, many are called by their pen names, such as "Ichiyō" for "Higuchi Ichiyō" and "Shōen" for "Nakajima Shōen," but others used their real names, as do contemporary writers, male and female.

3. Some diacritics are added to aid the pronunciation of Japanese names and words. Macrons indicate long vowels. An apostrophe is added to indicate that two characters in the English alphabet are to be pronounced separately as in "Kaichō'on." Some words, especially proper nouns that are commonly recognized, are not written with macrons, for example, Tokyo (Tōkyō), Osaka (Ōsaka), and Shinto (Shintō).

4. The vowels "a," "i," "u," "e," and "o" are pronounced approximately like "ah," "ee," "ew," "eh," and "oh." Every vowel, even an "e" at the end of a word, is pronounced, as in "Ichikawa Fusae." There are no diphthongs or sliding from one vowel to another. Although "saké" has become an English word, it is spelled without an acute accent mark in this volume and is written "sake."

5. The spelling of a Japanese word that is established as an English one may be altered to represent the proper pronunciation in Japanese, as in *shamisen* instead of "samisen" and *nō* instead of "Noh."

6. In English, the Japanese sound "n" is generally transcribed as "m" when it precedes a "b." In this volume, however, the proper Japanese pronunciation is maintained in the form "nb," as in "Kanbara Ariake" and *Asahi Shinbun*.

7. Throughout the volume, asterisks (*) denote the title of a work that is included in this volume, either in full or in part.

8. Japanese is traditionally written vertically and from right to left. In the case of Edo-style graphic fiction such as *Takahashi Oden, Devil Woman*,* adjustments have been made in placing English translations into pictures to allow for reading from left to right horizontally. On the other hand, "Catfish, Prostitutes, and Politicians: Satirical Cartoons"* represents a transition period from the vertical style text to Westernized horizontal script. These selections also include text that is imbedded in pictures.

9. The lunar calendar, which is still used in some of the old-fashioned works included here, cannot be translated precisely into the solar calendar. The gap between the two is about a month or more. What we call the "First Month" does not represent "January" in our calendar. The year consisted of twelve lunar months, and the day was divided into twelve "hours," each approximately two hours by the solar calendar. Hours were also movable and approximate: the dawn (rather than sunrise) and dusk (rather than sunset) determined the six hours of the day and the six hours of the night, so that the length of the "hour" varied according to the season.

10. Distances are represented by *sun* (approximately 1.2 inches), *shaku* (10 *sun*, or approximately 1 foot), *ken* (6 *shaku*, or approximately 6 feet), *chō* (60 *ken*, or approximately half a mile), and *ri* (36 *chō*, or approximately 2 miles).

11. In 1871, the Meiji government announced its new monetary system based on a gold standard. At the time, one *yen* was equal to one U.S. dollar. One *yen* equaled one hundred *sen*, or one thousand *rin*. In Meiji writing, the old Edo system was often referred to: one *ryō* equaled four

bu, sixteen *shu,* or four thousand *mon.* Often, these two systems were used interchangeably in artistic works of the period.

12. It is difficult to translate such monetary figures into dollars and cents, but during the early Meiji period, grade-school teachers earned a monthly salary of nine *yen,* and veteran artisans earned an average of twenty *yen* per month. A prestigious position at a college would pay about eighty *yen* per month. In terms of the *ryō,* the generally used example is that a craftsman's daily compensation was about two hundred *mon.* The *ryō* was not a denomination that lower- and middle-class citizens encountered on a daily basis, but one *ryō* was enough for one commoner to live on for two to three months. The figure of fifty *ryō* was often used as an unimaginably exorbitant sum in crime and revenge stories.

PART I

Responses to the Age of Enlightenment

Things Heard around a Pot of Beef

KANAGAKI ROBUN

 Kanagaki Robun (1829–1894) is remembered as the most prominent *gesaku* writer of the transitional period from the last years of the Edo period through the first years of the new Meiji order—and as the last *gesaku* writer of any prominence at all.

The vicissitudes of Kanagaki Robun's career reflect the turbulent nature of the late Edo and early Meiji periods. A commoner born and raised in Edo, he immersed himself in various aspects of Edo popular culture, including *haikai* and *kyōka* verse, and later acquired a familiarity with *nagauta* ballads as well as with the customs of the Yoshiwara pleasure quarters.

He eked out a living writing topical hack pieces, including song lyrics, quasi-journalistic broadsides, and an account of the Ansei earthquake of 1855, produced with a coauthor in a mere three days. Recognition came with *A Comical Fuji Pilgrimage* (*Kokkei Fuji Mōde,* 1860–1861), published when the prohibition against women climbing Mount Fuji in 1860 was lifted. Robun also worked on several vignettes reflecting another novel phenomenon, the presence of Western influences (and people) in Japan. Soon his output started to include works focused on the outside world, such as *Illustrated Accounts of International Notables* (*Bankoku Jinbutsu Zu-e,* 1861)

and *Nations of the World Illustrated for Children* (*Osana-etoki Bankokuban-ashi*, 1861), aimed at a popular audience.

In the years immediately following the Meiji Restoration Robun suc-ceeded in recycling favorite *gesaku* conventions with up-to-date subject matter. *To the West on Ship and on Foot* (*Bankoku Kōkai: Seiyō Dōchū Hiza-kurige*, 1870–1876) is a picaresque journey in the manner of Jippensha Ikku's celebrated *Along the Highway on Foot* series, in which Robun's pair of Edo-born protagonists journey to Europe by steamship. In *Things Heard around a Pot of Beef* (*Ushiya Zōdan Aguranabe*, 1871–1872), Robun adopts Shikitei Sanba's pattern of establishing a set locale where assorted characters en-gage in monologues or conversations whose contents and style reveal the distinctive essence of their social identities (gender, age, class, rank, profes-sion, economic status, personality type, and so on), a subject of inexhaust-ible interest to Edo, and also to early Meiji, readers. Here, Robun's locale is a restaurant serving beef, a dish that had long been proscribed by the Bud-dhist tradition but was now associated with "enlightened" and fashionable modernity.

While the novelty, benefits, or sheer pleasure of eating beef are lauded by the speakers in some sections of *Things Heard around a Pot of Beef*, in-cluding those translated here, they barely figure at all in the monologues of some of the other customers (including a country samurai, a much put-upon courtesan, a scheming merchant). Even when these characters do mention beef, they seem far less self-conscious about it than are the dedicated fol-lowers of Western-inspired fashion, such as the newspaper admirer in the final section.

The episode "A Teahouse Hostess Who Dines on the Sly" contains a more novice Europhile than the newspaper admirer. The geisha make fun of this character with the nickname "Dontaku," literally meaning "Sunday," from the Dutch *zontag*. Not having a weekly calendar, the Japanese found strange the foreigners' habit of leisurely strolls on the beach of Yokohama on Sundays. "Dontaku" became a popular term among the sort of young in-tellectuals who would gather at beef restaurants. Robun added an extra meaning to the term through his Japanese transcription of its components: *don*, meaning "stupid," and *taku*, often appearing in physicians' names, to-gether connoted a quack doctor as well as a Europhile. The word *dontaku* made its way into everyday vocabulary in the 1870s when the Japanese gov-ernment adopted the solar calendar and decreed Sunday a holiday. *Handon* came to mean a half-day off, usually a Saturday.

Robun was very much an Edo *gesaku* writer in poking fun at the preten-sions of aspiring men of fashion. Here the convention is perpetuated with a novel twist: the replacement of the stock figure of the would-be connoisseur

in Edo's licensed quarters with the half-baked expert on the new manners and ideas emanating from the West. The dialogue between a horse and a steer is an atypical excursion into whimsical fantasy, but it retains Robun's characteristically sharp ear for language and tone of gentle, bemused mockery.

Things Heard around a Pot of Beef was one of the last *gesaku* works to be published before the government issued a series of edicts calling upon writers to devote their efforts to the spread of Enlightenment and the promotion of a spirit of patriotism and respect for authority among their readers. In response, Robun and a fellow *gesaku* writer, Sansantei Arindo (1832–1902), published a memorial in which they pledged to abide by the government's stipulations. For several years thereafter Robun abandoned *gesaku* and occupied himself with writing practical works, including a textbook on world geography and a Western cookbook (both in 1872), delivering lectures on Enlightenment for the government of Kanagawa Prefecture, and contributing to the new and burgeoning field of newspaper journalism (which he had lampooned in the final segment of *Things Heard around a Pot of Beef*).

Unlike the great *gesaku* masters of earlier years, Robun did little to develop new forms of expression, nor was he a notably scintillating stylist; his main claim on our attention derives from his deft use of established *gesaku* forms and techniques to capture the look and feel of the age of unprecedented change that he found himself witnessing.

(JC)

A Thoroughly Modern Bovine-Equine Colloquy

Horse: Well Mister Bull, you've certainly risen in the world since the last time we met! A woolen cloak and trousers—the very picture of Western style! Nice going!

Bull: Hello there, Horsey! Now you're the one that's doing nicely for yourself these days, pulling a fancy carriage around. I hear that you're making the rounds of all the fashionable places on Sundays—I'm envious! Just look at us cattle now—sure we're on everybody's lips these days, but it's all a lot of bull. Before we're even old enough to know what's happening to us they put a ring through our nose, and then it's off to Tsukiji or Yokohama to be sold and we end up in the slaughterhouse with our legs tied to stakes. Humans stuff us into their bellies. It's awful!

Horse: No, no, to begin with, you cattle aren't the kind of creatures that are meant to be pulling carts at places like the Takanawa docks or Shibayamachi in Ōtsu. Until they became civilized, humans just didn't realize that the heavens had put you into this world to be food for them. All they saw was how big you are, and those horns, and how powerful you look, so they figured that you must have been made for pulling heavy loads and they loaded you up with bales of rice or made you haul festival floats and things for all these years. And they were wrong, of course. In China, even though they haven't started to adopt modern civilization yet, they've realized all along that cattle are something to be eaten, not to be used as beasts of burden—that's why they had those sayings about beef being a fit offering to the gods from a king and the aristocracy not keeping cattle and swine in their homes. As some wise man has told us, now that we live in an age of

(National Institute for Japanese Literature)

enlightenment or whatever they call it, not only humans but we birds and beasts must all do our duty. So there'll be no more horsing around for us, and your breed must do your duty by offering yourself up to sustain the bodies of the masters of all creation. Once you've gone under the butcher's knife and into the bellies of humans, your karma as beasts will finally come to an end and you can be reborn as humans yourselves—kind of like those humans who get themselves set up in business by their bosses as a reward for their years of loyal service. If you ask me, you'd be much better off doing your duty according to heaven's plan and leaving the sufferings of the life of a beast behind to be reborn in the world of men than spending all your days chomping on hay and bean husks. Look at us horses—even if we want some human to eat us, we can't find any. Of course, they do say that people will eat red horses as a cure for the clap, but that's kind of rare—so there's no way for us to redeem our karma.

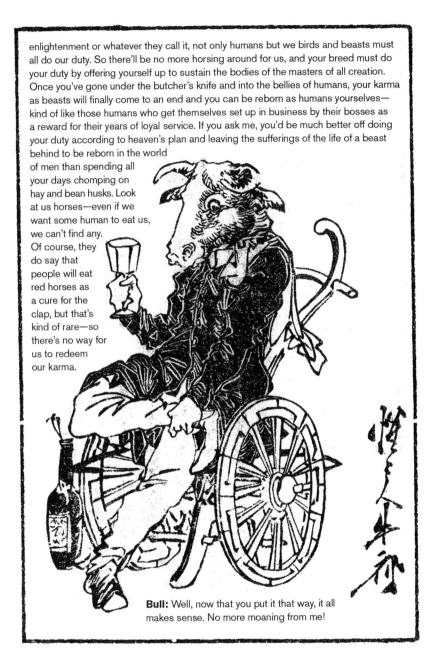

Bull: Well, now that you put it that way, it all makes sense. No more moaning from me!

(National Institute for Japanese Literature)

A TEAHOUSE HOSTESS WHO DINES ON THE SLY

[A woman who might be about seventeen or eighteen, or perhaps a year or so over twenty. Her hair is done in a flattened Shimada style; her kimono is of resewn, striped Kazaori crepe; not a high-quality outfit. In fact it does not even rise to the level of ordinary or store-bought attire. Over her kimono she sports a coarse indigo and gray striped crepe jacket that her mother must have picked up on the cheap at one of the secondhand shops in Umamichi or Nakamachi, and a black velvet sash: only its edges are purple crepe, while the middle part appears to be patches of woolen faux crepe. She looks to be the type who, while employed in the entertainment district of Okuyama in Asakusa, engages in a poorly paying side job at night: from ten o'clock she puts on a thick layer of makeup and goes to work as a hostess at a teahouse.

Her companion is a fiftyish lady who tries to conceal her false teeth by coloring them black; she also has dyed her hair black, like a female version of the warrior Lord Sanemori; the only crepe items in her outfit are a russet cambric lining recycled from another garment and a striped-indigo apron. Something about her appearance suggests the crone who guides the souls of the deceased as they cross the river of Hell, or perhaps a former lady of the night who has aged gracelessly. An atrocious old hag who seems to combine the attributes of the mother of Hanbei the Vegetable Monger, Oyoku the Brothel Manager, and Manno the Maidservant in the kabuki play, she's that type of woman who gets turned on with the slightest touch.

The teahouse hostess, who would not feel comfortable venturing into such an establishment alone, has asked the old lady to accompany her—not that she had needed any persuasion to embark on an evening of beef and sake. Their little party appears to have left both ladies totally plastered, as the old badger and the young fox start to show their tails, completely unconcerned that their neighbors might overhear their conversation. Plying each other with sake and side dishes of beef, they engage in a leisurely bout of hair-raising chatter, so that all of the pretension they have put on starts peeling off.]

KORO: Ohiki-san, the other night at Hyōgetsu you said that you don't eat beef. You must have been fibbing. You certainly had us all fooled! My goodness, you really know how to put it away! Here, have some more . . .

[The old lady pours her another drink, laughing with her mouth so wide open that her gums are exposed.]

HIKI: Ahahahahah, Okoro-san, how dim-witted can you be! Don't forget I was with customers then! I may be getting on in years, but I'm not enough

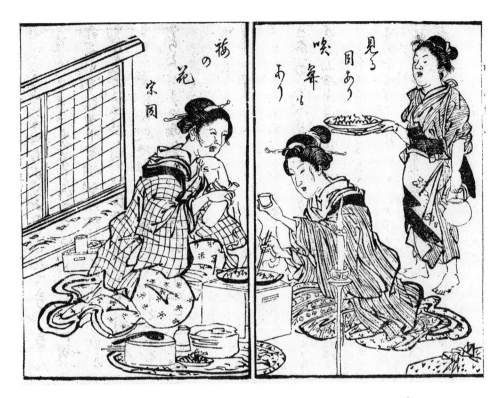

Shh! Teahouse hostesses like beef, too. (National Institute for Japanese Literature)

of an old lady to be led around by my grandson's hand yet, or need a cane, or while away my time feeding beans to the pigeons. If I said anything about how much I love beef when there were customers around, especially new ones, it would hardly sound very sexy, would it? They'd just think I was a nasty old witch—that's why I said what I did. Actually I'm crazy about meat! To tell the truth, even back in the days when most people wouldn't even think of eating it, when I ran one of those teahouses in Ryōgoku, the other proprietors would gather at my place. They'd talk about how good boar's meat is, and I just couldn't wait to try it myself. So one night when it was snowing I closed the shop early and invited an old lady from the Edo-ya to come with me. We walked over the bridge to a place where they served meat and we were all ready to try it, but it was lit up so brightly that we just didn't feel comfortable going in. Of course I was a lot younger in those days, and you know, after all, we were both women. So there we were just walking up and down in front of the restaurant when who should turn up but a young fellow called Anaguma from the Baba gang. He had come to have some venison. He took us by the hand and we sailed right in with him, and that was my first taste. Since that night I haven't been able to

control myself—and when winter comes around it's all I can think about. Meat's better than sex or anything else. Who cares what people think? You can't bring yourself to eat flesh unless you have some passion about it! I used to have it brought in to my home, but somehow it never tasted quite the same that way. Boar and venison both taste wonderful, but once beef started to become available I heard people saying that it's healthier for you, and that too much pork is bad, so I decided no more boar for me. Now I won't touch anything but beef! But look at you, Okoro-san—still so young, yet already so accustomed to eating beef. Very impressive!

[She sticks out a tongue that looks like a cow's and devours a piece of meat.]

KORO: Well, there's a reason for it, you know. When I was fourteen my father got involved in some kind of speculation and lost everything. He abandoned my mother and me and ran away. We lost our home and suffered all kinds of hardships. My mother was originally from Kanagawa, and the family took the two of us in. One day a relative of hers from Hama [short for Yokohama] urged her to think about sending me to be a foreigner's concubine. She said that there was an Englishman there called Konshirō [she means Consul]. He had red, curly hair, but he understood Japanese very well and was a perfectly good-natured man in every way. She also said that even though people look down on foreigners, in these modern times it would be silly and pointless to cling to old attitudes and pass up this kind of opportunity. Well, you know how greedy my mother was, so she was all for it as long as the money was good. According to our relative, the compensation would be fifty *ryō* a month, plus ten *ryō* for expenses, and even though there was no need for me to be too fancy about things there would be an allowance of twenty-five *ryō* for my wardrobe and accessories. What's more, if my mother was short of funds we could get a three month advance, and if the gentleman was pleased with me, I could cajole him into giving me a bracelet with coral beads as big as cherries. If by any chance I was to give birth to the foreigner's child, he'd be sure to take such good care of me that I'd never have to worry for the rest of my life, even if he eventually went back home, so we should agree to meet him right away. We went to Yokohama by jickshaw [she means "rickshaw"] the very same day. It was all for my mother's sake, of course, but I couldn't stand the idea of becoming the plaything of some strange man from who knows where, and while we were waiting for the go-between I felt like running out to the Yokohama docks and throwing myself into the water, but then I thought about how hard it would be for my aged mother if I did that. So I decided to endure it all and act as if it was all some kind of horrible dream in which I was being devoured by a python.

While these thoughts were running through my mind, we were told that the foreigner had arrived. I was quaking! I tried to shy away as much as I could, but the go-between and my mother were getting nervous and told me to step forward and show my face, pushing me from behind and poking me in the back for good measure. My head was swimming, but when I looked up at him I saw that he was a truly fine-looking man. He looked just like the kind of Western gentleman that Kikugorō-san has been playing lately! He seemed to be pleased with me despite my moon face, so he came over to me and said "You no like foreigners? Me think you very nice." He took my hand and I was all in a dither—ohohohohohoho, ohohohohoho—Oh no, now look! Here I am getting so carried away that I've gone and knocked over your cup! Ohiki-san, get up or you'll get a stain!

HIKI: Oh my, just look what you've done! You've spilled somebody else's sake while bragging about your love life! One of my best aprons, and now you've soaked it right through!

KORO: Ohohohohohoho, so sorry, so sorry, I must have become so wrapped up in my story that I simply lost control and made a mess of everything! Never mind the rest of it, let me pour you another cup . . .

HIKI: No, no, you mustn't stop now! Tell me the rest! I've heard the beginning so I have to hear the ending!! When you start bragging about your conquest again, I'll signal you to stop. Until then, go on.

KORO: Oh no, what have I said? Ahh, I'll have to pay for chattering so much! But I've told you so much I might as well tell you the rest. Just remember that you've got to keep it all a secret . . . and absolutely top secret from *him* . . .

[She sticks out the tip of her thumb indicating a male lover.]

HIKI: Okoro-san! What kind of hussy do you take me for? In our business talking about people's little secrets is absolutely unprofessional.

[She presses her index finger against her lips.]

Not that I want to boast, but when it comes to keeping a secret, just ask all the girls in Asakusa—I'm the one that they tell everything to, the one they come to when they need help, the one that helps out with the tricky

situations—that's this old lady's stock in trade. Nobody can accuse me of not knowing how to handle these things!

KORO: Now that I'm back in Tokyo it's not something that I want people to know about so I really should keep my mouth shut, but since I've had a little too much to drink I just started chattering. . . . Anyway, to get back to my story: Everything went along just fine, and as soon as the introduction was over the deal was arranged and I was whisked off to the foreigner's residence that very day. When I got there I was absolutely stunned—all the rooms were just gorgeous, and I felt awful about all the fuss I had made before. The gentleman made sure that I got three Japanese meals a day, but he would have beef for lunch and dinner, and so I started taking after him. Love makes you do the strangest things! I was the one who couldn't even pass in front of a beef place when I was in Tokyo! Nobody had even asked me to try eating it, but I decided I wanted to now. One day when the cook was boiling some beef I went down to the kitchen and asked him for a little slice. It was so delicious, before long I came to like it more than the usual fish! So you see, when it comes to beef, I'm not what you would call a beginner . . .

HIKI: My goodness, is that so? Well then I guess we'd have to say that when it comes to beef, you're quite an old hand!

KORO: Knock it off!

HIKI: Ahahahahahahaha, by the way Okoro-san, Ichiroku-san says that he'll be paying a call tomorrow night with Dr. Dontwork. If you already have an engagement, do figure out some way to get out of it and join us at five o'clock. And please drop a hint to Obara-san that Dr. Dontwork is coming—that doctor's so jealous!

KORO: And apparently wearing his hair Western-style now—that must be what's making him so jealous! That fellow's so full of vim and vigor he simply won't let up!

HIKI: Now, you mustn't be so nasty. Obara-san has been in hot pursuit all along.

KORO: You don't say?

HIKI: No, the doctor's very gentle with women.

KORO: He must not be so gentle with his patients—there's something creepy about that man, oho ohohohohohohoho!

HIKI: Okoro-san! I can't believe your nasty mouth! It's enough to do the likes of Ichiroku-san and Master Gekkyū in for good!

KORO: Now now, don't say such unpleasant things, please! The only things I've ever killed are mosquitoes that sucked too much of my blood, and autumn fleas!

HIKI: Very clever! No wonder . . . well, enough of this, let's have them bring on the rice . . . If somebody shows up at the house while I'm out, you never know, they just might slip off to some outfit in Minami Umamichi or sneak off to Yoshiwara—ah, all that money I'm losing by missing my customers!

KORO: Really, Ohiki-san, you should let yourself enjoy life a little more. What are you going to do with all that money you've got? It just makes you worry about burglars! You should relax a little and let yourself enjoy a drink every now and then. Waitress! More sake and raw beef!

HIKI: No, no, enough! The rice is already on its way, so let's stop with that.

KORO: But I already ordered more, so we might as well just go ahead. There's no point canceling the order—Waitress! Bring our order right away!

A NEWSPAPER AFICIONADO'S BEEF TARTARE

[A gentleman with his hair newly let down in the Western style, decked out in a Western outfit painstakingly assembled piece by piece from secondhand clothing markets in Yanagihara and the Tobisawa-chō street stalls: a French cloak, an English waistcoat, an old army cap on his head. Without the wherewithal to acquire a pair of shoes, he makes do with linen-soled sandals. This poser of advancing years creates the appearance of owning a pocket watch by sporting a chain, although it appears that he has not yet been able to acquire a silver-plated one; when asked the time, he replies that he has forgotten his watch. Having equipped himself with a barely rudimentary knowledge of the nations and places of the world, this good-for-nothing proudly plays the expert on all things Western. Of

The newspaper aficionado. (National Institute for Japanese Literature)

uncertain occupation but clearly well versed in the art of idling, he is a man of gushing eloquence yet his words are hard to follow and merely bamboozle the uninformed; when questioned closely on any topic he has nothing to offer and, rather like the writer Kanagaki Robun, is apt to suddenly fabricate some excuse and beat a hasty retreat. Sharing beef stew and cold sake with his companion, he acts as if he were the only man in the entire world worthy of being called civilized, and his partner nothing more than a foil; his real purpose is to impress all the other customers with the vastness of his knowledge. From a purple wrapping cloth he produces three newspapers, and, without even bothering to read them, he sets them aside as props. He exchanges sake cups with his companion.]

"Say, Gusuke, how old is that boy of yours now?"

"My son? Umm, oh, I suppose he must be eight by now . . ."

"Well, then, you mustn't leave him to his own devices and following the parental customs of the past. Now my own hobbledehoy—oh, of course you wouldn't understand a difficult Chinese expression like that, I mean my kid—he's turning seven this year, so no more of that shaved head of

his. This year we're growing his hair out modern-style. Not only that but I had another brilliant idea: forget about teaching him to read Japanese, start right out teaching him all about the West, in English! If you start stuffing his head with Chinese history, literature, Confucian glossaries, and 123,456 shipfuls of all that musty old trivia from the Confucian tradition, just think of the damage it would do him. Picking up so many old-fashioned Chinese ideas! You should be teaching your son about the West. The way things are today, we can't have a new dawn without it. You can't go wrong having him study Western things no matter what he becomes: there's enlightenment for the merchant, and enlightenment for the craftsman. Nowadays, thanks to our new government, the distinctions between the four classes have been abolished and we've all been granted the freedom to make our own way in the world: family names, wearing swords, kimono, Western clothing, horses, wagons, anything at all—it's all up to you! No matter how lowly or desperate your circumstances, you're no longer trapped by the identity you had before. That's what it means to be free to make your own way. But the problem is that when you start to expound this principle among the unlettered masses, some of them get the notion that they can do whatever they please, without worrying about the right or wrong of it, and that the government will let them get away with it. These days, people are allowed to preach their views in every corner of the land, and advocates of every school and sect are preaching away. But if I were entrusted with such a mission, I would spread enlightenment by expounding the doctrine of autonomy as interpreted by Nakamura-sensei of Shizuoka. And now, let's drink!"

[Throughout this lengthy discourse they fill each other's sake cups and eat their beef.]

"You see, what allows the light of knowledge to spread throughout the world? It's the newspapers! Just look at this. It's issue fifty-eight of the newspaper from Nisshindō in Yonezawa-chō, just arrived this morning. It's just full of useful information! Still, it's not as if you can believe everything that they print. For two issues in a row the *Yokohama Daily* carried a trumped-up story about Kanagaki Robun being fined for relieving himself on a public thoroughfare and even composing a poem about it. Of course, they say that the man is such a publicity hound that he's absolutely overjoyed, But even so, what a false report! What? This one? Oh, it's just a little plaything that I've been putting together to pass the time. I'm calling it the "Noisepaper." That's right, there are noisepapers just like there are newspapers! Look here, there's a funny story for you: a

petition from a truly earnest man of virtue. He's submitted it to the district office as if he thinks it really has a chance of being adopted. Just look at this wording. What kind of fools does he take us for? If this is passed up to the authorities it'll make the district office look bad. They say this fellow's been denounced roundly for proposing something so outrageous. What a lot of nonsense! Let me just read you a little of it before the next helping comes:

(Ahem)

'I the undersigned, humbly believing that devoting ourselves to economic matters and promoting the wealth of the nation is a task of the most urgent concern, and aspiring to convert the useless into the useful, humbly presume to present for your consideration the following petition.

When summer arrives no household in the land is spared from the infestation of fleas. These creatures torment us with their bites, depriving us of our precious repose by night and obstructing the pursuit of our livelihoods by day. Truly there is no fleeing from the onslaughts of these useless, harmful creatures, but all the same they are part of the hundreds of thousands of living souls of the world.

I submit to you that a method exists that would enable us to transform them into a beneficial asset.

Having pondered deeply on this matter, I cast some of these creatures into a flame and realized that in doing so I had converted them into combustible matter. By employing the same principle as the Englishman James Watt, who invented the steam engine by observing the action of vapor escaping from a kettle, I humbly submit that we too can amalgamate the power of minute things into a mighty power. If the authorities were to issue an ordinance requiring all households within their jurisdiction to collect and submit these myriad masses of fleas, they could then be used to replace the ammunition used for the firing of the daily noon cannon. Would not the ammunition retained in this manner over the course of the three months of summer suffice to afford us victory in a hundred battles? As the wisdom of the ancients instructs us, to sow a single seed is to be rewarded with ten thousand: that indeed is to convert the useless into the useful, to avoid predicaments in the short run by adopting the long view.

Unworthy as I may be, I make myself so bold as to offer my most modest proposal in this petition. Should it by any chance find favor I could ask for no greater honor or happiness.

With most humble salutations from your most obedient servant,
Tondari Hanetarō
Asakusa Kaminari Monzen'

"Now there's a strange fellow for you! A shortsighted scheme if I ever heard one! It may sound logical enough, but it's all just so much worthless flim-flam. Well, there are plenty of posers who pick up a little bit of half-baked knowledge and jump to conclusions, and when it comes to the West they usually have no idea what they're talking about. My own latest petition places the national interest above all else and, not necessarily considering individual benefits, aims at raising the dignity of our divine nation over the entire earth while seeking the deepest strategies that would be effective for billions of years to come. Now, when I present my own proposal it will be an ingenious design for the ages, one that will enrich the nation, and project the radiant magnificence of our divine empire throughout the world. It cannot be discussed in the same breath with any flea-based proposition or strategies depending on mosquitoes' legs. Say, it's time for another flask! Waitress! Waitress!! Ask the chef to make some thick slices of sirloin for me. I'm in the mood for tabletop grilling. This fellow here says that he likes it in soup, so boil it up in some broth with sweet sake and soy sauce, no, make that dunking sauce. No, no, it's not time for rice and pickles yet!"

[Just as he says this, the boom of the noon cannon is heard.]

"What was that—oh my goodness! Is it that time already?"

TRANSLATED BY JOEL COHN

Catfish, Prostitutes, and Politicians: Satirical Cartoons

The political cartoon was inspired by a foreign model. *Ponchi-e* (Punch picture), the first term for cartoon, signaled its foreign provenance. The origin of the *manga* genre is usually traced to *Japan Punch*, a comic magazine published in Yokohama by Charles Wirgman, a *London Illustrated News* correspondent who poked fun at life in the treaty port community. Copies of the magazine found their way into the hands of curious Japanese who experimented with this new style of visual satire in early Japanese-language newspapers. By the late 1870s

a sudden explosion of comic journals and magazines transformed the political cartoon into a popular genre.

Although the *ponchi-e* was new, visual satire itself was not. The impulse to tweak the pretensions and foibles of the rich and powerful was as strong in Edo Japan as it was in Georgian England. Anonymous comic prints, broadsheets, and picture books had lampooned the samurai class since the eighteenth century, and by the 1840s well-known ukiyo-e print artists like Utagawa Kuniyoshi (1797–1861) published "crazy pictures" (*kyōga*) that deployed oblique visual clues, puns, and double entendres to comment on current political struggles and leaders. Satirical prints were sold unauthorized, uncensored, and under the counter, and artists often found themselves in trouble with the authorities. But as the legitimacy of the Tokugawa regime melted away, the market was flooded with prints and broadsheets (*kawaraban*) that lampooned the regime's failure to keep the foreigners at bay and criticized its hapless efforts to deal with rising opposition.

Written texts in satirical prints were as important as visual images, and publishers employed *gesaku* writers to supply words to accompany the artists' pictures. Since the late seventeenth century, when Hishikawa Moronobu (1618–1694) provided Saikaku with illustrations for his *The Life of an Amorous Man* (*Kōshoku Ichidai Otoko*, 1682), artists and writers had worked in close collaboration. The writer's dialogue, narrative exposition, and authorial asides wound their way across the page through the artist's playful illustrations. The text, crowded to the edges and corners, had to struggle with pictures for the attention of the reader. The act of reading required decoding visual signs and their allusions as much as it required making sense of words.

The Meiji political cartoon was firmly rooted in these Edo practices of producing and reading popular texts. *An Illustrated Ja-pun* (*E-Shinbun Nipponchi*), the first comic journal published in Japan, was a collaborative venture between artist Kawanabe Kyōsai and *gesaku* writer Kanagaki Robun, who satirized the sudden craze for Western material culture. The *Weird News Circular* (*Marumaru Chinbun*) also recruited *gesaku* writers, not only to write "crazy essays" (*kyōbun*), "crazy poems" (*kyōshi*), and "comic editorials" (*chasetsu*) for the magazine, but also to provide texts for its *ponchi-e*. Unlike the one-line captions of later cartoons, these texts were talky chunks of prose, usually in dialogue form, that echoed the language of pre-Meiji popular literature.

There were also clear influences from foreign places. The artists who drew cartoons for the *Weird News Circular* were all trained in Western-style painting and drawing techniques. Oil painter Honda Kinkichirō (1850–1921) used cross-hatching, shading, and other conventional Western techniques for his cartoons; Kobayashi Kiyochika had already succeeded with his distinctively realistic woodblock prints called "light pictures" (*kōsenga*)

that rendered contemporary Tokyo landscapes in scientific perspective; and Taguchi Sakubei, Kiyochika's student and disciple, followed in his footsteps. All three men ultimately reverted to the calligraphic line of traditional brush painting, which was easier to compose and reproduce quickly, when they drew cartoons; but they did have these ties to Western techniques.

Early Meiji cartoons relied heavily on puns, visual and verbal, just as traditional satirical prints and *gesaku* fiction had. The Japanese language, so rich in homophones, lends itself to sly verbal (and visual) acrobatics. During the Edo period, the pun served to circumvent, if not evade, censorship, and it did so as well under the more vigilant eyes of Meiji censors. The pun's more literary, psychological function was to trigger in the reader the sudden delight of unlocking the verbal/visual puzzle.

Not surprisingly, the early Meiji cartoonists also drew heavily on the symbolic vocabulary of traditional comic prints. A kitten was a geisha; a badger was a trickster; a chess piece was a soldier or warrior; fighting sumo wrestlers were contending political factions; the wind god was a powerful political force; and so forth. It was easy for readers who were familiar with the tropes of traditional popular culture to decode these symbols, although the early Meiji cartoonists often deployed allusions to folk traditions and folktales in unexpected, novel ways.

The early Meiji cartoonists borrowed freely from Western humor magazines. References were commonly made to aspects of Western culture as varied as the steam engine and the Colossus of Rhodes; and the caricature, which Kuniyoshi and a few other print artists had experimented with but dared to use only to depict kabuki actors, became a standard convention.

The *ponchi-e,* with it curiously hybrid vocabulary, gradually faded as a genre at the turn of the century. The cartoons of the late Meiji period were far more cosmopolitan, far less local in feel than the *ponchi-e.* They acquired a new name, *manga,* which was meant to suggest a "casual sketch" as in the title of the sketchbooks by Katsushika Hokusai (1760–1849). The *Tokyo Puck,* founded in 1905, was the first popular magazine devoted exclusively to cartoons. Handsomely produced in tabloid format with color lithography, its model was the leading American humor magazine *Puck.* The magazine was an instant success, quickly reaching a circulation of 100,000.

Tokyo Puck abandoned the boldness of the calligraphic line for the subtler shades and tones of lithography, and adopted the new international language of cartoonists who drew from a common stock of symbols, such as Uncle Sam for the United States and John Bull for Japan. Even the sun goddess Amaterasu was turned into a Hellenistic goddess clothed in diaphanous robes like Columbia or Britannia. The rambling texts that characterized the *ponchi-e* also disappeared from Kitazawa Rakuten's (1876–1955) cartoons,

and in their place appeared terse captions or comic strips that carried a narrative over several panels. Over time, words were almost completely subordinated to pictures, and the pun ceased to play such an important role in visual humor as the cartoon became a predominantly visual genre.

These changes reflected a shift in audience. By the turn of the century the school curriculum, and rising levels of formal education, had transformed popular cultural literacy. Readers of cartoons were far more cosmopolitan than their fathers and grandfathers had been. Iconic tropes from Western history, literature, and art had worked their way into the cultural mainstream. The Battle of Waterloo was as familiar to the reading public as the Battle of Sekigahara, and Little Lord Fauntleroy as familiar as Momotarō. For such a public, the hybridity of the *ponchi-e* no longer seemed as clever as it had to an earlier generation.

Cover of the first issue of An Illustrated Ja-pun *(Eiri Nipponchi, June 1874) by Kawanabe Kyōsai. National Diet Library, Japan.*

Kyōsai caricatured himself with painting brushes on the left, and author Kanagaki Robun with a stack of books on the right. Above Robun's shoulder is scrawled "Published by monstrous spirits." The two men are perched on Mt. Fuji. The rising sun above them is inscribed with the characters meaning "officially rejected" as opposed to "officially approved," the standard mark of the government's authorization. Because it was published in the treaty port of Yokohama, the magazine escaped official censorship.

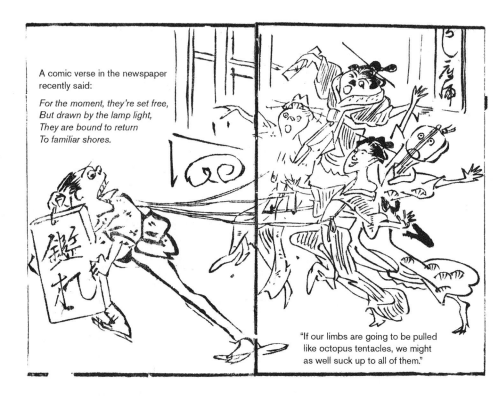

"Licensing Geisha," by Kawanabe Kyōsai. An Illustrated Ja-pun, *No. 2 (July 1874). National Diet Library, Japan.*

In December 1873 the Tokyo government issued regulations recognizing geishas and prostitutes as professionals and designating official brothel districts in Yoshiwara, Shinagawa, and elsewhere. Licenses for the brothel operations, however, were given only to the owners, not to the geishas and other entertainers themselves. In the picture the brothel owner holds his license, which he is about to display in his bordello.

Cover, The Weird News Circular *(Marumaru Chinbun, March 14, 1877) by Honda Kinkichirō. Archives of Meiji Newspapers and Journals, the University of Tokyo.*

The magazine's name refers to the blank circles (*maru*) that newspaper editors inserted in place of passages that might invite prosecution under the government's press and libel laws, and to the "weird news" (*chinbun*) that appeared in its pages. Written in the white circle is "No. 1, March 14, 1877, published every Saturday by the Blank-Blank Company, Inc." Punch-like figures in the center of the cover suggest that the magazine will see all evil, smell all evil, and hear all evil—and the large brush suggests that they'll write down all evil, too. The cannon, the conch shell, and the trumpet below probably indicate their determination to be heard. A horse and a deer peer out from the top corners. The combination of the characters for "horse" and "deer" is read "*baka*," meaning "idiot." The visual pun was a nod to the magazine's spirit of mockery, and the reader who deciphered it could compliment himself on his own cleverness. Between the two animals, it says "Wacky Pictures from Tokyo."

Well, congratulations to those born in the Year of the Cock and the Year of the Dog. Tootle-too! Tootle-too! Circle right! Circle left! Beat those happy drums! That'll be 270 yen for the lion dancers. The people just keep coughing it up! Regular imprisonment can last 10 days or a lifetime, you never know. Hauling around a gun on the battlefield, though, is only two years. It's not that tough. Children, you like to watch the lion dancer, but you'll be late for school. Go to school and work hard. Give it your best, or else come down with some big fake disease. Ha, ha, ha.

Conscription. The terror of old and young.

"The Conscription Lion Dance," by Honda Kinkichirō. Weird News Circular, No. 137 (December 6, 1879). *Archives of Meiji Newspapers and Journals, the University of Tokyo.*

In the fall of 1879, the conscription law was revised to include three years of active service, three years of reserve service, and four years of auxiliary reserve service—or a total of ten years altogether. In this cartoon the Lion Dancer is the conscript law, who is accompanied by two drummers, one beating a cannon and the other a knapsack. The children, ordinarily fascinated by such a performance, are fleeing from it, and their grandparents are offering the dancers a tip of 270 *yen*, the price of an exemption from conscription.

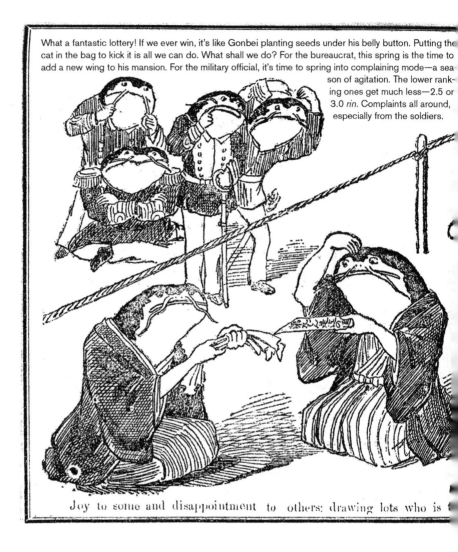

What a fantastic lottery! If we ever win, it's like Gonbei planting seeds under his belly button. Putting the cat in the bag to kick it is all we can do. What shall we do? For the bureaucrat, this spring is the time to add a new wing to his mansion. For the military official, it's time to spring into complaining mode—a season of agitation. The lower ranking ones get much less—2.5 or 3.0 *rin*. Complaints all around, especially from the soldiers.

Joy to some and disappointment to others: drawing lots who is t

"*The Great Official Salary Lottery*," *by Honda Kinkichirō.* Weird News Circular *No. 143 (January 17, 1880). Archives of Meiji Newspapers and Journals, the University of Tokyo.*

The catfish, with its prominent whiskers, was a symbol for high government officials whose beards and mustaches proclaimed their modernity. But the symbol also evoked the "catfish prints" (*namazu-e*) published after the 1855 Ansei earthquake. Popular lore held that a giant catfish's subterranean movements caused the quake. The catfish was thus a powerful and hidden force beyond the control of ordinary people, making it an apt metaphor for the men who ran the Meiji state. In the early 1880s the government adopted a fiscal retrenchment policy that not only reduced the size of the bureaucracy but cut official salaries as well. In this cartoon,

It's a brilliant plan—for the bureaucrats! Create a lottery and give yourself a prize. No way to lose that game. It's a lottery, all right, but why the sudden urge to harvest more money?

lary raised

"*Momotarō Returning from the Isle of Ogres,*" *by Kobayashi Kiyochika.* Weird News Circular,
No. 362 (August 11, 1883). Archives of Meiji Newspapers and Journals, the University of Tokyo.

Momotarō, the ogre-quelling hero of the children's tale, here represents Itō Hirobumi, who had just returned
to Japan from a trip to study constitutional systems in Europe (the "Island of Ogres"). His faithful follower,
a dog bearing a collar labeled "official," carries his "gifts" to the Japanese people—a "Russian dog yoke," a
"German fly swatter," a "Russian-made oil press," a "giant German-built mallet," and a "nail puller"—all tools
of torture and oppression.

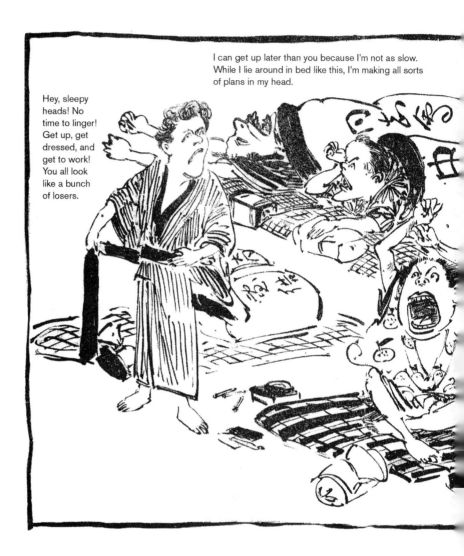

"Everybody, Awake!" by Kobayashi Kiyochika. Weird News Circular, *No. 685 (January 26, 1889). Archives of Meiji Newspapers and Journals, the University of Tokyo.*

With the promulgation of the Meiji Constitution in 1889, the government announced its intention to open the new Imperial Diet the following year. The political parties, constrained by government suppression and floundering finances for several years, took heart at the prospect of national elections. Here they are depicted as rousing themselves from a long sleep, i.e. inactivity. The two main opposition parties, the Liberal Party and the Reform Party (both in the bottom right), appear to be the most awake; the Neutral Party (top center) less so; and the Conservative and Local Government (top right) somewhat grumpy.

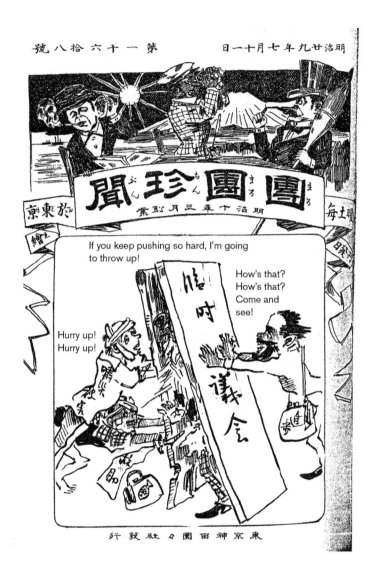

"A Plank Caught Between Planks," by Taguchi Sakubei. Weird News Circular, *No. 1068 (July 11, 1896). Waseda University Library.*

In June 1896 a devastating tsunami struck the north east of the main island, killing 30,000 people and destroying 10,000 buildings. During the emergency Imperial Diet session summoned to vote on aid for the displaced, Home Minister Itagaki Taisuke, a leader of the Liberal Party, faced opposition to his plan from the newly formed Progressive Party. In this cartoon, Itagaki—the first character in his surname means "plank"—found himself squeezed between two planks, pushed on the left by the victims of the disaster and on the right by the Progressive opposition. The plank is labeled "temporary Diet session." Post-disaster politics has not changed much since. Above the cartoon is the familiar tableau from the cover of *Weird News Circular*, and the bottom reads, "Published by the Blank-Blank Company, Inc."

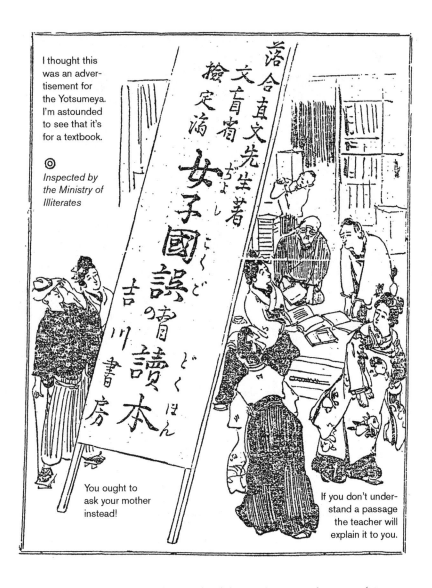

"Correcting the Textbook Review," by Taguchi Sakubei. Weird News Circular, *No. 1370 (May 3, 1902). Waseda University Library.*

In 1902 it was discovered that a Japanese language (*kokugo*) textbook written for the recently established Girls High Schools contained a selection referring to the Yotsumeya, a well-known Edo period "adult toy" shop. The national conference of middle school principals was outraged at the news, but the press had a field day. In this cartoon the signboard advertises a "Girls' National Error [*kokugo*] Reader, officially approved by the Ministry of Illiterates." The sign writes "*monmōsho*" ("illiterates") instead of "*mombusho*" ("Ministry of Education"). Later in the year another scandal erupted when it was revealed that a number of Tokyo publishing companies had bribed local officials to adopt their textbooks.

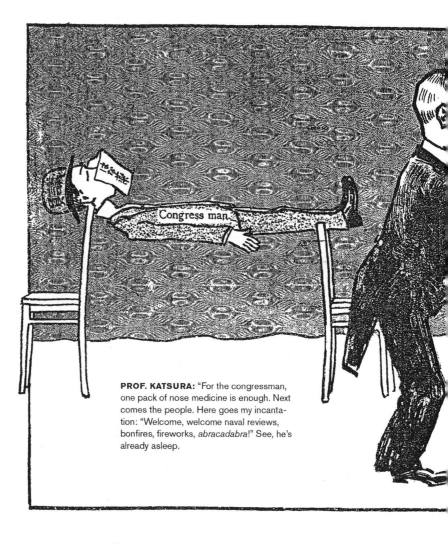

PROF. KATSURA: "For the congressman, one pack of nose medicine is enough. Next comes the people. Here goes my incantation: "Welcome, welcome naval reviews, bonfires, fireworks, *abracadabra*!" See, he's already asleep.

"Hypnotism," by Kitazawa Rakuten. Tokyo Puck Vol. 1, No. 8 (April 15, 1905). Archives of Meiji Newspapers and Journals, the University of Tokyo.

The cartoon mocks the Katsura cabinet's cynical use of patriotic celebrations, parades, and other events to bolster support for the war with Russia in the early spring of 1905, as Japanese troops bogged down in Manchuria. Prime Minister Katsura Tarō (1848–1913) is portrayed as a hypnotist on stage who has put the Diet to sleep with a dose of "nose medicine" (a colloquialism for a bribe) and is now turning his powers of suggestion on the general public.

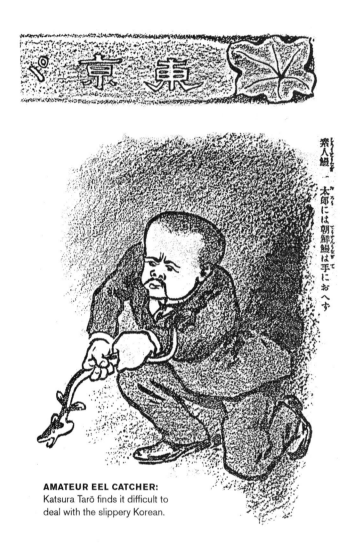

素人鰻　太郎には朝鮮鰻は手におへず

AMATEUR EEL CATCHER:
Katsura Tarō finds it difficult to
deal with the slippery Korean.

"Katsura Tarō Wrestling an Eel," Tokyo Puck *Vol. 1, No. 8 (April 15, 1905). Archives of Meiji*
Newspapers and Journals, the University of Tokyo.

This second attack on Katsura's policies in the same issue depicts the Prime Minister trying to hold on to a
wriggling eel, representing the tenuous situation in Korea.

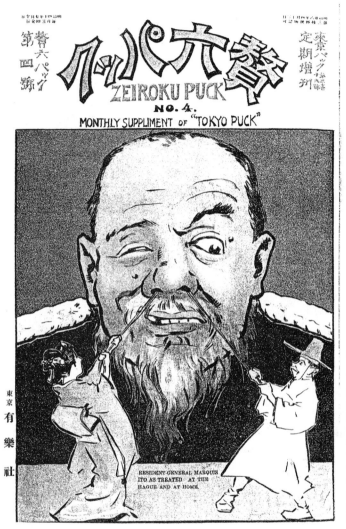

Itō Hirobumi, Resident Director Marquis, gets his nose hairs plucked by the Korean King, who sends a secret delegation to the tribunal at the Hague, and receives the same personal service at the office by his maid.

Cover, Tokyo Puck *(July 10, 1907) by Kitazawa Rakuten.*
Saitama Manga Museum.

Here Itō Hirobumi, now Resident-General of Korea, is shown being tricked not only by one of the geisha with whom he famously consorted but also by the Korean king who was internationally protesting the establishment of a Japanese protectorate in Korea. Colloquially, "Pulling out someone's nose hairs" meant "fooling or outwitting someone."

TRANSLATED BY PETER DUUS AND CHARLES SHIRŌ INOUYE

Toad Fed Up with Modernity

MANTEI ŌGA

 This satirical vignette is an illustrated booklet written and published in 1874 by Mantei Ōga (1818–1890), whose real and less-known name was Hattori Kōsaburō. Signed "Hattori Ōga," it carried the force of its author's reputation as an entertainingly acerbic senior critic of contemporary culture in the early years of the Meiji era.

Born to a wealthy Edo samurai family, Ōga received the finest possible literary education, with the expectation from childhood that he would occupy a prominent position in the government of the nearby Hitachi domain. His father paid grandly to secure a position for him in direct service to the lord of the domain, yet—no doubt to his family's great disappointment—Ōga resigned soon after taking office. Although the circumstances of his resignation are lost to history, Ōga's refusal to conform to the demands of society set the tone for his life. At age eighteen, he returned to a life of study and pleasure in Edo.

Within eight years, Ōga established himself as a vital member of a circle of like-minded writers led by Shōtei Kinsui (1795–1863). Although he never formally apprenticed himself to a master, his family resources allowed him to generously entertain and assist the other members of the group. Baitei Kinga (1823–1893), for example, was one of those who joined the writers thanks to Ōga's financial assistance. The seemingly carefree lifestyle led by the group belied their productive output of *gesaku,* or "playful composition," which combined humor, nonsense, and wordplay with rich literary allusion and occasionally trenchant social critique. Ōga in particular was noted for his vast erudition, of which he was justifiably proud—some say to the point of arrogance.

According to the Edo practice of publishing, all popular books were produced through a collaboration of illustrators, woodblock print craftsmen, printers, and booksellers. More than mere vehicles for written language, the booklets therefore were also works of visual and tactile art: elaborate calligraphy could be interwoven on each page between illustrations, often sporting multiple layers of color. Often the illustrators proved to be the stars of the operation: Ōga's writings were illustrated by many famed artists, from Utagawa Kunisada (1786–1865) to Kawanabe Kyōsai, who was known especially for his vibrant caricatures.

In 1845 Ōga embarked on his greatest project, *Eight Faces of Buddha: A Japanese Treasury* (*Shaka-Hassō Yamato Bunko*), a retelling of the life of Sakya-

muni adapted to a Japanese historical context and illustrated in particularly lavish detail. The project was serialized over the course of twenty-six years, eventually numbering 232 chapters gathered into fifty-eight volumes. Resituating an old tale in a contemporary context was one favored trick of Edo authors, the greatest example being Ryūtei Tanehiko's (1783–1842) *The Fake Murasaki's Bumpkin Genji* (*Nisei Murasaki Inaka Genji*, 1829–1842), a takeoff from *The Tale of Genji* and a swashbuckler-detective novel. Unfortunately for Ōga, the social upheaval experienced in Edo at the end of Tokugawa rule incurred major changes in readers' tastes, as they turned to the world outside Japan for new fashions and inspiration. The tale of the Japanese Sakyamuni ended on a subdued note in 1871, four years into the new Meiji era.

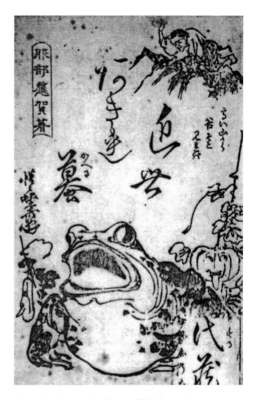

Cover by Kawanabe Kyōsai (C.V. Starr East Asian Library, University of California, Berkeley)

Ōga, however, refused to acquiesce to the new age. As can be seen from the example translated below, he was filled with love for the old Edo that he had known and bitter sadness for the world he was losing. The image of an abandoned manor, overrun by foxes and badgers, if not packs of wild dogs, was real and familiar to his readers throughout the city during the early years after the Meiji Restoration. The new government had issued major reforms to dismantle the Tokugawa class structure, cancelling the lavish stipends of nearly three hundred feudal lords and putting their domains under direct control. As the lords and their vast retinues scattered, their expansive estates were left to decay. The exhaustive sumptuary laws of the previous age—which had sought to regulate travel, food, clothing, housing, and even intercaste marriage—were abandoned. The eating of meat, which had been discouraged for many reasons prior to Meiji, became accepted as a "civilized" custom: in 1872 it was announced that even the emperor would henceforth eat meat.

For Ōga, such freedoms could bring nothing but chaos. Steeped in the pre-Meiji political tradition, he located his ideals deep in the cultural past of Japan and Asia, centered on the wisdom of ancient classics and kept in order over successive generations by a judicious and powerful elite. In a proper society, according to this view, men and women would hold to their proper social status, objects would be put to their proper uses, waste minimized, luxury eschewed, and the environment would not be sullied.

The Japanese title of the essay, "Kinsei akire-kaeru," employs a typically far-fetched pun (*kaeru* = "toad" or "return," and *akire-kaeru* = "appalled") to suggest "I've had it with the new times, and I just want to go back to the way things were." Point for point, the essay illustrates how that social order was being destroyed by the Meiji project of Enlightenment. People were beguiled by riches and acting out of place. Well-crafted weapons were no longer treated with respect, cherished books were thrown by the wayside, the environment befouled by waste. Only the toad—an image used in other essays and a voice for Ōga himself, intentionally made to sound blustering and pedantic—is left to keep watch and purify the waters. It is one of many ironies that the "man of government on his way home from a banquet"— another familiar image of early Meiji literature, most often depicted with an ostentacious mustache—has no sword to defend himself from that toad.

In this and a flurry of other essays published in 1873 and 1874, Ōga especially lampooned the elite Meiji intellectuals who shallowly sought to adopt Western technologies and practices. Most prominent among his targets was the Enlightenment theorist Fukuzawa Yukichi, who, in 1872, had published a satire of the practices of eyebrow-shaving and tooth-blackening by married women in Japan. Ōga responded by declaring that European ear piercing was no less preposterous and that no one can be a judge of foreign customs without having lived there for many years. In another article, Ōga belittled the scholars who pretended to embrace the ideas of Western science, including the bizarre notion that the earth might move around the sun.

To readers' sensibilities now over a century later, Ōga's writing style may seem hopelessly archaic, fraught as it is with vestiges of Chinese diction, strained wordplay, and mildly abstruse literary allusions that seem to browbeat the reader just as the toad browbeats the government functionary. But for his contemporary readers, the language and imagery would have been familiar and entertaining. The image of ancient trees refers to the nō play *The Old Pine Tree* (*Oimatsu*, written by Zeami in the early fifteenth century). This in turn alludes to a Chinese story that the first emperor of the Qin dynasty, Shi Huangdi (259–210 BC), found shelter during a storm under a group of large trees, to which he later granted court ranks. Ōga replaces the character "Qin," which is pronounced "shin" by Japanese, with another character, "shin"

(meaning "new"), implying the Meiji emperor. The fanciful image of ancient trees relinquishing their titles thus resonates with the reversion of domain territories to the emperor and the abolishment of the Tokugawa caste structure. In the ensuing paragraph, the "wise woman" points to the dancer Giō of *Tale of the Heike,* a fourteenth-century epic. When Giō was expelled from the capital by the military commander Kiyomori, she left behind a poem addressed to Kiyomori's new lover: "Whether sprouting or withering / the meadow grasses are all the same / destined to perish by autumn." In this reference, readers would have quickly recognized the analogy between the capriciousness of Kiyomori and that of Japan's new rulership.

Under the Meiji government, direct criticism of the authorities could bring swift and arbitrary punishment to a writer. Kawanabe Kyōsai, the illustrator of this text, was jailed for over six months in 1870 for having drawn a satirical caricature of Meiji officials. Yet despite the risks, Meiji era critics proved increasingly willing to attack explicitly, so that the literary conventions of *gesaku* came to be seen as unnecessarily cumbersome and indirect.

As other *gesaku* writers—including Ōga's close friend Baitei Kinga and a slightly younger generation that included Kanagaki Robun and Narushima Ryūhoku—bended toward accepting the new regime and its changing tastes, Ōga alone held to the ideals of his bygone era. His final work, *Twin-Leaf Tales of Wise Rule and Loyal Service* (*Meiryō Futabagusa*), serialized in eleven installments from 1883 to 1888, was the last of its kind to fully embrace the woodblock mode of text production. A biography of Tokugawa Ieyasu—who in 1603 had established Edo as the seat of the Tokugawa shogunate that lasted until 1868—the work was a fitting tribute to the old city that Ōga loved.

⌢(JPM)⌢

In China of yore, the wizened toad took lessons
 from the sages old,

But in Japan the toads now rule, and mock the
 world in ridicule.

My countrymen, to you I say,
 don't let them mess with you, no way!

The Seat and Foundation of the Warrior Capital looks aloft to the rays of the sun and back around to the noble Mount Fuji under an eternal song of

dancing cranes. Truly, the prosperity of Chiyoda Castle, Edo's very center, has spanned a myriad of generations, celebrating its longevity like the long-lived tortoise. But all things must come around, and the opening of the country has brought unprecedented change. Gold emblems from great palaces now hang glittering from city houses, and weapons of war lie in rows on cheap straw mats awaiting sale to passersby. An archer's bowstring passes to the hand of a cotton beater, while a firearm fuse is knotted to prop open a roof window. In the morning, the sound of gunfire startles a neighbor from his lazy dreams, while at night the glint of sabers planted atop a hideout's fence wards off a cat burglar. Fine books are bundled with rough cords and thrown to rag collectors, bringing profit by the pound to illiterates. These are the objects that brought countless years of peace to the masses and virtue to government—these are the valued treasures of the twin paths of literary and martial arts, and this now is their fate.

The image of a courtesan, painted upon a pleasure-house pedestal, now lies in the meadow, her sleeves knit with dew to be admired only by the sigh of a cricket. Lovebirds on the once-treasured mistress's screen have lost the colors of their feathers. In the pleasure quarter, the neglected courtesans and their young attendants bite their long sleeves and chirp feebly like bagworms. The branches of the old oak tree, once popular for reaching the second floor of the brothel, are now dying; and passersby are no longer interested in picking acorns. Even the ancient pine and giant oak, celebrated in the wedding song, are stripped of the honorary ranks granted by Emperor Shin. No longer addressed as Sir Viscount, they are merely old and withered trees.

Noisy cormorants offer no reward for good deeds, and herons turn their backs on Confucian virtues as they fly away to Shinto paradise. Some look back, while others leave behind nothing but the muddy wake of a footprint. The birds have left, and neither deer nor forest monkey remain. All of nature is in a state of deterioration, and as the poem of one wise woman went, none shall live to see the autumn. The grapethorn vine selfishly entwines itself high around the tree, while otters and foxes take refuge in whatever hole they can find. Anything that can be grabbed, whether fish a few days old or a turtle from time immemorial, is fair game to fry for supper. The shame is without beginning or end.

Westernization has entered; and the wind that has dried the dew from the grasses has blown in a storm of Restoration and Civilization. The white jade of old customs has turned green with a patina of bronze. Dense weeds fill the grounds of old daimyo manors, now fallen into disrepair, while the new government has opened the gates of its bureaucracy and is building a foundation to commemorate its new eternal reign.

Here, now, we find a bureaucrat on his way home from a banquet. His throat is parched, and he seeks water. Having taken the shortcut home, however, he is far from any human abode. Passing through the deserted estate of a former daimyo, he hears the faint sound of water, and lets his leather shoes lead him along a narrow path through the grass. A curious old pond is there, with water shooting up through a spout from below, supplying the pond with pure water. In its center the moon hovers in spiritual enlightenment. The bureaucrat, filled with quiet emotions, bends down to scoop up some water, when out of the thicket comes a voice. He looks around to find a giant toad crouching impassively by a clump of grass.

"Why I'll show you, you little insect," the bureaucrat says and grabs for his sword, only to remember that swords these days are banned. He scans the ground for a weapon and picks up three or four shards of roof tile from the swaying grasses. But as he prepares to throw them, he considers, "If these don't stop it, it may infect me with its poisonous breath. Too bad. I'd better back off first so I can catch it alive." But just as he steps back, the toad lets out a derisive snicker, *ka-ka-ka-ka.*

"How dare you—a bug!—mock my humanity," the man curses. "Catching a mere toad alive won't add to my illustrious career, but because you offer your life to me, I will pummel you with my fists—in respect of the law against swords—and pop you in my mouth. Now that would quench my choler." Whereupon he hits the toad with one of the shards.

The toad ejects a frothy spittle from its mouth, then rises up and says, in a human voice, "You say I mock you? You're not a toad, so how can you know what I'm thinking? One does not understand a being unless he is that being, the Master says. I, on the other hand, mere vermin though I may be, have the powers to know what you humans are thinking. You came here for a drink of water, yes? Just because I stopped you by speaking out like this, don't assume I'm mocking you.

"This property used to be a great estate and was kept in a state of aesthetic perfection; but since the Meiji Restoration, it has gone to rack and ruin. As you see, it's now overrun with weeds, a playground for children, which of itself is no great problem, but unfortunately, this great vegetarian nation of ours has turned carnivorous, and people come at night to this pond to secretly discard the rotting offal of pigs and cows. The stench has spread throughout the pond, and if you drink from it your clever Japanese soul will writhe in blind pain. I've tried to drink up all of the contamination, but there are still some people who come at night to discard their trash or take a drink, and I do my best to scare them off. Even if I am just an insect, at least I care about my countrymen, and that's why I do it.

"Seeing that you are still young and honest, I would like to tell you about the four great emotions that pertain to the modern world. You're welcome to stay and listen if you wish, but go ahead and leave if you don't."

The bureaucrat wonders, "Could I be dreaming? Could I be drunk?" But there is nothing to suggest the toad is a hallucination, and after all, what the toad is saying seems reasonable. If the four great emotions prove useful, then so much the better, and if not, he can ignore them easily enough. So he makes up his mind to listen to the holy words and take the bug as his teacher for a time.

Kneeling down upon the ground, he replies, "Now that I see you are a sentient being, please forgive me for slighting you. Do teach me the principles that will benefit the nation."

"Well then, listen to this. Here are the four emotional principles of a preposterous toad. The first is laughter, referring to things that are funny. The second is piteousness, by which I mean being sad. The third is loathing, which means hating things. And the fourth is joy, which means, well, to be happy. If we take these four emotions one at a time, we first need to talk about laughter. In the cities these days there are many people who are a bit dense, and among them one particularly laughable type is the head of household who works day and night to put coins in his box, without knowing that the box has holes in the bottom. I call this type of man the preposterous patriarch.

"And then there are the wives who have no idea how much money their households have, and end up spending money that isn't there. These I call the ludicrous ladies.

"Next are the errand boys, who are sent out on a task and end up wasting time and money stuffing their faces at a roadside eatery or riding home in a pricey rickshaw. These are the preposterous pageboys.

"And then there is the maid in every house, call this one Miss Ohatsu, who spends more money than she earns to buy fashion items. The recommendation letter she brought from home testifies that she can't even remember to close the door, and when it comes to breaking dishes she is a grand master. Under the kitchen veranda lies a heap of bowl and saucer shards like the skeletons kept in the cave of the blood-sucking hag of Adachigahara. In a moment of laziness she dents the door of the 'mouse-proof' food cabinet so that it no longer closes properly, and despite the government ordinance against name changing, she is the mother of moniker-makers, calling it the 'proof-of-mouse' cabinet.

"So there you have the news of this preposterous papa toad. But what he really wants is to find a good husband for his daughter, who will turn nineteen this year. Everyone around is asking for her hand, but it would be a pity to give her to a farmer when I can make her the wife of a bureaucrat

who fetches two or three hundred big ones a month. I've already put together a pretty penny for a dowry, so she'll be the wife of a rich man by next March at the latest. And when that happens, of all farcical froggies, she'll be worshipped as the heavenly angel of wasted wealth!"

TRANSLATED BY JOHN PIERRE MERTZ

Monsters! Monsters! Read All about It!

TALES OF THE EXTRAORDINARY FROM EARLY MEIJI
NEWSPAPERS (1875–1886)

Depictions of *yōkai*, or "monsters," as seen in "One Hundred Tales" (Hyaku Monogatari) and other narrative genres, were common in Edo visual arts. While elaborate drawings of *yōkai* had been produced in earlier eras, the rise of commercial publishing, advances in printing technology, and the application of taxonomic approaches to the natural world helped to make graphic knowledge about *yōkai* more detailed, widespread, and systematic. In the late eighteenth century, Toriyama Sekien (1712–1788) published several influential encyclopedias of *yōkai* such as *Illustrated Night Parade of a Hundred Demons* (*Gazu Hyakki Yagyō*, 1776), presenting an impressive series of bestiaries that included the familiar *kappa,* or "water sprite"; the *tengu,* or "long-nosed goblin"; as well as dozens of other creatures that Sekien gathered from local legends or dreamed up himself. While some *yōkai* were gruesome or terrifying, as specialists point out, not all of these fantastic creatures were shunned in horror. Manifesting an invitingly playful spirit often more mischievous than malicious, many *yōkai* appeared in children's games, as motifs in artwork, and as decorative ornaments on items of daily use, such as pipes, medicine cases, and sword sheaths. In short, a panoply of *yōkai,* by turns frightening and amusing, haunted many spaces in the Edo cultural landscape as the period drew to a close.

With the advent of the early Meiji, *yōkai* came to proliferate in a new habitat: the pages of commercial newspapers. Nestled among the news dispatches from both urban and rural locales were reports of individuals' encounters with phenomena that transcended ordinary experience; hundreds of such accounts appeared in late-nineteenth-century newspapers. The stories translated below are drawn from Tokyo-based newspapers of the 1870s and 1880s and focus on tales of two mysterious creatures in particular: the

fox and the badger-like *tanuki,* or "raccoon dog." Both of these animals were part of the everyday experiential world of Meiji Japanese, but along with cats they had a long-standing connection to the uncanny. Stories of foxes manifesting themselves as beautiful women who bewitch men date back to the ancient period, and similar shape-shifting was among the tactics that *tanuki* were believed to deploy in tricking human beings. Whereas the beguiling fox often took a seductive, sensual, and tempting form, the *tanuki* tended to be more comic: somewhat goofy figures fond of sake and given to contented drumming on their enormous bellies. Yet in spite of the threat that their shared talents at deception posed, both animals were also seen as potential bringers of luck. A complex blend of legends and iconography drawn from Chinese, Indian, and local sources established a link in Japan between foxes and Inari, a Shinto deity responsible for the fructification of rice paddies. This connection thus associated foxes with prosperity and fecundity and is also the reason for the fox's legendary fondness for fried tofu, a standard offering to Inari. Likewise, among the many legends concerning *tanuki* that began to circulate widely from the medieval period onward are those that in some way record the benevolent actions or material rewards offered by *tanuki* to repay humans who had shown them kindness.

One recurring attribute shared not just by the fox and the *tanuki* but by the cat and many other members of the motley array of *yōkai* was their liminal quality: their position at the boundaries between humans and animals, natural and supernatural, mundane and otherworldly, fortune and misfortune. Another name by which *yōkai* are known, *bakemono* (literally, "transforming thing"), is particularly revealing in this light, for it suggests how these creatures were in fact defined by their very instability and their transcendence of fixed categories of understanding. Scholars of *yōkai* observe that this ambiguity extended even to the matter of their ontological status: *yōkai* proliferated in the cultural imagination because they strained against the limits of credibility. The narrative structures employed in the stories appearing below exemplify this general feature of *yōkai* tales: several of them pose the question of their own veracity only to avoid offering a definitive answer.

It might seem surprising that tales of the supernatural should flourish in early Meiji, a period when the slogan "Civilization and Enlightenment" carried the day and a newly prominent category of "superstition" had been designated one of the "bad customs" of the past that government leaders and prominent intellectuals alike encouraged the populace to abandon. Perhaps even more unexpected is the fact that the newspaper, the institution widely seen as instrumental in helping the nation's citizenry gain a new sense of modern collectivity, should serve as a major vehicle by which such extraordinary stories were disseminated. In spite of the official disapproval,

interest in *yōkai* persisted among Meiji readers. Even well into the twentieth century, official government-approved ethics textbooks still began their list of instructions to schoolchildren with a firm prohibition against believing in tales of bewitching foxes and transforming *tanuki*.

The accounts of *yōkai* in late-nineteenth-century newspapers reflect not only the Meiji reading public's continued amusement by such tales but also merit attention for the ways in which they foreground the discursive tensions and sociocultural transformations that marked this transitional era. It was during this time that the philosopher Inoue Enryō (1858–1919) founded the discipline of "monsterology," enthusiastically gathering tales of *yōkai* from newspapers and through interviews, bringing what he considered to be a scientific approach to bear on questions of the supernatural. His student the folklorist Yanagita Kunio likewise sought out stories of mysterious phenomena, but rather than aiming to refute superstition, his purpose was to understand the lore and sentiments of the common folk. More recent scholars have turned to such discourse on *yōkai* to trace the ways in which disciplines newly established in Meiji, such as psychology, intervened to reinterpret phenomena: understanding fox possession, for example, in terms of mental illness. Similar negotiations with cultural and conceptual shifts are apparent in the stories presented here. In some, the fox and the *tanuki* may be seen to embody earlier attitudes and ways of life that were threatened by the changes that came in the Restoration's wake. In others, extraordinary phenomena are juxtaposed with a variety of new technologies, such as photography, competing structures of knowledge like Confucianism and scientific authority, and new forms of state power like the modern police system. By the early twentieth century, tales of *yōkai* would become rare in the pages of Japan's newspapers, but they remain a fixture of the cultural imaginary even today, as any fan of anime, J-horror, or Pokémon knows.

⌒(**MF**)⌒

THE CAVE OF THE GENEROUS *TANUKI*

The Dawn Herald, May 13, 1875

There is a large rock cave in the deep mountains of Kajiyama of Kuroiwa village in Niigata prefecture. A *tanuki* lives there, and it is the custom of the locals to call the place "the *tanuki*'s cave." In former times, whenever farmers from neighboring villages came there to borrow any dishware or tools, the *tanuki* would lend them what they needed. But in recent years, the farmers

have become sly and have kept the borrowed items without returning them. For this reason, the *tanuki* has ceased his lending. Moreover, perhaps realizing that such marvelous creatures as himself could not survive in this world of civilization and enlightenment, the *tanuki* has left his cave an empty shell and moved off to other parts. There are two people in the nearby villages who still have the large plates that the *tanuki* left behind when he moved out. There were also two giant bats—perhaps a male and a female—that lived in the deserted shell of a cave, but toward the end of last month, one bat was found at the mountain's peak with its mouth still clenched on the throat of a fox; both the bat and the fox were dead. The story of the *tanuki* is marvelous indeed, but surely it is also quite unusual for us to hear of a giant bat and fox dying in battle like this. So said a person who came to the capital from Echigo on the seventh.

THE HAIRDRESSER AND THE DRUMMING *TANUKI*

Tokyo Illustrated News for Easy Reading, November 27, 1875

A: "Have you heard the story of how a *tanuki* drummed its belly at the house of the hairdresser from Honkokuchō Itchōme?"

B: "No I haven't. Did the *tanuki* set out for a stroll to celebrate the Shinjōsai rice harvest festival or something?"

A: "Well it seems a *tanuki* darted in through the back door, but because this hairdresser was such a charitable soul, he let it stay under the floorboards of the veranda. That evening, the hairdresser's child, who was just about to enter his tenth year, was tapping out a rhythm on the lid of the hibachi stove. The beat must have put the *tanuki* in a merry mood, because he started drumming on his belly. 'This is marvelous! Have a listen!' and 'Come on over,' they said to their neighbors, inviting them to hear. The *tanuki* became so full of himself that he drummed his belly all through the night, and the master of the house could hardly sleep. Angered, he shouted, 'Confounded *tanuki!*' and 'How obnoxious!' but this only prompted the *tanuki* to beat his belly louder. The hairdresser was utterly flummoxed, but then his wife offered the gentle words, 'Mr. *Tanuki*, everyone has already gone to bed; won't you please be quiet,' and the *tanuki* stopped immediately. At noon the next day, he started beating his belly again, and so a great many people came to listen."

B: "Hmmm. Doesn't it sound made up to you? Even the setting seems off."

The hairdresser graciously welcomes the *tanuki*. Untitled item in Miscellaneous Reports/ Stories, *Tokyo Illustrated News for Easy Reading*, no. 135, November 27, 1875. (The Humanities Institute Library, Kyoto University)

A: "What?! It's no lie. If you doubt it, or think I've been tricked, then go ask the hairdresser yourself!"

A WEDDING CEREMONY AT THE INARI SHRINE

Tokyo Illustrated News for Easy Reading, February 28, 1876

Toward the end of January, Echigawa Asakichi, who lives in Kofunagi village, Umigami county, Shimōsa province, complained that he did not feel well and took to bed. Then one day all of a sudden he leaped up, his face not at all its normal color, and just went wild: creating quite a ruckus as he grabbed whatever objects he could lay his hands on, hurling them across the room or smashing them to pieces. His family members were astonished, and though they tried to get him treated by summoning the village doctor, Asakichi simply would not let his pulse be taken. It must be the doing of some possessing spirit, they thought, and so they called upon Kishichi, Sadakichi, and Kinnosuke, three men from the village who enjoyed reputations as skilled go-betweens. The three men engaged in a discussion with the sick man, and as they gradually asked him for more information, Asakichi suddenly adopted

Under the control of the fox, the possessed villager plays the bashful bride. Untitled item in Miscellaneous Reports/Stories, *Tokyo Illustrated News for Easy Reading,* no. 206, February 28, 1876. (Archives of Meiji Newspapers and Journals, the University of Tokyo)

the gestures and mannerisms of a woman and said, "I am the third daughter of the Coinpurse Inari of Ōgi village. I am called Osan, and recently I had something I wished to entreat the deity. In the course of making my pilgrimage there, I was unexpectedly chased by a dog, and had no choice but to borrow the body of Asakichi for a while." The three could not quite make out what she said, and asked, "What do you mean when you say that you came here because you had something to entreat the deity?" Asked this, she appeared embarrassed and brought her sleeve to her mouth, saying "It is difficult for a woman to say this, but three years ago, the son of the Totsuka Inari of the neighboring village of Takada came to stay in my shrine. We felt strongly for one another and formed a blissful bond, but ever since we parted, I have not once heard from him. The desperation of my woman's mind compelled me to come all this way to inquire after him; I ask that you consider my feelings and help me to achieve my marriage to the Totsuka Inari." The three men swallowed her audacious request and immediately set out for Takada village, where they called upon Miyauchi Riemon, who was in charge of the Totsuka Inari. One wonders how they explained the situation, but the arrangements were quickly concluded and a certain Shinto priest from the village of Shibazaki acted as the go-between. On January 29, at around five o'clock in the evening, just as the sick man Asakichi was loaded into a palanquin and was set to depart, the call went out that "Hey, it's the

wedding ceremony of the Inari deity!" and none wished to be left behind: young and old gathered from all of the neighboring villages, and needless to say from Kofunagi too. Everyone brought something, some had sacred *miki* sake, some had celebratory rice with red beans, and some brought the fox's favorite fried tofu. They say it turned out to be quite an auspicious wedding ceremony for the Totsuka Inari deity, but in any case this is the sort of amusing story one finds in the uncivilized countryside.

A MARRIAGE AT THE STOREHOUSE

Tokyo News Illustrated, May 8, 1881

A mysterious letter unexpectedly flew into our editorial offices one day. It cannot even be called a rehash of the story of the white fox of Shinoda in the play *Kuzunoha* (and it made its appearance without any ominous *usudoro* drumbeat sound effects), but we have written it up to bring some delight on these long spring days and invite you to peruse it, with the proviso that you ought to take it with a grain of salt. The story concerns Kurazō, who dwells in the village of Shimono in North Katsushika county, Saitama prefecture. Now an old man past fifty, he had lost the use of one arm while in the prime of his life. No woman could be found to wed this man, who was not only a cripple but extremely impoverished, and he had lived all the way until his present age as a bachelor. But then, on a certain evening last summer, he was straddling his charcoal brazier, cooking up some fried tofu, and enjoying a drink of sake before bedtime. Just then, he heard someone say, "Excuse me. . . ." It was a woman of perhaps twenty-four or twenty-five who bowed as she passed through his gate. "I have come from the village of Kamitakano, but I lost my way and now it's dark. I'm just in such a fix. I wonder if you might let me stay the night." Making no show of reserve or polite distance, she entered straightaway and sat down right beside him. As their talk turned to matters of this floating world, she looked at Kurazō, casting him a suggestive glance, and proposed, "Allow me to pour you a drink." This was in fact the first time Kurazō had ever been on the receiving end of a woman's kind words: from the instant he had his umbilical cord cut until that very moment. He had still not managed to completely wipe away the drool that began to dribble forth from his mouth when he offered her sake to drink as well. In the end, all reserve dissolved between them. Beneath the same paper mosquito screen, they shared fleeting dreams until, cursing the cry of the crow at dawn, they bid a reluctant farewell. After their parting, the same woman would visit about eight or nine times every month. She would always spend the night, and each time she would bring two or three *yen* of money as a gift.

The old man enjoys the attention of his Lady-Fox. Untitled item in *Tokyo News Illustrated*, no. 1768, May 8, 1881. (Archives of Meiji Newspapers and Journals, the University of Tokyo)

Kurazō was a man who begrudged even one hundred *mon*, but now that he was flush with cash, he would always buy one *shō* of fine sake from Dangoshin, the neighborhood wine seller. Observing this spectacle, the villagers thought it most suspicious, especially since there was a rumor going around that recently a young woman had been coming to his house and spending the night there. This led a group of five or six of his neighbors, motivated in part by envy, to act. One evening, they stood in his doorway and tried to catch a glimpse of what was transpiring inside. They saw that Kurazō was in fact sharing wine with a woman: the two of them having a merry time drinking together, quite carried away as they indulged in their flirtatious lovers' chatter. At this, the pack of envious villagers could stand it no more and they barged in through his front door. The moment they entered the room, however, the woman mysteriously disappeared, leaving Kurazō sitting by himself. Thinking this most bizarre, they said, "Hey, old man Kura! We heard that your favorite lady was paying a visit tonight, and so we all came to join the fun. But suddenly she's disappeared. Don't hide her away! Have her come on out so we can have a look at her!" Kurazō gave a wry smile and said with obvious regret, "We were enjoying our wine and

the pleasant mood just now; she must have sensed that all of you were at the gate, because she ran off through the back door." An awkward moment followed his answer, and the envious villagers decided that they had better hurry up on home. After they left, there was no sign of the woman again. Old Kurazō fretted as the days passed without a visit from her, until one morning when he discovered beneath the eaves an old exquisitely wrought silver hair ornament with a letter attached to it. Kurazō picked it up, but as he could not write himself and was completely unable to read the letter, he asked someone in the neighborhood to read it aloud to him. At the end of some charmingly seductive phrases, the letter said, "I have left this hair ornament as a sign of our pact to become a married couple. If you say that you will have me as your wife, it is my intent to bring two-hundred-fifty *yen* in cash, and so please send your firm reply to the foundations of the Ōnishi storehouse in Kamitakano village." When he got to this part, the man who was reading the letter out loud furrowed his brow and said to Kurazō, "You have no doubt heard the rumors yourself, but this man called Ōnishi was once a wealthy farmer. There was a fox who had lived beneath his storehouse floorboards for many decades, and when Ōnishi was prosperous, at the close of every year, perhaps as an end-of-year present, the fox would bring a large salted salmon to the back door. As an expression of thanks, Ōnishi made it his custom to put three *shō* of red rice beneath the storehouse floorboards. But one year, he took the salmon and provided no red rice. From the end of the next year onward, the fox did not bring the salmon anymore, and after that, Ōnishi's house gradually fell into decline. And now, the storehouse has rotted and only the foundation remains. That you are being told to send your reply there makes one wonder if that woman might not be a fox." Even though warned in this way, Kurazō said, "No matter what, I will make her my wife!" He had the man write his response, and, just as promised, he apparently took the reply to the storehouse foundation. Afterward, the villagers observed nothing at all out of the ordinary. But then one day, some people from the neighborhood passed in front of Kurazō's house. Old Kura with his crippled arm was there, smiling as he laid out a meal for eight or nine people. He must be holding the wedding ceremony tonight, the people thought. Afterward, though they tried in various ways to catch a glimpse, they were never able to see the figure of the woman. Is that not the most marvelous thing? So said the letter to the editor, which we have printed just as we received it.

THE FOX'S OBSTETRICIAN

Tokyo News Illustrated, June 7, 1881

Although what follows seems like something straight out of an old ghost story, a tale difficult to accept in this day and age, we have recorded the events exactly as they were related to us, and leave judgment about their veracity to our readers. There is a district called Inari Shinden in the town of Ryūgasaki, Kawachi county, Ibaraki prefecture. A rich farmer by the name of Inatsugu Chōzaemon (age 47) served as a district chief there, the successive heads of his household having worked in the village's administration for generations. The wealthy house was prominent enough to be known in the neighboring villages. Several generations ago, there had been an Inari shrine in the village, and the land under its control was overgrown with various trees and brush; there was a vast marsh and a large hill there, but the area had become the dwelling place of foxes and *tanuki*. Over the years, the shrine itself grew steadily more dilapidated. But one day the Inatsugu household head decided to develop the land and make paddy fields out of it. He contributed a large sum of money, and the land reclamation project was eventually completed. The Inari deity was transferred to the grounds of Chōzaemon's residence, where a gorgeous shrine was rebuilt for it. Even today, several hundred

Foxes thank the doctor, only to deceive him. Untitled item in *Tokyo News Illustrated*, no. 1792, June 7, 1881. (Archives of Meiji Newspapers and Journals, the University of Tokyo)

years later, the village residents apparently call these newly reclaimed paddy lands "Inari Shinden," or "Inari Newfield," and refer to Chōzaemon's household as the "Inari chieftain." Now then, this year, at around midnight on the evening of May 27, someone came knocking urgently on the gate of a certain Nakamura (age 53) who had lived in the same village for many years practicing medicine. His wife, thinking it must be a messenger sent to report someone had suddenly taken ill, got up and opened the window shutters. Looking out, she saw that her visitors were three or four men who carried a lantern on a bow-shaped handle. "Where have you come from?" she asked, and when they replied, "We are messengers of Inatsugu Chōzaemon," she took a closer look and saw that indeed the lantern bore his family crest. Once she had invited them in, the men said that Chōzaemon's wife, Osayo, (age 40) had begun showing signs of going into labor from around noon that day. Although she was on the verge of giving birth, she simply suffered to no avail. Both the physician who had been making regular calls upon her and the midwife as well tried everything they could think of, but they succeeded only in making her more fatigued. "Now her body is in no condition to give birth, but our master has heard that you are quite skilled at procedures involving pregnant women. We would like to entreat you to please accompany us back now." Nakamura heard their polite request, and inasmuch as the matter concerned the town official Inatsugu, there was no need for further discussion. He handed his medicine basket to one of the messengers to bear on his back, and set out with them for Inatsugu's house to have a look. The master of the house was already waiting out front to meet him and personally conducted Nakamura to the birthing room. It was not long after Nakamura had finished listening to the detailed explanations of her condition that he examined her. Though it was a difficult birth, the situation looked promising. Wasting no time, he prepared a mixture of medicines and had her drink it while he began to treat her. While he massaged her hips, all of a sudden the birthing process began, and she easily delivered herself of a boy, beautiful as a jewel. All the members of the household were cheered upon hearing the newborn's loud first wail. They conducted Nakamura to the parlor, laying out some food and drink for him. Some expressed their thanks and others their joy. A young maid was given the task of pouring drinks for him. Frequently urged to drink sake, he downed an unexpectedly excessive amount: so much that in the end he could not remain seated any longer, and took to the next room, where he fell fast asleep in the shade of a folding screen. Feeling the morning wind on his body, he suddenly opened his eyes and had a look around. He found that he was not lying down atop tatami mats in a room anymore, but lay reclined, a tree root for his pillow, atop the lawn of the Inari shrine on the grounds of the Inari chieftain.

No sooner had he been startled and begun to wonder what had happened than he was discovered by the employees of the house. As Nakamura sat there with his arms folded, two or three men regarded his expression with suspicion; one said, "I can't imagine why you had food and wine brought to this grassy area to eat and drink, but people came from two or three shops to collect the payment on orders that had been made in the house's name. We had no memory of placing the orders, and just as we were conferring about what a strange situation it was, someone said that 'Mr. Nakamura from the village is asleep in front of the Inari shrine' and so we came to have a look. The orders of food and wine must be your handiwork, and the plates and pots that you've eaten from and left strewn around are the evidence. Did you get a little drunk and pull this lame prank or have you gone completely mad?" When the question was put to him like this, Nakamura explained what had happened the previous night in detail. "I was completely taken in by the foxes. I didn't falsely assume your house's name in order to drink sake," he explained, but they would hear none of his protests. When Chōzaemon learned of the dispute, he summoned Nakamura to his parlor, apologizing for the rudeness of his underlings. "Foxes are sentient beings; they must have known that you were an accomplished physician and sought medical treatment from you. Even supposing it was the work of beasts, if my wife gave birth to a son, it truly would be a marvelous story that calls for celebration. Surely it would only have been proper for me to pick up the tab for the food and drink. You have no reason to concern yourself with it at all. Though it be meager, let me offer you payment for your examination on behalf of the foxes dwelling on these grounds." So saying, he handed over a package to Nakamura, and added, "When a messenger comes from my house in the future, whether it be a fox or a cat, I hope that you will come and provide treatment. I shall cover the charges." Having treated Nakamura lavishly, Chōzaemon apparently sent him on his way. We do not know whether the story is true or false, but the chieftain must be an extremely charitable person.

THE HAUNTED HOUSE OF MUSASHI

The Town Crier, March 28, 1879

Ever since the abolition of the barrier station at Hakone, it seems that ghosts and ghouls have increasingly transferred their residence here. Saitō Taichirō is a farmer in Nakayama village, Tsuzuki county, Musashi province, and as midnight draws near, apparitions such as the figure of a woman with wildly disordered hair or the One-Eyed Monk have manifested themselves where

the members of his household sleep. At first he thought he was just having frightening dreams, but with each passing night, the ghosts grew more numerous: standing right beside his family members' pillows. Terrified, he decided one night to make a test, and proceeded to light several lamps here and there. He stoked the fire in his hearth, and every member of the house intended to stay up all night. But at around 1:30, all of them had drifted off to sleep, and then the lamps were extinguished all at once. The house rattled, and, just as before, a woman's severed head rolled into the parlor. But no sooner had they noticed this than the form of the Giant Monk stood right in front of their noses. All of them gave out a shriek and took cover where they were, lying down to chant prayers as they waited for daylight. They soon abandoned their house and went to live with relatives in a nearby village, but the story of the ghosts became well known, and it got so that no one would pass through Nakamura village at night. The young people of the village all got together to discuss the matter, and there was a group of them, sturdy in their bravado if nothing else, who boasted that they "wouldn't stand for having these sorts of monsters in our village." Fourteen or fifteen of them packed themselves into Taichirō's house, each bringing his preferred weapon. Lighting every lamp in the place, they were full of energy and vigor as they dared the monsters to appear. As early evening approached, they redoubled their efforts to put up a bold front. Ten o'clock came and went. Then eleven o'clock. And when it became midnight, they began to feel hints of dread, and one after another they found themselves clustering together in a single spot. Without realizing it, each started to chant prayers. In their ears came the sound of a rushing gust of wind, like the tearing of silk. No sooner had they heard this than the cry of a woman being strangled to death rang out. All of them turned pale as though they had been splashed with cold water. They looked down, while above their heads came a tremendous cackle that was enough to shake the ceiling. Instinctively, they all fell down flat where they were. Early the next morning, a report on these events was lodged on behalf of the village as a whole with the police station in Sasashita, appealing for help. It is said that they are now investigating the matter.

YOSHIWARA GHOST STORY

Liberty News Illustrated, April 14, 1886

It is a ridiculous thing indeed for newspapers to write up stories that one has to take with a grain of salt because of the places in which they are set. But it seems to be quite popular of late. We are printing here a story for which there is a witness who says he saw it firsthand. No one is sure why exactly,

but it is said that for four or five days now, the most marvelous and spectacular things have been happening in a place familiar to all of our readers: the pleasure quarters on the second street of Kyōmachi, Yoshiwara. At the Fukuoka Pavillion, a house where lovely dolls are displayed to prospective clients, a customer requested the *oiran* courtesan Tamagiku by name the night before last. While he was having his fun with Tamagiku right by his side in the main parlor, she suddenly vanished into thin air. And last night, a prostitute named Hinadori was attending upon more than one customer at the same time. As she returned to the *zashiki* banquet room, offering apologies such as, "Tonight we're so busy. I'm really sorry—you'll have to forgive me," she joined the customer where he lay. But just as she did so, there was a clatter in the hallway, and another Hinadori entered the room and said exactly the same thing. And just as this Hinadori prepared to join the customer in bed, the previous Hinadori vanished like smoke. Then there was the time that the *shamisen* a geisha was playing suddenly sprouted feathers and was promptly sucked straight up to the ceiling; or the time that the rhythmic chants of festival music could be heard beneath the planks of the verandah floor. The master of the house was beside himself with worry in the face of this incomparably odd sequence of strange events. But it is human nature to be attracted to the marvelous, and so a number of stalwart men, each of whom sought to be the one to unravel the mystery, began streaming into the shop in droves. Its popularity perked up, and soon they were packed every night, doing quite a thriving business it is said. In any case, Yoshiwara is a quaint world, and perhaps it is no surprise.

THE MYSTERIOUS DANCING CAT

Reform News, November 11, 1885

True or false—who is to say—these strange tales about cats that have lately come from east of the Shirakawa barrier. We print here a report just as we have received it from someone dwelling in that area. About seven *ri* from the Iwate prefectural capital, a mountain range stretches from Hashiba to Obonai. The range is best known for the Kunimi pass, at the foot of which is the tiny settlement of Yakama village. Here Toyooka Sukenori, a former samurai from Iwate prefecture, has dwelt ever since the Restoration of imperial rule. He was originally a domain vassal who served the Nanbu house, but after the elimination of domains and establishment of prefectures [in 1871], he withdrew from the capital and came to live in this region: for it was where a few of his acquaintances dwelt. He took a wife named Osei (21), and in June of the year before last, a son named Sukezō was born to

The dancing cat kidnaps the baby. "The Mysterious Dancing Cat" (Neko no Kai) in Miscellaneous Reports/Stories, *Reform News,* no. 799, November 11, 1885. (Sophia University Library)

them. With one thing or another, their expenses were numerous. Sukenori had no intention of just scraping by penniless, however, and so he had decided recently to take a position as a live-in assistant for a certain merchant at Rokugō station. Two or three times every month, he came back home to provide for his wife and son, after which he would again return to his master's residence. Apparently it was on a certain night at the beginning of the previous month. As usual, Osei was minding the house while her husband was away. She was sleeping beside her son, Sukezō, when he suddenly broke out in a fever, as though he had been overcome by some malign force. Given the gravity of his condition, she was worried sick. She had no one with whom she might consult, for five or six days remained before her husband would be coming back from Rokugō. And so she was left to fret over the situation by herself, unable to sleep in peace. If only her husband were here at home, she thought, then he could at least help to share half of her worries, and that would make her feel stronger in spirit. As one might expect of a woman, she became lonely, and as the night grew dim, she found herself lost in thought, repeatedly adjusting the lamp's wick to make it glow brighter. Each time she turned to gaze into the face of her child, she would let out a

sigh as she tended to him in various ways. Their home was a solitary dwelling in the mountains, quiet even during the daytime, for they had no neighbors. The soughing of the wind in the pines that lined the ridge, the sound of the water running through the bamboo drainpipe, both made her feel more lonely as she surveyed her surroundings and the night wore on. Sukezō had fallen fast asleep, exhausted from the agony of his sickness, but in the dead of night, he suddenly let out a single howl, as though he had been possessed by something. Osei quickly gathered him up and gave him her breast to suckle upon. "You poor thing. It's no wonder you can't sleep with this fever," she said, softly stroking his head. Sukezō drank for a while but then released her breast and though he had not yet learned to talk, distinctly said the following: "Excuse me, Mother, why don't you take a good look under the lamplight and see how my face appears?" His mother was astonished and thought, "How weird that this child should be able to talk—how can it be?!" Before she knew what she was doing she turned to gaze into his face and found that her child, who had up until a moment ago been no different than usual, had now transformed into an old cat, moving its whiskers and twitching its ears as it got up to walk away. Thinking that it simply could not be, she tried to calm herself. As she looked carefully, she discovered that what she had just seen had now dissolved dimly like clouds or mist, returning to its original form. Her heart was pounding, but with this she breathed a sigh of relief and said, "What a mysterious thing!" After taking a look around, she opened the sliding door and was about to step into the next room, only to find that, marvel of marvels, Gorō, the cat that they had long kept in their house, was wearing a kerchief that someone had left lying around. He got right up on his hind legs and began to dance around crazily. Again she felt the hair all over her body stand on end. She fell back two or three steps, but then suddenly collected herself again. She had not forgotten the savoir-faire instilled in her long ago, and so she felt secretly in her bosom for the dagger that she kept there, an heirloom given to her by her mother. She drew toward the cat, but it was no easy mark; taking a backward glance, it must have realized that it had been found out, so it suddenly scampered off and disappeared. Both the episode with Sukezō's face and the bizarre sight in the next room had planted a deep hatred of Gorō the cat in Osei's heart. She could not wait for her husband to return, and when she heard that a certain resident of her village was going to Rokugō on an errand, she took advantage of the opportunity to write down an outline of what had happened and entrust it to that person. Sukenori was shocked when he received the letter, immediately explaining the matter to his boss and hurrying back home as quickly as he could. Osei was overjoyed from the moment she

caught sight of her husband. He listened attentively as she first explained Sukezō's condition and then continued with a detailed account of the affair with Gorō. He said that he had long been familiar with quite a few stories of pet cats undergoing mysterious transformations, and that this was an unusual calamity that could not simply be put aside. "As soon as I find out where he is, I'll trick him and stab him to death. That way we can prevent later grief." Osei thought this was most sensible, and so she began to casually look into the cat's whereabouts. It's the sad fate of a beast not to learn from experience, for on the evening of the third day, when the cat suddenly came in through the kitchen door, Sukenori had him just where he wanted him. He drew the sword that he had concealed at his side and struck the cat right between the eyes. Gorō was surprised and darted back, running away in a flash. "I'm not gonna let you escape!" shouted Sukenori repeatedly as he chased after Gorō, but since twilight had already fallen, he ultimately lost sight of him. "I've really shown him this time, so he won't be causing us problems anymore," said Sukenori. He was at ease as he entrusted the care of his son to Osei and returned to the home of his boss in Rokugō. Osei relaxed as well, having heard that Gorō had suffered grave injuries before fleeing. Having observed that Sukezō was sleeping peacefully, apparently not feeling so bad this evening, she thought that she would rest herself, for she had been unable to sleep for two or three days. Not long after she had put her head down on the pillow, she was startled awake by a scream from her child. She scrambled up to see that the old cat had its teeth around the knot of Sukezō's obi sash and was forcefully tugging away. It had kicked open the window and was attempting to escape with him. Startled again at this unexpected turn of events, she nimbly drew the dagger. She kept it in her bosom at all times, not leaving it out of reach even while she slept. She struck at the cat once, but she was hesitant, not wanting to injure Sukezō. The old cat was unfazed and with the obi knot in his mouth, ran off to who knows where. Osei chased after, screaming as hard as she could, "Return my child! Bring him back!" The villagers soon heard her, and shouted excitedly, "Something terrible has happened, everyone come out!" Their numbers grew to thirty-four or thirty-five people, and they spent the entire night helping Osei to search high and low. When they found Gorō in a thickly overgrown area in the mountains of Tsuruishi, more than five *chō* away from the village of Yakama, they shouted, "This is a monstrous cat! Don't let him escape!" They blocked off all routes of escape and surrounded him. He dodged their attacks, baring his fangs, sharpening his claws, and writhing as he attempted to bite them. It took many men to succeed at last in bringing him down. Having taken care of this, they surmised Osei's thoughts, as she sighed like a

madwoman, "Where is Sukezō?" The group then decided to divide up and search the area, leaving no stone unturned. Eventually they heard Sukezō crying from within the hollow of a petrified cypress tree. They all gathered together and somehow were able to bring him down. Fortunately he had not a scratch on him, and Osei was overjoyed. She thanked the villagers profusely, and the next day she sent a messenger to Sukenori's place in Rokugō. He too was astonished and quickly came back. Celebrating the fact that Sukezō was unscathed, Sukenori held a banquet and invited all the villagers, and they all happily poured wine for one another.

THE STRANGE CREATURE OF MONKEY ISLAND

Easy Reading News, September 19, 1877

On the fourteenth (this is rather old news, but still, please read on), in the midst of great winds and rain, thunder rumbled violently throughout Tokyo and the surrounding areas. Lightning struck the district of Honjo, and, in various places with low-lying land, there was flooding. At Shinagawa, some of the fishing boats in the harbor capsized. We have already received reports on how people were rescued from danger, but during the time that our newspaper company was on holiday for the past two days, other newspapers have published them. For this reason, we will not go into detail here, but we received yesterday an item, complete with illustration, sent to us by

A likeness of the mysterious sea creature from a 1992 reprint. Untitled item in "News" section, *Easy Reading News*, no. 472, September 19, 1877. (Akashi Shoten)

Ono Takatomo, who is now traveling in Iso, a town in the vicinity of Mangi-zaka in Bōshū. It states that in the same province, in the area of Amatsu, a crew of four fishermen set out in a fishing boat at around two o'clock in the afternoon to cast their nets in the sea. It was rainy that day, and they had caught nothing. From about seven o'clock, the clouds began spreading out darkly and the wind grew progressively wilder. With angry waves roiling the boat, their crests breaking high above the men's heads, the men decided to quicken their rowing and hurriedly make their way back to land. Just then a roll of thunder resounded to the water's depths, the crack blending with the roar of the ocean to produce an awesome din. With their boat on the verge of capsizing, the fishermen each chanted the names of the gods and bud-dhas. As they bobbed along at the mercy of the waves, night fell completely, and the violent winds and torrential rains only grew stronger. By this point all of the men were convinced they were done for, but just then the drifting boat approached a small island. The four of them felt as though they were the proverbial "blind turtle that encounters a piece of floating driftwood." They abandoned their boat at once and crawled up onto the small island's shores. Taking shelter beneath a tree, they escaped the wind and rain, and waited there for the night to pass. Gradually the winds subsided, and even the rains turned to a light drizzle. As dawn grew near, there appeared something with a strange shape crawling up onto a boulder that lay on the shore of the island where the waves crashed in. Among the four men, a fisherman named Kurotoku from Mangisaka was particularly stout hearted, and when he struck at it with the oar that he carried, it took fright and dove straight into the seas. Before long, the skies grew light, and the men caught sight of a boat being rowed out from the island. Calling to it, they begged for help. They learned that the boat they had abandoned the previous night had fortunately not drifted far, and that it was still in the offing around the island. The abandoned boat was towed back and presented to the four men. Boarding it again, they set off on their return journey. The place where they had landed is called Monkey Island, which lies in the bay of Uraga in the province of Sagami.

A reporter comments: On the manuscript that Ono sent to us was ap-pended a sketched likeness of the sea creature that the fisherman Kurotoku is certain he saw. We present here a slightly embellished version of it. Ex-amination of this figure shows that it resembles an image in the manuscript entitled "A Discourse on the Figure of a Water Tiger" [Suiko Zusetsu], which concerns a creature that is said to have appeared in Niigata, Echigo prov-ince, during the Kansei era [1789–1801]. We can conjecture that perhaps this sea creature is of the same type as the so-called *kappa,* which is also written with the characters for "water tiger."

THE BIRDKEEPER AND THE SNAKE OF TEN'ŌJI

Reform News, May 5, 1883

It is said that "extraordinary things, feats of strength, disorder, and spiritual beings were subjects on which the Master did not talk." In particular, strange dreamlike tales are really not the sort of thing that the present author is fond of, but for today's illustrated piece I shall record here precisely what I have heard in the hope that it makes our readers smile. Now then, the story goes that a hairdresser by the name of Horigoshi Junzō (58) lived in a neighborhood near the front of the gate of Ten'ōji in Yanaka. He had a natural fondness for birds, and he enjoyed keeping all kinds of them at his home, making no distinction between large and small. Recently, however, he found that every day some of the birds would disappear. Thinking that it must be one of his neighbors who had stolen them, he kept a vigilant watch to try to take stock of the situation, but discovered nothing whatever that was suspicious.

"The courtly lady reveals herself: 'I am a snake.'" Untitled item in "News" section, *Reform News*, no. 47, May 5, 1883. (Hitotsubashi University Library)

Nevertheless, when the next day came, he inevitably found that not all of the birds were there. Junzō could not shake his lingering doubts and thought, "This must mean that I'll have to look out for dogs and cats. If I catch them eating one of my birds, I'll shoot them dead!" He kept a close watch, but then one evening in Junzō's dreams, a lady-in-waiting not yet twenty years old appeared kneeling beside his pillow; she was dressed in the manner of a palace lady such as one might see in photographic portraits.

> I am the white snake who has lived in the five-story pagoda of Yanaka's Ten'ōji for hundreds of years. I have many descendants, and each of them acts to protect the safety of the temple. However, ever since a giant *tanuki* that dwelt for many years in Dōkanyama came recently to settle on the grounds of the Ten'ōji temple, it has plundered the little snakes who are my descendants and household members: making them its dinner. But that's not all—of late, the *tanuki* has even tried to eat me! Now then, having resided in this place for hundreds of years, I am certainly not frightened of some giant *tanuki*. But I do fear that if I just let things go, then ultimately it will mean that my children and dependants will all be gobbled up by him. Just as I was sighing to myself in sorrow over this matter, the *tanuki* has now begun to eat up the birds that you raise in your house. And I understand that because of the *tanuki*'s actions, even the faultless dogs and cats have come under suspicion. For this reason, I have come to meet you in this dream and tell you about these things. I would somehow like to borrow the hand of a human to execute the giant *tanuki*. Second, I have come to disabuse you of your suspicions about anyone else. Tomorrow, if you go and seek out the graveyard in the temple grounds, you will see the remains of the birds that he has plundered. You must not suspect others, but instead quickly drive away that bad *tanuki* and thereby dispel this peril. I have come for the purpose of making this earnest entreaty.

No sooner had Junzō heard her say this than he awoke from his dream. Junzō was struck by the wonder of it, and the next morning straight away he went to the grounds of Ten'ōji temple to investigate. Just as he had been told, he found bird feathers scattered all around, presumably the remains of what the *tanuki* had eaten, and there were bones strewn about as well. "Well, that must mean that the disappearance of the birds was the doing of the *tanuki*. I will hunt the *tanuki*: to avenge the birds for one, and also to effect retribution for the snake's grudge!" With this in mind, he consulted with a

bunch of young men in the area, and they all agreed that it sounded like fun. It is said that within a few days, a band of them will set out on a punitive expedition to smite the *tanuki*. But since this is a story about a *tanuki*, we hope that you will read it with a grain of salt.

TRANSLATED BY MATTHEW FRALEIGH

PART II

Crime and Punishment, Edo and Tokyo

The Bad Girl Prefers Black and Yellow Plaid

NARRATED BY SHUNKINTEI RYŪŌ

TRANSCRIBED BY SAKAI SHŌZŌ

The Bad Girl Prefers Black and Yellow Plaid (*Adamusume Ko-nomi no Hachijō*, first performed 1873; then published 1889) was orally delivered by Edo-born narrator Shunkintei Ryūō (1826–1894), who settled on this stage name late in his successful career as a *rakugo* narrator. Ryūō, whose works were based primarily on well-known stories that had circulated during the Edo period, was popular in his day but has not attracted a wide range of scholarly attention. His "human-interest stories," divided into a dozen or more separate shows, progressed at a relaxed tempo, weaving together a large cast of characters and episodes into a believable narrative of downtown Edo life. His gossipy attention to detail appealed to the traditional urban Edo sensibility that still burned in the hearts of true-born Tokyoites.

Like Enchō's works, some of Ryūō's orally delivered stories came to be published in shorthand. *The True Story of Impostor Ten'ichibō* (*Jissetsu Ten'ichibō*, serially published in 1890–1891) and *The Ghost Story of Yotsuya* (*Yotsuya Kaidan*, published in 1896) are among his well-known stories preserved in the printed form. *The Bad Girl*, of which the last part is presented here, was recorded presumably verbatim by Sakai Shōzō (1860–1915), a

leading stenographer for oral narratives, and published as a series of five special monthly supplements to the *Yamato Shinbun* newspaper from July 14 to November 22, 1889. It is one of the best-known human-interest stories, of the type in which Ryūō excelled.

The story of *The Bad Girl* centers around the Shirokoya case, an actual court case tried by Ōoka Tadasuke (1677–1751), Lord of Echizen, Edo's city magistrate of the South Office. Among the group of episodes commonly called "Lord Ōoka's Judgments," which extolled the virtues of the brilliant magistrate, the accounts of the Shirokoya case are the only ones based on an actual case judged by the legendary magistrate. Ryūō's narrative may have drawn material from earlier orators, in particular, Baba Bunkō (1718–1758), whose "Okuma of the House of Shirokoya" (Shirokoya Okuma), collected in his *Contemporary Stories Heard in Edo* (*Kinsei Edo Chomonjū*, hand-copied and circulated, 1757), is purported to have been the first publicly orated version. Ryūō's story is free of Bunkō's usual muckraking assaults on authority figures, but it is severely critical of the moral degeneration of the rich. Ryūō is a gentler orator: prioritizing narrative flow, his social critique proceeds by implication.

The Bad Girl draws the Tokyoite audience's interest to Edo itself: its neighborhoods and its systems of governance. The city of Edo had a well-developed police and judicial system, supported by highly respected citizen volunteers or appointees from the city's many neighborhoods. City magistrates, the number varying between one and four for the entire city of Edo, were appointed by the shogun from among *hatamoto,* or samurai who directly served him, to be responsible for presiding over civil matters. Once appointed, these magistrates acted as mayor, chief of police, and head judge in one. The magistrate's official mansion, popularly called "South Office," "Middle Office," or "North Office," depending on its locale within Edo, included his office as well as a court of law, which consisted of a cleared section of ground covered with white gravel. Litigants would sit upon the white ground, head bowed, while the magistrate placed himself on his office veranda. Along with the city magistrates, police inspectors, who were also appointed by the shogunate, cut dashing figures as they made their rounds through the city, always followed by subordinate officers. Hatchōbori was the equivalent of Scotland Yard, and the name applied both to the police force and the area in which inspectors and officers lived. Likewise, Kodenma-chō referred to the street as well as to the prison where suspects were held after the arrest and until the time of conviction. A neighborhood representative was officially appointed from the common population by the magistrate. Their job was to look after his community. In addition, landlords assumed

responsibility and authority for overseeing the behavior of tenement dwellers. As in the following story, matrimonial go-betweens supervised the affairs of young couples and their growing families so that he, too, answered to the magistrate's office if any questions arose. By the shogunate's order, a "Group of Five" was formed among property owners and the managers of each neighborhood; the members took turns monthly to attend to the official and unofficial tasks of supervising street repairs, crime and fire prevention, and many other matters. The popularity of crime stories in Edo had much to do with the citizens' fascination with the police and magistrates as well as with their own involvement in representing and guarding their neighborhoods.

The Bad Girl is not simply an example of an Edo-style crime tale, nor is it merely an account in the tradition of Lord Ōoka mythic trials. Ryūō's concerns are modern in their reflection of a Meiji-period interest in the judicial system and its faith in the rational outlay of evidence and eyewitness testimony. Suspenseful battles of wits, such as between the wily suspect Otsune and the genius judge, and the latter's manipulation of Okiku, a tongue-tied witness, in addition to unexpected twists of interpretation and judgment make the work a forerunner of modern courthouse drama.

The title *The Bad Girl Prefers Black and Yellow Plaid,* whets the appetite of the audience by referring to *kihachijō,* a fashionable silk fabric that came to be associated with Hachijō Island, not far from the city. The bold black lines woven into yellow suited the type called *ochappī,* or a high-spirited urban girl, most likely a teenage daughter of a downtown Edo commoner. The spotlight put on Okuma, a charming and fashionably dressed spoiled daughter of a millionaire merchant, is close to our contemporary media obsessions with the alluring and wild daughters of famous wealthy families. The patterning of the kimono worn by the young beauty as she is carried on horseback to her execution allows the story to tie her to Hachijō Island, both the origin of the fabric and the island of exile for her stepmother, Otsune. The title thus represents the mother-daughter theme of the work: a seductive pair, one driven by greed and the other by lust; one dominating the other, the only object of her affection. Incidentally, the prefix "O" was attached to women's names in familiar address, as in "Otsune" and "Okuma." The narrator uses this form of appellation for female characters. By contrast, the magistrate calls them by their legal names, like "Tsune" and "Kuma."

The plot of *The Bad Girl* focuses on the effects of money in human relations and destiny. Otsune is originally a Fukagawa courtesan who has been

ransomed by the wealthy merchant Shōzaburō and has become his second wife and stepmother to his son Shōnosuke and daughter Okuma. She now faces her aged husband's illness and the impending economic doom of the family. Like a good wife and manager of the household, she has schemed to save the family by marrying Okuma to Matashirō, a middle-aged clerk from another shop, for the sake of Matashirō's dowry of five hundred *ryō*. On Matashirō's part, the dowry is an investment. Instead of using his savings and the bonus from his former employer to open a shop of his own, he has chosen to recover and expand Shirokoya's fortune as the new owner of a formerly flourishing shop with an established clientele. Despite his mal-treatment at the hands of his new family, he is in no position to divorce Okuma or sever himself from her family. If he chooses to leave of his own accord, he will forgo all recourse to a legal reimbursement of the five hun-dred *ryō*. To protect Matashirō, Kagaya Chōbei, Matashirō's landlord and official go-between for his marriage to Okuma, looks for the chance to catch Okuma and her lover Chūhachi red-handed so Okuma can be charged for infidelity. Meanwhile, Otsune, who is determined to keep the money, has no choice but to either kick Matashirō out on fabricated charges of infidelity or murder him. Beginning with the fifty *ryō* paid by Shōzaburō to ransom Ot-sune, money expended, stolen, robbed, extorted, and gambled connects an extraordinary array of characters and episodes, establishing a complex and realistically satisfying narrative.

Presented here are Episode 13, depicting the circumstances sur-rounding the second trial of the Shirokoya case, and the end of the final episode, Episode 14. As illustrated in Episode 10, the first trial ends with the plaintiff, Zenpachi the porter, in handcuffs and the witness Kyūsuke, Shirokoya's former manservant, sentenced to prison. Both are being charged for their presumably false accusations of the defendant. Episode 13 thrills the audience by unfolding a reversal of the initial trial verdict in which Echizen has strategically reserved judgment. As the last episode of the entire series, Episode 14 concludes by presenting the final verdicts and resulting punishments. Characters and plot lines from earlier epi-sodes resurface here: the gang boss Yatagorō Genshichi, implicated in the murder of Shinza the Hairdresser, and the two woodcutters, Chōjirō and Kishirō, accused of helping Chūhachi in the attempted murder of Matashirō, are rounded up for the multiple executions that bring the tale to a close.

⌒(SJ)⌒

EPISODE 13

Let me pick up where I left off. Otsune, the mistress of the Shirokoya Store, had tricked the maid Okiku into attacking her son-in-law Matashirō and wounding him on the neck. She prayed that Okiku had by now managed to leave an incriminating scar, which would justify her trumped-up charge of Matashirō's infidelity. Only then could she sunder her family's obligations to him without paying back his dowry of five hundred *ryō*. Such was the nasty plot she had concocted. While Okiku slept in the tiny servants' room, oblivious to the implications of the ominous task she had agreed to perform, Otsune waited impatiently for her to bring news of the mission accomplished. At midnight, Otsune lost her self-control and barged into the servants' quarters next to the kitchen—only to find Okiku and the other maid Ohatsu fast asleep. Otsune didn't dare to rouse Okiku, let alone venting her anger by yelling at her, for fear that Ohatsu might wake up and complicate the situation. Thus the mistress tiptoed to the other end of the bed, pulling the sleeping girl by the feet from her bed and out of her mosquito net. While being dragged across the floor, the girl snored loudly, with no indication of waking. Only then did Otsune shake her and call her name.

TSUNE: Okiku, Okiku . . .

KIKU: Coming, coming! Oh, it's you, ma'am! Good morning!

TSUNE: Shhh. Come this way.

KIKU: Do you need something, ma'am?

TSUNE: Quiet, I tell you! Don't tell me you've forgotten what I asked you to do when we were on the boat!

KIKU: Oh, yes, you did say something. It slipped my mind.

TSUNE: Now, take this razor. Don't make a mistake! As I told you, you're going to say out loud, "There is no way for me to be married to you, Young Master. All we can do is commit a love suicide so we'll be husband and wife in the next world." Be sure you don't forget a single word!

KIKU: No, I won't, ma'am.

"Here it is," said Otsune as she handed the razor to Okiku. The mistress watched and followed the maid, who, wearing only a petticoat patterned with a geometrical design, walked to the room between the shop and the inner chambers. It was here that an unsuspecting Matashirō lay asleep. This occurred on the night of the twenty-eighth of the Fifth Month. Without warning, Okiku pulled up the skirt of the mosquito net and entered the enclosure. The nearly naked young maid sat by Matashirō's pillow testing the blade of the razor against her left palm as though she had been preparing to give him a shave. Finally, she put the knife on Matashirō's throat and neatly drew the blade across the flesh. As you might imagine, you can't stay sleeping while your throat's being cut. Matashirō opened his eyes and made out a strange shadow close to his head. He ran his hand across his neck, and felt a wet stickiness. When he cast his eyes on his hand, he saw blood. He jumped from out of the mosquito net shrieking, "Murder, murder!" Some of the rings on the corners of the mosquito net came unhooked in the commotion, making the entire tent collapse on Okiku. As she was overwhelmed by Matashirō's loud scream, confusion muddied what she had been instructed to say at this crucial moment—Otsune's carefully prepared script was now nothing but a mess of fragments in her mind.

Kagaya Chōbei, their next-door neighbor, had yet to retire for the night, having returned late after accompanying his family for an evening of fireworks in Ryōgoku. It was strange enough to hear a voice coming from the Shirokoya at this hour. But when he realized that cries of murder were coming from his former tenant Matashirō, he became greatly alarmed. He jumped to his feet and followed an alley to the back entrance of the Shirokoya. "Open the door! Open up!" Chōbei shouted, but nobody came to unlatch the door. While Matashirō bellowed "Murder! Murder!" inside the house, who should have come by but Master Hattori Kogorō, the chief inspector from Hatchōbori, making his rounds. As the word "murder" reverberated from inside the store out into the streets and into his ears, he stopped short and listened carefully. The maid Ohatsu, now awake and rubbing her eyes, finally opened the back door for Chōbei, who had been banging at it all this time. He yelled into the house.

CHŌBEI: Otsune, what on earth is going on here?

TSUNE: I haven't the faintest idea. Oh, my, oh, my, whatever happened to you, Matashirō?

MATASHIRŌ: My head's been cut off!

TSUNE: What a thing to say! Your head's still there where it should be.

MATASHIRŌ: A murderer slipped into my mosquito net just now. Look, my head's at least seventy percent cut off from my body.

CHŌBEI: I demand an explanation, Otsune. What's this all about?

TSUNE: Why, I have no idea.

CHŌBEI: Look! There's someone inside the mosquito net.

As he spoke, he removed the heavy folds of the fallen netting and uncovered Okiku, who sat in her geometric-patterned petticoat, dazed and still holding the razor.

CHŌBEI: Okiku, are you all right?

KIKU: Ah, the master from next door! Good morning, sir!

CHŌBEI: What's happened to you, you fool! Get a grip on yourself, Okiku!

MATASHIRŌ: It's this Okiku who sliced my throat.

CHŌBEI: That's outrageous! What an irresponsible woman you are Otsune, to keep a maid like this in your house! What's the meaning of all this, anyway?

Otsune impatiently waited for Okiku to repeat what she had been instructed to say, but Okiku merely sat dumbfounded, having forgotten the words her employer had pounded into her head.

TSUNE: I'll tell you what I think. Okiku here is the very reason my stepdaughter Okuma and Matashirō don't get along. It's clear to me that Matashirō and Okiku are lovers. No wonder Okuma can't be happy with her husband! Am I right, Okiku? Am I?

KIKU: Yes, ma'am, the fireworks were wonderful. I had such a good time!

Obviously, Okiku had completely forgotten the scenario that Otsune had cooked up. Suddenly, they were surprised by a loud knock on

the front door, and an authoritative voice yelling, "Open up! Open up!" By now, thanks to the repeated cry of "Murder!" the shop's employees were all awake. Hanbei the clerk got up and peeked through a small window in the door. He immediately recognized none other than the top inspector from Hatchōbori! Hanbei opened the gate wide and kowtowed as he showed him in. Master Hattori Kogorō strode in, followed by his men.

HATTORI: As I was walking by, I heard someone shout "Murder!" Did that come from this shop?

HANBEI: No, the owner's residence.

HATTORI: If that's the case, open the door to the middle room! Be quick! I did hear "Murder!"

HANBEI: Please be patient. The doors in between are locked. Hang on, hang on. Coming. . . . Ma'am, are you there in the middle room? Won't you please unlock one of the sliding doors? The chief inspector is here in the shop.

The store and the family residence were divided by sliding doors, which were regularly locked every night when the temple bell struck ten o'clock. Employees sleeping in the shop had a separate corridor for visiting the toilet at night. There was a chance that Chūhachi, now on the run, might show up during the night and raise havoc among the employees: Otsune had of late been diligent about locking the partition to avoid any such disturbance. This meant that, after ten, there was no way to open one of the doors except from within.

Naturally, the police officers' demanding entry frightened Otsune even more than it surprised Chōbei.

CHŌBEI: I told you it's urgent. I don't know if it's the regular officers making their usual rounds or a group of special recruits, called in to deal with some extraordinary situation. But there they are: they just happened to be passing by. . . . Yes, sir, please wait. Someone will open the doors to the family home. . . . Listen, Otsune, if this comes out in the open, even if Okiku's life is somehow spared, some sort of punishment can't be avoided. Okiku has injured her master, after all. It will be nasty for your shop's reputation that such a criminal has come from among its employees. Leave this matter to me, won't you?

While talking, Chōbei snatched the razor from Okiku's hand and tossed it into the kitchen.

CHŌBEI: Matashirō, won't you let me handle this? It won't come out badly for you, I promise.

MATASHIRŌ: No way! I'm going to report the whole story to the police.

CHŌBEI: Yes, yes, officers, we'll open the doors. Just one moment, please!

OFFICERS: Open up, we say!

CHŌBEI: Yes, right away, sirs!

Chōbei moved to unlock one of the sliding doors, but realized that Matashirō's body was covered with blood. He quickly ordered his clothes changed and the floors wiped. Still, the blood continued to ooze from Matashirō's neck. In the absence of any styptic, Chōbei tentatively applied a thick coating of chopped tobacco leaves to Matashirō's wound and wrapped a clean loincloth around his neck. As the officers persistently banged on the partition doors, Otsune suddenly regretted the hasty plan against her son-in-law. It was a bit too late for that. As she turned the key and pulled the door open, Master Hattori Kogorō entered, followed by his detectives and a servant.

HATTORI: Tell me what happened. Why did someone yell "Murder!" in the middle of the night?

MATASHIRŌ: Well, sir, this is our maid Okiku. She slashed my . . .

CHŌBEI: Stop! Let me report. Officers, I am Kagaya Chōbei from next door. When I heard someone shout "Murder!" I came by the back alley and saw this maid. She looked drowsy. That's why she's still in her nighties. And this Matashirō, he's Shirokoya's young master, having married into the family. The maid, half-asleep, entered the mosquito net in her master's room by mistake, so he thought it was a thief who came in and . . .

MATASHIRŌ: No, it wasn't like that!

CHŌBEI: Shut up, Matashirō! Leave it to me, will you? . . . So, officers, because Matashirō cried "Thief!" the maid was frightened and tried to run

away. Matashirō ran after her, and hit his nose against this pillar. That explains the terrible nose bleeding. . . . Wait, Matashirō, let me finish, please! The maid was drowsy and groggy, and that's all there is to it, officers. I am sorry this silly incident has disturbed the peace of your evening rounds.

Matashirō was incensed. He tried to appeal to the chief inspector, but Chōbei was determined to stop him. Matashirō tried to calm himself, reasoning that he owed it to the older man to let him have his way—after all, he had kindly acted as go-between when Matashirō married Okuma. He couldn't disobey his benefactor's order to keep his mouth shut.

Now, Master Hattori Kogorō was a seasoned inspector. He wasn't the fussy sort who would dig into the corners of a lunch box with a toothpick. He knew that an overly fastidious investigation would end up hurting a lot of people. The other officers, too, were smug, distracted by their suspicion of some hanky-panky going on between the maid and the master.

HATTORI: In that case, submit a written report stating that the maid did this because she was half-asleep. I'll be waiting at the Fukiyachō police station.

CHŌBEI: Certainly, sir. Thank you, sir.

After the officers left, Chōbei gave Otsune a lengthy talking to and wrote a report testifying to the maid's sleepiness at the moment in question. That was the night of the twenty-eighth of the Fifth Month. Okiku was promptly dismissed from service. Eventually, the truth did come to light: that Otsune had put poison in Matashirō's miso soup, that Matashirō had been beaten to death and thrown into the ocean on Haneda Beach, only being revived by luck and helped back to health by the dedicated attention of a certain Dr. Abe Tomonoshin. But all this came out later and had to be proven at court.

Returning to Matashirō: Having survived the attempted murder, when he appeared on the white sand grounds of the magistrate's court, he felt as though he had just awakened from a nightmare. Unlike Inspector Hattori, who had dismissed his injury as a case of the sleepy maid's error, the Lord of Echizen, the city magistrate of the South Office, asked him questions about the scar on his throat, and Matashirō was able to describe the events as they had truly happened. He was then placed, without any criminal charge, in the custody of his former employer Kuwanaya Yasōzaemon. But I'm getting ahead of myself here, again.

It was on the fifth day of the Tenth Month in 1725 when both the plaintiff's and the defendant's parties were called by written summons to court for a retrial. The servant Kyūsuke was brought out of prison, and the porter Zenpachi, still in handcuffs, joined him. The latter was the plaintiff and the former his witness. As for the accused, since Shirokoya Shōzaburō was ill, his wife Otsune had been summoned in his place this time as at the first trial. Their daughter Okuma had, again, pleaded illness, but had been ordered to appear at court, "carried in a palanquin if necessary." No proxy for her had been allowed. Such a strict summons this time! A proxy was authorized, however, for Kuwanaya Yasōzaemon, Matashiro's former employer— in his place, a certain Kichibei accompanied Matashirō. Okiku, who was identified as the daughter of Kihei, the used bric-a-brac dealer on the Second Street of Mikawachō in Kanda, attended the court hearing as well. Tamai Gentei, a town physician who resided in Ogawachō, and Kagaya Chōbei, the go-between for Matashirō and Okuma, were each accompanied by a designated neighborhood representative. A large number of people, indeed, were involved in this trial.

The Lord of Echizen, as usual, left his duties at the shogun's castle when the drum struck two o'clock; he immediately arrived at court. Those who had waited on benches outside were called to the sandy ground in front of the magistrate's veranda. The Shirokoya incident was the first case to be examined that day. When all concerned were seated on the sand, the Lord of Echizen pushed away the document tray, something that was used only for interrogations by inspectors, a customary gesture to announce the opening of the magistrate's own trial.

ECHIZEN: Zenpachi, the plaintiff!

ZENPACHI: Here, my lord.

ECHIZEN: Defendant Tsune representing her sick husband Shōzaburō. Have you brought your daughter Kuma with you?

TSUNE: Yes, my lord, she is with me.

ECHIZEN: Gentei, town physician from Egawa-cho!

GENTEI: Yes, I am here, sir.

ECHIZEN: Kichibei, proxy for Kuwanaya Yasōzaemon! Matashirō has also been summoned. Is he with you?

KICHIBEI: Yes, present. And he is here with me.

ECHIZEN: Kiku, daughter of Kihei! I understand Kihei runs a curio shop on the Second Street of Mikawa-chō.

KIKU: Here, my lord!

ECHIZEN: Are you called Kiku?

KIKU: Yes, my lord. My name is Kiku.

ECHIZEN: How old are you?

KIKU: I'm nineteen. That means I'll be twenty next year.

ECHIZEN: Well, well, what a learned girl you are! You are brilliant, I must say.

KIKU: Yes, I know. Everybody says so.

ECHIZEN: Advance! Come closer!

KIKU: Yes, here I am, my lord. What do you need, sir?

ECHIZEN: You must not hide anything from me when I ask you questions today. There will be no lying. Do you understand? Now, tell me exactly what happened. Tell me what really happened. If you do, I will give you a reward. But if you hide anything from me, then I will be compelled to imprison you.

KIKU: What's "imprison"? I don't like the sound of that!

ECHIZEN: You fool! I said I would put you in Tenmachō prison. If, on the other hand, you answer my questions honestly, then I will give you a prize.

KIKU: Wow! Thank you soooo much! What might you want to know, my lord?

ECHIZEN: On the twenty-eighth day of the Fifth Month this year, you went to Ryōgoku to watch fireworks with your employer Tsune and her daughter Kuma. Is that correct?

Okiku could have admitted, without destroying the case for her mistress, that she had indeed gone to watch fireworks, but the poor half-witted girl was frightened of Otsune, who sat nearby. She glanced at her mistress uneasily. Otsune was on pins and needles. If the girl uttered one word of the truth, she knew it would spell her ruin. It was against Otsune's strategy to raise her voice, let alone order Okiku to keep her mouth shut. So, she dutifully held her head low and kept her hands on the sand, all the while flashing glances at Okiku. Naïve as she was, the girl took these pointed looks to mean that she was not to tell the truth.

KIKU: No, my lord, I don't remember anything at all about going to watch fireworks.

Sitting far above those bowing on the sand, the Lord of Echizen had detected Otsune's attempt to use sidelong glances as a way to compel the maid's testimony.

ECHIZEN: Kiku, did your mistress just order you to keep quiet? Listen: I, too, went to the fireworks. In fact, I was in the covered boat right next to yours. Tsune and Kuma weren't the only ones who were with you, were they? A man called Chūhachi was in the party. He shared the boat with the rest of you. In other words, he was with you in the same boat.

KIKU: Wow! You know everything! Ma'am, did you hear that? The lord was also watching fireworks, and he was on the boat next to ours! Yes, my lord, you're right. You know everything. On our way to Ryōgoku, my mistress sent a messenger to Chūhachi and invited him to come with us. Chūhachi caught up with us at the Miuraya Boat House in Ryōgoku, and that's where we got on the boat.

ECHIZEN: I am aware of that. I saw it all myself. If you are honest, young lady, I will give you a reward. Now tell me, while on the boat, you were told by Tsune to scar Matashirō's throat with a razor, were you not?

KIKU: Oh, my goodness! You know that, too?

Okiku was at a loss. She glanced nervously at the magistrate's countenance, then at her former employer's face. Both Otsune and Okuma inwardly cursed themselves for having involved this dull girl in their scheme. Seeing no way for them to convey their wishes to the girl, they could do

nothing but hang their heads low and keep their hands planted on the sand. But the wheels of Otsune's mind were turning quickly as she searched for a way to extricate herself from this predicament.

KIKU: I think, my lord, you know what's inside everybody's heart, so I might as well tell you that I was given a coral hair ornament and two *bu*-coins. On top of that, madam promised me Okuma's tie-dyed silk jacket if I did what she wanted me to do. She also said, "Five *ryō* will be yours if my big plan succeeds." Five gold pieces! Weren't you amazed to hear that coming from our boat, sir? That night, I forgot all about it and fell asleep. My mistress suddenly grabbed my feet and pulled me out of the mosquito net in our room. Boy, was she mad! She gave me a razor. With it, I slipped into the young master's bed, and cut his throat just a little. But because the master was surprised and yelled, "Thief! Murderer!" I forgot all the words I was supposed to say. Then the old master of the house next door came through the back door, scolded my mistress, and called me an idiot. That was so funny! The young master said that his head was missing and looked for it all over the place! I laughed so hard my belly got twisted inside out. Then, police officers came through the front entrance. The master of the Kagaya next door was so surprised, and he said the young master's blood was from crashing into the pillar. What a horrible lie! Is this what you wanted to hear, my lord?

ECHIZEN: Yes, you're doing fine. What happened next?

KIKU: I ended up getting fired. No gold coins, no tie-dyed silk jacket. I think my mistress is a rotten liar. Is this what you wanted to know, my lord?

ECHIZEN: Good girl! You are doing fine. . . . Tsune, what do you have to say to all of this? You unpardonable she-devil! Confess!

TSUNE: I venture to say, sir, that Okiku's story is nothing but a fabrication. I would be disappointed, my lord, if you were to believe that idiot's lies. I swear I had nothing to do with the horrors described by my former servant girl—not even in my dreams.

ECHIZEN: Silence, Tsune! Kyūsuke, I can see why you've never given up pressing charges against this merciless employer of yours. Kiku!

KIKU: Here, my lord.

ECHIZEN: Do you know the physician Gentei who sits over there?

KIKU: Oh, you're here, too, Dr. Gentei? Yes, my lord, I know him.

ECHIZEN: Then, of course, you also know that Gentei and Tsune were intimate with each other?

KIKU: My lord, you *do* know everything! I wouldn't go to bed with such a greasy baldhead myself! He looks like someone pulled him out of a used oil jar. One night, when I was going to the bathroom, I sort of peeked in my mistress's room and saw the two of them whispering to each other inside the mosquito net. But, my lord, you know that, too, already, don't you?

ECHIZEN: Tsune, you claim you put Uzusan in the soup for your husband. But in fact it was the deadly poison Hanmyō. Tell me the truth!

TSUNE: I'm afraid I don't understand what you're referring to. I swear it was Uzusan that I prepared for my sick husband.

ECHIZEN: Gentei, come forward!

GENTEI: Yes, my lord.

ECHIZEN: You were deceived by this temptress. All for her sake, you dispensed the poison and called it Uzusan when you sent it to the family. Confess!

GENTEI: Medicine is a science of mercy, if I may say so, my lord. No physician would prepare any poisonous substance. Of course, poison does occasionally turn into a miracle drug depending on the situation, but that's another matter.

ECHIZEN: Silence! No matter what excuses you make, it wasn't Uzusan but poison you dispensed. Clearly I will need to examine you further. You will not be permitted to go home today. Men, tie him up!

So Gentei was the first to be tied with a rope.

ECHIZEN: Now, Kuma, where is Chūhachi, your till-death-do-us-part sweetheart? Tell the truth!

Intimidated, Okuma, who, after all, was only twenty-one, turned white and began to shake. Otsune whispered to her.

TSUNE: Don't you say a word!

KUMA: I know, Mom.

TSUNE: Don't you talk! Something horrible will happen if you do. Excuse me, my lord, but please let me speak on my daughter's behalf. Chūhachi ran away some time ago, and nobody knows his whereabouts. It's no use asking my daughter. I swear I don't know anything either, my lord.

ECHIZEN: Just see if you can keep your silence now. A magistrate's job is not to listen to idle pronouncement but to loosen mouths that are tightly closed so that the proper judgment can be made. Tsune and Kuma, you two will be detained today. Men, tie up these women!

So they were both detained. While all this was going on, Chūhachi was tucked away in a wooden trunk in the Shirokoya house like an illicit lover in an old romance. He had secretly returned there during the Ninth Month. As the women were preparing to leave for the retrial at the courthouse, Chūhachi was taken upstairs and hidden in a huge trunk that normally contained bedding. It was pushed closely against the wall of the room. For his comfort, the trunk was lined with a futon of Kai silk, on top of which lay a quilt in Hachijō silk and a padded cotton jacket. Even a bedpan had been placed in the corner of the trunk. If he needed to come out, Chūhachi could open the lid from inside. Food in a lacquered picnic box was delivered discreetly by Otsune or Okuma. In short, Chūhachi was well taken care of: he had both a toilet and a kitchen right in his bed, so to speak. When leaving the house, Otsune opened the lid and spoke to him:

TSUNE: Chūhachi, my dear, Okuma and I have been summoned to the magistrate's court today. The famous Lord of Echizen is overseeing the trial, so it's possible we might be arrested. Don't worry, Okuma will come back to you, no matter what. But, there's a chance I might not. I want you two lovebirds to run away and become husband and wife wherever you can settle. Here is a hundred *ryō* for your escape. And these leg covers and straw shoes, they're for the two of you.

Before leaving home for the court, Otsune had thoughtfully prepared the young pair for their journey. While the trial was on, Chūhachi prayed inside the trunk. He petitioned all the gods and buddhas he could think of, but prayers for the success of evil deeds will never be answered. Chūhachi could have no way of knowing that Otsune, Okuma, and Gentei were all bound in ropes.

ECHIZEN: Kiku, Kiku.

KIKU: Yes, my lord. Do I get my reward now?

ECHIZEN: You miserable wench! Because of your malevolent employer, are you doomed to fall into Hell with her and her accomplices? If it is officially established that you injured Matashirō, then you, too, are guilty according to the law. I am afraid I will have to keep you in prison today. Men, arrest her!

KIKU: My lord, were you lying to me, too?

She realized the magistrate's trick much too late.

ECHIZEN: Kyūsuke, it has taken us a long hour to reach the heart of the matter. I am setting you free today. Zenpachi, I order your handcuffs removed immediately.

ZENPACHI: Thank you, my lord.

KYŪSUKE: Thanks, judge.

Kyūsuke was particularly happy because he was finally released after many long days of confinement. At the magistrate's order, "Rise, both of you," the two stood up from the sandy ground to take their leave. Kichibei, Kuwanaya Yasōzaemon's proxy, was informed that Matashirō was to be returned to the custody of his former master.

In the meantime, back at the Shirokoya house, even from inside the trunk, Chūhachi could tell that it was approaching sunset.

CHŪHACHI: Strange! It's almost evening, and yet the ladies aren't back yet. Is it possible they're being held in jail? No. That old lady's so smart. I

wouldn't be surprised if she's seduced the genius magistrate and got both of them set free.

Anxiously, his thoughts began to whirl between the two possibilities. Before long, the sound of wooden clappers and the night watchman's call of "Seven o'clock!" came from the direction of the Inari Shrine in the Suginomori woods. "Aren't they awfully late?" Chūhachi muttered to himself as he heard footsteps coming up the stairs.

CHŪHACHI: Great! I hope it's Okuma.

APPRENTICE: Say, Ohatsu!

HATSU: What?

APPRENTICE: What happened to the mistress and Miss Okuma?

HATSU: Imprisoned, I hear.

APPRENTICE: Say what?

HATSU: Too big a word for you? It means they're in the clinker, you fool. The mistress is a criminal, they say. I know nothing about it, but I hear there was some hanky-panky going on between the mistress and Tamai Gentei, that disgusting dark-skinned baldhead. Poor Okiku! She had no idea what she was doing. She's in prison, too, just because her mistress was a villain.

APPRENTICE: That's awful! And what will happen to the shop?

HATSU: Probably confiscated.

APPRENTICE: There's another word I don't know.

HATSU: The government will take it away. That's what it means.

APPRENTICE: Boy, the government is so sneaky! And what will happen to us employees?

HATSU: We'll all be sent home.

APPRENTICE: Wow, that's great! I'll be glad to go home again. "Confiscated" is a bit like New Year's, isn't it?

HATSU: Don't be silly! The one I am really sorry for is the Old Master. So old and sick—what'll he do? Shōnosuke, too. He's been disowned by his parents and banished from Edo by law. He won't have anywhere to go.

Listening to the two young employees from inside the trunk, Chūhachi was alarmed. "So my uncle Gentei was put away with Otsune and Okiku. Even Okuma wasn't spared, either," he thought. "I can't be wasting any time here," he told himself. While still inside the trunk, he stealthily put on his leg covers and straw shoes. Tying the purse containing the one hundred *ryō* he had received from Otsune to his sash, he planned to wait until everyone was in bed before climbing out of the trunk and sneaking out of the house.

APPRENTICE: Ohatsu, won't you sleep next to me? Just once, I want to snuggle in Okuma's soft silk covers with you.

HATSU: Sure, but don't pee in the bed! Why don't we lie down feet to head? Your head here, my feet there.

The two lay down in the formation suggested by Ohatsu. The fate of their master's household made them uneasy, and neither could fall asleep. The sound of wood clappers came again from the direction of the Suginomori woods, accompanied by the night watchman's voice announcing nine o'clock. Thinking that the boy and the girl were asleep by now, Chūhachi began to push up on the lid of the trunk. Ohatsu, too anxious to sleep, was startled.

HATSU: Wake up, boy!

APPRENTICE: What?

HATSU: Look, it's a trunk monster!

APPRENTICE: It is! A trunk monster! Help!

The boy covered his head with the bedding. He peeked out to witness the trunk lid slowly lifting and a dark figure emerging from inside.

APPRENTICE: The monster has a dagger in his left hand and the edge of a sedge hat between his teeth. He's just stepped out of the trunk . . .

As Chūhachi was about to leave the room, Ohatsu screamed. She had no idea that it was Chūhachi, someone she actually knew, and she certainly didn't expect a human being to come out of the bedding trunk. "Monster!" she cried as she jumped out of the bed and started to run down the stairs. "Damn!" Chūhachi muttered to himself, releasing the hat from between his teeth and shaking the scabbard off his dagger. He chased Ohatsu down the steps and slashed at her through her chignon. "Ah!" cried Ohatsu as she rolled down the stairs with a loud rattle and landed with a thud. Because the apprentice was still covered with the bedding, Chūhachi didn't see him.

There was no time to delay. Without wiping the blood off his dagger, Chūhachi pushed it into the scabbard, put on his sedge hat, and slinked out of the room onto the veranda. From there, he slid down a pile of lumber into the back alley and succeeded in getting away. The shop employees of Shirokoya who heard the noise rushed to find Ohatsu unconscious at the bottom of the stairway. Thanks to their care, she revived and described how a person came out of the bedding trunk. The boy apprentice was unharmed and perfectly conscious. It didn't seem to be an incident to let pass, so the employees reported it to the police. As the inspector examined the inside of the trunk, he found a Kai silk futon, a Hattan silk quilt, a padded cotton jacket, and a lacquered box of half-eaten dishes as well as a bedpan in the corner. The inspector concluded that someone must have been living in the trunk and it was very likely Chūhachi, the wanted man. He sent his men on a relentless search for the fugitive.

EPISODE 14 (FINAL SEGMENT)

Chūhachi said farewell to his protector Yasubei and his family. Then he headed for Edo. This time, he had no fear of being seen. In fact, he was eager to be caught. That way, he could walk around in broad daylight and check in at an inn like any other traveler. He would leave late in the morning and travel without any guilt gnawing at his conscience. Nobody on the road would suspect him of any dark crime. By the time he reached Abekawa-chō where his parents lived, he realized the intensity of the police investigation. He knocked on the door of his parents' house. He told his father everything that had happened since he had last seen him.

CHŪHACHI: I'm going to the South Magistrate's Office to confess. So this is my last chance to see you.

YOHEI: Don't talk like that! Please, run away and save yourself!

CHŪHACHI: No. My mind's made up. I've finally become a decent human being. Sorry to have made you worry. I won't burden you any longer. Please forgive me.

The maid recalls the fateful pleasure cruise. *Yamato Shinbun Newspaper,* November 11, 1889. (Collection of Shinji Nobuhiro)

His parents could do nothing to stop their son's determined farewell. Chūhachi appeared at the South Police Station and appealed to be heard. Believe it or not, Otsune and Okuma had persisted in their refusal to confess. During the inquisition about Chūhachi's whereabouts, both women had been tortured but neither had opened her mouth. Tamai Gentei, the physician, had died in prison. The woodcutters Kishirō and Chōjirō, suspected of aiding Chūhachi in his attempted murder of Matashirō, were in prison after having been arrested in Nikkō, where they had taken part in the temple's repair. Still, the only, and the most essential, link had been missing: without Chūhachi, no prosecution had been possible. That's when the wanted fugitive made an appearance on his own accord. Otsune and Okuma were compelled to confess. Kishirō and Chōjirō had to open their mouths as well.

The culprits were all sentenced to execution in 1726. In the Third Month, the six criminals were paraded on horseback through the city, riding from the prison to the scaffold. At the head of the parade was the gang boss Yatagorō Genshichi, embroiled in the Shirokoya case only by chance. The second and the third were the woodcutters Chōjirō and Kishirō, the fourth Okiku, the fifth Chūhachi, and the last Okuma. Okuma was twenty-two years of age now, and her attire perfectly reflected the fashion of the time. Over a gleaming white silk under-kimono, she wore a robe of black and yellow plaid, and hang-

The maid is poised to slit her master's throat!
Yamato Shinbun Newspaper, November 11,
1889. (Collection of Shinji Nobuhiro)

ing from her neck was a rosary of folded paper, probably a gift from a merciful prison guard. Her hair, freshly washed, was tied up in an informal version of the Shimada style. The sight of this beauty on horseback with her hands tied behind her back drew a crowd of spectators.

In Nihonbashi, Chūhachi's horse turned away from the rest and headed to the Suzugamori execution grounds. The other five horses were to go back to Kodenmachō, where the criminals were to be beheaded. At that point, Okuma turned around and shouted to her lover.

KUMA: You're just a few steps ahead of me! I'll follow you to the afterworld!

CHŪHACHI: Do hurry and catch up!

SPECTATOR A: They talk love even when they are about to be killed!

SPECTATOR B: Boy, what a beautiful woman!

SPECTATOR C: Why didn't they let those two marry each other? None of this trouble would've taken place.

Tens of thousands of people watched the procession. Their opinions on the pair varied. Chūhachi was hung from a scaffold at Suzugamori. The remaining five had their heads cut off at Kodenmachō prison. Their heads were displayed in public. Tamai Gentei's corpse, which had been preserved in salt for the occasion, was hanged at Suzugamori. Shirokoya's property was confiscated. Shōzaemon, who was over seventy, ill, and without anyone to care for him, is said to have died by the roadside. As for his son Shōnosuke, he chose to take the tonsure in order to pray for the repose of the souls of his

deceased parents and sister. Reduced to a shabby monk begging on the streets, he exposed himself to public ridicule. His stepmother Otsune was exiled to Hachijō Island, where she was undeservedly blessed with a long life. She was forty-five when she was put on the boat, and, at the age of seventy-five, was pardoned and returned to Edo. Nobody would take her in, so Mikawaya Zenbei, a shipping agent on Odawara-chō in Tsukiji, felt obliged to care for her as she was his former employer. As a young boy, he had worked as an apprentice at the Shirokoya shop and had been sent home, like everyone else, when the incident we speak of occurred. Having succeeded over the years, he was now the owner of an impressive business. Otsune

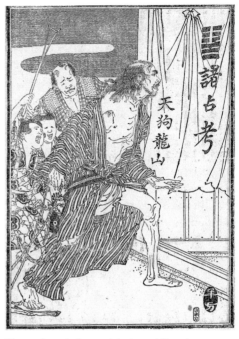

The madman is the crucial witness! *Yamato Shinbun Newspaper,* October 10, 1889. (Collection of Shinji Nobuhiro)

lived to the ripe old age of eighty-one. An evildoer's longevity is not the most satisfying outcome, but thus concludes the Shirokoya case.

Thank you for your attention.

TRANSLATED BY SUMIE JONES

Takahashi Oden, Devil Woman

KANAGAKI ROBUN

ILLUSTRATED BY MORIKAWA CHIKASHIGE

 Quick to read the political climate and a growing market for print culture, Kanagaki Robun was an Edo *gesaku* writer turned newspaperman, who made a successful transition into the new era. By combining the form and convention of *gōkan,* or multivolume illustrated fiction, with contemporary topics and techniques of modern journalism, he catered to both the sentimental ethics of the masses and the Enlightenment ideology of the elites. In 1878, Robun

edited a *gōkan* book version of the newspaper series *The Nautical Story of Omatsu the Street Singer* by Kubota Hikosaku. Possibly inspired by its popularity, Robun went on to write his own true-crime series, *Takahashi Oden, Devil Woman* (1879). The first installment was such a phenomenal hit that Robun was commissioned to write sequels. After Book 5, where he planned to conclude, readers' demands for greater detail prompted him to continue to the end of Book 8.

Book 1 was produced with the modern technology of movable type, but ironically it proved to be too time-consuming to keep up with demand. Beginning with Volume 1 of Book 2, the printers returned to the old Edo method of woodblock printing, embedding the narrative text in the pictures. *Takahashi Oden* became one of the chief works of the revived *gōkan* that flourished during the late 1870s and early 1880s. As is often the case with a serialized best seller that requires rapid work, precision could not be expected. The temporal coordination between picture and narrative is not necessarily exact; the story sometimes moves ahead of the illustration and vice versa. In the translation presented here, no attempt has been made to make the placement of words and pictures cohesive. Moreover, even chapter titles might announce an event that actually takes place much later in the story.

Not only is the format a mixture of old and new, the content, too, combines the premodern with the modern. For example, the concept of karma, used to justify certain turns of events, comes from a long tradition of popular Buddhism, while the heroine Oden's criminality is traced to her heritage and milieu in the fashion of Zola-esque naturalism. On the topic of Hansen's disease, then called leprosy, the novel oscillates between two ideologies: disease as karmic retribution meted out by heaven versus disease as a problem solvable by modern science. While the narrative is indifferent to the suffering of Naminosuke, a Hansen's disease patient who is visited by increasingly severe punishments until his unnatural death, it expresses a public trust in modern medicine imported from the West.

An advocate of social reform, Robun joined Narushima Ryūhoku and other intellectuals to propose the Philanthropic Leprosy Hospital, which was established in 1879. The frontispiece of Book 4, Volume 3, proudly presents a sign marking the construction site for the new hospital. Indeed, mention of the newly established School of Medicine within the authoritative Imperial University of Tokyo also suggests a self-congratulatory display of Japan's modernity. In this sense, the novel is Robun's way of celebrating both modern science and government sponsored Westernization. Again, he

made a name for himself by catering to dominant Meiji politics while at the same time pleasing the less-educated masses in their nostalgia for old ethics and sentimentality.

In contrast to the horrible crimes committed by Oden and her cronies, the common people are represented as continuing to exhibit Edo-style friendliness and innocence. Oden and Naminosuke have no shortage of neighbors and strangers who show them the way, offer them money and lodging, and pass on useful information—mirroring the sentimental *ninjō* virtue and good-natured joviality of common citizens in Edo literature.

Reflecting the author's split desires, the characterization of the protagonist Oden is paradoxical. In contrast to Otori, the gangster Genji's wife, an older archetype of the jealous female who turns into a snake or other monstrous figure, Oden is a sophisticated "bad woman" (*akujo*) à la Edo who fabricates plausible stories and deceives men by her seductive allure. At the same time, her devotion to the ailing Naminosuke is clear—she seems determined to find a cure for him no matter the trouble or cost, drawing sympathy from other characters as well as from the reader. Whenever she begins to turn into a sympathetic character, the narrator hastens to remind the reader that this appearance of loyalty is deceptive.

Oden was born to the promiscuous Oharu and the gambler Onisei. In the story, she is adopted by the respectable farmer Kyūemon and marries her sweetheart Naminosuke. Soon embroiled in a fight and murder by Onisei, the young couple flees their village. The selection below begins just after Naminosuke is diagnosed with Hansen's disease. It depicts the couple's flight from the Jōshū region. The two chapters translated here are followed by the remaining books, in which Oden continues to take up with, deceive, seduce, rob, and murder men, including her husband, Naminosuke, and Kichizō, her last victim whom she frames as the murderer. To thrill the reader, Robun, at the end of the novel, describes modern methods of criminal investigation and reports the elaborate statement that the real Oden made about her life—from her upbringing to her false tale of "revenge," which drew out her trial for over two years until 1879, when she was found guilty and beheaded. As a final celebration of scientific progress, the novel ends by noting that her body was dissected for research purposes.

Takahashi Oden is written primarily in the modern "colloquial" style, and its dialogues mimic modern conversation. The narrative slips into *gōkan's* conventional classicism in passages of high comic emotion such as Oden and

Naminosuke's flight into the mountains from the Kōfu brothel and Oden's struggle along steep mountain passages after her escape from Genji's grip. Here Robun uses a traditional "journey" (*michiyuki*) style, observing the poetic seven-five-syllable scheme and making allusions to nature. Aside from the absurd context, linguistic parody is largely missing in those "journey" scenes. Good wordplay is not entirely absent in this work, however. The phrase "a dream of Mount Wu," based on the legend of King Huai's dream of sharing a bed with an angel, conventionally refers to a chance romantic meeting. In the scene where Oden and Genji are wrapped in the same quilt, the phrase Robun uses is, "the snores on Mount Wu." There are stock references to classics such as to Lady Murasaki's "lies" in the preface to Book 5, Volume 2. This preface, by the way, relies upon the *gesaku* technique of puns and "related terms," characterizing the newspaper office and the business of publishing as Hell, and at the same time advertising the author's trademark cat.

According to the practices of *gōkan* and earlier genres of pictorial books, illustrations and writing were not only of equal importance, but also interdependent. Pictures enhanced the atmosphere of the written story scene by scene and often supplied details missing from the narrative. Morikawa Chikashige (dates unknown, but active from 1870 to the 1890s) was well known for his portraits of actors and depictions of stage scenes. During the early 1880s, he shifted his attention to illustrations for serialized narratives in newspapers and books, which earned him greater popularity. As with *gōkan* and other genres of pictorial books, Chikashige's illustrations for *Takahashi Oden* are stagy: characters strike exaggerated kabuki poses, the fight scenes are made to resemble heroic battles on stage, and the polychrome frontispieces recall heavily decorated kabuki theater signboards. A more modern cinematographic sense of movement, however, is pronounced in Chikashige. The picture of Oden escaping from the brothel descends vertically down two pages. Free from the stagy tableau typical of kabuki images, this picture evokes in the reader a sense of physical movement and a pressing danger. A similarly paired two-page illustration shows Oden plummeting upside down against the craggy surface of a bottomless ravine. This is obviously an exaggeration, given that the narrative informs the reader that Oden lands safely on soft grass, without injury. With dynamic design and appeal to the spectator's senses, this picture is far superior to the image of Omatsu falling into the ocean in *Omatsu, the Begging Musician*.

Chikashige's physicality and sense of movement perfectly matches Robun's sensationalist realism. It is not hard to imagine that the talents

of the popular author and illustrator worked together to fan the reading public's enthusiasm for "the new" as well as their nostalgia for what had passed.

＜(sJ)＞

TAKAHASHI ODEN, DEVIL WOMAN

BOOK 4, VOLUME 3, EPISODE 11

**In Which the Wayward Woman
Deceives Her Ailing Husband
(She Will Strangle Him Next)**

WRITTEN BY KANAGAKI ROBUN
ILLUSTRATED BY MORIKAWA CHIKASHIGE

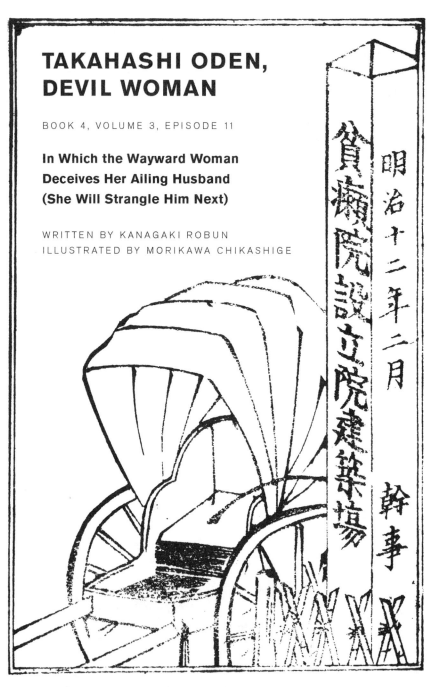

明治十二年二月

貧癩院設立院建築場

幹事

The post on the right identifies the location for the philanthropic leprosy hospital. It was put up by a committee that campaigned for the establishment of the hospital. It also shows the date as February 1879.

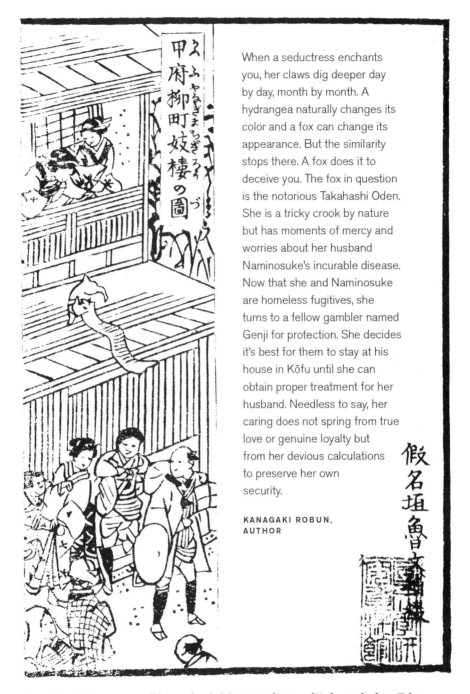

えふやまびさぎろう
甲府柳町妓楼の圖
づ

When a seductress enchants you, her claws dig deeper day by day, month by month. A hydrangea naturally changes its color and a fox can change its appearance. But the similarity stops there. A fox does it to deceive you. The fox in question is the notorious Takahashi Oden. She is a tricky crook by nature but has moments of mercy and worries about her husband Naminosuke's incurable disease. Now that she and Naminosuke are homeless fugitives, she turns to a fellow gambler named Genji for protection. She decides it's best for them to stay at his house in Kōfu until she can obtain proper treatment for her husband. Needless to say, her caring does not spring from true love or genuine loyalty but from her devious calculations to preserve her own security.

KANAGAKI ROBUN, AUTHOR

假名垣魯文

Yanagi Machi Street was a well-known brothel district in the city of Kōfu, not far from Tokyo.

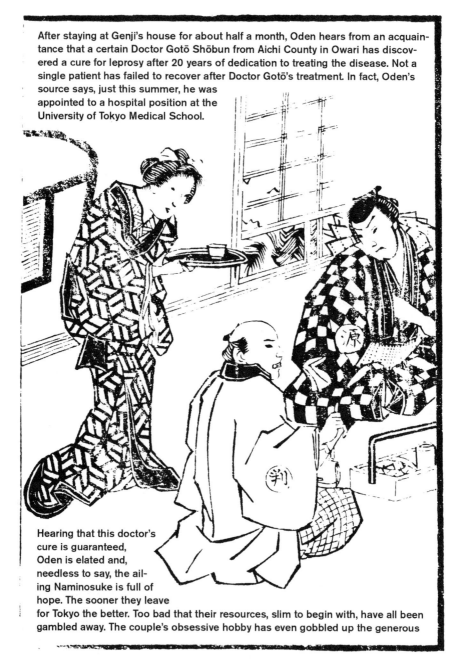

After staying at Genji's house for about half a month, Oden hears from an acquaintance that a certain Doctor Gotō Shōbun from Aichi County in Owari has discovered a cure for leprosy after 20 years of dedication to treating the disease. Not a single patient has failed to recover after Doctor Gotō's treatment. In fact, Oden's source says, just this summer, he was appointed to a hospital position at the University of Tokyo Medical School.

Hearing that this doctor's cure is guaranteed, Oden is elated and, needless to say, the ailing Naminosuke is full of hope. The sooner they leave for Tokyo the better. Too bad that their resources, slim to begin with, have all been gambled away. The couple's obsessive hobby has even gobbled up the generous

Genji, a fairly influential gambler, and his wife wear stylish geometric kimonos and entertain a talent scout, commissioned by the brothel.

gift they received from their benefactor, Kawabe Yasuemon. They now lack the pennies for salt and miso, and have no clothes but those on their backs. One day, Oden finally speaks to Genji.

"We meant to stay with you for just a few days, but we ended up mooching off you for more than half of the month. 'If you just sit and eat, a mountain of fortune will be gone in no time,' as they say. That's exactly what we've been doing here.

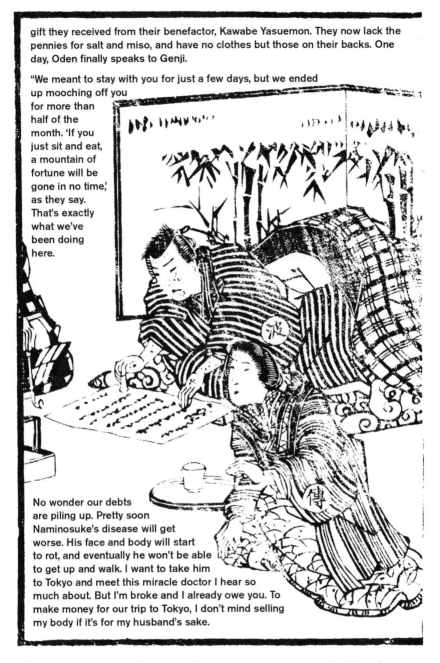

No wonder our debts are piling up. Pretty soon Naminosuke's disease will get worse. His face and body will start to rot, and eventually he won't be able to get up and walk. I want to take him to Tokyo and meet this miracle doctor I hear so much about. But I'm broke and I already owe you. To make money for our trip to Tokyo, I don't mind selling my body if it's for my husband's sake.

Marked by obvious signs of his disease, Naminosuke signs a contract, selling his wife to a brothel.

I've got to put Naminosuke in the best hospital money can buy even if I have to pay somebody to carry him all the way to the capital. You have connections, Genji. Introduce me to a brothel around here." Oden assures him that she and Naminosuke spoke in bed last night and he agreed to the plan. This is not the first time, dear reader, that Genji and his wife have squeezed profit out of penniless women by bringing them into prostitution. Without a moment's delay Genji visits the office of a brothel called Sakuraya in the Yanagi-machi district. He describes Oden's situation to the proprietor and acquaints him with the merchandise. "She's from Jōshū," Genji claims, "the only daughter of an upstanding farmer. She has fabulous looks and great hand-writing. She's also tops in sewing, dancing, singing, and even haiku poetry." He proposes that the brothel hire her for the term of one year for 50 yen. He assures the proprietor that the woman's hus-band and Genji himself will be her guarantors.

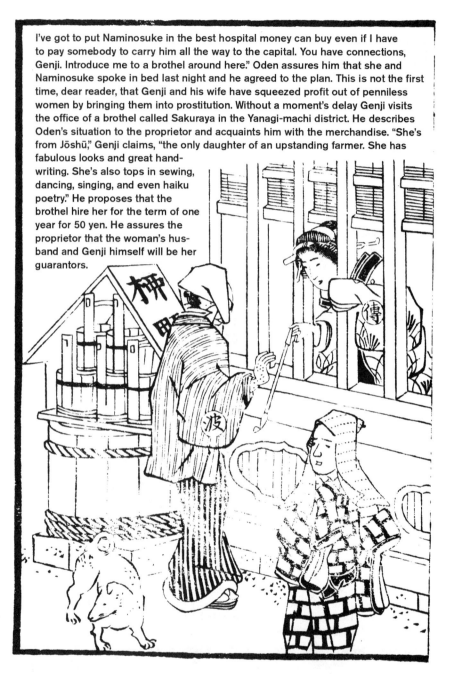

Naminosuke schemes with Oden by becoming her client. She holds a long pipe characteristic of a prostitute as she peeks through the barred window.

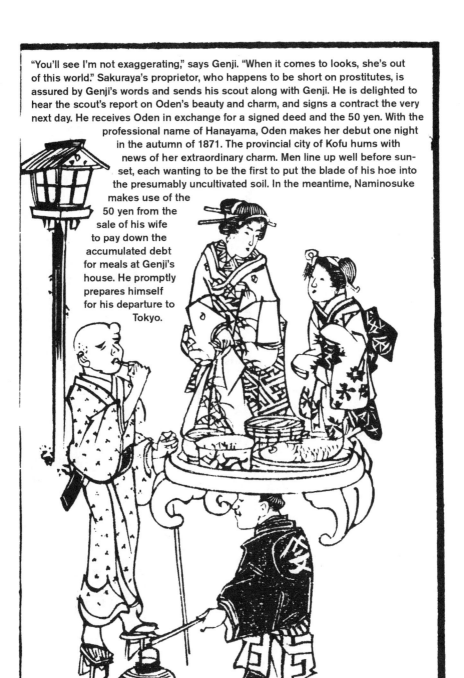

"You'll see I'm not exaggerating," says Genji. "When it comes to looks, she's out of this world." Sakuraya's proprietor, who happens to be short on prostitutes, is assured by Genji's words and sends his scout along with Genji. He is delighted to hear the scout's report on Oden's beauty and charm, and signs a contract the very next day. He receives Oden in exchange for a signed deed and the 50 yen. With the professional name of Hanayama, Oden makes her debut one night in the autumn of 1871. The provincial city of Kofu hums with news of her extraordinary charm. Men line up well before sunset, each wanting to be the first to put the blade of his hoe into the presumably uncultivated soil. In the meantime, Naminosuke makes use of the 50 yen from the sale of his wife to pay down the accumulated debt for meals at Genji's house. He promptly prepares himself for his departure to Tokyo.

A blind masseur uses a whistle to attract clients. A high-ranking prostitute and her assistant are on the lookout for a client while a caterer carries a table of party dishes to the brothel on his head.

But he is not planning to set out on the trip alone. He explains to Genji and his wife that he wishes to go to Sakuraya to see Oden one last time. He stands outside Sakuraya and calls Oden through the latticed window, where, instead of good-byes, they whisper schemes. When darkness falls, he poses as a first-time client: covering his face with a scarf, he enters the brothel. They abridge the customary period of drinking and promptly retire to bed to discuss their plan, further dropping their voices. "It was a smart scheme of yours to get 50 yen out of the deal," he says. "After paying back Genji, I still have close to 40 yen." It's enough, he assures her, for both of them to disappear without a trace.

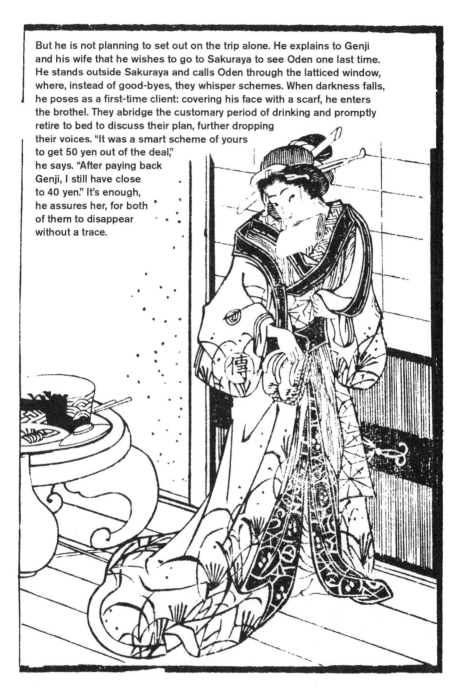

Oden is a star prostitute. Since her hands are already full, she carries a pack of tissues in her mouth on her way to meet her client.

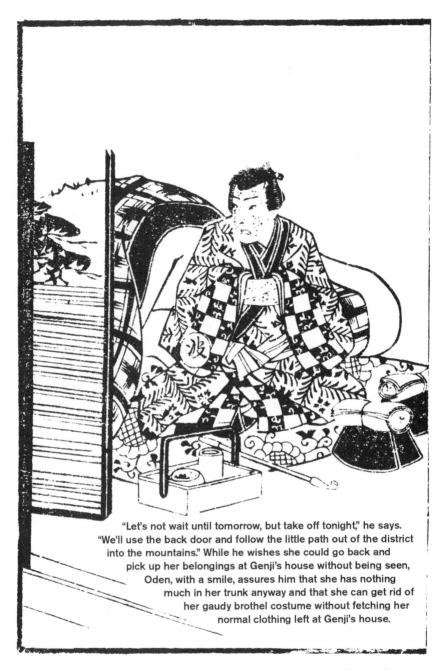

"Let's not wait until tomorrow, but take off tonight," he says. "We'll use the back door and follow the little path out of the district into the mountains." While he wishes she could go back and pick up her belongings at Genji's house without being seen, Oden, with a smile, assures him that she has nothing much in her trunk anyway and that she can get rid of her gaudy brothel costume without fetching her normal clothing left at Genji's house.

Despite his boils, the client receives a full treatment, complete with fancy bedding, tobacco, and pillows perched atop drawers.

This is the right moment, they agree. Hand in hand, they steal through the garden, which is now familiar to Oden, breaking through the hedge at its end. No one realizes their absence until morning, when Sakuraya's employees are alarmed to discover that Hanayama has run off with her very first client. Recalling that she has a husband and Genji's signature is on the agreement, the proprietor at once runs to Genji's house in Atago-machi. Sakuraya's men report to Genji what has happened during the night and the news startles Genji and his wife. "Come to think of it," says Genji, finally putting two and two together, "Naminosuke went to Yanagi-machi last night to say good-bye to Oden, but he isn't back. They must've run off together."

"I'm the one who's been taking care of both of them," fumes Genji. "And on top of that, I'm on the hook for her contract. What ungrateful crooks they are trying to double-cross me of all people," he roars. "They can't have gone far. I'm gonna chase them to the end of hell, strip off their clothes and take their money. That'll teach them!" With a long sword dangling from his waist, he starts to run. Two tough guys from among his men jump to follow. Determined to catch up with the runaways, they run as fast as their legs will carry them.

The leaves have fallen, making the mountains look lean and the sky all the more vast. A flock of geese graces the horizon. The craggy Byōbu cliff hides the autumn moon, perplexing the fugitive travelers as they struggle along the trail that follows the mountain-folds. Taking Naminosuke's hand as his diseased legs betray him, Oden guides him through hidden paths to Minobu highway. From here they should be able to reach the broad Tōkaidō. Deep in the mountains where villages are few and far between, their feet monotonously trample the wild grass. Frustrated by the severity of the mountain road as she is, Oden is nevertheless as unflinching as ever. Naminosuke, in contrast, is swollen with boils and exhausted to the point of collapse. As the pair sits down on the roots of a tree to rest, darkness lifts, revealing the flamboyant colors of Oden's clothing. She covers them up with a drab kimono pulled out of Naminosuke's pack. They are starved but

they make do with water from a stream, at least quenching their thirst.

It's the same old Edo story: the courtesan escapes with her poverty-stricken lover.

They cross the ridge and walk on, looking for a glimpse of a house. By sunset they come upon the Daigahara station on the Kōshū highway. They decide to stay the night here and hire a palanquin tomorrow for Naminosuke for the rest of the trip to Yokohama. Regular inns are risky for fugitives, so they look for a bring-your-own-firewood type of cheap lodging. As they search the roadway for the typical lanterns that advertise such establishments, they catch a glimpse of Genji and his men returning from the direction of the Kiso highway. The husband and wife turn quickly to hide, but Genji and his men are faster. They spot them and grab both by their collars. "Brazen broad," shouts Genji, "how dare you run away!" He instructs his men to strip Naminosuke bare and swipe all his money. "We're on it," shout back the two, and stepping on Naminosuke's body, they undo his sash and rip off his dew-soaked kimono. With equal ease they rid him of his wallet. While they beat him up with their fists, Genji pushes Oden to the ground. With one look he signals his men. Without a word, they carry

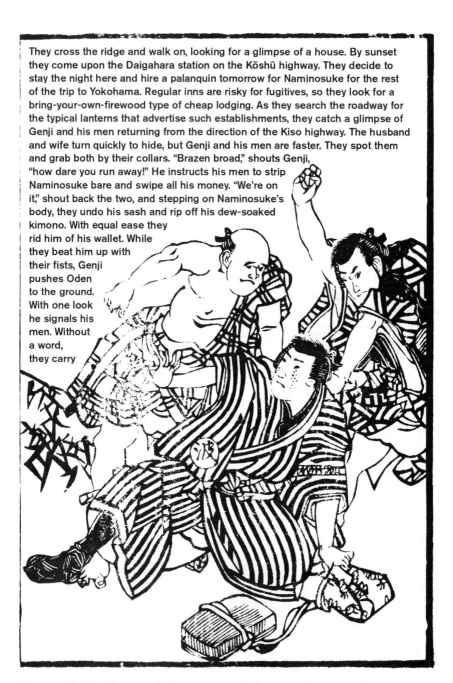

Like a good kabuki fight scene, the fugitives are caught by the gambler Genji and his men.

the naked Naminosuke off into the mountains. Making sure that the men have thrown Naminosuke off the cliff into the depths of the ravine, Genji now turns to Oden. "Now it's my turn to devour this witch to the bone! How dare you stab me in the back! Prepare for Genji's revenge," he shouts. He and his toughs drag her several hundred yards along the back roads to a shabby flophouse, where they tie her to a pillar. Squatting down in front of her, Genji drinks and eats and speaks in a voice full of ha- tred. "As soon as I heard this morning that you and the bastard slipped away from Sakuraya, I ran after you with my men to the Kiso highway. There was no hint of you along that highway so we

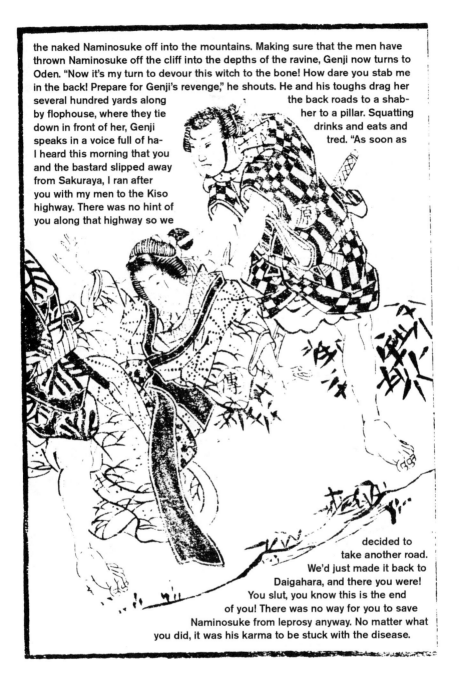

decided to take another road. We'd just made it back to Daigahara, and there you were! You slut, you know this is the end of you! There was no way for you to save Naminosuke from leprosy anyway. No matter what you did, it was his karma to be stuck with the disease.

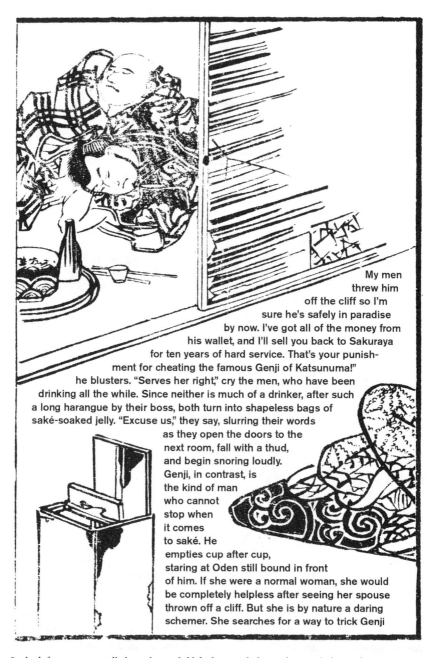

My men threw him off the cliff so I'm sure he's safely in paradise by now. I've got all of the money from his wallet, and I'll sell you back to Sakuraya for ten years of hard service. That's your punishment for cheating the famous Genji of Katsunuma!" he blusters. "Serves her right," cry the men, who have been drinking all the while. Since neither is much of a drinker, after such a long harangue by their boss, both turn into shapeless bags of saké-soaked jelly. "Excuse us," they say, slurring their words as they open the doors to the next room, fall with a thud, and begin snoring loudly. Genji, in contrast, is the kind of man who cannot stop when it comes to saké. He empties cup after cup, staring at Oden still bound in front of him. If she were a normal woman, she would be completely helpless after seeing her spouse thrown off a cliff. But she is by nature a daring schemer. She searches for a way to trick Genji

In the left corner, a candle lamp has its lid lifted to spotlight our heroine's daring feats.

and escape. Genji's thoroughly drunk gaze is now on her disheveled hair and pale face. She casts a seductive sideways glance in return. Peaches and plums can attract admirers without speaking, as the Chinese say. Oden's beauty is such that she needs no words to seduce men. Suddenly realizing that she is the sort of prize never to be found in the countryside, Genji's desire is stirred. "Look, Oden," Genji says with a sudden change of tone. "Naminosuke's now a dew drop in the bottom of the ravine, so you have no man to depend on. Don't even think of avenging your husband—nobody does that stuff anymore. I don't have to sell you back to Sakuraya. I'll be willing to get rid of Otori, my old hag of a wife, and make tonight our wedding night if you feel like being mine," he coos. "If not," he spits with harshness again in his voice, "I'll take you to Sakuraya in the morning and you will live the life of a prostitute for the next 10 years." Snuggling up to her, he demands an answer. "That did the trick," Oden says to herself, and she turns her dazzling smile to Genji.

Seduced by Oden, the gambler boss, suddenly mellows. Note the beauty of the fabric design.

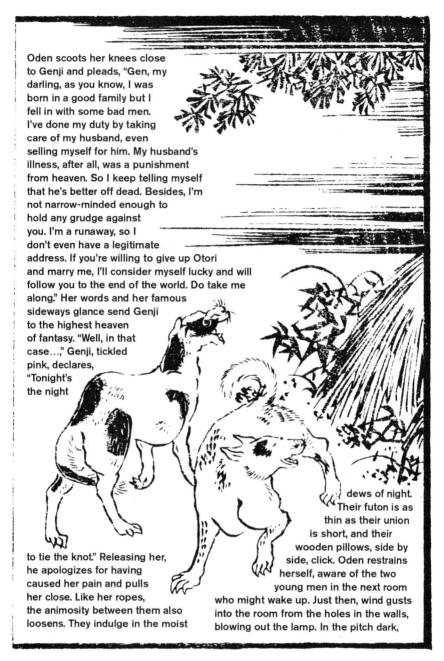

Oden scoots her knees close to Genji and pleads, "Gen, my darling, as you know, I was born in a good family but I fell in with some bad men. I've done my duty by taking care of my husband, even selling myself for him. My husband's illness, after all, was a punishment from heaven. So I keep telling myself that he's better off dead. Besides, I'm not narrow-minded enough to hold any grudge against you. I'm a runaway, so I don't even have a legitimate address. If you're willing to give up Otori and marry me, I'll consider myself lucky and will follow you to the end of the world. Do take me along." Her words and her famous sideways glance send Genji to the highest heaven of fantasy. "Well, in that case...," Genji, tickled pink, declares, "Tonight's the night to tie the knot." Releasing her, he apologizes for having caused her pain and pulls her close. Like her ropes, the animosity between them also loosens. They indulge in the moist dews of night. Their futon is as thin as their union is short, and their wooden pillows, side by side, click. Oden restrains herself, aware of the two young men in the next room who might wake up. Just then, wind gusts into the room from the holes in the walls, blowing out the lamp. In the pitch dark,

Barking dogs warn of an ominous threat.

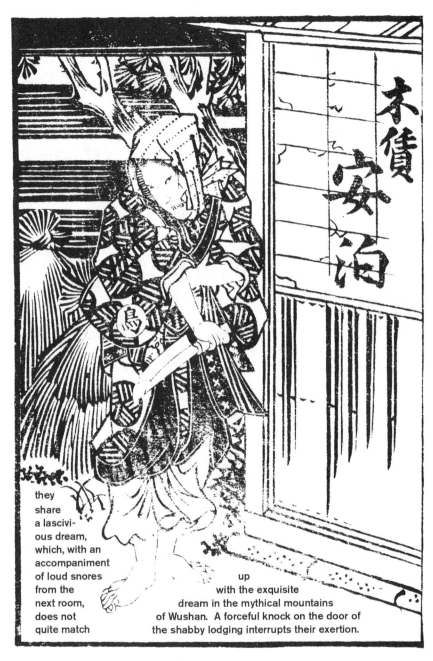

they
share
a lascivi-
ous dream,
which, with an
accompaniment
of loud snores
from the
next room,
does not
quite match

up
with the exquisite
dream in the mythical mountains
of Wushan. A forceful knock on the door of
the shabby lodging interrupts their exertion.

Fate comes knocking on a dark and stormy night.

They hear the groggy proprietress answer the door. The visitor turns out to be Genji's wife Otori, a familiar face to the proprietress. Hearing that Otori has come with urgent business for her husband, the proprietress lets her in, not knowing that Genji is in bed with another woman.

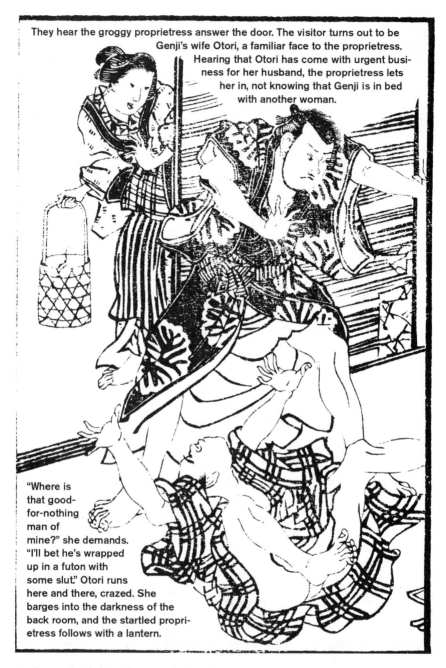

"Where is that good-for-nothing man of mine?" she demands. "I'll bet he's wrapped up in a futon with some slut." Otori runs here and there, crazed. She barges into the darkness of the back room, and the startled proprietress follows with a lantern.

Tussling in a brothel is nothing new for Genji's men.

At the sight of her man and Oden in bed together, Otori turns into a demon. She rips off the bedding, grabs Oden's hair, and shrieks in the voice of a broken temple bell. Genji promptly jumps up and twists the dagger out of Otori's right hand. This only causes his wife to shriek louder. "You bastard," she bellows, "what an idiotic sight! You neglect your wife of many years for this?" Grabbing his arm and twisting it, she throws him over her shoulder into the corner of the room. The noise startles the drunken men.

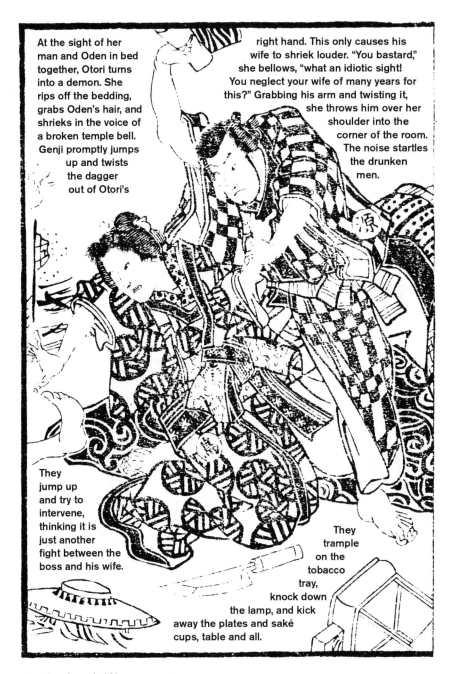

They jump up and try to intervene, thinking it is just another fight between the boss and his wife.

They trample on the tobacco tray, knock down the lamp, and kick away the plates and saké cups, table and all.

Genji's wife can hold her own, too!

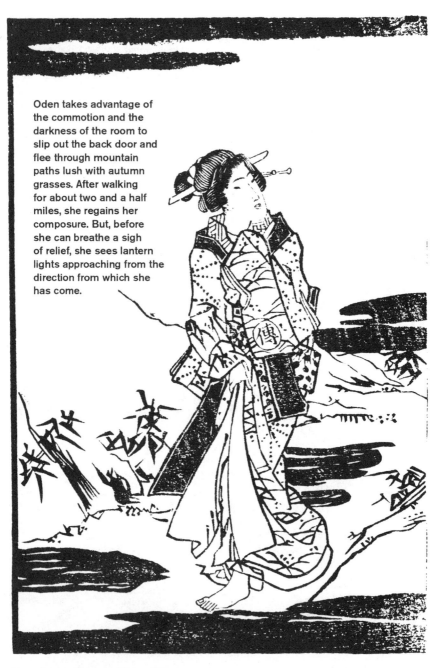

Oden takes advantage of the commotion and the darkness of the room to slip out the back door and flee through mountain paths lush with autumn grasses. After walking for about two and a half miles, she regains her composure. But, before she can breathe a sigh of relief, she sees lantern lights approaching from the direction from which she has come.

The seductive felon as traditional beauty.

Frontispiece of *Takahashi Oden, Devil Woman,* Book 4. A cat cooking in front of a barrel of sake called "Cat Brew." The author calls himself "The Old Man of Cats," probably playing on "cat" as slang for a prostitute.

TAKAHASHI ODEN, DEVIL WOMAN

BOOK 5, VOLUME 1, EPISODE 12

In Which the Couple Is Reunited in the Ravine of Bad Karma

WRITTEN BY KANAGAKI ROBUN
ILLUSTRATED BY MORIKAWA CHIKASHIGE

PREFACE A writer as lowly as I am cannot help but be trite. Lady Murasaki went to Hell because of her fabrications, as everybody says. Like that courtly lady, I mix lies with facts, deliberately confusing Tsukiji Bridge with Aibiki Bridge. Novelty is my business. Think of Shintomi Street with its impressive modern buildings. Like a devilish creditor at the end of the year, my publisher Kinshōdō harries me to finish installment upon installment. Kinshōdō's apprentice runs around trying to collect manuscripts like those Sinners on the Run who keep fleeing from one hell to another, while the authors struggle with their writing stones full of ink, rather resembling Hell's Pond of Blood. Lording over all and pressing me to finish, the owner of Kinshōdō sits close to me in the little room of the newspaper office, looking like Enma, the Emperor of Hell. Scandalous news collected from Starved Sinners, the "Catty Ladies of Town" column reporting on the goings-on along the roads of the Hell of Beasts, in addition to other meow meows and buzz buzzes: these are what I produce. Rubbing eyes that sting from mosquito incense, I am tortured in the Hell of Darkness. The loud cries of Sinners are unbearable at this office of journalists. This is where I am, The Old Man of Cats.

The end posts show that Tsukiji Bridge is on the left and Eibiki Bridge is on the right. Above them are lanterns bearing the names of "Kyobashi Ward" and "The Ward Office."

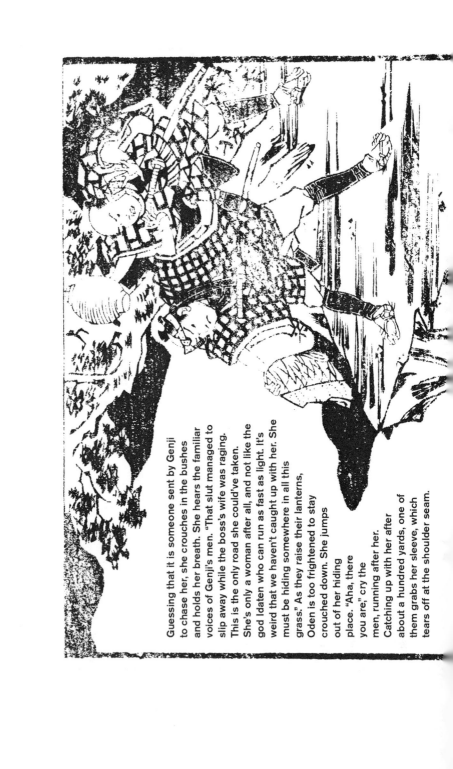

Guessing that it is someone sent by Genji to chase her, she crouches in the bushes and holds her breath. She hears the familiar voices of Genji's men. "That slut managed to slip away while the boss's wife was raging. This is the only road she could've taken. She's only a woman after all, and not like the god Idaten who can run as fast as light. It's weird that we haven't caught up with her. She must be hiding somewhere in all this grass." As they raise their lanterns, Oden is too frightened to stay crouched down. She jumps out of her hiding place. "Aha, there you are," cry the men, running after her. Catching up with her after about a hundred yards, one of them grabs her sleeve, which tears off at the shoulder seam.

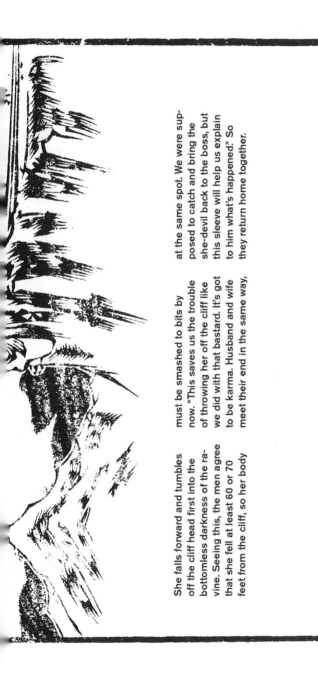

She falls forward and tumbles off the cliff head first into the bottomless darkness of the ravine. Seeing this, the men agree that she fell at least 60 or 70 feet from the cliff, so her body must be smashed to bits by now. "This saves us the trouble of throwing her off the cliff like we did with that bastard. It's got to be karma. Husband and wife meet their end in the same way, at the same spot. We were supposed to catch and bring the she-devil back to the boss, but this sleeve will help us explain to him what's happened." So they return home together.

Petty crime plays out against a forbidding landscape.

In this world, life and death are fleeting. I realized this for the first time when I was moved to tears by a poem about walking alone deep into the mountains and hearing the sad voices of a buck and a doe calling for each other. Our Oden has all sorts of talents, and she is perhaps smart enough to compose a poem or two, but her heart is too thorny for that kind of undertaking.

She falls through the thorny brush down the ravine. You would think she would be smashed to pieces, but no, landing on a flat plateau of soft soil and grass saves her. She is only scratched by thorns—minor injuries. She is happy to be able to walk on, but it is still pitch dark and these are all unfamiliar mountain trails. If she runs into a wolf, that will be the end of her.

Oden plummets to her demise.

She comforts herself by remember-
ing that dawn will come, although an
autumn night is long. But she is a gutsy
woman. She goes to sleep with her arm
on a stump, expecting to have a good
dream inspired by the songs of insects.
In reality, though, the sound of wind is
too noisy to allow her any sleep,
and as soon as she dozes off,
crows, launching from their
nests, wake her up. As she
looks around, mountains
upon mountains soar
before her eyes.

Just around the corner, Naminosuke wanders at the bottom of the cliff.

In a small brook of clear water, she rinses her mouth and washes her face. She remembers the wallet she has stolen back from Genji during the racket, still dangling from the cord tied to her sash. Smiling, she caresses the wallet. She brushes the dirt from her clothes and then throws the shabby kimono over her shoulders. She tidies up her hair. In search of a village, she walks west and reaches, finally, the pass at the summit.

As she sits down on the roots of a tree, she hears a voice coming from a hollow in a huge camphor tree.

Somehow unseen by her husband, Oden busies herself with freshening up.

"Is that you, Oden?" asks the voice.

A beggar wrapped in a straw mat sits inside the hollow. When he removes the scarf from his head, she sees that it is Naminosuke! "No, no, it's a ghost," Oden tells herself and backs away. Naminosuke comes out. He sits on a stump and explains, "I'm no ghost or monster of any kind. I'm completely the real Naminosuke from head to toe. Two nights ago, Genji's men threw me off the cliff. I was unconscious after my fall, but yesterday morning a woodcutter found me and brought me back to life. I told him I was naked because I'd been attacked by bandits while traveling. He gave me this straw mat to wear and showed me the way, so I limped along leaning on this stick, nursing my pains from the fall, and reached this tree. I was just resting in here." Oden is convinced that this is indeed her man, and tells

The couple reunites after their steep descent.

him about what happened beginning with Genji dragging her to the flophouse. Naturally, she skips the part about sharing a pillow with him. She reports that she slipped away from her confinement while Genji and his wife fought, but was caught by his men and thrown off the cliff, just as he had been.

"I'm not just alive and here with you!" she cries triumphantly, "I have all the money that Genji stole from us. We have enough to ride to Yokohama. I want you to consult the best doctor there is and be totally cured from your illness."

The flourishing port of Yokohama, displaying the Japanese flag prominently. The American flag is somehow reversed.

Naminosuke is encouraged
by her reassurances, so they walk down
to the village and go from farmhouse to
farmhouse asking the way to Yokohama.

The famous Yokohama landscape, complete with foreign ships in the background. Next to that of England, the East India Company's flag, shown backward here, marks their outpost.

They finally reach Iwabuchi in Suruga, and from there Oden leads Naminosuke by hiring a cart some of the way and engaging a pack horse on discount at other times. Oden is just as strong as a man and is smart about economics, so she spares no effort in avoiding expenditures. At sunset on the fifth day they reach the popular shrine of the God of Ne, guardian of pregnant women and children, on Noge-machi Street in Yokohama.

The office of the *Town Crier* newspaper is at the left bottom, and an advertisement for the *Easy Reading News* is on the right. An outdoor theater where *kōdan* stories are delivered is behind the protagonists.

With a letter of introduction from Kawabe Yasuemon, which Oden and Naminosuke obtained while staying at Kōshōji Temple, they look for Ozawa Ihei, a construction contractor who lives on Hanasaki Street in the city.

Pedestrians enjoy *oden* stew and sushi at a food stand.

After receiving directions from the neighbors, the couple reaches the door of Ihei's house.

The contractor lends a hand by inviting Naminosuke and Oden to lodge at his inn. The sign on the door shows that he also houses day laborers. *Takahashi Oden, Devil Woman* (National Institute of Japanese Literature)

TRANSLATED BY SUMIE JONES

Rat Boy

SHŌRIN HAKUEN

 The following selection comes from the oral narrative tradition of *kōdan,* which owes its origins to explications of Buddhist texts performed by itinerant monks during Japan's Middle Ages. As time went on, the repertoire enlarged to include disquisitions of military tales, most famously the *Chronicle of Great Peace* (*Taiheiki,* completed by around 1370), which was delivered in a long series. During the Edo period, "oral interpretations" (*kōshaku,* as they were then known) became a popular form of both entertainment and education. Besides the tales of battles and their heroes, popular topics included ghost and monster stories, as well as biographies of historical characters, including gamblers, priests, and prostitutes. Interestingly, unlike in other forms of oral narrative, women were very much active in *kōdan* performances as they are now. This genre coexisted with the already established form of short jokes (*rakugo*) and more extended human-interest stories (*ninjōbanashi*). *Kōdan* flourished during the nineteenth century, with over eight hundred performers and eighty theaters in Tokyo in the 1880s.

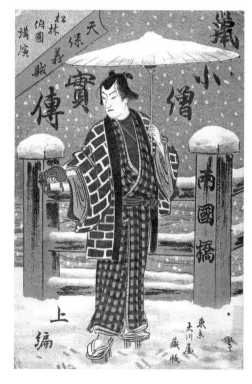

Famous among the Meiji *kōdan* performers was Shōrin Hakuen II who joined Sanyūtei Enchō in *rakugo* and Ichikawa Danjurō VIII in kabuki as the premier performance artists at the end of the nineteenth century. During the pre-Meiji years, Hakuen earned his keep performing traditional *kōdan* tales for members of the samurai class, and cultivated the genre of thief tales with his creation of *Rat Boy* (*Nezumi Kozō*), which earned him the sobriquet

"Cover of the *True Story of Rat Boy,*" published by Ōkawaya. (Collection of J. Scott Miller)

"Hakuen the Burglar" (Dorobō Hakuen). Always an innovator, Hakuen is noted for his dramatic recitations of stories from fledging Tokyo newspapers in the mid-1870s. He subsequently created *kōdan* adaptations of Western novels and pioneered the use of Western clothing and furnishings in his performances—eschewing the traditional kimono and lectern. Many of his stories were subsequently dramatized on stage to great acclaim, and his performance before Emperor Meiji helped elevate the status of *kōdan* as an art form. His other famous works include *An Ansei Era Love Triangle* (*Ansei Mitsugumi Sakazuki,* a shorthand transcription published in 1885) and *The Six Rogues of the Tenpō Era* (*Tenpō Rokkasen,* transcription published in 1892). The latter, particularly, has inspired kabuki plays and fictional works that remain popular today.

Rat Boy is the tale of a precocious, young, Robin Hood–like thief, whose inherent goodness allows him to bring about justice and assist the downtrodden. The following excerpt demonstrates Hakuen's skill in constructing a variety of characters and making them come alive through mimetic one-man dialogues. The translation joins the story-in-progress, wherein the protagonist, Jirokichi, a boy of fourteen, has been kicked out of his home for his predilection for thievery. He quickly becomes the ringleader of a gang of pickpockets, and is nearly apprehended by authorities on his way to an assignation near Eitai Bridge in Edo. Rather than surrender his freedom, he jumps off the bridge in an attempt to escape his would-be captors.

The third episode opens with a brief digression, elided in this translation, wherein raconteur Hakuen uses the context of an innkeeper searching for thieves to present a humorous lineup of traveler stereotypes.

☞(JSM)☜

EPISODE 2

Jirokichi dived deep, swimming away from Eitai Bridge and emerging on Tsukuda Island. He decided to wait for sundown before seeking more permanent refuge and, spotting a fisherman's dwelling to rob in the meantime, helped himself to clothing that served as an immediate disguise. Having only a few small coins in his pocket, he considered his future.

"Under the circumstances, it would best to avoid Edo for a while. Perhaps I'll take a little pilgrimage—go see Kyoto, Osaka, maybe Shikoku or Kyushu. I'll get myself some on-the-road training and come back to Edo a proper man."

He would be recognized, no doubt, along the Tōkai Road, and, moreover, the Hakone Barrier was notorious for being a "tight spot," so he resolved

to take an alternate route by way of Shinjuku and the Kōshū Road, spending nights at cheap inns along the way.

On his second day out from Edo he found himself eight miles from Hachiōji, on the Kobotoke Pass, a road that is rough going even now, but at that time was a nearly impassable trail, particularly for someone traveling alone. To make matters worse, it was the beginning of the Twelfth Month and, as Jirokichi approached the pass, the snow that had been threatening for three days finally began to fall, transforming the path into silver slush. Jirokichi, of course, was chilled to the bone and felt his resolve waning with each step. As he desperately glanced right and left he spotted a small traveler's shelter dedicated to the bodhisattva Jizō. He quickly slipped in. Although he wanted to build a fire, he had nothing to light it with, so he just wormed his way in behind the offering box, shivering and chattering his teeth. The wind blew snow through the cracks as he tossed and turned, unable to sleep.

As twilight approached the snow suddenly increased in fury, and the woods and fields were quickly covered in white. Jirokichi heard the approach of three travelers, who had apparently set their sights on the shelter. He held his breath as he watched them from behind the offering box.

"Finally, we're in! Let's get a fire goin' and bring us back to life. You got somethin' to light it with?"

"Sure do! Got me a fire striker and even some tinder here."

"What a boy scout you are! While he's doin' that, Inosuke, go find some dried branches to burn!"

"Sure. Will do!"

One of the men went into the woods to gather whatever kindling he could find. As soon as he got back the fire was lit, and soon the three formed a tight circle around it.

"Ooh, feels good! Let's stoke 'er up! Don't have much wood, though; let's pull out the slats from that offering box."

"It's bad luck to do that to a Jizō or whatever . . . let's break some dry branches off that pine over there and throw 'em in." The fire was soon roaring.

"There, now I'm feelin' better. Well, let's divide up what we've got, or nobody's gonna settle down here. From what I reckon, there's a good thirty or forty *ryō* in there. Quick, let's see that money belt!"

"Hey, it's sealed. Let's split it open!"

The belt was made of patterned cotton with a Kai silk backing. With its heavy lump in the center it looked like a snake that had swallowed a frog. Pulling out the bundle, the men found that the money came in three packages, each neatly wrapped in scrap paper. The first contained silver pieces,

totaling ten *ryō*. The second contained ten *ryō* as well, all in gold coins, and the third another ten *ryō* in small pieces: three packages in all.

"Hey, Gonkurō!"

"What?"

"You said 'Divide it for thirds' and that's exactly how it comes, one for each. Take whichever you want."

"Well, I'll take the silver one. That'll last a while."

"I'll be savin' mine, so the gold'll be my choice."

"What a chump. You're gonna save it? Well, all right, Inosuke gets the gold, and since I found this job, I'll take the money belt as a bonus."

"If that's the way you want it, go ahead. But that belt's evidence for a hangin'—be careful!"

"Are you really worried about that?" the thief replied. He put his bundle back into the belt and shoved it deep into his kimono.

And who, exactly, were these three men? None other than the infamous Kōshū Road bandits, who went by the colorful (but odd) names of "Black Bear" Kumazō, "Pot Weasel" Inosuke, and "Temple Bell" Gonkurō. On first glance they appeared to be harmless traveling merchants, or perhaps silk buyers, but these were the very scoundrels who put fear into travelers' hearts. And as each put his bundle into his pocket a gleeful smile passed across their faces. Gonkurō spoke first.

"I don't know what you two think, but, frankly, today's job was really a shame. That pilgrim duo, the father and daughter, they weren't run-of-the-mill folk, you know. They must've been livin' the high life, and I don't know what would possess the father, let alone the daughter, to become Buddhist pilgrims and come all the way out here, just the two of them. And to choose the Kobotoke Pass, in the snow! Seems to me they must've been plannin' to go down by Sekino and stay the night. And the way he begged for mercy, hands clasped, whinin', "Spare me! Spare me!" Such a pity, I thought, to choke his neck like a cormorant fisher. Nearly lost my nerve! But it's our job, and that's that. So I strangled 'im, grabbed the cash, and threw his body down into the ravine. Showed 'some mercy to his kin, however."

"A true shame, just like Gon says. As for me, why, if that pilgrim daughter had been one or two years older, I wouldn't have left her behind like junk. What a pity. Hey, Inosuke, whaddya think—she was probably only twelve or thirteen, wouldn't you say? And there she was, tryin' to get away even after we knocked off her father! She faced the three of us, making as if to start chantin' prayers, then surprised us by turnin' around and throwin' herself into the ravine after her father. Like a camellia flower suddenly droppin' from the bush. Of course, she was sunburned and looked pretty rough from the pilgrim's life, but she was a good-lookin' gal . . .'"

"Ain't that the truth! If she were only two or three years older, why, she'd a made a daimyo's playmate for sure! And she'd have had no mercy from us, I tell you!"

"Well now, Inosuke, why don't you go down into that ravine and save her, then?"

"Don't be stupid. Let's forget about dead pilgrim girls and all the rest, and concentrate on where to go from here. Even if we went to the inn at Komagino, that's no place to spend the night; besides, it'd be crazy to do a job up here on the pass and then check right in to a place at the foot of the mountain. We ought to at least go the eight miles to Hachiōji and stay at a place to stay that people don't know very well, somewhere we can relax, settle down, take it easy for a bit. Whaddya say? It's been a while since we've had ourselves a good time, bought a few broads, made a ruckus. Wouldn't it be nice to have some fun?"

"I'm all for it. But where shall we stay?"

"Good question. In Hachiōji, there's the Tokuri-kameya, which is a fine place, but a bit too public. Lots of guests, so there's a chance we might get caught. Better avoid it."

"Well, from what I hear, Yokoyama-cho has a new place, the Kōchiya. Until recently he was an official of the town's authority, and I've heard that, now that he's running an inn for travelers, he treats his customers real nice. So, it being new and all, there's little chance he'd recognize us. I'm for going to the Kōchiya and acting difficult. Whaddya say?"

"Well, sounds good to me. Let's go."

And with that the three ended their conversation and prepared to head eastward, through the pass and down the mountain. Jirokichi, who had heard every word from behind the offering box, chuckled to himself as he considered the circumstance.

"Oh, this is good. Those three let slip that they are planning to stay in Hachiōji, at the Kōchiya," he whispered to himself. "Looks like I can do a job on them!"

Impatiently, Jirokichi leaped out of the shelter and set off after the three as they cleared the pass. They were making quite a racket as they moved along the mountain path, oblivious to their surroundings, when, from behind, they heard a voice.

"Hey! Hey! Could you wait up a bit?"

Kumazō turned around.

"Wait—was that someone calling?"

"What's that?"

"What the . . . there's a boy over there! Might be the kid of a water sprite or somethin'. Who are you, boy?"

"Did you come from over that way?"

"Us? Well . . . we came from . . . from the west."

"Through Yoshino, then?"

"Yes, that's right. Through Yoshino. What about you?"

"Well, I got separated from my master a ways back. So here I am on this mountain path, and it's starting to get dark. The snow's beginning to fall and I don't know what to do! So I've been wandering all over the place, and there's no one on the trail at all. And then, just when I think it's hopeless, I saw you from behind and now, after quite a struggle, I've caught up!"

"So you caught a glimpse of us? And that's why you're here now?"

"That's right."

"Who are you?"

"I'm from Edo; Asakusa, actually. I serve the head priest of the Myōrenji Temple in Tofudana, a Nichiren temple. I was accompanying my master on a trip to Mount Minobu. But I lost my master and don't know where he is."

"What do you mean, lost him? How'd you do that?"

"Well, I was doing my best to help him along. But there are no toilets on the trail, so he ducked into a thicket to do his business and told me to keep an eye on the road in case someone came along. I did exactly as he told me and stood guard, waiting, until a very long time had passed and he still had not come out. I shouted for him until I was hoarse but he never replied. As it got later in the day I started thinking that he might have been attacked by wolves or something, and I was at my wit's end."

"You . . . you think the priest got attacked by wolves? Now, why would you think that? Did you hear a scream or something . . . ? What're you goin' to do now?"

"Well, I thought since I can't do anything myself to help him, I'd find someplace to spend the night then get some help to look for my master in the woods. Or perhaps he went on to Mount Minobu without me; in any case, with the snow and all there's nothing I can do now."

"Well, that's true. You're really in a fix. Well, since the trail's cold, go down to Komaki village at the base of this mountain. There's a small inn there; get them to put you up for the night. You're right, there's nothin' else to do, and you wouldn't want to get stuck up here freezin' in the snow now, would you?"

"You're right. Thanks for the advice. Say, where are you staying tonight?"

"In Hachiōji, another eight miles."

"Well, if that's the case, I am all alone. Would you mind if I come along with you to Hachiōji . . . ? I'll pay your night's lodging if you let me come along."

"Well, if you want to come along, that's fine with us . . . but you're so young! Shouldn't you get to bed early?"

"Not at all. You see, I've got some money with me that belongs to the priest, and I'm guarding it with my life. If someone should take that, why, it'd be like they were taking my life!"

The three quickly exchanged glances.

"So you have some money, eh? How much've you got?"

"The priest gave me a money belt full of cash, and told me to wear it. He said that since I was just a kid no one would suspect I had it, and we'd be safe from the prying, sharp eyes of bandits on the road. He said I should keep it on me at all times; even if I should lose my life, I wasn't to take it off."

"I see. So how much money do you have . . . ?"

"I think around fifty or sixty *ryō* . . ."

The three men said nothing, but their sinister smiles reflected pleasant surprise.

"Well, that really is somethin' to worry about. So it's settled. You certainly can't be stayin' alone at an inn. Very dangerous. You come along to Hachiōji with us! Let your older friends take good care of you."

"Why, thank you. That would be very kind of you. And I'll take care of you by paying for your lodging at the inn."

"What? Don't worry about that, kid. It's on us."

"Thank you. Thanks a lot."

"And tomorrow, when it's mornin', we'll ask the town lodging official to round up some more help and get them to search this whole mountain! Personally, I think the priest went on to Mount Minobu by himself, though."

"I'm starting to think so . . ."

"Well, from here on, the road to Mount Minobu is pretty rough. So even if he was in a hurry he'd still be makin' slow progress. Once we get to Hachiōji we'll make some inquiries about it. Somethin's bound to turn up. Don't worry."

"Oh, thank you so much."

Soon they had cleared the pass and were heading down the mountain. Along the way, in muffled conversation, there were plans to kill the boy, as well as protestations that, in light of two pilgrims' murders, it would be a terrible thing to kill the boy as well. They settled on stealing his money once they checked in to the Kōchiya in Hachiōji. He was too young to drink, but if they filled him up with rice cakes until he fell asleep they could certainly relieve him of his money belt.

The snow began to fall with more fury as they passed by the inn at Komagino, and by the time they arrived in Hachiōji, made their way through the police district to the inns of Yokoyama-cho, and arrived at Kōchiya Hikobei's place (on the left side of the street), it was well past the Fifth Hour (around nine o'clock in the evening by our reckoning). The lantern was still

lit in anticipation of business. With the storm, there was little hope of travelers staying for the night, and some had suggested, when the evening bell rang, that they close up shop for the night. But the owners demonstrated their willingness to bargain by accosting the recently arrived entourage.

"Won't you stay with us tonight? We still have crystal clear bath water! Stay here tonight!"

The four travelers, the boy included, stepped up to the entryway, brushing off the snow.

"May we stay here tonight?"

"Why, of course, thank you very much. Please, step right up here. Hey, Otake, bring them something to clean up with! And heat up the bath water . . . So, there are four in your party tonight. Where are you coming from?"

"By way of Yoshino."

"Is that so? Well, that must have been rough going in this snow!"

"Really, as you say, with the blizzard we were afraid that any little slip might send us tumbling down into those deep ravines."

"Yes, very dangerous. Here, leave me those straw raincoats to dry. Step up, right up here. I think number seven will be to your liking."

A maid came and showed them to their quarters, a spacious ten-mat room.

"Here we are. The bath is ready at your convenience."

"Oh, thanks."

"There is even room in the bath for two, if you wish."

"Great!"

While they were taking their baths, the food arrived.

"Ma'am, if you please, I'd love an additional snack, and could you put a bottle of sake on to heat?"

"Certainly. Although our fare is unworthy of praise, we do have a chicken stew."

"Oh, chicken stew'd be great!"

The three sat around, enjoying the sake and talking.

"Hey, kid, we've never asked your name."

"Oh, I'm Yokichi."

"Yokichi, you seem like a decent kid. How old're you?"

"Fourteen."

"Fourteen! Well, you certainly seem to be a clever one. You're from Edo, right?"

"A true blue Edokko!"

"Where were you born?"

"In Asakusa."

"So you're doin' service at a temple or somewhere? Gonna be a monk someday?"

"Yes, that's right."

"Well, think it over. Bein' a monk—what a waste! Ought to be an actor; they get all the girls!"

"Well, I'll give it some thought."

"Sake?"

"No, thanks, I can't have a drop of the stuff."

"Well, if you don't like sake, how about some rice cakes or some other treat? It'll put you to sleep quick . . . so you can wake up tomorrow and go out lookin' for your lost priest."

"Oh, thank you."

"And, by the way, what about your money belt? Why don't you let us grown-ups take care of your precious bundle?"

"No, thanks anyway. I'd rather die than part with it. Someone would need to kill me to get it; as long as I'm alive, I'm keeping it close."

"Well . . . ! Then you better make sure it's safe and sound."

In those days inns weren't so fussy as they are today about having their customers register and such. As the night deepened, and all lay down to sleep, the three kept their eyes fixed on the boy's waist, and the boy, determined to rip off the others, kept his eyes fixed on their purses. Soon the three, owing to their day's labors, as well as the sake they had guzzled down, were sprawled out on the floor, snoring away.

The snow kept falling and piling up, and the blizzard howled outside. Hachiōji is a cold, cold place, but due to the sake, the three slept on in sweet oblivion. In time the midnight bell struck and, the entire household being fast asleep, a lonely silence prevailed. The boy lightly crept out of his bed, stealthily stepped into the hallway, and headed toward the front of the inn. As he got to the linen room he found an elderly maid on night watch huddled by the foot warmer spinning hemp thread. Though the spindle made a whirling noise, she nevertheless heard the boy approach.

"Who is it? Who's there?"

"It's me, ma'am. I'm trying to find my way to the owner's quarters. Where is it?"

"You want the owner? What's the matter?"

"Well, a terrible thing happened. Someone stole all the money I had hidden in my kimono. I need to see the owner so I can recover my cash."

"Oh, that is terrible!"

"Not so loud—the thief's here somewhere!"

"Sorry. Okay, come this way . . ." And the maid led the boy to the place where the owner and his wife were sleeping.

"Sir, sir."

"Uhhh, what is it?"

"Here's the boy with the party of four sleeping in room number seven. He had his money stolen! Says the thief must still be close at hand, and he didn't want the thief to escape, so he wanted me to bring him here to talk to you."

Upon hearing this, Hikobei, the owner, gave a muffled snort upon hearing this and jumped out of bed.

"What's that, say, what? Hey, come in here, right away. You say you've had your money stolen? But you're just a boy. Kid's don't usually carry money."

"Well, that's true. How do I explain it? I'm from Edo, a servant of the Nichiren Renmyōji Temple in Tobudana, Asakusa. I'm accompanying the head priest on a journey, but yesterday I got separated from him around Kobotoke Pass, and as it was getting late I got lost myself until I saw those three come out from a roadside shelter. They said I should join them and go to Hachiōji for the night, and the next day they'd help me find my master. Somehow or other they found out that I carried money in my kimono, and they tried to get me to let them watch it. But I told them even fear of death wouldn't make me part with the money. Then, as they were drinking sake, they tried to get me to drink it as well. I told them I don't like sake, so they told me to eat some rice cakes and go to bed, and soon I was fast asleep. Just now I got up to use the toilet and saw that the money belt was missing from my pocket. I'm sure those guys took it, but there are three of them and only one of me, and if I made a fuss they'd probably grab me and kill me. Do you think, sir, that you could use your influence to get me my money back? Hurry, please!"

"Astounding! What a clever priest; he knew that people would target him and so had you carry the cash. Oh, that's shrewd. Tell me, boy, how much money did you have, and give specifics if you can."

"Well, there were thirty *ryō*, sir."

"Thirty *ryō*? Hmm, Anything particularly memorable about the money, or maybe you never saw it . . ."

"No, I saw it. The priest wrapped it in packages using old paper, two ten-*ryō* bundles of small change—one is silver—and one ten-*ryō* package of gold pieces."

"Ahh, I see. In a money belt, you say?"

"Yes, sir."

"Anything noteworthy about the money belt?"

"Yes, it was made of patterned cotton cloth and backed with Kai silk."

"Oh, very fortunate to have that much detail. Should cinch the case, I think. If they have something of that description in their possession, then surely it's yours. Now, to conduct my examination! Otake, wake up the help quietly, okay? And have them lock the front and back gates, too."

"Will do, sir."

Next, the owner of the inn, a former government official, awakened all his staff, from the chief clerk to bath attendants, and with this entourage, armed with the lantern of the Hachiōji Yokoyama Inn Authority, confronted the three bandits. I'll recite the fascinating details of this story in my next installment.

EPISODE 3

As Hikobei approached the room, Inosuke, Gonkurō, and Kumazō suddenly awoke.

"Hey, Inosuke!"

"Huh?"

"Did you hear that?!"

"Yeah, I heard it. The boy's not here, is he?"

"Nope. He's not here, and they're sayin' some strange things out there, like the boy that came with us had his money stolen, so they're doing a routine check of everyone's baggage and pockets. Look there! An investigative lantern, and all those people, followin' behind with poles and such!"

"Hold on, hold on! The owner of this place used to work for the government, so he's probably just makin' as if he's the police."

"Well, if what the boy says is true, while we were snorin' away here somebody slipped in and nabbed the boy's things! But, like they say, water spills from even the best hands; in the end that rogue's gonna get what's comin' to him!"

As they were speaking, the noisy group entered the room. Having suspected them from the beginning, the owner took great, deliberate pains in his approach.

"Hello, sorry to bother you. Please wake up for a moment. All of you, wake up, please."

"We're all awake here."

"Already awake, then, are you? Well, could you please gather over there? Sorry we had to awaken the 'innocent' just as you've fallen asleep, but this is house policy, and we've examined all the rest. From the beginning you've been suspects, and complaining won't get you anywhere. Pull out the cash, right here, and we'll go soft on you. Just throw it down there, while you have a chance to retain some innocence."

"Now hold on a minute here, don't jump to the wrong conclusion. That's quite an accusation; we may be rough and uncouth, but we're still your customers, and you're the host!"

"Just be quiet! Since you're customers I've considered you as guests, but I'm the fool who let your kind stay here. You may have thought you

could fool us easily because this is a new business. Even though I may be a rookie as an inn owner, I, Kōchiya Hikobei, am no stranger to this station town. I've learned how to tell proper travelers from lowlife Hachiōji horseshit! You didn't think I'd notice, but when you arrived here in the blizzard I quickly saw that you were suspiciously free with your money, and wondered how it would all end up. And here we are. You ripped off this poor boy's money. Now give it back to him, all of it. Two-bit crooks! Complain all you like, it won't do you any good. Who do you think I am? I'm Kōchiya Hikobei! I worked for the Hachiōji Inn Authority as an investigator," he declared, striking a pose like Amakawaya Gihei in the kabuki play.

This grandiose attitude annoyed Gonkurō, but there was nothing he could do at the moment.

"Well, of course, as you say, we're not the respectable travelers we appear to be. But I don't remember stealin' nothin' from that kid!"

"Shut up! Yotarō, Chōkichi, Sakichi, and Jinzō! Take hold of these three men so they won't make a fuss and check their possessions."

"We're on it, sir."

The four tough men grabbed the three and held them fast. Thrusting their hands into the three men's kimonos, they withdrew the money belts, including a wallet from one of them, and dumped out the contents. On inspection, there were three bundles: ten ryō in gold coins, ten ryō in silver pieces, and another ten ryō in small change.

"Well, look here. Boy, is this it?"

"Yes, sir. See there, the backing is Kai silk and the front is patterned cotton."

"Yes. Fits the description exactly."

"And ten ryō in gold, ten ryō in silver, and another ten in small change, wrapped in old paper."

"Yup, just as the boy said. Well, I'll just take this money for safekeeping, and as for these worthless bums . . . you thought you were so clever and smooth, there on Kobotoke Pass, bringing this poor, masterless child to my inn, trying to ply him with sake he couldn't drink, then with rice cakes, to get him to fall asleep. And why? So you could rob him blind! Brazen-faced robbers is what you are. I'll see to it that the authorities don't go easy on you—your worst nightmare's come true!"

"Hold on, hold on! I think you're makin' a big mistake. You're relying only on what that kid says. But this isn't his money! Really! He said he had fifty or sixty ryō."

"What's that you're mumbling? Idiots!"

"That money there came from . . . well, it's from . . ."

And as he tried to explain the origin of the money to clear things up, Gonkurō realized he would have to tell about murdering the pilgrim and his daughter. As he considered how severe the penalty for a double murder might be, he realized that the boy was the shrewd one, and backpedaled his explanation.

"S-s-sir, that boy there, he's roadwise as well, and I'd watch him, if I were you."

"Shut up! This is a case of the gods watching out for the honest man, as they say."

"Sir, how can we call *him* honest!"

Jirokichi interjected. "Sir, what a way to talk after having taken all my money!"

"There, there! Don't worry, boy. These are outrageous criminals. I thought of painting their faces black and chasing them out, but the audacity of their crime disgusts me. Tie 'em up, men!"

"Yes, sir."

"Rough 'em up and tie 'em to the maple tree in the inner court. We'll leave 'em there for three days, give 'em nothing to eat. When three days are over, and they're thinking twice about life, we'll beat 'em up again and kick 'em out, and make sure the authorities are waiting for them. Yeah, go ahead, tie 'em to the tree!"

"Oh, no! This is terrible!"

"Let's go!"

And they dragged the thieves out to the central garden and bound them hand and foot to a tree, so tightly they were unable to move.

"Well now, young man, you needn't worry any more. It's Yokichi, right? And you're a servant of the Renmyōji Temple in Tofudana?"

"Yes, that's right. I'm still quite worried about robbers, so do you think you could keep the money until morning?"

"Certainly. It's safe with me. . . . Men, I'll bet you're famished after all this. How about a bowl of noodles?"

"Sounds great!" And all the staff headed off to the kitchen, then back to bed.

"Sir, would it be possible for me to sleep near you tonight?"

"Why, of course! You certainly shouldn't sleep alone after all that. Come with me."

So Hikobei took the boy to his room and tucked him in.

When the bell rang its early morning toll, Jirokichi crept out of the room and went to the toilet, where he made as if he were washing his hands. As he did so he opened one of the shutters on the veranda to peer at the three, who were shivering and nearly frozen.

"What rotten luck!"

"You're right. Terrible luck. Must be in the stars. I'm twenty-five, you know, a bad year for my zodiac sign."

"You're twenty-five? Oh, that is a bad year!"

"How old are you, Gon?"

"Forty-one."

"That makes next year your bad year! Kuma, how old are you?"

"I'm thirty-three, so it's a bad year for my sign, too!"

"Age thirty-three brings bad luck to women. It has nothing to do with men."

"Well, then the bad luck must be splashin' my way somehow. Anyway, whaddya think about that kid?"

"Man, he really was clever. Played every card right. And look at the mess we're in now!"

Young Jirokichi spoke from the veranda.

"Hey, 'grown-ups'! Now this is something, isn't it!"

"What the . . . !! Whaddya mean, gettin' us in trouble like this?"

"It serves you right! Like the owner says, the gods look out for the honest! Look where you are now! Justice is served; the money you never earned is now safely in my pocket. Ha, ha, ha! Well, you're still rookies when it comes to doing a job proper. You need to get some practice, polish up your skills. I'm Jirokichi the Kid, well known around Ryōgoku in Edo, and I'm as honest and proper as the day is long. I'll put your thirty *ryō* to good use, rest assured. It's my road money now; I'm going to take a tour along the Tōkai Road, maybe even visit Kamigata. Perhaps someday we'll meet again somewhere down the road. Until then, take my advice and brush up your skills. Take a lesson from me: age alone doesn't amount to anything. Bad deeds lead to bad ends! Say, for instance, you kill a couple of pilgrims, throw their bodies down into a ravine . . . that's the kind of behavior that will reap a bad end for sure. You're lucky to get out of this alive, since the victims happened to be strangers to me. Otherwise, I'd take my revenge with your lives."

Jirokichi spit in their faces.

"Lick that! It might make you smarter, you bastards!"

"Oh, shut your damn face!"

The three gnashed their teeth in anger, but could not break free.

As the morning broke, Jirokichi thanked the owner for his hospitality, paid his bill, and asked for some men to help search for the lost priest. The owner, feeling obliged to help, called two or three of his staff, and off they went to climb Kobotoke Pass. When they reached Komagino there was a fork in the road, one branch heading off to Mount Takao and the other up a

narrow mountain path. Jirokichi was nowhere to be seen, and the men were stumped as they tried to figure out which path he had taken.

In our next story, Jirokichi takes a byway and is soon on the Sagami Road, where, in the Ogino Hills, he meets with the formidable samurai-in-training Tengu-Boy Kiritarō.

TRANSLATED BY J. SCOTT MILLER

Wedlock and Electricity

KUROIWA RUIKŌ

 The following two selections, written by Kuroiwa Ruikō (1862–1920), midwife and godfather of detective fiction in modern Japan, provide a glimpse into the beginnings of that genre in the mid-Meiji period. In the late 1880s, Ruikō began translating Western crime stories into Japanese. Using the fledgling newspapers to good effect, he brought this new genre to the attention of readers high and low. His ambitious and prolific career involved recasting dozens of stories and novels into Japanese, including both *Le Comte de Monte-Cristo* by Alexandre Dumas *fils* and *Les Misérables* by Victor Hugo. Ruikō, who could read English, but not French, relied heavily upon translations and collaboration with others, to the extent that we might imagine him as a kind of a studio director overseeing a process that was able to produce a huge number of works in a short amount of time, not unlike the woodblock printing studios of the Edo period that combined the talents of many under one author's name. A political activist and journalist, he saw his translations as tools of reform, as one can see in the occasional narrative aside or editorial comment interspersed throughout his best-selling works. Of these, two reveal the extent of Ruikō's influence. One was *The Iron Mask* (*Tekkamen*, 1892–1893), an adaptation of Fortuné du Boisgobey's *Les Deux Merles de M. de Saint-Mars* (1878), a two-volume novel set in Louis XIV's France. This work was ultimately forgotten in Europe but became a sensational hit in Japan, not only finding its way into reprinted editions but also appearing as redactions for young readers, manga, radio dramas, and cinematic versions. Likewise, *Ghost Tower* (*Yūreitō*, 1899–1900), another popular detective novel, was translated and adapted from Alice Muriel Williamson's *A Woman in Grey* (1898). The tale involves a mysterious woman living in a clock tower, a murder, a hidden treasure, and a detective who solves the mystery as he falls in love with the woman. The novel was received with

enthusiasm in Japan. It became the basis for at least two films (one an early silent movie), and was also rewritten and adapted by Japan's most popular detective fiction writer, Edogawa Ranpo (1894–1965).

Ruikō understood the power of the press and founded his own newspaper, *Myriad Treasures/Morning Report for the Multitudes* (*Yorozu Chōhō*), which became Japan's largest by the early 1900s and served as the venue for the majority of his writings. Combining flowery traditional prose with iconoclastic experiments in narrative perspective, Ruikō's style broke with linear, chronological presentation by shifting narrative point of view in an almost cinematic manner. He took great license with his translations, which were in effect adaptations that often leaned heavily toward contemporary social commentary.

The two stories presented here, which first appeared in newspapers in 1890 but were reprinted together later that year in a collection of Ruikō tales, represent two different subgenres of mid-Meiji adapted literature: foreign and domesticated adaptations. Foreign adaptations usually retain the setting of their originals, while domesticated adaptations are reset in Japan. Curiously, in both cases the main characters have Japanese names, yet in the former they act in general consonance with the customs of the foreign locale in which they are set. Domesticated adaptations, on the other hand, are like modern cinematic versions of Shakespeare in that they take greater liberties with setting, characterization, and cultural cues, giving the final version much more of a Japanese flavor, sometimes to the extent that the original work, if not explicitly noted by the writer, remains unknown.

"Wedlock" represents one of Ruikō's foreign adaptations. The original source is unclear, although elements of the story appear in works by both Thackeray and Arthur Conan Doyle. It is set in Wales and London, with authentic geographical and cultural elements, in particular the disparity between the extremely wealthy and the working and impoverished classes. The main characters, however, possess Japanese names, although there is no sense in the story that they are ethnically Japanese. Narrative perspective shifts, keeping the reader guessing as to who is good and who is bad. The ending of the story, with its strong moralistic overtones, stems directly from the didactic fiction of early modern Japan, even as both the suspenseful narrative flow and the revelatory final paragraph reflect Western-style detective stories.

"Electricity" represents a domesticated adaptation; its source, if there is one, has not been identified. Ruikō took great pains to domesticate the story, setting it in contemporary Tokyo, with characters who realistically portray contemporary life, including great attention to the details of clothing, interior decoration, and social dynamics. The same kind of cinematic narrative

sweep comes into play at the beginning of the story, and its building suspense and shocking conclusion follow the style of detective fiction. The ending involves the use of deductive reasoning in line with that of Sherlock Holmes, and throughout the story the tension between traditional fashions and manners and Western ways underscores Ruikō's activism and awareness of the pros and cons of Japan's modernization.

Both stories contain curiosity-whetting one-word titles as well as endings that are emblematic of the genre. The title "Wedlock" uses the Japanese term *kon'in*, which gives readers a sense of the rigid, cannot-turn-back finality of a marriage commitment, while that of "Electricity" (*denki*) underscores both the power and the danger of Westernization. The respective endings are both tragic and didactic, warning upper-class daughters about the dangers of eloping with swindlers. The rapid-fire endings that tie up all the loose ends in the final paragraphs of both are representative of the earliest modern detective stories, and while they may seem a bit rushed to twenty-first-century readers' suspense-immersed sensibilities, the style was revolutionary in the 1890s and helped establish the detective story as a popular and enduring genre in Japan.

⌒(JSM)⌒

WEDLOCK

Part 1

Llyn Llywenant is a lake in Wales, a region in the western part of England, surrounded by forests, mountains, and scenery of such robust beauty that multitudes from London summer there, July through September, to escape the capital's heat. One such escapee, a young man, was strolling along the narrow path beside the lake, leisurely taking in the scenery along the route to the village of Hafford. He appeared to be in his midtwenties, with prominent eyebrows and bright eyes, and wore the lightest of traveling clothes, revealing, without the need for inquiry, that he was a young gentleman raised in the capital. After a short distance he stopped.

"What magnificent scenery! Transport this to the middle of Europe and it could hold its own against the grandest of prospects, even the Swiss lakes. But, sadly, I cannot sit and enjoy it at length. I must leave this pleasant scene and travel on. . . . Where, I wonder, is Akiba Senzō's house? When I asked, they said I only needed to follow along the lake and continue straight on. But it seems as though I still have three or four miles to go. That distance, even at a slow pace, should take no more than two or

"Wedlock," *Ruikō-Shū* (1890). (The National Diet Library)

three hours. So strange that there is no one in sight to ask for directions. In the summertime there are usually crowds everywhere, but today it is Fahrenheit six or seven degrees hotter than London . . ."

He suddenly came to a fork in the path.

"Now I *really* wish there were someone to consult. Should I go right or left? Wait! Over there is an elegant manor. Perhaps they'll know . . . and look, a young lady, enjoying the cool shade of that large tree just outside the gate. Such a rare beauty, too. Even in this remote countryside she is a veritable rose among the thorns. I need to ask directions anyway, and so much more charming to inquire of such a beauty!"

Muttering this under his breath he walked over to the woman and began to speak to her in polite terms.

"Pardon me, but do you know if someone named Akiba lives anywhere near—"

After hearing only a fragment of the question, the young lady raised her head and, upon catching the briefest glimpse of the man, instantly flushed bright crimson.

"Yes, many of us share the Akiba surname. After which Akiba are you inquiring?" she replied with some embarrassment. The young man took a long look at her face before replying.

"Mr. Akiba Senzō."

Her face reddened even more.

"If you are looking for Senzō, this is, indeed, his home."

The young man appeared ecstatic.

"So I've arrived at his house, then? I thought I still had another two or three miles to go! Well, since I'm here, please. My card."

He pulled out a single name card and passed it to the woman, who took a quick glance and then went immediately inside. After a brief interval, a gentleman in his fifties—no doubt Mr. Akiba—came out holding the same card in one hand.

"So you are . . . Toshikawa Matsuo?" he said, comparing the card with the face.

"Yes, sir, I'm Toshikawa. Although you may not be familiar with my first name, you might know my second. My father often spoke of you."

"Your father . . . ?"

"Yes, my father, Toshikawa Takinojō . . ."

The older gentleman raised his eyebrows when he heard the name.

"So Takinojō is your father? You should have told me that right away. Why, thirty years have passed since I last saw him. We graduated from university together. I was the valedictorian and he the salutatorian. And now, in what seems like no time, he has produced an heir such as you! Since we last parted, Takinojō has gone on to become a lawyer. I've moved here to the countryside to inherit my father's home, and it's been ages since I last heard anything from him. Now he sends you out here to show off what a fine son he has raised! Just what I would expect from the man. And you are handsome as well. . . . Is there anything he sent you along to tell me?"

The gentleman's face was all nostalgia and inextinguishable smiles. He continued.

"So what message did he send me? Is he, perchance, planning to come out here this year to avoid the heat, and wants me to get ready for his visit? Is that it?"

Matsuo, the younger gentleman, hesitated.

"I'm sorry, but my father Takinojō passed away eight years ago . . ."

Senzō took a step backward in surprise.

"What? Takinojō came to an early end? Who would have imagined . . ."

Senzō's weepy, aging eyes glistened with tears.

Matsuo replied dispiritedly. "He spoke of you even to his dying day. I've remembered what he told me about you, and wanted to pay a call on you, but until now have not had occasion to do so. Fortunately, I graduated from university this year and, since I came to summer in Llyn Llywenant, I thought that I might drop in, being in the neighborhood."

"Then welcome, welcome indeed. Make yourself at home. Stay with us through the rest of the summer, if you wish. Unfortunately I have no children in my approaching old age, but have adopted my niece and reared her as my daughter. Her name is Sonoko, the young lady who brought me your name card. Aside from her there is only my wife here; the others are all

servants with whom you can feel at ease. Here, let me introduce you to So-
noko and my wife. Come in, come in!"

He drew Matsuo into the house by the hand and introduced him to his
wife and Sonoko, then threw a feast for this visitor from the capital. During
the festivities, Sonoko, from her first glance, fell deeply in love with him.
Both the wife and niece refused to allow Matsuo to return to his inn. Unable
to resist such a united front of kindness, Matsuo went to his lodgings the
next day to retrieve his modest luggage and agreed, at least until the heat let
up a bit, to stay in their home. From this point on, Sonoko never left Mat-
suo's side, taking his hand in the morning as they entered the garden and
remaining inseparable even while rowing beside him upon the lake in the
evening. Her flirtations continued, and he was rarely without her. Scientists
say there is a strange kind of *electricity* that flows between man and woman.
Even though Sonoko was their cherished adopted child, Senzō and his wife
acted in a manner uncharacteristic of parents, especially considering that
they knew nothing of Matsuo's reputation, since they allowed her great free-
dom and let the two of them get to know one another privately. That soli-
tary name card was the only go-between they had, and he just a traveler who
had arrived at their home from out of nowhere. It is no trivial matter to let
the heart run freely without corroborating the everyday conduct of someone,
even if he is the son of a close friend from the past. Finally, after a number of
days had passed, in the clear breeze beside the cool waters of the lake, Matsuo
told Sonoko that the two of them should be married, and she joyfully prom-
ised to be his wife.

As an only child and adopted daughter, Sonoko could not easily bring
herself to reveal her engagement to her devoted mother and father, how-
ever, so she made plans to run off to London with Matsuo and marry him
in secret, meaning to apologize after the fact to her parents. Matsuo, who
was also blinded by the thrill of first love, agreed to elope with her without
regard for the consequences. Although the story up to this point is merely
the common sort of tale one tends to hear, when careful readers discover
hereafter what happens in the end, they will be so astonished as to be
left speechless.

Part 2

Toshikawa Matsuo promised to elope with Akiba Sonoko, and one evening,
under cover of darkness, he hired a carriage and waited in the shadows. At
the prearranged meeting time in the middle of the night the two climbed
aboard and rode away. The approaching dawn found them over ten miles

away, arriving at the railway station, where they planned to catch the train from Wales to London. They boarded the first train out and arrived safely in London that day. Within only a few days of their arrival they proceeded to a certain church where the wedding ceremony was performed. Sonoko felt immeasurable happiness. She grew more familiar with the London she had once only dreamed of, and there was no greater pleasure than spending each day as the wife of the man she loved. This condition of beaming happiness lasted for five weeks. Up to that point, her fullness of joy had given every moment a dreamlike quality. From that time onward, however, a certain doubt entered into Sonoko's heart regarding the subject of Matsuo's background.

He represented earlier that he had graduated from university and taken up his father's occupation as a lawyer, but she saw no evidence whatsoever that this was truly the case. Each day he left their lodgings during the morning hours and returned in the evening, but did not appear as though he possessed any kind of occupation. It was also odd that he had them living in such meager, hired lodgings, with him coming back to stay like an overnight traveler, and gave no indication that they would soon move out. Did he even *own* a house, a place to share with his wife? Even that was not clear to her. And, if this did not raise enough concerns, an even greater source of apprehension was the fact that it seemed as though Matsuo lacked even a single friend! A full five weeks following their marriage not a solitary soul had come to call and express good wishes, nor had Matsuo provided any names with whom to share their good news. Sonoko had always heard that London was the capital of polite society, and that any kind of a man holding the title of gentleman would be invited to this evening party here or asked to attend that banquet there, to the extent that he would rarely have occasion to spend time in his own home. And yet why was it that Matsuo alone never received any invitations nor attended social events? When she was single, in the countryside, she imagined herself going to London and being received among high society, rubbing shoulders with grand ladies and daughters of good families, and thereby seeing her own status and dignity rise all the more in the world. In contrast, here she was, confined forever to this tiny one-room lodging, waiting upon Matsuo, aside from whom she never saw another human face.

One day Sonoko, in this very extreme state, confronted Matsuo. "Won't you please make arrangements to take me with you to some friend's house?"

Matsuo seemed lost for a reply, although his face flushed, and then his anger quickly boiled over.

"I don't see the need for making a bunch of useless friends!"

And, with that scolding, he walked out in a huff.

From this point on Matsuo's behavior grew more unpredictable from day to day, and many days he did not come home until very late at night. Sonoko, unable to endure feeling so lonely and helpless, sent a letter home to her faithful parents, apologizing for her disloyalty in running away and briefly informing them about her marriage and current state of affairs. Her father, Senzō, sent back a furious reply. Her mother's letter, however, was full of feminine sympathy, noting that, although a wedding was a felicitous occasion, Sonoko would find it hard to earn her father's forgiveness unless something were done. Accordingly, she herself would come to London to visit Sonoko and investigate the situation.

Sonoko's mother arrived as promised, a few days after her letter. She first learned that Matsuo went out every day but, curiously, never talked about his work. Then, as Sonoko told her more, the circumstance grew ever more intriguing. She waited for Matsuo to come home that evening, then asked a full complement of questions, to each of which he replied in an off-hand manner.

"What do you mean, Mother? I *do* have a law degree, you know. Don't worry about my job."

Nothing more. He gave a casual response no matter what she asked, and for the time being seemed satisfied that there was nothing to worry about. However, after several more days she saw that Sonoko's feelings were still unsettled and found more grounds for suspicion. She called her daughter in and spoke to her softly.

"You married while still young and unable to distinguish right from wrong; but I myself am also troubled about a few things, so tomorrow I shall go out alone, investigate Matsuo's circumstances, and let you know what I discover."

"Yes, that would be so helpful of you," Sonoko replied, also greatly concerned over her husband's situation.

The following day her mother set out from the house after Matsuo, and it was not until past sunset that she returned, her frame weighed down with despair. Sonoko was worried.

"What's wrong, Mother? Were you unable to find out what's going on?"

"Tonight I will tell you nothing more. You shall go out with me tomorrow and I will reveal the full truth of the matter to you."

And with that she retired to her bed for the night. Afterward Sonoko thought about her mother's condition, realizing that she must certainly have uncovered something very surprising while following Matsuo, or else there would be no other reason for her normally carefree mother to have

gone to bed early, looking so drained. Sonoko was even more unsettled as she considered what that discovery might be, worrying until, in due course, morning came and, as usual, Matsuo left the house at the same time as the day before. Sonoko and her mother quickly got themselves ready, left their lodgings together, and, taking pains to keep Matsuo from discovering them, tailed him from afar. He turned right here, swung left there, and walked on and on until he arrived at what was known as the lowliest borough in all of London. Sonoko was greatly concerned, and realized that, if she had been alone, she would have run over and flung herself upon Matsuo, asking him to explain himself. However, in consideration of her mother, she restrained herself all the more, watching from the shadows as Matsuo stepped over to the corner of an even narrower side street and paused. Then he quickly glanced all around, as if to make sure no one was watching, and ducked into the alleyway.

This was where beggars and cripples lived, and the surroundings reeked with a terrible stench so powerful that the two had to hold their noses. Sonoko's concern was solely for her husband as she dashed ahead of her mother to the entrance of the alley. She watched as Matsuo entered the most wretched hole—nay, hutch—in a series of squalid shacks lining the passage, and at this moment her misgivings were almost unbearable. A short while later, as she watched a very different Matsuo emerge from the hutch, Sonoko screamed and collapsed, unconscious. Matsuo himself appeared too mortified for words, averted his eyes, and ran away.

Kind reader, what had happened to Matsuo's appearance? A sketch will help reveal the truth. He had put on the guise of a very ugly, limping, one-eyed cripple, intending to go out to beg. Despite his having a perfectly sound body, the foolish man knew no shame and had no heart for honest labor. He disfigured himself in order to extract from others' sympathy enough money to live from one day to the next. How could such a person transform himself into a gentleman? Evidence led to his arrest soon after, when he was found hiding among the vagrant class. He confessed that, by sheer chance, he had found a huge sum of money while working as an itinerant beggar in a certain quarter, and from that wealth was able to live as a gentleman. So was this man truly the son of Toshikawa Takinojō, the friend of Sonoko's father, Senzō? The mother's subsequent suspicion and investigation revealed that Takinojō died years earlier without a single heir. The man had somehow learned about Takinojō and used that knowledge to deceive Senzō. And what about Sonoko? Alas, after she lost consciousness, she passed on to the other side, this sad fate her punishment for running away from her parents. How pitiful!

ELECTRICITY

Part 1

The time is mid-August, between three and four in the afternoon, and the heat is at its peak. Around noon clouds swarmed like thick cotton comforters in the sky, blocking any hope of a breeze. The oppressive swelter was by now unbearable, made worse by the threat of an imminent cloudburst. The setting is in Tokyo's Kōjimachi-Banchō quarter, where the grand mansion of a government official had once stood. The manor had been torn down and, in its place, a Western-style two-story home had been erected by Colonel Takekawa Takeo, who was currently away supervising troops in Hiroshima's Military District.

Decorated in the Western style, the main parlor looked out on the street through two open windows above a wrought iron fence. In the room, a woman in her late thirties stood next to an elegant table as she prepared tea, her hair in a Japanese-style coiffure. This was Takeo's sister, Tokiko, who, having married early in life, left her husband shortly thereafter, returning to live with her brother, where she presided over the house in his absence. Tokiko was also responsible for the general's daughter, Hideko, a young lady who turned nineteen that year.

The daughter was very accomplished, having graduated from a teachers college. She was skilled in speaking English. She normally wore Western-style clothing, and was an aficionado of all things Western, most especially the merits of love marriage, a topic that occasionally left her aunt, Tokiko, speechless. Having turned away from her aunt moments earlier, she was standing by the half-shaded window looking out upon the street, deep in thoughts that seemed equally shaded in mystery. Her aunt spoke to her softly from behind.

"Hideko, the tea's ready. Hideko?"

She repeated herself before the young lady finally turned her way, speaking as she came over to the table.

"Time for the 'five o'clock tea,' is it? I was just looking to see if the post had arrived, but it looks as though it will be late today."

"Waiting for a letter from Hiroshima?"

"Yes, the paper mentioned that the mail steamer had arrived from Nagasaki this morning, and the mail usually gets delivered by now."

"Well, no mail could actually be good news after all. My brother did say in his last letter that he would probably be coming home soon."

"Is that so?" Hideko replied casually, her mind fully lost in thought. She sighed as she glanced down and, with her left hand, absentmindedly broke off a piece of the biscuit on her plate.

Previously, the aunt, having suspected what was brewing in Hideko's heart, had attempted to offer some roundabout advice, at which the niece

had rebuffed her in an impetuous Western manner. "In matters of love, even parents should keep their opinions to themselves!" Tokiko had abruptly ended that earlier conversation with silence.

Just then, the sound of a bicycle bell came ringing from the street, and Hideko quickly stood and ran over to the window. The aunt, wondering who it might be, rushed over behind her and looked down to see that it was one of her brother's junior officers, Aoyama Fukashi, who had just turned thirty and was recently back from the Hiroshima District. The young woman, upon seeing the man, greeted him as a Western lady might, by placing the back of her hand to her lips, which gesture Fukashi returned by lifting his hat. He then peddled away. The aunt, having learned earlier of Aoyama's less-than-savory reputation, waited for Hideko to turn toward her.

"Wasn't that Aoyama Fukashi?"

Hideko suddenly blushed, then replied nonchalantly. "Yes, that *was* Mr. Aoyama."

"And didn't you get to know him quite well in Hiroshima?"

"Well, actually, since I was living in the District barracks, I got to know everyone quite well!"

"Yes, but I hear he came to Tokyo the minute you returned, and now he's living near Ueno. Isn't that so?"

"Yes, he's living with his sister, near Shinobazu Pond."

"Ahh, so *that's* why you went over to Ueno the other night. You went to Fukashi's place, didn't you?"

"No, I went to his sister's home."

"But didn't you just say he was living with his sister?"

Hideko's eyes flashed.

"Is there anything wrong with calling upon someone with whom he happens to live? I'm actually visiting there again this evening. I have an appointment to take dance lessons!"

"Oh, so you're going over there again, are you? If I'm not mistaken, that makes at least six times this month!" the aunt replied, perturbed.

"Well, isn't Auntie's memory remarkable. I've completely lost track. If you don't want me to go, just say so, and I won't!"

"Well, I'm not saying you can't go. It's just that you come back so late in the evening. And, as your father's letter said, with your bad health you shouldn't be out and about. Besides, didn't Doctor Takenouchi say that the waltz and other such dances overtax your strength?"

"If the waltz is bad for one's health, then all Western women would be dead! You're just saying that because I dance with Mr. Aoyama, aren't you? If that's the case, just say what you really think!"

"I say both the dancing and the partner are bad for you!"

"What makes my partner so bad?"

"He's not just bad. He's shameless and dangerous! It scares me to think of you taking someone like him as a friend. You don't think there's something wrong with 'falling in love' with someone like that?"

Hideko flushed.

"Do you think love cares about good and evil? Even Shakespeare said that love should not be a prize women give to men. If a prize, it would only be awarded to upright men, and not to rogues; but *true* love is blind. Once you are in love there's no room for concerns such as virtue or vice, or differences in social status."

And with that declaration, Hideko stood up abruptly, went over to the window, and recited a famous quotation—in English, just to spite her aunt! *"She may love against her will, against her judgment, against her duty . . ."*

As she finished, Hideko reached out the window to retrieve a solitary letter just delivered by the postman, and, scanning the return address and postmark, let out a gasp. Her face turned pale.

Part 2

The letter was from her father, Takeo, and the canceled postmark revealed that it had been sent from Yokohama, *not* Hiroshima. So he must have arrived in Yokohama by ship that morning! The nerve-racked Hideko felt as if the characters "Yoko" and "Hama" were two needles piercing her chest.

"Where's it from?" her Aunt Tokiko asked nervously, seeing the surprise and shock on her niece's face.

"It's from Daddy!"

"To whom?"

"Oh, it's addressed to you, Auntie."

"Fine, then let me see it, quickly. . . . Look, it's from Yokohama! He must have some reason to come to Tokyo so suddenly . . ."

Tokiko opened the letter.

Dear Tokiko,

I just arrived in Yokohama aboard the *Yamashiro*. It will be difficult for me to make it into Tokyo today because my old shoulder wound flared up again during the journey. However, regarding Aoyama Fukashi, who recently returned to Tokyo from Hiroshima, there are a number of compromising factors and loose ends to be dealt with, and it is my desire that you take pains to ensure that

Hideko not meet with said person, whom I forbade her to see while she was in Hiroshima. The reasons for such precautions have multiplied, so I must insist. I will give you all the details in person.

<div align="right">Takekawa Takeo
Yokohama lodgings</div>

Unable to restrain her curiosity about a letter that likely concerned her, Hideko silently peeked over Tokiko's shoulder and read every word. She blanched, and her aunt turned to face her.

"Well, aren't you something! You've been back from Hiroshima for three months, deceiving me the whole time! And although you were strictly forbidden from seeing Mr. Aoyama, you kept that from me as well! Maybe all this is just part of 'love,' or that Western way of living you keep going on about all the time. But I'm sure that even at your teachers school they didn't teach you how to deceive your aunt! I don't know anything about Western ways, but I do know that it would have been much better for you not to hide all this from me. You should have talked to me about it. I certainly would have been able to give you some good advice!"

Hideko bowed her head while Tokiko delivered her lecture, then lifted it again to respond, defiant.

"Would you, then, at least let me write Mr. Aoyama a letter, telling him I will be unable to attend this evening?"

"No, you'll not be sending any letters to him. I'll put him off myself!"

"What if I write the letter but you check it over and then put it in the envelope? That would suffice, wouldn't it?"

"Well, if you let me read it over once, I guess it would."

"Then that's what I'll do!" Hideko stood up to get a pen and some ink. Tokiko added a warning.

"And I will *not* allow you to write using that horizontal English, which I can't read!"

"Oh, I can just read it aloud to you. Wouldn't that work?"

"No, that won't do. Write it like you should, using a proper Japanese lady's hand."

Muttering something under her breath, Hideko spread out a sheet of paper on the desk and sat there, looking into the air and brooding for a full five minutes, with no indication she was going to write anything down. Tokiko's patience wore thin.

"If you don't write something, it's going to be sundown!"

"I am writing!" replied Hideko. After flourishing her fountain pen, she dashed something off. "There. Does that suit you?"

Tokiko snatched up the letter held out by the girl. Her niece had written that she was not feeling well and would be unable to attend dance lessons that evening.

"Fine. This will do," said Tokiko, and returned the letter to Hideko, who, after a moment's consideration, turned to her aunt.

"Do you perhaps have an envelope?"

"Oh, I'll go get one," she replied, stood up, and went upstairs to retrieve it. Watching her leave, Hideko quickly tucked the letter away in her pocket, took out another sheet of paper, and quickly dashed off a very different letter, folding it precisely in the manner of the first. "Well done!" she muttered (in English) under her breath just as her aunt returned with an envelope. Hideko quickly inserted the replacement letter, sealed the envelope, and calmly held it out to her aunt.

"Now, have this delivered!"

Unaware of her niece's subterfuge, Tokiko quickly called a rickshaw and instructed the man to deliver the letter to the Ueno residence of Aoyama Fukashi. Hideko managed to deceive her aunt without revealing so much as a sliver of her inward joy. With a scowl on her face, she turned toward Tokiko.

"Having just been made to write that I was indisposed, I've actually started to feel sick. Staying here is depressing. I think I'll go visit the neighbors."

"If you're really not feeling well, instead of going next door, you should go upstairs and get some rest. Besides, it looks like rain."

"No, the kind lady next door is good at cheering me up. I'm sure I'll feel better after a chat with her."

Hideko went upstairs to change her clothes, and Tokiko took out her brother's letter and read it over once more. Hearing what sounded like footsteps in the hallway, she turned to find Hideko standing there, already changed and looking as though she were about to leave for the neighbor's home.

"So you're going now?" asked Tokiko. Hideko made no reply, but hurried out to the garden. The aunt, slightly suspicious, followed her out of the hallway and saw her entering into the neighboring house by way of the garden, still wearing her indoor slippers. "It looks as though she's gone next door, then," Tokiko said to herself aloud, and returned to the parlor. Just then, the clouds, which had been building up all afternoon, suddenly let loose a torrent of rain, and as is often the case with summer storms, a thunderstorm began to shatter heaven and earth with booms, rumbles, and lightning bursts.

Part 3

No summer is devoid of thunderstorms, of course, but the thunderclaps on this occasion were unparalleled in their fury. The glass panes rattled incessantly, as though lightning and an earthquake were occurring simultaneously. The storm ceased as quickly as it had begun. In less than half an hour, the sky had cleared, all was silent, and the sweltering heat of midday was completely swept away. One might have been led to think that an autumn breeze had sprung up suddenly. Tokiko, by nature afraid of thunderstorms, had been lying underneath the table, praying for the gods to stop the noise. Eventually she raised her head.

"That was frightening," she thought. "It seemed as if this very house might come down around me! Now it's over, and I'm safe and sound. But what about Hide next door? I wonder if she's all right. With all her nerve she's probably not even afraid of thunderstorms . . ."

Suddenly she heard some distant rumblings and turned pale. "Oh no, it's started again!" Covering both ears with her hands, she retreated once more under the table and started praying. Then she felt a hand upon her shoulder.

"Hey, the storm's long gone. What are you doing down here?"

Her ears covered, Tokiko did not hear what the person said, but she apparently recognized the touch of the hand upon her shoulder and looked up in surprise at her brother, Takeo. His unexpected appearance left her frozen for a moment. Staring into his face, she finally came to herself.

"Oh, it's you! That must have been your rickshaw rumbling away. I thought it was more thunder . . ."

"How ridiculous!" Takeo muttered under his breath, then scanned the room. "Where's Hide?"

"Hideko? She went over to the neighbor's a while ago. Should I go get her for you?"

"No, wait a bit. I need to talk with you about something." Takeo pulled a chair over and plopped himself down.

Tokiko surveyed her brother's pale face, haggard and lined with fear.

"Your letter said you'd be spending the night in Yokohama and arriving tomorrow morning. That's what we thought . . ."

"Well, my old wound was acting up so I thought I'd wait, but I kept worrying about Hideko and so I took the four o'clock steamer."

It was highly unusual for Takeo to be so apprehensive. He was not the worrying type.

"Has something come up?"

"It's that Aoyama Fukashi. The scoundrel deceived Hideko in Hiroshima and would have persuaded her to elope with him had I not discovered the

plan and sent her back here. Fukashi quickly transferred to Nagasaki, and so I stopped worrying about it. But then I heard that the rogue had moved from Nagasaki to Tokyo. Worried about what mistakes Hideko might make, I hurried back here, only to learn that Fukashi came to Tokyo three months ago!"

"Had you told me that earlier, I would have done all I could to keep Hideko away from Fukashi."

"Well, I assumed the villain was in Nagasaki, so I was careless. Has Hide gone to see him since he arrived here?"

"Nearly every other day! I've heard rumors about his conduct. But when I warned her about him, she made fun of me."

"Well, I guess I was wrong to let her get so much education. She wouldn't be so impertinent if she hadn't completed teachers college. It's too late now, though. Listen, I also learned that Fukashi is married!"

"What?"

"He got himself a wife last year, in secret, when he was in Osaka. She's more a scoundrel than he, constantly manipulating him into trying to seduce rich young ladies."

Tokiko was shocked.

"I can't believe such audacity!"

"Apparently even his sister doesn't know about this. While I was on the ship from Kobe to Yokohama I happened to meet the man who served as the go-between for that cad and his wife, and he told me all the details. What's more, the go-between has had a falling out with Fukashi's wife, so he told me all about their schemes and even gave me a photograph of the couple. On the back Fukashi has added, 'A gift to our go-between, Mr.——,' and written both their names with his own hand."

"So what were Mr. Aoyama's intentions for Hideko?"

"I think his plan was to take Hideko's money. He found out that I opened a trust account in Hideko's name and invested three thousand yen when her mother died. I think he was scheming to swindle that money from her."

"Oh, that is frightening! I'm so glad, then, that I just had her cancel her plans to go over to Mr. Aoyama's tonight."

"You did? Then go get Hide and bring her back here."

It so happened that the house next door that Hideko said she was going to visit belonged to a man who, like Takeo, was in government service. In fact, the two gardens connected in such a way as to allow the occupants of both to come and go on a daily basis, and their interactions had made them as close as relatives. Tokiko stepped into garden clogs and headed next door with the intention of bringing Hideko back, but after a short interval she returned alone, her face ashen.

"This is terrible. Hide is gone!"

"What?" Takeo exclaimed.

"Just before the thunderstorm, I saw her entering the neighbor's garden. But they say she hasn't been to see them. I checked the front gate. It was left wide open, so it appears that she went from the garden to the front gate and fled."

"This is bad! She knew I was returning, so she escaped. I'm certain she is going to run away with Fukashi. We've got to catch up with them quickly or it'll be too late. Quick, call a rickshaw! Change into your kimono, since we'll be riding."

Part 4

Takeo was very angry upon hearing of Hideko's flight, and Tokiko was secretly worried.

"Takeo, if we catch up with her, please don't be too harsh."

"When we catch up I'll kill her! Now hurry and get ready!"

"This is just youthful fancy. I'm sure she'll come to her senses if we explain things to her. Just leave everything to me. I'll go alone and bring her back."

"If this were something I could have left to you, I wouldn't have come all the way here this evening. Hurry up!"

"Brother, please!"

"While we stand here talking like this they're just getting farther away. Hurry up, I say!"

Just then the rickshaw arrived. Takeo and Tokiko got into the double carriage, headed toward Ueno, and rode off. Tokiko knew of her brother's quick temper, and, knowing what might possibly be the final outcome if he remained enraged, she tried to calm his anger. Presently they arrived at the Aoyama residence and saw an English sign announcing a "*Little Dance*" event taking place that evening. Silver candelabra glistened in the main room, which was filled with guests laughing and gossiping. The rickshaw pulled up to the entryway. Hearing their arrival, Fukashi's sister Tsuneko came out to receive them, thinking they were guests.

"Why, you're quite late this evening, aren't you?" she said. But then, recognizing Takeo and Tokiko, her face suddenly went pale and she staggered back two or three steps. Being a lady of social composure, she quickly erased the look of surprise from her face.

"Well, if it isn't Mr. Takekawa! When did you return to Tokyo? Oh, and there's Miss Tokiko as well. Come right in and enjoy yourselves. Here, come this way. Isn't Miss Hideko with you this evening? Why didn't she come tonight? Is she ill or something?"

Tsuneko's words were tactful and smooth, but her face revealed her heart's inner turmoil, and Takeo confronted her sharply.

"Actually, 'something' may very well have happened to Hideko. That's what we've come to find out!"

Tsuneko staggered two more steps backward. Seeing her pale face, Takeo deduced that Fukashi and Hideko had already escaped and clenched his fists in regret.

"They're already gone. We're too late!"

Tsuneko looked even more puzzled.

"'They'? Who do you mean, *they?*"

Until then Tokiko had been silent and reserved, but Tsuneko's obvious lie brought her blood to a boil.

"Why, Tsuneko, *they* would be your younger brother Fukashi and my niece Hideko, of course. Didn't you know?"

Tsuneko's face registered increasing surprise.

"What? Miss Hideko and Fukashi, eloping? I don't think so. And even if they did, I know nothing about it. My brother has told me nothing."

Takeo stepped toward her.

"So, Fukashi's said nothing of this to you, then? I suppose he hasn't told you about his wife, either?"

"What? He has a wife? Don't be ridiculous. Fukashi isn't married."

"He most certainly is. And to prove it, I have here a wedding picture he sent to their go-between!"

Takeo took out the picture and handed it to Tsuneko.

"Make sure you look at both sides!"

Tsuneko took the photograph and examined the couple. The groom was Fukashi, no doubt about it. And the inscription on the back, clearly written in his own hand. "Presented on——, following nuptials, by Army Junior Lieutenant Aoyama Fukashi and his bride, Kishiko, as a gift to Mr.——, their go-between."

Despite Tsuneko's cunning nature, she could not deny the evidence. The tone of her voice changed suddenly.

"Mr. Takekawa, I knew nothing of this! I am shocked. Is this really him? He even kept it from *me!* What to do? And to think, unsuspecting, I was working so hard to find him a wife . . . I'm just, just . . ."

With these words Tsuneko betrayed her hand in helping Hideko run off with her brother. Seeing how her face reflected her heart's confusion, Takeo tried to calm her.

"I really can't blame you much for a mistake you made in ignorance of the facts. But please do all you can to rectify this wrong." Takeo pressed her

for an answer. "Where did they go, those two? Tell me now and it will redeem your error. Where did they run off to?"

Part 5

Even Tsuneko could not avoid Takeo's sharp and forceful words. She shamefully replied.

"The truth is, Hideko sent a letter saying that, because her father was returning to Tokyo, there was no choice but to elope sometime this evening, and that she would be waiting for him at Shinbashi Station to catch the 8:45 train. Fukashi immediately packed his things and headed off. Since it's now nearly ten o'clock, the two must be long gone."

"Well, what about their destination?"

"The letter mentioned nothing about where they were going."

Takeo pondered the situation, and then suddenly turned to his sister.

"Toki, let's go!"

"Where?"

"Shinbashi!" he said, looking at his watch. "It's just 10:00 now, and we can still make the last train at 11:15!"

"We're going to Yokohama?"

"Of course. They think I'm in Yokohama. They're assuming that's the last place I'd expect them to run off to. Come, hurry!"

Pressing Tokiko along and without taking leave of Tsuneko, they flew to the rickshaw and headed for Shinbashi. Within less than thirty minutes the two found themselves arriving in front of the station. Takeo suddenly turned toward Tokiko and pointed out a man standing at the top of the stone steps leading to the station entrance.

"Look there! That's Fukashi, isn't it?"

It was night, but the gaslights allowed Tokiko to recognize Fukashi waiting there expectantly. She was shocked.

"Yes, that's Fukashi, without a doubt. But for some reason Hide's not here yet, and he's still waiting for her."

Before she could finish her words, Takeo sprang from the rickshaw and bounded up the stone steps like a hunting dog after a rabbit. He grabbed Fukashi by the lapels of his Western-style jacket.

"You've abducted my daughter. Wh-wh-where have you taken her?"

Fukashi tried to flee, but was bound by Takeo's brute strength.

"Sir, I can't br-breathe . . ."

"Tell me the truth, the truth or *this!*"

"Sir, it's so tight I can't . . . speak!"

Tokiko arrived at the violent scene.

"Takeo, don't do something you'll regret. Ask him nicely, please."

"You think his kind will confess if I'm lenient? I'll get him to speak. How about this? Or *this*? Or THIS!"

"I'll tell you everything. Just loosen your grip!"

"I'll loosen up when you start talking. Now tell us!"

"Sir, your daughter hasn't arrived yet."

"You lie. Tell me where she is!"

"Sir, she hasn't been here at all. I was supposed to meet her to catch the 8:45 train, but she never came, so I've been waiting here ever since, worried about her. That's the truth! Something must have happened to her along the way."

"Still insist on lying, do you? Well, it's a court martial for you. Let's go!"

"No, sir, I'm telling you the truth!"

"Lies will only make my grip tighter, and *tighter* . . ."

As the colonel strengthened his grip even more, his sister, Tokiko, standing by throughout the interrogation, sensed some truth in Fukashi's story. Perhaps Hideko *had* fallen into trouble along the way. This concerned her to the point that she thought it might be worth going back to the house to think things over carefully. She turned to Takeo.

"Brother, please. Mr. Aoyama is, after all, a man of status and would gain nothing from lying to us. It's getting very late. Why don't we pursue this tomorrow?"

She pleaded with him more fervently and in various ways tried to get him to stop, and he finally relented.

"Well, Aoyama, that will be all for this evening. But if we fail to discover her whereabouts by noon tomorrow, it's a court martial for you, and then you'll *really* have something to worry about!"

Takeo jerked his hands away from Fukashi's lapels. Without turning back to watch him fall down onto the flagstones, he grabbed Tokiko's hand and, in the cavalier manner of a true officer, climbed back into the rickshaw. The two rode on to the Banchō house, arriving around midnight. Tokiko turned to tell her brother about a hunch.

"Takeo, maybe she left a note behind. Let's go upstairs and see!"

Together they went up to Hideko's room, and what greeted them as they slid open the door? There, in the dim light cast by a flickering Western-style candle, was Hideko sitting at her desk, pen in hand, writing something.

Surprised at the sight, they both shouted her name in unison, but she gave no reply. They rushed to her side in suspicion and placed their hands on her shoulders.

"Hide, what's going on here?"

Shaking her, they discovered that her body was already cold and stiff, and she no longer seemed to be of this world. Had Hideko killed herself, perhaps? No, it was not a suicide. Was she asleep? No, this was no slumbering state. Tokiko was even more puzzled than Takeo.

"Brother, what do you think happened here?"

Takeo was mystified, but after a short while had an idea. He carefully examined the still-open window in front of the desk.

"I've got it!" he exclaimed as he looked up at the clock hanging beside the window, its hands stopped precisely at 6:35. He turned to Tokiko.

"Hide should be wearing a small gold pocket watch, I believe."

"Yes, it's right here in her pocket."

"Let's see it!"

Tokiko looked doubtful but put her hand in the pocket, and therein discovered the gold watch that never left Hideko's side. Further inspection revealed that its hands were also frozen at 6:35.

When Takeo saw this, the warrior-father's eyes flooded with tears. He turned to his sister.

"Toki, listen. Earlier, although Hideko told you she was going next door, she was actually eloping. But she only got as far as the neighbor's garden when it started to rain. So she came back to get rain gear and decided to write a letter. Just then thunder pealed and lightning struck. These two clocks with their stopped hands are the final proof. The roaring flash came through this window at exactly 6:35 and escorted my daughter to God! It is sad when death comes outside its appointed time, of course, but there are actions that bring a shame far greater than death. Hideko was about to disgrace herself but, sitting beside this window, was spared such dishonor by a servant of God named *Electricity*. It left her body undefiled as it took her up to Heaven. Look at her face, no different from the countenance of one still living, and not a single wound upon her body. Thanks to the deep benevolence of God. Hallelujah! Hallelujah!"

"Amen!"

TRANSLATED BY J. SCOTT MILLER

PART III

The High and Low of Capitalism

Money Is All That Matters in This World

KAWATAKE MOKUAMI

Kabuki was one of the fulcrums around which the popular culture of the Edo period revolved. Its stars were wealthy and instantly recognizable, celebrated in prints and illustrated novels, but the authorities treated these plays with great suspicion, doing everything in their power to constrain their influence. Strict controls were placed on the numbers of kabuki theaters, their locations and construction, the salaries of actors, and the content of plays. In its turn, kabuki responded to the censorship and control by developing covert ways to refer to forbidden topics and by developing extravagant, exuberant styles of theatrical presentation.

However, this relationship between kabuki and authority changed during the early years of Meiji. The new government decided that kabuki should become a tool for moral education and international diplomacy. Attempts were made to bring Enlightenment to the kabuki stage, led by the Society for Theatrical Reform. Campaigns were launched to cleanse the theater of overt eroticism and gore, to make its costumes and acting styles more historically accurate, and to persuade intellectuals to write morally edifying plays that would be suitable for the eyes of "women, children, and foreigners." The campaigns were not entirely successful, but nevertheless

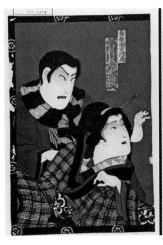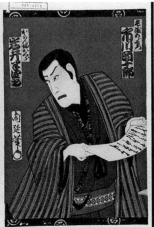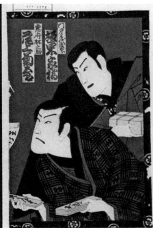

Advertisement for the production featuring Ichikawa Danjūrō IX (center), Ishikawa Sadanji I (far left), and Iwai Hanshirō VIII (second from left). (National Theater, Japan Arts Council, Tokyo)

the image of kabuki had changed sufficiently by 1887 for performances to be mounted for the emperor, empress, and foreign dignitaries. While some within the theater saw these campaigns as a chance to raise their social status, audiences were less enthusiastic, however. In the plays created in this period we can discern conflicting impulses—toward classicism and respectability on the one hand and toward the desire to continue to depict the changing social realities of commoner life on the other.

These impulses are best visible in the new genre known as "cropped-hair plays" (*zangirimono*)—a name taken from how these plays used costumes and hairdos in the new Western-influenced styles. Kabuki had always thrived on its representation of the contemporary, from political scandals and horrific crimes to the depiction of new fashions. Cropped-hair plays were essentially a continuation of this tradition, with actors keenly studying the mannerisms and styles of dress of new, fashionable professions such as policeman, lawyer, or newspaper reporter. Plots began to turn on the arrival of telegrams, or according to the schedules of steamships and railways—in much the same way as e-mail and mobile phones became central to the plots of Hollywood films in the 1990s.

Those plays have been criticized for their obsession with the visible symbols of modernity, while continuing to construct plots that followed the theatrical conventions and moral logic—reward virtue and punish vice—of the Tokugawa period. The late nineteenth century was a complex period, however, and many cropped-hair plays managed to sensitively capture the

realities of a period of social, political, and moral uncertainty. The hybrid nature of the visual language of those plays, with characters wearing bowler hats and carrying umbrellas while still wearing kimono in traditional patterns, is reflected in the push and pull between the values of the past (the importance of sincerity, generosity) and those of the present (the primacy of money) that are readily apparent in many of the genre's plots and themes. We can see the same push and pull in the staging of these plays: on the one hand, exotic locales and costumes that represent modernity, sometimes in unsettling ways; and on the other, playwrights referencing the theatrical past and deliberately retaining old theatrical techniques in order to reassure the audience. In *Money Is All That Matters in This World* (*Ningen Banji Kane no Yo no Naka*), for example, during the will-reading scene, Usuemon and Gorōemon play out a brief parody of the famous play *The Subscription List* (*Kanjinchō*), in which a priest, Benkei, reads from a blank scroll an impressive statement of purpose for his fund-raising campaign. Similarly, the play contains several examples of "passed-along dialogue," a vocal technique in which a single speech is split up between several characters speaking in succession.

The most prolific author in this genre was Kawatake Mokuami, the preeminent kabuki playwright in Tokyo during his day. Mokuami made his name writing plays about thieves, pickpockets, and murderers, nimbly capturing both the grim reality of underclass urban life in the 1850s and 1860s, but also casting the romantic, self-actualizing spell that these kinds of criminal-heroes cast upon contemporary audiences. In the Meiji period, he tried to keep up with a new, radically changed world by writing both cropped-hair plays and a new type of realistic history play known as "living history."

Money Is All That Matters in This World is one of the best known of Mokuami's cropped-hair plays, and it was also the first modern Japanese adaptation of a foreign drama, based on Edward Bulwer-Lytton's (1803–1873) 1840 comedy, *Money*. Mokuami's play opened on February 28, 1879, at the Shintomiza Theater in Tokyo, with Onoe Kikugorō V (1844–1903) in the role of the orphaned Efu Rinnosuke, Nakamura Nakazō III (1800–1886) as his avaricious uncle Henmi Seizaemon, and Ichikawa Danjūrō IX (1838–1903) as the bequest-dispensing merchant Keori Gorōemon. Keen-eyed readers might notice that the unusual names of some of Mokuami's characters contain hidden references to Bulwer-Lytton's originals—Efu Rinnosuke for Alfred Evelyn, Okura for Clara, and so on. Mokuami's version is in two acts, and the scene translated here takes place at the end of the first act. It shows how the orphaned Rinnosuke, long dependent on his avaricious Uncle Seizaemon and Aunt Oran, comes into an unexpected inheritance. The second act follows Seizaemon as he tries to get his hands on the inheritance by marrying his shallow, greedy daughter Oshina to Rinnosuke.

The play ends happily, as Rinnosuke sees through his uncle's plot and instead decides to marry the orphaned Okura, another miserably treated dependent of his uncle.

Several stage directions, mostly to do with costume, have been added, based upon information introduced in earlier, untranslated scenes in the play.

☙(AC)❧

Characters

HENMI SEIZAEMON, master of the Henmi Shipping Company in Yokohama

KEORI GORŌEMON, merchant from Yokohama and relative to the late Monto Tōemon

TŌTARŌ, clerk to Monto Tōemon

MŌHACHI, chief clerk at the Henmi shipping business

ORAN, SEIZAEMON'S wife

OSHINA, SEIZAEMON'S daughter

OEI, their maidservant

EFU RINNOSUKE, nephew to **SEIZAEMON**

GARATA USUEMON, relative to Monto Tōemon

YAMAMOTO TŌSUKE, relative to Monto Tōemon

OKURA, niece to **ORAN** and daughter of Monto Tōemon's friend Kurata Sōemon

(To offstage music, the stage rotates to reveal a formal reception room at the Henmi Shipping Company. To stage left and right are small rooms, with sliding doors. To rear left is an alcove with staggered shelving, and to right a plastered wall with a sliding paper-screen window above. GORŌEMON sits in the center, holding the will. To his left sit SEIZAEMON, ORAN, and OSHINA, to his right the clerks TŌTARŌ and MŌHACHI. The men all have cropped Western-style hairstyles, and they wear short jackets over their soberly striped, darkly colored kimono. MŌHACHI wears an apron over his kimono. The white-haired ORAN also wears a dark kimono with a short coat. OSHINA has her hair tied up in a Shimada-style chignon, and she wears a colorful long-sleeved kimono, both appropriate for a teenage girl.)

SEIZAEMON: In any case, why don't you unseal the will and read it out?

GORŌEMON: Absolutely not. Propriety deems we await the arrival of all the late Master Tōemon's relatives before we proceed. To do otherwise might occasion who knows what complaints, and then I would have failed in my duties as executor to the deceased.

TŌTARŌ: In which case, is there any sign yet of Usuemon from Honmachi and Tōsuke from Ōtamachi?

MŌHACHI: I just sent the shop boy to hurry them along, so they should both be here presently.

ORAN: How will my poor heart stand this waiting till we find out how much our bequest will be?

OSHINA: Mine is pounding, just like when I play the lottery.

SEIZAEMON: Mōhachi, send the boy to fetch them again.

MŌHACHI: I already sent Nogematsu, and he's not back yet.

SEIZAEMON: A kid like that will never get results. You go yourself.

MŌHACHI: No need for that. They should be here any minute now.

SEIZAEMON: How long do you expect us to wait? I'm telling you to go, sir, so go!

MŌHACHI: All right, all right, I'm going. (*He stands up with great reluctance, but as he does so, the sliding doors to stage right open and the maidservant* OEI *enters.*)

OEI: Sir, he's just come back.

ORAN: Nogematsu is back?

OSHINA: Has he brought the relatives with him?

OEI: No, madam, I meant that Master Rinnosuke has returned.

SEIZAEMON: Who cares about him!

GORŌEMON: Master Rinnosuke is related to the deceased, so he should be present. Please tell him to join us.

OEI: Yes, sir. (*Exits to stage right.*)

MŌHACHI: Fine, I'll go looking for them. (*He also exits to stage right, just as* RINNOSUKE *enters.*)

RINNOSUKE: Master Gorōemon (*bows*). Just now I heard in the shop that Uncle Tōemon has passed away, in spite of all the efforts of his doctors. Sad news, doubly so since I was prevented from attending his deathbed by the distance to Nagasaki. I can only offer my deepest condolences. (*Bows deeply to all.*)

TŌTARŌ: So you are Rinnosuke, the son of Master Efu? My name is Tōtarō, and I was a clerk to your uncle in Nagasaki. I am honored to meet you.

RINNOSUKE: Ah, so you're Tōtarō. I have heard mention of your name. After all your care and devotion to my uncle during his illness, it must have been a great blow that your only reward had to be his death.

GORŌEMON: Master Rinnosuke, you are a blood relative to the late Tōemon, his nephew, I believe. So, please, no standing on ceremony, come and sit here by me.

RINNOSUKE: That's far too elevated a position for the likes of me.

GORŌEMON: This is no ordinary occasion. For the reading of the will, the nearest of kin should sit in the best seats.

RINNOSUKE: In which case . . . Master Tōtarō, I beg your pardon.

(*He bows briefly to* TŌTARŌ *and passes in front of him, kneeling next to* GORŌEMON. *Meanwhile,* SEIZAEMON, OSHINA, *and* ORAN *sit and stand, fidgeting impatiently.*)

SEIZAEMON: Where are these blasted relations? That shop boy we sent as a messenger is useless.

ORAN: He's probably watching the foreigners playing billiards again.

OSHINA: Mother, shall I take a run over there and fetch them?

TŌTARŌ: There's no need to rush, I am sure they will be here soon.

(*Just then, voices are heard from behind the sliding doors at stage right.*)

MŌHACHI: Please, sirs, come through this way.

SEIZAEMON: Thank goodness! They're here at last.

(*An offstage melody plays as MŌHACHI enters, followed by USUEMON and YAMAMOTO TŌSUKE. Their dress marks them as prosperous merchants, sporting cropped Western-style haircuts and jackets over soberly colored kimono. RINNOSUKE catches sight of them.*)

RINNOSUKE: Now I definitely can't sit in this spot. (*He begins to rise.*)

GORŌEMON (*stopping him*): Stay where you are, just for now.

USUEMON: Seizaemon, what's all this fuss about?

SEIZAEMON: I sent two messengers to get you. What the devil took you so long?

USUEMON: Tōsuke sent word that he was going to come with me, so I was waiting for him to arrive.

TŌSUKE (*stepping out from behind*): Such an unexpected and tragic event. The poor deceased. I read your note with great concern, Master Seizaemon. To have lost your wealthy relation, Tōemon from Nagasaki. It must have come as a great blow to you all. And how bitter to be steeped in the tears of grief . . .

SEIZAEMON: Yes, yes, save the pretty formalities for later—they take so long.

ORAN: Yes, now that we're all assembled . . .

OSHINA: Let's hurry up and open the will!

GORŌEMON: No, there is one more relative not yet seated.

SEIZAEMON: No, I think this is all of us.

GORŌEMON: Kurata's daughter should be here as well.

ORAN: Okura? She is my niece. If there is any legacy due to the girl, I should rightfully receive it in trust.

OSHINA: Or I will, Mother.

RINNOSUKE: She is weeping in the next room. I'll call her in.

ORAN: There's no need.

MŌHACHI: It's no trouble at all. (*Calling out.*) Miss Okura, Miss Okura!

(*He calls her, and OKURA enters from stage right. Her hair is tied up in a chignon, and she is dressed poorly, with an apron over a shabby kimono. She looks tearful as she kneels down to stage right.*)

OKURA: Is there something you need?

TŌTARŌ: We are about to open the will and announce the late master's bequests. Since you are related by blood to him, please sit beside Master Rinnosuke.

OKURA: Oh no, I am perfectly happy here.

USUEMON: Now it seems like we are all present . . .

TŌSUKE: So, with no further ado, let's get on . . .

SEIZAEMON: With the reading of Tōemon's will.

GORŌEMON: I am not experienced with such duties, but since the will has addressed me as executor, I will take the liberty of reading it aloud.

(*A melody begins playing offstage. GORŌEMON sits formally in the center, with SEIZAEMON, USUEMON, ORAN, and OSHINA to his left, and RINNO-SUKE, TŌSUKE, TŌTARŌ, MŌHACHI, and OKURA to his right. GORŌEMON lifts the will, and the others strain forward to listen.*)

"The Last Will and Bequests of I, Monto Tōemon. Having moved to the port of Nagasaki some years previously for better business opportunities, I have been blessed with both good fortune and financial success. However, I have been struck down with a grave and unforeseen illness. Every attempt has been made to stay its course through treatment and medicine, but now

my time has surely come and I face the inevitable final journey to the next world. To my great regret and distress, I am alone in this world and have no child on whom I could bequeath my fortune. Neither have I relations on whom I could rely for support and succor, as they all live far off in my home province. Therefore, even now as I approach the end, my care has fallen to strangers and I face a lonely death. While my death is fate, still I find myself consumed with the bitterest of regrets."

(As they listen, SEIZAEMON, USUEMON, ORAN, and OSHINA put on a great show of grief.)

SEIZAEMON: Ah, poor, dear Tōemon, how pitiful. How he must have longed to see his beloved relations at the end.

USUEMON: When I heard he was ill, I had a premonition, and I bought gifts for him, intending to embark on the steamship tomorrow.

ORAN: What? You mean you already bought the presents?

OSHINA: That means that half of the cost of the presents that mother and I gave you has been wasted!

SEIZAEMON: And that too . . .

ALL FOUR: Is the bitterest of regrets.

RINNOSUKE: But what does he write next, Master Gorōemon?

TŌSUKE: What has he put down in the will?

TŌTARŌ: Just listening, I have tears rolling down . . .

MŌHACHI: And we are just getting to the best bit, so . . .

OKURA: Read on . . .

ALL: We pray you.

GORŌEMON: "Accordingly, I would have liked to bestow my personal possessions upon my nearest kin, but due to the distance from here to Tokyo, it will be more convenient to send my fortune via bills of exchange. I would be grateful if you could distribute them to the beneficiaries as

follows. First, to you as the nearest and dearest among my relatives, I would like to bequeath the sum of one thousand *yen,* and I dearly hope that you will accept it. Second, to Yamamoto Tōsuke of Ōtamachi I hereby bequeath the sum of fifty *yen,* in small recognition of his disinterested affection in always sending me newspapers after I moved to this distant part of the country. Third, to Usuemon of Honmachi, who claims to be my relation, but who neglected to send me even a single letter after I moved to Nagasaki until we began to correspond about business, please only tell him the news of my death."

(USUEMON hears this and despairs.)

USUEMON: Come now, Master Gorōemon, that surely can't be reliable. You get to feather your own nest, while I just get a message about his death? Are you sure you're reading it right?

GORŌEMON: Do I look like Benkei in *The Subscription List,* making up something that isn't written here? If you have doubts, please read for yourself. *(Holds out the will to* USUEMON, *who studies it very carefully.)*

USUEMON: Blast him! If I had known he was going to do this, I would have sent him a letter or two.

SEIZAEMON: My bequest must be coming next. I am surely the dearest among his relations, looking after poor orphaned Rinnosuke and Okura as I am.

ORAN: But he already said at the start of his will that he would give one thousand *yen* to the nearest and dearest relative, and that was Master Gorōemon . . .

OSHINA: So the market rate for us must be one hundred *yen* or so.

SEIZAEMON: I hear that his entire fortune amounts of tens of thousands, so let us remain hopeful. Please read on, Master Gorōemon, and let us hear the remainder.

GORŌEMON *(taking up the will once more)*: "Since my father's time, our family has enjoyed the fondest bonds of intimacy with Kurata Sōemon of Honmachi, who was engaged in the raw silk wholesale trade but passed away some two years ago. To his daughter Okura, I hereby bequeath the

sum of one hundred *yen*. After her father's death she became the dependent of her aunt in Sakaimachi, and I felt the greatest pity for her situation. From our close bond of familial affection, I wished to see her settled in a more comfortable position, therefore I presume upon your best offices, Gorōemon, to find her a suitable husband."

ORAN: He's given my niece Okura one hundred *yen*!

OSHINA: And those who come later can expect much more!

OKURA: Poor uncle Tōemon, for your pity and generosity, I offer my thanks.

TŌTARŌ: That leaves just Master Rinnosuke and this household. I wonder what bequests he has made to each? Even I cannot guess what my former master was thinking.

SEIZAEMON: It's just like the final moments in a raffle. Due to my advancing years I have a constant ringing in my ears, so please Master Gorōemon, read the rest in a loud voice.

GORŌEMON: "Next is someone to whom, ever since I moved to Nagasaki I have often sent letters and gifts of local delicacies in the winter and summer seasons, yet not once has he ever replied. To call him unfeeling would be an understatement. To him, I bequeath the sum of three *yen*."

(*As GORŌEMON reads, SEIZAEMON begins to wriggle uncomfortably.*)

SEIZAEMON: Come now, Master Gorōemon, surely he means young Rinnosuke here?

GORŌEMON: No, it clearly says, "To Henmi Seizaemon, his wife, and daughter."

(SEIZAEMON, ORAN, *and* OSHINA *cry out in shock.*)

SEIZAEMON: There's a time and place for jokes!

GORŌEMON: I'm not joking. That's exactly what it says. (*He holds out the will to SEIZAEMON, who reads it in obvious desperation.*)

ORAN (*anguished*): My dear . . .

OSHINA: Daddy . . .

SEIZAEMON: Blast and confound him! (*He snatches the will and throws it on the floor.*)

TŌSUKE: So, just how much has he left to young master Rinnosuke, then?

MŌHACHI: If they've only got three *yen,* I guess that means nothing for me.

OKURA: Please, read the rest.

GORŌEMON (*picking up the will*): "In stark contrast to his unfeeling uncle, my nephew Efu Rinnosuke has proved his affection and love for me over many years by his diligent correspondence each month inquiring after my health. While he is still in the green flush of youth, the depth and thoroughness of his feeling is impressive. Since, in addition, he is my only nephew, I hereby bequeath to him the sum of twenty thousand *yen.*"

(*On hearing this SEIZAEMON jumps to his feet.*)

SEIZAEMON: What? Twenty thousand *yen* you say?

(*He collapses from the shock, causing an uproar. ORAN and OSHINA rush to his side to aid him.*)

ORAN: Dear, what's the matter?

OSHINA: Daddy, Daddy!

MŌHACHI: They say you can cure that by putting a slipper on his head.

(*He grabs a slipper and puts it on SEIZAEMON's head, tying it in place with a towel*).

ALL (*calling his name*): Seizaemon, Seizaemon . . .

ORAN: My dear! What happened to you!

OSHINA: It looks like he is having a fit.

ALL RELATIVES: Wake up, Seizaemon!

OSHINA: Stay with me, Daddy!

SEIZAEMON (*coming to*): I'm not dead yet! I'm fine, I'm fine.

USUEMON: So, young Rinnosuke ends up with a twenty-thousand-*yen* inheritance from his uncle.

GORŌEMON: He does. No mistake about it. (*Holds out the will to them.*)

ORAN: Now I really do feel devastated.

OSHINA: Mom, I do, too! (*They both wail.*)

RINNOSUKE: Twenty thousand *yen*—I have never even dreamed of such an amount. By giving me this legacy, he must mean for me to restore my family name. I am quite overcome by my uncle's boundless compassion and affection.

TŌTARŌ (*reaches into his kimono to pull out the money orders*): Since it is such a large amount of money, I have taken the liberty of preparing a money order for each of you. I will now distribute them to the beneficiaries. (*Passes the money orders to* RINNOSUKE, OKURA, *and* TŌSUKE). And this one for three *yen,* this is for you Master Seizaemon. (*Places it in front of* SEIZAEMON.)

SEIZAEMON: Ehh, what do I want with this! (*He grabs it to throw it to the floor, but* ORAN *and* OSHINA *hold him back by his sleeves. After a moment of thinking*) But it's better than nothing. (*He stuffs it inside his sleeve.*)

GORŌEMON: It was no less than I would have expected from Master Tōemon.

TŌSUKE: A just disposition of rewards and punishments . . .

TŌTARŌ: The ruined Efu house restored . . .

RINNOSUKE: I am still speechless with joy . . .

OKURA: Such a happy day!

SEIZAEMON: Ha, a happy day for you two!

ORAN: While we have nothing at all to rejoice about.

OSHINA: For us such a miserable day!

USUEMON: And after I bought all those gifts for him, too.

MŌHACHI: Such are the lessons of avarice.

USUEMON: Bah!

MŌHACHI: I think you should leave.

USUEMON: I don't need you to tell me what to do. I'm leaving by myself.

GORŌEMON: Well, then, relatives of the late Master Tōemon . . .

TŌSUKE: Now we will take . . .

TŌTARŌ: Our leave of you.

RINNOSUKE: Master Gorōemon, these money orders . . .

OKURA: We entrust to you. (*Both hold their money orders out to* GORŌEMON.)

SEIZAEMON: No, let me look after them for you. (*Goes to take them, but* GORŌEMON *snatches them away.*)

GORŌEMON: No, the last wishes of the deceased . . . (*He stands, holding the money orders, and, just at that moment, a single wooden clack rings out to signal the end of the scene*) must be honored.

(*GORŌEMON smiles. SEIZAEMON, ORAN, and OSHINA gaze with undisguised greed at the money orders, while RINNOSUKE and OKURA beam with happiness. They freeze into a mie pose as the curtain closes to the strains of a lively fisherman's song accompanied by a xylophone from offstage.*)

TRANSLATED BY ALAN CUMMINGS

Oppekepe Rap

PERFORMED BY KAWAKAMI OTOJIRŌ

UKIYO-E ILLUSTRATION BY NAGASHIMA SHUNGYŌ (ACTIVE 1850–1907)

 "Oppekepe Rap," first performed in 1891 by Kawakami Otojirō (1864–1911), was one of the most popular protest songs of the Meiji period. The disarming playfulness of the piece, best exemplified by the ludic refrain "oppekepe, oppekepeppō, peppōpō" (an onomatopoetic expression suggesting percussive beating), channels feverish pitches of wit and wordplay to become a scathing critique of politicians and high society. While many versions of the song exist, with the earliest dating to 1889, Otojirō's version stands as perhaps the most powerful expression of moral indignation at the economic inequities and political corruption that plagued Japan during the years leading up to the First Sino-Japanese War (1894–1895). In this respect, it anticipates, albeit in a different time and cultural context, the most powerful anthems from contemporary hip-hop.

The moral perspective of "Oppekepe Rap" is grounded in the ideals of the Liberty and Civil Rights Movement, a grassroots social and political campaign for democracy that gained force during the 1880s. While the movement provided the impetus for the adoption of a constitution in 1889, the formation of a national legislature in 1890, and for language reform, it was suppressed by the government before its core ideals of freedom, democracy, and human rights could fully be realized. Otojirō was no stranger to this movement, nor to the widespread sense of disappointment and disillusionment that set in after its demise. Having moved to Tokyo from Fukuoka in his teens, he became a student and political activist. Under the influence of political theorist and statesman Nakae Chōmin, one of the central thinkers of the Liberty and Civil Rights Movement, Otojirō began staging theatrical productions as an outlet for his political views.

Otojirō's version of "Oppekepe," which he performed as the opening act to many of his theatrical productions, roused audiences with its powerful affirmation of democratic ideals and its unfettered criticisms of the political establishment. At the same time, the song warns against confusing materialistic affinity for Western things with real ideological commitment to progressive ideas. To that end, each segment is conceived as an accusatory address to an imaginary figure, and to the underlying social, economic, or political problems that he or she personifies. In the third stanza, for example, a high-class woman is criticized for indiscriminately embracing all of the trappings of Western culture—from Western hairstyles to Western

cuisine—and using this to project an authority on philosophical matters like Enlightenment, about which she probably knows nothing. In the second stanza, the narrator delivers an unrelenting attack on an opportunistic investor who has benefited from the rampant commodity inflation of the 1880s, highlighting the consequences of his greed for the fiscal health of the nation. Reflecting the narrator's lack of faith in the moral order of his own society, he projects a scenario in which this scrooge is damned to hell for his misdeeds, delivering a strict moral remonstration that the man presumably never would have otherwise received in Meiji Japan.

While "Oppekepe" does not explicitly endorse the abolition of prostitution, a hotly debated topic in newspaper editorials and intellectual circles of the time, it does insinuate associations between prostitution and other societal problems—namely, economic exploitation and political corruption. The force of this social criticism is sustained by the authenticity of its details. The depictions of prostitutes in stanzas four, five, and six all display Otojirō's intimate knowledge of his subjects, from how they wooed clients to how they wore their hair. Otojirō refers, for example, to the cheap version of the Shimada chignon sported by many prostitutes of his day—an approximation of the traditional geisha style, in which the hair was gathered at the top of the head in a large bun and brushed back at the sides. Less flattering is his reference to the women of the "Cat House," following popular slang expressions of the time likening prostitutes to cats. Otojirō seems to take special delight, however, in divulging the more sordid secrets of the brothel quarter, as when he reveals how the procuress secretly pawns her girls' accessories to maintain her finances.

According to the moral of the song, sexual indiscretions—be they with geisha, married women (the "women with shaven brows" indicated in stanza six), or kabuki actors ("men with bulgy eyes")—carry a real danger: namely, that they distract from civic responsibility. Otojirō's criticisms of philandering politicians, who are more interested in extramarital affairs than affairs of state, target well-publicized scandals involving figures like Itō Hirobumi (1841–1909), one-time prime minister of Japan. Ironically, it was Itō who first introduced Otojirō to his future wife, the popular geisha Sadayakko (1871–1946), whom he married in 1891.

In many ways, 1891 was a consequential year for Otojirō, for it was also during this year that he formed his new theater troupe in Tokyo and began doing barnstorming performances throughout the surrounding areas of Yokohama, Shizuoka, and Sendai. He promoted his new, avant-garde form of kabuki performance, which was billed simply as "kabuki." Sadayakko quickly became an integral member of the troupe, traveling on tour and performing various roles on stage. In 1899, the troupe set sail for the United

States, where it presented performances in Chicago, New York, Washington, DC (with President McKinley in attendance), and Boston. On the heels of their enthusiastic reception in America, the troupe was invited to perform at the Paris Exposition in 1900, and then again before various dignitaries and members of royalty (including the Prince of Wales and Czar Nicholas II) during their European tour the following year. Otojirō and Sadayakko created a sensation everywhere they appeared, in part because of their exoticism, but mostly for their lively performances. These tours demonstrated that Otojirō was equally adept at playing the role of cultural ambassador abroad as he was at playing the provocateur at home. After returning to Japan, Otojirō maintained his commitment to touring, but most of the plays he staged were adaptations of Shakespeare, not the overtly political plays of his earlier years. Perhaps the most fitting testament to Otojirō's commitment to theater was that he kept at it to the very end, literally dying in the middle of a performance in 1911 at the age of forty-seven.

The woodblock print illustration published with this translation provides a lively depiction of Otojirō in character. During stage performances of "Oppekepe," Otojirō is known to have donned an ensemble consisting of a warrior's waistcoat, a headband, and a formal skirt for men—traditional dress of samurai warriors that served, in this performative context, as a fitting display of Otojirō's militant opposition to political corruption and economic inequality. Borrowing a stage trick of *rakugo* raconteurs, Otojirō sported a folding fan decorated with a rising sun, presumably to fan the flames of patriotic pride, as well as a kettle for serving out the cups of liberty promised in the opening lines. In the print media of the day, Otojirō is referred to as a "Lead Performer of the Student Theater"—a sobriquet given to Otojirō by journalists when they covered his first performance of "Oppekepe" in Yokohama.

(**DM**)

THE OPPEKEPE RAP

A new piece by Kawakami, giving a sneak peek into today's world

All ye who scorn people's rights and prosperity—
Step right up and take a hot swig of liberty!
Oppekepe, oppekepeppō, peppōpō!

Men of the world, you've shed your old hides
For mantles and trousers and rickshaw rides.
Women, you wear bonnets with your hair cropped short.
Made up like ladies and gents of a high-class sort.
That finery of yours may be easy on the eyes,
But it can't disguise your politics of lies!
Wake up to the truths of heaven and earth!
Sow the seeds of freedom in your hearts!
Oppekepe, oppekepeppō, peppōpō!

Today, you grow fat on commodity inflation,
Not giving a damn about the poor of our nation.
Hiding your eyes 'neath the brim of your bowler,
Gold watches, gold rings—you're an effing highroller.
Dressed to the nines, you bow to the politicians,
Then dole out your coin on geisha and musicians.
Is this the same scrooge who stockpiles rice?
While letting his fellow countrymen die off like mice?
It's one thing to be a heartless old miser, but do
You have to be such a wicked old kaiser?
Take all of your treasures and go straight to hell!
When you're standing before Enma, there'll be truth to tell!
Think you can bribe your way into paradise?
If you think that'll work, you'd better think twice!
Oppekepe, oppekepeppō, peppōpō!

You say you know nothing 'bout your hubby's line of work,
Yet that 'do on your head is a perk from that jerk.
You hug foreign dogs, use words like "enlightenment,"
But that won't settle what you owe on your rent.
You're a know-it-all poser, too dumb to discern
The smell of what's right from what's simply Western
You say you've lost your taste for Japanese wine,
Only beer, vermouth, or brandy when you dine.
Down the chute, too, goes that strange foreign grub,
Which you can't bear to stomach but never dare snub.
Then, ever so discreetly, you barf it back up,
Put on a straight face, and sip coffee from a cup.
Tell me, now! Is that ridiculous or what?
Oppekepe, oppekepeppō, peppōpō! ►

"Otojirō in a pseudo-samurai getup with fan in hand as he performs Oppekepe."

If I had my way, I'd wash everything clean!
I'd free Japan of all that's filthy and mean!
Oppekepe, oppekepeppō, peppōpō!

In the cathouse, every whore's got her locks
Done up in a Shimada to prowl round the blocks!
How chic that you wrap your shoulders in sable
And get dolled up in fancy foreign labels!
You've paid a pretty penny to make the boys purr
And to look hot in the summer, decked out in fur.
But your old mother hen, she's the sharpest of all,
She's got more up her sleeve than your fancy ol' shawl
Why, she hocks shit out of season to pay for it all!
Oops! Guess I shouldn't let that one out of the cage!
You see, things can get crazy when I take the stage.
Oppekepe, oppekepeppō, peppōpō!

Ain't nothing so unenlightened, I'd venture to say,
Than to take a hooker to see a morality play.
How can she learn "punish evil, praise the just,"
When all she sees are scenes of passion and lust?
Watch her now, she'll give you the cold shoulder
And go off, arm-in-arm, with some other lover.
Ladies and gentlemen, why all this cheating
When our National Assembly is supposed to be meeting?
Stop fooling around with your kabuki friends!
It's on you that the fate of our country depends!
If women with shaven brows are your thing,
Then find yourself a leper and give her a ring.
Or if men with bulgy eyes are what you're after,
Then jump into bed with a horny ol' badger!
Oppekepe, oppekepeppō, peppōpō!

Poor old man, bedraggled as his bedding,
Looks to drive his daughter to a high-class wedding.
Oppekepe, oppekepeppō, peppōpō!
Here comes the bride, in a shawl of the finest taste,

Carted around by her pop, a blanket round his waist.
Both are looking to take their passengers for a ride,
With the girl scheming to turn tricks on the side.
Don't glance back as your daughter gets hitched!
Wait for the ride back home to make your pitch.
One wrong turn and you'll flip this cart into a ditch!
Oppekepe, oppekepeppō, peppōpō!

You learned Western words, but not what they meant.
Simply eating bread won't bring enlightenment.
You want to know the urgent business at hand?
Bringing freedom to all the people in our land!
What we need is vision, not more bureaucracy.
Your inept leadership has us all feeling antsy.
Let's move to the forefront of science and innovation,
And show those foreign powers they're no match for our nation!
In the name of our sacred land—Japan! pō! pō!

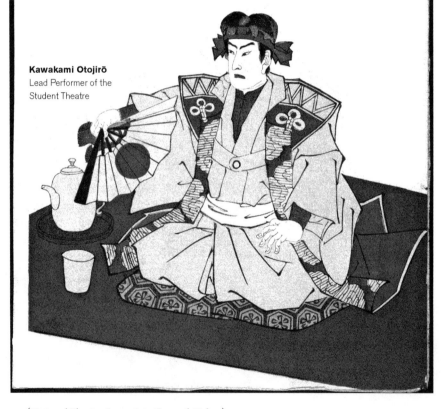

Kawakami Otojirō
Lead Performer of the
Student Theatre

(National Theater, Japan Arts Council, Tokyo)

TRANSLATED BY DYLAN MCGEE

In Darkest Tokyo

MATSUBARA IWAGORŌ

Matsubara Iwagorō's (1866–1935) *In Darkest Tokyo* (*Saiankoku no Tokyo*) was an immediate success. Ten days after it first appeared on November 9, 1893, it was printed a second time. Three months later, it was issued again. Numerous reviews praised its realism and freshness, and, in 1897, a partial English translation published by a certain F. Schroeder, editor of the weekly *Eastern World,* introduced this Japanese best seller to English readers.

In Darkest Tokyo is a firsthand account of the slums of Japan's new capital. Matsubara himself did not naturally belong to this world of day laborers, itinerant entertainers, and pilgrims, but he was poor. Like so many other Meiji-period writers, he came to Tokyo from the countryside (Tottori Prefecture in this case) to make a living as a self-made literatus and intellectual. He was fortunate enough to make the acquaintance of the influential writer Kōda Rohan (1867–1947), and to be hired by Tokutomi Sohō, brother to Tokutomi Roka, as a staff writer for Japan's first general newspaper, the *Citizen's News* (*Kokumin Shinbun*).

In order to write about the denizens of darkest Tokyo, Matsubara chose to live and work with them. This hands-on approach was the very reason Sohō employed him. His up-close-and-personal account of life among Japan's urban poor on the eve of the Sino-Japanese War (1895) was groundbreaking. Yet it was not exactly as he claimed: an account "of things never before seen, . . . and my observations of them necessarily unprecedented and novel." There were precedents.

Realism was central to the development of modern sensibility, and an evolving realistic impulse had already begun to widen the sphere of literary topics. Before Matsubara's *In Darkest Tokyo* was Sakurada Bungo's (1863–1922) *The World of the Poor, A Recorded Investigation of the Slums of Hunger and Cold* (*Hintenchi Kikankutsu Tankenki*) and two other journalistic pieces. Sakurada's study of the urban poor was serialized in the progovernment newspaper *Japan* from August to November of 1890, and was published as a book in June 1893. Matsubara's similar study was serialized from November 11, 1892, in *Citizen's News,* and was added to and published as a monograph in November of 1893 by Min'yūsha Press. Today, both books are considered early classics of progressive thought.

If *In Darkest Tokyo* is the more notable of the two, it is because it influenced not only socialist thought but also literary realism. Writing in

the first person about Tokyo's dark side, Matsubara was a precursor to naturalists such as Tayama Katai, who would follow ten years later with "human-nature-revealing" confessional I-novels. If Matsubara's work has been delayed in its consideration as a literary text, it is probably because the darkness that Matsubara both describes and lyrically evokes in *In Darkest Tokyo* is pointedly political and journalistic. It is reportage (*kiroku bungaku*) rather than the more dramatic "grief novels" (*hiai shōsetsu*), "serious novels" (*shinkoku shōsetsu*), and "conceptual novels" (*kannen shōsetsu*) that pointed out life's bitter realities during the latter half of the 1890s. As rediscovered here, it points forward to not only naturalist texts but also to the proletarian literature of the 1920s.

In style, the work is high yet low, rhetorically elevated yet focused on the mundane. Its prose is rich in Chinese characters and grammatically confusing in the way so many Meiji-period texts are in their trial-and-error evolution toward what eventually came to be modern Japanese literature. By this point in time, illustrations enhance the text rather than vice versa, but the inclusion of figures was still deemed essential. The images included here were created by the Kubota Kinsen (1875–1954), who was active in the genre of Japanese-style painting (*nihonga*). He was still in his teens at the time of their creation. His father, the well-known painter Kubota Beisen (1852–1906), was staff illustrator for the *Citizen's News* and drew a salary seven times that of Matsubara's.

Both the Min'yūsha Press and *Citizen's News* were owned by Sohō. Populist in thrust, they were a thorn in the side of the first Matsukata Masayoshi administration, persistent in their criticism of corruption and scandal. Following the war with China, however, which Matsubara had covered as an overseas correspondent and written about in his *My Account of Calvary Dust* (*Seijin Yoroku*, 1896), Sohō was appointed, in 1897, to be a member of Matsukata's second administration, which lasted less than two years. Feeling betrayed by Sohō, many readers of the liberal *Citizen's* turned away; and Matsubara and numerous others on the staff were let go. The paper itself continued until 1929, becoming increasingly conservative and eventually aligning itself with the Meiji oligarchs.

Matsubara landed on his feet, finding work at Ōhashi Otowa's Hakubunkan Publishing Company as a writer and editor. He edited and contributed to *A True Record of the Eastern War* (*Tōyō Sensō Jikki*), an account of the Boxer Rebellion of 1900, then became the editor of the monthly magazine *Girl's Education* (*Jogaku Sekai*) in 1901, a job he continued to do for the next sixteen years. In addition to journalistic pieces, Matsubara wrote short stories and novels. But it is *In Darkest Tokyo* for which he is remembered. The translated portion here comes from the early chapters, where he is settling

in—spending the night in an insect-infested lodging house and finding employment at a shop that sells leftovers to the hungry masses. In later chapters, he goes on to report on the lives of money handlers, thieves, rickshaw pullers, and others. The industrial boom that followed the Sino-Japanese War was yet to come, so Matsubara does not describe male factory workers or the many young women who contracted tuberculosis as they labored in the silk mills that earned Japan a place in the international economy.

⁀(CSI)⁀

TO SLEEP OUTDOORS OR IN A CHEAP LODGING HOUSE

To speak of armies of mosquitoes and fleas is to fall back on the usual clichés. In truth, I am at a loss for words to describe the noisy attacks of mosquitoes and the unbearable fleas and lice that I experienced during my stay in a cheap lodging house. All night long, I rubbed my sleepy eyes. I slapped my neck, rubbed my underarms, reached around to my back, scratched my legs, sat up to the left, rolled to the right, tried getting up, tried lying down, stood up, shook out my clothes. Endless discomfort made my mind a blur. Unable to sleep, I spent the entire night tossing this way and that. Truly, this is the reality of life in the slums.

Although I wanted to wash up in the morning, there was no decent washbasin for me to use. The only thing available was a rusted tin pan sitting beside the outhouse, along with a small pail for scooping up warm dirty water. I felt no desire to use either, even to rinse out my mouth, so I exited as

Instruments of the poor: wooden boards are used as shoes (Collection of Yasunori Tan-o)

soon as the front door opened. I ran at full tilt this way and that, breathing the fresh air until I located a well where I was finally able to wash my face.

As a student of poverty, I presented a most cowardly figure. Seeing so many things for the first time, I found myself astonished by the monstrous quality of life in the slums. I was afraid even to be near the old candy peddler who picked lice from his body and crushed them with his teeth. How, then, was I to have the wherewithal to care for some beggar stricken with leprosy? My single night of sleeping in the lodging house filled me an endless desire to be outdoors with the soft grass for my bedding. Think of it. How can even the relatively well-off day laborer or construction worker, these men with the strength of demons and bodies of steel, afford to pay the three *sen* per night for a spot in one of these hovels, seeing how they cannot pay for three meals a day or for clothes?

Of course, even though accosted by fleas, lice, mosquitoes, stench, fetidness, and oppressive heat, one finds that a place indoors has certain advantages over even the soft, cool, beautiful luxuries of a natural bed. What is more comforting than being able to enjoy the vagaries of the weather, and to experience the sheer elegance of that one night in a thousand spent upon a bed of grass? Still, even though one cannot argue against the luxury of nature's soft verdant mattress, one must admit that, when used night after night, such a bed would become nothing but dew-drenched thorns. While the challenge of being pickled alive in a foul steam of malodorous bodies is something one might be able to endure, it is quite impossible to tolerate for long the lonely vastness of earth and sky, where one's only friends are the stars in the dead of night. Indoors, the attack of mosquitoes and fleas poses a suffering that is great indeed, yet even this is not so terrible as the disgusting feeling of snakes, frogs, and toads crawling around in one's bed.

Come to think of it, Saigyō, that wandering holy man of old whom I held in my heart as one who had accomplished true freedom, said in a poem, "My only friend / is the moon of this winter night— / seen after the storm / in my lonely dwelling / among the mountains." Then there is Bashō's song of the bright moon, also a masterpiece that is forever upon our lips. Gazing at the brightly shining moon in the clearing sky at morn, he too went through the trouble of carrying a big pack on his shoulder. I myself was looking forward to a dream world of travel—hat in hand, leaning on my walking stick. But, thinking of that now, I must say that I have fallen to the level of ordinary men. Even if one lived alone in a "deep mountain village" with nothing to eat, one would not feel much poetry in one's bones. Even if I were to wander around a pond all night while observing the bright moonlight, I would not take in and retain such a beautiful sight unless I had a hut or bed to give me rest. Even Saigyō, upon sleeping under the stars for three nights in a row,

would begin to yearn for a spot in a boarding house. As for Bashō, were he to spend three nights gazing at the moon, he too would lose his dislike of a rented roof, even with its army of mosquitoes, its fleas and lice.

Ah, the cheap lodging house. The day laborer, the construction worker, and the temporary hand—these bachelors of the boarding house are not unlike Saigyō on the third night. And had they experienced Bashō's third night on the road, they would also yearn for a resting place among fleas and lice. Heat and stench are meaningless to them. Neither do they complain about being treated like animals, given one mat per person to sleep on, or even crammed ten people into a five- or six-person room. For them, such a communal space is a jeweled platform on which to lie down and to spread one's body; it is a place to recover from fatigue and to gain energy for the next day. Determined to live a hundred years, such people consider a torn futon to be a brocade quilt, and a piece of discarded lumber to be Kantan's miraculous pillow of dreams.

HOUSING AND FURNISHINGS

As I thus considered various theories about the pros and cons of spending the night under the stars versus in a cheap lodging house, I wandered from hovel to hovel. Finding a home proved to be a real challenge. First of all, I had no idea about where I was going. Second, I lacked a magic compass that might point me to exactly the right place. Coming to the conviction that studying various people's means of livelihood would provide the most efficient way to proceed, I made my way through this and that corner of the slums, letting no place escape my investigation. In this way, I happened to stumble upon numerous objects of such intricacy and beauty as I had never before encountered in all my days, not at any exhibition hall, demonstration space, or studio. Truly, I had never before seen such marvelous natural objects, such wonderful manufactured goods, such surprisingly impressive handmade articles.

Dear reader, do not laugh. For life is truly sacred, and poverty is a most solemn reality. There is no great distinction to be made between the fancy balls held at the Deer Cry Pavilion and the commotion that takes place in the kitchens of the poor. On the other hand, laughing at the silliness of fancy balls is mere rudeness, while laughter directed at the kitchens of the poor must be called cruelty of an extreme sort. Ah, what do we know about the homes of the poor? What do we understand about their possessions, their clothing, their food? What we do know about how they live?

Dear reader, I must leave a great deal to your imagination. For until now, the domiciles and furnishings of the poor have not been captured in

pictures nor recorded in any book. In today's world, although we have no shortage of exhibitions, art shows, and conventions, the dwellings and possessions of the poor have never been accurately represented. The world has its share of renowned painters who have given us images of ladies playing instruments, nobles feasting, flowers and birds, mountains and streams; yet none of them has ever depicted the furnishings of the poor. Similarly, the world has many great writers who have written enthusiastically about talented men of letters taking baths, beautiful women being given in marriage, and of So-and-so Kusunoki waging his noble battles. But has anyone ever written about actual living conditions? This reality is not to be seen at any exhibition or convention. It is not depicted by any painter nor described by any novelist. As a special world of things never before seen, such matters are entirely new, and my observations of them are necessarily unprecedented and novel.

Precisely because of the possessions of the poor, my eyes and ears have received a baptism. Ah, the shacks of the indigent are little more than enclosures of boards, nine feet across, and situated in places dilapidated beyond description. The floors are low to the ground; the uprights barely enough to support roofs that seem ready to fall in at any moment. Their tatami mats are tattered around the edges and have straw protruding from their corners; yet, just the same, they receive the crowds of people who kneel upon them. From the walls hang Buddhist altars tied up with ropes, and from the ceiling dangle consecrated baskets that house the gods. With such objects, the denizens of the slums maintain their enduring devotion to the deities and spirits.

Most surprising are their household items, things one might well call "prized possessions." I speak of earthen pots as forlorn as a leper's countenance, kettles with rims broken like old roof tiles, serving trays without edges, bowls with chips in them, every one. A broken bowl for grinding sesame seeds has been made to serve as a hibachi for heating. A vase's cracks are patched over so it somehow holds water. And what of the umbrella, this essential instrument of daily use? Its spokes are patched with rags of every sort, so that the mechanism can barely open and close. As for footwear, the clogs of the poor are nothing but pieces of wood tied with rope, and patches of bamboo strips strung together and fastened to the feet. Perhaps bedding is the best example of the lack of daily necessities that plagues the poor. The very quilts that serve as portals to the mysterious world of sleep are painstakingly patched together from old towels, bundling scarves, and scraps of fabric taken from old umbrellas, all pieced together in a way that keeps their cotton stuffing from falling out.

Such are the day-to-day objects of the poor. People of the world might laugh at such extreme neediness; and no doubt there are those who find the lives of the poor amusingly colorful. Still, think for a minute of the suffering that makes these lives supposedly like a comedic scene. Truly, the poor are forced by their daily lives to express such indigence; and their need causes them to live in a way that might seem comical to others. Yet know that every aspect of their existence is circumscribed by the word "need." That is, everything about their lives occurs within the realm of dire exigency. The poor, are they not simply managing their affairs in order to cope with a trying situation?

From pieces of wood and rope come clogs. Is this not their way of dealing with need? With strips of paper and glue, they patch up the cracks in the earthen pots with which they cook. Is this not their miserable resourcefulness at work? Those who are not moved by the misery that inspired the sculptures of Michelangelo or Left-handed Jingorō are said to lack the ability to understand art. Consequently, we must consider cruel the derisive laughter of those who look at the possessions of the poor and, without understanding the inspiration behind them, dismiss them as clumsy stage props for our amusement. Although we might consider ugly and without merit bedding that is patched together from umbrella scraps, when it comes to the inspiration that went into its creation, it is not so unlike the work of the great masters in their answer to a similar need. In this way, the poor live their entire lives within the confines of exigency.

Money is something that flows through society, but very little currency stays with the poor. The value of finely crafted goods and beautiful objects is said to be determined by the market, a mechanism that allows people to find what they want. Yet it is as if the right to make use of this structure has been taken away from the poor, the accumulation of riches remaining far out of reach—like flowers in a mirror or like the reflection of the moon upon water. Thus, while the needy live in cities where great concentrations of wealth exist, they themselves seem to inhabit a desolate, still unsettled wilderness. Homely and crude were the fur boots purchased by Lieutenant Colonel Fukushima in Siberia, or so I am told. If by chance such footwear were to be worn on the streets of Tokyo, they would quickly become the laugh of the town. Yet when traversing the hungry, cheerless Mongolian plains, such footwear would have been a necessity for Lieutenant Fukushima, who traveled six hundred miles with them on his feet. For him they were a treasure of a lifetime, something to be carefully preserved. Likewise, the cracked vases and broken bowls of the poor. They are found useful in the similarly hungry and cheerless desert of darkest Tokyo. For those who

drink soup and sip gruel from such vessels, they are items of great value, precious possessions hardly deserving of the passerby's derisive laughter.

I might mention that only by visiting the hovels of the poor does one come to know what people who lack purchasing power actually own. Pieces of rusty tin gathered from here and there, along with lengths of scorched sheet metal fished out from the rubble of a burned building serve as patches for leaky roofs. A sake barrel without its lid serves as a washbasin; old roof tiles make up a homemade hearth; and sacks for Indian cotton are stretched over the tatami floor for use as bedding. All these paint a most miserable scene.

One thing that can be considered of their own vintage are the wheeled wagons that the disabled use to travel to work. Wooden gutter covers provide the sides, and lengths of bamboo make a floor. Two poles, attached front and back, serve as axles for the wheels that are nothing but cross-cut slices of pine trees. Punted over the ground with a stick, the vehicles move forward with a clamor. Assembled in the fashion of Robinson Crusoe, these wagons for the disabled are their indispensible means of moving through the desert. When compared to the foreign-made jinrikisha, painted black and equipped with metal spokes and wheels, these handmade carts are clearly more intricate, requiring ten times the effort to construct.

OCCUPATIONS ON POVERTY STREET

Like Sakurada Bungo, who performed his own investigation of the slums, so too did I walk this world from one back alley to another, from one hovel to the next. I happened to come upon a dead end and a sight that made me step back in surprise. Built in this nondescript location was the so-called communal toilet, or public outhouse. To repeat a point I made earlier about the slums in general, the tenements are very much like the four-wheeled cars of a steam train bound for nowhere. Having neither a discernible front nor back, the buildings here leave no decent passageways for human comings and goings, since they all have been built in a series of mazes and cul-de-sacs. No wonder, then, that we hear no complaints when a toilet is established right in the middle of a precious roadway. Viewed by the residents of the surrounding shacks, the outhouse provides neither the fragrance of southern winds nor the blessings of sunlight and moon, but, rather, only a constant stench.

As we might expect, the outhouse is provided as a free service by the property owner, who busily does what he can to get as much rent from his land as possible. For those who live here, this must be recognized as an act of benevolence. Of the people whose journeys have brought them to this

The outhouse is right in front of a tenement (Collection of Yasunori Tan-o)

neighborhood, the majority are rickshaw pullers, day laborers, and con-
struction workers. Add to these those who gather discarded materials for a
living—trash buyers and refuse collectors, tobacco pipe sellers, tinkers, um-
brella repairmen, basket makers, tinsmiths, lacquer artists, pottery repairers,
and tissue makers. In addition, there are also traveling minstrels, itinerant
storytellers, puppeteers, peep show operators, lion dance trainers, loan
sharks, rental dealers, vendors at festivals, fortune-tellers, moxa doctors,
masseurs, abortionists, and poster artists. There are religious travelers of
various stripes—"Thousand Temple" pilgrims, Buddhist devotees, Shinto
worshippers—and ballad singers, old fish and vegetable freshen-uppers,
melon and eggplant vendors, dried fish and firewood hawkers, baked sweet
potato peddlers who also deal in utensils and pots, small shopkeepers who
gather children around them to sell cheap crackers, nighttime street salesmen,
used clog dealers, secondhand clothing merchants, match box fillers, tooth-
pick whittlers, sandal strap sewers, lithograph printers, stocking sellers, cigar
rollers, fan makers, pot scrubbers, scrap paper gatherers, and other small-
time businesspeople of a number too great to mention here.

I have noted dozens of different ways to make a living in this world; and
though the number of preferable professions is not small, the most success-
ful people among those listed here make no more than twenty to thirty *sen*
per day, while the least successful make only five or six. How, then, are they

supposed to have the wherewithal to let in even one newcomer and provide him with employment? If organizations existed to bring people together and to promote healthier working conditions—whether a day laborers' group, a rice pounders' guild, or an acrobats' or peep show operators' organization—we might expect that the poor would immediately bustle about to join a group as newcomers and to be given a job. But here in the slums, as there are no fully developed profession-based organizations for this or that line of commerce, I see that my concerted efforts as a student of Poverty College must take me to another campus. I must leave this place for another, postponing my ultimate investigation of poverty to a third semester of coursework.

DAY LABOR AGENCIES

I left Shitaya and traveled to Asakusa, where I inquired at a certain construction office on Abekawa Street. I put in an application but was rejected, the reason given was that all the jobs had already been taken. I next visited a boss at a similar office in Hanakawado, but they also were dealing with too many workers as it was, so no one took the time to talk with me. My next stop was the office of a well-trusted boss who resided on Umamichi Street. Hoping to join a group of acrobats and outdoor peddlers, I made another application for work; but this too seemed to go nowhere and finally came to naught.

By way of these efforts, I came to learn a few things about my fellow travelers and their poverty. As if suddenly struck by inspiration, like a schoolboy who clings to his English dictionary while plowing through Mill's *Considerations on Representative Government,* I resolved to plunge myself without hesitation into the darkest reaches of Tokyo's monstrous slums in order to accomplish a thorough study of the poor. What was I to expect? I would go to the darkest monster-ridden neighborhood in all of Tokyo— no, perhaps in all of Japan—the carcass of an anachronistic world, a place whose name you will not likely hear from the lips of any gentleman—a monstrous cavern that is a crystallization of all that is vile in this world. It is a shared cave where life's many victims, along with various demons, gods of temptation, and slaves of lust fight one another over the hearts of men. It is where Tokyo's secrets—no, Japan's secrets—no, the entire world's secrets—are gathered together as if to flare into one great final battle in which the gods of temptation and the servants of evil vie with one another in full fury!

Once one steps over into this other world, as represented by the depths of this monstrous slum, one sees the ragged patterns that exist on the re-

verse side of life's elegant brocade of lies. I wanted a close look at the world of human passion in its overflowing warped state, to see the madness of a melodramatic suicide play with its veneer of beauty ripped off. This is the sort of topic that ought to be discussed in ordinary conversation, while enjoying a meal or a few puffs of tobacco. Think of it, right there, no more than a few feet in front of me was an institutional labyrinth that might teach me the secrets of the world. Seeing this, I jumped to my feet, jettisoned my original plan, and resolved to march directly to the devil's lair. Those, at least, were my fearless thoughts, yet the reins of fate held me back even as I chomped at the bit. I reflected. If I haven't had opportunities to serve my brothers and sisters until now, how was I supposed to be able to serve demons? And if I didn't know even the simplest things about the lives of the poor, how was I to make sense of the complications of evil that faced me? In spite of myself, I started off with this thought filling my body and soul.

On to the caves of hunger and cold, where the world is in tatters for as far as the eye can see! I left Asakusa and returned to Shitaya. I then went to Yamazaki Street in Ueno, and from there I made my way to Miyashita in Nezu, then to Yanagimachi in Koishikawa, to the back streets of Dentsūin, Akagishita in Ushigome, then Chōenji and Tanimachi in Ichigaya. Having traveled through these slums that form a perimeter around the city, I finally came to the place that is said to be the inner city's greatest cavern of hunger and cold, Samegahashi in Yotsuya.

Once in Samegahashi, I visited a boss named Kiyomizuya Yahei whom I had heard of earlier. Yahei was from the country, and had spent his life working in construction. He was a kind man. Because of his compassion, he had won the trust of the poor, and his word carried considerable authority among them. Although I had never met him before, he helped me with my plan to become a laborer. "You can't make a living by playing." "Young people should never be afraid of work." Living by these words of wisdom, he had enough influence to open the doors that allowed me to find work at a neighborhood leftover food shop.

Ah, the slop shop. What exactly are leftovers? I am simply referring to the uneaten food that comes from large-scale kitchens. Dear Reader, what words best describe the poor? "Hungry and cold," "shabby," "homeless," "unpresentable"? I believe that the term "leftovers" is the most appropriate term for representing the concerns of the impoverished. And there, right before me, was the one place that made a reality of "leftover rice" and "leftover vegetables"—the very essence of poverty. Seeing no reason to hold back, I forged ahead.

First of all, what did such a shop look like? If one approaches from the west, one finds a house slightly off the street but not far from the entrance to

The Leftover Shop: Exterior (Collection of Yasunori Tan-o)

The Leftover Shop: Interior (Collection of Yasunori Tan-o)

the slums. In the relatively large open space out front, five or six straw mats are laid on the ground; and spread on top of them is rice that has turned sour drying in the sun. It looks like crumbled yeast, but is actually unsold rice, being parched for sale as food storage for even more desperate times. I imagine this represents, for the poor, a way to brace for unexpected disasters. The house itself is leaning over, and would probably collapse were it not for the boards that keep it propped up. The walls are dilapidated, and the roof is covered with moss. The eaves are rotten and in some places entirely missing so that those who come and go wonder if clods of dirt won't fall down on their heads.

The shop's dimensions are like that of a farmhouse, where the yard outside is much larger than the rooms inside. Two-thirds of this space is filled with numerous earth-carrying baskets, shallow basins, soy sauce barrels, large urns, rough jars, and other vessels for holding leftover food. Unsanitary in appearance, these vessels are arranged in no noticeable order. Filthy though it is, this broken-down house was the perfect place to get a glimpse into the lives of the poor; it was a museum of unsurpassed quality for the collecting of information.

Allow me to add. Due to the kind efforts of Boss Yahei, whom I had never met before, I was able to become a guest worker at this leftover house. His wife was a kind, rustic woman, who carried a baby on her back as she led me to the shop. To me she said, "Give it two or three days, and see how things work out." And to my employer she noted, "He's just a beginner. Take care of him." Treating me as the neophyte that I was, she deftly let me know who was in charge. Two or three days later, she came back to check up on me. "Are you going to make it? If it's too hard, we could find someone else." She thus comforted me with her kindness. Time and time again I partook of her compassion.

THE SLOP SHOP

From that day on, with Yahei's introduction, I became an employee at the leftover shop. Every day at eight in the morning, at noon, and at eight in the evening, three of us would push a two-wheeled cart loaded with large "rifle baskets"—long and about a foot across—buckets, basins, soy sauce barrels, and other containers to the rear entrance of the Military Academy. Our job was to load up the food that had been left over from the day's three meals and to bring it back to the shop. For someone like me, who had never lifted anything heavier than chopsticks before, suddenly becoming a member of this hardworking crew was no small challenge. I had to keep up with the others no matter my degree of fatigue. Not having the knack for physical

labor, I kept making childlike errors that displeased my boss. Since this was my first semester at Poverty College, I knew that I had to exercise patience; and, by and by, I became accustomed to the routine. The miserable ones who came to buy the leftovers from us even started to call me "Clerk! Clerk!" as a sign of their respect. That's how much the leftover food meant to those who referred to it as "army rations," an old term used for meals once served at the various military headquarters located throughout Japan.

Our shop would purchase the food from the Military Academy for fifty *sen* a basket (approximately 56 kilograms, or 123 pounds); and we would then sell this for about fifty-six *sen*. Of course, the great advantage of dishes other than rice was that they were disposed of "free of charge." Be that as it may, the food came from a huge kitchen that served over a thousand people, including students and teachers. Sometimes we would get five or six baskets of leftover rice, not the usual three baskets, along with soup, pickled radish slices, crusts of bread, fish bones, and burned rice. It was hard work putting into containers all the food that was carried out to us by a small regiment of men.

What of the people who purchased these leftovers from us? They were all from neighboring slums, and their regard for what we brought them was remarkable. In their eyes, the food was as precious as bear paw and phoenix marrow. When we would pass by with our cart, they would worship it as if it were an imperial palanquin. Old and young, men and women, they would stand on both sides of the road holding baskets, wooden bowls, stacked lacquered boxes, rice containers, small buckets, pottery bowls, and covered pots. We could hear them whispering, "Here they come. They got lots today. Quick, let's go." They would fall in line behind us, but when we arrived at the shop, a huge crowd of people would already be waiting. As soon as those people caught sight of the cart, a roar would go up, as if everyone there had been waiting for Lieutenant Fukushima's homecoming. They would fall back and let the cart go through, but soon were upon us with their baskets and pots: "Me first." "Give me two *sen's* worth, please." "Three *sen's* worth over here." "Give me one *kanme* of rice." "Pass me half a *kanme*." How could I describe the way they stuck out their buckets over the shoulder of the person ahead of them and tossed their coins with an underhand throw? It reminded me of the vegetable market at Kyōbashi, or the fish market between Nihonbashi and Edobashi—yet the confusion here was even more glorious. Side dishes, pickles, boiled fish—we sold these by the handful. We scooped soup straight out of the barrel as if it were cloudy sake. We weighed rice on a scale, but when things got hectic we just guessed at the amounts.

In essence, leftover rice and vegetables were otherwise disposed of by the academy without any charge and given away to the needy. But when

purchased by a shop like ours, they became a valuable commodity. I was amused to learn that our customers appreciated them so much that they gave the various kinds of leftovers nicknames—"tiger's pelt," "kid's haircut," "cook stove," "chilled sashimi." To be sure, there is something odd about putting sliced turnips on top of leftovers and bestowing them with some fancy new name. "Kid's haircut" is what they call the chopped off ends of radishes, cucumbers, and eggplants—slices that still have the stems and roots attached to them. "Chilled sashimi" (*arai*) is another name for the rice that gets washed out of the bottom of a pot, and "cook stove" refers to the crust on a loaf of bread, which does look like an earthen stove when you hollow the insides out. As for "tiger's pelt," here's a touch of poor people's humor to consider. It's their name for burned rice. When cooking in giant vats, it is impossible to make a good batch of rice without burning some of it. Like the coat of a tiger or leopard or some such animal, the crusty layer that inevitably sticks to the bottom of the pot develops dark markings.

Whether tiger's pelt or cook stove, this leftover food is viewed as a precious commodity that the poor are willing to fight over. The saying "Burning *katsura* wood to boil jewels" well describes the luxurious life of the rich. But those who actually do such a thing are not the wealthy but the poor. It is they who are on the borders of extreme poverty, hunger, and cold. It is they who actually cook jewels and burn *katsura* wood. Why? First of all, consider the extraordinarily high cost of the one or two *sen* of charcoal, firewood, or pickles that the poor customarily purchase; then consider how small the amounts of rice and cracked wheat they buy are. It is said that cooking for ten or twenty people in a large kitchen allows one to acquire rice and firewood economically, making it possible to stay within budget. By contrast, in the kitchens of the poor, if one must make do with a few coins a day in order to buy ingredients, then the indigent will always be purchasing their firewood and charcoal as if they were pearls.

Yet how can we expect the impecunious denizens of the slums to stay alive if required to boil pearls for dinner? This is why the leftover shop is a merciful savior for the miserable and their penniless kitchens. A day's food for a family of five would include seven kilograms of rice, plus two *sen* of side dishes and one *sen* of pickles. This comes to about fourteen or fifteen *sen* per day. If they actually were to buy the ingredients for these meals, the cost would come to around thirty *sen* per day. For this reason, the success of the slop shop continues to be a bright spot in this tale of the poorest of the poor.

TRANSLATED BY CHARLES SHIRŌ INOUYE

The Jester

TANIZAKI JUN'ICHIRŌ

 At the age of twenty-five, after dropping out of the Japanese Literature Department of Tokyo Imperial University, Tanizaki Jun'ichirō made his striking debut in the tightly organized literary world. By then, only a year before the end of the Meiji period, he had joined a few young writers challenging the dominant group of so-called naturalists, whose spare confessional fictions were as colorless as possible. But Tanizaki's brilliant early stories, each different in setting, atmosphere, and style, had attracted the attention of novelist Nagai Kafū and other influential figures. Takita Choin (1882–1925), the legendary editor of *Essential Debates* (*Chūō Kōron*), became Tanizaki's lifelong patron. Now Tanizaki was not only celebrated, even notorious, but paid.

"The Jester" (Hōkan) was published in September 1911 and included in *The Tattooer* (*Shisei*), his first story collection, in December. Unlike the title story, "The Tattooer," "The Jester" was set only a few years earlier, evoking without a trace of nostalgia the vibrant city culture that had somehow survived the transformation from Edo under Tokugawa rule to modern Tokyo. In "The Jester," the season of holiday making is at its height, when hundreds of cherry trees are in full flower along the western embankment of the broad Sumida River.

This was a milieu with which Tanizaki was familiar to a fault. As a son of Edo's deep-rooted merchant class, he knew Edo's arts and guiltless, or guilty, pleasures, not the least of which were centered in Yoshiwara, Yanagibashi, and other traditional quarters. Yanagibashi in particular was noted for its vivacious geisha, but teahouse parties were customarily also enlivened by *hōkan*, male entertainers descended from the long line of *taikomochi*, "drum-bearers," or "jesters," of the seventeenth century. (In an *Essential Debates* editorial meeting the year before, Tanizaki had said that he was drawn to writing about a member of this self-debasing profession.) These entertainers were often recruited from former playboys who had squandered their fortunes but could not bear to give up all chance of entrée to this glamorous demimonde.

Though not as intentionally lurid as most of the other early tales with which Tanizaki hoped to shock the complacent reader, "The Jester" pursued the theme of humiliation with the aid of an imported fad for hypnotism. Far from therapeutic, hypnotism here soon descends from playfulness into darker forms of domination, combining elements of the erotic and grotesque later stigmatized as "erotic-grotesque" (*ero-guro*). Confident in his

art, Tanizaki disdained the critics who accused him of being insufficiently intellectual, scandalously self-indulgent, or both.

The story's protagonist, Sampei (the professional name of the once-prosperous broker Sakurai, who becomes a *hōkan*), has not only the temperament for this exacting role but a natural talent for wit and flattery. It goes without saying that he knows all the popular songs of the day and can keep the chatter flowing with an endless supply of jokes.

Here, however, Sampei makes his spectacular appearance in the comic guise of a creature from Edo folklore: a long-necked female specter who sometimes appears in plays and sideshows. His love of theater reveals itself even when he is blindfolded, as he instinctively mimics a character pretending to stagger drunkenly, groping in pursuit of teahouse girls in a game of blindman's bluff, in a scene from the classic kabuki revenge play *The Treasury of Loyal Retainers* (*Chūshingura*). The artful ellipses at the end of the story not only elude censorship but also heighten its suggestiveness.

⌒(HH)⌒

It was around the middle of April in 1907, the fortieth year of Meiji. The Portsmouth Treaty had at last announced the end of the Russo-Japanese War that had shaken the world from the spring of 1904 till the autumn of 1905; all sorts of new enterprises had sprung up one after another under the banner of developing national power, creating new members of the nobility and the newly rich. The whole country seemed to be on a festive holiday.

Just then the cherries along the bank of the Sumida River at Mukōjima were in full bloom. From early Sunday morning, under a glorious blue sky, the trolleys to Asakusa and the little steamboats coming up the river were crowded with passengers. Beyond the Azuma Bridge, where throngs of people were streaming across like ants, a warm mist had settled from around the Yaomatsu restaurant to the Kototoi boathouse. The opposite bank, from Prince Komatsu's villa down to the districts of Hashiba, Imado, and Hanakawado, drowsed in the hazy indigo light, with the Twelve-Story Tower in the park looming dimly in the background against the stiflingly moist deep blue sky. Emerging out of a dense fog in Senjū, the Sumida wound its way around the tip of Komatsu Island and broadened into a languid expanse of tepid water, as if spellbound by the springtime along its banks, and then, glittering in the sunlight, flowed on under the Azuma Bridge. On the river's surface, gently billowing waves, soft as a downy quilt, lapped lazily against the many boats, some of them especially for flower viewing. Now and then a ferry would leave the mouth of the Sanya Canal and cut across the line of boats going up and down, to carry its overflowing load of passengers to the other shore.

It was about ten o'clock that morning when a roofed flower-viewing barge came rowing out of the Kanda River, past the stone wall of the Kameiseirō restaurant, on into the very midstream of the Sumida. Aboard this large vessel, draped with gaudy red-and-white-striped curtains, was a professional jester along with geisha from Yanagibashi. In the middle of the boat, surrounded by half a dozen hangers-on, sat a gentleman named Sakakibara who was said to have made a fortune as a broker in the Kabuto-chō stock market. Glancing around at the men and women in the boat, he would often pause, tilt up his large sake cup, and take another gulp, even though his plump, reddening face showed that he was already more than a little drunk. Around the time that the boat was floating along midstream past the walls of Count Tōdō's villa, a burst of *shamisen*-accompanied song welled up from within the curtain, ruffling the waters of the great river and ringing out cheerfully to the shores of Hyappongui and Daichi. The people on the Ryōgoku Bridge and on the streets along the river in Honjo and Asakusa craned their necks to gaze at the source of this gaiety. The scene aboard the boat seemed close enough to touch, and from time to time they could hear coquettish feminine voices carried by a gentle breeze across the water.

About when the boat passed the riverbank at Yokoami, someone disguised as a creature with a fantastically long neck appeared at the bow and, to the rhythm of the *shamisen,* went into a ludicrous dance. The dancer's head seemed to be covered by an immensely long, slender paper bag, which was tethered to a large toy balloon painted with a woman's features. His own face was entirely hidden by the bag, and he wore a gaudy *yūzen*-print long-sleeved woman's kimono, along with white socks, though occasionally, when he flung his hands up in dancing, you would catch a glimpse of gnarled, swarthy fingers and a sturdy masculine wrist peeping out of the scarlet sleeve opening. The balloon-top woman's head swayed lightly here and there in the breeze, and as it peered under the eaves of a house near the riverbank or grazed a sailor on a passing boat, spectators along the shore clapped their hands and laughed.

Meanwhile the boat had proceeded toward Umaya Bridge. A line of pale yellow faces from the dark swarm of people crossing the bridge stared down at the shipboard performance pressing toward it. As the boat neared, onlookers were fascinated by the long-necked woman's features, with their indescribably odd expression, now as if weeping, now smiling, now nodding sleepily, clearly visible against the sky. In a moment, the bow had passed into the shadow of the bridge, and the head, what with the swollen level of the river, rubbed lightly against the railing close to the faces of the spectators and then was dragged on by the boat, bent down low, and crawled idly

along under the bridge girders until it floated gently up toward the blue sky on the other side.

By the time it had come to the Komagata Temple, even the revelers in the boat could see that they had attracted the attention of passersby as far ahead as the Azuma Bridge, who looked as if they were waiting to welcome victorious troops.

Again, as at Umaya Bridge, the comic performance made everyone laugh. At last the boat reached Mukōjima. Another *shamisen* joined in, and the music grew wilder and wilder, until it seemed to propel the boat steadily up the river, just as the clangorous musicians on festival floats urged ahead the oxen drawing them. There, where the Sumida was narrowed by a cluster of flower-viewing boats, the crowds along both riverbanks, including students who were waving red and blue pennants to cheer on their own school boats, were startled into keeping their eyes on the progress of this outlandish comic vessel. The long-necked woman's dancing became more and more frenetic. Tossed by the breeze, the toy balloon would suddenly dart through a puff of steam from a passing ship or leap up high enough to look down on Matsuchi Hill, riveting the attention of everyone along the river, as if performing these antics to flirt with them. Around Kototoi, the boat went on upstream away from the shore, but even then people wandering along the bank from the Uehan restaurant past the Ōkura villa gazed far into the sky beyond, transfixed by the sight, wondering what on earth that uncanny head could be. Soon the boat that had caused so much excitement along its course by the brazen audacity of its behavior tied up at the jetty of the Kagetsukadan restaurant, and the whole party rushed pell-mell ashore onto the lawn of its garden.

"Thank you, thank you!" Sakakibara said, as the long-necked performer, ringed round by cheering and applauding geisha, took off the paper bag to reveal, rising out of a flaming crimson neckband, the beaming face of a bald, dark-complexioned man.

Taking over the shore to continue their fun, they started partying all over again. Sakakibara and the other men and women joined in a noisy melee of dancing on the lawn, bounding about, and playing tag or blind man's bluff.

Still wearing his long-sleeved woman's kimono, white socks in red-thonged sandals, the man who had been entertaining everyone chased after geisha with faltering, pigeon-toed steps, or was chased himself. The clamor reached its height when he was the blind man in blind man's bluff. As soon as they tied the towel over his eyes, people started clapping hands, shoulders swinging and shaking with laughter, and began prancing about him.

"Kii-chan! Kii-chan! Now I've got you!" he would cry in the high, slightly rasping voice of a professional entertainer, as he ran around aimlessly, exposing hairy shins beneath his crimson underskirt, trying to grasp at a woman's sleeve, now and then bumping his head into a tree. But in spite of the speed of his energetic movement, he was somehow so comically inept about it that he never managed to catch anyone.

They liked to stifle their tittering and steal up behind him. Suddenly a woman whispered seductively, "See, I'm right here!" and then tapped him on the back and ran away. "How about this?" Sakakibara said, tugging his earlobe hard enough to spin him around, while the jester screamed "Ouch! Ouch!" as if in agony, knitting his brows with a purposely exaggerated grimace of pain. Yet there was something so appealing about his expression that no one could help wanting to tease him a little, rapping him on the head or pinching his nose.

This time a naughty fourteen- or fifteen-year-old fledgling geisha circled around behind him and grabbed one of his feet with both hands, tripping him up. He took a splendid pratfall, rolling on the lawn, but got up again slowly during all the laughter, eyes still covered, opened his big mouth and bellowed, "Who is it? Who's tormenting this old man?" Then he began groping his way forward, hands outstretched, like the drunken character Yura-san in the teahouse scene of *Chūshingura*.

This man was a professional jester called Sampei, who used to be a broker in Kabuto-chō. Even then he had been eager to try his hand at his present occupation, and four or five years ago he had at last been taken in as an apprentice to a jester in Yanagibashi. His singular knack for clowning soon made him popular, and by this time he was one of the most successful members of the guild.

Men who had known him in earlier days considered Sakurai—that was his real name—hopelessly easygoing. Now they would remark, "Sakurai's a lot better entertaining at parties than being a stockbroker. He seems to be making plenty of money—he's a lucky guy." But at the time of the Sino-Japanese War he was running a sizable brokerage house, with four or five employees, near the Kaiun Bridge, and was a good friend of people like Sakakibara. They all liked having him along at parties—"He's sure to make it a lively evening!"—and thought of him as an ideal drinking companion. Good at singing, a wonderful conversationalist, no matter how prosperous he was he never put on the least airs. Rather, he would forget that he was an important broker, even a fine gentleman. Nothing pleased him more than to entertain friends and geisha, and to bask in the warmth of their praise. Chuckling merrily and cracking one joke after another, his tipsy smiling face shining under the brilliant electric lights was his very life. His whole attitude—his

shoulders shaking in helpless mirth, eyes twinkling amiably as if he could not contain his joy—was innocence itself. He seemed to personify the spirit of pleasure, as if he had penetrated to the essence of enjoying life.

At first the geisha secretly disliked him and felt a little uneasy with him, thinking that his efforts to please and to be amusing, as if *he* was supposed to entertain *them*, came from some nasty impulse of his. But little by little, as they got to know what he was really like, they began to realize that he had no such thing in mind, he was just a good-hearted fellow who enjoyed being the life of the party. Eventually they were all on intimate terms with "Sakurai-san." However, at the same time that they were glad to have his company, not one of them, for all his money and influence, made advances to him or fell in love with him. Instead of addressing him politely, they simply called out "Sakurai-san!" and saw nothing rude in treating him as a person of lower rank than the other guests. The truth is, he was not the sort of man to arouse a sense of respect or amorous feelings. By nature, he had a temperament that invited friendly condescension, a kind of warm disdain, or sympathetic pity. Probably not even a beggar would have felt impelled to bow to him. No amount of ridicule could make him angry; rather, he seemed to enjoy it. As long as he had money, he was sure to invite others along to spend it at a tea-house. And whenever he was asked to a party or to join friends going drinking, no matter how busy he was, he could not resist the temptation to throw his work aside and head out cheerfully.

"Well, thanks for the entertainment," his friends would often tease him by saying when one of these affairs broke up. And he would put on a serious look, thrust both hands out, and reply, "So please be good enough to give me a tip." A geisha would jokingly imitate the gruff voice of a guest and add, "All right, all right. Take this and be on your way." Balling up a scrap of paper, she would toss it to him.

"Oh, thank you so much," he would say, bowing his head up and down two or three times and reverently placing the wad of paper on his outstretched fan. "I'm very grateful. Won't everyone please toss in a little? Even two cents more would be all right. My family needs it. Tokyo gentlemen are known to help the helpless and smite the strong." He rattled this off as glibly as a huckster at a festival booth.

It seems that even this happy-go-lucky fellow could fall in love. From time to time he would arrange to have a former geisha come to live with him, but once he was in love, his efforts to curry favor would be even more extravagant, so that he lost all authority as master of his own house. He would buy her anything she wanted, and when she curtly ordered, "Do this!" or "Do that!" he would spinelessly murmur, "Yes, dear." Sometimes a woman who had been drinking would call him "Idiot!" and give him a whack on the head.

When there was a woman living with him, he usually didn't go to tea-houses. Night after night he gathered friends and employees in his upstairs sitting room and gave a wild party, drinking and singing to the accompaniment of his woman's *shamisen*. Once a friend of his stole away his own woman, but even so he hated to part with them. He kept on doing all sorts of things to please her, bought her lover new clothes, took them along to the theater, and gave them the seats of honor, happy to play his usual role as entertainer, completely at their disposal. He even found himself buying geisha out to stay with him on condition of paying to support their fondness for actors. The man hadn't the slightest sense of masculine pride or jealous anger.

However, he was extremely fickle. He went from one woman to another, falling in and out of love, suddenly losing interest just as he seemed most infatuated. Of course none of the women were in love with him, so they would leave when they had squeezed out as much money as they could. In this way his employees lacked all confidence in him; now and then there were huge losses, business was neglected, and before long his brokerage went bankrupt. After that he worked as a spot dealer or broker's tout, but when he met someone he would boast, "Just watch me. I'll be back before you know it!" Since he was a pleasant fellow and had a rather good eye for business, there were times when he made money. Still, he kept losing it to women, so he never managed to struggle out of poverty. Once he was over his head in debt he had to appeal to his old friend Sakakibara—"Just give me a try for a little while"—before he could find any firm to take him in.

Even though he had been reduced to an ordinary employee, he could not put out of mind his haunting memories of partying with geisha. Sometimes while sitting at his desk he would recall an alluring woman's voice or the lively notes of a *shamisen,* and then, lost in reverie, spend the rest of the day humming old love songs. At last it would be too much for him. Using all his powers of persuasion, he would scrape together a little money by cadging it from one friend or another and then slip out quietly to enjoy himself.

A few gave him money the first two or three times, saying, "You can't help liking the poor fellow." But he kept coming back so often that it made them angry. "I'm fed up with Sakurai," they would think. "You can't get involved with a deadbeat like that. He didn't used to be so bad, but the next time he comes scrounging around I'll really tell him off." Yet when he did show his face again there was something so pitiful about him that they couldn't be too harsh.

"Let me make it up to you next time," they might say, trying to get rid of him. "I'm afraid I can't spare anything today."

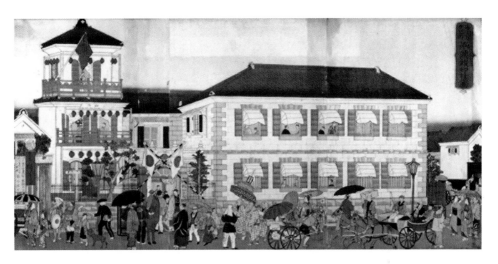

PLATE 1 "Tokyo's Famous Places: The Hōchi Building in Ryōgoku," a triptych by Utagawa Hiroshige III (1842–1894), who specialized in depicting urban Meiji landscapes. The *Post Intelligentsia* (*Hōchi Shinbun*) was an early newspaper company housed in this brick building in the Shinbashi district, one of the spots that showcased Tokyo's modernity. As a symbol of Enlightenment, a newspaper building was often accompanied by a prominent tower for observation of the landscape and other types of entertainment. (Archives of Meiji Newspapers and Journals, University of Tokyo)

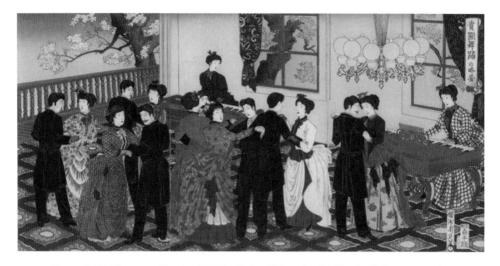

PLATE 2 "A Glance at a Dancing Ball," by Yōshū Chikanobu (1858–1912). Banquets and balls in the European style became popular in the Meiji era, and Western clothing and musical instruments were among the most apparent signs of Enlightenment. Popular prints of the time tended to feature either beautiful women or landscapes, so it is rare to find an image in which both men and women are represented dancing. Rarer still are depictions of foreigners in such social situations. (Museum Meiji-Mura)

PLATE 3 "The Success of the Hisamatsuza Theater," by Utagawa Hiroshige III. The theater was established in 1879, following the innovations of the Shintomiza Theater, which claimed to be the first Western-style theater in Japan. Various transformations and mergers eventually culminated in the Meijiza Theater in 1893. Under the leadership of great actors, this theater has survived and thrived to remain the center of New Wave (*shinpa*) theater today. (Tsubouchi Memorial Theater Museum, Waseda University)

PLATE 4 Illustration by Kaburaki Kiyokata (1878–1972) for *A Modern Woman* (*Tōsei Onna*, 1907) by Murakami Namiroku (1865–1944). The master of female portraits depicts here a woman speaker addressing intellectual men who are clad in Western attire. A handful of daring women made waves in their feminist challenges to the patriarchal system of the day. (C.V. Starr East Asian Library, University of California, Berkeley)

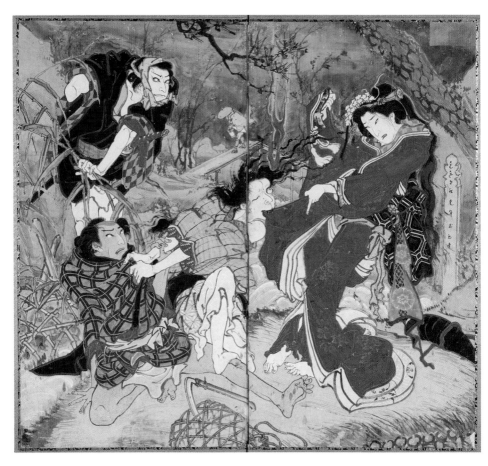

PLATE 5 A two-panel screen advertisement for the kabuki *Dashing Men in a Kabuki Play: Kasane* (late Edo to early Meiji period) by Ekin (Hirose Kinzō, 1812–1876). The play represents the bloody revenge of a betrayed wife. The screen is among a number of works exhibited during the annual Ekin Festival, featuring rustic kabuki performances. Ekin was famous for brutal and monstrous depictions of kabuki scenes in striking colors. (Ekingura Museum)

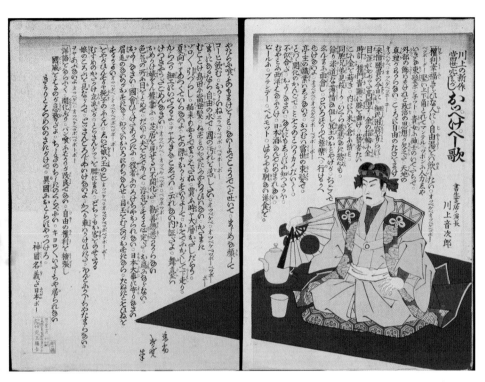

PLATE 6 A color flyer depicting the "Oppekepe Rap," which Kawakami Otojirō often performed as the opening act to his productions. A critique of his contemporary social climate, the song was arguably the first popular song of the Meiji period. In the ukiyo-e image by Nagashima Shungyō (active 1850–1907) framing the text, Otojirō is seen dressed as a samurai warrior, wearing a headband to recall riotous soldiers of the recent past. (National Theater, Japan Arts Council)

PLATE 7 The image of the heroine, Namiko, on the frontispiece of Tokutomi Roka's novel, *The Cuckoo*, is by Kuroda Seiki, a leading figure in the practice of Western-style oil painting. The portrait highlights the romantic feature of tuberculosis in the context of love and family. By presenting the tragic combination of beauty and illness, Kuroda certainly helped the novel become a phenomenal best seller. (Tokutomi Roka Memorial Museum of Literature)

PLATE 8 *Spencer the Balloon Man and Asakusa's High Tower,* a vertical diptych by Toyohara Kunichika (1835–1900), shows star actor Onoe Kikugorō V as the character Spencer. Shows by foreign troupes fascinated Japanese audiences during this period, but the act of flying with a balloon in midair startled them. Suspending an actor above the stage was one of kabuki's traditional tricks, but to suspend an actor from just a balloon, a realistic sign of modern technology, was astonishing. This spectacle benefited from the popularity of the hills of Ueno, Spencer's starting point, and of Asakusa's observation tower, from which his act was best seen. Casting Kikugorō, who gave his opening speech in English for the first time in 1891, also encouraged enthusiasm for Western entertainment, which profoundly affected Japanese popular culture during the late Meiji period. (National Theater, Japan Arts Council)

あめりか物語

PLATE 9 Although realistic fiction and Western influence made Japanese literature more involved with the verbal text, the Japanese taste for visual images never died out. Meiji period literature, of which the novel represented the apex of modernity, was still graced with large numbers of illustrations. This cover for Nagai Kafū's *Tales of America* is characteristic of the Meiji sense of the modern and its taste for sophisticated combinations of color and calligraphy. The two-dimensional decorative designs on the covers of Meiji journals and books resonate with the European trend that centered around the design firm of William Morris and Company. (C.V. Starr East Asian Library, University of California, Berkeley)

But he would keep right on badgering them. "Please, I've got to have some money, don't turn me down. Just lend me a little something—don't worry, I'll pay you right back. Please, for God's sake, help me out!"

Most of them gave in.

Even his boss, Sakakibara, could hardly put up with it. "I'll take you out now and then," he said, "so don't give other people so much trouble."

Once in three times or so he would take him along to his favorite tea-house, after which Sakurai would bustle about his work diligently, like a changed man. His boss began taking him out more often—when he was troubled by business worries there was no better medicine than the sight of that happy face as they drank sake together—in the end it became Sakurai's principal duty. He took pride in lounging around the office all day, joking, "I'm the resident geisha of the Sakakibara Company."

Sakakibara's wife came from a strict, old-fashioned family, and they had several children, beginning with a fourteen- or fifteen-year-old daughter. But everyone from the mistress of the house down to the maidservants was fond of Sakurai and liked to invite him into the inner quarters to enjoy his amusing chatter. "Sakurai-san," they would say. "We have a nice snack ready, come to the kitchen and have some."

One day the mistress said, "For anyone as easygoing as you, running out of money can't be too bad, I imagine. If you're always laughing, you're bound to be happy."

"You're absolutely right," he replied proudly. "That's why a person like me never gets angry. It's because I've always managed to enjoy myself." Then he went on chattering away for about an hour.

Now and then he would sing for them in his low, husky voice. He knew all sorts of love songs and theater songs, and was delighted to sing them, mimicking a *shamisen* accompaniment, intoxicated by the beauty of his own voice.

Always first to learn a popular new song, he would ask the elder daughter, "Miss, shall I teach you an interesting one?" and immediately introduce it to the inner quarters. After every change of program at the Kabuki Theater he would go to see the plays two or three times from standing room, and he soon learned to imitate the voices of actors like Shikan and Yaozō. Sometimes he was so absorbed with mimicking them that he kept on practicing, eyes rolling, head swaying, even when he was in the toilet or out in the middle of the street. If he had nothing else to do, he always occupied himself with humming a little song or performing an impersonation.

Ever since he was child Sakurai had loved music and comic storytelling. It seems he was born in the district below Atago in Shiba, had a quick

memory, and did so well at elementary school that he was called a prodigy. But even then he appears to have had a taste for clowning. Although he was at the head of his class, he enjoyed having his friends treat him like a mere entertainer. And every night he pestered his father to take him to the vaudeville hall. A *rakugo* storyteller inspired a kind of fellow-feeling, a yearning to become like him. The splendidly dressed performer would take the stage, make a brisk bow to the audience, and launch into his story:

"Well, people say that sake and women are a gentleman's downfall, and that a woman's power is truly awesome. From the very beginning, when the Sun Goddess hid in the rocky cave, our country has been called 'the land where the sun would never rise without women.'"

The storyteller himself must have taken pleasure in his skillful tongue and his subtly ingratiating way of talking. Every word, every phrase charmed the women and children, as from time to time his beguiling glance swept round the audience. There was something fascinating about it. At such times the boy had a powerful sense of what might be called "the warmth of human sociability."

Ever since his childhood a voice ringing out in song to a lively *shamisen*—popular ballads, love songs, comic songs, any kind of fashionable tune—would arouse a deep longing for pleasure in him. It seemed to suggest the ultimate joy of life. On his way back and forth from school he often stopped to listen, entranced, under the window of a Kiyomoto ballad teacher. When he was sitting at his desk studying at night the distant voice of a street musician would instantly captivate him and he would put down his book. At nineteen, he had his first invitation to a geisha party. When the dazzling women were there in a row before him and someone brought out the big theatrical *shamisen*, he sat, sake cup in hand, with tears brimming from his eyes. It was no wonder that he became such a fine entertainer.

Becoming a professional jester was actually the idea of his boss Sakakibara.

"There's no use loafing around here forever," he told him. "I'll help you get to be a jester, so how about it? You can't imagine a better job than drinking teahouse sake for free, and getting tips besides, can you? It's the perfect spot for a lazy guy like you to wind up."

The idea instantly appealed to him, and through the good offices of his boss he was accepted as apprentice to a Yanagibashi jester. The name Sampei was given to him at that time by his teacher.

"Sakurai's a professional jester?" his Kabuto-chō friends would say. "Well, it just goes to show you nobody's completely useless."

As the rumor spread, it helped him get more and more engagements. Though still considered a novice, he knew all the necessary arts and was

good at entertaining a party. Moreover, he had long had the reputation of being a funny fellow, and so almost overnight he became very popular.

Then one evening Sakakibara was upstairs at a teahouse with five or six geisha and announced that he was going to practice hypnotizing them. One after another, he tried to put them to sleep, but only the youngest apprentice geisha showed any hint of drowsiness. At that point Sampei, who was in the party, began to quiver with fright.

"Please, sir, don't do that anymore! I just can't stand seeing anybody hypnotized. It makes me feel as though I'm losing my mind!"

He seemed genuinely afraid, and yet somehow it sounded as if he wanted to have the experience.

"That's interesting," Sakakibara said, scowling fiercely at him. "In that case, why don't I try it on you? There! You're getting very sleepy. . . ."

"Please, please, I'm begging you! Anything but that!"

Ashen-faced, Sampei tried to get away, but Sakakibara sent after him and managed to stroke his face several times.

"Now I've got you!" he said. "It's no good struggling—you can't escape me!" Suddenly Sampei collapsed limply to the floor.

Just for fun, Sakakibara gave him various suggestions, all of which were followed. When he said, "You're feeling sad, aren't you?" Sampei grimaced and wept bitterly. At "Now you're angry" he turned red and became furious. He drank water, thinking it was sake, and held a broom in his arms like a *shamisen,* each time to peals of laughter from the women. Finally his boss thrust Sampei's nose down to his backside, hiked up the skirt of his kimono, produced a resounding fart, and asked, "Doesn't this musky incense smell nice?"

"Indeed it does," Sampei agreed, sniffing appreciatively. "It's a delightful fragrance, most refreshing."

"Well, that'll do for now." When Sakakibara clapped his hands right behind the man's ear, Sampei opened his eyes wide and stared all around.

"So I was hypnotized after all," he said, apparently fully conscious. "I've never been so terrified. Did I do anything ridiculous?"

Then a mischievous geisha called Umekichi sidled near him and said, "With Sampei, even I can do it. There! You're hypnotized. See, you're getting sleepy."

Sampei tried to run away from her, but Umekichi chased him all around the room. Leaping close behind him, she cried, "You may as well give up! You're under my control." As she rubbed her hands over his face, Sampei again went limp, mouth lolling open, and slumped heavily against the woman's shoulder.

This time Umekichi told him she was the bodhisattva Kannon, and had him worship her, or frightened him by saying there was a big earthquake.

Always Sampei reacted with the inimitable contortions of his expressive face. From then on both Sakakibara and Umekichi could hypnotize him with a single scowl, and make him fall down limp. One evening, passing him on Yanagi Bridge as she was coming home from a party, Umekichi simply called out, "Sampei-san! Look here!" and glared at him. He fell over backward right in the middle of the street.

It was Sampei's passion for entertaining that made him carry his performance to such a length. And yet he did it so adroitly, and with such daring boldness, that no one had the least idea that he was shamming.

Before long a rumor began to spread that Sampei was in love with Umekichi. Otherwise, people said, he couldn't have been so easily hypnotized by her. In fact Sampei was attracted to spirited, strong-willed women like Umekichi. Since that first night, when he had let her put him through so many humiliating tricks, he had found her irresistible. Whenever he had a chance, he hinted at his feelings toward her, but she only called him a fool and refused to take him seriously. Every time he caught her in a good mood and tried to flirt with her, she would instantly bridle like a spoiled child.

"If you say things like that, I'll hypnotize you again," she would warn, fixing her stern gaze on him. And when she did he would give up his attempt and obediently drop to the floor.

In the end he could no longer bear it. He went to Sakakibara for help and told him all about his infatuation.

"I know it's weak of me, not something a man in my position should even think of," he said, "but won't you use your influence and put in a word for me? Even one night with her would be enough."

"Just leave it to me, I'll see that you get what you want," Sakakibara assured him. He had agreed at once, having a secret notion to play another joke on Sampei. That evening he went directly to his usual teahouse, called for Umekichi, and told her what Sampei had said.

"It may seem a bit mean, but how about asking him to come here tonight and leading him on with sweet talk?" he proposed. "Then when he's all worked up you can hypnotize him. I'll be watching out of sight—you can have the guy strip and do anything you like!"

Umekichi herself hesitated at first. "I can't help feeling sorry for him," she said. But he wasn't the kind of man to get angry even if he found out about it later, and it sounded like fun, so she decided to go along with the joke.

That night a rickshaw man came for Sampei with a letter from Umekichi: "I'm alone tonight, so won't you please come to see me?"

Trembling with joy, Sampei felt sure that his boss had worked something out. He dressed up meticulously in his finest clothes, like a dashing man about town, and set out for the teahouse.

Umekichi greeted him like a favored guest, urging him to take a cushion next to her and pouring his drink. "Oh, do sit a little closer! Actually, Sampei-san, I'm going to be all alone tonight, just relax and make yourself at home."

Sampei felt taken aback. He was timid, unlike his usual self, until the sake began to have its effect and he was able to pluck up his courage. After a while he ventured to remark, "You know, Ume-chan, I'm attracted to a woman with a strong personality like you." He had no idea that Sakakibara and several geisha were peering in through the carved transom above the sliding doors.

Umekichi could hardly keep from laughing, but went on showering him with praise.

"Really, Sampei-san," she said, "if you're in love with me, I'd like to have you prove it."

"Prove it? How can I? I wish I could cut my heart out and show it to you!"

"All right, then," Umekichi went on, "let me hypnotize you and find out exactly how you feel. I just want to make sure."

"Oh, please don't talk about hypnotizing me anymore!" Sampei had resolved that he mustn't spoil tonight of all nights. He had even hoped to confess: "I was only pretending to be hypnotized, because I was so much in love with you."

But Umekichi suddenly fixed a stern look on him and cried, "There! Now you're mine!" Under that cold gaze the urge to let a woman make a fool of him surged up, and once again, at that critical moment, his head fell limply to his chest.

Then he began blurting out "I'd gladly give my life for you, Ume-chan!" or "I'm ready to die any time you say!" As soon as they decided he must be safely unconscious, Sakakibara and the geisha came down into the room and circled around him, biting their tongues to keep from laughing at the things Umekichi made him do.

Sampei was shocked to see what was happening, but there was no way to stop at this stage. Being ordered around by the woman he loved exhilarated him, and he did whatever she said, no matter how shameful it seemed.

"Since it's just you and me, dear, you needn't be so formal. Go ahead and take your *haori* off."

Obediently he slipped out of his black silk-crepe *haori* coat, self-lined in a design of cherry blossoms at night. After that she had him unwind his peony-patterned indigo sash, and take off his red-striped silk kimono, all the way down to his white crepe undergarment dyed with the Thunder God on the back and red lightning flashes zigzagging to its hem. One by one, she made him strip away all the finery he had so carefully decked himself out in, until he was stark naked. Even so, for Sampei, Umekichi's cruel orders

carried an overpowering thrill of joy. In the end he obeyed every one of the woman's most humiliating demands.

After she had toyed with him to her heart's content, Umekichi was ready to put him into a deep sleep. Then she and the others left the room.

The next morning, when Umekichi called his name to awaken him, Sampei suddenly opened his eyes and looked up adoringly at her sitting there by his pillow wearing only her thin night kimono. Her clothes were scattered about the room, to deceive him.

"I just got up now to wash my face," she said, looking utterly innocent. "You had a good long sleep, didn't you? You must have been blessed in a former life."

"Indeed I must, to have a night like this with Ume-chan! My dreams came true, I couldn't be happier!"

Then Sampei hurriedly got out of bed, made a few rapid little bows, and began dressing.

"People will talk, you know, so I'll say good-bye. Don't forget me!" He tapped his forehead lightly—"What a lucky man!"—and went away.

A few days later, Sakakibara came to see him.

"How did things go, Sampei?" he asked.

"Wonderfully, I'm very grateful!" Sampei replied, radiating pleasure. "When you come right down to it, there's nothing simpler. No matter how stubborn or willful she is, a woman is still a woman. It turned out to be just an ordinary everyday affair."

"Quite a lover, aren't you?" Sakakibara said teasingly.

Sampei laughed, a self-deprecating "professional" chuckle, and tapped his forehead knowingly with his fan.

TRANSLATED BY HOWARD HIBBETT

PART IV

Modernity and Individualism

To My Fellow Sisters

NAKAJIMA SHŌEN

 Poet, essayist, and feminist Nakajima Shōen first received attention as an orator. Then known by her maiden name, Kishida Shun (and later Toshiko), she was a regular on the lecture circuit for the Liberty and Civil Rights Movement. She was nineteen when she made her first speech. "Enchanting, just like the princess in a play," one admirer said of her. Her hair was arranged high atop her head in an elegant Shimada coiffure, her red crepe kimono set off by a black silk obi. Shōen had lived something of a charmed life. Born to a well-to-do merchant family in Kyoto, she received an above-average education, matriculating into the Kyoto Women's Normal School in 1877, as a member of its first class. In 1879, having caught the eye of Prince Arisugawa with her wisdom and beauty, she was invited to enter court service, the first commoner so distinguished. Her primary role was to tutor Empress Shōken in the Chinese classics. Unable to abide the sequestered life of the Imperial Court, she tendered her resignation in 1881 and joined the Liberty and Civil Rights Movement, participating enthusiastically and tirelessly in lecture tours—traveling far beyond her home and occasionally into venues typically off-limits to respectable women. Wherever she went, her message was unwavering: women were not only entitled to equality in education and marriage, but also to equal political representation as well.

Shōen was a media sensation. Her lectures, delivered with passion and poise, never failed to rouse her audiences. More than a few future female orators and political agitators cite her as the stimulus that inspired their own activism. Shortly after she began appearing on the lecture circuits, her popularity as an agitator earned her the suspicion of the authorities. On October 12, 1883, she was arrested in Ōtsu for the crime of political speech, jailed for eight days, tried, and fined five *yen*. Her speech "Daughters in Boxes" (Hakoiri Musume) was less a critique of the political system than it was an indictment of the Japanese family structure that kept women sequestered and denied access to proper education.

Undeterred by her arrest, Shōen continued to lecture until the Liberal Party—and much of the movement she had supported—collapsed in 1884. She then transferred her energies to journalism and teaching. Although her contemporary Fukuda Hideko claimed that Shōen's attitude changed after she married Nakajima Nobuyuki, one of the founders of the Liberal Party, in 1884, her record of publication shows, if anything, a more determined and focused stance. Without question her most ambitious essay at the time was "To My Fellow Sisters" (Dōhō Shimai ni Tsugu), published in ten installments from May to June 1884 in *Light of Freedom* (*Jiyū no Tomoshibi*). The essay reveals her erudition in Japanese and Chinese classics as well as in contemporary Western polemics, such as Herbert Spencer's chapter "The Rights of Women" in his study *Social Statics* (1851)— then accessible in a Japanese translation. Before her death from tuberculosis seven years later, she also distinguished herself as a novelist, translator, teacher, and poet. Following Nakajima to the Kantō region, where he was eventually to become the first president of the Lower House of Parliament, she took a job as a teacher at Ferris Women's Seminary in Yokohama. She also contributed regularly to Iwamoto Yoshiharu's *Women Erudites* (*Jogaku Zasshi*). It was here that she published in 1887 "The Crossroads of Good and Evil" (Zen-Aku no Chimata), her adaptation of Edward George Bulwer Lytton's *Eugene Aram* (1832). In 1889 she contributed an original work, *The Noble Flower of the Valley* (*Sankan no Meika*), a "political novel" based on her own experiences, to the literary journal *Flower of the Capital* (*Miyako no Hana*).

Nakajima Shōen came of age during an era of rich possibilities. But by the time she died in 1901, the promise of the new age had dimmed for women. When the long-awaited Meiji Civil Code was unveiled in 1898, women were stunned to find that it remanded them to a patriarchal system that earlier had been expected only of the samurai—the most repressive of the prior four classes. Despite the brilliant example of Nakajima Shōen, it

would be decades before women were able to step beyond the confines of their "boxes."

⌒(RC & AO-M)⌒

PART 1

My beloved and cherished sisters, old and young, what has stolen your hearts and dulled your spirits? Should I be so brazen as to stand before the world and address you, my sisters, those around us will surely grow angry and suspicious. They will try to dismiss me by calling me crazy and my message the ravings of a lunatic. Let them call me crazy, let them laugh at this lunatic woman. I am not afraid. I will avail myself of the platform provided by the newspaper *Light of Freedom*, because, my fellow sisters, I wish to address you with all my heart. My reasons are urgent, compelled by nothing less than my deep love for my country and my sincere concern for its future. My beloved and cherished sisters, both old and young, I muster my courage because of my desire to promote your happiness and freedom. Please, allow me to elaborate.

Since days of old, our country has harbored pernicious habits, customs, and teachings. We should feel ashamed to stand before others from civilized, liberated lands. Among these pernicious customs, the worst by far is that which venerates men while denigrating women—a wretched practice, which seems to hold sway over all the Orient. Needless to say, it is senseless. Please, consider this: Our human realm consists of men and women and is not created by men alone. If women absented themselves from our society for even one day, mankind would perish and countries would crumble. In spirit, body, and mind nature has endowed men and women equally and has made them flawless in their own respective forms. "He having aught where she hath naught"—their forms are devised to complement each other with equal rank and equal right so as to perpetuate human society. Is it not the depth of depravity that, far from enjoying equality, men are revered as lord and master while women are despised as if they were maidservants?

Some would argue that because men are strong and women weak, inequality is justified. But what is meant by strength and weakness? If the difference between an aristocrat and a plebeian, between respect and degradation, were determined by the muscle of one's arm, then the hierarchy among men would accord with the ranking list of the sumo world. An ordinary man cannot possibly best a sumo wrestler. By reason then, the sumo champions Umegatani and Tateyama should take their place among the

highest in the land and serve as chancellor and regent, and our aristocrats, with their delicately pale skin, should surely count themselves beneath the lowest of our low—the former outcasts. Where is the sense in such logic?

If there are those who still continue to insist that strength earns respect and weakness scorn, then let them consider the women warriors of ancient times, Tomoe and Hangaku, whose courageous might was incomparable. They possessed a nobility that was unsurpassed by any man, and their power ought to have earned them a place far above the various and sundry. But our polemists refuse to recognize these women and insist simply that because men are strong and women weak, equality between them is impossible. Their logic is farcical; their argument flawed. Their theory that respect and honor are determined by physical strength is utter nonsense and deserves no further discussion.

PART 2

In ancient times, before our ethical codes were fixed, man made his way through the dark by clearing a path with his fists. Knowledge had no role to play, and morality entertained no consideration. Those endowed with strong muscles captured wealth and were exalted while the weak remained poor and despised. To refer to this age as a time of human community is perhaps a misnomer, when in fact it was more akin to a society of birds and beasts. Please, consider this: birds and beasts know neither etiquette nor ethics; their destinies are dictated by physical might alone. Forced by fate to endure horrific deaths, beaten and devoured by the stronger of the species, the weak live in fear. Cringing submissively before the strong, they admonish their peers to do likewise, praying that they might not provoke the mighty's wrath. Eagles and hawks hold sway over birds; while lions, tigers, and the like rule the animal kingdom. And so it was that in the realm of man, wherever people gathered in number, the right to rule fell to he who had the greatest strength, with no regard to wisdom or righteousness.

In our modern society, when we encounter those who act without moral discipline, we charge them with "barbarous behavior." And wars that are waged without just cause are chastised as "barbaric incursions." "Barbarity" we define as a deed based solely on physical force, undertaken without recourse to knowledge and in defiance of moral principle. It is only natural that by contemporary standards we would find such deeds despicable, detested above all by those who are civilized. How then can we justify our illustrious polemists who, ignorant of this truth—or who at least feign ignorance—belittle women and consign them to inferior status simply because they are weaker than men?

The desire to place another under one's power and expect them to obey one's command without defiance is indeed a barbaric desire. A command, by definition, implies that force, even brute force, might be leveled against whomsoever does not obey. Should the one in power be dissatisfied with an underling's lack of obedience, he will assuredly resort to brute force. And so I call this desire barbaric. From what I have seen of society, men in Oriental countries are abundantly endowed with this very barbarism. Indeed their barbaric desires are so unbridled, it is no exaggeration to say that they are little more than beasts terrorizing all with their show of force. Just imagine how miserable the lives of the women in such a world—to be dominated by these horrid beasts. And so my sisters, I cannot but grieve for you—you who have endured these hardships for so long that you are unable even to feel your own pain and sorrow. My sleeves grow damp with tears whenever I think of you. My pitiable sisters, my beloved sisters, what think you now?

And then there are others who argue that compared to men, women are mentally inferior and lack knowledge. As a result, it is impossible to accord them equal rights. Here again we are met by another sublimely senseless argument, unworthy of serious consideration. The fact that men are more learned than women is not the result of any natural aptitude but is rather attributed to the fact that one has had a greater access to education than the other. Consider the facts: in our country, during the Age of the Gods that start with Amaterasu, the great Sun Goddess herself, and down to the Heavenly Maiden, Ame no Uzume-no-mikoto, many were the women who were exalted above men. Since the Age of Emperors, the female sex has been represented by the fearless Empress Jingū and the talented writers Princess Soto-ori, Murasaki Shikibu, Izumi Shikibu, and Sei Shōnagon, not to mention countless other women—ranging from the most exalted of the nobility to the lowliest of commoners—who have composed poetry, crafted prose, advised their husbands, and instructed others on the path of righteousness. To enumerate all the women whose deeds have surpassed those of men would be impossible. Neither are these examples limited to Japan, for in China we have Empress Zhen of Wei, who by the age of nine had made a name for herself as a woman scholar. Then there is Xu Xiaode's daughter, who mastered writing at the age of eight. Cai Yong's daughter, when only six years old, could tell which string of a harp had been broken simply by hearing the instrument played at night. Wei Cheng's mother, Zhu-shi, had a lecture hall constructed where she taught over one hundred students. And so on and so forth . . . to exhaust the list of wise and learned women would be impossible, for countless are they who over the centuries have composed poetry and crafted prose. So too in the West the number of women who have left their names in the annals of history are impossible to reckon on

one's fingers: Catherine the Great of Russia; Empress Maria Theresa of Austria; the nineteenth-century English science writer Mary Somerville and the economist Miss Harriet Martineau; the French Romanticist Madame de Staël and the Revolutionary Madame Roland; and the famous poets William Blachford's daughter Mary Tighe, Felicia D. Hemmans, Letitia E. Landon, Elizabeth B. Browning, and so the list goes on. As these examples prove, in Japan, China, and the West, haven't countless women distinguished themselves in the very fields that call for knowledge and learning? Now, if there still be those among us who will argue insipidly that women are mentally inferior to men, might we not conclude that they are adept only in stupidity?

PART 3

In the previous section I clarified, through numerous examples, that women's intellectual prowess is in no way inferior to men's. Even those with a jaundiced view of the world have no choice but to bite their tongues and refrain from addressing these issues again. Even so, there will surely be belligerent men among us who will argue tenaciously, saying: "Indeed, it cannot be denied that there were exceptional women in the past, but when their numbers are compared with the scores of talented men, they are so few as to be barely visible at all—thus proving all the more that women are inferior to men." Shame on you men who propagate this theory—for how misguided is your grasp of the social conditions women face today and in the past! Consider this: since ancient times the custom in the Orient has been to equip men with an education. From the craft of writing to the arts of war, men have been trained by teachers and furnished with schools. Leaving aside those few who thoughtlessly abandoned their studies of their own volition or those who hated to study and ruined their chances or those who were poor and received not the opportunity to learn, by and large the vast majority of men have been educated. But even men who have not been formally trained are able to improve their knowledge by interacting with other members of society in a manner denied women who are relegated to the interiors of the home and discouraged from associating with others. The difference in the intellectual abilities displayed by men and women has nothing to do with innate mental capacity but is directly correlated to the fact that men have by tradition been accorded far greater access to education than women and have been granted a social sphere that is far more vast.

An education that is not adequately administered produces no fruit, and by producing no fruit becomes a simple waste of time and energy. And so it is that countless numbers of capable women have perished without being able to deploy fully their intellectual and mental potential. They are

like jewels left to languish in the dark. Moreover, education, when improperly administered, can harm those who receive it. This has been the case with the education that the majority of women have received in our country since ancient times. It has subsequently stifled the development of knowledge within female society. Is it not natural, therefore, that the number of exceptional women falls far below that of men? How loathsome the shortsighted view of our narrow-minded naysayers who arbitrarily clutch their clichéd notion of women's intellectual inferiority without attempting to explore the real causes for this difference!

Suppose we say that men do surpass women in intelligence, does it mean they should be entitled to greater rights? Even among men there are differences in the depth and breadth of intellect. So then are their rights to be distributed accordingly? If rights are determined by intellect, then each man should be asked to sit for a ministerial or doctoral examination. They should then be divided into classes, like elementary school students, and their rights distributed accordingly. But would such a scheme be possible? Clearly not. And for this very reason, even if we indulge men's caprice and admit that they surpass women for the present, this is not to suggest that rights are to be doled out according to the depth and breadth of an individual's intelligence. Surely there is more to superiority than intelligence.

Consider what you see around you every day. There are rickshaw drivers who run to carry women. There are porters who trail after geisha shouldering their instruments. There are young stewards who leap to obey their courtesan's command. There are actors who beg for women's sympathetic patronage. There are countless other men of the lower classes who depend on women for their livelihood. When confronted with the examples I have just presented, will our polemists still accuse women of being inferior to men? In these particular cases, where it is evident that women are superior, will they admit that women deserve more rights than men? Even the most biased and belligerent will bite his silver tongue and say no more when the argument has reached this stage. My beloved and cherished sisters, old and young, steady your resolve and steel your heart as you stand before the hostile and despotic men of this world and advocate the correctness of equal rights.

PART 4

The perverse notion that women are entitled to fewer rights than men because they are intellectually inferior has been demolished by my previous discussion, and no shred of evidence remains to lend it credence. Even so there will be biased and belligerent men who will wish to take issue with my logic. What pretext can they possibly use? Property. They will covet victory

in our debate by trotting forth the issue of property. Let me now proffer my own opinion on the matter.

"Private property" is a term that would seem to include everything from house and storehouse, clothing, furnishings, and implements therein, land, currency, bonds, and other such instruments, down to the pet cat sleeping above the hearth and the ashes in the kitchen oven below. As regards this property, our narrow-minded naysayers will note: In our country the number of women who own property is extremely slight. When it comes to our family structure, it is the man who heads the household, and all the items in its possession—from the treasures in the storehouse to the ashes in the oven—are thereby his to do with as he pleases. His wife has been trained solely to serve men, and, by seeing to her tasks without disobeying her husband's orders—keeping the house by day and attending to her husband at night—she is, in a word, nothing more than her husband's servant. If, in addition to the legal wife, we add the host of others who depend for their livelihoods on a man's largesse—from mistresses and concubines to geisha and prostitutes—then it should be clear that the right to own property in this world is indeed a man's privilege. Drawing their conclusions from these observations, some will aver that man is meant to enjoy full rights while woman is nothing more than his slave. Alas, how can men speak with such a selfish disregard for the feelings of others? Have they no shame? It must be that men, blinded by the customs of the past, allow their minds to be clouded by their own selfish needs. They fail to notice the trend of the times or the logic of equality. Out of touch with the current social climate, they spout their illogical rubbish with no hesitation. And so I stand before you speaking my mind—for I will dash the dreams that lead men astray.

To begin with, we might cite the feudal era as the most obvious example of an age when men enjoyed the right to own property to the exclusion of women. This was the era of the great warlords known as daimyo. The samurai retainers who served these daimyo received stipends in the form of rice and in return were prepared to go to war at their lord's behest. Because women could not perform a similar service, it was stipulated that the head of the family would be male. When the family head died, his inheritance was passed automatically to his male successor. In the unfortunate event that there was no son to succeed to his father's name, the family would hastily adopt a son and see to the legalization of his inheritance just before the father's death. If, however, the head of the family died before a son could be adopted, the family sometimes concealed the death until an heir could be identified and adopted. Of course, it was often the case that these very same families had any number of beautiful and talented women in their midst. But no matter. When it came to the family inheritance, women were worthless—a fact that we remember well today.

Of course, members of the peasant and merchant classes followed the example of their samurai superiors. Wives may have been nicknamed "Lady Shogun" or "Mountain Goddess" when it came to housekeeping, but in their businesses they assumed the patrilineal family or shop names, or else they established a young male relative as a surrogate master while they handled all the details of the family business discreetly in the background. And so it was that in the feudal era it was a perfectly common occurrence that men possessed the right to property while women did not. Although today this system of inheritance has been discontinued, old customs die hard. As a result, the number of men who inherit their family wealth is still great, while the number of women is relatively few. And so our narrow-minded naysayers, refusing to acknowledge the historical facts that gave birth to this grievous custom, glance hurriedly at our current situation and, without making the slightest attempt to understand the rationale behind it, conclude that because more men own property than women it is thereby a natural law of heaven. They then protest unceasingly, without the slightest grounding in fact, that this further proves men's superiority over women.

In today's Japan, a woman can legally become the head of the family regardless of whether she is an aristocrat or commoner. Some women own tens of thousands of hectares of land, while others possess bonds that amount to several thousand *yen,* and there are many female heads of households who live wealthy and comfortable lives overseeing their residences, storehouses, and all the attendant furnishings and garments. There are even more than a few who are responsible for giving orders to dignified and handsome men. No one can predict how society will change over the next few decades, and so it may well be that we will see more and more women succeeding to property. If it should happen that women surpass men with their wealth, can we then argue that men are the inferior of the two? I rather doubt men will want to agree with such an argument. To determine a man's or a woman's natural rights based merely on the value of his or her possessions is inept and idiotic.

There are also those who suggest that mistresses, geisha, and prostitutes make their living by begging for men's pity. I have an opinion on the subject, but shall save the discussion for another occasion.

PART 6

One argument disputing equality between men and women is especially pernicious. Being particularly apt to our country's current social reality, it offers men a specious pretense for opposing equality. Men who subscribe to this argument state that they have no objection to equality between men and women, per se. However, they are concerned that given the current

climate in our country, the time is not right for such modifications. Forcing the issue, they caution, would grievously damage the moral fabric of our society; and our comforts and happiness would be greatly destroyed. If man and woman were accorded equal status, and man and wife afforded equal rights, they predict, the home would then become an arena of incessant disputes and arguments, where the following scenario would become all too common: a husband turns to his wife and orders her to do this or that, and if she, being uninterested in or displeased with her husband's command, does not respond with eager alacrity, the husband will grow irritated and blame his wife. If the wife talks back to her husband, they will fall into a row, which, as the proverb describes it, "is so distasteful, it will cause even a dog to turn up its nose." Soon, one of the two will sally forth with the wooden pestle, while the other will parry with the mortar stone, and by the time the dust has settled, the husband will have sent his wife packing with the customary three-and-a-half-line divorce decree. In fact, these polemists observe, this kind of behavior is not unusual today, even without equality between the sexes. How much worse would it be if, for all to see, man and woman were legally accorded equal status and given equal rights! Why then the authority of wives who already lord it over their husbands as if they were "Her Highness the Heavenly Goddess of the Home" or the "Honorable Queen Mother" would become so resplendent, no mere mortal would be able to approach her at all. The household disputes would never cease from morning to night. Lamps and cups and the like would break daily, until finally there would not be a single object in the house left intact. In a situation as devastating as this, peace and harmony would vanish from the home and human happiness would be no more. Thus it is that the equality of the sexes will doom the family and wreak havoc in society at large, and their argument continues so forth and so on. At first this prediction may seem reasonable. But upon careful scrutiny, it is clear that the points made are superficial and deserving of no further consideration. Yet, for those men who are still troubled by senseless anguish, I will state my convictions here and so set your hearts at ease.

No one enters into a marriage squabble willingly. Yet any number of these unpleasant incidents occur, disturbing the neighbors and becoming the source of gossip and laughter. A more lamentable situation is hard to imagine! Upon closer inspection, it becomes clear that in our country the one named as the culprit in these marital squabbles is always the wife. Either it was her unreasonable jealousy that lit the fuse or her errant mouth, or so the explanation goes. I find this one-sided justice most objectionable. And yet because our polemists insist that women are to be blamed for these incidents, they cling to their unreasonable fear that should equal rights be insti-

tuted, this kind of discord will continue unabated. If we clear our mind of our prejudices and consider the situation carefully and levelly, however, we will see that women are not the only ones responsible for marital quarrels. Indeed, many are instigated by men.

Suppose, for example, that the cause of the quarrel is a wife's jealousy. If the husband behaved appropriately and did nothing to arouse jealousy, then even a hardhearted woman would find no reason to pick a fight. But, based on the commonness of such occurrences, we know that many a fight begins when a woman lashes out at her husband once he has dragged himself home after a night in the pleasure quarters. Some fights are caused by the couple's poverty. Perhaps the wife is too much of a spendthrift. More likely the husband is lazy and refuses to work, or perhaps he has to sell off his wife's clothing to make up for his gambling debts. Of course, some fights ensue because the wife has a bad character and is given to hurling abuse at her husband. She cannot seem to stop herself from talking back. But even in such situations, unless the case is correctly examined at court, who is to say one party is right while the other wrong? And who has determined that the proper path for a woman is to bite her tongue and refuse to speak up, even when a man is unreasonable? Could there be a more preposterous principle? If henceforth we should refrain from censuring only women in domestic disputes, if husbands would seek to take as their principle one that appreciates the wisdom of equality between the sexes and that encourages prudent behavior and respectful treatment of wives, then what woman, being inherently of a sympathetic nature and physically of a weaker stature, would intentionally abuse her husband and willfully seek to fight him? If our world became a place where men were gentle and filled with compassion, then there can be no doubt that the women of this world would observe polite social graces, speak with reverence, and maintain their feminine virtues. Hardhearted, narrow-minded men take courage! There is no need for your senseless anguish.

PART 8

The Chinese sage said: "Do not impose on others what you yourself do not desire." Christianity teaches: "Do unto others as you would have them do unto you." East meets West in the teaching of benevolence. Benevolence means having compassion for others and the sensitivity to put yourself in their shoes. Any human being, whether man or woman, who can go through the day without a benevolent heart is that much closer to being a beast.

Women do not take delight in those things that men abhor. Men and women share equally in their likes and dislikes, and, consequently, the things

women enjoy are not abhorrent to men. Is it not a heartless act, therefore, for men to force women to do those very deeds that men abhor? It is hard to imagine that such men could be human. If we were to turn to a man and ask what he thinks of his rights, he will surely reply: "My rights are as precious to me as gold and silver, as valuable as jewels." If we ask him what he imagines the head of the family next door thinks of his rights, he will surely answer: "He values his rights as much as I do mine." Rights, you see, are precious to those who own them, as well as to those around them who, from their own experience, value their rights just as dearly. How, then, is it that when it comes to a woman's rights, they alone are not deemed valuable or precious—that she is incapable of appreciating them as such? What if, even briefly, these heartless men put themselves in a woman's place? What would they think of men then? But truly such is beyond their ability to imagine.

The women of our country, much accustomed to the practices of old, do not even realize they have rights. They follow the actions and words of men and endure cruel mistreatment. I can write until I wear my ink brush to a nub and lecture until my voice grows hoarse and still not be able to bring all women to their senses. But this must not be used as a pretext for men to argue against giving rights to women. Suppose someone usurps a parcel of land from its rightful owner. Because the theft took place a long time ago, no one remembers when and from whom the field was taken. Or perhaps the original owner was too young or too weak when the land was usurped and, without even being aware, was duped by the smooth persuasion of the usurper. Now, suppose that, upon closer examination, the original owner is discovered and papers proving the true ownership of the land produced. At that point, if the person who committed the theft were a conscientious man, he would voluntarily return the field out of a sense of remorse. But if the person were stubborn and shameless and refused to return what he had stolen, what would society say then?

In our country, the way men treat women is comparable. Blinded as they are by the customs of the past, women do not even realize that they have rights. Knowing now the truth of what occurred in the past, it is only appropriate that men should make haste to restore these rights to women. That men continue to take advantage of women's ignorance and pilfer from them is shameful and reprehensible! Men are much practiced in insisting that women are ignorant and unlettered. If men are truly superior to women in intelligence and learning, then they should be the first to recognize the logic of equal rights for the sexes. They ought to be able to imagine the challenges a woman faces. And once they have grasped the logic of equal rights, they ought to put it into practice without a single day of delay. Why then do they waver so, with feet so firmly planted in the past? Is it because they lack the

virtue of benevolence? No wonder then that they can be so callous as to insist that women cling to the wifely virtue of docility.

If, having come this far, I encounter men who disparage their own education and invent an excuse for their inability to fathom the logic of equality by hiding behind their own ignorance, to these heartless, soulless men I have nothing left to say.

PART 9

To every force in society there is an equal counterforce. If we press a person down, eventually he will spring up against us. If we rebuke a person, he will in turn rail against us. In our country, whenever women speak abusively or act unkindly toward men, they do so not because they are naturally predisposed to such behavior or because they are ignorant but because they are recoiling instinctively against the unreasonable oppression imposed upon them. Of course, you will always find some women who, being naturally predisposed to bravado and controversy, take advantage of mild-mannered men to quash them into submission. But you will only find one or two of their kind for every one hundred women; and with such insignificant numbers, it is unreasonable to use them to support any kind of theory. At any rate, when we consider the feelings of most women today, none sets out with the intention of subjecting her husband to such an onslaught of verbal abuse so that he ends up on his knees before her as if she were "Her Holy Mountain Highness"! It is only when husbands behave unreasonably in word and deed and treat their wives with the petulant arrogance of a wayward tyrant that wives are provoked to strike back with the aforementioned force.

Let me offer an analogy in which man is wind and woman water. If the wind blows gently, the water remains calm. But if the waves grow rough enough to overturn a boat, it is the fault of the wind. This is not to say that woman, as water, is of a nature that can only respond to the wind's beck and call. I mean by this analogy merely to prove the point that I am making in this section. If men, knowing that their oppression of women is unreasonable, were instead to treat them kindly and with compassion, then the winds will grow gentle and the waves still, and in the four corners of the sea all will be quiet, not even the twigs on the tree branches will stir. In such a world husband and wife will live a long and happy life like the old couple celebrated in the nō play *Takasago*. Men of the world take note and admonish one another—to every force there is an equal counterforce.

If men would heed the wisdom of what I have herein explained and relinquish the authoritative attitudes they have harbored up to now, if they would accord to women the respect that they expect for themselves, if

they would return to women the rights they are owed, then women will forgo the reactive violence that has become their vice. They would in turn respect men and love their husbands. Men and women could then vouch-safe their rights together. Man would cherish a woman's rights, and she his; and if they could do so without violating the other's freedom or coveting the other's privilege, then man and woman would entertain each other with kind thoughts and sweet words. Commands would transform into consulta-tions, and these consultations would bring about family peace. Disputes would cease; the pestle and mortar would stay where they belong in the kitchen; lamps and cups would break only as a consequence of ordinary wear and tear, and the home would become a site of tranquility and mutual joy. Humankind would then, without a doubt, enjoy supreme happiness. Can there be a more joyous, encouraging prospect?

In the real world, however, men are so blinded by hackneyed social conventions and habits that they cannot even conceive of a world as won-drous as the one I have just described. How greatly mistaken are they to dream of happiness and pleasure while they selfishly seek to expand their own power in complete disregard for honor, principle, and human decency! In the same vein, what is more deplorable than those who are so entrenched in their antediluvian convictions and so wedded to contemporary social practices that, being incapable of giving new ideas thoughtful consider-ation, they criticize, disparage, and revile as evil those couples who do try to practice, even by small degrees, equal rights and egalitarian relationships? Alas, you men of society, pay heed. When you open your mouths to protest, do you not cry out for progress and clamor for reform? Why then, when it comes to this single issue of equal rights do you suddenly clam up and cling with such affection to the customs of the past and yield so compliantly to the vulgarity of the present day? My beloved and cherished sisters, old and young, redress past practices, destroy contemporary customs, and awaken these heartless men from their deceptive dreams.

PART 10

There are alarmists who will argue that equality between the sexes is not practiced in even the so-called civilized and enlightened countries of the West. They will point out, for example, that in the West men have political rights. They can be elected to parliament, and they have the right to vote in these elections, whereas women have no such rights. This is proof that men and women do not have equal rights. Moreover, British divorce law stipu-lates that a husband may petition to divorce his wife if she commits adultery after the marriage has been contracted. On the other hand, a wife cannot

similarly petition the court simply on the grounds that her husband is adulterous. Rather, the wife may file for divorce only if her husband engages in an act the courts determine to be incestuous or polygamous, or if he rapes another woman, or if he engages in bestiality. Numerous are the examples, they state, that equal rights are not practiced in the countries of the West. If they are not practiced there, how can we expect a country like ours, where civilization is still maturing, to institute equality? Moreover, if we try to force the practice of equality, it will be to our great detriment, and so forth and so on! Their argument is greatly flawed. The West may be deemed civilized, but it is only so in comparison with less civilized nations. Even in the West, civilization has not reached its zenith. We will find in the countries there many practices that are inhuman, irrational, ugly, and evil. When it comes to social morality, we can very nearly conclude that, in many of their customs, they are inferior to us. Therefore, we must not affirm and adopt everything Western simply because it is from the West. But neither can we categorically reject everything because we perceive it to be detrimental. Our duty as patriots is to promote civilization by adopting those advantages that will help us overcome our own disadvantages. Granted, equal rights between men and women are not perfectly enforced even in the civilized Western nations of England and France, but that is why erudite women like Millicent G. Fawcett have emerged to rectify mistakes. Moreover, recently, female scholars and other learned women have convened and have garnered the strength to petition parliament for the promulgation of female suffrage. It should be clear to us, as clear as the image reflected in the looking glass, that in the not-too-distant future the Western nations will reach the level where equal rights will become a reality, and true moral virtue will emerge victorious.

And yet, in the Western nations, the ancient custom of hegemonic rule, whereby the strong subjugate the weak, is still in practice today. The rich exploit the poor; the highborn oppress the humble; and stronger nations subjugate the weaker. Because moral principle is compromised in so many ways, men still retain remnants of those customs that allow them to exploit their might at the expense of weaker women, who are oppressed and made to suffer. Perhaps this is why equality between men and women has not yet been fully realized. Here we have our proof that civilization in the West is flawed and has not yet attained its zenith. Nevertheless, what are we to make of those who agitate against the enactment of equal rights between the sexes in our country by touting the weak points of the West? Aren't these the very same people who profess their hope that our country will see reform and will civilize along the lines of the very countries they denigrate? The ineptness and idiocy of their argument is beyond limit!

Are we then to adopt everything Western without question, as these reformists advocate? They would seem to have no objection. In the West they practice monogamy. Will our reformists have us do the same? In the West men escort women on and off carriages and trains. Will our reformists also be respecting this courtesy? In the West a man stands when a lady enters or exits a room. Will our reformists object? In the West a man opens the door for a lady and closes it when she has passed. At a meal he dare not begin until she has first been served. Surely our reformists will voice no complaint. In the West women are entitled to sit comfortably in a crowded room or train compartment, even when men may not. If a man wishes to smoke, he must first receive a woman's permission. In fact, there are numerous such special rights to which women in the West are entitled. I expect our reformists to follow them all with appropriate decorum. If a man accorded a woman this kind of courtesy in our country, onlookers would single him out for the most uproarious censure. Nevertheless, if our reformists are determined that we should do whatever is done in the West, then I will gladly indulge them. I will defer the issue of legal suffrage until some other day and will for the time being content myself with inequality, enjoying all the while the same special services that men bestow upon women in the West. My beloved and cherished sisters, both old and young, pray share with me your thoughts on these matters. What do you think of this?

TRANSLATED BY REBECCA COPELAND AND AIKO OKAMOTO-MACPHAIL

The Origins of My Colloquial Style and Confessions of Half a Lifetime

FUTABATEI SHIMEI

 Futabatei Shimei is renowned as the author of Japan's first modern novel, *The Drifting Cloud*, and one of the main originators of the colloquial style movement. *The Drifting Cloud* is often seen as the bold and largely successful attempt of a precocious, immensely talented young man to create a radically new form of fiction using an equally new form of expression. However, the two pieces presented here, in which Shimei looks back on the process two decades later, show the novel in a different light, as a work written for money by a young man riddled with self-doubt.

Being remembered principally for the literary achievements of his mid-twenties was not a destiny to which Shimei aspired. From a young age, his values were strongly shaped by the Confucian tradition, which prized philosophy, history, and poetry above all other forms of writing; fiction was dismissed as mere entertainment, and its composition was considered a pursuit unworthy of men of substance.

As Shimei intimates in these pieces, his great lifelong ambition was not to modernize Japanese literature or to reform the written language. Like so many other young Japanese intellectuals of his time, he aspired to serve the nation and advance its regional and global interests. After the possibility of a military career was eliminated by his poor eyesight, he resolved to become an expert on Russia, the power that he viewed as the greatest threat to Japan's security. This led to his enrollment at age eighteen in a state-run school where he was to spend almost five years receiving instruction in a full range of subjects, all taught in Russian. He thus attained an unusually high level of linguistic proficiency.

It was through these studies that Shimei was exposed to works of the great nineteenth-century Russian novelists and also to the ideas of Russian critics who maintained that the principal duty of writers was to reveal the social and political conditions of a nation. This concept, which enabled him to reconcile his interest in literature with his ideal of service to Japan, remained central throughout his career.

It was also at this time that he met Tsubouchi Shōyō, who was then establishing himself as a major figure in the introduction of modern Western ideas about literature, including the role of the novel as the most important literary form. Contact with Shōyō further impressed upon Shimei the need to create a new mode of writing that reflected the values of nineteenth-century European realism but also drew upon native sources in its development of a more colloquial style.

Shōyō served as a mentor to the slightly younger Shimei in his early attempts at translating Russian fiction and then in composing a new kind of realistic novel expressed in a colloquial idiom—an undertaking that, Shimei claims in his reminiscences, was prompted as much by a need for cash as by literary ambition. These translations made the works of major Russian writers accessible to Japanese readers and established a new standard of translation in Japan by striving to recreate the meaning and feel of the original works as closely as possible.

Even more significant was *The Drifting Cloud,* wherein groundbreaking innovations in language, detailed depictions of individual characters' thought processes, and penetrating observation of the new Meiji social order and

its contradictions represent major steps in the development of modern real-
istic fiction in Japan. The self-doubt that is a salient psychological feature of
this novel's protagonist, Bunzō, reflects the uneasy position of young Meiji
intellectuals as they came to terms with the predicaments of living in a rap-
idly changing society, struggling not only with the obvious conflicts be-
tween tradition and modernity, but also with the disconnect between lofty-
sounding ideals and the sometimes unsavory realities of modernization as
they were experienced by ordinary people. *The Drifting Cloud* was left unfin-
ished after its third installment, and the ever-restless Shimei virtually dis-
appeared from the literary scene.

The years after the turn of the twentieth century saw a renewed interest
in Shimei as a kind of respected elder statesman of modern Japanese litera-
ture. A revived inclination on his part to get involved in literary activity led
to the publication of his first works of fiction since *The Drifting Cloud,* the
well-received short novels *An Adopted Husband* (*Sono Omokage,* 1906) and
Mediocrity, and also to the appearance of a series of articles presenting his
transcribed comments on various topics in the magazine *Literary World*
(*Bunshō Sekai*), including the two presented here.

In "The Origins of My Colloquial Style" (Yo ga Genbun Itchi no Yurai,
1906), Shimei is characteristically diffident as he speaks of his lack of abil-
ity, his reliance on the guidance of Shōyō and on linguistic models provided
by the popular Edo-period writer Shikitei Sanba and the Meiji-period sto-
ryteller San'yūtei Enchō, and the feelings of failure and futility that plagued
him even while he was playing a decisive role in Japanese literary history.
The title of "Confessions of Half a Lifetime" (Yo ga Hansei no Zange, 1908)
enfolds an inadvertent but grim irony: the piece appeared less than a year
before his untimely death at the age of forty-five. The word *zange*, translated
here as "confessions," is a somewhat old-fashioned word with religious over-
tones, suggesting a stronger sense of repentance than the more common and
neutral term denoting confession, *kokuhaku*. The words in quotation marks
were supplied by Shimei as English glosses for terms that were printed in
Japanese, an interesting touch in a piece that originated as a transcribed ver-
sion of spoken recollections delivered in a distinctly colloquial tone.

<p align="center">☞(JC)☜</p>

THE ORIGINS OF MY COLLOQUIAL STYLE

My views on writing in the colloquial style? Well, I haven't done much in
the way of studying the topic, so instead let me just offer a bit of a confes-
sion. This is the story of how I originally came to write in the colloquial

style—which sounds momentous, but in actuality it all started out with my inability to write decent prose. That's the long and the short of it.

It was quite a few years ago, I can't remember how many. I had been wanting to write something, but I had never been good at composition and had no idea of what direction to take. So I decided to call on Mister Tsubouchi and ask him what I should do. "You know how Enchō tells his stories, don't you?" he said. "Why don't you try writing something like that?"

So, I gave his suggestion a try. But since I'm a Tokyo native, of course I use Tokyo language. In other words, I came up with a composition in Tokyo dialect. I took it to Mister Tsubouchi right away, and after looking it over carefully, he slapped his knee and said, "You've got it! Just keep going—if we start fiddling with it, we'll spoil everything."

I still felt a little uneasy, although now that he had praised it, I could hardly object. At the same time, though, deep down I felt kind of happy about it as well. Since it was modeled on Enchō's style, it was in fact, a colloquial piece, but I still had a problem: was it more appropriate to use Enchō's idiom of formal, polite speech with the *de gozaimasu* ending, or the rougher and informal *da* as in our daily conversation? According to Mister Tsubouchi, it was better to avoid the polite style. I wasn't entirely satisfied with this advice, but since it was the verdict of my mentor, who had given it to me at my own request, that is what I did. And that's how I got my start in writing in the colloquial style.

Some time afterward, when Yamada Bimyō began to publish his own colloquial-styled pieces, I saw that he was taking a different approach and was using the more polite *masu* form. When I asked about it later, I learned that Yamada had first tried using the informal *da* style, but he could never get it to sound quite right, so he settled on the *desu* style. I had started out intending to use *desu* but ended up with *da,* so in effect the two of us had proceeded in exactly opposite directions.

At any rate, since I wasn't very well equipped for literary composition to begin with, I had a tendency to come up with expressions that were outlandishly vulgar. Mister Tsubouchi warned me that I needed to be a bit more polished. Tokutomi Sohō, whose magazine *People's Companion* [*Kokumin no Tomo*] was publishing my work, felt that while there was nothing wrong with bringing the written language closer to the spoken, it would be better to make our speech sound a little more like writing. But it was hard for me to accept the ideas of either of these mentors, because my own rule was to avoid the use of any words of Chinese origin that had not been established as part of the ordinary Japanese vocabulary. For example, a term like *gyōgi sahō* [etiquette], although it must have originated in China, is now a part of Japanese, so it is all right. But a Chinese term like *kyoshi kanga* [of

debonair comportment] has never been "baptized" into Japanese, so it should be avoided. And a word like *rairaku* is now part of Japanese, at least when it is used in the sense of "equable," but when it is used with its original Chinese meaning of "rolling stone," it is not. Avoiding these Chinese words that are not commonly used in Japanese was my principle. Among native Japanese words as well, those whose natural lifespans had already reached an end, such as *haberu* [to attend upon], I would not use. In all cases, my policy was to use the words of the present age, to let them evolve naturally, and wait for them to bloom and bear fruit. Trying to force Chinese and classical Japanese expressions into the mix, I thought, would be a pointless act of human presumption, and so I created all kinds of ridiculous problems for myself.

Long-established turns of phrase and idioms I rejected entirely. I did occasionally look to some of the so-called Low City language of old Edo from the writings of Shikitei Sanba. Expressions such as "You damned numbskull, it's not like you're some kite that's crashed into a pumpkin patch, so don't try to get me tangled up with your nonsense" or "This ain't no well and you ain't no bucket, so don't expect me to carry you up and down" are certainly crude, but they are also, as the English would put it, "poetical." This, I believed, is where the real soul of common speech is to be found, and so I occasionally relied on such expressions, but that was all. Of course I was also attempting to introduce some of the structural patterns of Western languages at the same time, but that was not a matter of word usage.

In those days, Mister Tsubouchi would sometimes urge me to weave in a bit of elegant phrasing, but I resisted. If anything, I was making a conscious effort to eliminate such things from my writing. I was also trying to improve on commonly used expressions by "elaborating" them, but all of these attempts ended up failing. Probably anybody else who tried would have failed as well. It's just too tricky, I tell you. Those are the kinds of pointless projects that I wasted my time on . . .

Now that I think of it, all of this happened before a certain point in my life. And nowadays? Well, I've surrendered myself completely to Mister Tsubouchi's principles, and I'm doing a study abroad program in ancient Japan and China.

CONFESSIONS OF HALF A LIFETIME

Since my literary career, if you want to call it that, has involved no particularly brilliant achievements, let me instead say something about the way that my thinking has evolved over the years. In other words, confessions of

half a lifetime . . . which, serving as an expiation, might in fact be a better choice.

So, the first question to address is why I came to take an interest in literature, but for this I have to start by explaining how I came to study Russian. Here is the story. There had been a big uproar about Russia because of the Sakhalin-Kuriles Exchange Treaty, and in the aftermath of that there was a magazine, the *International and Domestic Relations News* [*Naigai Kōsai Shinshi*], that was busy stirring up a mood of indignation toward the Russians. Public opinion was running at a very high pitch in those days, and the nationalistic ideology, what you might call nationalism in the style of the patriot-activists of the Meiji Restoration era—something I had been committed to ever since I was a boy—raised its head and ran head-on into that public mood of patriotic indignation and alarm. This led me to view Russia as the obvious source of future concern for Japan, and to feel that it was essential for us to find a way to deal with this threat right away, so knowledge of the Russian language would also be essential. So it was with this notion that I entered the Russian Department of the Institute of Foreign Languages.

As for my first exposure to literary works, when I entered the Institute, being carried away by this form of "imperialism," a need to study literature naturally arose in the course of my language studies. That was because our studies were based on the Russian intermediate school curriculum, and along with being taught subjects such as physics, chemistry, and mathematics in Russian, we also studied rhetoric and the history of Russian literature. In the literary history course, the instructor had us read the major works of the major Russian writers.

In this way, without even realizing it, I was falling under the influence of literature. Of course, the groundwork for this had already been laid, since I had had a kind of affinity for the arts since my childhood years, and it naturally developed under the inspiration of Russian literature. At the same time I was also feeling that sense of righteous indignation inspired by my patriot-activist spirit, and at first these two tendencies proceeded on more or less parallel courses, with neither of them dominating the other, but eventually my imperialist passions abated, while my passion for literature only grew more intense.

Here, though, a bit of explanation is required.

My case involved something different from the love of literature felt by typical literary men. Rather, it was the subject matter of Russian literature, the way writers used literature to observe, analyze, and speculate on social issues—topics that were far from the minds of anyone who aspired to literary eminence in East Asia—that came to be of great interest to me. Now, if

it were merely a matter of being interesting, there would be little more to say about it, but my interest evolved into a way of thinking, namely "socialism."

And so, to get to my point, although I had become so deeply involved with literature that I was poised to make it my primary pursuit, I began to devote myself not to literature but to socialism. In other words, my commitment to socialism was stimulated by my interest in literature. And while socialism involves one's attitude toward actual society, at the same time I was developing an interest in philosophical questions such as one's attitude toward life and human destiny. At the outset, it was not purely philosophical. Rather it was a sort of cultural critique that engaged me, on the one side; on the other, regarding the structures and institutions of the real world, there was socialism. My thinking was divided in these two directions, even though they shared a common source.

There were quite a few authors who had played a role in leading me to embrace socialism. The works of Turgenev, especially the character of Bazarov in *Fathers and Sons,* made an impression on my mind that remains to this day. There were also Chernyshevsky, Herzen, and, although he was not a Russian, Lassalle, all of whom I read intently.

Although I was of course very earnest in my socialist beliefs in those days, when I look back on them now it all seems exceedingly juvenile. For example, I detested the government's policies, I resented any interference by my parents, and I recklessly shouted "Liberty! Liberty!" as my watchword. I was always singing this kind of tune, so of course I wanted no part of a government-run school. At this point, the Institute of Foreign Languages was closed, and it became the Department of Foreign Languages of the Institute of Commerce, and, shortly after that, the department was in turn closed, and its students were all reassigned to the Institute of Commerce. I left immediately. At that time, my father and others were continually urging me to enter the university, but I was no more willing to enter that government-run institution than I was to stay in the government-run Institute of Commerce. In the end, reluctant to have my freedom restricted by dependence on my parents, I resolved to cut myself off from them entirely and pursue my studies on my own.

This meant that I would have to go to work in order to support myself, and that is how I came to write *The Drifting Cloud*. Of course, I had already done some translations. I had tried my hand at translating a little of the beginning of the aforementioned *Fathers and Sons* by Turgenev, but all I did with it was show it to Mister Tsubouchi, and nothing ever came of it. Did I have any models for *The Drifting Cloud,* you ask? It's not as if there weren't some, but as models go they were more like guides than something I just copied. Nor of course was it the case that I had discovered some-

thing so interesting that I decided to make a model out of it. Rather, I already had some vague, abstract notions in my head about what young men and women in Japan were like in those days, and as I was turning over various ideas about how to put them into a concrete form, I noticed that, among the various people that I encountered, or those that I already knew, there were some who matched those abstract concepts of mine to some extent. So I used those people as starting points and developed them into various types. Of course those originals each had their own "individuality," but I left that out and refined them into types; and since types are not mere "notions" but concrete things, to that extent my initial objective was achieved. In this sense I can't say that there were no models for *The Drifting Cloud,* but the kind of model that I'm talking about may be somewhat different from what most people mean by the term.

At any rate, I cannot deny that my thinking as it was reflected in this work was heavily influenced by Russian literature. I was avidly reading things like Belinsky's critical writings in those days, so I had a desire to probe beneath the surface in my portrayal of Japanese society, which is why it was basically a tendentious novel. In its style, the first volume is a muddle of Shikitei Sanba, Hiraga Gennai, Shiba Zenkō, and Aeba Kōson; by the middle volume I had left Japanese writers behind and adopted a Western idiom. That is, I had been studying writers like Dostoevsky and Goncharov with the intention of importing that Western idiom, and ultimately it was in Dostoevsky's direction that I turned. The influence of these writers may be seen to some degree in the final volume as well, but it was the writing of Goncharov that I emulated most frequently.

Speaking of *The Drifting Cloud,* I have already mentioned I wrote it to earn some money. This may sound like a simple enough matter, but in truth nobody realizes all the difficulties that it caused me.

In those days I took the word "honesty" as my ideal, and my mind was set on trying to live in such a way that I would have nothing to be ashamed of before heaven or earth. This ideal of honesty had been nurtured by Russian literature to some extent, but my Confucian influences played a more important role. If I may backtrack a bit in my explanation, at the same time that I was being influenced by imperialism, I received the powerful influence of Confucianism. So, on one hand, the Confucian doctrine of acting on one's beliefs was firmly implanted in my mind . . . in reality this was nothing more than a superficial enthusiasm on my part, but superficial as it was, I was passionately committed to it. For example, when I attended my professors' lectures, I would always maintain an extremely respectful posture, not so much out of reverence for the professors as for the Way itself. This kind of religious, philosophical tendency was something that had been

a part of my makeup from early on. In this way, the Eastern influence of Confucianism came together with the influence of Russian literature and Western philosophy, and then came the influence of socialism to form the central concept of my morality, namely the belief in an honesty that would have nothing to be ashamed of before heaven or earth.

All of this, however, is about my way of thinking. How, then, did it relate to my literary efforts? First of all, let me talk about *The Drifting Cloud.* Although it would be fair to say that its critical reception was reasonably favorable, it left me feeling chastened. At that time, just as now, I was entirely lacking in self-confidence. And then there was that ideal of honesty. Add to this my feelings of respect for art. When these three elements—frustration, honesty, and respect for art—finally reached their saturation point . . . well, the result was that I began to think that, however things might turn out in the future, at that point the very idea that I might make myself part of the literary world was the height of presumption, and an affront to art. Although I believed that I had failed to live up to my ideal of honesty, holding that ideal still meant that it would not do for me to live off of my parents or rely on the favors of others; for that, I must be independent. And so, of course, I wanted money. And since I wanted money, I would have to write something, probably fiction, even though it would be an unforgivable artistic offense. Even worse, I wasn't able to get it published under my own name; only when Mister Tsubouchi agreed to lend his name to it was it deemed acceptable. In other words, for my own gain I caused my mentor to commit an impropriety that he had never intended. It was tantamount to exploitation. Moreover, there were the readers whom I had also wronged with this deception, or, if one were to put it more strictly, defrauded.

Here was an awful "dilemma": the conflict between the "practical" and the "ideal." It was a dilemma that my mind was unable to resolve. But as I was finding myself harder and harder pressed by the exigencies of daily life, I was left with no alternative but to create *The Drifting Cloud* for money. This was, according to my own ideals, an outrageous, simply outrageous act, and while it did in fact bring me some money, it also filled me with a deep sense of shame and self-loathing. In the depths of my anguish, I suddenly heard a voice from within shouting *Kutabatte shimē* (Drop dead!)— Futabatei Shimei!

Although various explanations have been offered about the origin of my pen name, this is the truth. And when I heard that command to drop dead, I thought that such a time might well be on its way. Because, when the decision came, it would at least put me out of the misery that was my life. And as far as I'm concerned, that phrase, *Kutabatte shimē,* still has a meaningful resonance today. As for the question of how this feeling reveals itself

in my work, it is etched into my very bones and inscribed on my flesh; the ordeal is enough to make me break out in a clammy sweat. But the cause of this is nothing more than a wish to lighten the burden of my own guilt: what drives me to such exertions is the exceedingly fainthearted "honest" desire that, instead of advertising mutton and purveying dog meat, I might at least be able to come up with something a little more palatable, such as pork. When it comes to translating, this strain is even greater. In those days, I had the deepest respect for Turgenev, and it seemed inexcusable for someone like me to take the fruits of this great master's labors and make a hash of them, so even if it was utterly impossible to convey their spirit, I thought that if I was at least able to faithfully reproduce the form of the original in a Japanese version, readers who knew no Russian might be able to conceive some sense of the wonders it offered. Thus I struggled to match every comma, every period, even the number of letters in the original. When I think of it now, it all seems absurd. Of course, when I put it this way, it sounds as if I was thoroughly pursuing my ideal of honesty, but in fact there was a major contradiction in the form of my towering sense of ambition. And so I threw myself into my work, thinking that mastery over the literary world was certainly within my reach. . . . Indeed, it was utterly contemptible.

At this same time, I found myself falling into deep misery over practical difficulties in my life. This came about because my ideal of "honesty" was gradually disintegrating: first in my "honesty" as a novelist, and then in various other ways. In other words, my whole way of living was disintegrating. And because this was my frame of mind as I was engaging in my literary efforts, it was impossible for me to make any headway. The earnings from my writing being far from sufficient even to support myself, conditions at home became more precarious by the day, and finally descended into abject misery. My parents never experienced a moment of ease. There were other sufferings as well; and these sufferings all boiled down to not having money. Forgive me for saying it again: I wanted money, but in order to get it I would have to abandon all those principles of mine, and even if I did, I wouldn't be able to get enough of it anyway.

Dilemma! Dilemma! How tormented I was by this! It became the prime impetus for my agonizing over my attitude toward life. Existing in such a state of suffering, it was only natural that my thinking ran toward such questions as "Where will this life lead me?" and "What is the purpose of living?" This was truly painful. And being too hard pressed to even have a chance to study these questions carefully, I was in a continual state of misery. Being at wit's end, my only purpose in studying these questions about life was to find a way of escaping from my suffering. This was not the kind of reflection on life that one pursues in one's free time for amusement, but something

that I pursued in a state of anguish. It was in this period that I devoted my-self to poring over books of philosophy, as well as looking into Christian-ity, investigating the Buddhist scriptures, and even extending my inquiries to theology.

It might have been easier to just give myself over to a romantic sense of world-weariness, but a contradiction kept tearing at me: even though life had somehow lost its interest for me, I was not willing to give it up. Some-how, I still felt bound to it. On an abstract level, I could not tell whether life was worth living or not; nor could I tell on an emotional level. In the end, the only thing I was sure of was the misery that this feeling of being at a loss was causing me. But this, I think, was not what people mean when they talk about being "world-weary."

Let me offer one example of what this distress was like. There was a Christian magazine that was very widely read in those days. It never hesi-tated to proclaim the usual Christian perspective on all matters ("This world of ours, created by our Lord," and so on), in the most emphatic style. I found this annoying: How could such empty people, with such limited minds, dare to issue such sweeping pronouncements, and in such self-satisfied tones? It was inexpressibly, infuriatingly vulgar and sordid. So imagine my feelings when one day, while walking through Ogawamachi, I happened upon a poster for this magazine in the front of a little shop where cheap printed materials were sold. One quick glance at the drivel they were spew-ing was enough to make me feel sick. I was literally on the verge of throwing up, so I hastily turned my face away and rushed off, just barely managing to stifle my urge to retch right then and there. This will give you some idea of my state of nervous agitation in those days. My mind was in a frenzy, even my nerves were deranged—sheer absurdity!!

And then I did something absolutely outrageous. When one reaches this point, all that remains is "animal appetites"—all one can think of is to eat, to drink, to chase women. I, who had never been able to touch a single drop, became a drinker; I, who as a boy had learned to trail after neighbor-hood women in the frivolous Edokko style, now began to chase women again as a middle-aged man, and this time in earnest. . . . Having sunk to such a bestial level of existence, I came to think that even stealing would not be beneath me. This is the truth.

And yet, I could never quite bring myself to go that far. Even as I was feeling that life is meaningless "nonsense," I also felt that I was living a lie, and that the hour when the light would begin to shine might not be far off. In other words, it was that absurdity again. And so acting badly made me feel miserable. Even as I was doing these things, I remained stymied, unable to take them to their logical ends.

At that point, as I was doing all this, I made the acquaintance of an utterly low-grade woman. She was my exact opposite, a tremendously vivacious type, the kind of woman who made her way through life humming a tune. Of course she was shallow, but this gave her a kind of vital force, where part of me was already dead. Her ability to laugh out loud at things, mouth open wide, with a lusty *Ahahaha haha,* gave her a kind of truly curious "attraction" in my eyes. I'm not saying that I had fallen for her. But somehow I had this feeling that while my own life force had diminished to a mere trickle, hers was gushing on ceaselessly. Perhaps it was only natural that a man who felt himself to be almost within the shadowy, chilly clutch of death would seek a bright, sunny place full of vital energy, and, unable to find it, suffer in agony. And so, no matter how shallow and hopelessly impervious to any kind of reasoning she was, there she was, right before my eyes; and so it was that my heart became drawn to this woman.

This, however, became an impetus for me. I had let things proceed all this way . . . and in the end this was just the thing that provided the impetus for my coming to a turning point.

Seeing this actual example, right before my eyes, here is what I realized: feelings like suffering and pleasure depend entirely on the person. Something that made me suffer, for example, might seem like nothing at all to a woman like her. Now, in her case it might have seemed like nothing because she was shallow, but there was another person, someone by no means shallow, who would feel the same way. That person, I believe, was Master Confucius. A truly great man can take pleasure in the will of heaven with equanimity. Let us take, for example, the problem of death, which at present admits of no solution by means of the intellect. And yet, even if such a solution were to be found, we would still not want to die, would we? At least if a solution were to be found, it would make it a little easier for us to accept it, but since there is no reason for our aversion to death—we simply feel this way because we do—even if we were able to understand what it means, we would never overcome this aversion. Therefore it is impossible to free ourselves from such a fear by knowledge alone. The fear of death, or the lack of it, is not a matter of reason. To put it another way, it is a matter of one's "mentality." Or, in the case of a man of deeply humane understanding such as Confucius, of one's temperament. If one had the mentality of such a sage, one might never be troubled by the fear of death, nor by the sufferings of life. Even a sage will have his sufferings, but he can face them with composure. He is a man of temperament, in other words, of humane understanding, whose equanimity is impervious to all pressures. In this way, I thought, regardless of whether there was any philosophical solution to the problems of life, if man could cultivate the temperament of humaneness, he might somehow transcend his life and

attain a better state, no longer vulnerable to suffering or anything else, entering that realm of perfect freedom that is known to Buddhists as *jizaiten.*

It was at this point that I began my studies of psychology.

The ancients cultivated their sense of humaneness "mentally," but I came to think that for us men of the new age it might be more suitable to cultivate it "physically."

After my studies in psychology and medicine, I took up psychophysiology. Having acquired quite a large number of English books on these subjects, I devoted the better part of a decade to them, taking me past the age of thirty. These were the days of my exchanges with Doctor Kure and of my throwing myself into the study of German in an effort to read all the available source materials. But the result of all these exertions was the discovery that it was simply beyond the powers of the individual to accomplish something in this field. Unless one had something on the order of Wundt's "laboratory," or William James', I came to realize, one could never hope to accomplish anything more than a vague approximation of true research. This being the case, it was necessary to employ a research methodology that would not cost any money, but the only way to do that would be to undertake an anatomical study by offering one's own self up as the object for dissection. In those days I was aware of the stories of men who had striven to make great medical discoveries by ingesting poisons themselves, and I resolved to offer myself up for the same kind of sacrifice. That is to say, I would carry out various experiments on my own "mindstuff" by subjecting it to different kinds of stress and hardship under a range of conditions. In this way, even if I did not achieve success in analyzing the principles of "mental tone" in an academic sense, I thought that I might succeed in mastering its art, and so I commenced by determining my direction. The best option, I surmised, might be the business world. And so, in great haste, I set out to become a man of business. However, since there would be no hope of gaining entry into this world for me without my knowledge of the Russian language, I decided that I should work my way in by means of commerce with Russia. I became intrigued by the image of men like the well-known Cecil Rhodes, seeking to make a mark by getting involved in international affairs, combining the patriotic spirit with the spirit of commerce, and adding in a moral element as well. It was not simply that I envied their wealth. Rather, it was the vision of achieving that kind of grand undertaking, in a somewhat different form, that impelled me to set a course in that direction. And so, my career path took me from becoming a translator in the office of the official government gazette to working as a language teacher at the Army Staff College, an editorial assistant at the Navy Ministry, and Instructor of Russian at

the Institute for Foreign Languages, at which point my developing interest in international affairs led me to cross over to Vladivostok and into Manchuria, and then, in hopes of proceeding into Mongolia, to engage in a period of service at the Imperial Chinese Police Academy.

All of these, however, are merely matters of fact, that is, of externals. In my inner world, my actions were motivated by a desire to see to what extent I could make something of my ineffectual mindstuff by subjecting it to discipline, whether I could take control of life rather than being controlled by it, and whether I could thereby naturally free myself from the cares of life. By taking part in these various fields of activity, I found myself being slapped into shape by real life: the suffering would still be there to be sure, but it was no longer unbearable. Becoming more capable of engaging in the struggle, I began to feel that as long as I persisted in it, life would be worthwhile somehow.

In July 1903, hearing reports that war with Russia was imminent, I returned to Japan and took a position with the Tokyo *Asahi News*. In order to fulfill my obligations as a staff member, I composed *Sono Omokage* and *Heibon* and some other pieces for them, and I resumed some connections with the literary world; but even so, I do not presume to think of myself as a full-fledged man of letters. That old ambition to engage in activity on a grand scale, and in struggles on a grand scale, remains—even to this day, it still remains.

TRANSLATED BY JOEL COHN

The Impasse of Our Age

THE POWER OF THE STATE, THE DEMISE OF PURE NATURALISM,
AND CONSIDERATIONS FOR TOMORROW

ISHIKAWA TAKUBOKU

 Ishikawa Takuboku was a romantic poet, a committed socialist, and a critic who explored the relationship of art, life, and society. Each of these dimensions informed the others. His most well-known and loved works are poems in the traditional thirty-one-syllable *waka* form. While Takuboku would evoke the sensibilities of bygone poets in his diction, he would also shatter those rarified worlds by inserting at times a modern vocabulary, gritty sensibility, or volatile emotional state. His revolutionary spirit spilled from literature into

his criticism, particularly after his discovery of the works of Russian anar-chist Peter Kropotkin. Takuboku died of tuberculosis in April 1912. He was but twenty-seven years old, and we can only guess where his literary sensibilities and political convictions would have led him had he lived longer.

The essay translated here represents the pinnacle of Takuboku's career as a critic, but it also exhibits both the literary sensibilities that made him such a fine poet and the sensitivity to injustice that brought him to socialism. "The Impasse of Our Age," presumably written in August 1910, but pub-lished only posthumously in *The Unpublished Works of Takuboku* (*Takuboku Ikō*, 1913), is cast as a response to a newspaper essay on naturalism by Uozumi Setsuro (1883–1910). In fact, Takuboku's major concern is neither Uozumi (with whom Takuboku, in fact, mostly agreed) nor naturalism in any narrow, literary sense. He is, rather, alerting his generation to the immi-nent threat to individual liberties posed by the increasingly repressive state.

The danger was not a figment of Takuboku's imagination. Just months before, twelve individuals, including the famous social activist Kōtoku Shūsui, had been executed after a secret trial based on questionable evidence led to their conviction of plotting to assassinate the emperor. Takuboku's close personal friendship with the lawyer for the defense gave him access to infor-mation otherwise unavailable. He knew better than most that the trial set precedents that threatened thinkers and activists working for social reform. He could not speak out freely, however, because the Diet's 1909 modifica-tions of the 1887 Press Regulations had given the authorities even greater power to censor writing that was considered injurious to public morals or harmful to the status quo. This threat of censorship, it has been argued, may be the reason Takuboku chose to frame his essay in literary terms. Consider-ing the extent to which his literary, critical, and political concerns were syn-thesized in all his writing, however, it is just as likely that Takuboku simply envisioned social reform as an endeavor requiring a literary as well as politi-cal agenda.

In fact, the naturalist literary movement serves as an ideal springboard for Takuboku's social critique because the theoretical debates associated with it at the time speak directly to the core of the relationship between the individual, art, and the world at large. Pure naturalism in the mode of Émile Zola and his "novel as experiment" had posited the literary work as a disin-terested, objective record of how social forces work on an individual. This theoretical stance was appealing for its "scientific" air, but in its determin-ism it seemed to reject human agency, an aspect of naturalism that Takuboku labels "self-negation." At the same time, literary expression is ultimately rooted in the vision and sensibilities of the author. As such, it remains always an

affirmation and celebration of the individual, a romantic notion Takuboku refers to as "self-assertion." "The Impasse of Our Age" traces the eternal tug-of-war between these seemingly mutually exclusive stances, and Takuboku weaves his solution from elements of both.

In a word, Takuboku contends that literary production is ultimately an assertion of a personal vision. In his mind, however, acknowledging this fact does not preclude paying careful attention to the social, economic, and political forces working on an individual. In fact, Takuboku suggests that these *must* be accounted for if the literature is to be relevant. Therefore, unlike pure naturalism's contentment with the observation of external forces working on the individual, Takuboku's agenda advocates literary work that *engages* with those realities, critiquing them from one's vision of a more just and equitable future. What is groundbreaking in this essay by Takuboku is his insistence that the conception and realization of a personal vision for the future is meaningless without an engagement with the state and its machinations. This image of the artist standing in bold opposition to the state may seem hackneyed today, but such was not the case in Meiji-era Japan. The spread of the philosophy of individualism came at precisely the same time that Japan appeared as a latecomer to the community of modern nations. The realization prompted a conception of the individual as functioning in parallel to the state—just as Japan was now forging a place for itself in the world, so too was the individual struggling to establish a place in society. This parallelism was ubiquitous in Meiji thinking, evident everywhere from Enlightenment thinker Fukuzawa Yukichi's *An Encouragement of Learning* (*Gakumon no Susume*, 1872–1876) to the attitudes of the "patriotic" youth Takuboku summarizes in this essay. In this essay, Takuboku clearly identifies this "logic unique to the Japanese people." He alerts his audience to its inherent dangers, and calls for an oppositional stance vis-à-vis the state.

"The Impasse of Our Age" is rightly considered a classic of modern Japanese criticism. The evaluation is warranted not only by the essay's trenchant social critique, but also by its sophisticated understanding of how creativity and one's social being are inextricably intertwined. For Takuboku, the solution to the "impasse" requires an exercise of the literary imagination as much as political and social activism. Arguing these points, this essay is a forerunner to the proletarian literature, Marxist criticism, and political reform movements that would mark the coming Taishō and Shōwa periods.

☞(JD)☜

PART 1

An essay by Uozumi Setsuro, entitled "Naturalism as a Philosophy of Self-Assertion," appeared several days ago in the pages of this very newspaper. It is most deserving of our attention for it points out in comparatively lucid fashion a too-often-ignored side of the intellectual life of young people today: our failure to rigorously investigate a number of contradictions that have from the start riddled the theoretical trends we collectively refer to as "naturalism." Both the naturalists and the antinaturalists have been to some extent aware of these contradictions, but the aura of authority emanating from the label "naturalism" has prevented a thorough dissection. Both camps have also forgotten that such an analysis would resolve the differences between them. Although this "ism" has now been debated incessantly for the past five years, it remains to this day without a proper, widely accepted definition. Furthermore, in spite of the fact that we have witnessed the theoretical demise of pure naturalism, its name is now borrowed to make completely different assertions, which, in turn, elicit meaningless rebuttals in a listless cycle that sputters on endlessly. With everything pulled into this chaotic mix, many of us are now personally experiencing the painful tragedy of the movement's internal schism. Whatever might have once grounded naturalism is now lost.

The recent trend toward a stronger assertion of the self represents a new stage in our intellectual life, but since its very inception a few years ago it has been fused to the contradictory belief in a scientific, deterministic worldview that negates the importance of that very same self (pure naturalism). Although the assertion of the self has often been treated as an attribute of pure naturalism, the movement has more recently prompted an attitude of objective contemplation toward life, and with this development the chasm separating the two poles is rendered unbridgeable. Uozumi's article deftly captures the current state of naturalism's evolution. We must not, however, overlook the inclusion of a grave error in his essay. Uozumi is explicating "Naturalism as a Philosophy of Self-Assertion," and for the sake of the internal coherence of this argument, he works a deception on us. In order to explain the perplexing five-year coexistence of two mutually exclusive inclinations—self-assertion and self-effacement—under the single label of "naturalism," the author fabricates a motivating factor: a common enemy in the form of the state. He makes the false claim that the opposing philosophies were fused in a strategic marriage for the purpose of resisting the authority of the state.

This assertion is so clearly a misconception, so obviously a falsehood, that the matter requires no elaboration here. We of Japan's younger genera-

tion have never, not once nor in any way, confronted the power of the state; to this day we have not experienced an occasion that has forced us to view the state as our enemy. The fact that this very attempt must be made to revise Uozumi's oversight is yet new cause for regret. The need for it attests to the exceedingly superficial nature of our current understanding; it is evidence that the history leading up to the present is even more lamentable than one in which we *had* been able to recognize the threat posed by the state.

Anyone calmly considering our relationship to state power today would undoubtedly be shocked to discover that it is distinguished not by discord but rather by an unexpectedly high degree of estrangement. Our situation is not unlike that of women in the new society of Meiji. For the past forty years, because they entrusted to men the task of forging a new social structure, women have been defined and trained as slaves to them, whether in the courts, in the educational system, or even in their very homes. Yet women remain content with this state of affairs—or at least they seem unaware of a reason to object. In the same way, we of the younger generation fully entrusted our elders with all matters of state, whether contemporary issues or the problems that our generation will face tomorrow. We might have done so willingly, or we might have chosen this path because it offered the least resistance; the older generation may have desired this relationship, or they may have forged it for convenience's sake. It is also possible that this relationship is rooted in some factor of which neither side has been conscious. Regardless of the reasons behind it, the estrangement of the people from the state is a fact. The question of the proper role of the state enters our minds only in relation to our personal interests, and once those specific concerns are addressed, we are once again complete strangers.

PART 2

Conceptual understandings of the world are not always shaped by unique encounters or unusual occurrences; everyday events can also play a role. For example, every young man today feels intense anxiety when he undergoes the physical examination leading to military conscription. Similarly, our entire generation has witnessed how education, something to which all youth should have equal access, was made a special privilege enjoyed by those backed by wealthy relatives, and then further limited by two-thirds through an arbitrary examination system. We have also watched as the vast majority of the population has been forced to restrict their diets in order to pay the exorbitant taxes levied on them, taxes that were then squandered away. Surely these phenomena, each an everyday occurrence, could potentially motivate us to investigate the nature of state power. Surely this interrogation should

already be well under way. However, the embarrassing truth is that our understanding of the situation is not yet up to the task. We are obstructed by the incessant workings of a logic unique to the Japanese people.

This logic is the point on which we must be most wary of our elders. In their hands, it has protected the state and functioned as the most precious weapon of those furthering its development; if transferred into the hands of the younger generation, it might lead to results that nobody could possibly have predicted. Consider this train of thought: "The state must be immensely powerful. We have no reason whatsoever to stand in its way. Let others contribute as they may, but we will do nothing to help it." Doesn't this express the entirety of the patriotism possible for the vast majority of our relatively well-educated younger generation, alienated from the state as they are? This sentiment is even more obvious among those youths with aspirations in the business world. They claim: "The imperialism of the state makes it more powerful with each passing day, and this is a good thing. We would do well to follow its lead in ignoring justice, human rights, and the like, and instead dedicating ourselves single-heartedly to turning a profit. As for service to the state, who has time to consider that?"

Philosophical nihilism, for example, which has infiltrated our ranks from the start, is merely one step more advanced than this kind of smug "patriotism." It seems at first glance to take state authority as the enemy, but in fact does not. It is, rather, a surrender to the very entity that our generation should have made its enemy. Just as they disdainfully distance themselves from all forms of activism, so too have the nihilists ceased all engagement with the powerful state. That is how hopeless our situation has become.

With this, then, it is clear that what Uozumi called the bitter enemy shared by both strains of naturalism never actually existed at all. This is not to say, of course, that the state was not an enemy; the point is that we never recognized it as such. The fusion of the mutually contradictory principles, therefore, was not prompted by some external factor such as a shared enemy. What made this fusion of contradictory philosophies possible was their common refusal to acknowledge an enemy at all. I return to this point below.

Based on the same misconception, Uozumi rejects as "inadequate" the attempts made by certain practitioners to reconcile naturalism with nationalism. While I fully sympathize with his intent, I object to the flippant manner of his dismissal. Without the state ever having been considered an enemy, and without an understanding of the philosophy constituting naturalism, on what grounds can he possibly base such a claim? Even if the "inadequacy" he speaks of applies to what he calls "self-assertion," it cannot be said of naturalism as a whole.

Uozumi does point out the self-contradictory trends included under the label of naturalism, but he fails to rigorously examine them. All his misconceptions are rooted in this oversight and in the grandiose illusion, laughable as it is, that we can attach the label "naturalism" to each and every modern movement that comes along. Furthermore, the fact of the matter is that every individual who today utters the word "naturalism" is guilty of the very same muddled thinking.

PART 3

Naturalism has yet to be precisely defined, at least in Japan. That is why people can employ the term whenever and wherever they please without fear of reprisal. Discerning individuals, however, would not be so free and easy in their usage. Don't we find it terribly inconvenient when five or even ten people in our neighborhood share the same name? That sense of inconvenience, in and of itself, should be enough to prompt us to organize our thinking and systematize the labels we use for the various elements.

Consider the cases of Tayama Katai, Shimazaki Tōson, Hasegawa Tenkei, Shimamura Hōgetsu, Iwano Hōmei, and Masamune Hakuchō, as well as others who are today largely forgotten, such as Oguri Fūyō and Mayama Seika. They are, one and all, naturalists, but even today it is virtually impossible to discover a single shared characteristic other than this label. A common theoretical stance, of course, does not mean they must write the same things and proffer the same arguments. Even if they had, we would be hard pressed to explain the divergence in attitudes toward life that we see, for example, between Hakuchō and Tōson or Hōmei and Hōgetsu. We are unable to do anything to resolve the confusion because the reputations of these men are now for the most part solidified in the historical record.

More to the point, however, are the irresolvable contradictions within the literary movement termed "naturalism." How can we explain a shift within a single literary movement from the scientific, deterministic, static, and self-negating positions represented by terms such as "the exposure of reality," "irresolvability," "surface depiction," and "a straightforward attitude" to the dynamic, self-asserting stance expressed in such phrases as "primary desire," "life criticism," "subjectivism," and "romantic elements within naturalism"? How can we make sense of the fact that the naturalists have showered such praise on Nagai Kafū? Moreover, at this juncture we are reading an essay titled "Naturalism as a Philosophy of Self-Assertion." What are we to make of that? The contradictions found here are not superficial; the closer one looks, the more internally inconsistent it all becomes. The word "naturalism" is sphinxlike, its body and face changing in appearance with every

second. What is the nature of naturalism? Wherein lies its central hypothesis? Is there any practitioner able to stand and offer an answer to these questions? Surely they would *all* stand and answer—and each in a completely different manner.

This state of confusion is not limited to the naturalists. It extends to others in the current literary community, including those who reject the naturalist label. How fundamentally different are these people from the naturalists? For example, in the recent past those espousing hedonism and those advocating a contemplative stance were both attacked by the naturalists, but other than the fact that the former may have been a bit excessively self-indulgent and the latter somewhat more restrained, how great was the gap between them and the naturalists? And how incompatible with naturalism are advocates of New Romanticism as they revel in subjective anguish? Consider the unsightly expressions on the faces of naturalists leaving the whorehouses and those on the faces of the art-for-art's-sake advocates as they emerge from the geisha houses. Is it possible to rank one above the other? Or, to offer a slightly different example, consider Iwano Hōmei's novel *Wandering* [*Hōrō*], which moves toward a holistic union of body and spirit. Outside the novelty of its logic and mode of representation, how different is it, really, from the novels once conceived in the name of instinctivism?

Uozumi accounts for this obviously unruly chaos in a most contrived way: "The name for this most peculiar union (of the philosophies of self-assertion and determinism) is naturalism." This interpretation is a convenient and ingenuous way of explaining the situation, but, if we accept it, we must resign ourselves to perpetrating a shocking, terrible injustice: because any emerging philosophy that deals with the human condition will be trapped in the binary that renders it in some way either self-affirmative or self-negating, we will be forever forced to label them all "naturalism."

Uozumi's misconceptions become clearer still if we return to naturalism's origins and consider the issues from that perspective. As everyone knows, the trend toward self-negation gradually emerged under the name of naturalism in the wake of the Russo-Japanese War of 1904–1905. The other half of the formula, the self-assertive component, however, was in evidence much earlier, even as much as a decade earlier. Are new labels, then, to be reserved for new things, or to be assigned to unions of the old and the new? As noted above, this union originated in their mutual lack of an enemy; the self-negating component was by nature unsuited to resistance and the element of self-assertion simply refused to acknowledge its enemy. One might also say that the union was rooted in a temporarily shared economic condition, with the former self-assertive component antithetical to ideals and the latter self-denying component simply abandoning them. To explain further,

pure naturalism was derived from the earlier movement, emerging as a reaction to its own elements of self-assertion.

We have watched the results of this union play out to this day. In the beginning, both sides lived together in harmony. What pure naturalism simply observed and accepted, its partner began to enact and assert unreservedly. With this development, our eccentric couple began their first and final bout of bickering, contemplation squaring off against action. In the course of the dispute, pure naturalism more precisely defined the uniform stance to which it had been committed from the beginning. In time it announced its own theoretical dead end, and these two elements of naturalism suffered an irreconcilable separation.

PART 4

After all this, we are left with nothing but an intense desire for self-assertion. This desire, which has accumulated over an extended period of time, overwhelms us now as we languish in a state devoid of all ideals, all sense of direction, and all chance of escape from our predicament, just as we were when naturalism first appeared. Our inability to recognize that the union with pure naturalism is now void, along with our inclinations toward inner turmoil and self-destruction clearly tells the sad tale of our lost ideals. The tale has indeed resulted in the "impasse of our age."

Look around you. How can you find your bearings today? Imagine a young man who would be a teacher. He knows that education is a matter of marshaling all the resources of one age in order to forge the next. However, in today's world, education has become nothing more than a matter of training people to meet our immediate needs. All a young man can do as a teacher is either repeat the first five lessons in his classroom primer or lecture daily on the very same introductory elements of some other subject in an endless cycle to be repeated until death. Should he strive to accomplish something else, there would be no place for him in the world of education. Or, alternatively, imagine a youth who is on the verge of making an important discovery. In the world today, however, all inventions are, like all efforts, doomed—unless, of course, they are backed by the mysterious forces of capitalism.

The impasse of our age is more than just the sum of such isolated problems. For the most part, the older generation today happily pronounces the average student to be of dependable character. But that "dependability" is actually nothing more than a result of the anxiety these students feel, even while still at school, that no suitable employment awaits them. Their reliability does them little good, as half of the hundreds of public and private university graduates each year are unable to find employment and spend

their time lounging about in their boardinghouses. Still, these are the lucky ones. As mentioned above, hundreds of times more have been robbed of the very *right* to a full education. An incomplete education means an incomplete life. As diligent and as hardworking as they may be to their dying day, never will they be allowed to earn more than thirty *yen* per month. Surely we do not expect them to be satisfied with that. This curious class of "idlers" grows in number by the day. Even in the most remote village you will find three, or as many as five, educated middle school graduates. They are occupied with nothing more than eating away at their parents' resources and gossiping their way through life.

The air surrounding us, the younger generation, is now completely stagnant. The authority of the state now reaches into every corner of our land, the system that is modern society now spreads over every square inch. It is near completion. This we know from the increasingly conspicuous defects in that system. What are we to make of an economic system that makes little progress in any direction save in response to war, rich harvests, famine, or other acts of God? What are we to make of the exploding population of prostitutes and the poor, whose moral compasses have vanished along with their material assets? In our country today the state no longer prosecutes minor offenses, and Tokyo and other metropolitan areas all but officially recognize prostitution because they are unable to incarcerate the countless offenders. What are we to make of the fact that the criminal population as defined by law is increasing at such a startling rate that the state is suspending enforcement of parts of the criminal code right before our eyes?

Readers are already aware of how the most radical among us are asserting the "self" at this impasse of our age. Try as they might to control it, the self is unable to bear the strain. Boxed in, these individuals hurtle themselves blindly against the box's thinnest planks and cracks, the systemic defects of modern society. Surely it is no coincidence that virtually all the novels and poetry of today are records of debauchery, whoring, marital infidelity, or promiscuity. The older generation, though, has no right to denounce these developments. Aren't these practices all legally recognized, or at least tacitly approved?

Robbed of their futures, some among us react to our fate with surprising deference and submission. A nostalgia for the Genroku period [1688–1704] is a case in point. Their sense of alienation from their own country is translated into an affinity with, and nostalgia for, ancestors who similarly encountered an impasse in their own historical moment. This reaction, in turn, prompts some of our peers to shamelessly champion the aesthetics of that bygone era.

We of the younger generation have reached the point where we must be conscious of our "enemy" if we are to escape our current self-destructive condition. It is not a choice based on some nebulous hope for the future; it is, rather, an absolute necessity. We must rise up as one and declare war on the impasse of our age. We must discard naturalism, we must abandon blind resistance and a nostalgia for the Genroku period. We must instead dedicate ourselves wholeheartedly to consider tomorrow, to do a systematic analysis of the age that will belong to us.

PART 5

Thinking about tomorrow! It is the one task we must undertake today. Everything hinges upon it.

How and where are we to begin this investigation? Such matters are, of course, for each individual to decide. Nevertheless, if we of the younger generation ponder how the "self" has been asserted in the past and how these attempts have failed, we can imagine the general outlines of a course for the future.

We, the new generation of the Meiji era, were educated to become a useful asset for the completion of the nascent Meiji society that was established entirely by our elders. During this period we also became aware of a distinct set of rights held by the younger generation, and we instinctively began to assert ourselves based on that awareness. This consciousness began to take hold, as everyone knows, shortly after national pride was awakened throughout the country by Japan's victory in the Sino-Japanese War of 1894–1895. Takayama Chogyū, with his promotion of individualism, was the first voice representing that consciousness, and some consider him the forerunner of naturalism because of it. (At that juncture we were as yet unable to recognize our status as secondary to that of established authority. Chogyū, for his part, was preparing for his work on the nationalistic religious thinker Priest Nichiren, in which he forcibly wed his philosophy to state power much like his friends experimented with a compromise between naturalism and nationalism.)

It goes without saying that the weakness of Chogyū's brand of individualism rested within his philosophy itself. His conception of human greatness was riddled with inherited superstitions, and his understanding of the relationship between the "establishment" and youth was exceedingly parochial (just as the intellectual life of all Japanese was parochial in the days before the Russo-Japanese War). Granted, Chogyū's philosophy did influence the younger generation in a "magical way," to borrow an idiom from his

critique of Nietzsche. But this continued only until he parted ways with Nietzsche, an architect of the future, and discovered in the historical figure of Nichiren an idol more fitting for his superstitions. At this point, the younger generation, their hearts set on a future rightly theirs, abandoned Chogyū, not even bothering to wait for his passing.

What does this failure on Chogyū's part teach us? The lesson is that it is utterly impossible to build for ourselves a new universe without changing the establishment that surrounds it. With that lesson learned, we have unexpectedly entered the second stage of our experience: the age of religious yearning. This new stage was interpreted at the time as a reaction to the earlier one, and was critiqued as simply the collapse of individualism under the strain of its own inflation. This interpretation, however, misses the mark. Our first and second stages differed only in their methods and the arenas that concerned them. Both were attempts to assert the self, the earlier stage simply being based on the efforts of the individual exercised within the confines of the establishment while the latter invoked otherworldly powers and concerned itself with a realm beyond the borders of the establishment. This second stage of our experience, too, ended in utter failure. We read Tsunashima Ryōsen's reports of his uncanny religious experiments, narrated with pure and beautiful sentiments. Although we gave full rein to our longing for his pure, transcendent psychological state, we could not for a moment forget the fact that he was suffering from tuberculosis. In the end, the heavy burden of "science" that had wormed its way into our hearts prevented us from rising out of the swamps to soar through the heavens.

The third stage of development was, of course, the union of our desire for self-assertion with pure naturalism. At this stage, the science that had been our enemy in the quest for religious transcendence now served as an ally. Our experience of this third stage taught us a lesson even greater than those that had come before: "Glorious ideals are, without exception, illusory!"

The path we must take from here is broadly indicated by the three stages of experience I have outlined above. Our experience makes it clear that we must no longer focus our ideals on fanciful daydreams like "goodness" and "beauty." Instead, we must ruthlessly reject all such illusions and concentrate on the single truth that remains: *necessity*. This truth is indeed the entirety of what we must pursue as we move into the future. We must discover what is necessary for the "tomorrow" that belongs to us, and we must do it by rigorously, boldly, and imaginatively examining "today." Necessity is the most trustworthy of all ideals.

At this point in time, having realized that our vision must be focused on the necessary, we are faced with the question of how and where it might best be pursued. Should we strive to realize our ideals within established par-

ameters, or outside of them? Are we better served by leaving conventions in place, or by altering them? Are we to pursue the fulfillment of our needs by relying on our efforts alone, or are we to turn to a religious realm for aid? The answers are clear. We are not the same as we were before; we will not repeat our former mistakes.

There was a time in the early days of naturalism that its practitioners discovered and confirmed the "truths" of the movement and it served in a "critical" capacity. Once this age passed, however, it devolved into mere chronicles and stories. But the sleeping spirit of literature—even this naturalist literature—will awaken. The younger generation will take possession of "tomorrow," and then for the first time a relevant critique will be leveled on all aspects of "today." Trapped within an era, we are unable to critically interrogate it. My hope for literature is that it will provide this critique.

TRANSLATED BY JAMES DORSEY

PART V

A Sense of the Real and Unreal

Raw Depiction

TAYAMA KATAI

Although the name of Tayama Katai rarely appears on short lists of modern Japan's most admired writers, he is regularly acknowledged, and sometimes condemned, as a key figure in a decisive turning point for modern Japanese literature. Katai made his biggest impression in the first decade of the twentieth century, when he played a central role in the emergence of a homegrown version of naturalism that differed from the European original in various ways, including its frequent reliance on the autobiographically based variety of fiction known as the "I-novel," a development that would have far-reaching effects on Japanese literature for several decades.

As was the case with many other writers who became prominent in the Japanese naturalist movement, Katai's origins were provincial, and the circumstances of his upbringing were less than comfortable. He was born in what is now Gunma Prefecture into a samurai family that had lost its privileged status and economic security as a result of the political and social upheavals that followed the Meiji Restoration. The family's situation grew increasingly difficult following the death of his father while serving with the government army that suppressed the Satsuma Rebellion in 1877; in 1886 they moved to Tokyo, where Katai published romantic poetry and fiction to little acclaim.

Through the 1890s Katai continued to write and began to familiarize him-
self with recent developments in European literature, often through English
translations of Continental writers including Maupassant, Zola, Turgenev,
Dostoevsky, Ibsen, Strindberg, Nietzsche, Sudermann, and Hauptmann.
His growing interest in the ideals of the naturalist movement, at that time a
major force in Europe, gradually led to changes in his own values and writ-
ing, culminating in the publication of *The Quilt*, a novella that caused a
sensation by boldly portraying degrading and humiliating aspects of the
protagonist's life that were immediately taken to be revelations of actual events
in the lives of the author and members of his immediate circle.

The Quilt was not the first widely heralded example of naturalist fiction
to appear in Japan; that distinction had already gone to Shimazaki Tōson's
The Broken Commandment, published in the previous year. And it was
certainly not the first example in modern Japanese literature of a writer using
a work of fiction to engage in acts of autobiographical confession; prece-
dents can be found at least as far back as Mori Ōgai's *The Dancer*. It is,
however, generally recognized as the work that firmly established the link be-
tween lightly fictionalized self-exposure and naturalist-inspired exploration
of an individual's struggle to come to terms with innate physical and emo-
tional urges in conflict with socially imposed restraints and conventions, a
combination that would continue to be identified as the "mainstream" of
Japanese literature long after the naturalist movement itself had run its
course.

Here we have two translations of Katai's work, an essay and a short story.
In the essay "Raw Depiction" (Rokotsunaru Byōsha, 1904), Katai called for a
fundamental change in the understanding of realism. Appearing three years
before *The Quilt*, this essay concentrates on expounding a radically new ap-
proach to language that would soon come to be recognized as a hallmark of
Japanese naturalist literature, and in particular of his own work.

A key point in Katai's argument is the dichotomy between the terms
rokotsu and *gikō*. *Rokotsu* has variously been translated as "blunt," "bold,"
"frank," "straightforward," "unadorned," "plain," and "bare-boned" as well as
"raw," but it commonly carries negative overtones of crudity or inappropri-
ately graphic revelation, not infrequently of a sexual nature. Katai seems to
have these negative overtones (and their potential for shock value) in mind
as he adopts the term as his rallying point, holding up the naturalist ideal of
unflinching and sometimes downright offensive exposure of all aspects of
reality, even the repulsive ones regularly shunned by conventional writers as
inappropriate subjects for artistic treatment. Devotion to *gikō*, a term that
conventionally carries positive connotations of skill, technique, or artistry, is
paradoxically condemned by Katai as a dead end that has prevented Japanese

writers, and their readers, from engaging in the direct confrontation with reality that he holds up as the artist's highest duty.

Despite its forthright call for a direct approach to the description of ideas, Katai's polemic is not without some contradictions and confusions of its own. While he repeatedly points to contemporary trends in European literature as a principal source of support for his assertions, anyone who is familiar with the work of some of the writers he names (Fyodor Dostoevsky, Émile Zola, and Gabriele d'Annunzio, for example) will be bound to question his claim that they are all practitioners of a "raw" form of depiction. By the same token, one of the established Japanese writers whom Katai seems to associate with an overwrought, "pretty" style, Mori Ōgai, was in fact notable for the restraint and dignity of his prose.

On a more personal level, "Raw Depiction" can be viewed as an attempt by Katai to deflect criticism of certain features of his own language (clumsiness, carelessness, repetition) that were often cited as damning evidence of his ineptitude as a writer. Some evidence of these tendencies may be found in this essay as well, but if, as he claims, getting one's point across in a forceful manner is what matters most for a writer, he has at least managed to succeed in living up to his own standard.

Interestingly, while Katai's penchant for bluntness is certainly on display in this forthright, hard-hitting attack, he often expresses his ideas in an idiom that has a paradoxically formal, artificial, and, to modern-day readers, hopelessly old-fashioned ring—a sign, perhaps, of how deeply ingrained were the notions of "appropriate" literary language that he was struggling to eradicate. Nevertheless, although "rawness" was not accepted as a stylistic virtue in the long run, Katai's bold appeal, and the raw power of his best fiction, can be said to have played a significant role in the emergence of a more direct approach to literary expression in the twentieth century in Japan.

≈ (JC) ≈

Recently there have been those in the literary world who have preached the importance of technique. Ah, technique! You may count me among those who bemoan the costly sacrifices that the writers of the Meiji era have placed on the altar of this so-called technique! Unless we do away with our "technique," I believe, the literature of Japan will never be able to achieve its full development.

According to these advocates of technique, when we survey the present-day literary landscape in Japan, we see that Ozaki Kōyō, Kōda Rohan, Tsubouchi Shōyō, and Mori Ōgai, the founding masters of the modern age, have fallen silent, while their successors stumble along ineffectually in a derivative

literary landscape, without direction or meaning; their writings, crude and coarse, are simply unworthy of serious consideration as works of artistic merit. And in fact this may be the case. Compared with the age of Master Kōyō, the crudity of their style and coarseness of their language may well be considered shocking. But the question I would like to pose is this: Just how many examples of unconstrained, irrepressible thought could one discover in the days when their "technique" was at its zenith?

During what is called the "age of technique," there was certainly wonderful writing, replete with richness of language, exquisiteness of thought, wonderful structure, and ingenious presentation. But in that so-called age of technique, were there any examples of works so perfectly formed as to create effects as flawless and natural as the trailing clouds and still waters?

Falsehood is something to be despised, as everyone knows. And the inability to make one's writing fit one's ideas, as all thinking people agree, is a failing beneath contempt. Nevertheless, our present-day advocates of technique compose phrases devoid of ideas and fill their pages with falsehoods they do not even believe in themselves, and yet they seem to regard them as works of greatness and beauty. But what must be realized without even having to state it yet again is that in writing, all that matters is getting one's meaning across: as long as one can capture one's thoughts in words, that will suffice. Be it clumsy or skillful, as long as one can feel the conviction that its ideas have been adequately expressed, a piece of writing has done all it needs to do, and done it well. There is no point in painstakingly stringing together elaborate phrases, nothing to be gained from straining for colorful wording.

This is not to say that I am rejecting well-crafted writing out of hand. I am well aware that one must make every effort to ensure that one's expression matches one's ideas. But that is certainly not what the current proponents of literary technique are calling for; rather, they indignantly claim that the writing of today has sunk into a state of intolerable rawness, saying things that should not be said, writing what should not be written, and offending the delicate sensibilities of those who style themselves connoisseurs of genuine art.

According to these connoisseurs, all writing must be pretty. Thought must always be subordinated to aesthetic considerations. To write of nature just as it is would be to commit a grievous error; you must not write about anything, they assert, without properly idealizing, or gilding it. This is the doctrine that has held sway for many generations, and followed wholeheartedly by romanticism as well as classicism, so much so that up until the second half of the nineteenth century anything other than this gilded literature was hardly considered to be literature at all.

But what has happened to literature in the West since the innovations of the nineteenth century? That gilded literature has been thoroughly destroyed: everything must be raw, everything must be honest, everything must be natural—this is the cry that is sweeping across the entire continent, this is the current of thought that has done away with romanticism with the force of a mighty gale that blows away so many dead leaves! If not blood, then sweat—this is what today's voices of the new have proclaimed with all their might.

If you do not believe me, look at the works of Ibsen, of Tolstoy, of Zola, or of Dostoevsky, and see how astoundingly full of blood and sweat they are! Especially, a work like Dostoevsky's *Crime and Punishment* would make the advocates of technique shrink with dismay: this is bold, raw depiction, concealing nothing, going far beyond anything that the advocates of technique, with their pursuit of pretty style and gilded ideas, could even dream of.

The same can be said of Ibsen: most of his plays contain not a single bit of fabrication or artifice. Let us take *John Gabriel Borkman* as an example. Can you find in its pages a single passage where technique has been flaunted for its own sake, or structure fabricated? One can find nothing here but a natural reality that keenly resonates in one's soul, without a hint of artifice or conceptualizing. We feel, in fact, as if our own blood and sweat are mingling with the blood and sweat of his characters, and flowing together with them. Or take *The Wild Duck:* as he shows the nature of human character evolving, or the working out of an evil heredity—how powerfully we feel his keen, fresh ideas!

Or, read the work of the new champion of Italian literature, Gabriele d'Annunzio! There may be some who see nothing beyond his skillful prose, and simply acclaim him as a master stylist, but I observe something entirely different. What strikes me most keenly in d'Annunzio is not only the skill of his prose, but the relentlessly bold, raw, and unflinching nature of his depiction. He too, in other words, is a man who has immersed himself in the new current of the late nineteenth century. In particular, in a work like *The Innocent*—bold as bold can be, raw as raw can be—he makes it all but impossible for the reader to keep from trembling.

Not only these, but any writer worthy of the name who has immersed himself in this new current of the fin de siècle has been influenced in the same way: in Germany, as well, where Hauptmann, Sudermann, Halbe, Holz, and others have raised their banners against the gilded literature of such mature artists as Wildenbruch and Heyse, we are presented with a tableau that is truly inspiring.

When we turn to our own country, we see that the age of Kōyō, Rohan, Shōyō, and Ōgai was, if nothing else, an age of maturity. This is evident when one considers the prevalence of aesthetic discourses, the regular appearance of works of idealist and social literature, and the insistence on attending to the slightest nuances of style in every composition. In fact, most men of letters gained their reputations by their spellbinding powers of expression, and won admiration through their mastery of construction. When we ask ourselves just what kind of works this approach has yielded, what we find is idealist fiction filled with, if not heavily cosmeticized expressions, then miserably timid depictions, or gilded fiction that goes out of its way to captivate readers with intentionally overblown characters and situations.

This, however, is not to say that the writers of the present day have produced any outstanding masterpieces themselves. On the contrary, their works may be said to be less perfectly realized than those of the older generation. Still, I believe that the "raw description" seen in the works of those Western innovators offers much to our present-day writers.

As examples, I would point to Tengai, Fūyō, Shun'yō, (Kyōka, one of the brilliant figures of Meiji literature, is, I believe, far removed from this current), Shūsei, Ryūrō, Bizan, and Chūgai among the authors in whose works this can readily be noted, whether directly or indirectly.

Therefore, in my view, this raw, bold description—which is assailed by the advocates of technique as crude and incoherent—in fact represents the way forward, indeed the very lifeblood of our literature, and those critics who condemn it have fallen far behind the times.

There may be some who wonder why raw description must be incompatible with technique, and suppose that it should only attain the highest level of effectiveness when they are deployed together. It is my belief, though, that as one takes raw description toward its definitive form, it comes to distance itself from considerations of style and technique in a way that becomes irrevocable. This is because, just as the most common reality inevitably requires the use of the most common expression to capture it, it is only natural that the rawest conceptions will require the rawest expression.

I have thought it truly regrettable that the development of literature in the Meiji period has been prevented from realizing its full potential by the continued prevalence of these notions of so-called style and technique. I have also deeply regretted the way that so many of our writers have taken such pains over their expression and agonized over their technique, laboring under self-imposed restrictions and falling into the somewhat idiosyncratic patterns of the Kōson style, the Kōyō style, the Rohan style, or the Ōgai style, and the like; although they possess new ideas, they lack the means to convey any of them, squandering their talents as mere slaves of

style. And so I have been both pleased and encouraged to see that it has finally become possible to cast off these restrictions, move forward in some new directions, and present bolder ways of thinking. But now, hearing the advocates of technique raising their voices yet again here and there, I can hardly remain silent.

To make things even worse, their arguments are not limited to matters of method but are also related to the current intellectual climate in a broader sense, which makes it all the more important for you, my readers, to devote careful attention to this controversy and study it seriously. Moreover, in recent days we have seen the new romanticism come to be championed by Professor Anezaki and others, and the music dramas of Wagner seem to be gaining currency in our literary world as well; as these trends have important links with the "raw description" that I have been discussing here, there would seem to be some room for meaningful engagement between these new romantic elements in Japan and the naturalist movement.

I fear, however, that if I am too raw in the way I wield my arguments, I will lay myself open to charges of crudity and incoherence by the advocates of technique, and so for now I will come to a stop here.

TRANSLATED BY JOEL COHN

In the Next Room

TAYAMA KATAI

 Tayama Katai's "In the Next Room" (Rinshitsu, 1907), a short story composed in the same year as *The Quilt*, lacks the element of self-revelation that made the latter work famous and even notorious, but its raw descriptive power makes it a good example of two related stylistic principles that Katai advocated as essential features of naturalist writing: "flat," or "surface," description (*heimen byōsha*) and "raw," or "blunt," description (*rokotsu naru byōsha*), which are particularly apparent in the story's intense focus on the auditory and visual senses. Its raw or blunt description, as justified in the essay above, is joined by a tendency to engage in awkward, artificial, and repetitive expression. Noted by critics as a weakness in much of Japanese naturalist writing, this lack of polish is glaring in the case of Katai. That said, the rawness of Katai's language in this story fits well with the shocking nature of the scenes that he depicts, and the employment of every available resource to create this effect was surely part of his narrative strategy. This is not simply an avant-garde

gesture to shock the complacent bourgeois reader. As a naturalist, Katai means to force us to face a significant aspect of reality that we might prefer to hide from ourselves, one that other, more refined writers would not dare to portray.

"In the Next Room" is also an example of one of the prominent themes in Katai's fiction: confrontation with various aspects of death, which he explored in a series of well-known works, including "The Last of Jūemon" (Jūemon no Saigo, 1902), "One Soldier" (Ippeisotsu, 1908), and "A Country Schoolmaster" (Inaka Kyōshi, 1909). The searing portrayal of a man's agonized death brought on by beriberi (a vitamin deficiency disease not uncommon at the time in Japan), is reprised in the more famous "One Soldier," a story set behind the battle lines of the Russo-Japanese War of 1904–1905. But where "One Soldier" inevitably raises broad questions about the nature of war and militarism, "In the Next Room" is relentlessly focused on the unbearable details of one man's death and the cruel indifference of other human beings to the dying man's fate. If there is a social dimension in this story, it is to be found not in the common naturalist theme of conflict between an individual's natural impulses and repressive social conventions, but rather in the innkeeper's and doctor's failure to live up to the standards called for by conventional morality, whether by taking responsibility according to the expectations of their respective professions or by simply showing compassion for the suffering of a fellow human being.

<p style="text-align:center">☞(JC)☜</p>

As I awoke, I was startled to hear a voice—something between a laugh, a moan, and a whisper—coming from the next room. It was, I was sure, the kind of flirtatious voice uttered by a man and a woman who rendezvous in a country inn like this one deep in the night. If I had known what kind of place this was going to be, I certainly wouldn't have stayed here. I was running low on funds on a long journey, so when I got to this town I had made a point of staying away from the first-class inns and settled on this dreary, run-down-looking place on a backstreet not far from the jail. That next room, where the voice was coming from, was the best one here on the second floor: the alcove had nice zelkova wood flooring and a celadon vase with an arrangement of China asters that were almost unnaturally deep red, and a south-facing window covered by a six-foot greenish bamboo blind. This was the room that I had asked for, but the proprietor, a middle-aged fellow with a heavy beard who looked like he could easily be some kind of shyster, told me that they didn't rent it to single parties and insisted that I take the grimy six-mat room right next to it on the north side instead. This one had no nice alcove, and no view of the yard; on the other side of the

shoji sliding panel the battered wall of the storehouse next door was right in front of your nose, and if you looked down in the narrow space between the two buildings there was a muddy little patch littered with piles of old potato peelings, fish bones, onion stalks, and other garbage from the kitchen—an altogether repulsive sight. Then there was the filthy toilet right at the bottom of the stairs, which made me wonder why I ever made the mistake of staying at this place at all. It got even worse when the pug-nosed chambermaid came in to serve my supper: peeled lacquerware and dirty chopsticks charred black at the tips, herring boiled in an unsavory soy broth that I couldn't even get down my throat, and when I asked her for something to drink and something to go with it, all I got was a plate of doughy fried eggs and a cup of the local sake, which had a horrible rancid smell that stung my nose every time I took a swallow. By this point I was well on my way to a state of utter despair and, unusually for me, proceeded to down two or three flasks, which at least allowed me to banish from my mind the misery of my plight as a traveler, the dreary darkness of the room, and the rock-hard futon. Dimly aware of nothing more than the summer night's rain that continued to fall and the reflection of the lamplight on the darkly glistening leaves of a banana plant by the eaves, I finally drifted off into a deep sleep.

It was when I awoke that I heard those sounds of someone in the next room.

Feeling certain that it must be an intimate scene between a man and a woman, I fell into an almost unbearable rage, but my throat was so painfully dry that I immediately reached for the teapot to take a drink.

"Unnh, unnh, unnh . . ."

Then the faint, moaning voice suddenly turned into a roar:

"Ohh, the pain!"

"What's the matter? Where does it hurt?" asked a woman's voice—obviously the same pug-nosed girl who had served me dinner.

"Ohh, the pain!" was his reply, and then, almost immediately, almost unbearably, "Ohh, the pain, it hurts, my legs . . . my legs . . . right here . . . ohh, they're all cramped, they're cramped . . ."

"What could it be?

"What? It's just . . . just, . . . ohh, it hurts so bad, it's awful . . ."

I realized how wrong I had been. These were the moans of a man who was desperately ill—much worse than any sound that might come from a man and a woman making love.

Eventually I heard the chambermaid go back downstairs. I was completely awake now, and as my mind emerged from the haze of drunkenness, the ceaseless cries of agony rang in my ears like the crashing of a cracked bell. The heat inside my mosquito net was oppressive; a dim light shone

feebly from a paper lantern in a corner of the room. The rain shutters had been left open, so I could still see the glint of raindrops on the banana leaves, but it must have been the middle of the night by then, and there were no human voices to be heard in the hushed air. I fumbled for my watch by the futon, and turning it to catch the faint light of the lantern I saw that it was five minutes before midnight.

Various notions played across my mind one after another. My first thought was resentment of how unbearable it would be to have to put up with this groaning all night long, but soon that was tempered with some sympathy for the misery of this man, a traveler just like me, who was suffering from such a dire illness in such a place, and so I came to pity him, whoever he was. Meanwhile, his cries of torment continued unabated, and as they gradually grew even more intense I could also hear the sound of his body writhing in agony on his futon. Suddenly a fearful recollection occurred to me: cardiac beriberi. A friend of mine had been stricken with this disease, and I remembered how he had died after a night of relentless, sheer suffering, so terrible that it was impossible to witness it. The awful feeling that it would have been better to kill him rather than to let him go on enduring such agony coursed through me. . . . And now, could it be claiming this man, too . . . ?

Having come to this realization, I could hardly just go on lying there, doing nothing. Death creates this curious kind of sensation in the human heart: once we have seen that someone is going to die, all our feelings of discontent, annoyance, and resentment disappear. And what was happening here? It was simply outrageous that they could remain indifferent to suffering this terrible: it was already a full half hour since the maid had gone downstairs, so how could it be that there was still no sign of anyone coming back up? Could they be out trying to get a doctor? Suddenly: "Ohh, it hurts, it hurts, somebody, please . . . isn't anybody there . . . , ohh, the pain, my legs . . . , my legs . . . , please somebody . . . , somebody come!" As he screamed, his big body was thrashing on the futon.

I couldn't stand it any longer, and I went downstairs.

At the bottom of the stairs a lamp was shining dimly on the front desk; in the adjoining room the proprietor's family seemed to be half asleep. Since I had come down, the proprietor emerged in his night robe.

"Have you sent for a doctor?"

"Weeell," he stammered, "at this hour everybody is in bed."

"If they're in bed," I said, raising my voice now, "shouldn't you just bang on the door or do whatever you have to to wake them up and bring them over here? It's cardiac beriberi—if you go on dawdling like this he'll die! What kind of an innkeeper would let one of his guests die without even calling a doctor?"

"Of course, sir, you are right," he said, gazing at me intently. "As innkeepers, it is indeed our duty to treat our guests just as we would our own families. . . . But we didn't think that his condition was that serious. At any rate, this has been most unpleasant for you as well . . ."

"Never mind about that. It doesn't matter."

"Is he really in that much pain?"

"It sounds really awful."

"Well, then . . ."

He called over the maid, who had been standing by drowsily. "You go over to the clinic now, please, tell them what's going on, and ask for Doctor Sugiyama, or whoever is available."

Sullenly, the maid opened the door and started out.

"Do you know anything about him, what kind of person he is?"

"No, he's a first-time guest. . . . We generally try to steer clear of single travelers that we've never seen before, but this one showed up about two hours ago on the last train and told us that he had looked all over for a place to stay, but it was too late and all the other inns were already closed up for the night. In fact he got here just as we were closing up ourselves; he said that he didn't want anything to eat, all he wanted was a place to spend the night, so we put him up . . ."

"Where is he from?"

"He said he was on his way back to a place called Namekawa, about a dozen miles up the road from here. He was going home because he was sick and couldn't work anymore, he said, it was someplace far away, what was the name of it—oh yes, Wakamatsu, over in Kyushu—he said he had gone to work at a steel mill there, or something like that."

"Still a pretty young fellow, then?"

"Twenty-eight, is what he wrote in the register."

I felt terribly sorry for him.

I advised the proprietor that if the doctor found that things were looking critical they should be ready to send a telegram off to the man's hometown; then I went back upstairs.

After another hour of the same screams and the same agonies, I heard the sound of the doctor arriving. The proprietor, the maid, and an old lady were in the room with him.

The doctor must have set down his bag and sat himself down by the patient. He listened as the proprietor began to explain, but with the patient continuing to suffer minute by minute, second by second, it seemed that he

finally turned to him and began his examination. "Are you in a lot of pain?" This was all he asked, and then he seemed to be examining the man's legs. The night was absolutely still, and there were no other voices to be heard, so my ears could make out every sound, including the patient's labored breathing and the doctor's tapping on his chest, with perfect clarity, as if I was right there with them. Softly I raised myself and peered in at the edge of the sliding door.

The first thing I saw was the man, his large body splayed out on the futon, nearly naked. Even his loincloth had been loosened, and I could see his thick thighs flung out crazily in front of the doctor's knees. His cropped head had slipped away from the pillow and was facing down and his arms were stretched out straight to his sides. The doctor, who seemed to be in his midtwenties, most likely still an assistant physician at the clinic, was wearing a kimono. He was a slender man with foppish looks and gleaming hair. The people from the inn must have been seated on the side closer to me, but I couldn't make them out in the shadows. The China asters in the alcove that I had seen during the day were still there, in the lamplight that shone through the bamboo blinds under the eaves I could see the rain glistening on the leaves of the trees in the yard.

"Ohh, it hurts!"

As soon as the words left his mouth, the big body writhed all over like a giant serpent, his thick legs shaking violently, and he turned his head upward, so I now had a full view of that pain-racked face. The pain seemed to be rippling through his body in massive waves, minute by minute, second by second. I could hardly bear to watch as the muscles from his chest to his waist shuddered violently, he gritted his teeth, and thrust his arms straight up in his agony.

The doctor began his treatment with an injection.

It took effect soon enough, and it appeared that the man was feeling some relief. If only he could just settle down for now, I thought, even if he wasn't going to pull through this anyway, at least he might be granted one night of decent rest. This hope, however, was in vain. Just ten or fifteen minutes after I had lain back on my futon, those cries of pain started up again. What an illness!! It was beyond the powers of even the greatest of doctors to keep the black shadow of death at bay.

I could hear the disappointment in the doctor's voice.

"This is really awful. If that injection couldn't even hold him for ten minutes, I don't think there's anything else I can do. He's too far gone." And then, in a lower voice:

"Where is this guest from?"

"From Namekawa, he said."

"In that case, please send off a telegram right away."

"Is it that bad?"

"Well, that is not what I'm trying to say," he said in an annoyingly affected tone, "but when you have a case of beriberi, things can get worse very fast, so you can never be sure that the end isn't near. With a really bad cardiac case, you can't even tell if the patient will make it through the night or not, so . . ."

"Ohh . . ." The proprietor sounded utterly surprised. Right away I could hear several whispering voices, and then a clatter as the maid hurried down the steps. It was just as I had feared it would be, and as various ideas about this traveler crowded my mind, there was no longer any chance that I might fall back asleep. It seemed as if death's fearful shadow was approaching closer and closer to the window with each of his groans, and if there really is such a thing as an invisible, silent god of death, I thought, he must certainly have been lurking in that pure darkness, black as lacquer. An utterly, weirdly, desolate kind of feeling swept over me, and a dim sense that there was something pale skulking in the shadow of the lantern that made my flesh crawl. To make things even worse, just at that point my mind began to be filled with vivid memories of scenes from some of Maeterlinck's plays, such as *Intruder* and *The Blind,* which, together with the shadows cast by the lamp through the blind that hung by the eaves outside the window of the room, the gleaming of the rain-moistened leaves of the banana plant, and the almost inaudibly faint sound of the rain on the deep silence of the night, was more than enough to put my spirit in a mystical mood.

Ten minutes later, though, I heard the voice of the doctor again: "Well, I tried the injection, and I'll leave a dose of laxative right here. This is all I can do for him, I believe. If you think that it's not sufficient, please feel free to call in someone else." It sounded like he was closing up his bag and getting ready to leave a patient who was at death's door.

"Is there any hope?"

"No, I don't think so. I doubt that he'll be able to hold on until dawn," he said, without the slightest bit of concern that he was standing right by the patient. "It looks like it's all over—but if you have any misgivings, there might be some other doctor that . . ."

"No, doctor, if in your opinion it's hopeless, so be it, but . . ."

"Anyhow, it will be just as hopeless if I stay. . . . It looks as if he's simply meant to die here at your place, but I hope you'll do your best to care for him. Well, then . . ."

And with that the doctor went down the stairs. I suppose that from his point of view the death of a man was no big thing; tomorrow, like every other day, he'd have to get up early in the morning to care for his patients,

and it wasn't worth his while to spend the entire night attending on a man
like this one, who wouldn't bring him any income anyhow, and I could see
why he would feel that way. And yet, here was this poor traveler, in his final
hours, without a single familiar face at his side! I was deeply struck by the
lack of human feeling this doctor had displayed.

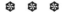

By the time the doctor left it must have been about half past one. The injec-
tion provided some relief for about twenty minutes, but then the shrieks
began again as the agony assailed him with all its terrible force. How can I
possibly describe it? Suffering to end all suffering . . . howling to end all
howling . . . It sounded as if his moment of death, raving with sheer agony,
would arrive at any moment; no sooner had the words "Ohh, it hurts, it
hurts" escaped his lips yet again then he screamed, "Somebody, please, come
quickly and cut my legs off, please, please, somebody . . ." And no, that was
not all: finally even dying no longer mattered; all that mattered was being
released from that torment, from that pain: "Why can't I just die? Haven't I
suffered enough yet, ohh, it hurts, it hurts, please, cut them, cut them off I'm
telling you . . . get a sword, a sword . . ."

Can you imagine what it felt like to be there hearing those screams? An
agony so intense that it could make someone lose all fear of any kind of
dreadful death—just the thought of it was enough to make my flesh crawl.

The man was someone's son, perhaps someone's father, someone's hus-
band. Probably there would be not a few who would shed sad, bitter tears at
his death. And he as well—how unbearable the devastation, the despair
must have been for him, as he came to the end of his brief life in this inn, in
the company of strangers! Yet here he was, no longer able even to think of
his fate, or to regret it, wanting only to die and be released from the reality
of his agony as soon as possible! People may talk casually of things like the
soul, the spirit, the ideal, but how pathetically meaningless and worthless
they all seem in the face of such relentless physical suffering . . .

Once the doctor had abandoned the patient and gone home, the pro-
prietor of the inn also went back downstairs. Now there was not a single
person to keep watch by his miserable deathbed; now he had been left to
toss and turn in hopeless agony. My mind, driven to the edge of derange-
ment by all that I had witnessed, had virtually lost any sense of ordinary
notions: time after time I thought to myself that I at least should go and care
for the man, and yet I could not bring myself to do it. The night wore on; it
was past two o'clock, the hour when even the trees and the grass are said to
be asleep. Imagine, if you can, that frightful feeling as I lay there listening

to the rain beating down with a sound like some message from the other world while in the dim light of the lantern the black shadow of death pressed ever closer.

After another hour went by, the proprietor, who must have felt some concern after all, came back up with the old woman. When he saw that the laxative had done its job and the patient was now wallowing in his own filth, I could hear him setting about with the clean up, complaining grievously all the while. Then the old woman was left by herself to play the role of attendant at the deathbed.

There was nothing left to do now but wait for the end. Each time the patient let out one of his agonized cries, the old woman would chant a Buddhist invocation, and then: "Oh, this poor man! What kind of karma could ever have led him to this? . . . They say that it's a horrible thing to die so young. *Namu Amida Butsu, Namu Amida Butsu,* may the Buddha grant my wish and summon you as soon as he can, please don't worry, after all the moment of death must come for every one of us . . ."

"Ohh, it hurts, it hurts. Chop my legs off, chop them . . ."

Then there was some kind of terrible rumbling sound.

"It must be horrible . . . and so young . . . *Namu Amida Butsu, Namu Amida Butsu.*"

"Ohh, isn't there a sword, a sword? Or even a pistol, please, just shoot them off, shoot them . . ." Again he made that terrible sound. "Ohh, it hurts, it hurts, enough, can't I die now? Now, right now, kill me, I beg you . . ."

"Yes, he's coming for you now, I call on the Buddha, *Namu Amida Butsu, Namu Amida Butsu.*"

Human beings, I had now come to realize in the clearest possible terms, are simply not equipped to endure physical affliction, and they are ultimately incapable of transcending the boundaries of the ego.

The prayers of the old woman and the anguish of the sick man went on assailing my ears without cease, but between the tumult in my mind, which had now continued for almost three hours straight, the excessive agitation of my nerves, and the fact that I had been awake for so long, my body insensibly began giving in to fatigue, and finally I came to feel as if the cries of the death agony were growing more and more remote, and my spirit's sense of sympathy gradually grew fainter; at the same time, even as I sensed that his time to die had finally come, I had fallen into a kind of trance where death no longer seemed like such a sad thing, not something to be concerned about, as if I were listening to the sound of far-off waves—but even so, there

was still no getting away from that sensation of unease, and I reviled myself for meanly allowing my fatigue, no matter how intense it was, to overpower all those noble-sounding pronouncements about human sympathy and the like that I made so often in the past. That feeling too grew fainter in its turn, and finally I was overcome by a lethargy that felt heavy as lead.

As I woke up, a faint light was already filling the room. From next door, not a sound—so silent that it made me wonder if perhaps all that agony, all those screams had only been a dream. Finally, I thought, he had breathed his last. A sense of unspeakable sadness and desolation assailed my breast; I felt a totally indescribable sense of misery. That agony—the agony that had even caused a man to lose his fear of death—had ended. The soul of a man who had existed in this world until yesterday had vanished, to someplace unknown. How bitter it must have been for him to come within ten miles of home, only to die among uncaring strangers, without his own flesh and blood at his side! And what tears of grief they, unable to be there at that last moment, would shed when they arrived today! The moment of death, we know, will come for each one of us. The sages, no doubt, would teach us that this is nothing to grieve over. And no matter how deep our grief may be, it will vanish like a dream with the passing of time. But even so, how easy is it for us to maintain our ordinary composure when confronted with the actuality of death itself?

Suddenly I heard the sound of someone moving about in the next room, so once more I stole over to the edge of the sliding door and peered in. The proprietor, with his back to me, was kneeling over something in the alcove, obviously examining it intently. It was, I soon realized, the dead man's travel bag. I felt as if I was being exposed to the darkest corner of human nature. After the callous way he had cared for the patient last night, and now this unscrupulous act—the realization that, depending on the circumstances, a man can have it within him to do something so cold again filled me with a tremendous sense of unease.

The lantern had gone out, but the dawn light was already beginning to make its way into the room, and although its recesses were still hidden in darkness, I could dimly make out the still uncovered corpse sprawled out on the floor, the disheveled quilt and robe lying there in silent evidence of the torments of that night, and a teapot and a few cups scattered by the pillow. The proprietor went on intently searching through the bag; then suddenly, no doubt becoming afraid that someone might be watching, he stood up and began to close the shutters, which had been left open all night.

My mood was growing even gloomier.

Looking outside, I saw that the sky was already filled with the summer dawn light; there was something unearthly about the sound of the wind-blown rain. Droplets were quaking on the banana leaves that had glistened in the rain last night; somewhere in the distance the melancholy boom of a temple bell could be heard. The battered storehouse wall and roof studded with broken tiles, the worn-looking scroll hanging in the alcove, the equally worn mosquito netting that was full of patches: everything that met the eye was tinged in a forlorn shade of gray. It was enough to make me want to cry.

I went down the stairs to wash my face; the water in the washbasin that had been left next to the toilet was tepid, and the stench was awful. The basin, the little bowl heaped with salt, everything—there wasn't a thing there that wasn't filthy. Amid the muck of the open drain that ran nearby you could see all kinds of festering refuse, and to add to the wretchedness of the scene, a one-eyed dog, covered with rain and mud, wagged its tail incessantly, begging for a bit of compassion. By the time I went into the toilet after washing my face and saw the slippers on the floor, soggy with rainwater that had dripped down from the roof beams last night, my misery was all but unbearable.

Finding the proprietor standing by the stairway, I greeted him.

"So, he finally passed away, then!"

"No," he replied, throwing me a suspicious glance, "that is not the case, but . . ."

What did he mean, "not the case"? Did he mean that the man hadn't died? You damned disgusting fool, I thought—but just talking to him was making me feel miserable all over again, so I hurried back up the stairs.

To her credit, the maid who came in with my breakfast was a little more sympathetic: "My goodness, it's so sad. Wakamatsu—that's so far away, isn't it? And then to come down with beriberi and lose your job, and come all that way by train or by boat just trying to get home, he said . . . It must have been terrible, I suppose . . . And they're saying that he was from Name-kawa, just ten more miles from here, and a wife and children at home, too, they're saying . . ."

I asked what had happened when he came in looking for a room last night. "Well, it was already after ten. He said he had arrived on the last train and all the other inns were already closed for the night, so he was in real trouble, and he begged us to let him stay. He looked like he was going to break down and start crying any minute. Of course we had no idea how sick

he was, so we gave him a room. When I went up to bring him some tea, he was already stretched out on the floor looking really tired, and he said he didn't want it, he just wanted to go to bed so please get the futon ready—I guess that he was already giving us a kind of sign then. So, I laid out the futon for him and went back downstairs, and then, hardly even half an hour later, it all started . . ." Here she stopped short for a moment. "But still, it must have been so awful for you, really . . ."

"Did you send a telegram?"

"Oh yes, they should be here soon. But still, when you think about how sad it will be for them, those poor things . . ."

As soon as I finished my breakfast, I went out to take care of the business that had brought me to that town, so I don't know much about what happened afterward, but when I got back around half past eleven, the bereaved family was already assembled in that dismal, lonely room, and now and then I could hear the shrill sound of their wailing. I was planning to take a noon train at a station two miles away, so I hurriedly packed my things and set off in a rickshaw through the pouring rain.

TRANSLATED BY JOEL COHN

Messenger from the Sea
IZUMI KYŌKA

 Izumi Kyōka (1873–1939) was the most accomplished of the many students of Ozaki Kōyō, the most influential popular novelist of the day. He was fond of monsters. With equal passion, and for the same reasons, he also had a fearful respect for language, especially for its wonders of nuance and transformation. Writing in an age of realism, he, like his teacher, was considered a throwback to an earlier time. Although he worked during the ascendancy of the modern novel, he himself never hid his indebtedness to tradition—whether to illustrated fiction (*kusazōshi*), the humorous stories of Jippensha Ikku, the *nō* theater, or, in the case of the short story "Messenger from the Sea" (*Umi no Shisha*), to haiku poets such as Matsuo Bashō's disciple Mukai Kyorai (1651–1704).

At the same time, Kyōka never clearly articulated an antiquarian or nostalgic position either. Above all, it was his respectful, even fetishistic, re-

gard for the physical reality of words that provided the source of his stubborn genius and nearly untranslatable prose. In response to Tayama Katai and the other naturalists who sought to fashion a transparent linguistic medium that might make the realistic truth and unadorned accuracy of modern fiction possible, he likened realists to archers who, rather than shoot their arrows through the air from a distance, preferred to walk up to the target and stick the pointed tip directly into the bull's-eye. They did not understand the wonder (*myō*) of language.

Published in *The Literary World* (*Bunshō Sekai*) in 1909, "Messenger from the Sea" is Kyōka's answer to the naturalists who both controlled this journal and had gained the upper hand within the literary establishment. At first glance, this simple sketch seems to be a fairly straightforward descriptive piece. A man goes out for a walk. He discovers a tidal pond among the reeds, and encounters a creature that inhabits it. But as we proceed, the realistic bridge begins to totter beneath our feet. A careful reading of the story reveals how the whole thing is a poetic deconstruction and reconstruction of a single word: jellyfish. The word "jellyfish" (*kurage*), represented in Japanese by two characters meaning "ocean" (*umi*) and "moon" (*tsuki*), transforms and expands to become the story. Ocean suggests water, pool, river, tide, and wave; while moon connotes light, jellyfish, head-shaven monk, the ship-sinking sea monster, and, of course, traditional lunar images of Enlightenment and of the dead as they journey to the Western Paradise. By skillfully layering and interweaving these two sets of imagery, Kyōka spins out a subtle tale of monstrous fear and linguistic wonder.

⁂(CSI)⁂

PART 1

With no particular thought in mind, I started across the bridge behind my house, drawn to the reeds on the other side, when my feet suddenly came to a stop.

Was that a bird crying? How gentle and sweet its voice—*kirikiri, kiririri.*

The sound came from somewhere close by. Not from the tree branches right there before me, nor from the shadows of the beans that edged the eggplant patch, but from somewhere lower, near my feet.

I paused and listened carefully. The crying stopped. All was still.

It was a little past three on a fall afternoon, and the sun in the west was hidden behind a thin layer of clouds. The sky was changeable, yet there were no signs of rain. Beyond the cherry-covered hill, gray clouds flowed by; but the peak where the Genmu Temple sat was pale blue in the sunlight, the

cliff's face of cutaway stone bright against the sky, its base illuminated as if the moon were residing there.

I could see the plain of reeds beyond the bridge, stretching all the way to the foot of that peak. The plants had already flowered, and their fluffy plumes formed a bank of fog that enveloped thatched roofs and covered forests, waving in unison with the miscanthus and eulalia grasses of the mountains, uninterrupted by anything that might block them from my sight. There was no wind, yet the reeds seemed to be whispering sibilantly of late autumn's passing.

My intention was to take a stroll on the dike, where the reeds' broken leaves had fallen and formed a crisscrossing net upon the path. When I finally started walking again, I heard the cry of a bird once again—*kiririri.*

"What was that?"

It wasn't a sound an insect would make. It had to be some kind of bird. And it came from below, just as I had thought. Apparently something was down there, among the pilings of the bridge.

"A plover?"

No. Where were the pebbles? The boulders? Where were the channel markers that might urge a plover to pause for rest? Even if there were such things here, a plover would certainly have taken wing at the sound of my approach.

Were there other birds hiding in the reeds at the water's edge? As I trained my eyes on the plants, I carefully took another step. I put some energy into my stride, and the cries came in profusion—*kirikirikiri, kiririri.*

Carefully listening, I reached the far end of the bridge before I knew it.

The bridge itself was little more than three or four planed logs lain down next to each other. They lay unconnected and had become so rotten that they crumbled beneath my feet. There was a handrail, nothing more than a few lengths of bamboo lashed with rope. Standing at about knee height, it wobbled back and forth with every coming and going. The pilings of the bridge, too, were haggard. The water of the small tidal river into which they had been driven was smooth, sluggish, and stained. Although the current was feeble, hardly enough to move the bridge, the structure's reflection on the water seemed to waver next to the underside of the reeds there.

However decayed the bridge might be, unless they used trees with holes already grown into them, the timbers below would hardly provide homes for the birds—even though you do hear people talk about rats building nests in horses' tails.

"Must be the bridge."

Once again, as a test, I went back to the edge of the bridge and took a few steps. My footfalls were immediately joined with *kirikirikiri, kiririririri.*

Feeling the vibrations of the sound in my feet, I tiptoed a hasty retreat, sensing warbler chicks being trampled beneath me. How pathetic and pitiful their voices!

They came from down there. I knelt on the bridge and parted the reeds. Two or three days ago, a heavy storm had overflowed the levee. From the cracks in the still-whitish mud, the pale reed roots rose up to where I peeked into the darkness under the planks as if inspecting the backside of a ceiling that had been left loosened and gaping after a receding flood. Nothing there. I turned my head upside down. I twisted my body so I could see. One bright red crab scuttled away. A number of hermit crabs formed into a string of prayer beads and shifted about in the darkness. Nothing there seemed like it had a voice.

I waved my hand.

"The hill goby cries," I said, and laughed to myself.

PART 2

Tiger goby. Garbed goby. Dowel goby. I've heard all these names. But what of the hill goby? Even if there were such a creature, I doubted it could cry.

Yet those were my thoughts at the time.

I once visited a shrine with a friend of mine who was living in Yakenbori. We left from Kiba, visited the Hachiman, then walked up to the dike via Shioiri-chō, and doubled back to the Eitai Bridge. It was autumn, and the sun was already setting when we reached the dike. Before us stretched an endless plain of reeds, a sky of waterless clouds, and, in the distance, the cloudless ocean. Here and there, leafless branches were scattered over the path like twigs.

"This is the place and the time of day when hill gobies come out," he said.

"So there really are such things as hill gobies?"

"Yes. They live on land. They crawl out from the reeds and climb trees, like those over there. They're fish, so they can't get very high. But they do get up into the pussy willows and stay there. When they hear someone coming, they jump down and hide. This dike's famous for hill gobies. People say the older, more knowledgeable ones can cry."

"Sounds like they might also be able to change their shapes."

"Like little monsters. Creepy, no?"

It was like hearing a fairy tale. My friend's story had me believing that, like shape shifters, the gobies came out at witching hour. That's why I thought something might be here, some slimy black thing with yellowish markings.

Later, I found out that my friend had made it all up. But for some reason I still thought there might be something beneath the bridge—crying.

"The thing chirps," I laughed to myself. One more time, I grabbed a bunch of reeds in each hand, leaned back, and gave the edge of the bridge a solid kick, *ton. Kii*, it sounded. *Ton, ton*, I kicked again. *Kiriri*, it cried.

Kiririri
Kiri, kara, kii, kara
Kiririri, kiikara, kiikara.

The sound was like the echo of crimson ropes attached to a jade pulley as it emerged from the depths of a golden well.

"So it's the bridge planks—squeaking. Someone should use this wood to make a Stradivarius." So saying, I touched the railing, bid farewell to the exquisite instrument, and began my stroll along the dike.

There ahead. A pond in the reeds? It turned out to be nothing more than a small basin of about forty square yards, one that filled with water when the tide was high and emptied when there was only freshwater to replenish it. The ground around the pool was muddy; and the leaves of the reeds were disheveled and pointed in all directions, making it look like the plate on a *kappa's* head. It was the kind of place where small fish would get stranded during low tide, and where children of the village would pull up their sleeves and splash in the water. A number of hermit crabs were moving about now. But in midsummer, if the tide was out for even a short while, the bottom would quickly dry out, turn rock hard, and become covered with lightning-like cracks. Then the tide would come up the Tagoe River, soak the basin, and bubble up in those cracks until a pool formed.

At high tide, there was no way to cross over to the other side and stay dry. So someone had made a second bridge. It was no more than sixty feet from the previous one, a simple affair, nothing but a plank carried over and thrown down. The spot where the board spanned the pool was narrow, no more than five steps across. The water flowed in from the river, under the bridge, along the dike, disappearing into the reeds, then down toward the paddy dikes. Right now, the tide happened to be in, so the entire area was under a shallow covering of water, which was a tint lighter than the shadows of the reeds themselves.

Wait! Because of what I had just experienced with the first bridge, how could I cross over this plank so innocently? Maybe this one will sing, too, I thought. So I took two steps and stopped halfway across. I didn't hear anything. Of course, I wasn't really trying to hear anything. Still, I could feel the quiet sound of the evening water.

"On the cliff's edge, here am I, a moon viewer." As if resting on a ve-
randa, I lingered like the poet Kyorai, and stared at the incoming tide.

PART 3

Something was moving there beneath the surface of the water, something
floating like a shadow. At first, it looked like a crab, clinging to a leaf and
moving with the current. But no. It seemed to have its own mind, moving
back and forth beside the bridge. The water was still fresh and clear from the
sea, so when I looked down into the pool I immediately understood what it
was. It was the size of a baby's fist, the buoyant shape of a captured bubble,
its aimlessness like the soft, light shadow of scattered clouds fallen to the
earth. Its faded reddish yellow and ocher spots appeared and disappeared as
it flowed, gathered, dispersed, then disappeared. Translucent, half milk, half
water, it could be nothing other than a spotted tiger jellyfish.

It was a living thing. So why be surprised that it could play with such
abandon? It moved freely, neither settling on the bottom, nor holding in the
middle, nor breaking the surface. It trailed lines of flowing water as it moved
this way and that—stretching, flowing diagonally, then abruptly raising its
head. As I tried to follow its movements, it turned sideways and passed by.

I could see no other floating shapes. With its well-adapted body, it had
the pond all to itself.

Was it because it had no eyes and ears? Suddenly it swam through the
reflection of my face on the water. Once, twice. It passed by. Then it came
back, and cut across the image of my eyes gazing intently down.

I wasn't just imagining it. As I crouched down, it actually swam back
and forth over the width of my chest, and it did so on purpose. It was show-
ing off, the faceless monster!

Something in me started to hate it.

I got down on my haunches and thrust in my hand. The water splashed
up my forearm, and the bald-headed monk immediately retreated, without
leaving a shadow. He escaped beyond my reach—swimming in circles, ig-
noring me for a time, then swimming again.

"Damn it."

I heard myself mutter those words, then laughed bitterly.

"Wait now."

A trophy, I thought, as I stood and started making my way back to the
foot of the bridge. The jellyfish followed me to where the end of the board
met the reeds. It came over to where my feet were. Was it a crab's hole? Or
the roots of the reeds? Bubbles started coming up from the bottom, and the
creature seemed to be covered by them, unawares.

It seemed to sigh. As if sweeping the bubbles away, it quickly floated up.

I procured one of the reeds by breaking it off at the root. I held it with a backhand grip. Slimy bastard! I'll wrap your fat round body around this stick, and send you flying from this pond!

Quietly, I reached over to the side and inserted my reed into the water at a distance from the creature. Now slowly over, over from the side, I moved it to where the jellyfish was swimming in abandon. Now, lift. Got it, the slippery thing!

It seemed to be tangled up with watergrass. As I lifted, it slipped away with the dripping water. Suddenly, it was gone.

"An octopus spirit, floating away like a burning bubble. A rout!"

Take that! I quickly posed, my cheek brushing against the reed's plume, my bow planted in victory on the bridge. That was one thing. But at the same moment, the inlet where the tide enters caught my eye.

There it was, right in the middle of the twelve-foot channel in the reeds, where the tide rustles in. In the area directly in front of the bridge, the bald-headed monk was swimming around in circles, creating its own whirlpool. Its color seemed to flare red as its rotund shape danced and floated to the surface.

Fearful of mankind, the monk was fleeing back to the ocean on the river's current. Or so I thought.

It lingered in the same spot for a moment, rising and sinking, playing with its own shadow. Then it sidestroked quickly over, cautiously over, making a wide circle near the roots of the reeds, back to where it had been.

The colors of dusk, dark among the leaves and whitened plumes, spread over the withering tips of the reeds.

Moving out from the jellyfish and its dark shadow, the circles of water grew larger and larger. The more the monster moved, the more the tide seemed to rise. The surface of the water pulsated and spread. The swelling tide poured from both sides into the inlet and swayed the reeds on the riverbank. Swaying, swaying. With each movement of the reeds, the water level grew higher, as if welling up from the bottom of the pond. The reflections on the water, whether of man or bridge, plunged to the depths. Should the entire Genmu Temple be thrown upside down into the water, its top would never reach the bottom of the pond's depths.

The water kept rising in growing circles and spreading through the reeds. It rose up like the ocean tide, breaking whitely about the plumes of the reeds, deepening and flowing in off the river, one slapping roll after another, crashing down with a roar. As the river was also the only outlet for the water, a rip formed beneath the bridge, striking the dike and swirling into whirlpools. Now assaulted from behind, the reeds began to dance, exposing

themselves below, with the blue cotton of their seeded plumes spewing into the indigo of nightfall.

Sa, sa, sa,
Shu, shu, shu
Eisa, eisa!

The water sounded its battle cry, as the jellyfish shot through the waves and galloped forward. A cloudy light came from its moonlike body, as if the pine torches in the Dragon's Palace had burst into flame.

When the shadowless white fire reached the bridge, the reeds had all but disappeared beneath the water. The plank under my feet groaned and shook. I escaped on wobbly legs to the bank, and found that the water was already there to greet me.

My god!

The bridge suddenly moved with a deep groan, and the plump jellyfish came forward. The water splashed over the plank; and the luminous creature abruptly passed by, trailing its silken tail.

I had heard tales about how the ghoul *umibōzu* rides upon the foul-smelling wind to do harm to sailors at night; and how, upon the storm-tossed sea, jellyfish turn themselves into sea goblins.

Now, with darkness descending upon me, I made a hasty retreat. I leaped to the safety of the first bridge. I made it sing once again, *kiriririri*. Because it was slightly higher than the plank I had left, I felt some measure of relief, as if I had safely boarded a ship. But then I looked back and saw that the water had already come up to the foot of the bridge, and that the jelly-fish was there, pressing forward, waiting. Of course, it could not leave the water, swelling and bulging, like a bubble on the surface. But with its hostile breathlike light it seemed to be urging the water, "Rise higher, rise higher."

Sa, sa, sa,
Shu, shu,
Sa, sa.

The battle cry came again, and the moonlight flashed across the whet-stone face of the peak where the Genmu Temple towered.

TRANSLATED BY CHARLES SHIRŌ INOUYE

PART VI

Romance and Eros

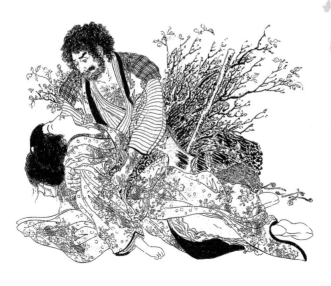

Pessimist Poets and Women

KITAMURA TŌKOKU

 Poet and critic Kitamura Tōkoku (1868–1894) was a revolutionary thinker on the topic of love. His enthusiastic style of writing, coupled with his suicide in his twenties, sensationalized his standing as a radical advocate of romantic idealism. With a stress on a spiritual approach to *ren'ai,* or "romantic love," he articulately introduced Japanese readers to the Western notion of the separation between the soul and the body. His criticism of Japan's traditional depiction of love, which does not differentiate the erotic from the spiritual, added to his Western-inspired understanding of the emotion. Unlike the orthodox Western understanding of love that is completed through the union of man and woman in marriage, he was, however, led to conclude that the convention of marriage inevitably crushes idealistic passion amidst one's quotidian concerns.

Tōkoku was the eldest son of a samurai family that moved from Odawara to Tokyo when he was twelve. He soon became ardently involved with the Liberty and Civil Rights Movement. Through this activism, he met Ishizaka Mina, a sister of one of his activist friends and a daughter of a political party leader. He fell seriously in love with this Christian woman, a missionary school graduate, who was three years older than him. He converted to Christianity in 1887 and married Mina the following year. The

intense spiritual emotion he experienced in his relationship with Mina was the foundation of his notion of *ren'ai* as discussed in the essay presented here. After marriage, Tōkoku realized that the spiritual inspiration he originally found in Mina was quickly fading away. Written in 1892, "Pessimist Poets" profoundly reflects the tumultuous history of his idealization of love through his relationship with Mina. He grew mentally unstable and eventually killed himself. He was twenty-five years old.

Represented by this and other essays, together with his dramatic poems, Tōkoku is considered one of the leading authors of the first stage of the romantic movement in modern Japanese literature. Inspired by Western romantic poets, Tōkoku invented the form of poetic drama as seen in "The Poem of the Prisoner" (*Soshū no Shi*, 1889) and *Mt. Hōrai: A Play* (*Hōraikyoku*, 1891). In the essay translated here, he cites from Alexander Pope's *An Essay on Man*, Samuel Coleridge's "Notes on Romeo and Juliet," and Lord Byron's *Childe Harold's Pilgrimage*, sometimes adapting from Byron's lines. "Love" by the Transcendentalist Ralph Waldo Emerson also appears in this essay.

"Pessimist Poets" is the best known and most highly acclaimed of his essays. Many young contemporary authors, such as Shimazaki Tōson (1872–1943) and Kinoshita Naoe (1869–1937), were profoundly moved by it. The modern critic Itō Sei (1905–1969) and poet Yoshimasu Gōzō (1939–) have been drawn to his texts as the paradigm for discussions of notions of love and literature in modern Japan. Feminist critics call attention to Tōkoku's ideology of love as a typical "male" fantasy, one that allows the male to justify his refusal to face the reality of being in a relationship with women as individual . But the general power of Tōkoku's expressiveness remains strong and vivid even today.

It is true that Tōkoku's romantic fever for love looks dated to the majority of contemporary readers. In his writing, Tōkoku was an authentic poet, whose youthful exuberance attempted to renew the fundamental vision of modern Japanese language, literature, and religion, as well as love and selfhood. The historical limitations of the visions he displays can be critically argued. However, we can learn much from the ways in which he expresses those visions: every piece of his writing is enriched by an inspiring urgent tone of voice trying to articulate the limits of his imagination and emotion.

⌒(**ES**)⌒

Love is the secret key to life. Life becomes real only after experiencing love. Without love, our days are colorless and tasteless. Why is it, then, that the monsters of humanity we call poets, these men who observe human life most studiously and understand the secret essence of humanity so well, often fail to have meaningful relationships with women? From ancient times to

the present, countless poets have lost their lovers, to the extent that women are warned to stay away from such men if they wish to find a good mate. Poets are far from emotionless animals. To the contrary, they have far stronger emotions than ordinary men. So why are there so few who have enjoyed enduring intimacy with their female partners? It is said of Goethe, a genius who was also known for his infidelity to his lovers, that his mind was gold, but his heart was lead. Another of the great poets, Byron, was also guilty of infidelity. His faithful and quiet wife believed he was mentally ill. After he left her and wandered around Italy, he was often not welcomed by those who had wives or daughters. As for Shelley, his wife left him and killed herself when they were still newly wed; and his own life ended prematurely as well by accidental death. Even Milton, a man of high and solemn character, almost committed the same mistake as Shelley. The posthumous publication of Carlyle's writing revealed that the frank, bighearted poet also had a troubled and cold relationship with his wife. We can also add André Malraux, Ben Jonson, and others to the continuously expanding list. Thus we understand why it is that women are afraid of marrying poets.

Are thought and emotion enemies? Poets know that profundity of thought is born of the mother of love. Emerson once pointed out, "the coldest philosopher cannot recount the debt of the young soul wandering here in nature to the power of love." Love has the miraculous power to leave a brushstroke deep in the heart, a trace that remains invisible yet impossible to erase for the remainder of one's days. Though seemingly dark and distasteful its consequences, love is not mean. Those who have not loved are like sad, lonely trees waiting for the arrival of spring. Only after experiencing the power of love do we begin truly to understand life's essential meaning. This is because love has an impalpable power that penetrates the truth of beauty. Without love, one senses a world filled only with strangers with whom one cannot relate. With love, one's outer reality suddenly seems rich in sensation and more real than illusory. One feels like one has returned home after having stayed at a neighbor's for a duration.

All human beings possess innate reason, maintain hope, and wish to better their present conditions. Free of the social constraints of the adult world, children grow straight and tall within the pure realm of ideal thoughts, in their ignorance of the real world. No adult lives, however, are untouched and unbound by the laws of the real world. We necessarily reach a stage when our world of ideals—otherwise known as the world of innocence—and the world of reality—otherwise known as the "floating" or "trouble-ridden" world—begin to compete with and to confront each other. How mighty the real world's power! The ideal world establishes itself before we know society's various discordances. Once stabbed by the mean blade of mortality,

advocates of the ideal fight valiantly, only to grasp the inevitable fact that their luck has already become exhausted. The fallen warrior, discouraged and depressed, wants to console himself by acquiring some sort of reward from life. Labor and social duties are the friendly troops of the ally of reality, whose advocates are always ready to attack the idealist army. They who support this ally of realism with hundreds of other ethical principles will also fight the idealists with their swords and spears. Where on earth could the desperate warrior of ideals find someone who might support and please him? Only in love. At this point, he discovers a powerful light in his love for a woman: he looks to a heavenly beauty in the sky above him, and he spends sleepless nights turning over and over in bed. If it is only through an inborn instinct that men are attracted to women and vice versa, then humanity's value is reduced to mere animality. The pseudonovelists of our tradition have established the poisonously biased opinion that love is an emotion automatically produced by lustful arousal. They seek only the low pleasures of life, based on their pathetic understanding of human ideals. How could love be as simple a matter as a man's emotional attraction to the opposite sex? In effect, love is a true fortress for the idealistic warrior, a place to confine himself after being defeated in the battle between the real and the ideal.

Thanks to love, reasonable human beings do not all go mad and die; and it is also thanks to love that people are encouraged to enter into the real world. In his essay on *Romeo and Juliet,* Coleridge observes in Romeo's feelings for his first love, Rosaline, nothing but a love of his own making: that she is a "mere creation of his fancy." His observation implies a message critically applicable to all novelists who equate love with lust without seeing the truth of love. Love goes beyond the realm of that delicate music that made the obstinate Byron cry. Love is a precious stone whose purity goes beyond the fine art of Goethe's creation. Love's inspiration caused the manly and sensitive Dante to cry out to the universe of heaven and earth. Swift's hard and miserable life was created through his numerous failures at love. Ah, love! You capture poets and make them yearn for you, so much that they end up falling into misery. What a lamentable cruelty you exercise upon them!

Whether of the East or the West, all pessimists display their cold contempt for women. Sakyamuni cursed women loudly, and Shakespeare indicated his displeasure on a number of occasions. Recently in this country, Kōda Rohan wrote "One Word, One Sword" (1890), in which he skillfully expressed his philosophy through his protagonist Oran; and in "Awakening to Romantic Elegance" (1891) he stressed the necessity of deliverance from earthly bondage. I could not agree with him more. Women are indeed emotional creatures. Poets, too, are also rich in emotion, so that we might consider them "womanly" men. Byron once frightened his bed

partner when he chased her in the middle of the night with a firearm in his hand. But a madman he was not. From a certain standpoint, women do seem narrow-minded and stubborn. Yet poets are much the same. If women are elegant and delicate in nature, so are poets in their way of thinking. Even when they express themselves in bold, heroic verse, their words are based on a graceful creativity and are necessarily feminine in nature. Moreover, when we carefully examine the physiological traits of poets, we find nervousness, obstinacy, and hundreds of other traits similar to those associated with women. Is it because they know women too well, as a quasi-equal gender, that poets fail to maintain long-term bonds with them? That might be a legitimate argument. But I have other thoughts on the matter. As for my own understanding, I should like to appeal to the opinions of experts.

While all poets tend to fail in their long-term relationships with women, I would like to note that this tendency is heightened in pessimistic poets in particular. When a man starts to form his own view of the world, he naturally longs for goodness and beauty; he abhors ugliness. When a boy who is still too immature to understand the depths of reality begins to discover disharmony and injustice in human life, he is hurt and saddened by the way real lives are lived. With his mind filled with this confrontation between knowledge and experience, with the competition between fantasy and practicality, he will start to develop, as we might expect, a suspicion and dislike of the floating world. A man does not grasp the notion of duty from birth. He does not have morality as his inborn nature. Duty and morality are relative virtues, learned after one has grasped the nature of society and clearly understands one's own "self." When a naïve boy who has little experience with duty and morality first encounters the incomprehensively complex core of social reality, how can he remain himself without being gnawed by misanthropic thoughts? Honesty should overcome pessimistic emotions, but living with true honesty is the hardest of all things to do. Even the great Saint Paul cried out in recognition, "I am a sinner." It must be that only a chosen few are allowed to become truly honest with themselves, to overcome the pessimism that has penetrated them. We may find such a rare example in Pope's optimism. His was, however, of an exceptionally enlightened state, as given voice by the following lines:

All Nature is but Art, unknown to thee;
All Chance, Direction, which thou canst not see;
All Discord, Harmony not understood;
All partial Evil, universal Good:
And, spite of Pride, in erring Reason's spite,
One truth is clear, WHATEVER IS, IS RIGHT.

I believe that such optimism was only made possible by Pope's conscientious will to suppress reality's overwhelming pressures. In short, he acquitted it as an effect of his real life experiences. It is quite impossible for inexperienced young thinkers to reach such an enlightened state of mind.

As for young souls who are still idealistic and need no effort to be honest, should we believe that for them all phenomena in the real world appear unreal and untrustworthy? I would say no. There is one thing only that does not seem untrue, a thing so real that even death cannot erase it. That one thing is love. Strife is a fundamental element of our emotions, but when we are in love, we become peaceful and harmonious. With no conscious effort, we portray the objects of our affection as calm and gentle women. When lovers are with each other, the world holds no hostile opponents; dissatisfaction and discordance are replaced by the truthful, beautiful mind of angels. So many times young souls are smashed by the harshness of the real world; in particular, when the minds of poets, so-called, are working at the fullest capacity of their creative imagination, they often cannot endure reality's hostile offensiveness. Imagine how unbearable the pessimist poet must find his depressing and pathetic life in this impure world. He cannot help but seclude himself within the fortress of love, and to glorify his love as being larger than it actually is. Love belongs not only to the present, but also partially to one's hopes for the future. Lovers wish that their partners would become supporting, encouraging friends, a better half. Honor and worldly profit, whether a king's throne or a railroad tycoon's fortune, cannot provide the pessimist poet with any sense of hope. Worldly hope and pessimist poets are as water and oil, simply unable to mix. Only love has the exceptional power of penetrating the secret of the pessimist's moaning heart to form the miraculous source of hope. Emotion is contrary to calm: once a poet becomes emotional, his heart is easily stirred. Especially when these beings who are so easily excited meet the true emotion of love, they are suddenly overwhelmed by this uncanny and magical power. Obsessed with unfounded hopes, they quickly become complete slaves to this emotion.

Love becomes a clear mirror of the "self" when we learn how to sacrifice for our loved ones. After we experience love, we begin to understand the concept of social unity. Just as any small insect does not work alone and in total freedom for its individual needs, so do we human beings form into groups, depending on and embracing one another. To be connected by love with our partners is the first step toward understanding why we would want to construct and maintain society in the first place. As long as one lives alone, one has no real motivation to become a part of society. But when one forms into a pair with one's beloved, one becomes aware of his

identity as a constituent of society and clearly pictures himself integrated into that society.

Once one is united with his partner, he suddenly realizes that each cloud trailing in the sky has its own personal face, and each trill of birds singing in the forest has its particular tone. He senses that yesterday was the distant past of decades ago, and that today is the solid existence that will last eternally. Once a remote reality, society suddenly comes very close, and rituals and duties that once were ignored become urgent interests. A once formless picture of social existence suddenly becomes solid truth; and his indifference is replaced by detailed concerns as he becomes bound to both the regular and irregular rules that give connection to society's organizations. In other words, he is subjected to the laws of the real world, losing his independence as an inhabitant of the world of ideals. As a man of elegance once put it, marriage ends up making men ordinary and secular. As long as this secularization places men in a normal and just social position, they become aware of their duties to superiors and to humanity in general, as well as of morality, which people in the past have symbolized as gorgeous flowers. Secularization through marriage thus makes people serious; they daydream less and think more practically. Marriage is, therefore, a basis for men to enter the afternoon phase of their lives.

As I have already mentioned, pessimists have reasons to trust in the possibilities of love in a more extreme manner than ordinary people. Odd it is, then, that marriage disappoints as quickly as it enchants. By nature, pessimists do not conform to social rules, since their home is not in society. As Byron put it, "I loved not the world, nor the world me." Rules and regulations cannot bend them. It is because "My pleasure is not that of the world." In sum, while cursing this life as an impure land, they are unmotivated to join organizational members of society. Married life is ultimately a hostile territory, even though it begins with much hope and imagination. When they see their true selves in the clear mirror of consciousness, their pessimism intensifies. Pleasure in marital unity is not powerful enough to lead them to sincerity and optimism.

As they hate this world and seek escape from it, they have no desire to be further constrained by it. Thus, marriage encourages them to despise society more harshly, to escape duties, and to accelerate their dissatisfaction. That is why they become as disappointed as they were hopeful before marriage, and why they end up in miserable confrontations with their wives.

Since women are emotional animals, they tend to love their husbands when they are loved by them. Their natural strength resides in their responsiveness to male love rather than in taking the initiative in relationships.

They lean on men like vines wrapped around the trunk of a tree. They rejoice and worry in response to the slightest actions and words of their husbands. They sensitively respond to their husband's love. When they detect in their husband's attitude an air of avoidance, they quickly become jealous, suspicious, resentful, and bitter. If husbands do not try to reaffirm their love, their emotion toward them might deteriorate and go somewhere unpredictable. Can the pessimist poet still continue to maintain harmony with his wife, considering the fact that he is already hostile to society, harboring destructive thoughts and lack of respect for secular duty and morality?

Indeed, poets are obstinate souls; they do not like to stride along the road of this world. Rather, they wander around in the universe they have created for themselves. Since the pessimist poet's created universe is positioned far from the real world, they might feel as if their small realm of ideals becomes more and more narrowly suppressed when bound to this world through marriage. Originally, they enter into love relationships believing that love is the fortress of their ideals, but they end up feeling as if they are punishing themselves by being constrained to the detestable bondage of love.

Sakyamuni's harsh words should be understood in this context. He cursed women. "Evil are women. When I now observe them with my naked eyes, I find no single part, from their heads to their feet, to which I feel attracted." He has bitter things to say elsewhere as well. "A woman's interior is foul and filthy, while her exterior displays ostentatious show. Our homes are inhabited by scorpions, whose poison is as strong as that of snakes and dragons." His criticism continues. "Women are not reliable friends. They constantly oscillate like the flame of a lamp. What is constant in them is their ill will. It resides in them like letters inscribed in stone." Such words inaugurated a long tradition of mistreating women in that pessimistic religion of the East.

Emerson correctly points out that marriage and death are topics we incessantly discuss—from infants who can barely speak to those who are close to the grave. If a first-grader comes to school with his new textbooks in his arms and blushes when his eyes meet those of the girl sitting next to him, or if a child reads a romantic novel, following the words he can recognize, and a vision of love swells his imagination, such youthful interest in love is only a natural part of the development of human life. To love someone is life's basic law, as equally expected as life's end. Love actualizes our ideals in a concentrated fashion, marriage transports us from the world of ideals to the world of the real, and death allows us to transcend the real, material world. When love is just beginning, we become enamored of our own vision of love by excluding any serious engagement with the reality of

those we love. However exciting this stage of infatuation might be, it is inevitably followed by a realistic and stable state of love. It is truly deplorable that this stable love becomes a burden to the pessimist poet, who ends up destroying his happy unity with his beloved. When Byron left England, he composed a verse that contained the following line: "For who would trust the seeming sighs / Of wife or paramour?" This line clearly exposes the heart of a pessimist. When reading his poem "To a Lady," one ponders over the emotion hidden behind Byron's bitter remarks about women in a country like England, where a gentlemanly code vis-à-vis ladies was strictly upheld.

Oh! How unfortunate women are! They represent the ultimate in elegance and finesse for the pessimist poet, who then translates them into worldly symbols of impure ugliness, concentrating his harshest criticism on them and treating them with ill will. For the rest of their lives, women hold back their tears and, whether asleep or awake, continue to stew over and resent their lovers to the extent of wasting to death in melancholy. How sad indeed they are! Byron once confessed, "When love fails, and lovers part with broken hearts, both are endowed with an eternal winter night."

TRANSLATED BY EIJI SEKINE

The Cuckoo

TOKUTOMI ROKA

 Japanese culture was suffused with melodrama at the turn of the last century. Modern critics of melodrama see it as a structure of feeling that thrusts its way to the cultural forefront in moments of historical upheaval. It stages polarized and hyperemotional conflicts between good and evil in a search for moral certitude. In the Meiji period, Japanese fiction employed melodrama to address the pervasive social and ideological changes wrought by modernity—among them the explosion of mercenary impulses tied to the rise of industrial capitalism, the reconfiguration of social hierarchy caused by the abolition of old status categories, and the challenges to family issued by new discourses of gender, love, and individualism.

Melodramatic fiction was a blockbuster genre: it rode the explosive growth of the publishing industry, took advantage of technological advances in movable-type printing, and found an audience in the expanding body of literate consumers created by the new universal education system.

The Cuckoo (Hototogisu, serialized 1898–1899), one of the defining works of Meiji melodramatic fiction, provides an example of the form's reach. Like many other melodramatic novels of the period, The Cuckoo first appeared in newspaper serialization; it was initially published in the People's Newspaper (Kokumin Shinbun). It was when The Cuckoo was brought out in book form in 1900, however, that it became a Meiji publishing sensation. The book went through one hundred printings by 1909, and by 1927 there had been 192 printings amounting to total sales of some 500,000 copies. The Cuckoo, moreover, had a further life adapted into other genres. It inspired a retelling in verse that went through twenty-nine printings within two years after being published in 1905. It was produced countless times on the stage. And at least fifteen films based on The Cuckoo were released between 1909 and 1932. This pattern of repeated adaptation was characteristic of the most popular examples of Meiji melodramatic fiction, which went beyond being a literary genre to function as a media-spanning commercial and cultural phenomenon.

Using melodrama's binary moral structure, The Cuckoo dramatizes the conflicts between two competing models of the family. On the dark side is the "house," a diachronic model of lineage connecting ancestors with descendants. The house organized its members into a hierarchy, where men were valued over women, parents held sway over children, and older siblings stood over younger ones. Although the house was represented by the Meiji state as the "traditional" form of family in Japan, it was in actuality a modern institution of social control, in which patriarchy was mobilized as a bulwark against the social dislocations of modernity. Its ideological use by the state was underscored by the often-made analogy that the family, ruled by the head, was a microcosm of the state, ruled by its emperor. The main exponent of this ideology in The Cuckoo is ironically a woman, Kawashima Keiko, who seeks to preserve, at the expense of her son's marriage, the lineage of the family into which she married.

On the side of light are the newlywed couple, Kawashima Takeo and his wife, Namiko. They exemplify a model of family called the "home," which regarded the married couple, rather than lineage, as the core of a family. Influenced by Western ideologies of domesticity, the proponents of home valorized the romantic attachment of husband and wife; viewed sentiment, rather than duty, as the glue of family; and defined family in terms of the synchronic existence of a couple and their children.

The following translation comes from Part 2, Chapter 6, of the novel, where the climactic confrontation between Kawashima Takeo and his mother takes place. Here, the "house" and "home" collide over Namiko's infection with tuberculosis. At the turn of the century, the etiology of tuberculosis was poorly understood, and the disease was thought to be both inherited

and contagious. This belief caused tuberculosis to be construed as a disease doubly dangerous to the family: it wiped out both bloodlines and family members who lived in close proximity to each other. The mother, operating on these assumptions, precipitates a characteristically melodramatic moment when two characters enunciate polarized moral positions: she argues for sacrifice in the name of lineage, and the son begs for compassion in the name of sentiment.

The family conflict in *The Cuckoo* occurs against the background of the novel's fervent nationalism. Near the beginning of the work, its hero is identified as "Navy Ensign Baron Kawashima Takeo"; he is then both an imperial soldier and a member of a modern aristocracy created to support the imperial institution. As Takeo's departure for naval maneuvers at the end of this scene suggests, his identity as a national subject will become an increasingly important element of his portrayal. Takeo and Namiko will be separated, and the latter will die, evoking the melodrama's trademark emotional excess. But from within the pathos, Takeo will emerge as an example of imperial manhood. He will fight courageously in the Battle of the Yellow Sea, the defining naval encounter of the Sino-Japanese War (1894–1895). And, at the conclusion of the novel, he and his father-in-law, a lieutenant general in the Imperial Army, grasp hands over Namiko's grave, sealing with their shared loss their alliance as fighting men in the service of the nation.

Tokutomi Roka was born in Kumamoto, the second son of a locally prominent family. As a young man he followed his older brother to study at Dōshisha Academy, a Christian institution in Kyoto, and he was baptized a few years later. It was probably through Christian circles that Roka was first exposed to ideas about the "home," for Japanese Christians were at the forefront in importing Western concepts of domesticity. At the time of *The Cuckoo*'s publication, Roka was an obscure staff journalist working on the newspaper and journals controlled by his then more-famous brother, Tokutomi Sohō, a social critic, historian, and publisher. As he later told it, Roka was staying in the seaside town of Zushi (where he would locate the villa where Namiko is sent to convalesce) when he was told the story of the daughter of the army general, Ōyama Iwao, who was divorced by her husband's family after contracting tuberculosis. Using this as his inspiration, Roka wove the story that would bring him out of his brother's shadow and establish him as a writer.

Roka's subsequent writing combined social criticism with autobiography and an idiosyncratic spiritual quest. Among his works are a bildungsroman about a young man from Kumamoto growing up to become a writer amidst the modernizing currents of the Meiji period, as well as a novel about the fractious and unprincipled politics of turn-of-the-century Japan. The

writer's spiritual yearnings culminated in an adulation of Tolstoy, whom he eventually visited at Yasnaya Polyana, a pilgrimage recorded in a travel memoir. Upon his return to Japan, Roka withdrew to a house in the countryside, where he dabbled in farming while continuing to write. His final work was a four-volume autobiographical novel.

<p align="center">(KKI)</p>

It was the beginning of May. Takeo's ship was scheduled to sail from Kure to Sasebo and then back north in order to take part in joint fleet exercises off Hakodate. He would be unable to come home for forty or fifty days, and so he returned to Tokyo to look in on his mother and say farewell.

On his recent visits home, his mother had been testy, as though she had something she wanted to say to him. But tonight she doted on him with a rare smile, ordering a bath to be filled and serving him Satsuma soup and other favorite dishes of his that she made with her own hands. Takeo, who normally did not catch such details, wondered at the change. Of course, every child likes being spoiled, no matter his age; and Takeo was all the more attached to his mother after the death of his father. He happily ate his dinner, pleased that his mother's mood had improved. Afterward, as he took a bath to the sound of gentle rain, his only further wish was for Namiko to recover quickly and be waiting for him here upon his return. He luxuriated in the bath, remembering the scene at Zushi, where he had stopped on the way. Getting out, he quickly arranged the kimono a servant draped over him. He entered his mother's room, rubbing his forehead with the back of his right hand, in which he held a cigar.

His mother was getting her shoulders massaged by a maid and smoking fragrant tobacco in her long bamboo-stemmed pipe.

"That was a quick bath," she said, looking up at him. "Just like your father. Have a seat on the cushion there."

"Matsu," she said to the maid, "that's good for now. Go make some tea." She herself stood up to get some sweets from the cabinet.

"I'm getting the royal treatment," Takeo said with a smile, drawing on his cigar and blowing out a mouthful of blue smoke.

"I'm glad you've come home, Take. Actually, I'd just been thinking about asking you to come, because there's a little something I need to discuss with you. It's good you've returned. You stopped by Zushi, I suppose?"

Even though he knew his mother frowned on his frequent visits to Zushi, he couldn't very well lie to her. So he said, "Yes, I stopped by for a bit; her color seemed to be better. She was worried, saying she felt badly she couldn't be here with you."

"Is that so?" His mother studied Takeo's face.

Just then, the maid arrived with the tea tray. Takeo's mother set everything on the table and dismissed the maid. "Matsu, leave us for a while. Close the door as you go—"

Takeo's mother poured the tea with her own hands and served her son. She drank some herself and slowly raised her pipe. She took her time before finally speaking.

"Take, I've gotten weaker as of late. Last year's rheumatism sapped my strength. All I did yesterday was go visit the grave, and my shoulders and hips still hurt. When the years pile on, you get helpless in so many ways. It's sad. Take, I want you to take care of yourself and make sure you don't get sick."

Takeo tapped his cigar on the edge of the hibachi, knocking off the ashes. He looked at his mother's face, which, though plump, showed the undeniable signs of age. "I'm constantly away," he said, "and you have to be the leader of this family; I wish Nami were well. She's always saying she wants to get well quickly and take some of the burden from your shoulders."

"I'm sure she feels that way, but the disease is what it is."

"Things are headed in the right direction. It's getting warmer now and, after all, she's young."

"The disease being what it is, we can only hope for the best. Take, wasn't it the doctor who said—that Nami's mother died of tuberculosis, too?"

"Yes, something like that, but—"

"Could this illness be one that's passed down from parent to child?"

"I've heard of that happening. But Nami's case definitely came from a cold. Don't worry, mother. It's just a matter of taking precautions. They talk about contagion and inheritance, but it's really not so bad. Her father's a strong man, and her sister—the one called Okoma—you couldn't find a 't' for 'tuberculosis' in that girl. Human beings aren't as weak as doctors make out." Takeo punctuated his thoughts with a hearty laugh.

"No, it's no laughing matter, Take," said the mother, tapping the ashes from her pipe. "Even among diseases, this is an especially terrible one. You must know about this, but do you remember Governor Tōgō? You used to fight with his son all the time. How about that child's mother? She died of consumption—that was last April—and then at the end of the year the governor died, too. Are you listening? On top of that, the son—he was working as an engineer somewhere—he just recently died of consumption as well. They both caught it from the mother. There are lots of stories like this. Take, that's why when it comes to this disease you can't let your guard down. If you do, it'll soon be a crisis."

Takeo's mother put her pipe down and slid forward a little on her knees. She gazed at his silent profile, then added, "Actually, there's something I've been wanting to talk to you about—"

She hesitated for a moment, looking intently at Takeo's face. "It's about Nami—"

"Yes?" Takeo raised his face.

"What would you think about having them take Nami back?"

"Take Namiko back? How is she going to be taken back?"

Still looking at Takeo directly, his mother said, "By her family."

"Her family? Are you talking about her going home to recover?"

"Convalescing is one thing, but in any event we'll have them take her back—"

"Zushi's the best place to convalesce. There are children at her family's place. If we're going to have her stay there, then our house would be much, much better."

Takeo's mother sipped the tea, now grown cold. Her voice trembled slightly as she said, "Take, I hope you're not drunk. Are you pretending not to understand me?" She looked steadily at her son's face. "What I'm talking about is having Nami—having Nami return to her family."

"Return—? You can't be talking about divorce?"

"Take, careful. Lower your voice." She continued looking steadily at Takeo as she said, "Divorce. Yes, I'm talking about divorce."

"Divorce! Divorce? But why?"

"Why? As I've just been saying, the disease is what it is."

"Because it's tuberculosis—you're saying you want her divorced? Nami divorced!"

"Yes, that's what I'm saying. I feel sorry for her, but—"

"Divorce!"

The cigar slipped from Takeo's hand and fell into the hibachi where it sent out a heavy trail of smoke. A single lamp burned with a sizzle, and the night rain beat against the window.

Takeo's mother slid forward as she buried the smoking cigar in the ashes of the hibachi. "Take, this is sudden and I know you're surprised. But I've been thinking about this for a while now. You need to listen to me. As you know, I don't fault Nami for anything in particular. And you're fond of her. So I don't like bringing up divorce. But the disease is—"

"It's getting better," Takeo blurted out, sharply looking up at his mother's face.

"Listen to me," she said. "Perhaps it isn't so bad just now, but I've made it a point to find out from the doctors. When it comes to this illness, you might improve for a while, but it soon gets worse again. It comes back when

the weather gets warm or cold. There's not a single person who's ever been cured of tuberculosis; that's what the doctors say. Granted, Nami might not die now, but she'll surely get worse again soon. And there's no doubt it'll get passed on to you. Isn't that so, Take? You'll get it, and then when you have children, they'll get it. It's not only Nami we're talking about. You're the precious master of the house, and your children the precious heirs. If you become consumptives and die, the Kawashimas will be destroyed. Listen to me. You got where you are because of your father's care. And now, the House of Kawashima, upon which the emperor has bestowed his personal favors, will end in your generation. I do feel sorry for Nami, and I know it's hard for you. It's not easy for me to be a parent and to bring up something like this. It's awful, I know. But, no matter what you say, the disease is what it is. I can't give you up, or let our family go to ruin, just because I feel sorry for Nami. You need to think deeply about this and resign yourself to what has to be done."

"Mother, I can't do such a thing."

"Why?" Takeo's mother asked, her voice growing louder.

"If we do this now, Nami will die!"

"Yes, she might well die. But, Take, your life is precious to me; the House of Kawashima is precious!"

"Please. If you care so much for me, then try to understand how I feel. You may disagree with me, but I could never do such a thing. Nami isn't used to us yet, and so she may be lacking in many ways. But she takes good care of you, and she's good to me. There's no way I can divorce someone so utterly guileless, so innocent, just because she's fallen ill. Even with tuberculosis there's hope for recovery; in fact, she's starting to improve. If it turns out she can't get well and she has to die, Mother, please let her die as my wife. If the illness is dangerous, I'll stop going to see her; I'll take extra care. I'll do whatever it takes to ease your mind. But divorcing her is one thing I can't do."

The mother chuckled nervously. "You keep on talking about Nami, but don't you care about dying? Will you happily destroy our family?"

"You keep on talking about my health, Mother, but what do we gain living to a ripe old age if we achieve this by doing something so unfeeling, so wrong? We do our family no favors if we trample on feelings and ignore ethics. This brings neither honor nor glory to us. There's no way I can divorce her. I adamantly refuse to do this."

Although she had expected some difficulty, Takeo's mother was surprised at her son's violent resistance. Her usual temper started to burn in her chest, the veins rose on her temples, and her jaw tightened. She barely managed to still the trembling hand holding her pipe as she tried to maintain a smile.

"Settle down and think about this calmly," she said. "You're still young and you don't know how the world works. They say, save the plant even if you rip off a leaf. Don't you see? Nami is the leaf, and you—the Kawashima family is the plant. I feel sorry for the other family, and I pity Nami, but it was her misfortune to get sick. No matter how badly people think of us, isn't it better than allowing our family to end? Isn't that so? You may say this is unfeeling or wrong, but there's a lot of this sort of thing in life. Women are divorced if they don't fit in with the customs of their husbands' houses. They're divorced if there are no children. They're divorced if they get a serious illness. That, Take, is the way it is in life. There's nothing unethical or unfeeling about it. In fact, when a bride comes down with an illness like this, her family should come to take her back. We're just bringing it up now because they haven't yet. There's nothing wrong or shameful here."

"You say that's the way life is. But there's nothing that says we're free to do what's wrong just because everyone else does. Divorcing a woman just because she's ill is something out of the past. If I'm wrong, and that's what's being done in our society now, then perhaps we should, we *must*, destroy that society. You only talk about us, but what about the Kataokas? Do you think they'd be pleased to see someone they gave away as a bride come back to them? And what kind of face could Nami put on this, if she had to return home? What if this were reversed, and I was the one with tuberculosis? Would you be pleased if Nami's family came to take her back, saying that tuberculosis was dangerous? It's the same thing."

"No, it's different. A man and a woman are two different things."

"It's the same. In terms of sentiment and reason, it's the same. Nami has finally stopped spitting up blood, and she seems, at least a little, to be headed in the right direction. To do what you say now would be like making her spit blood again. Nami would die. I know she would. We couldn't do such a thing to a stranger, yet you ask me to do this to Nami. Are you telling me to kill her?"

Takeo could not keep himself from shedding warm tears.

His mother suddenly stood up, took down a memorial tablet from the family altar, and, returning to her place, thrust it before Takeo's eyes.

"Takeo, you seem to think nothing of me because I'm a woman. Now, see if you can say that one more time in front of your father. Go ahead and say it. The tablets of all our ancestors are looking down at you. Say it again, you ingrate!"

Glaring at Takeo, she rapped her pipe repeatedly on the edge of the hibachi.

With the color rising in his face, Takeo said, "Why am I an ingrate?"

"Why? How dare you ask why? Someone who always sticks up for his wife and doesn't listen to his parents is an ingrate, isn't that so? Isn't an in-

grate someone who disregards the body his parents gave him, someone who destroys the lineage passed down to him through the generations. Takeo, you're an ingrate, a terrible ingrate."

"But, what about feelings—"

"Are you still talking about feelings and ethics? Is your wife more important than your parents? What a fool you are. Whenever you open your mouth, it's always 'my wife this, my wife that.' What about your parents? You're always talking about Nami, you ingrate. I'll disown you."

Takeo bit down on his lips and tried to hold back his tears. "Mother, that's going too far."

"Why is it going too far?"

"My feelings aren't so disrespectful. Don't my feelings reach you?"

"If that's the case, why don't I reach you? Why won't you divorce Nami?"

"But, that—"

"No, 'buts.' Now, Takeo, do you care more for your wife or for your parents? Well? Your family or your wife—? You fool."

The mother slammed her pipe on the hibachi. Its stem broke from the force and the bowl of the pipe flew through the air, ripping through the sliding doors. There was the sound of someone gasping on the other side of the sliding door, and then eventually a trembling voice: "Pardon—me."

"Who's there?" the mother asked. "What is it?"

"Pardon. A telegram . . ."

The sliding door opened. Takeo took and read the telegram and the servant quickly departed, shrinking at the glare she received from her mistress. In this two-minute interval, the heated emotions between mother and son cooled somewhat, and for a while they looked at each other silently. The rain again fell in a torrent.

The mother finally opened her mouth to speak. Anger still flashed in her eyes, but her words were somehow softer. "Please listen, Take. When I say this, I'm not trying to harm you. You're all I have. All I hope for is to see you succeed and then to hold a healthy grandchild in my arms."

Takeo, who had been silently lost in thought, raised his head. Gesturing toward the telegram, he said, "Mother, as you can see, they've moved up our departure. At the very latest, I've got to be on board the ship tomorrow. I'll be back in about a month. I beg you, please don't talk to anyone about what we discussed tonight. No matter what happens, please wait until I return."

The next day, Takeo again extracted a promise from his mother. He then visited Namiko's physician to implore him to take care of his wife and left for Zushi on the afternoon train.

By the time he got off the train, the sun had already fallen and a sliver of moon hung in a faded purple sky. He crossed a stream in the fields and

walked along a sandy path that disappeared into a dark grove of pines. Just as he saw the well outlined against the evening sky, he heard the unexpected sound of a tune being softly plucked. "She's playing the koto. . . ." He felt a wrenching in his heart as he stood for a while at the gate and wiped away his tears. Namiko, feeling a little better today, had taken out her long-forgotten koto to play as she waited for her husband.

When Namiko saw him and asked why he was pale, Takeo covered things up by saying he had stayed up late the night before. Namiko had waited to eat dinner because her husband had promised to come, but when they sat across from each other neither had much of an appetite. Hiding her despair behind a lonely smile, Namiko reattached a loose button on her husband's coat, which she brushed with care.

Soon, the hour for the last train drew near. As Takeo stood up, reluctantly Namiko clung to his hand. "Dear, do you have to go so soon?"

He grasped her hand and said, "I'll be back soon. Nami, take care of yourself and get well by the time I come back."

At the front door, Namiko's old nursemaid, Iku, had laid out his shoes. Mohei, the manservant who was to accompany him to the station, had Takeo's valise in his left hand and, though there was plenty of moonlight, a lantern in his right.

"Well, Granny, please take care of my wife.—Nami, I must be going."

"Please hurry home."

Takeo nodded and, stepping in the light of the manservant's lantern, took ten paces or so beyond the gate. He turned and saw Namiko wearing a white shawl around her shoulders and standing beside the gate with Iku. Waving a handkerchief, she called out, "Dear, please come home quickly."

"I'll come right home; Nami, you'll catch cold in the night air. Hurry inside."

When he turned to look a second time and a third, however, her white form was still vaguely visible in the darkness. Soon the path curved, and she could no longer be seen.

Only a voice filled with yearning followed him from behind, calling out three times, "Please hurry home."

When he turned, he saw a shard of the moon hanging coldly amid the pines.

TRANSLATED BY KEN K. ITO

Tangled Hair

YOSANO AKIKO

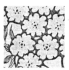 Yosano Akiko (1878–1942) was born during the second decade of the Meiji period, and like many young artists of her time, was buffeted and inspired by the many changes brought on by the Meiji Restoration. She first achieved fame—even notoriety—with the publication of her first volume of poetry in 1901. In this stunning volume, suggestively entitled *Tangled Hair* (*Midaregami*), she celebrated the sensuous pleasures of her own youthful body and the beauty of love and the natural world. For the expression of these topics, she did not choose the newly adopted Western-influenced free verse form but, rather, the centuries-old and even stultifying *waka* form, restricted by its five-seven-five-seven-seven scheme. Her remarkable synthesis of traditional form and modern content demonstrated new possibilities for classical poetry in the twentieth century.

The daughter of a middle-class shopkeeper, she secretly began to write poetry and publish it in the magazines of the local literary societies. Having falling in love with Yosano Tekkan, a well-known poet and editor who was still married to his third wife, she ran away from home in 1901 to join him. Although the couple married a few months later and began their long life together—during which Akiko would give birth to thirteen children and raise eleven to adulthood—Akiko retained her reputation as a rebel and independent thinker. Over the next four decades, she published volumes of poetry that presented her readers with frank expressions of her emotions. In numerous essays, she

Illustration from *Tangled Hair* (The Museum of Modern Japanese Literature)

offered equally frank opinions on social, political, educational, and literary matters.

During her lifetime, Akiko revealed herself to be a woman of enormous contradictions. She was a soft-spoken woman who could be so bold as to seem foolhardy and so frank as to be shocking. She was a forceful advocate for women's independence although she had a long and seemingly successful marriage to a man known for his difficult and domineering personality. She was a woman who raised a large family while also producing an astonishing quantity of poetry and prose: more than fifty thousand poems, as well as short stories, plays, a novel, children's literature, textbooks, translations of classical literature into modern Japanese, literary criticism, and wide-ranging essays on social issues. She was a highly original poet who made her mark by revitalizing one of the oldest and most tradition-bound forms of Japanese poetic expression, the *waka*.

By the Meiji period, the *waka* form had become hackneyed, with poets repeating again and again the same expressions and reiterating the same emotional responses to nature and human relationships. Akiko criticized poets who employed old-fashioned language and lacked true feelings and new ways of expressing them. She believed a poet should reveal "actual feelings" (*jikkan*), as discovered by individuals for themselves. Akiko's insistence on individuality ("a work of art is an image of the self") made her the harbinger of a new, modern way of thinking; and it is this quality that inspired a generation of poets who looked to her for guidance.

Illustration from *Tangled Hair* (The Museum of Modern Japanese Literature)

Especially influential were the 399 poems of *Tangled Hair*. Vividly descriptive, they express the honest and intense emotions of a young girl coming of age, falling in love, and celebrating the world around her. The highly personal imagery of her poems and Akiko's willingness to write boldly and openly about sensuality and the body were shocking to many, but they brought *waka* back to life and made it clear that this classical form could be the vehicle for twentieth-century poetic expression.

Akiko herself thought *waka* was a superior literary form. Yet she is also known for the many powerful "new-style" poems (*shintaishi*) she produced, many of them on social and political topics. In 1904, during the peak of the chauvinistic fervor occasioned by the Russo-Japanese War, she published "My Brother, You Must Not Die" in the new style. Her cry for her younger brother, who had recently been conscripted, was considered critical of the government and of the emperor himself, as it included such lines as, "Whether the fortress at Port Arthur falls / or not—what does it matter?" and "My brother, you must not die / Let the Emperor himself go / off to war." The publication led to a denouncement of Akiko as a traitor, and her pacifist outpouring probably cost her eventual membership in the prestigious Society of Literary Artists, which was founded by the Ministry of Education in 1912.

In the early twentieth century, as various small groups of Japanese women coalesced and dissolved under pressure from an increasingly repressive and militaristic government, Akiko's literary reputation and her influential literary and social criticism won her the role of elder

Illustration from *Tangled Hair* (The Museum of Modern Japanese Literature)

stateswoman. Her poetry came to seem prophetic of a new era. The editors of a new woman's journal, *Bluestocking,* sought a contribution from Akiko for their first issue, which appeared in 1908. For them, Akiko provided a series of poems, "Verses in Idle Moments" (*Sozorogoto*), using the first poem, "The Day the Mountains Move," to introduce the metaphor of a rumbling volcano, long dormant, for the awakening power of women. The poem has since become a hallmark of international feminism, and the metaphor a catchphrase for the movement.

The following poems are representative of the *waka* in *Tangled Hair.* In some, a young girl celebrates the comely beauties of her own body; in others, she revels in the colors of the world around her. In still others, she obliquely criticizes the traditional morality of Buddhism and celebrates the freedom to act on one's individual emotions and desires. Her poems were praised for the freshness of their language, the boldness of their imagery, and for their creative passion. But, as mentioned, Akiko's open expressions of romantic passion and youthful narcissism also attracted criticism. One reviewer even called her poems "immoral words that belong in the mouths of whores and streetwalkers." Despite such criticism, *Tangled Hair* proved to be a literary sensation and established Akiko not only as one of the leading poets of the Meiji era but also as an important figure in the centuries-long tradition of Japanese poetry.

⌒(**LRR**)⌒

Illustration from *Tangled Hair* (The Museum of Modern Japanese Literature)

Within the curtain
of the night she whispered
her fill—a star now
fallen to the world below,
a mortal with tangled hair.

Ask of poetry:
who would reject the red one
among the flowers in the fields.
How appealing is that charm—
 sinful child of spring. . . .

My five-foot tresses
unbound, softly melt and drift
across the waters,
yet I'll not set free
the secrets of a maiden's heart

My blood's on fire
in this inn of a dream
of a single night.
Do not scorn the gift of gods,
you who travel through spring.

The camellias, they too,
and the blossoms of the plum—
white, pure white, were they.
But in the color of the peach
I see no reproach for my sins.

Heavy hair unbound,
the fragrance of the lily
in the room of love
so soon to disappear
pale pink color of the night

You've never even
tried to touch the warm tide of blood
that flows beneath this
soft skin. Is your life not lonely,
you who preach the Way?

Spring day turns to dusk
without sending him back to me.
Dark evening feelings—
scattered upon the koto,
strands of tangled tangled hair.

Head pillowed on
my arm I slept. A strand of
hair caught and snapped,
and I heard a koto plucked
in my dream of a spring night

Taking the waters
at the bottom of the spring
shimmers a white lily.
So lovely do I seem this
summer of my twentieth year.

Do not burden these
lovely lips—layered like
the crimson petals of
a rose—with a poem that
lacks the fragrance of a soul.

Sweet breezes that
come in the darkness
of a spring night—
for just a little while
leave her hair unruffled.

Maiden of madness—
those wings of flickering flame
were light to bear,
on my feverish journey of
one hundred thirty leagues.

When now I look back
upon the road I've traveled,
my ardent passion
was like a blind man's
fearlessness in the dark.

Lie down and rest,
I said, and left the room
that soft spring evening.
His robe hung from the rack.
I wrapped it around me.

Holding my full breasts,
silently I kicked aside
that curtain of
mystery. Deep crimson is
the flower that blooms here.

 Taking the waters,
I rise from the bubbling spring.
How cruel to bring
together this soft skin and
garments of the world of man.

"In my loneliness
I have come to you, recklessly,
these hundred twenty leagues."
If a man said this to me,
ah, what would happen then?

The rowboat is late
this evening, carrying back
that young monk I love.
Was it those red lotuses that kept him?
Was it all the white lotus blossoms?

Fresh from the bath,
perfecting her toilette,
smiling at her image
in the full-length mirror. I too
once knew such feelings.

Taking up a scrap
from the piles of waste paper
scribbled over
with curse poems, I trap
a black butterfly.

A keepsake it is,
its cooling breeze precious,
this small folding fan.
Now the pivot has worn thin,
become achingly fragile.

As I recite again
and again the poem he wrote,
evening approaches.
In the autumn rain, cold
is the pillar against my back.

Small lilies open
amidst the soft grasses where
I wait for my love.
Brightening the distant meadows
a rainbow takes shape.

Wonderingly
I brushed my youthful lips
against them—
so frigid were they, those
dewdrops on the white lotus.

As I reached to pluck
white blossoms of waterweeds,
the chilly waters
from the mountains drenched my thin
sleeve—and the letter hidden there.

Once again cast
into confusion, seeing someone
who resembles him—
always toying with my feelings,
you cruel gods of love!

From the wings of
passing swallows drops of
spring rain fall.
Shall I gather these to smooth
my tangled morning hair?

In the depths
of the heart I hide
you will see
fragments of the golden clouds
of an evening in spring.

The crystalline waters
that flowed over my breast
have become sullied.
Now you are a child of sin.
I too am a child of sin.

Breaking off wild roses
to decorate my hair,
making bouquets,
all the day long I linger
in the meadow, yearning for you.

Just last year taken
from us. Calling my sister's name,
he stands this evening
at the door of their house.
How I grieve for him!

Invited by love,
when I try to cling he
brushes my hand away.
The scent of his clothing,
the tenderness of darkness.

Hand raised to strike
my sweet tormenter, I pause,
sleeve fluttering
delicately about me.
What dance shall I dance tonight?

Spring is short.
What is there in life that
does not decay?
I let him caress
these strong young breasts.

Yesterday now seems
a world a thousand years
ago . . . or more.
But your hands on my shoulders,
ah, those I can still feel!

I wouldn't call it love,
but in those sweet dreams I had
there were visions—
one was a poet
and one was a painter.

When the god of doubt and
the god of disbelief came upon me,
suddenly the world changed:
my spring became a spring
where flowers have no hue.

To punish men—
those men of many sins—
was I created
with skin clear and pure,
with black hair hanging long.

TRANSLATED BY LAUREL R. RODD

At Yushima Shrine

A SCENE FROM THE PLAY *A WOMAN'S PEDIGREE*

IZUMI KYŌKA

 Izumi Kyōka (1873–1939) published *A Woman's Pedigree* (*Onna Keizu*) in installments in the newspaper *Yamato Shinbun* from January to April 1907. The novel was such a success that a stage version soon followed, in October of the same year at the Shintomiza Theater, dramatized by Yanagawa Shun'yō (1877–1918), another Schoolmate Society member.

The scene translated here was neither in the original novel nor in its first stage version, but was expressly written by Kyōka for a later production

at the Meijiza Theater in April 1913, featuring two stars of New Wave the-
ater (*shinpa*), Ii Yōhō (1871–1932), in the role of Hayase, and the *onnagata*
Kawai Takeo (1877–1942), as Otsuta. The New Wave theater, Japan's first
overture toward a modern theater, still retained many elements from kabuki,
including the *onnagata* and incidental music like the *kiyomoto* style of ballad
featured in this play. For a generation, New Wave theater rivaled kabuki for
popularity, and Kyōka's novels provided much of its best material. *At
Yushima Shrine*, along with *Waterfall Shiraito* (*Taki no Shiraito*, 1895), the
stage version of one of Kyōka's first successes, *Noble Blood, Heroic Blood*
(*Giketsu Kyōketsu*, 1894), and Kyōka's own dramatization of his 1913 novel
Nihonbashi, remain New Wave staples. Kyōka would go on to write more
than a dozen original plays and several other adaptations of his own fiction,
especially during the Taishō era, a time when many novelists tried their hand
at drama. Unlike the New Wave adaptations of Kyōka's fiction, however, most
of Kyōka's own plays—works like *Demon Pond* (*Yashagaike*, 1913), *The Sea
God's Villa* (*Kaijin Bessō*, 1913), and *The Castle Tower*—were more character-
istic of his supernatural fiction. A far cry from the sweet, tragic sentimentalism
of the New Wave melodramas, most of these plays, which often feature spirits
and witches in love with humans, were not performed in Kyōka's lifetime, but
since the 1960s have come to be hailed by many of Japan's avant-garde.
Mishima Yukio (1925–1970) praised Kyōka's original drama, and others
like Terayama Shūji (1935–1983), Kara Jūrō (b. 1940), Ninagawa Yukio
(b. 1935), and Miyagi Satoshi (b. 1959) have adapted, staged, or filmed
versions of these plays. The kabuki *onnagata* Bandō Tamasaburō V (b. 1950)
is a great champion of Kyōka's work, starring in and directing both the fanta-
sies and the older-fashioned melodramas.

A complex melodrama with a revenge plot worthy of kabuki, *A Woman's
Pedigree* appealed to most readers and audiences because of the tragic ro-
mance of two key characters, Hayase Chikara and Otsuta. Hayase, a transla-
tor of German for the Japanese army's General Staff Office, lost his job when
his past as a pickpocket was made public. But it is his relationship with the
geisha Otsuta that his mentor, Sakai Shunzō, most disapproves of. Sakai gives
Hayase an ultimatum: leave the girl or him. The plot is complicated by a
number of other twists, some of which are alluded to in the scene: there is a
suggestion that Sakai had wanted Hayase to marry his daughter Taeko, who
is in fact the illegitimate child of Sakai's own affair with the geisha Oyoshi.
Another man, Kōno Eikichi, also seeks Taeko's hand. Hayase resents Eikichi
and his whole family, regarding them as blatantly hypocritical in their pry-
ing into Taeko's "pedigree." In fact, Hayase has learned from the fishmonger
Me no Sōsuke (called "Menosō" here) that Eikichi's mother Tomiko her-
self had a child out of wedlock from a fling with a stableman. The work is a

paean to romantic love and an indictment of Japan's old marriage system, which traded in women's flesh and reputations.

Otsuta's frequent references to the moon are a veiled declaration of her affection for Hayase. Bathed in moonlight, the scene presented here depicts the lovers' final parting. (Otsuta later dies in the arms of Hayase's remorseful mentor.) Otsuta buys what the translator here calls a "pillow" (*magekata*, unfortunately known as a "rat" in English), an accessory inserted into her hair to create a *marumage*—the style distinctive of a married woman—a gesture of devotion to Hayase, and of her desire for respectability and stability. What she does not yet know, however, is that this will be their last night together.

Their clandestine love clearly mirrors Kyōka's own love for Itō Suzu, a geisha he had met at a New Year's party held by the Schoolmate Society in 1899. Kyōka's own mentor Ozaki Kōyō adamantly disapproved of their affair, probably because he wanted Kyōka to marry someone more respectable, and, with the support of his own mistress (another geisha, Oen), Kōyō demanded that the two break up. Kyōka was not able to marry Suzu until after his mentor's death in 1903.

The tragic lyricism of this scene is accentuated by the use of a *kiyomoto* ballad taken from Mokuami's kabuki play *Cherry Blossoms Are Clouds over Ueno Hills* (*Kumo ni Magou Ueno no Hatsuharu*, 1874, commonly known as "Kōchiyama"). Audiences who heard this ballad in Kyōka's play would have immediately recalled the scene in Mokuami's, which portrays the thief Naojirō's parting from his beloved geisha, Michitose.

⁀(MCP)⁀

Characters

HAYASE CHIKARA, *a young translator of German*

OTSUTA, *a geisha*

TWO MINSTRELS

KIYOMOTO *musical accompaniment*

KIYOMOTO:

SET TO MUSIC: The rain that falls in early spring, so cold and clear

It turns to snow when eve draws near.

(Enter two MINSTRELS, men whose profession it is to mimic kabuki actors.)

The peals of the bells of Ueno

Chill streams trailing down

Till they join the Tagawa in Iriya Town.

(The MINSTRELS stop in front of a restaurant, singing at their pleasure, then leave.)

It's a thin path to the pleasure quarters,

A slender thread, white on left and right.

(Enter HAYASE CHIKARA and OTSUTA, crossing paths with the MINSTRELS.)

They linger, shy of others' eyes,

Lucky no one else is passing by.

(HAYASE and OTSUTA stop as the MINSTRELS exit.)

OTSUTA: Dear! . . . Dear . . .

HAYASE: Ah! *(Surprised.)*

OTSUTA: The moon is lovely.

HAYASE: Is it now?

OTSUTA: Look! What a scene!

HAYASE: Why, so it is.

OTSUTA: What's the matter with you? It's as if you wouldn't have noticed till I told you.

HAYASE: Indeed, something's the matter. The moon may be bright, but my heart is dark.

OTSUTA: So's all the world, but it's no matter to us. We're ones who have to hide in the shadows.

HAYASE: (*Stiffly.*) Otsuta.

OTSUTA: Yes?

HAYASE: I know it's late to ask for your forgiveness.

OTSUTA: Why so reserved, all of a sudden? . . . We resigned ourselves to this life, didn't we? We're husband and wife, though secretly. Actually, I enjoy hardship. What do we care if there's a moon or if it's snowing? (*Looks around.*) Why don't we go take a look at the plum blossoms? . . . No one's around. Here, sit down. (*Lays her hand lightly on his shoulder.*)

KIYOMOTO: SET TO MUSIC: As they come to that familiar gate . . .

(*Held back, HAYASE sits down on the bench.*)

OTSUTA: (*Sitting next to him, happily lays her hands on her lap.*) Aren't you impressed? Don't I look like a real woman? I too have given up my profession.

KIYOMOTO: SET TO MUSIC: The clappers rattle loudly in the wind.

(*Whereupon, the sound of two or three worshippers is heard clapping their hands in prayer at the shrine.*)

OTSUTA: (*Pulling away.*) But don't you think it strange?

HAYASE: What? The moonlight?

OTSUTA: Our love may be hidden, but we share a house. So what if our roof leaks? The moon too spies in on us. No, the moonlight's not a mystery. What's stranger is your coming here with me tonight.

HAYASE: Why, I suppose it is. The world's full of mysteries.

OTSUTA: I do hope it doesn't start to snow all of a sudden.

HAYASE: (*Warily.*) Why?

OTSUTA: You've never taken me out before. It's strange enough to make it snow. (HAYASE *says nothing.*) You know, dear, I feel as if my deceased parents' love for me has possessed you. . . . The moon's out tonight, but earlier this afternoon, when you were gone, it went all dark, just the right kind of weather for someone like me, who cannot go out in broad daylight. So I visited my mother's grave. . . . It was the first time since we moved to Iidamachi. From the grave I heard my mother say to me, "Lucky girl you are, Otsuta, to have the prayers of your life answered, become a respectable woman, and make such a handsome catch!" And she wished you well. You seem heartless, but you're loving; you leave me to my own devices, but you do take care of me.

HAYASE: Otsuta.

OTSUTA: "But try to take her out every once in a while. Ever since she became your wife, she's lost her mettle and gone all soft, like some helpless country girl who only wants to cling to her man. And as for Edo, Hongō is so exotic a place she can't help but want to go there."—So said my mother. . . . You've been so depressed these past few days that I told you go pray to Tenjin, since the God of scholars is your patron spirit. I begged you to take me with you, though I knew you shouldn't, and you were kind enough to do so. How happy my mother is for us, lying there under the grass!

HAYASE: Please forgive me. Since last night, the night before last, really, I've thought it a sin to be so falsely praised, to be the cause of so much happiness. (*Sighs.*)

OTSUTA: So faint of heart you are! Having your name in the papers as an accomplice to a pickpocket. . . . Didn't you resign from your official duties because of that? I said nothing because if I had, it would seem as though it was the loss of your salary that irked me. So that's why you've been so unhappy. And where was the wrong in helping out even a pickpocket? It was manly of you. You couldn't just stand by and watch him getting kicked and beaten like that! Were I still in Yanagibashi I'd have come to the rescue too. If that's a sin, then the world can go to hell. Who cares about your job anyway? My mother said that, too, from her grave. "Otsuta will happily put up with any hardship, so no need to worry about money," she said.

HAYASE: I'm much obliged. You don't know how happy that makes me.

OTSUTA: What kind of man would go on thanking his wife like that? There really is something the matter with you.

HAYASE: Silly—It's not you I'm thanking, it's your mother. You thought I was worried about supporting ourselves from here on.

OTSUTA: Then why so low?

HAYASE: Nothing special. But look at the moon! Sometimes it's hidden in the clouds. We're only human, no stars are we, so soon to return to the dark! . . . But it's selfish of us to be praying for domestic bliss, trying to get in the gods' good graces when we've been remiss in our prayers. A sin to complain in these holy precincts! . . . Well, now, surely it's time to head home. (*Stands.*)

OTSUTA: (*Drawing close to him.*) Ah, wait a moment.

HAYASE: What is it?

OTSUTA: Well, I was born in the year of the Snake, so Benten is my deity. . . . To have come this far and not pay my respects would be wrong, so please wait here while I go down the stairs to pray to her.

HAYASE: Why, of course. And since you're going that way anyway— pardon how I take advantage of our shrine visit—wouldn't you like to go to Shinobazu Pond, too? Come with me.

OTSUTA: Why, you are acting strange! Inviting me to join you! (*Looks at him.*) Strange, but not unpleasant, so I'm happy. But it wouldn't look good for us to go together to Benten. Besides, there's something I want to buy and I don't want you to know about it.

HAYASE: As you please, then.

OTSUTA: You're much too sweet. It bothers me. Perhaps I should forget about it. . . . Maybe I won't go after all.

HAYASE: Why? Neglect your other duties, but never matters of faith.

OTSUTA: But you look so lonely! I can't help but feel as if something awful is going to happen.

HAYASE: Don't be a fool. I'll vanquish any misfortune that comes our way.

OTSUTA: Bravo! That's my man!

HAYASE: This is no teahouse! Don't you know where you are?

OTSUTA: Do you know how long it's been since you've scolded me? I'm delighted! But (*worried again*) your voice lacks conviction.

HAYASE: Hurry up and go.

OTSUTA: Yes, sir. You are trying to get rid of me! Let me leave you the coat you took off. You'll catch your death with the night dew if you don't put it back on.

KIYOMOTO: SET TO MUSIC: As if on a whim, she heads inside the gate.

OTSUTA: (*Clapping her hands.*) Lord Tenjin, Lord Tenjin!

HAYASE: Hardly through the gate and she's hailing the God. How rude!

OTSUTA: (*Not responding.*) Please protect my husband.

(*HAYASE weeps.*)

OTSUTA: (*Begins to leave.*) Please watch out for me, dear, till I've gone all the way down the stairs. I'm frightened.

HAYASE: Coward! You've certainly no right to call me one. Is there a girl in Shitaya or Ueno who's too scared to go out on her own?

OTSUTA: When I was a geisha I could stare down demons, but now even blind men frighten me.

HAYASE: All right, then. I'll keep my eyes wide open for any trouble. You'll be fine. Go on now.

OTSUTA: Yes, sir.

KIYOMOTO: SET TO MUSIC: Their hearts are locked as one . . .

(*HAYASE watches her go.*)

KIYOMOTO:

SET TO MUSIC: A heart that must hide from everyone,

Deep indoors on days of sun,

Michitose delights to hear the news.

(*HAYASE, arms folded, looks lost in thought. By the end of the song, OTSUTA hurries back.*)

OTSUTA: (*From behind.*) I'm back, young man.

HAYASE: Ah.

OTSUTA: I . . . This way.

HAYASE: You were fast.

OTSUTA: No, I've kept you waiting. . . . Something troubled me, so I hurried. Come, show me your face, dear. (*Claps her eyes on his downcast look.*) Ah! (*Happily.*) It's like we haven't seen each other in ages. (*Gazes more closely.*) What's the matter? You really do look like something's bothering you.—I'm so happy you were good enough to come out with me, but I'm afraid of doing something outrageous. We may be fine while we are near Lord Tenjin, but on our way out of here we may yield to temptation.—Let's hurry and catch the train home instead.

HAYASE: You seem in a hurry, my love, but you really ought to rest a while here.

OTSUTA: I've rested enough, thank you!

HAYASE: Did you go pray?

OTSUTA: Yes, from the corner at Nakachō. (*Clasping her hands together.*) My hands in prayer.

HAYASE: And what did you pray for?

OTSUTA: You shouldn't ask.

HAYASE: But I want to know!

OTSUTA: Then I'll tell you. You have no parents, so your master is your father. I prayed first of all to the man to whom you owe your life, your mentor in Masago-chō, and to his wife, for their health and goodwill. And I prayed that their adorable daughter would never have to marry that Mr. Kōno.

HAYASE: And then?

OTSUTA: Then?

HAYASE: Then what?

OTSUTA: Why, you already know the answer to that! (*Laughs.*)

HAYASE: (*Also laughs, sadly.*) Hah, hah, hah. And then you went shopping. So, what did you buy?

OTSUTA: (*Smiling innocently.*) Something nice. . . . But not anything you'd like. Still, I won't let you get away with not liking it. Something a bit frivolous, something happy but also hateful. A bit embarrassing, too.

HAYASE: What? Tell me!

OTSUTA: Oh, I forgot. . . . You were waiting for me to get you a treat, little boy. I should have picked up something for you. . . . Forgive me! You're a good boy.

HAYASE: Yes, yes. Just tell me what you bought!

OTSUTA: Shall I show you? Are you sure that you're not going to scold me?

(*HAYASE is silent.*)

OTSUTA: I don't care if you scold me, 'cause I bought it already. (*Takes something wrapped in paper out of her kerchief.*) A "pillow" for a *marumage.* The shop in Nakachō is famous for these.

HAYASE: A pillow for your hair? Otsuta. (*Unconsciously lays his hand on the package.*) You'd have been better off buying my mortuary tablet.

OTSUTA: Mortuary tablet? Why, we already have two, one for your mother and the other for your father. Though they may not like it, I say a prayer to them every morning and evening, as any proper wife should do.

HAYASE: I'm a branch that fell off the tree. . . . My parents won their posthumous names thanks only to their dutiful daughter-in-law. After all, I'd been disowned. . . . My dear, you are all anyone could ever be for my mom and dad.—Those tablets are tablets in memory of me—.

OTSUTA: What?

HAYASE: Otsuta, please listen, like you were listening to a dead man, to what I have to tell you now. (*Hearing this,* OTSUTA *immediately puts her hands to her ears.*) Please, sit down again. (OTSUTA *remains silent, shaking her head.*) Here now. Please, sit down again.

OTSUTA: (*Without a word she shakes her head.*)

(*HAYASE lays his hand on her bosom and presses, then suddenly withdraws his hand as if from a flame.*)

HAYASE: Why, just saying I was dead makes you tremble, your heart beating like a bird's! It's as if you'd been struck by lightning! . . . Poor thing! . . . I wish we could run off and go on a pilgrimage. . . . Ah, but I promised the master!—Oh, this is a fine mess! What am I to do? (*Slumps down on the bench as if collapsing.*)

OTSUTA: Tell me! Tell me! My body's racked with fear. (*Speaking softly.*) Hurry, please tell me what it is.

HAYASE: Hear me out, but as if I were dead.

OTSUTA: No! (*Again, violently claps her hands to her ears.*) I don't know what you mean to tell me, but these past few days I've feared the look on your face more than any lightning.

HAYASE: (*Rests his hand on her shoulder.*) You're really shaking like a leaf.

OTSUTA: No matter how hard I'm shaking, how weak I am, if you told me to die for you I'd happily comply. But never so long as I live will I stand here and let you tell me you're dead.

HAYASE: Ah, I won't die, and I certainly won't kill you. But do hear me out.

OTSUTA: All right, then, but close your eyes. They scare me.

HAYASE: Otsuta. (OTSUTA *says nothing.*) I want you to leave me.

OTSUTA: What!

HAYASE: Leave me. Have done with me.

OTSUTA: Hayase-san. (HAYASE *is silent.*) Is this a joke? No, I see it's not.

HAYASE: How could I ever joke around about anything like that? I wish it were all a dream!

KIYOMOTO:

SET TO MUSIC: And then, the two are left alone! Michitose wipes her tears,

Looks up at him with regret and fear.

OTSUTA: You're in earnest.

HAYASE: I'm so sorry.

OTSUTA: Leave me, break up with me—that's what you say to a geisha. . . . I'd sooner have you tell me to die. Tell your Otsuta to wither away! (*She stands bolt upright, her back to his.*)

HAYASE: Otsuta, don't think I have no feelings for you.

OTSUTA: I don't think you're unfeeling.

HAYASE: I'll always love you. I promise!

OTSUTA: Do you think I could bear it if you tired of me?

HAYASE: Look at me. Please, hear me out. I'll tell you what's been troubling me so much these past couple of days that you've worried about the way I look. I kept thinking, I'll tell you now, now's the time, but every morning there you were, making broth for the soup, and every night, long after I'd gone to bed, you were still up sewing by the light of the lamp. I watched you, worriedly puffing on your pipe, thinking about what to make for dinner, or heading off with a sieve to buy some tofu, or offering tea to my parents' memorial tablets, hands in prayer, and I'd sooner have my throat slit, or my lips ripped off, or be knifed in the chest, than ask you to leave me. Yesterday and today, every time I heard you utter something kind or delightful or endearing I sweated blood, feeling that if I were to come out and tell you what was on my mind, it'd be like stabbing an innocent, blameless creature in the back, and smashing it to pieces! Please try to imagine how hard it's been for me to speak like this! Please understand how much this hurts me! Accept this as our fate and agree to break up with me, I beg you. . . . If you keep on sulking like this, do you think I could survive under the same sky?

OTSUTA: I'd sooner have you tell me to die than leave or break up with you. If you asked me to die I'd happily say yes. My life isn't so precious to me.

HAYASE: In that case, you must know there's someone whose life is more precious than yours, or mine, or both our lives rolled up together. If what you said before—that he was the first one you prayed for to the gods and buddhas—if that was no lie, then you'd know what I mean. He was the one who commanded me.

OTSUTA: (Collapses as if wilting.) Then, this is not your wish, but (vacantly) your mentor's bidding?

HAYASE: (Writhing.) I'd sooner die but I can't.

(OTSUTA bursts into tears and clings to HAYASE.)

KIYOMOTO:

SET TO MUSIC: One day apart is a thousand without love,

No needles or medicine could heal or move

This heart more than these pillow-soaked tears

That drown our dreams:

Mirror of true love, these feelings.

(*HAYASE rises from the bench, OTSUTA following him, clinging. Gazing up at the moon with tear-filled eyes, the two slowly circle the bench. OTSUTA drops first to the bench and clutches the still standing HAYASE's sleeve.*)

OTSUTA: I can't endure this! Is it true, must it be, that we'll never be together again? Are my tears, my entreaties worth nothing?

HAYASE: Professor Sakai gave me an ultimatum in the formal guest room at the Kashiwaya. Koyoshi turned pale and tried her best to appease him, but, in words that drove a stake into my heart, the professor replied, "You can weep and wail all you like and drop dead for all I care, but this is an order!" We had no more to say, all Koyoshi and I could do was collapse in tears on the tatami.

OTSUTA: (*Furious.*) Drop dead, he said, did he? Well, then, I'll bet you he doesn't believe she would. . . . That know-it-all would stake Koyoshi's life on it, would he? Cold fish, he doesn't know what a true geisha is! I'll show him, then! I'll die! Otsuta from Yanagibashi will give up her life for her man!

HAYASE: Don't be ridiculous! What good will it do for you to get all riled up like that? You think your bravado is enough to shield me against my mentor? I won't let you. Stop! Hush now, I tell you, and listen to me!—Yes, it was the professor who said he couldn't give a damn if we died, but the one who said he'd break up with you, have no more to do with you . . . that was me. What do you have to say about that?

OTSUTA: What could I say? How could you ever ask me? If you loved me, if your love was true, even if you couldn't stand up to your mentor when he said that, why didn't you tell him how I felt?

HAYASE: I did! I told him, even if it made me sick to say it. Koyoshi couldn't sit by and stay silent, either—she spoke on your behalf with such

passion it embarrassed me—but we'd run out of arguments. It's either the woman, or me—make up your mind! I had no comeback for that. Those words cut me to the quick. There was no answer I could give to that—not then, not till even hell freezes over.

OTSUTA: (*Pausing.*) Ah, I see. So, then, you told him you'd leave the woman.

HAYASE: Forgive me, please. I promised him.

OTSUTA: Well said—most manly of you. You made your wife happy. . . . So saying, you've proved yourself to be a man, Hayase-san.

HAYASE: Only you know if I'm man enough or not. You understand, then.

OTATSU: There's no reason why I shouldn't.

HAYASE: You'll break up with me, then.

OTSUTA: Yes, but . . . Hayase-san, my sweet Hayase-san . . . won't you regret it even more if I do?

HAYASE: There you go again! Don't be so impossible.

OTSUTA: Which of us has been more impossible, I wonder.

HAYASE: So, after all I've said to explain the situation, you still won't listen to reason?

OTSUTA: No.

HAYASE: Promise you'll make a clean break with me.

(*OTSUTA is silent.*)

HAYASE: (*Impatiently.*) Otsuta!

OTSUTA: I'll say it. (*Sobbing.*) But before I say I'll break up with you, I want to see your face again, just once, as your wife. (*Clinging to his breast, she looks up at him.*)

KIYOMOTO:

SET TO MUSIC: More pale and wan her face has gone

Each time she gazes upon him,

If I cannot live, I can't go on,

Then I beg you, kill me, she tells him.

OTSUTA: Is this good-bye, then? All right, I'll leave you.

HAYASE: (*Wiping away the tears, tries to take heart.*) Here's some money. . . . He gave it to me. Please accept it. (*Gives her the money.*)

OTSUTA: (*Taking it.*) A payoff, is it? (*Her arms droop in resignation.*) The professor gave you this, did he?

HAYASE: You still owe the teahouse some money, don't you? This should tide you over for a while, he said.

OTSUTA: (*Crestfallen, she accepts it reverently.*) In the heat of the moment I might have done something I'd regret. I'll accept it, grudgingly. (*She puts the money in her obi. Her eyes focus on the fallen package of the "pillow." Weeping, she picks it up and brushes off the sand.*) It seems heavier now than it was. I'd sooner throw it away, but that would seem spiteful.

HAYASE: What will you do?

OTSUTA: It's you I worry about. . . . Ogen's hardworking, so you'll make do for the time being. Because early cucumbers are coming to the market soon, I thought I'd start making pickles to hear your praises. . . . Ah, whatever I say now sounds like a complaint! By the way, you were always good at giving me orders, but could never bring yourself to tell the maid what to do. . . . Don't hold back, now, tell her her job, and make sure you're not in want for anything. . . . Mind you cover yourself well when you sleep. I bought some lilies and I've been blowing on the buds to make them bloom early. Don't forget to water them. . . . And . . .

HAYASE: (*Looking down, listening. Then, no longer able to go on.*) I'd be a poor excuse for a householder if you leave me.

OTSUTA: But why?

HAYASE: Not just that—do you think I could go on nonchalantly living there after being made out to be some kind of pickpocket, a felon, in the newspaper? I'm sloughing off that tenement and running away to Shizuoka. Besides, I've got some things to mull over, so I'm going to hide away for a while.

OTSUTA: So far! Shizuoka's the other side of Hakone, no? And I was in such a hurry to run back to you when you waited for me while I went down the steps, eager to see you again! (*Slumping over into her lap.*)

HAYASE: That's why I'm more worried about you, Otsuta. Even if you forget me, never leave Edo by yourself. To hear you ask if Shizuoka's farther than Hakone makes my heart bleed. . . . Ah, no mother, no father, nor brother or sister, no aunt or uncle to look after you! There was only me. If only you had a cousin, I wouldn't feel like I do now! . . . Otsuta! What will you do to get by?

OTSUTA: (*Raising her head.*) No need to worry about me. I'd rather you took more care over what you ate and drank. Since I was little I always loved dressing hair, and you know that since I left the teahouse I never asked anyone else to do up my hair. I did it in the ginkgo-leaf style, and I even managed a Shimada like Ogen's. Just for fun, I even did a "split-peach" for the waitresses. People praised me. Mrs. Menosō in Hatchōbori dresses hair for a living, so I can go apprentice myself to her.

HAYASE: An apprentice, you say.

OTSUTA: Yes, I'll train under her. . . . I'll die before you and to my end do other people's hair. I'll live like a nun who's shorn her own locks off. (*With her kerchief, she covers her hair like a cleaning lady.*) I'd so wanted to do my hair in a *marumage* for you, but this probably suits me better.

HAYASE: (*Pulling off the kerchief from her head, he stands.*) Let's go home. Together.

OTSUTA: (*Throwing his coat over his shoulders.*) You mean . . . it's all right if I come home with you tonight?

HAYASE: Now you understand, don't you, Otsuta? Were you ready to plod off all by yourself to Hatchōbori tonight?

OTSUTA: Yes, I was. . . . But if I can spend one more night with you, I can feed the sparrow one more time. She's ever so tame, coming right to the lattice window, the sweetest little thing. . . . It'll be hard to part with her.

HAYASE: Come now, tell me all your troubles on the way home. I won't interrupt.

OTSUTA: (*Hesitating.*) Take my hand.

KIYOMOTO:

SET TO MUSIC: So she says, but it's hard for a bird

Who makes her pillow on the billows

To leave the reedy Yoshiwara behind.

(*HAYASE takes her hand. OTSUTA and HAYASE both look longingly back, their heads reverently bowed. As they prepare to leave, OTSUTA suddenly breaks away.*)

HAYASE: Where are you going?

OTSUTA: I want us to walk on opposite sides of the street so that I can try to feel what it'll be like after we part. (HAYASE *nods. They stand to left and right on stage.*) But if I fall because I can't bear it any longer, will you run to catch me? (HAYASE *nods.*) We'll take the shortcut, right? Not that our love is cut short, but rather we part like a body cut in two.

(*HAYASE nods. OTSUTA trudges on sadly, then stops, pressing her hand to her bosom painfully. HAYASE abruptly turns toward her, concerned. They gaze at each other.*)

KIYOMOTO:

SET TO MUSIC: Verily the sadness of these cold hills

Would turn cold rain ever colder still,

Freezing rain to snow, the valleys filled.
(HAYASE and OTSUTA stand before the curtain as it closes.)

Full too my thoughts of love for you.

(HAYASE exits swiftly, OTSUTA quietly.)
—Curtain—

TRANSLATED BY M. CODY POULTON

PART

VII

The City Dreams of the Country

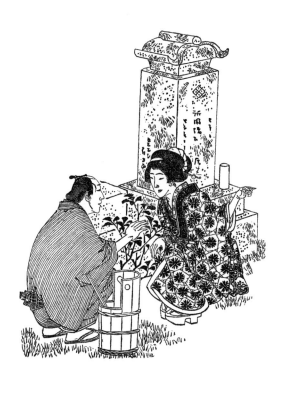

A True View of Kasane Precipice

NARRATED BY SAN'YŪTEI ENCHŌ

TRANSCRIBED BY KOAI EITARŌ

ILLUSTRATED BY TAISO ("TSUKIOKA") YOSHITOSHI (1839–1892)

 San'yūtei Enchō (1837–1900) is by far the best-known performer in the history of oral storytelling in Japan. Thanks to the devoted efforts of stenographers and newspaper journalists, most of his prolific production is available to us: at least forty-one novel-length works and a large number of short pieces are extant.

It was during the late Edo period when Enchō, a teenager, began his career as a narrator of comical *rakugo* and serialized *ninjōbanashi* stories. He adapted to Meiji urban culture remarkably, appealing to Tokyo's audiences, uptown as well as downtown, by modernizing old subjects and inventing new ones. His move to create his own stories is often attributed to the behavior of his jealous master, San'yūtei Enshō II (1806–1862), who would preempt Enchō's presentation of a prepared story by telling it just before it was Enchō's turn to appear on stage. Focusing on serialized stories of inspiring biographies and scandalous crimes, often filled with vengeful ghosts, Enchō eventually abandoned sound effects and elaborate gestures. By maintaining close associations with intellectuals, he kept himself abreast of socially relevant topics, reflecting their concerns in his work. At the same time, ever

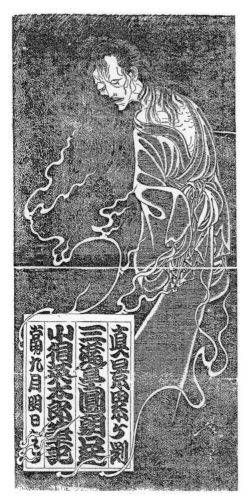

Toyoshiga's Ghost in the announcement of the publication of the series. Image by Tsukioka Yoshitoshi, *Yamato Shinbun Newspaper,* September 8, 1888. Photograph by Kazuya Oya. (Mita Media Center, Keio University Library)

conscious of popular taste, he kept himself from being a banner-bearer for any highbrow Enlightenment ideology. If he praised a Western person in a story, for example, the praise was based on old-fashioned Edo-style ethics and sentiment. If he presented the modern and educated view of ghosts and monsters as symptoms of nervous disorders, he also sided with the downtown audiences' belief and fear of supernatural beings. All incidents were explainable either as the influence of nerves or the power of a curse, and entire storylines were built on cause-and-effect probability as well as mystically karmic ties. The tension caused by this type of innovative ambiguity, coupled with Enchō's skillful narration, made each moment of crime and revenge shockingly real.

A True View of Kasane Precipice (*Shinkei Kasanegafuchi,* performed 1873), an improved version of a youthful composition, is Enchō's first ghost story free of stagy effects. At the age of twenty-one, Enchō had composed *The Latter Day Ghost Story of Kasane Precipice* (*Kasanegafuchi Gonichi no Kaidan*), basing his story on the legend of Kasane, a woman who turns into a vengeful ghost after her husband, Yoemon, brutally kills her. Seeking to avenge herself, she brings death to every woman Yoemon later marries. The story had been presented in a popular tale (*kanazōshi*) in 1690, in a *jōruri* puppet play in 1790, and, more contemporaneously to Enchō, in Kyokutei Bakin's historical novel (*yomihon*) *A New Story of Kasane's Redemption* (*Shin Kasane Gedatsu*

Monotagari, 1807) and Tsuruya Nanboku's dance play, *Snatching a Pea in a Pod* (*Iromoyō Chotto Karimame,* 1823), among others. Enchō took advantage of the popularity of the legend generated by his predecessors, but he did not limit his borrowings from them to their stories of Kasane. The theme of the journey, the intricate plot structure, and the complex human relations that neatly tie together the end of Enchō's revised version of the tale are obviously modeled on Bakin's long-running best seller, *The Tale of the Eight Dog Warriors of the Satomi Clan* (*Nansō Satomi Hakken Den,*1814– 1842). The dramatic force of evil, bloody crime, merciless revenge, and supernatural phenomena in Nanboku's plays also find echoes in Enchō's story: Shinkichi's cruelty to his wife and child in *A True View* is borrowed unapologetically from a brutal domestic scene in Nanboku's kabuki play *Epic Yotsuya Ghost Tale* (*Tōkaidō Yotsuya Kaidan,* 1825).

Performed twenty years after his first version of the Kasane story, or five years into the Meiji period, *A True View* marked Enchō's venture into more modern storytelling. Converting to straight narration without stagy gimmicks, and clearly separating his work from kabuki, he created something more like a novel. The persistent presence of the sickle, which appeared as murder weapon in the preceding Kasane works, serves in Enchō's version as both scientific evidence and a symbol of karmic retribution, connecting one crime to another and opening the work up to two separate readings. Structurally, the entire work is a play on the word *kasane,* also read *rui,* meaning "layering" as well as "ties" and "entanglement." The name of the precipice, Kasane, and that of the protagonist's wife, Orui ("o" being an affectionate prefix to a woman's name), underscore the meaning of the word in relation to the story. It is, indeed, a saga of massive entanglements delivered as an additional layer placed upon previous iterations of the same theme. The title of the new version was chosen, by the advice of a scholar friend of Enchō's, to suit the Age of Enlightenment. *Shinkei* is a pun on "the true landscape/view" and "nerves," the latter constituting a favorite topic of scientific discussion as well as a fashionable term in social life. The transcribed text was first serialized in 1887–1888 by the newspaper *Yamato Times* (*Yamato Shinbun*), which extravagantly advertised the series with illustrations by Taiso (Tsukioka) Yoshitoshi (1839–1892). Inoue Katsugorō published a book version illustrated by the same artist in 1889.

A True View consists of two narrative strands. The chief one depicts a series of crimes committed by the brothers Fukami Shingorō and Shinkichi, sons of an Edo *hatamoto,* Fukami Shinzaemon, who has accidentally murdered a moneylending masseur, Minagawa Sōetsu. Unintended or inevitable murders trigger malevolent links that connect one murder to the next and suggest principles of cause and effect as well as karmic connections.

The venomous cycle begins when Shingorō, the first son and a ronin-turned-shop-clerk, accidentally murders Osono, Sōetsu's younger daughter. The testimony of Sanzō, the Fukamis' former servant and now a successful businessman, facilitates Shingorō's arrest and execution. Second son Shinkichi's amorous relationship with the much older Toyoshiga, Sōetsu's elder daughter, leads to her death, which triggers Shinkichi to commit a series of murders. The initial victim is his first love, Ohisa, whom he mistakes for Toyoshiga as they run off to Ohisa's uncle Sanzō in Hanyū Village. The violent cycle spreads outward, claiming more victims, as Shikichi's wife Orui, Sanzō's sister and Ohisa's aunt, is driven mad and commits suicide. While under a delusion, Shinkichi kills their baby by dousing it in boiling water. Strangers fare no better at Shinkichi's hands: Shinkichi takes part in the murder of the village elder, Sōemon, instigated by the man's mistress, Oshizu, and then assists with the killing of the village scoundrel, Riverbank Jinzō, the sole witness to the crime.

The second strand features the family of the murdered village elder, Sōemon, and their struggle with the evil swordmaster-turned-bandit, Yasuda Ikkaku. When Ikkaku murders Sōemon's heir, Sōjirō, the latter's widow, Osumi, becomes a courtesan in order to catch Ikkaku unarmed in a brothel's bed. When the chance arrives, however, she is no match for Ikkaku's brutal talent for killing. Sōjirō's mother, accompanied by her grandson, Sōkichi, age ten, travels to avenge her husband and son but is killed by a villainous woman, Okuma, who is disguised as a nun. With the help of a righteous sumo wrestler, who is also a natural detective, Sōkichi is left to take up the mantle of familial revenge.

The two strands begin to cross and wind together as Shinkichi reappears in the story as the murderer of Sanzō, his deceased father's former servant. Sanzō is a witness to the crimes of the Fukami brothers and their father, but he is also the uncle of his first love, Ohisa, his wife Orui's brother, and his own benefactor. As Shinkichi meets Sōkichi, now Priest Sōkan, he recognizes the sickle that he used to kill Ohisa and with which Orui committed suicide. The nun Okuma then confesses to the murder of Sōkichi's mother and kills herself with the same sickle. To close the revenge cycle, Sōkichi finally gains the opportunity to end Ikkaku's life after the sumo wrestler Hanaguruma beats him. The ending is Dickensian in the sense that all of the loose ends are tied together through the discovery of the true relations between the chief characters. Okuma, the evil nun who killed Sōkichi's mother and pulled him into the cycle of revenge seeking, turns out to have been the mistress of Fukami Shinzaemon, whose accidental killing of the masseuse has been the cause of all the family's troubles. Shinkichi's last lover and conspirator, Oshizu, is discovered to be the daughter of Okuma and Shinzaemon,

exposing her and Shinkichi as incestuous siblings. The discovery of the sin-
fulness of the relationship prompts Shinkichi to murder both himself and
his sister/lover.

In the translation that follows, the "Prologue" represents the prefatory
opening of the first of ninety-seven episodes of this lengthy work. This por-
tion illustrates Enchō's struggle with the conflict between the modern and
the premodern, exemplifying his dual interest in the scientifically rational
and the nostalgically weird as he sought both to entertain and enlighten his
audience. The following excerpts focus upon circumstances under which
Shinkichi erroneously murders Ohisa soon after the two have run away to-
gether to Hanyū Village. His unfortunate encounter with Riverbank Jinzō
leads to the series of crimes that Shinkichi is compelled to commit in the
remainder of the story. If Toyoshiga is Shinkichi's karmic nemesis, Jinzō,
with his criminal tactics, is her modern counterpart.

(sj)

PROLOGUE

Ladies and gentlemen, today I present to you the first installment of a new
horror story. Scary stories have been out of fashion lately—you haven't
heard one of those being narrated on stage these days, have you? The master
proponents of the Enlightenment don't look kindly on this kind of story:
they tell us that there are no such things as ghosts and that their appearance
is merely a symptom of some nervous disorder. As a result, spooks have
been dead for a while. Ironically, though, in our thoroughly modernized
world, something old and dead begins to sound new to our ears. I don't ex-
pect you to believe in ghosts, but, with the encouragement of my advisers, I
will dig up the dead for you and entertain you with a rather unorthodox
horror story.

I give the story titled "The True View of Kasane Precipice." The story is
nothing new: you all know the legend of Kasane, from the Hanyū Village in
Shimōsa, that's been featured in kabuki plays and everywhere else. I have
invented a new spooky story in which a chain of murders are committed,
and so, as a result, ghosts appear one right after another. Please remember
that, in the days when these Kasane stories were told, we still believed in
ghosts. Whenever something weird happened unexpectedly, we attributed
it to a ghost out of surprise and fear. Now we have presumably given up the
idea of ghosts so we can no longer be frightened by anything. We no longer
believe that foxes trick us, so we must blame their transformations on our
own nervous disorders. *Tengu* no longer abduct children; we explain the

disappearance of our young ones as an irrational operation of our own nerves. Indeed, everything frightening is explained as some sort of neurosis.

As a matter of fact, a perfectly enlightened gentleman, who insists that there are no ghosts in our modern world, may suddenly scream and fall on his buttocks upon seeing something weird right in front of his nose. He's having some problems with his nerves, I would imagine. But some learned persons say, "Even in the West, there are spirits and goblins. Why not in Japan?" In response, we storytellers say, "Ah, indeed! So mysterious beings do exist, after all." But others with advanced knowledge say, "Don't tell me! It's irrational to think there can be any such thing as ghosts!" To them we say, "Of course! Now that you say so, it makes more sense to think that there cannot be anything of the sort." We storytellers know how to avoid taking sides. We say "there is" when someone says so, and we also say "there isn't" when someone else says so.

The "disconnection theory" of the old days was something close to what we now call "philosophy" in denying the karmic relations of things. Polemicists of that school insisted that what was not visible simply did not exist. No matter what theories might oppose it, they claimed any existence had to be physically visible right in front of the spectator. Sakyamuni confronted one of them by refuting, "Your claim is totally wrong-headed. Anyone who says that something does not exist simply because it is not visible is mistaken." This confused the man thoroughly, so he said, "Is that so? Do you mean to say that what is *isn't* and what isn't *is?*" Sakyamuni then said, "Well, even that isn't completely true." According to him, there was no way to tell one from the other. A mad verse says, "Sakyamuni descended on earth / To confuse all of us / What a prankster!" Whether it's Shakyamuni or anyone else, we tend to follow the words of any wise person. We assume, as long as we behave ourselves, no evil spirit will make an appearance; but if we kill someone and steal from him, for example, then there is a vengeful ghost to deal with. We now know this is the working of nothing but a neurotic disorder. In other words, if we commit a crime, we carry our own ghosts on our shoulders, causing us to behave in the neurotic way we do, or so we are told. If you worry about your victim's grudges as you remember the glare of the man at the moment of being murdered, anything you see can take the appearance of a weird being. In short, you are creating a ghost within your own bosom. If the victim is tenacious, he can turn into a ghost within your chest while he's still alive. I must admit that I've never seen one, but I hear that living ghosts do appear sometimes.

Tenacity is the most frightening feature of human nature. Often a jealous wife is said to burst into the house of the marriage go-between to demand an immediate divorce. An extreme case is one of those infuriated and

disheveled women who recently ran through the streets with such intensity that she collided with a policeman and bit his face. Obsession with money also turns people into ghosts: those who have saved money with passion are said to hate making any payments so that their living ghosts might possess anyone who attempts to collect from them.

EPISODE 21

As I say, this is a horror story that's a bit different from the usual standard. Mr. Koai has been recommended as the best person for transcribing this sort of narrative. You think I'm telling the story slowly because it's being heard by the stenographer and written down, but that's not the reason. When it comes to frightening the audience, talking fast won't do at all. To create horror, we need to be soft-spoken and deliberately s-l-o-w. It's generally known that if a story is told with a pleasant tempo, the element of fear can be extinguished. But there's no chance of that as far as I'm concerned because I'm so inarticulate that my stories are repetitive and roundabout anyway. This is why the theater's management decided I'm right for horror stories. Most everything is explained nowadays as a symptom of neurosis so that there can't be anything weird anymore. Still, it's no crime to recall the old times when obsession persisted as a karmic connection between people for many generations, and when some sort of curse would cause eerie appearances.

Toyoshiga, the music teacher in our story, is a case in point. She's the older daughter of Minagawa Sōetsu, the masseur and moneylender, who gets killed by a *hatamoto* named Fukami Shinzaemon in the beginning of the story. In an episode I presented to you earlier, the *hatamoto*'s younger son, Shinkichi, unknowingly becomes Toyoshiga's lover and freeloading student at her house. In addition to the karmic connection between the son of the murderer and the daughter of the victim, Toyoshiga's jealous grudges against the young and attractive Shinkichi dictate his fate as well as those of women who associate with him throughout the story.

Here is her death letter: "Falling in love with a man young enough to be my son is not something that I can be forgiven for. I thought he had true love for me and I did all I could to show mine. I misjudged him. How could I tell that he was such a heartless young man! He forsook a woman with a fatal illness who had no one else to depend on. I hate myself for believing he was as good as my spouse and for showing him all the sincerity that a wife would. I know I'm dying but I assure you I won't die without retaliation! My curse will stay with him for the rest of his life. If he ever marries, I'll make sure to kill his wives one by one up to seven." Her handwriting is agitated, obviously because of her illness and her anger.

Terror grips Shinkichi as he reads this. The letter, though, is not something that he would dare to show anyone. He hides it in the bosom of his kimono, but its existence there keeps him agitated. Not able to imagine what else he can do with it, he slips it into the casket with Toyoshiga's corpse. She is then buried in a grave at Seishōin Temple on Tosaki-machi Street in the Koishikawa district. His uncle advises him to pay respect to the deceased by frequently visiting her grave. Frightened of the darkness of the graveyard at night, he makes visits only at high noon. August 26 happens to be the third of her seventh-day anniversaries. He's anxious to visit the temple while it's light outside, but his business keeps him slightly late. Edo people are warned against going to a graveyard after the seventh hour, which is today's four o'clock in the afternoon. It's still shortly after three o'clock, but low-hanging rain clouds turn the place much darker than is warranted by the hour. He rushes to buy flowers at a shop right in front of the temple's gate and fills two buckets with water. The well is excessively deep, and the task occupies Shinkichi far longer than is desirable. Carrying the bouquet of flowers and the two buckets, he runs up the stone steps and approaches Toyoshiga's grave. He's surprised to encounter a figure of someone apparently praying in front of the grave. Coming closer, he recognizes Ohisa, the daughter of the Hanyūya Shop's owner and a former student of Toyoshiga.

OHISA: Oh, it's Shinkichi!

SHINKICHI: Is that you, Ohisa? I've been wondering how you are. What a surprise!

OHISA: My music teacher has been on my mind all this time. I've made sure to come here every seventh day at least.

SHINKICHI: That's so kind of you! Thank you very much.

OHISA: I'm so sorry about what happened to Miss Toyoshiga. I haven't seen you since her funeral, but I can imagine your distress.

SHINKICHI: Well, I'm broken up about it, all right. I'm really at a loss about what to do. Thank you so much for the beautiful flowers.

OHISA: May I ask you something? The other day when we met in the upstairs room of the Hasumi Sushi Shop, you suddenly got up and took off, leaving me alone there. What happened?

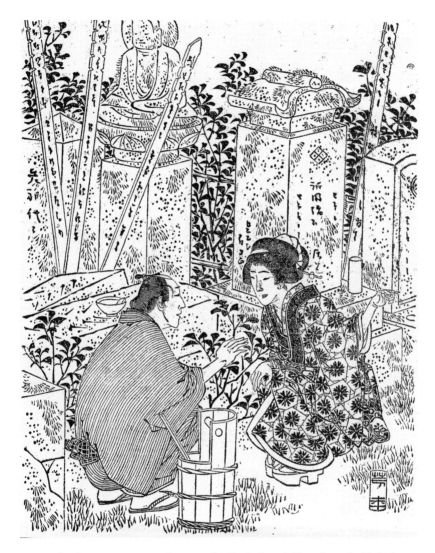

At Toyoshiga's grave: momentary happiness for Shinkichi and Ohisa. Image by Tsukioka Yoshitoshi, *Yamato Shinbun Newspaper,* 1888. (Collection of Shinji Nobuhiro and Mita Media Center, Keio University Library)

SHINKICHI: Oh, that. I suddenly remembered an urgent business matter and left in a hurry. Sorry I didn't even give you an explanation.

OHISA: I was really surprised. You pushed me away and ran downstairs. I had no idea what the problem was, but I waited for you. You never came back! I was so embarrassed that I told the restaurant people something

urgent had just come up at home. Since the sushi was ready, I had them pack it in a box and took it home.

SHINKICHI: Well, I'm very sorry. It's just the way you looked. I'm sure it had something to do with my nerves. Something affected my eyes, so I saw what wasn't there. Come to think of it, it's totally unreal that I saw such a thing on your face. And such a beautiful face you have.

OHISA: So what did you see?

SHINKICHI: Never mind. It's perfectly fine now.

OHISA: Actually, I'm glad to run into you here, Shinkichi. I meant to talk about this with you for a very long time but never had the chance. My mean stepmother punishes me because she thinks there's something going on between you and me. "There must be something going on," she says, "otherwise the music teacher would never have been jealous, let alone die from jealousy." I tell her there's nothing immoral going on between you and me, but she never stops beating me. I thought of running away from the house and throwing myself into a river. I know that's really reckless, so I want to go to my uncle in Shimōsa and ask for his help. But it isn't possible is it, for a woman to go that far alone?

EPISODE 22

SHINKICHI: If that's the case, maybe I'll go with you.

Her suggestion to him is so clear that he is ready to go with her, completely forgetting his anxiety.

OHISA: Really? Are you going to take me there? If you're willing, I'll do absolutely anything for you. If your feelings don't change, as soon as we're there, I'm sure I can ask my uncle to take care of you in any way he can. Please go with me.

Well, they're young. Still, this is extreme. They make up their minds to run off straight from the graveyard. They head for Matsudo, where they stay overnight, and the next day they go along the banks of Kogasaki and, passing through Nagareyama, take the ferry at Hiregasaki Point to get onto the Mizukaidō Highway. It's a bit late, but they learn that Hanyū Village is only a short distance ahead. It's embarrassing to ask for a meal upon arrival at the uncle's house, they think, so they take a simple supper at a shop called Kōjiya.

They are told by the kind people at the shop that a ferry along the bank just up ahead will take them right across to Hanyū Village.

It's now the evening of August 27, I remind you, that Shinkichi leads Ohisa, her hand in his. It's pitch dark: you couldn't tell who just pinched your nose. On top of that, it starts raining, drops falling on their faces. In that part of the country, rain clouds rise from the Tsukuba Mountains. The path to the riverbed is sluggishly gentle. They take the ferry to Yokosone Village, intending to follow the riverbank to Hanyū Village. The spot is called Kasane Precipice. The locals say this is where Yoemon slashed his lover, the tragic heroine Kasane, to death with a sickle. Others say that in truth Kasane, with a heavy load of brushwood on her shoulder, was knocked down until her head was practically buried in the sand. Yoemon is said to have mounted her body and choked her by pushing her head further into the ground. Another legend has it that Priest Yūten, who was still in his ascetic training, was asked to offer a prayer for Kasane's salvation. Sitting on a rush mat right by the precipice, Yūten rang the bell and prayed for her. As a result, Kasane was enlightened and entered Paradise. After Kasane's salvation, the sound of the priest's bell, "kan, kan, kan . . . ," was always heard along the river Kinugawa. When you come to the spot following the riverbank, you will find a trail going lazily down to a little reservoir surrounded by something locally called *bossaka,* which is hard to describe except that it's shaped like a clump of grass or a bush of small trees. Shinkichi and Ohisa are walking down the lazy incline of the riverbank when the dripping rain turns into a violent storm. Before long, thunder sounds and lightning pierces the darkness.

OHISA: Shinkichi! Shinkichi!

SHINKICHI: Yes, Ohisa.

OHISA: It's scary, isn't it? I hate the thunder.

SHINKICHI: Have no fear. People at the restaurant told us that we will get to Hanyū Village as long as we stick to this path along the riverbank. We'll get there as soon as we can and tell your uncle about us.

OHISA: Of course. As soon as we get there we'll be okay. And my uncle will listen to us. But right now it's so dark and frightening I can't walk a step.

SHINKICHI: Alright, we'll go this way.

OHISA: I'm following you.

As she tries to step down after Shinkichi, she slips and falls on her knees.

OHISA: Ouch!

SHINKICHI: What happened?

OHISA: I think I hit my knee against a big rock or something like that. It hurts! Take a look!

SHINKICHI: Let's see. Wow! There's an awful lot of blood! What did you do? What did you fall on? Was it really a rock?

As his hand gropes around, it hits a sickle. In the country, children are often sent to collect hay. They are sometimes too lazy to take the tool home and back again so they leave it stuck in the ground as a marker. This particular sickle must be one of those left by a child. Ohisa has fallen on top of the blade, which cuts into her leg. This explains the alarming amount of blood.

EPISODE 23

SHINKICHI: This is terrible! Hold on! I've got a scarf to make a tourniquet for your leg.

OHISA: It hurts! It hurts! I can't stand it!

SHINKICHI: I know it hurts but it's pitch dark and I can't see what's what. Be patient. I'm putting my scarf around here and I'm tying your leg hard. Do you feel it?

OHISA: Thank you, Shinkichi. I think it's hurting much less now.

SHINKICHI: Keep a hold of yourself. I want to carry you on my back but our luggage is in the way. Hold on to my shoulder and walk slowly.

Ohisa limps along.

OHISA: You know, Shinkichi, the gods must have heard my wishes. Here I am running from home to the country with you. It's been my dream to be

married to you and spend the rest of our lives together. But you're so handsome and I know people call you a ladies' man. If you ever find another woman, I know you'll get tired of me and cast me aside. That's what I worry about.

SHINKICHI: What are you talking about? We've slept with each other only once—in Matsudo last night, I mean. How can you be talking about me dropping you?

OHISA: I know you'll desert me. You're the kind of man who'll abandon a woman.

SHINKICHI: How can you say that? Listen, I'm someone who is about to beg your uncle for protection. If I ever part with you, I'm in big trouble.

OHISA: You're a smooth talker. I know you'll talk yourself out of any kind of trouble.

SHINKICHI: Why do you think that way?

OHISA: Why? Because my face looks like this.

SHINKICHI: Eh?

In the deathly darkness Shinkichi kneels to look into Ohisa's face. Strangely her face is clearly visible, distinctly showing every detail. He notices that a little growth has suddenly appeared under her eye. The thing swells, spreading over Ohisa's face until it becomes Toyoshiga's. Overtaken by fear, he swings the sickle around, arbitrarily slashing the throat of the girl who has risen to flee.

OHISA: Aaaahhhhhhhh!!!!!
As she falls forward, the sickle digs deeper into her throat. She writhes in agony, grasping the tall weeds.

OHISA: Ah!
With a glare at Shinkichi, she breathes her last. Shinkichi, still holding the sickle, prays fiercely to Amida Buddha. At that moment, a downpour of rain and thunder attacks him, sounding like the rolling wheels of a cart. Now that he has committed a murder in an unfamiliar land, the sound of the storm works heavily on his conscience. Afraid that he may be seen, he forces

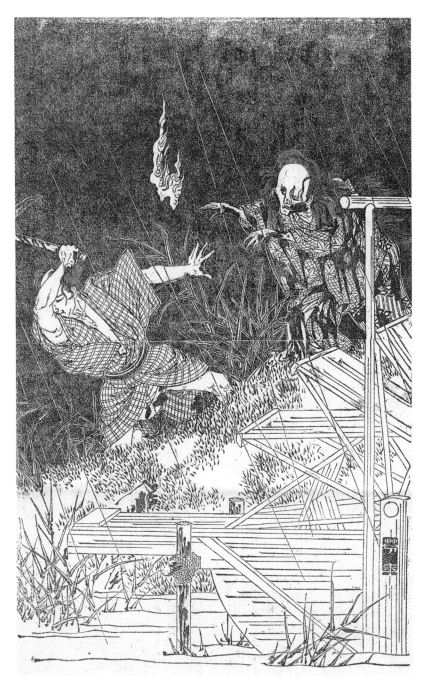

Ohisa turns into Toyoshiga's evil spirit. Image by Tsukioka Yoshitoshi, *Yamato Shinbun Newspaper*, 1888. (Collection of Shinji Nobuhiro and Mita Media Center, Keio University Library)

his shivering legs to run. As he slips on the slimy soil into the clump of *bossaka*, he is alarmed to find a man rising from the bush.

SHINKICHI: Aahh!

He nearly stops breathing. As he steps back and looks through the dark, the figure also peers through the bush. He too is probably afraid. Luckily the darkness hides Shinkichi's face from the stranger. He only needs to turn away to avoid illumination from the occasional bolt of lightning. The other person seems to be afraid of the thunder, and never looks up. Only after the lightning is gone and complete darkness returns does the man open his mouth.

THE MAN: You, thief!

The stranger grabs Shinkichi's collar. He is a scoundrel known as River-bank Jinzō. He has just slipped out of a gambling house at the moment of a police raid and has been chased along the reservoir into the *bossaka* bush. While Shinkichi imagines a monster rising from the bush, his fall beside Jinzō certainly shocks the latter in turn. As Jinzō pulls to tighten Shinkichi's collar, it seems to be the end of the world for him, but he fights frantically until Jinzō lets go of him. Jinzō, trying to catch him, stumbles on Shinkichi's body and rolls through the *bossaka* into the reservoir. Shinkichi is about to run around him when Jinzō yells "You bastard!" and tackles him. Shinkichi falls on his back. Jinzō jumps on Shinkichi, who kicks him in the balls.

JINZŌ: Ooouuuuccccchhhhhh!

Shinkichi takes the opportunity to hold him down but, for that purpose, he needs to put down his luggage, which hits Jinzō in the face.

JINZŌ: Bastard!

As they grapple with each other, twisting each other's arms, they keep slipping and falling, each completely covered in mud. Something like a heavy rod of fire falls about half a mile away, and the thunderbolt strikes Jōzenji Precipice with the sound of Pssssss! Riverbank Jinzō certainly looks impressively large, and he obviously has guts too. But he's chicken when it comes to thunder and lightning, so he falls and hides in the bush. Shinkichi, on the other hand, is far more afraid of Jinzō than the storm, so he picks up his luggage, climbs up the bank, and runs, not at all knowing where, over the bank and through the fields. Finally he sees a grass-thatched house, where, judging from the lights, an evening meal seems to be cooking. He bangs on the door shouting for help. The idiotic thing, though, is that this particular

Shinkichi encounters Riverbank Jinzō, who turns into his nemesis. Image by Tsukioka Yoshitoshi, *Yamato Shinbun Newspaper,* 1888. (Collection of Shinji Nobuhiro and Mita Media Center, Keio University Library)

house belongs to the same Jinzō from whom Shinkichi has fled. I'm going to tell you, in the next episode, how Shinkichi falls into Jinzō's hands again. From here on, horror will take over.

TRANSLATED BY SUMIE JONES

A Woodcutter Falls in Love

OZAKI KŌYŌ

 Ozaki Kōyō (1868–1903) was the founder of the literary group Schoolmate Society (Ken'yūsha), which published *Rubbish Literature* (*Garakuta Bunko*), a journal that became a hotbed for the discussion and practice of literary reform. Kōyō nurtured young aspiring writers, including Izumi Kyōka, Tokuda Shūsei (1871–1943), Tayama Katai, and others who became leading authors of their time. With rhetorical genius and masterful obsession with factual details, Kōyō succeeded in styles both ornate and plain, old and modern.

His position as a staff writer for the *The Town Crier* (*Yomiuri*) daily newspaper facilitated his use of contemporary events and town gossip as materials for his writing. Inspiration for his *Three Wives* (*Sannin-zuma*, 1892), for instance, came from a gossipy news item about a rich man's funeral attended by his wives and mistresses. Much of his writing resembles the sentimental novels of Tamenaga Shunsui, who remained the favorite among readers of popular fiction in Kōyō's time. Kōyō's minute attention to the description of manners and clothing for men and women of different ages and classes marks him as a virtuoso of Edo-style "books of manners."

The More Passion, the More Sorrow (*Tajō Takon*, 1896), which came after *Three Wives,* is a modernized book of manners, in which two male characters are juxtaposed—one a self-absorbed whiny widower and the other a generous and convivial married man. While the married friend represents conventional but mature love—erotic, playful, and social—the pining widower awkwardly portrays a fashionably modern romantic love that is spiritual, melancholic, and monogamous. The characterization of the latter is paradoxical, implying the difficulty for the Japanese in imagining a new type of "love" that is separate from the familiar eroticism of times past. Although the author indulges in the details of the widower's pain and loneliness, he also draws a caricature of his behavior that undermines the concept of romantic love.

The More Passion is written in the "colloquial" style, which Kōyō used effectively in later essay-like narratives for the description of illnesses—particularly his own, which claimed his life at the age of thirty-five. Here, his obsession with realistic detail effectively dramatizes the visceral images of pain and anxiety. As illustrated by his masterpiece, *Gold Demon,* Kōyō perfected melodrama through his technique of description. The process of piling expression upon expression in order to draw in the reader is a hallmark of his experimentation with form, distinguishing his works as masterpieces of melodrama. The following translation attempts to re-create this style.

In "A Woodcutter Falls in Love" (Koi no Yamagatsu, 1889), presented here, Kōyō continued to explore the theme of the impossibility of love. With the exception of *The More Passion,* in which the object of love is deceased, most of his works focus on unrequited love that derives from economic class differences. The typical case is *The Pitch Darkness of His Heart* (*Kokoro no Yami,* 1894), which depicts a blind masseur's anguish in his longing for an upper-class woman and his grudging appearances in her dreams after her marriage. "A Woodcutter Falls in Love" pursues the same theme but emphasizes ambiguous eroticism rather than ominous intensity. This short story moves from comical to suspenseful to erotic, demonstrating Kōyō's virtuosity.

Kōyō was well read in European literatures in Japanese and English translations. Many of his works are called "adaptations" and even "translations." Although Émile Zola and other naturalists have been mentioned as sources of inspiration, "A Woodcutter" in particular shows that Kōyō does not directly draw from these authors' storylines and characters, and that he departs from European realism. There is no stable third-person narrator, as the dialogue often merges into narrative, sometimes incorporating the characters' inner thoughts. In addition, the past tense, the hallmark of realism, is discarded, as the author reinvents the use of the present tense that was popularly used in playful Edo writings. In short, the story is more firmly embedded in the Japanese narrative tradition.

The inaccessibility of the object of love is a standard motif in any literature. Here it seems to crystallize in the figure of the lowly man carrying on his back a beautiful young woman of unapproachably high rank. "A Woodcutter Falls in Love" recalls episode 6 in *The Tales of Ise* (*Ise Monogatari,* tenth century), in which "a man long ago" steals an imperial consort and carries her on his back across a river, allowing the young consort's innocence to move him to compose a poem. This short episode has remained a prominent trope, used not only by Kōyō in this work but by later authors as well. Tanizaki Jun'ichirō's *A Blind Man's Tale* (*Mōmoku Monogatari,* 1931), in which a blind masseur saves the life of a young princess from a burning

castle by carrying her unconscious on his back, mimics the scene and echoes the sensuality of Kōyō's work. The vast difference of class in the episode of *The Tales of Ise* is replayed by Kōyō in the exaggerated use of the classical term *yamagatsu,* which refers to a rough man living deep in the mountains, here applied to, as it turns out, an employee of the household where the young woman is visiting. As in nearly all of his works, Kōyō is sharply sensitive toward newly emerging class differences based on nothing but money.

(**MK & SJ**)

PART 1

In the balmy days of spring, it is better to amuse oneself in the mountains than at the sea. Deep in the forest, lone cherry trees stand amid others: here a blossom opens today, there another opens tomorrow, seeming as if they might last until summer. Even if the fresh grass grows high on the mountain paths, the tips of the tree branches are not yet weighed down by the leaves. The cry and the pounding wings of pheasants are strange to the ear of the city girl. Enchanted by the lightness of the unfamiliar straw sandals on her feet, she lets them seek their own path, gamboling across a meadow filled with blooming violets. Their purple petals scatter on her scarlet petticoat as a beautiful young girl of seventeen or eighteen wanders along the mountain paths, accompanied by two women and one man. They call her "Miss," and her elegance is in keeping with this form of address. She has come to gather mountain herbs, lured by the thought that doing so would be much more interesting than plucking dandelions in the cramped quarters of the city. This is the diversion decided for today. As for the women escorting her, one is older, about thirty and thin; the other is burdened with the looks of one born to be a serving girl, and is plump at that. This second one appears to be about twenty-one—even with such looks, at least she is a young girl. Both women have come with the young lady from Tokyo, but the man appears to be from this area, perhaps a servant of the house where the ladies are lodging. He is an old country codger of about sixty, shriveled and burned by the sun. Because he is so energetic in spite of his age, he has been ordered to go along with them today. He carries a pole across his shoulders, lunch boxes and luggage dangling from each end. Following several yards behind the women, he occasionally calls out, "There's a cliff that way, turn left and go straight," and so on. He plods along, bringing up the rear. The older maid (her name is Omasa) stops, turns around, points to a tree next to the path, and says:

"I wonder what kind of tree that is."

Although the question is intended for the old man, the plump one (her name is Okane) responds, "That's a mangled-nolia tree."

"You're not funny," says Omasa, and at this reproach, Okane runs off laughing, only to be warned by the old man, "Careful! You'll fall!"

"Well, if she falls and hurts herself, let her bleed all she wants. Maybe she'll lose some of that flab!" Omasa laughs but stops short: "Wait! Where's the miss?" All of a sudden the girl they have been watching over is no longer there. The two women suddenly look frightened. For days they have been hearing, half believing, half doubting, that goblins and demons live in these mountains and that they kidnap people. They grow agitated and look at each other as if to say, "Did something like that just happen to the miss?" When they turn to the old man, he says, without batting an eye, "Maybe she fell down into the gorge over there." He is completely nonplussed, this old fellow, upon whom the women are to depend for their safe return. The women are distraught to think that his will is to be their command for as long as they are in the mountains. Omasa asks, with a trembling voice, "What should we do?" In her despair she even begins to consult Okane, whom she was just now teasing. But Okane is even less help than the old man. Omasa begins weeping and wailing, "Miss!"

Her voice echoes wretchedly. As the women grow more anxious, neither is able to speak a word. When he sees how they dart fearful glances around them, the old man, Uhei, unveils his plot. He laughs and jerks his chin in one direction, "Don't you see that?" When they look, there, between the thickets in a grove, is it a spring maple? Or, if not, what is it that they see under the tall camellia bush, those specks of bright red?

"Oh! A sash!"

"*Her* sash! The young lady's sash!"

Okane, furious at being so completely fooled, beats Uhei on the back, turning red with fury. "Uhei, you're terrible! You're an awful old man!" Unrepentant, the old man laughs out loud again. Omasa, in the meantime, is angered by the bad behavior of the young lady, who, however much they called out to her, did not respond. To teach her a lesson, she makes her voice sound alarmed.

"A snake! Miss! A snake!"

With a single shriek of fright, the girl throws to the ground the thirty or forty camellias she had strung on a bamboo branch and flies out from the trees. She lands on Omasa's lap and clutches her tightly. "The snake isn't following me, is it?" Truly, it's a prank that amuses the mistress and her servants alike. They giggle until their voices tremble and their bodies shake. They cackle until their sides split.

At last they come to the place that Uhei's practiced eye chooses for them. He sets his load down and points into the grass.

"There, over there, the herbs you are looking for. But let's rest first, then take our time picking."

Until today, the women have only seen the herbs bundled up for sale at the market, so they stand there dumbfounded. At length Omasa pulls an indigo cloth out of the sleeve of her kimono and spreads it on the grass.

"Miss, why don't you take a little rest? Oh, look, Okane has collapsed already."

"My legs feel like logs."

As the young lady sits down, she pokes at Okane's shoulder. "Oh, a caterpillar!" Okane shrieks, jumps up, frowns, and examines the spot where she has just been sitting with her face contorted in disgust. "Where?"

The girl presses her sleeve to her mouth and giggles.

"Oh, miss! I won't forget that. You can be sure I won't!"

Omasa puts her tobacco pipe in her mouth, strikes a match and says, "Serves you right, Okane, you coward."

The girl lies down next to Omasa. "Okane, please forgive me. No more practical jokes."

After they rest here for a bit, it's off to gather herbs! Plucking shoots from the dense clumps—it's hard to think of a greater pleasure. In the beginning, the women work cheek to cheek and shoulder to shoulder over the same clump, but gradually drift apart until each is alone. Although they stay away from the gorge, they venture to the edge of the thicket. Mistress forgets servant, vassal shakes away lord, and each is preoccupied by the delight of what is discovered. The old man, left behind, at first plucks a bunch or two out of duty. But then—what am I supposed to find interesting about this at my age?—he wraps the lunchbox carefully and uses it as a pillow, placing his head in the soft sunlight. Tired from staying up braiding rope the night before, he dozes off, noticing neither the butterflies dancing around the elaborate bow of the girl's brocade sash, nor the piercing call of the warbler flying past his pillow.

PART 2

Her bundle filled, swollen to bursting, the girl continues to pluck here and gather there, so delighted that she wanders far, mindless of where her feet are taking her. When a bunch becomes too much for one hand, she stuffs it, with the dirt still clinging to it, into her long kimono sleeve with its bright crimson lining. She moves ahead, both sleeves dragging, until she knows not where she is. She turns around and looks back. Have I come to a place

where others seldom set foot? She sees, in the bamboo scrub, the trail she has made in the grass behind her. She stands on her toes and cranes her neck—no one to be seen—and just when she moves three feet to the side to peer around a spruce that blocks her view, she snags her foot, stumbles, and strikes her left elbow. "Careful!" she thinks, springing up instantly. Less than one foot in front of her is a precipice! Deep below the rushing stream echoes in the chasm. At that sound, her heart beats faster. The shriek of a bird—she doesn't even know its name—pierces her ear, lonely and despairing. Why did she ever dare to come to such a lonely place? It's not likely that she has come here on her own. What goblin has led her here? What road can lead her back?

A breeze suddenly stirs the branches, filling her with a fear of the unknown. She can't go forward; she can't go back. She stops, briefly rooted to the spot. She wheels around at the sound of wood creaking, and there—hitherto unnoticed—stands a tree so huge that it would take three men to encircle it. The noise is coming from its branches. Is it a bird? No, the sound is too loud—What could it be? As she approaches, she sees the bold flash of a blade. Before she can even cry out, she bolts three or four yards forward, feet barely touching the ground. She turns back—with the irresistible desire to see something horrible. Partly hidden in the shadows of the high limbs is a silhouette—Is it a man? A wild man! He is standing there, holding the blade, the gleam of which has frightened her. She cannot see his face, but he seems to be staring this way. Help! Now is the moment when he will lunge at me and grab me by the hair. Keeping her eyes fixed on his form, she takes five or six steps when something catches her foot, a rock or a root, and she falls with a thud to the side. She lands on her hip and scrapes her knee. Oh, am I to forfeit my life here? She has not yet been caught, however; perhaps there is a way out. She hastens to flee, and yet, before she is even able to stand up—How can she possibly escape? She places her hands on her hips, writhes, rubs her hair into the earth and moans. And then—has he seen her through the leaves?—a huge man with an axe in his right hand comes sliding down the tree. He is nimble as a monkey and runs toward her. If only she were not suffering from her wounds! If only she still had all of her senses about her! Should she scream, run, or bite? Is she being taken from behind, embraced by this monster? Is this demon wiping the blood off the white flesh of her knees, which she would be ashamed to show anyone? Is he sucking blood from them? It all seems like a nightmare.

"My lady!"

His voice is rough and vulgar. Yet, however frightening, he turns out to be human at least. It is not that she doesn't hear him. Because of her injuries she cannot answer. She furls her brow, opens her eyes a slit at the one who

has called to her, and nods. The man places his arms securely under her, one below her knees and the other above her sash. His embrace keeps her from falling, for she lacks the strength to support herself. Her head, which rolls back and hangs down, makes a pillow of the man's patched trousers.

The indescribable scent of the oil on her disarrayed hair! Is it the smell of aloes, plum blossoms, or something else? It caresses his nose, unaccustomed as it is to such riches. Her head is tilted back in repose, so that he can never see his fill of her face. Just a while ago, when he stood among the branches and caught his first glimpse of her—No, he had never seen anyone like her before! Her clothes, her hair, the pallor of her face, her graceful figure. Five or six days ago he heard rumors of guests from Tokyo who had come to visit the village headman, among them a beautiful young girl. She must be the one that Nizō Sakusuke described after seeing her for himself: With one glance she became everything my heart could desire! Well, if I see her, sneered the woodcutter, she won't turn my head. You'll be struck dumb, Sakusuke insisted. And his words turned out to be true.

Never has he seen such a woman, never in all of his days. He was once shown by Suzu, a girl from the outskirts of the village, some ukiyo-e prints. They were a souvenir from Tokyo, and he could hardly believe that there really were such beautiful women. He simply thought that the pictures were a fabrication. But this lady is even more ravishing than those images. Because the girl's beauty has so enchanted him, it does not occur to him that the girl, her teeth gnashed in agony, is in pain from her injuries. Ignoring her suffering and with a smile of satisfaction on his face, he gazes intently at the color of her cheeks, the velvety skin, and all that is wondrous about her. Truly, this is a memory to cherish for a lifetime. It will never happen again, he thinks. His nails long, his knuckles rough, and his fingers stained with sap, he gingerly pokes her smooth cheeks. He boldly pinches her lip, glances with pleasure at the rouge on his finger, licks it and looks around. Suddenly he is aware of the weight of the body resting on his knees. As he tries to shift her body, his hand happens to touch the spot on her hip that is injured. Her cry—"Ahh"—finally brings him back to his senses. He has no medicine to offer. As much as he worries about not being able to treat her wounds, nothing can be done. He decides to take her down the mountain.

He picks up his axe and looks for his lunchbox. How did it happen? The box is broken in two and the rice and pickled plums have spilt from it. Aha! It's his lunchbox that tripped her. Two misfortunes at once! He places the contents back in the broken box, ties it shut with a rope, and fastens it at his side. He shoulders the girl and hangs his ax on his sash. Once on the road, he comes two and a half or three miles down the steep incline with no problems at all, for he knows the way.

The beauty and the beast, Japanese style, by Takeuchi Keishū. From Ozaki Kōyō, *Autumn Rain*, 1889 (Archives of Meiji Newspapers and Journals, the University of Tokyo)

Suddenly, without understanding why, he feels happy and embarrassed at the same time. Without any concern for the actual state of the person he is bearing on his back, he feels a kind of joy that radiates on his face. He walks two or three more yards and looks back over his shoulder. To see what, you might wonder. To see the hands of the woman barely holding on to him, and those white fingers, those supple, slim fingers, with two golden rings on the left hand and one on the right. One ring is set with a purple stone. Another has a chrysanthemum-patterned arabesque finely engraved into it. And the third is a simple gold band. Such hands on his shoulders! On the place where he usually slings coils of rope for a portable ladder. Never for a minute, never in a dream, could there be such a burden on these shoulders! A fleeting spring snow atop a withered tree or on a half-bare cliff, that is what the lady and I look like now. It would never happen again. His shoulders have borne loads of eighty to a hundred pounds, but the lightness

of these two hands weigh down his muscles of iron. With such a burden slung across his shoulders, he regrets the time when he will have to set her down. Let it be in twenty miles or two hundred, or even a thousand miles or two thousand. He has only one fervent wish: to walk on like this for the rest of his life.

So he walks on. He looks back again and again for a glimpse of those hands. Every time he turns back he strokes her cheek, and gradually passion wells up in his heart. It is now not enough to worship just those hands—no, he wants to see that face again, a face as beautiful as he can ever imagine. He turns his neck this way and that, but the young lady has her face buried in the nape of his neck. If he cannot reach his goal that way, then . . . he unclasps his hands from behind her and shifts her forward so that they are face to face. The more he looks at her, the more his love deepens, a feeling that tears painfully at his insides. Never has he felt anything like this! I will turn her over quickly, as soon as we meet up with her party, he has been thinking. But now he begins to dread that moment. He is more timorous of the sound of a human voice than of the howling of a far-off wolf. When he has gone another one hundred yards, his ears are pierced, not by the cry of a predator, but by the voices of several people.

If only there were an escape route in the thick shade of this grove, he would certainly enter it and cover his tracks behind him. Certainly, that one desperate deed would lead to another—no good coming of it. Luckily or unluckily, the road ahead is leading them straight down the mountain. However he may twist and turn, he has no recourse but to encounter those who are coming up from below. Even if his love is worth sacrificing his life, there has never been any hope for him from the outset. He still regrets. Is my happiness to go no further than a memory of this moment? Must I yield up so lightly someone so dear to me? His knees go weak at the thought, and he stops dead in his tracks. What can he be thinking? He hurries back the way he has come, retracing his steps for a few yards. Again, what is he thinking? Sadly, he turns and walks down the slope to the spot where he has just turned back.

The sounds of steps grow near. People are loudly calling, "Miss! Miss!" Among them is the husky voice he knows so well—Old Man Uhei. I should have known that this woman is my lord's guest. It isn't that I didn't realize who she was. It's just that . . . without wanting to, I did something awful, something I can't undo. What now? She must have been in pain from her injuries. It didn't look like she knew what was going on at the time. But if she wasn't completely unconscious, then she does know what I've done. And if she tells the others, how will I explain it to Old Man Uhei? Even worse, how can I explain it to my master? I'll be fired on the spot. I'll be

driven out of the village. It's all over, because of a whim, a disastrous mistake. Like the coarse country man that he is, he judges himself harshly. Cold sweat runs down his brow. He grows pale and wavers. At that moment, Omasa appears before him. "Oh, miss!" Omasa shouts for joy at the top of her voice. The sound of her shriek pierces the man to the quick. All he can do is stare back.

"Why, it's Manzō!" When Uhei calls out to him, his evil secret makes him quail. See, even in Uhei's lusterless aged eyes, there is a glint of accusation. Manzō meekly answers, "Why, it's you, Uhei."

When the two women pull the girl off Manzō's back, she is still unconscious and falls over. They hold her up from left and right. "Miss!" they cry out through their tears as they tend to her. When Manzō sees this, he realizes that the girl is clearly unconscious. He places his hand on his chest in relief. He feels as if he has lowered his muddied body into the clean, hot water of a tub. Suddenly gaining courage, he tells how she injured herself. Uhei beams with joy and says, "Tell the story to our lord when we get back." He even mentions something about a reward. "Sorry to make more work for you, but won't you carry her back to the lodging?" To Manzō's ears these words are like an unexpected reprieve from a death sentence. It is even better than that. At the idea of a reward, he begins to tremble at such heavenly intervention. Manzō vows to fully accept Buddha from that moment on—if it can only blot out one-tenth of the terrible crime that he has committed. He gingerly lifts the girl onto his back again, and whenever he sees her rings flashing, he tightly closes his eyes and recites the holy name.

TRANSLATED BY MATTHEW KOENIGSBERG

Maidens, Stars, and Dreams

POEMS BY SHIMAZAKI TŌSON AND KANBARA ARIAKE

 Both Shimazaki Tōson (1872–1943) and Kanbara Ariake (1876–1952) composed poems not in the traditional short forms, such as *waka* and haiku, but in longer, "new-form" poetry inspired by Western verse. Among their contemporaries were still many poets with extensive knowledge of classical Chinese literature who composed poems in Chinese with ease, but Tōson and Ariake lacked such classical training. Their literary backgrounds were instead heavily steeped in English literature, especially that of the romantic period. Like all

Japanese poets of this period, they tried their hands at traditional Japanese verse before embarking on new forms; but they are primarily remembered as innovators of Western-inspired forms. In the chronology of world literature they were predated by such postromantic poets as Rimbaud and W. B. Yeats, but Japanese literature needed to wait another decade or so before the emergence of poets and writers who avowed wholehearted sympathy with the precursors of modernism. By that time, Tōson had given up poetry for a career as a novelist, and Ariake had been completely forgotten. As in other areas, Japanese literature too was forced to play catch-up, and it did so by discarding old shells as new literary trends continued to reach the nation. Both Tōson and Ariake digested and adapted their Western influences to fully transform the Japanese poetic language, perhaps before their readership could appreciate them. Romanticism thus enriched by their contributions was short-lived but nevertheless constitutes an important stage in Japan's modernism.

Tōson's poetry focuses on the innocence and melancholy of the pastoral that is characteristic of English romanticism. For him, the cycle of nature is curative for human suffering, and youth is beautiful in its evanescence. As evidenced in the selections here, Tōson often uses the perspective of a melancholic, older man observing the sadness and beauty of youths' lives. Almost all of his poems have the traditional seven-five rhythm. The two poems presented here are taken from the *Collection of Young Greens* (*Wakanashū*, 1897), which first brought him success. Later, Tōson's poems were put to music to be sung in primary schools as part of the Ministry of Education's centralized curriculum, thereby gaining tremendous popularity.

Ariake is one of the first poets who introduced the sonnet form to Japanese poetry and arguably the one who refined it to a level Japanese poetry has not seen since. His most notable accomplishment as a poet lies in his use of complex metrical schemes. Indeed, no other poets had strived so hard to avoid the monotony of the regular meter of seven and five syllables as Ariake. He not only tried combinations of different numbers of syllables but also gave an interesting twist to the traditional seven-five rhythm by deliberately making line breaks out of sync with metrical breaks, thereby creating an effect of syncopation and taking Japanese verse to a new level of complexity. In 1908, he published the collection *Ariake's Poems* (*Ariakeshū*), which contains the poems translated in this volume.

The vocabulary and grammar of the original poems, not to mention their traditional meter, sound dated to the ears of contemporary Japanese readers. Ariake's poems might even give an impression of gratuitous artificiality. Although it is always impossible to give an objective answer to a question of this kind, it may well be the case that the poetry of Wordsworth

The cover of *The Collection of Young Greens.* (C.V. Starr East Asian Library, University of California, Berkeley)

(Tōson's hero) and D. G. Rossetti (Ariake's hero) are more accessible to modern readers of English than Tōson and Ariake are to their Japanese audience.

While Tōson's poems convey a warm feeling of rustic communality, Ariake's poems have the brooding tone of a lonely individual in a modern society. "Soul's Night" (Tama no Yoru) is a curious example of this kind. Cast in a technically sophisticated syllabic verse of nine syllables with many enjambments and arcane vocabulary, it sings about a man in debt contemplating suicide. Sexual overtones are subtle but evident in many of Ariake's poems such as "Soul's Eclipse" (Rei no Hi no Shoku) and "Daylight Thoughts" (Hiru no Omoi).

A Drinking Song (Suika, 1897)
Shimazaki Tōson

You and I both travelers
kin to each other. Let me
drink and show you,
my sober companion,
the poems in my notebook.

Before your young life passes
joyous springs are quick to age
your crimson face—who wouldn't
want to have a treasure like yours?

Your face shows tears.
Your eyebrows show sadness.
Your mouth, tightlipped, shows
your voiceless distress.

Don't preach a nameless road.
Don't follow a nameless journey.
Rather than cry over wasted effort,
come and cry over good sake.

The agony of loneliness
on a lightless spring day—

You look old,
my fellow traveler,
tainted with the wisdom
of this sad-tasting world.

Light your young life
with the candle of the heart's spring.
Wouldn't it be sad if you scattered
your petals even before you bloom?

Where is the destination
you hurry so intently toward?
A koto is here. So are flowers and sake.
Linger awhile. My fellow traveler.

I'll Spend Time with You (Kimi to Asoban, 1897)
Shimazaki Tōson

Under the shade of young summer leaves,
I want to spend time with you.
My short dream has not come true
but let's sing the night away.

Now it's clouds; now it's rain.
Sad daydreams come incessantly.
But tonight count the stars' light.
Countless is the joy of the night.

Is it a dream or is it real? The Milky Way.
The weaver maiden drowsing in the stars.
How could we miss
the clean sound of the shuttle
echoing in the distance?

Soul's Eclipse (Rei no Hi no Shoku, 1908)
Kanbara Ariake

The door of life is being shut dim without notice.
What is this? The eerie atmosphere that surrounds me.
And how did this happen? Someone has extended the nape
and sucked the fountain of guilt in my heart.

The sweet-smelling flowers close their petals in vain.
The evil fruit ripens and drops, and involuntarily
I smell its lukewarm fragrance at the bottom of my palm.
How unbearably dry my lips are!

Listen. Things have sounds. Flitting wings of locusts
swelling from the bottom of a large swamp—or is it
the sound of poisonous bubbles bouncing on a water surface?

Or is it a rustling of the plague, a stray dog
howling in the palace of lust? Ah, look up
at the faint star of the heart, a soul's eclipse.

Soul's Night (Tama no Yoru, 1905)
Kanbara Ariake

Just before four o'clock p.m. A yellow
winter day. Shadows hang
thin. The bank's doors—
about time to close, now.
Crowds of people overflowing already
gone. This modern
palace of affluence, now,
certainly, time to close—
So, too, are the doors of life.

Meanwhile, the last one,
a merchant in debt,
comes out plodding along.
From his back,
the sound of gold runs,
saying it is vain,
a song of glittering fortune,
the troubled shore mocks
the voice of dazzling waves.

Look, the gold letters on the ledger—
are stars. Fate
swirls without a sound.
No doubt, the comrades
in debt (I too) lead a life

of precarious repayment.
The profound darkness of prison,
the mound of death—Ah, how is it like,
their souls' night?

Daylight Thoughts (Hiru no Omoi, 1908)
Kanbara Ariake

A strip of cloth that a daydream weaves
the weft of joy and the warp of grief
the colors of threads, twisted and disturbed, shriek
and then in intoxication fall dizzy.

Now on the lap under the lamp of rest
lie the woven patterns unrolled. Revealed
at close look are sleeping animals obscure and dangerous
and weary birds—nothing like their natural shape.

Shall I cut it and sew a party dress—
no, better keep it 'til my last day
for a shroud, no, that, too, is crazy.

In life we seek a shroud for the dead
in death the scent of the incense of life; a dream
sways, in the unreal, to the soft waves of a flame.

Grass on the Roofs (Yane no Kusa, 1905)
Kanbara Ariake

The grass on the roofs is dried in drought.
Your nape droops dry under the sun.
With your eyes like dewless tips of leaves
watch the waves of the roofs scorched by the sun.

So this is how heat burns the thatch.
Summer is at its peak in the capital.
Houses and eaves. Thatches and roof tiles.
People inside are silently being steamed.

The roofs over there are joyfully reflecting the heat.
The thatches over here are being baked smiling.

The world of humanity underneath—now
the wheels rumble and the people stir.

They just suffer and only
the trace of decay (hence the lights
of Heaven) remains; since when have they become
feeble grass in the shades of mounds of dust?

Has the grass on the roofs finally dried?
Even so, under the brimming golden
scarves goes dissolving
the splendor of a ruby.

A Wise Diviner Looking at Me
(Chie no Sōja wa Ware wo Mite, 1908)

From *A Leopard's Blood, Eight Poems*
Kanbara Ariake

Today, a wise diviner, looking at me, said;
Your eyebrows show clouds, a bad omen;
your heart weakly succumbs to love—flee
before its clouds and gales run you over.

Ah, flee from where you are, the softhearted.
The roll of a green pasture and even
softer surge of black locks of hair—
How can you accept this?

Close your eyes and see the stretch of sand.
There, in the dusk, a shadow of someone, his head low, walking—
you might take him for an animal wandering starved.

That is you, a shadow fleeing from yourself
on a parched journey monotone and somber.
Well, then, to the whirlpool of fragrance, to the storm of colors.

TRANSLATED BY TAKASHI WAKUI

PART VIII

Interiority and Exteriority

My Grandmother's Cottage

WAKAMATSU SHIZUKO

 Wakamatsu Shizuko (1864–1896), perhaps more than any of her peers, embodies the early Meiji ideal of the woman writer. Highly educated, bilingual, and progressive, she nevertheless lived modestly, dedicating herself above all to her husband and children. Born Matsukawa Kashi in Aizu-Wakamatsu, she witnessed first-hand the tumult that attended the Restoration. Her mother died amid the chaos following the Boshin War, and her father, a samurai in the Aizu clan who had been loyal to the losing Tokugawa army, fled to Hokkaido. Shizuko was sent, at the age of six, to live in Yokohama with a merchant-class couple. Less than satisfied with their taciturn and sickly adopted daughter, Shizuko's new parents enrolled her in a Christian mission school in Yokohama, where she would come to spend most of her childhood and early adult life.

The school Shizuko attended, which came to be known as the Ferris Seminary for Girls, was run by Mary Kidder, a missionary with the Dutch Reformed Church of America. Under Miss Kidder's tutelage, Shizuko received a Western-based education, developing fluency in the English language and an understanding of American customs and values. Despite her progressive Western-style education and her fervent Christian beliefs (she was baptized in 1877 at the age of thirteen), Shizuko never lost sight of her

heritage. In 1886, when she began publishing in *Women's Education Magazine* (*Jogaku Zasshi*), she adopted the pen name Wakamatsu Shizuko. "Waka-matsu" referred to her birthplace and celebrated the pride she held as a member of the Aizu clan, while "Shizuko" (meaning "servile") denoted her position as a "servant of the [Christian] Lord." Shizuko contributed essays in English to the *Japanese Evangelist*—a mission-funded journal intended to acquaint American readers with Japanese culture and the evangelistic efforts under way in Japan. She also distinguished herself as a translator of works by Longfellow, Tennyson, and Dickens. She is best remembered for her translation of Frances Hodgson Burnett's *Little Lord Fauntleroy* (1885; translated 1892). This work opened the door to the entirely new genre of children's literature in Japan. Moreover, the language she crafted both substantially advanced the campaign to invent a modern literary idiom and raised the contemporary artistic level of literary translation, inviting warm praise from the literary luminaries of the time, including Morita Shiken and Tsubouchi Shōyō.

Traces of that language are found in the story translated here, "My Grandmother's Cottage" (Omukō no Hanare), which appeared in *Women's Education Magazine* in 1889. Written with a surprisingly modern diction, the story also utilizes a first-person narrative, still unusual for the time. Nevertheless, Shizuko's grounding in both Protestant and Confucian didactic principles compelled her to end the story with a moral—as if the story itself had not sufficiently conveyed her message.

Shizuko devoted herself assiduously to the improvement of the female condition in Japan by writing and lecturing in Japanese on the topic. In 1888 she married Iwamoto Yoshiharu, journalist, educator, and women's rights advocate, and assisted him with his dual endeavors of managing a private women's Christian academy and editing the journal *Women's Education*. Her early years of poverty, successive childbirths, and constant overwork took their toll on her fragile health, and she died a few weeks before her thirty-second birthday, but not before leaving behind an outstanding record of accomplishments: Japanese essays on education for women and on "home science," English essays on Japanese literature and culture, prose fiction, poetry in both English and Japanese, and, most notably, a series of translations from English into Japanese.

⌒(RC)⌒

It was the spring of my sixteenth year. The maples in the garden were just beginning to put forth buds, and in the evening twilight the wild *fukuju* grass lazily stretched into yellow blooms. The maid from my aunt's house

came by to say that the kimono shop clerk had stopped over with his bolts of fabric. "Wouldn't the young lady here like to have a look?" she relayed the invitation. My mother urged me on, "Okiyo, the collar on your visiting kimono is showing wear. See if you can't find a new one." Thrilled to have my mother's permission, I ran to my aunt's house, which was just across the way from our own.

My aunt had three girls who were about my age. We had been great friends as children, playing all sorts of games. My beloved grandmother, who had raised me since I was a baby, occupied a detached cottage behind my aunt's house, where she lived in quiet retirement. I enjoyed going to see her whenever the mood took me.

That afternoon my three cousins were in my grandmother's cottage. The kimono shop clerk had filled the eight-mat room with his wares, and my cousins were picking through the fabrics with great delight. My grandmother sat in a corner, winding flaxen thread around a spindle while the young women gaily went about their selections, holding up sashes and matching their favorite colors with the patterned and striped kimono material. Although she spoke not a word, the smile on her face seemed to suggest that she too had once been enamored of pretty kimonos—when she was a girl. From time to time her granddaughters held up fabric for her to see. "What do you think of this one, Grandma?" they would ask through their giggles. Each time she would look up over the rim of her glasses and patiently offer her assessment. If they annoyed her, she never let on. I still have not forgotten the scene that day.

No one noticed me come in, so taken were they all with their selections. But soon my cousin, who was the same age as I, called out, "Okiyo! When did you arrive? Take a look at this sash. Isn't the combination of colors irresistible? I'm thinking to line it with lavender satin. You'll buy it for me, won't you, Mother? Won't you? You're buying the *haori* material for Su-chan, after all!"

My aunt fell into an exasperated silence before turning to me, "Okiyo, what will you buy? A kimono collar? I say, shopkeeper, where are your collars? Oh, look, there's a stack of nice ones in that box, there."

"Thank you," I said, as I carried the box over to the corner where my grandmother was sitting. I pulled the collars out one after another until I settled on a dove gray fabric with a cherry petal design. Suddenly my grandmother spoke up—as if she had just remembered it herself—"That's right, Hisa (that's my aunt's name), I wonder if you'd buy a collar for me, too. I've been using this black silk one for more than five years now."

My aunt glanced at us from over her shoulder. "A collar, you say? But you've no need for a new one. I have plenty of old ones that I never wear.

You can have one of those." With that she turned back around to haggle with the shop clerk over the cost of her daughters' purchases. I found her tone of voice and her posture chilling.

I had heard that during my grandmother's time the family finances were tight. My grandmother had to toil through the night, doing piecework for other people, just to ensure that my aunt would have a nice kimono for her flower-viewing excursions. Even now that the family was wealthy, my grandmother still denied her own wants. I never heard my grandmother ask my aunt for anything. Not once in two years, not once in five years. And now all she wanted was material for a new kimono collar. It wasn't too much to ask, even if she did not venture out of the house often. How I regret that my aunt did not buy it for her.

My grandmother went back to spooling the flax. She did not say another word. Her downcast eyes seemed to glisten, and from time to time I thought I heard her sigh. Or perhaps it was the heaviness in my own heart. My grandmother was not the kind to complain of her daughter's avarice, this daughter she had struggled to raise; but I thought if I were in her position I would certainly feel bitter about it. I wanted to give my collar back and ask my mother to buy one for my grandmother instead. But to do so would only insult my aunt. And so that day I simply bade farewell and returned home before the shop clerk had even left.

Two weeks to the day something terrible happened at my aunt's house. My grandmother, who had been uncommonly robust for a woman her age, suddenly passed away, as often happens to old people who are strong. At the funeral, when I beheld her peacefully laid to rest, she was dressed in a white silk-crepe kimono—as pure and spotless as her life had been—and with a beautiful collar of white figured satin. I was reminded of the incident with the collar not so long ago. Her funeral went without incident, and the days passed. Gradually, my grief over the loss of my gentle grandmother began to lessen. One evening, I felt myself uncontrollably drawn to the cottage where my grandmother had spent her days in retirement. Quietly, by the light of the moon, I let myself into my aunt's garden, which I knew so well, and from there I peeked into the cottage. The furnishings were all just as they had been. The chest of drawers that my grandmother had used was there as before. As my eyes slowly adjusted to the darkness, I noticed that someone was standing before the chest. A drawer was open.

Straining my ears, I heard the sound of muffled sobbing. At first I was not certain of what I had heard, but as I peered more intently, I saw that my aunt had pulled my grandmother's under kimono with the faded collar out of the drawer and was crying into it. Again and again she pressed the gar-

ment to her eyes, and, unable to stifle her tears, she wept with all her heart. She did not seem to realize that I was there, and so I softly tiptoed out and returned home.

This aunt of mine, whom I had thought a heartless demon after the incident with the collar, had not really meant to be unfilial to my beloved grandmother. If only she had listened to my grandmother and had done whatever she had asked, no matter how unreasonable her demands, she would not now be suffering this way. But because her foolish stinginess caused her to behave in an unfilial manner, her regret could never be erased.

And so I say to all of you, there is no call for filial behavior after your parents have died. Don't wrap their tombstones in blankets or lavish money on their funerals. Pleasing an old person does not take such great effort. They have raised us since we were babies, and now their arms are tired. Give them rest from their labors. They have loved us selflessly with no thought of reward. Now it is our turn to comfort them in their final days and return the love we have received.

<div style="text-align:center">TRANSLATED BY REBECCA COPELAND</div>

Hilltop

NAGAI KAFŪ

 Nagai Kafū left Japan for the United States in September of 1903 and lived there until July of 1907. At the time of his departure, at age twenty-three, he had already written a number of works under the influence of the Schoolmate Society writer Hirotsu Ryūrō (1861–1928), including a fine novel entitled *The Woman of the Dream* (*Yume no Onna,* 1903). The stories and sketches written in America and collected as *Tales of America* are thought to be the first works that demonstrate Kafū's mature literary voice. Before his departure, Kafū's writing had reflected both his extensive acquaintance with Edo-period fiction and the Zola "fever" that had swept Japanese literary circles at the turn of the century. While both of these influences continue to be felt in *Tales of America,* Kafū's reading of other French writers—including Maupassant, Baudelaire, Loti, Daudet, and Flaubert—while in America clearly affects the themes, motifs, characters, and narrative forms of the stories. The work established Kafū's reputation as an antinaturalist, a writer of decadent romantic fiction that celebrated human desire and artistic excess. It also

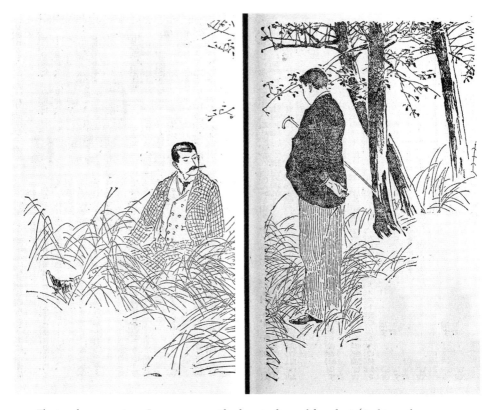

The traveler encounters a Japanese man with whom to discuss life and art. (Archives of Meiji Newspapers and Journals, University of Tokyo)

created a sensation in the Japanese literary world, where dour, didactic naturalism held sway. The real appeal of the work for most readers, however, was no doubt the intimate, highly literate portrait of America it provided to an audience that had previously had to settle for more mundane newspaper accounts.

"Hilltop" is based on the seven months in late 1904 and early 1905 that Kafū spent studying English and French at Kalamazoo College in western Michigan. The pastoral setting and rigid social strictures of the Baptist institution are captured here and in "Spring and Autumn," the other work from the collection set in the Midwest. The natural environment of these stories contrasts with darker pieces set in coastal cities—"A Bad Friend" (Akuyū) in Seattle; "Women of the Night" (Yoru no Onna) or "Long Hair" (Chōhatsu) in New York—perhaps reflecting Kafū's enthusiasm for the vastness of the American continent and the unfamiliar pleasures of rural life. But the theme

of "Hilltop" is one that is repeated throughout the collection: the self-defeating nature of human desire, which tends to dissipate when fulfilled—an idea Kafū apparently garnered from his reading of Flaubert's *L'Éducation sentimentale* at about this time. The depiction of this insight in "Hilltop" seems almost formulaic: Watano's passion for his nurse is as arbitrary as her icy rejection of him once they've married. But Kafū's understanding of the mechanism that triggers these responses is acute, and the epiphanic vision of the butterfly and the napping maid is beautifully realized. The imagery in the story, both in the Michigan countryside and in Japan, is lush yet perverse in a way suggested no doubt by Daudet and Flaubert.

The narrative structure of "Hilltop" is also familiar from elsewhere in the collection. As he does in at least ten other tales of America, Kafū uses a framing technique, embedding Watano's account of his youthful dissipation and unfortunate marriage (the only narrative in *Tales of America* set in Japan) within the nameless narrator's description of life in Kalamazoo and his friendship with Watano. The device is borrowed from Maupassant's short fiction, which absorbed Kafū during this period, and is perhaps overused in an attempt to create the illusion of aesthetic distance—possibly in reaction to the overly personal, subjective fiction of Japanese naturalism. The Kafū surrogate narrates many of the tales of America but remains an outsider to the action, objectively observing local customs and the (often sordid) interactions of his fellow expatriate Japanese. But it is also possible, in a story such as "Hilltop," to see the device as Kafū's way of reconciling art and life, of depicting the intimate storytelling situation as the proper subject of art and the storyteller as romantic hero. The final gesture in "Hilltop," Watano's promise to complete the open-ended narrative by sending the narrator a pictorial message, suggests the narrator's elevation to the crucial role of sympathetic friend in a lonely world, a world where stories provide an occasion for connection. This notion no doubt appealed to Kafū as he wrote in American exile, just as it must have pleased the audience for the stories he sent back to Japan.

☙(ss)❧

PART 1

When I first came to America, I spent some time studying language at a college in a small town of less than four thousand people about a hundred miles down the Mississippi River from Chicago. It is common knowledge that most American colleges are run by religious denominations and are

built in the countryside, far from the temptations of the city, so that the students and teachers can pursue a religious life. Such was the school I attended, and because of the remote location, I had thought it unlikely that I would meet any other Japanese. Yet I did meet one, a man who was leading a strange and troubled existence in that out-of-the-way place.

It had been four hours since we left Chicago, but all we had seen were cornfields, stretching out to the horizon in every direction. At last the train stopped at a tiny station in the middle of this vast prairie, and I got off, carrying my heavy bag. I made my way along the main street of the town, past the chickens and the children at play, until I came to the college, which was situated atop a small hill and surrounded by a thick growth of trees. The elderly president of the school greeted me, barely glancing at the letter of introduction I had brought from an acquaintance in Chicago.

"I'm delighted you've come," he said, smiling as if we were already old friends. "And I'm sure Mr. Watano will be happy to see you as well. In the three years he has been here among us, he has not seen another of his countrymen." I was at a loss, not taking his meaning at first, but the old gentleman continued, the smile never leaving his face. "Did you know Mr. Watano in Japan? Or did you meet after coming to this country?" Because I was Japanese, he had assumed I'd come to visit my compatriot here at the school. His mistake was soon cleared up, and after we had shared a laugh over it, I was taken to meet Mr. Watano.

He appeared to be in his late thirties. He was dressed simply, in a well-worn, striped suit and faded black tie—not the fashion one encountered in a gaudy city like Chicago—but he struck me as quite handsome, with his shiny black hair grown long in the American manner and a pair of gold-rimmed spectacles perched on his nose. He would have made a beautiful woman. His complexion was very fair, one might even say pale, and his large eyes seemed nervous and oversensitive.

Contrary to what the school president had led me to expect, he seemed neither pleased nor particularly surprised to see me, and after shaking hands in silence, he made a point of staring at the ceiling. To be honest, we were well matched in this sense, for I, too, tend to be quite unsociable. Consequently, I learned nothing about him at this point, except that he was assisting with the collection of materials on the history of Oriental thought for the department of philosophy, and that he occasionally attended Bible study. In fact, I saw no more of him until one Saturday afternoon three months later.

I had come to the school in the last days of September, when the air was still warm and the cornfields were a sea of deep green. Now, however, they had become a dry plain, stretching out endlessly under the gloomy gray sky. It was just after four o'clock on Saturday afternoon, but the sun had already

sunk below the horizon, leaving only a faint streak of crimson light. The wind had died, but a bone-chilling cold seemed to rise from the barren fields. I was climbing a hill near the school on my way back from the post office at the station when I saw Watano. He was standing beneath the lone, naked tree at the top of the hill, watching the sun as it disappeared beyond the frozen prairie, and the look on his face was unspeakably sad. He noticed me at last.

"How desolate," he said, turning to look at me. Startled by his strange manner, I was unable to reply. He looked away and went on, as if talking to himself. "They say it's sad to watch the sunset by a grave, simply because it reminds you of death. . . . But look at this view: dusk in this wilderness makes you feel the whole sorrow of human existence. . . ." Without another word, we made our way slowly down the hill. Then suddenly he turned to me again. "Tell me," he said, "do you think our purpose in life is to seek pleasure?" He paused and watched me intently, as if afraid that his question had been imprudent. "Do you believe in the Christian god?" he said at last.

I told him that I wanted to believe but as yet I was unable to, that I was sure I would be a happy man when I could believe. My reply seemed to animate him.

"You're a skeptic, then," he said, waving his arms wildly. "That's fine!" But then his voice grew quiet again. "What sort of skeptic?" he asked. "I myself don't have the sort of faith the Americans have. . . . But I'm curious to hear what you think." So I told him my views on life and religion, and as I spoke, his eyes seemed to light up with delight, apparently at the great degree of agreement between his ideas and my own. When he spoke again, it was to praise me in the warmest terms.

There is perhaps nothing more pleasant than the discovery of a like-minded individual, the sharing of ideas and opinions inevitably resulting in a feeling of mutual intimacy. So it was that we became fast friends, continuing our discussions day and night; and in due course I came to know something of Watano's history without ever directly questioning him. He was, I learned, the only son of wealthy parents. He had come to America seven years earlier and had taken a degree at a university in the East; afterward, as he had found nothing he wanted to do, he spent some time amusing himself in New York. Eventually, he happened to meet the president of this college, who told him they were looking for a Japanese person to assist in research on Oriental thought and customs, and he had decided to come. He had, he said, no particular knowledge of Oriental learning but felt he could at least help with collecting materials. His real purpose, however, had been to overcome his skepticism and gain the assurance of true faith; and for this reason he had chosen a remote spot where he could lead a quiet, spiritual existence. I knew that he could have returned home to live a life of leisure, so I could

not help but admire his decision, born of his very real anguish, to remain here alone in this foreign land.

PART 2

I passed that cold American winter quietly and agreeably in the company of this new friend for whom I came to have great respect. But at last April came, and after Easter the days grew warmer. Then came May, with its balmy skies, so welcome after the unbearable cold of winter. The prairie, which only yesterday had been unsightly and drab, was suddenly covered in tender young grass, a sea of bright green beneath an azure sky.

I walked endlessly that spring, wandering through apple orchards, white with blossoms, to lay in the meadows with the cows on their soft bed of clover; or stopping by a brook, drunk with the scent of violets, to sing with the meadowlarks. In the afternoons, well-to-do farmers would hitch up their carriages to bring their families out to enjoy themselves, and the fields would be filled with the laughter of women and children. One person was missing in this lovely scene, however—my friend Watano. As spring approached, he seemed to grow more forlorn, hiding himself away in his room and refusing to join me on my walks.

One evening I went to visit him, thinking I would force him to tell me the cause of his melancholy and perhaps find a way to comfort him, but when I reached the door of his boarding house, I hesitated. I realized that I still knew very little about him; and just as one feels a mixture of admiration and dread when meeting a famous man or a hero, so I now felt a certain discomfort at the prospect of confronting Watano. Turning away, I walked off into the spring night and wandered until I came once more to the top of the hill where I had first spoken with him that winter.

The lone tree, which had been so barren and lifeless that day, was now a cloud of indescribably fragrant apple blossoms. I stood in the soft grass and looked up at the hazy disk of the moon hanging over the vast plain. Its pale light was caught, here and there, in the puddles that dotted the ground. Behind me, I could hear music from the college, where the girls must have been amusing themselves; and nearby, the windows of the houses in town glowed with a warm light—the very image of a magical spring night in a faraway land. I was seduced by the scene and had fallen into a quiet reverie, when suddenly someone tapped on my shoulder and spoke my name. It was Watano.

"I was just at your place," he said, his voice sounding urgent.

"At my place?" I echoed, stopping short of telling him that I had nearly knocked on his door.

"I have something I want to tell you," he said.

"What is it?"

"Let's sit here," he said, settling down under the apple tree. For a time he was silent, perhaps struck as I was by the mystery of the prairie cloaked in the spring night. At last he turned to me. "I'm afraid I will be saying good-bye to you in a few days."

"You're going away?"

"Back to New York, or perhaps to Europe. In any event, I've decided to leave."

"Has something happened?"

"No, it's just that I've been thinking about things," he said, sounding quite dispirited.

"About what?" I asked. He paused for a moment.

"That's what I wanted to tell you this evening. I've known you for barely half a year, and yet I feel as though we've been friends a long time. So I wanted to tell you everything before we part; though we may perhaps meet again when you finish your trip across America, as you've said you plan to do." He smiled sadly and then continued in a quiet voice.

PART 3

"Soon after I graduated from the university, I took my leave from my father and received my share of his property. Thus, I was suddenly in the happy position of having my own means and being able to do whatever I wanted. I had studied literature at the university, and so, at the urging of a number of friends, I decided to form a society and publish a monthly magazine de-voted to the consideration of social problems.

"I had occasionally contributed articles to various journals and newspapers while I was still at school, and so my name was not unknown. Now, with the help of my inheritance, I was able to make a fine start. The organization represented by our journal was made up entirely of young men who had recently graduated and were just starting out in life. Nevertheless, from the time we began to advertise, before the first issue was published, our journal was considered to be one of the most influential. As a result, there were soon those who started to flatter me, and, I must confess, at the time I had ears for little other than their praise.

"I was twenty-seven years old and still single. I do not know whether they were true, but I began to hear rumors that the daughter of a certain count had become lovesick after hearing one of my lectures, or that there had been some sort of disturbance at a girls school set off by an argument about me. In fact, I even received a number of love letters. Accordingly, I

became convinced that I had some sort of strange power over the opposite sex, a discovery that pleased me to no end—more even than my earlier realization that my opinions were being taken seriously in the world at large. I realize now how foolish this must sound, but I'm only telling you that this was how I felt at the time.

"Still, the pleasure I took in my newfound power soon led me to want to put it to the test. An inner voice told me that I must not marry; for I knew, from a man's perspective, that even a relatively plain maiden was far more alluring than the most beautiful woman once she had become someone's wife. Having no reason to think it would be any different with me, I decided to listen to this voice. I learned to pay careful attention to my appearance before going out. By day, I was abroad in society but constantly bewitched by the smiles of beautiful women; at night, I sought out the brightest, noisiest places, where a different sort of woman was entertaining. And so several years passed like a dream.

"One day, I found myself in the company of three women of questionable reputation at a quiet geisha house by the sea—a place where we could avoid the prying eyes of Tokyo. It was dusk, sometime in winter, and I remember waking from a nap to find my head cradled in the lap of my favorite of the three. She was dozing as well, her head resting against the wall behind her. There was no sign of the other two. The room had grown dark, and the only sound was the low moaning of the distant tide.

"I let my eyes close again, and considered my situation. I realized that no one could possibly have imagined where I was or what I was doing. I was known in the world as a man who championed virtuous causes, not as a womanizer, and the realization that my reputation was based on such a sham was sad and unpleasant. Nor was this the first time I had experienced this sensation; from the beginning, I had known that the pursuit of such pleasures was not something admirable or worthy of cultivation, not something to be bruited about in public as one might with one's charitable works. But I had been able to keep my secret up to this point, skillfully concealing my amorous activities; and I thought it would be simple enough to go on this way, for who can get along in the world nowadays without being able to keep a secret? In that respect, I suppose you could have called me quite clever. At that moment, however, I began to wonder what it might be like if I no longer had this secret, if I were as pure as I seemed. Would I find happiness if I were suddenly as virtuous as the world imagined me to be? I decided that I would try, since secrets, like relatives, tend to become a burden.

"And so it was that I finally came to repent and renounce worldly pleasures; and at the same time I decided that I should find a good and wise

woman to marry, one who could support me in my resolve to avoid the dangers of single life."

PART 4

"So what sort of woman did I choose? She was a nurse, someone I had hired on my doctor's advice when I was down with a bad cold. She was twenty-seven years old and virginal, rather tall and extremely thin. I wouldn't have described her as ugly, but she was completely lacking in the sort of charms that capture a man's heart. Her cheeks were almost sunken, her skin snow white, and her large, sad eyes were forever downcast, as if she were deep in thought. I gathered that she had been orphaned at a young age and was, as a consequence, deeply religious.

"During my illness, I often woke at night, and invariably I found her reading the Bible in the yellow light of the lamp. The sight of her prim, pale figure sitting beside my bed in the dead of night filled me with an indescribable sense of peace—a noble feeling that I felt could only come from someone who dwelt on a higher plane than the rest of us. If I were to marry such a woman, I found myself wondering, what sort of influence might she have on me? And I quickly concluded that I could have no one else. As soon as I had recovered, I asked her to marry me.

"She was clearly shocked by my proposal, but she managed to keep her composure as she quietly refused. I, however, took her hand and poured out all my past sins, telling her that only the love of a virtuous woman could save me from the worldly vices and give meaning to my existence. She listened intently and then burst into tears as she began to mutter a prayer. You may laugh, or think me out of my mind, but at that moment I honestly believed that she had been sent from heaven to save me.

"Of course, I could not have been more badly mistaken, and it was a mistake that gave rise to still greater misfortune. In the beginning, I clung to her as the source of my salvation, and I tried desperately to love her. But it was no use: I felt nothing, no passion, no tenderness. At most, I respected her, but I knew that our two souls would never be united.

"Then, in spring, we went walking in the garden. It was a glorious day, and I had been trying to draw her out on various topics. The sky was jewel-bright above clouds of cherry and peach blossoms; the birds were singing with all their might—just the sort of day to enflame my youthful ardor. So, as we were sitting down in an arbor beneath the flowers, I took her hands in mine and kissed her on the cheek. She didn't resist me, but her skin, always white as snow, now felt cold. I had worked myself into a heat of passion, but

as my lips touched her, they instantly cooled. She was a marble statue. I let go of her hands and stared at her. She returned my look with a sad smile—a smile that made me shudder—and though I could not have said why, at that moment a feeling of revulsion welled up inside me.

"I left her there and wandered off toward a grove of trees; and I can only imagine that she went on sitting as before, her melancholy eyes glancing occasionally up at the sky. A short time later, I heard her quietly singing a hymn, and again I found myself inexplicably repelled. I was baffled. Even in my profligate days, I had always found hymns to be a most comforting sort of music, overhearing them as I had through the windows of a church on a quiet night. So why should they sicken me now? Feeling utterly confused and miserable, I walked through the grove and headed toward the back of the house.

"I came to the large kitchen garden, a place I dearly loved, especially under the summer moon when the melon and bean vines were covered with blossoms. But now they had just been planted, and there was nothing to see but a smooth patch of earth; and with nothing to obstruct it, the bright spring sun beat down, warming me until I began to perspire. Her hymn had faded, replaced by the songs of the swallows darting across the sky. In spring, it sometimes happens that the middle of the day may be even quieter than the dead of night. And so it was now, as my troubled thoughts seemed to melt away, and I stood staring at the clouds drifting along the horizon. After a moment I roused myself and made my way toward the house.

"A mass of peach blossoms rose up before my eyes, and from among them, the vision of a woman. I stopped short. The flowers nearly obscured the roof of the house; but beneath them, through a low, open window, I could see a woman napping peacefully, her head resting on her folded arms. The spring sun shone through the canopy of blossoms, dyeing the woman's face an indescribable shade of red, and from my vantage point I would have sworn I was looking at a painting.

"It was one of the maids, a girl of nineteen who had come into service the month before in order to learn proper manners. But her circumstances were the farthest thing from my mind, for at that moment an exquisite butterfly came fluttering into the scene and landed on the woman's marvelous crimson earlobe, perhaps mistaking it for a flower petal. I was utterly entranced. I have no idea whether I had fallen in love with her, but my raging blood urged me forward to touch her cheek, which seemed to be on fire. As I drew near, however, she suddenly opened her eyes, looked around, and, catching sight of me, vanished into the next room.

"The incident in itself was unimportant, but its effect on me was profound. Without even fully realizing it, from that day on I began to look back

at my former life of pleasure. My ears could once again hear gay music and the murmuring of beautiful women; my eyes could see them flutter by in their gaudy robes. But as for the woman I had once worshipped as the very embodiment of my salvation, the woman I had all but forced to marry me— she had vanished from my thoughts. Had that been the end of it, I might still have been able to forgive myself; but my dislike for her deepened to hatred. I fought against this evil feeling, and I made every effort to conceal it from her, but it was useless. Though she never spoke of it, or gave any sign that she knew, you could see it in her sad, downcast eyes. I grew to fear her company and sought to avoid her; and she, for her part, took to shutting herself away in her room. The whole unspeakable situation made me want to weep.

"I knew that things could not go on this way, that having once taken her as my wife, I was duty bound to love her. But the more I struggled against my revulsion, the more it grew, until finally I feared I might lose my mind. One night I was startled from a sound sleep. I heard a noise, and for a moment I thought I saw her sitting next to my bed in her nurse's uniform. Then, from somewhere, I could hear a voice reading from the Bible. The sound was somber and unearthly, and it caused me to leap up from bed. I fumbled for a match and lit the lamp, but the room was empty and the quiet of the night settled once more around me.

"From that night on, I often heard that gloomy voice, and I found it difficult to get to sleep. It occurred to me to try sleeping next to my wife, the way we had when we were first married, but that was worse still. As the night wore on, I was still wide awake. I could feel the chill from her body, cold as stone, lying next to me. It seemed to sap the warmth from me, and I feared that if I stayed there any longer my senses would be numbed, that I might never again take pleasure in the sight of a beautiful flower or in the taste of warm sake. I rubbed my body, trying to warm myself, but it was no use. If I fell asleep now, I thought, I might never wake; and tomorrow, I would not see the warm sun on the flowers or hear the birds sing. The thought left me unable to close my eyes.

"Some time later, I became aware of her shallow breathing. From time to time it seemed to stop altogether, as if her soul were flying off through the quiet night toward the heaven about which she was always dreaming. Without thinking, I reached over to touch her chest. She lay utterly still, her hands clasped tightly together, and when I touched her, I felt something ice cold. My hand drew back, but when I reached over again I realized it was the gold cross she wore around her neck day and night.

"After this, I was unable to sleep at night and grew terribly fatigued, my only rest coming in the form of an occasional nap. And so I decided that I

would have to leave her. As long as we were together under the same roof, I was doomed to this miserable existence. I concluded that I had no choice but to travel, and I decided it would be best to go abroad. One day I suddenly announced that I would be going to America, ostensibly to study; and she, true to form, raised no objection whatsoever, almost as if she knew what I was thinking. Though she tried to refuse, I forced her to take a third of my estate for her living expenses, and I came to this country with no particular aim in mind.

"There is no need to tell you what has become of me since then. You know well enough that this is a country where one encounters the best and worst in human society, where one can follow his inclinations in whichever direction they might lead. There is little here to distinguish between a life of debauchery, hidden away in an opium den, head pillowed on the shoulder of some naked beauty, and a spiritual existence such as this one, far away from the blandishments of the world, where we can sit in this pasture and hear the peals of church bells.

"I have seen a good deal of this country and have no need to linger on here. I can go back to Japan at any point and resume my former activities, no doubt with even greater success than before. But the questions remain. Would I once again be haunted by memories of the pleasures that the world can offer? And could I live happily with my ice-cold wife? The answer, of course, is that I could, given sufficient self-control. But would I ever be truly satisfied with such a life? And if I couldn't resist temptation, if I ended by opening the Bible in the morning with the same hand that secretly lifts my sake cup at night, then wouldn't it have been better to choose the latter right from the start? Self-control is meaningless except as a way of demonstrating one's willpower. So it is that the greatest saints are to be found in prisons, since men do no wrong without the opportunity.

"I have spent three years here in this lonely Illinois countryside, but I am still troubled by doubts. I am going off to see the bright lights of the city one more time, and then I'll decide what sort of life to lead. Tomorrow, we'll say good-bye, but soon I'll send you one of two photographs to let you know my decision. If I have truly overcome my desire for worldly pleasures, you'll receive the wedding picture I had taken with my wife. If not, it will be a picture of some charming young thing, a French dancer perhaps. And that's how you will know the sort of life I've chosen."

TRANSLATED BY STEPHEN SNYDER

Short Pieces from Long Spring Days
NATSUME SŌSEKI

 Natsume Sōseki was born in Edo in 1867, the year before the city became the capital of Japan and was renamed Tokyo. Partly because his life perfectly straddled the Meiji period (he died four years after the Meiji emperor's death), and especially because his novels express so well the emotional and philosophical dislocations of that watershed era of industrialization and modernization, Sōseki is often thought of as the ultimate twentieth-century Japanese intellectual and writer. At one time his portrait was featured on the one thousand *yen* note.

Sōseki studied English literature at Tokyo University and taught English in provincial schools for several years before he was sent by the Japanese government to study in London, in 1900. His unhappy stay in England persuaded him that he should do his own writing, rather than compete with English scholars in the study of English literature. Returning to Japan in 1903, he succeeded Lafcadio Hearn at the First Higher School and Tokyo University, where he lectured on literary theory and criticism. While teaching, he began to write fiction. In 1907, after publishing several well-received novels and short stories, he gave up teaching, accepted a position with the *Asahi Shinbun* newspaper, and devoted himself to writing. With the *Asahi,* he not only serialized his own novels on the pages of the newspaper, but also fostered the careers of a number of promising young writers.

Every Thursday evening, beginning at 3:00 p.m., Sōseki hosted an open house for aspiring authors at his home. Those who benefited from his encouragement included the poet and novelist Nagatsuka Takashi, who is mentioned in "Copper Pheasant" below, and, most famously, the short story master Akutagawa Ryūnosuke.

Sōseki is best remembered today for his novels, particularly *Botchan* (1906), *The Three-Cornered World*, *Sanshirō*, and *Kokoro*. As he matured as a writer, his prose grew more spare and his tone increasingly unassuming, as his narrators look with ironic detachment at the humor, irony, and alienation of his characters. He wrote relatively little short fiction. *Ten Nights of Dream* (*Yume Jūya*, 1908) presents short accounts of ten more or less bewildering and disturbing dreams. *Short Pieces from Long Spring Days*, the collection excerpted here, was serialized in the *Asahi* from January through March 1909, and published in book form in 1910. It consists of twenty-nine sketches and stories, some apparently fictional (such as "Persimmon"), some apparently based on his own experiences and those of people he knew (for example, "Copper Pheasant"), and some nonfictional, such as his sketches of

William James Craig, his first English tutor in London. "Snake" is set near the Inari Kiō Shrine, in what is now Shinjuku Ward, Tokyo, and near which Sōseki lived for several years when he was a small child. This may lead the reader to assume that the story is semi autobiographical, but there is no evidence one way or the other. It is probably best read simply as an intriguing insight into a child's perceptions of the world.

Also noteworthy is a talk Sōseki delivered at Gakushūin University in 1914, "My Individualism" (Watakushi no Kojinshugi), in which he explained his own views on personal responsibility and freedom directly, rather than through a fictional character. He also wrote poetry in Japanese (mainly in the haiku form), Chinese, and even in English. Sōseki's last novel, considered by some to be his finest, is *Light and Dark*, which he left unfinished at his death.

Several references in the stories translated here should be explained. Two celebrated painters are mentioned in "Copper Pheasant," Watanabe Kazan (1793–1841), a pioneer in Western-style Japanese painting, and Yokoyama Kazan (1784–1837), a Kyoto master. Hoashi Banri (1778–1852), mentioned in "Voice," was a Confucian scholar.

⌒(AHC)⌒

SNAKE

When I opened the garden gate and went out front, big hoof prints in the road were full of rainwater. With each step I took, the sound of mud flew up and clung to the soles of my feet. It was almost painful to lift my heels. Carrying a wooden pail in my right hand made it awkward to walk. When you're unsteady, you want to drop everything so you can regain your balance from the waist up. In spite of myself I planted the bottom of the pail in the mud with a squish. About to fall over, I braced myself on the handle and looked down the road. Uncle was about six feet ahead of me. A straw raincoat covered his shoulders, and from them hung the bottom of a triangular net. His sedge hat moved a bit. He seemed to say from under the hat that the road was in terrible shape. The shadow of his raincoat was blown by the rain.

When we reached the top of the stone bridge and looked down, black water came pushing up through the weeds. The stream was murky today, though normally it was clear, with long water plants swaying lazily at the bottom, and the water no more than three inches above the ankle. Churning up mud from below, struck by rain from above, forming swirls and eddies in the center, the stream rushed past. Uncle studied the eddies for a while.

"We're gonna catch some," he murmured.

We crossed the bridge and turned left. The eddies spread, making their serpentine way through fresh, green paddies. There was no telling how far the current would push. We followed it more than one hundred yards, then stood, just the two of us, alone in the middle of the vast paddies. I could see nothing but rain. Uncle looked up from under his hat. The sky had been sealed off darkly, as if with the lid of a teapot. From somewhere up there the rain fell without a break. Standing still, we listened to the sound of the rain striking our straw capes and sedge hats and the paddies on all sides. We could even hear it striking Kiō Wood, visible in the distance.

Atop the wood, black clouds had been summoned to the tips of the cedars, forming deep piles that drooped toward the ground under their own weight. Now the legs of the clouds were clinging to the heads of the cedars. The clouds seemed about to drop into the trees.

Looking at my feet, I saw eddies flowing endlessly toward me from the headwaters. The pond behind Kiō Shrine must have been struck by those huge clouds, for the eddies had suddenly grown stronger. Watching the swirls, Uncle said again, "We're gonna catch some," as if he had already caught something. Then he went down into the water, still wearing his straw raincoat. For all its frightening energy, the water wasn't all that deep. It soaked him up to his waist as he stood. Uncle settled himself in the middle of the river. Facing upstream, toward Kiō Wood, he lowered the net from his shoulders.

Standing still in the sound of the rain, we stared at the eddies as they surged straight toward us. Surely some fish had been washed from the pond at Kiō and now swam below these eddies. We watched the frightful color of the water intently, thinking we could catch a big one if all went well. The water, of course, was murky. There was no way of telling from the movement of the surface what might be carried along in the current below. Even so, I waited without blinking for Uncle's wrist to move, as he stood immersed at the edge of the water. But his wrist did not move.

The rain gradually darkened. The color of the water grew heavier. The swirling patterns surged toward us from upstream. At that moment, in the dark waves that passed sharply before my eyes, I glimpsed a shape of a different color. Catching the light in a less than a blink, it gave the impression of length. That's one big eel, I said to myself.

Uncle had been standing against the current, grasping the handles of the net. Suddenly his right wrist moved, as if it were on a spring, from under his cape to above his shoulder. The long thing came out of Uncle's hand. Through the ceaseless, dark rain, drawing a curve like that of a heavy rope, it landed on the opposite bank. A snake reared its head abruptly, about a foot out of the grass. Holding this position, it glared at us.

"Remember."

The voice was undoubtedly Uncle's. The snake vanished into the grass. Uncle, his face pale, was staring at the spot where he had thrown it.

"Uncle, was it you who said 'remember,' just now?"

Uncle turned toward me. In a soft voice, he answered that he didn't know who it had been. Even now, whenever I talk to my uncle about this, his face takes on an odd expression and he replies that he doesn't know.

PERSIMMON

There's a child called Kii-chan. She has smooth skin and bright eyes, but her cheeks lack the freshness of a healthy child reared in a normal family. Her complexion is a bit sallow. The lady hairdresser who makes regular calls at the house blames this on Kii-chan's mother: she dotes on the child too much and won't let her go out in front to play. Even now, when a simpler, Western-style coiffure is in fashion, Mother has her hair done every four days, without fail, in an old-fashioned, Japanese-style chignon; and she always calls her daughter "Kii-chan," "Kii-chan," using the affectionate diminutive *chan*. Besides Mother, there's Grandmother, who has the simple bangs of a widow; she, too, calls the child "Kii-chan." "Kii-chan, it's time to go to your koto lesson"; "Kii-chan, you mustn't stray out to the street and play with those children."

As a result, Kii-chan has hardly ever gone out front to play. True, it's not an especially good neighborhood. In front is a salt-cracker shop. Next to that lives a tile maker. A little farther down are a clog repairman, a tinker, and a locksmith. Kii-chan's father, however, is a banker. A pine tree grows inside the wall. Every winter a gardener comes to spread dry pine needles on the surface of the little garden.

Having no alternative, Kii-chan goes out back to play when she feels bored after school. The back is where Mother and Grandmother do their starching. It's where Yoshi does the laundry. It's where a young man with a dashing cloth tied around his head lugs in a mortar and pounds rice cakes at the end of the year. It's also the place where they sprinkle salt on pickling greens and press them into a keg.

Kii-chan comes out here and plays with Mother, Grandmother, and Yoshi. Sometimes she comes out alone, if she has no one to play with. At these times she often peers through the straggly hedge to the tenement beyond.

The tenement contains five or six units. Since the ground drops off several feet behind the hedge, Kii-chan has an excellent view when she peers down. In her child's heart, Kii-chan takes great pleasure in looking down at the tenement this way. She reports what she sees. When a half-naked Tatsu,

an employee of the munitions factory, is drinking sake, she tells Mother, "He's drinking sake." When Genbō the carpenter is sharpening his ax, she informs Grandmother, "He's sharpening something." "They're arguing." "They're eating baked sweet potatoes." Yoshi bursts out laughing. Mother and Grandmother laugh, too. Making others laugh like this gives Kii-chan great satisfaction.

Sometimes when Kii-chan is peering out back, her eyes meet those of Genbō's son, Yokichi. They'll talk about one time in three. Being who they are, however, Kii-chan and Yokichi don't get along. They always fight. "What d'ya want, eh, fat face?" Yokichi will say, and Kii-chan, tossing her round chin in contempt, will say, "Snotty brat! Pauper!" Once Yokichi got mad and thrust a bamboo pole at her from below, causing the startled Kii-chan to run into the house. The next time, Kii-chan dropped a rubber ball, prettily stitched with wool, which Yokichi picked up and wouldn't return. "Give it back, throw it to me," she insisted, but Yokichi, standing his ground, glared up at her with the ball in his hand. "Apologize," he said. "If you apologize, I'll give it back." "Why should I apologize? Thief!" said Kii-chan. She ran to Mother, who was sewing, and burst into tears. Upset, Mother sent Yoshi formally to retrieve the ball, but Yoshi came back saying that Yokichi's mother had merely sent an apology. Kii-chan never recovered her ball.

Three days later, Kii-chan went out back clutching a large, red persimmon. Yokichi, as usual, approached the base of the hedge. Kii-chan thrust her hand through the hedge and offered to give the red persimmon to him. Yokichi glared up at it. "What do I need with that? Eh?" He stood stock-still. "You don't want it? All right." Kii-chan pulled her hand back through the hedge. "Eh? Eh? I'll slug you," said Yokichi, drawing closer to the base of the hedge. "Do you want it, then?" Kii-chan held out the persimmon again. "What do I want with a thing like that," said Yokichi, looking up with wide eyes.

After this exchange was repeated four or five times, Kii-chan said, "You can have it, then," and dropped the persimmon below the hedge. Yokichi snatched up the muddy fruit and took a huge bite.

His nostrils trembled. His thick lips twisted to the right. He spat out the bite of persimmon. A fierce hatred gathered in his eyes. "It's bitter!" he cried, and threw the persimmon at Kii-chan. It sailed over her head and struck the shed behind her. "Glutton," she said, and ran inside. Soon, Kii-chan's house echoed with laughter.

COPPER PHEASANT

Part 1

Five or six of us were seated around the brazier, talking, when a young man unexpectedly came calling. I'd never heard his name before, never met him—he was a complete stranger. He hadn't even brought a letter of introduction. He simply came to the door and asked to see me. I had him shown in. When he entered the room where we all were gathered, he was carrying a copper pheasant. After the initial introductions were over, he presented the pheasant as a gift, saying it had been sent from his home in the country.

It was a cold day. We immediately set about making pheasant soup, which we then ate. The youth had gone into the kitchen and pulled out the feathers himself, carved the meat, and cracked the bones for us. He had a long face with delicate features. Eyeglasses with thick lenses shined below his pale forehead. More remarkable than his nearsightedness or his dark moustache, however, was the formal divided skirt he wore over his kimono. Made of a Kokura weave with wide stripes, it was far showier than one expects to see on an ordinary student. With his hands resting on it, he told us he was from Nambu, in the northeast.

The young man came again about a week later. This time he brought a manuscript he'd written. It wasn't very good, and I told him so directly. He would rewrite it, he said, and took it away with him. He brought another manuscript the following week. Each time he came, he'd leave something he'd written. He even brought a long trilogy. That was the worst of all. I was able to place one or two of his best pieces in a magazine, but this was only due to the kindness of the editors; he apparently didn't receive any money at all. That's when I heard about his financial difficulties. He said he intended to scrape out a living by selling his writings.

Once he brought a strange gift: dried chrysanthemum blossoms, pressed into thin sheets like seaweed. One of the fellows who happened to be present boiled them, saying they were a vegetarian substitute for dried anchovies. We ate them with sake. Another time he brought an artificial stalk of lily of the valley. His younger sister had made it, he said, twirling between his fingers the wire that formed the core of the stem. This is when I learned that he lived with his sister. Together they had rented a second-floor room above a firewood dealer, from which his sister commuted every day to her embroidery lessons. The next time he came, he brought a necktie with a grayish-blue knot, embroidered with white butterflies and still wrapped in newsprint. He left it behind, saying he would give it to me if I'd like to wear it. Asuno asked for it and took it with him.

He came a number of other times. He'd always talk about his home—the scenery, the customs, legends, old-fashioned festivals, and so on. He told me that his father was a scholar of Chinese. He said he was good at seal engraving. His grandmother had been in service at the late daimyo's mansion. She was born in the year of the Monkey. A great favorite of her lord, she received monkey-related gifts from him. One of these was a scroll painting of a gibbon, done by Kazan. Next time he would bring it to show me, he said. Then the young man stopped coming.

Part 2

Spring passed and summer came, and I gradually forgot about the young man, when one day—a day so hot I could barely stand it, even though I was only wearing an unlined robe and reading in the coolest room in the house—he suddenly appeared.

As usual, he wore that showy divided skirt. He carefully wiped the perspiration from his pale forehead with a hand towel. He appeared to have lost a little weight. It pained him to trouble me, but could I possibly lend him twenty *yen*? A friend of his had been hospitalized with a sudden illness, he explained, but for now the problem was money. He had done his best to raise some, but without success, and so reluctantly he had come to me.

Setting my book aside, I looked intently at the young man's face. His hands resting politely on his knees, as before, he said "please" in a whisper. I asked if his friend's family was as poor as that. No, but they lived so far away the money wouldn't arrive in time, and so he was turning to me; it should come within two weeks, and he would pay me back then. I agreed to provide the money. Unfolding a piece of cloth, he took out a hanging scroll. "This is the Kazan I told you about," he said. He unrolled a long, narrow painting mounted on paper. I couldn't be sure whether it was any good or not. I consulted a book of seals, but the seal on the scroll didn't match either Watanabe Kazan or Yokoyama Kazan. The youth said he would leave the scroll with me. I said that wasn't necessary, but he left it anyway. He came for the money the next day. I heard nothing more from him. The promised two weeks passed, and there was no sign of him. I might have been swindled, I thought. Autumn came, and the gibbon scroll still hung on the wall.

With the season for lined kimonos and sober thoughts came Nagatsuka, as always asking for a loan. I didn't like lending out money so often. Suddenly I remembered the young man. I told Nagatsuka about the money and asked if he'd be willing to go claim it; if he were successful, I'd lend it to him. Scratching his head, Nagatsuka hesitated a bit, but then seemed to

make up his mind and said he would go. I wrote a letter asking the youth to give the money to the bearer, and sent Nagatsuka on his way with the letter and the gibbon scroll.

Nagatsuka came back by rickshaw the next day. He immediately produced a letter. Taking it, I saw that it was the one I'd written the day before. It was still sealed. "Didn't you go?" I asked. Frowning, Nagatsuka answered, "I went, but it's no good. Tragic. The place is a shambles, his wife does embroidery, the fellow is sick . . . I couldn't very well bring up the subject of money, and so I told him not to worry and returned the scroll to him." "Is that right?" I said, a little surprised.

The next day a postcard arrived from the youth, apologizing for having lied to me and confirming that he'd received the scroll. I put the card in a box with some other correspondence. Then I gradually forgot him again.

Winter came. We busily greeted the New Year, as usual. I was working one day during a break between guests, when the maid came in with a round parcel wrapped in oil paper. It landed on my desk with a thud. The sender was the young man I'd forgotten. Unwrapping the oil paper and tearing away the newsprint, I found a copper pheasant inside. A letter was attached. For this reason and that, he had returned to his home in the country. He would repay the money when he arrived in Tokyo in March. Stiff with the pheasant's blood, the letter had been hard to peel off.

It was a Thursday, the evening when young people gathered at my house. I sat with five or six of them around a large table, eating pheasant soup. We prayed for the success of the pale youth who wore the showy Kokura fabric. After the others had left, I wrote a thank-you letter. I added a note saying that he needn't trouble himself about the money.

MONA LISA

Every Sunday, wearing a muffler and warming his hands in his kimono sleeves, Ibuka visits secondhand stores. Choosing the shabbiest shops, the ones lined with rejects from a previous era, he'll finger this and that. Not being a connoisseur of the tea ceremony, he can't distinguish good from bad, but he tells himself that once a year he'll find a real bargain as he buys amusing, inexpensive things.

About a month ago, Ibuka purchased the lid from an iron teapot for fifteen *sen* and used it as a paperweight. Another recent Sunday he spent twenty-five *sen* on an iron sword guard; this, too, became a paperweight. Today he was looking for something a little larger—perhaps a hanging scroll or a framed picture. Hoping to find an eye-catching ornament for his study, he made the rounds until he discovered a color print, covered with

dust and propped sideways against a wall. It depicted a Western woman. His view of it was obstructed by the mouthpiece of a yellowing bamboo flute, protruding from an odd vase that sat atop a well pulley with worn grooves.

This wasn't the sort of secondhand shop where one would expect to see a Western picture, but the coloring of this picture transcended the present to lie darkly in the air of the past. It seemed just right for the shop. Ibuka guessed it wouldn't cost much. Hearing that the price was one *yen*, he inclined his head a bit to one side; but the glass was intact and the frame solid, and so he talked the old man down to eighty *sen*.

It was a winter evening when Ibuka carried the half-length portrait to his house. Going into his gloomy room, he unwrapped the picture, stood it against the wall, and sat down before it. His wife came in with a lamp. Asking her to hold up the light beside the picture, he studied his eighty-*sen* acquisition. The face was faintly yellow against the sober darkness of the whole. This would be due to the age of the picture. Still seated, Ibuka turned to his wife and asked what she thought of it. She raised the lamp a little more and peered silently at the woman's yellowish face. "Creepy, isn't it?" she said finally. Ibuka just laughed. "It was eighty *sen*."

After dinner, he stood on a stool, drove a nail into the wooden lattice, and hung the picture above his head. His wife tried to stop him. "You can't tell what that woman's thinking," she said. "Looking at her makes me uncomfortable." "It's just your nerves," said Ibuka, and went right ahead.

His wife withdrew to the sitting room. Ibuka turned to his desk and began to work. After about ten minutes he raised his head and felt an urge to look at the picture. Setting down his writing brush, he turned his eyes. The yellow woman was smiling faintly. Ibuka stared at her mouth. It was all in the way the painter had managed the light. The thin lips turned up slightly at both corners, where they formed slight indentations. She might be about to open her mouth. Or she may have just closed it. There was no telling why. Feeling a bit odd, Ibuka turned back to his desk.

Much of his work consisted of transcription. Since he didn't need to pay close attention, he soon lifted his head again and looked toward the picture. Yes, there was a story behind that mouth. But she was very calm. From her long, narrow eyes and single eyelids she looked quietly down into the room. Ibuka turned back to his desk again.

Ibuka looked at the picture many times that evening. He began to agree with his wife's appraisal. The next morning, however, he went to the office without saying anything to her about it. When he returned home at four o'clock, the picture lay faceup on his desk. It had fallen suddenly, just past noon, his wife said. Naturally the glass had shattered. Ibuka looked at the back of the frame. One of the rings through which he'd passed a string

the night before had somehow come loose. Then Ibuka opened the back of the frame. Against the picture lay a piece of Western paper, folded in four. He opened it. Written in Western ink were these strange words:

"In Mona Lisa's lips lies the riddle of Woman. Since ancient times, only da Vinci has been able to paint this riddle. No one has ever solved it."

At the office the next day, Ibuka asked everyone, "Who is 'Mona Lisa'?" No one knew. "Then, who is 'da Vinci'?" No one knew this, either. At his wife's urging, Ibuka sold the inauspicious picture to a junk man for five *sen*.

VOICE

Three days had passed since Toyosaburō moved to this boarding house. On the first day, he moved about like a busy shadow in the dim twilight, unpacking his bags and arranging books. Then he bathed at the neighborhood bathhouse and went straight to bed. The next day, after returning from school, he sat at his desk and tried to read, but he found that he couldn't concentrate, probably because of the sudden change in his surroundings. He heard the sound of sawing outside the window.

Toyosaburō reached out with one hand and opened the shoji. Right under his nose, a gardener was busily pruning a Chinese parasol tree. As he sawed remorselessly at the base of some fairly large branches and dropped them to the ground, conspicuous white cuts multiplied rapidly on the tree. Simultaneously, the empty sky began to look wider, as though it were gathering at the window from the distance. Resting his chin on his hands, Toyosaburō gazed aimlessly at the clear autumn sky, high above the tree.

As Toyosaburō moved his eyes from the tree to the sky, he suddenly felt a powerful emotion. As the feeling subsided, a memory of his hometown appeared before him, as if someone had marked it with a dot. The dot was far in the distance, but it was as clear as if it lay on his desk.

At the foot of a hill stood a large, straw-thatched house. A path rose some two hundred yards from the village and ended at his gate. A horse was going in at the gate. A bunch of chrysanthemums had been tied to the saddle; tinkling its bell, the horse disappeared behind a white wall. From high in the sky, the sun shone on the roof. The trunks of the pines that cloaked the hillside all seemed to glow. It was mushroom season. Toyosaburō smelled the freshly picked mushrooms on his desk. Then he heard his mother's voice, calling "Toyo, Toyo." Her voice was far away. And it was so clear he could have grasped it in his hand. His mother had died five years before.

Startled, Toyosaburō moved his eyes. The tips of the Chinese parasol tree reflected again on his pupils. Where spreading branches had been cut off, the tree was ugly from the cramping force of the welts it had formed.

Once again, Toyosaburō felt as though he'd been pinned in front of his desk. Looking down, past the tree and beyond the hedge, he saw three or four shabby tenements. A quilt with stuffing coming out had been hung without embarrassment in the autumn sun, and beside it stood a woman in her fifties, looking at the tips of the parasol tree.

The stripes on her kimono were faded here and there; over it she wore a single narrow sash. With her thinning hair twisted around a large comb, she stood gazing absentmindedly through the branches to the top of the tree. Toyosaburō looked at her face. It was pale and swollen. Her narrow eyes peered through puffy eyelids and looked up at Toyosaburō, as though straining in the sunlight. Toyosaburō quickly lowered his gaze to the surface of the desk.

On the third day, Toyosaburō bought chrysanthemums at a flower shop. He looked for the variety that blossomed in the garden at home, but unable to find it, he had the florist choose three stems and bind them with straw. These he placed in a vase the shape of a sake flask. From the bottom of his wicker trunk he pulled a small scroll written by Hoashi Banri and hung it on the wall. With the intention of decorating his room, he had brought the scroll back with him from a visit to his home the previous year. Sitting on a cushion, he gazed for a while at the scroll and the flowers. A voice cried "Toyo, Toyo," from the direction of the tenement outside the window. In pitch and timbre it was no different from the gentle voice of his mother at home. Toyosaburō opened the sliding door with a bang. As the setting autumn sun bathed her forehead, the woman with the pale, swollen face whom he'd seen the day before was beckoning to an urchin of eleven or twelve. At the bang of the door, she turned her puffy eyes and looked up at Toyosaburō from below.

TRANSLATED BY ANTHONY H. CHAMBERS

Rich Boy

IWANO HŌMEI

Although a list of major naturalist writers would certainly include Iwano Hōmei, a critical appraisal of his work has been slow in coming. He was born into a samurai family that had fallen on hard times following the Meiji Restoration. Educated for a career as a Christian missionary, Hōmei worked at a number of jobs: English teacher, boardinghouse landlord, cannery owner and entrepreneur,

journalist, beekeeper, and, of course, poet and novelist. The details of his life are largely available to us because he made himself the subject of his writing. His life was his topic, and his topic was his life.

Drawing inspiration from Mallarmé, Swedenborg, Maeterlinck, and Emerson, Hōmei pioneered a new direction for modern letters. In "Mystical Bestialism" (Shinpiteki Hanjūshugi, 1906), he argued that life must be honestly lived according to one's instincts, and that art must unflinchingly display life's aggressiveness, cruelty, and greed. Human beings are by nature beastly, and life is purposeless and meaningless beyond the moment. Truth is found only in the moment—in the bestial operation of human impulses. In pursuit of the honest depiction of such moments, he rejected realism and its facile division of the good from the bad, its cause-and-effect mentality, and its omission of ambiguity. By affirming the naturalist emphasis on sexual desire as countered by the constraints of social mores, Hōmei's amoral and rather unorganized depiction of degenerate life produced a unique brand of modern fiction.

As articulated in "The New Naturalism" (Shin-shizenshugi, 1908), Hōmei's theory of "single-perspective description" (ichigen byōsha) aligned itself generally with standard first-person narration as we know it. His understanding of truthfulness, however, went on to create a peculiar kind of third-person narration that does not assume any superior objectivity or insight. Analysis of the protagonist's own motives and judgments are described with the same detachment as when making observations of others. In this sense, the perspective of his protagonist/narrators is not privileged. Even the self is seen not from within but from without, as though the "I" is just another object of scientific experimentation or disinterested observation. His works, therefore, are not typical I-novels that guide the reader into the protagonist's interior. Rather, the narrator reports what he himself does, hears, and thinks only as he might speculate about the motives of others.

The main body of Hōmei's work is a series of five novels that closely follow the events of his personal life. A Vagrant Life (Hōrō, 1910) launched the saga of the protagonist Yoshio, whose unrealistic business ventures and licentious lifestyle are depicted with unflinching honesty. The Ruptured Bridge (Dankyō, 1911), Expansion (Hatten, 1912), The Woman Who Takes Poison (Dokuyaku o Nomu Onna, 1914), and The Avenger (Tsukimono, 1918) followed. Although not written in temporal order, they form one narrative that generally follows the same set of characters, with the names slightly changed, and the story told in the third person.

The pentalogy traces the story of Yoshio, a halfhearted schoolteacher who inserts himself into suspicious deals, dreaming of instant fortune as a trader of lumber or an exporter of rice in order to find ways to support his

family and extramarital liaisons. The author-narrator makes no secret of his ambition, pride, and egotism. The narrator minces no words in exposing not only his own unsavory behavior and coarse intentions, but also those of all members of his intellectual circle. Dialogues between the narrator and his enraged wife or his scheming mistress are often crude and violent in a way rare in Meiji-period fiction. His relationship with Otori, his mistress, is troubled. Their sexual attraction to each other is obvious, but there is little tenderness between them.

As parts of the pentalogy, no single novel is complete in itself, and each describes the protagonist as he writes a previously published novel. To complicate matters more, each book repeatedly refers to the same episodes as they were being revised and rearranged into new selected volumes. At least two separate sets of the pentalogy were published, resulting in a project that gave readers access to the author's life even as it was being lived. They see him living the material for his writing and reporting it in a way that simultaneously reflects on and revises the past. For these reasons, contemporary readers of Hōmei were far more involved in the author's life than in that of any other writer. In 1919, Hōmei earned a total of 4,500 *yen,* which made him one of the best-paid writers then at work.

"Rich Boy" was written the year of Hōmei's marriage to Endō Kiyoko, his second wife, a time of relative happiness and productivity. As a masterpiece of Hōmei's "single-perspective" description, the story eschews sentimental identification for either the protagonist or the characters surrounding him. A strange sense of objectivity focuses on the protagonist's observations of the merciless world in which he finds himself. While the excruciating pain from his unfortunate accident threatens his life, he is all too aware of his friends' indifference. His good nature as the spoiled son of a wealthy Osaka merchant makes his misfortune seem almost humorous. The following represents the first translation of this story into English and the first translation of any of Hōmei's vast corpus.

☞(CSI & SJ)☜

PART 1

Sada secretly complained. "Some friends they are. Someone's in trouble, and they all stay away. They only care about one thing. And those geisha, not one of them came to my rescue."

He thought about how he had gotten to this point. After dinner, he had gone to play pool. The hundred-point Chō and the eighty-point Shige were at it. Chō won easily. He made a hundred points before. Shige broke fifty.

Sada had wanted to play someone better than himself. But just as he was about to take up his stick, Shige came up to him and challenged him to a game. "I'm not losing my Shikishimas like last night."

"I wouldn't count on me to lose."

"Then we'll make it a beer this time."

"Fine."

Sada set his stick down. He untied his jacket and rolled up his sleeves so his silk undergarment showed. Wearing a silk-crepe kimono tied with a finely woven men's sash, he thrust his hips back and lowered his face toward the edge of the pool table. He blinked his eyes as he took aim, and moved his face back and forth. Chuckling quietly, Chō got up off his chair. "That's no way to play pool." He pushed Sada's butt to the right, showing him how to align his body.

Sada was a beginner, so he went first. He missed with his first and second strokes. His third was his only good shot. He made a disgusted sound and looked over at Chō as Shige took aim.

"Pull yourself together or you're gonna lose," Chō gave Sada some encouragement.

"It's not the end of the world." Sada excused his poor start. He actually won the first round, but blew the next two. After each game, Shige opened another bottle of Asahi.

It killed Sada to watch Shige tip his glass with such satisfaction. So he asked for another round, which he also lost in fine fashion. He had finally given up and was taking a break when Matsu showed up.

"Look what the dogs brought in," Sada thought to himself. Matsu was a slob.

"We're living off the Rich Boy tonight!" Bragging about his string of wins, Shige offered a glass to the newcomer.

"Hmm," Matsu took the glass with little enthusiasm. "I'm not in the mood for beer."

"Look, I won three times in a row."

"Hey, Rich Boy," Matsu set the empty glass down. "How about a game to seventy?"

"That's a little unfair," Chō came to Sada's defense. "Matsu, you should go to eighty."

"Okay, make it eighty. But if I win—" He banged the butt of his pool cue on the floor. "Then we all go to Takarazuka. Takarazuka!"

"Now you're talking," Shige agreed.

"Go get 'em, Rich Boy." Encouraged by Chō's words, Sada gave it everything he had.

"Hey, don't take it so seriously," Matsu said in a disagreeably calm voice. Two. Five. Seven. Ten. Counting points, Matsu made it to eighty while

Sada came up empty three times and got two points twice, and three points once.

"So it's Takarazuka!" Matsu danced with joy. He kept whispering something into Chō's ear, then into Shige's. Finally, all four of them left together.

As they rode the city train from Edobashi, Matsu was in high spirits. He talked in a loud voice, making plans with the others about where to go. "Should we go to the Aioi, or to the Hishitomi?" Sada thought it was poor form to be making plans to go drinking when others could overhear them. Matsu, it seemed, could care less. With a joyful smile on his face, he came up to where Sada was sitting to get his opinion on the matter. On the one hand, it felt good to think his opinion actually mattered. He was paying for everything, after all. On the other hand, it was embarrassing, since he didn't have a clue about where to go. He hadn't been drinking beer, but his face felt a little flushed anyway. With his eyes, he secretly asked Matsu for advice.

Matsu was too fidgety to catch Sada's signal. He was a short man with a beer belly. He wore a checkered cotton kimono with a white crepe sash around his hips. Clinging to the strap hanging down, he wavered with the movements of the train car. "Hey. Where should we go?"

Sada didn't answer. He had never felt so embarrassed. He finally couldn't stand it. He stood up and whispered into Matsu's ear so no one could hear, "Which one do you think?"

"Well, the Hishitomi," Matsu named the place he frequented.

"Then let's go there."

"Just what I wanted to hear," he said loudly, then looked over at his friends. Matsu looked at Sada again.

"Four geisha, right?"

"I didn't say anything about geisha," he thought to say, but didn't. If they got four, that meant he would have one for himself. The thought made him shiver.

PART 2

Before they transferred to another train in Umeda, Matsu put in a call to let the Hishitomi know they were on their way.

"That Matsu knows what he's doing." Sada was secretly impressed as he paid the twenty-five *sen* for the long-distance call.

By that time, it was easy enough to tell by their flushed faces that Chō and Shige were already drunk. But if anyone stood out, it was Matsu, who was all excited. Apparently, he had been drinking before he showed up at the pool hall. Struggling to stay on his feet in the train car, he shuffled over to Chō, then to Shige, whispering in their ears. He finally made it over to Sada and sat down. Doing his best to play the part of a drunk, he shook Sada's

shoulder and said, "Hey, Rich Boy." He thrust his round face in front of Sa-
da's eyes. "I'll fix you up with a nice girl."

Sada was embarrassed. He turned his eyes away. It occurred to him that
if the other passengers in the car happened to be family acquaintances or
business associates, the news would soon get back to his father or to his
older sister.

"Hey, Rich Boy. Don't worry. Everything's going to be fine." Matsu had
no self-control. When he saw that Chō and Shige had taken off their ki-
mono tops, he did the same. Unlike them, however, he wasn't wearing any-
thing underneath, so his bare chest showed. When the conductor came
along, he made them all put their clothes back on.

Matsu tried all the more stubbornly to cling to Sada, kicking his san-
daled foot into the air. When nothing seemed to calm him, he finally went
back to his place across from Sada. That was when, for some strange reason
(Sada laughed when he remembered it), Matsu exchanged his straw hat
with that of the passenger next to him. He had already taken off his own, so
he simply plucked one off the head of the other man and put it on his head.

"What do you think you're doing?" The man scolded him in a Tokyo
accent and immediately rescued his hat.

Was he surprised by his mistake? Matsu got up and without a word of
apology began searching for his own hat, which had fallen off to the side. He
sat back down, and with the same quickness with which he had committed
his blunder, he put the hat back on.

The other two friends were laughing and talking. They didn't notice.
But many in the car directed their attention to the sound of the angry Tokyo
voice. Some of them who had watched the whole proceedings couldn't help
but burst out laughing.

With a deflated look on his face, Matsu changed places and sat down
next to Sada again. "It's hot," he quipped and looked out the window.

One of the passengers on their side of the car forced a laugh, but Sada—
even though he thought it was all very funny—didn't have what it took to
laugh out loud.

"Food for four, plus four geisha. What's that going to cost me? I'm not
carrying that kind of cash. I'll have to call home and have someone run it over."
As he thought about such matters, he vacillated between happiness and fear,
exuberance and sadness. He couldn't wait to get to their destination. Along
with Matsu, he stared silently out the window. The breeze created by the
rushing train struck his face and blew away the smell of his sweaty body.

As the train crossed the bridge at Shin-Yodogawa, the torchlights of
fishing boats across the way glimmered on the water. They had a kind of
coolness that couldn't be found inside the billiard parlor.

"It's trout season already."

"So it is."

As they conversed quietly, the train passed the station at Jūsō.

The sky above Osaka looked reddish. Beneath that sky were Sada's family members and the women he was fond of, especially his neighbor Shizue. As if to see the parts of the city that the changing direction of the train hid from his sight, he stuck his head out the window. That was when something struck his head with a blow, as if an obstinate father had laid into his son with a heavy stick.

"Watch out!" Suddenly, Matsu's hand was rubbing Sada's head.

"What happened?" Hearing Matsu's voice, Chō and Shige came over.

"He just hit his head on a pole."

"Is he hurt?"

"Maybe." Matsu pushed Sada's hands away and started rubbing the injured spot. Bearing his injury in silence, Sada wanted to tell them all to leave him alone.

The train conductor came over. "Is something wrong?"

"Nothing serious." Matsu said that because he was afraid they might not get to where they were heading if he told the truth. That's what Sada thought later.

"I should have turned around and gone to the Osaka Hospital right away. It might be too late now." Sada reflected, wondering if death weren't quickly approaching. His head seemed to be swelling. He felt like his brains were leaking out of a crack in his skull.

PART 3

Even when he squeezed his head with both hands, it throbbed with pain. Matsu, the leader of their party, wasn't really thinking about him at all. He was only putting on airs, treating Chō and Shige as if they were his clerks, and the geisha as if they were all his. "Hey, Rich Boy. Get a hold of yourself. Why so glum?" It was a bit much, hearing him talk like that.

"When we get to Takarazuka we should have a doctor take a look at that," hadn't he said that? By the time they got off at the end of the line, Matsu had forgotten everything. All he talked about was sake and geisha.

Sure, Sada had lost the pool game. But who was going to pay for all this? He was indignant. Everyone seemed to be trying to get their hands on his money. At the same time, the words came to him like a prayer, over and over again, "Why did I stick my head out the window?"

He had thought the power poles ran along the outside edges of the railroad tracks. But in some places that wasn't true. As the conductor explained, "Here and at Hotarugaike, the poles run down the middle. So it's dangerous to be sticking your head out."

Why had it come to this? He shouldn't have leaned out. No. He shouldn't have even gotten on the train. No. Where he really went wrong was making that bet in the pool hall. These thoughts kept repeating themselves in his mind, but nothing was going to change the fact that he had hit his head on one of those power poles.

Sada tried to endure both the surprise and the pain. He sank back in his seat.

"It's nothing," he laughed. He tried to keep his hands on his knees, but they came up and grabbed his head on their own accord.

"Does it hurt?" Matsu asked.

"Not much," he meant to say and put his hands down on his knees and moved his head back and forth. But his hands came up again.

"Does it hurt?" asked Matsu again.

"Not much," he answered curtly. Matsu was such an ass.

When he tried to hold still, the pain became unbearable. But when he rested his head against the brass pole by his seat, trying to use the chill against his skin to forget his pain, he found it hard to breathe. He turned his body and pressed his face against the windowsill. His life seemed to be shriveling up. Even so, he couldn't very well whine to the others about going home. He was a man.

"Stupid fool." He could hear the Tokyo man's voice coming from some corner of the train car. He knew that all the other passengers were looking his way, with ridicule on their faces.

Feeling oppressed from within and without, Sada suddenly tried to get to his feet, as if rising to the surface to get a breath of air. He didn't care what they thought. At least Shizue wasn't there to see him. It would have been terrible if she saw his mistake. She would start treating him with contempt, just like the others; and he could never look forward to the fruition of his unspoken love for her.

Just then, the train jolted and his legs started to give way. He collapsed with dizziness, facedown. Who cared that others were looking?

The vibrations of the moving train felt like a pain in his back. When Sada came to, he realized that his head was on Matsu's soft lap and that Matsu's hard elbows were heavily and painfully resting on his back.

As if to say "Take 'em off," Sada twitched his back. Matsu removed his hard, heavy elbows and replaced them with the palms of his hands.

Sada smelled the warm scent of another body close to his nose. Since leaving his mother's bosom, he hadn't smelled another person's body quite so close as this. "If only this were Shizue's lap," he thought. Was it this stimulation that made him feel a sense of familiarity toward Matsu? He was a man, not a woman. And yet he felt the desire to be held—just like this, forever.

"I won't listen to this nonsense, Denbei," Matsu chanted the courtesan's complaint from a love-suicide play. He then brought his mouth close to Sada's ear. "Hang in there. You'll be in the arms of some girl in no time."

Matsu stepped across the car to where Chō and Shige were sitting. He plopped himself down between them. Leaning back toward the window, he put his hand on Chō's neck and pulled him over in order to whisper something in his ear. Chō responded by brushing Matsu's hand off and saying, "We can't do that!" He pulled back and looked at Matsu through the corner of his smirking eye. When Matsu did the same to Shige, he let out a vulgar laugh.

"Rich Boy's our god of fortune." Matsu smiled and forced a laugh. He kicked his legs up in the air one at a time.

Sada guessed they were talking about the girls they would hire. He pretended not to pay any attention but he himself was filled with the same anticipation. And that made it possible to bear the pain.

PART 4

Sada couldn't wait another minute to get off the train. He stood, wobbled over to Matsu and tried to discuss his situation with him. He didn't want to make the others angry, but he had to get off.

"I'll get off by myself."

"Where?" Matsu glared at him with a threatening look. "What would you do, in a lonely place like this?"

It was a hard question to answer. He looked sheepishly at Matsu, then reluctantly made his way back to his seat. To hide his embarrassment, he looked out the window and saw the cool-looking lights of the foothills in Ikeda as the train noisily crossed the steel bridge at Inagawa.

"Since we've come this far," Shige seemed to agree with Matsu, "it's faster to keep going than to go back to Umeda."

"That's the thing to do. That's it," Chō blurted out, leaning back heavily against his window.

"You know nothing of my pain," Sada spoke with his eyes as he looked at his friends. He now understood that the throbbing in his head was his to deal with alone. Even Chō, the kindest of the three, wouldn't sympathize with him. He hadn't known them that long, but weren't friendships created over a game of pool supposed to be fast and strong? All they really wanted, every one of them, was to take advantage of a thirty-point beginner and have some fun at his expense.

"What are you doing?" Sada heard a harsh voice and focused his attention in that direction.

"Sorry about that." Matsu went to retrieve one of his sandals, which was lying at the feet of the passenger sitting directly across from him.

"Jackass," Sada said to himself. He thought about Matsu, Chō, and Shige and their insensitivity. He wanted to say to them, "I'm about to die, don't you see that?"

The more he tried to endure, the more he felt himself slipping toward death. They passed by Hanayashiki and he knew they were almost to their destination. This was the moment he had been waiting for. As soon as he was freed from the train, he'd leave the others and go off on his own. It didn't matter who the doctor was—as soon as he saw a sign for a doctor's office, he intended to barge right in.

PART 5

They reached Takarazuka and inquired of a conductor there about where they might find a doctor's office. But Matsu urged them to keep going. "It'll be better to call someone once we get there." Relying on Matsu and Chō to lend him their shoulders when he walked, Sada stumbled down the brightly lit street that led them to the Hishitomi. A number of men and women were waiting to greet them. Shouting in unison.

"Welcome to the Hishitomi!" They sounded like a firing squad to Sada. With Chō and Shige's help, he made it through the entrance.

Matsu addressed one of the maids, who obviously knew him. "Hey, Okiku. Here we are again."

"Welcome." She laughed and said in a loud deliberate voice, "As soon as I saw your face, I knew it was you." She turned to Chō and Shige for confirmation.

"What are you talking about?" Matsu threw an arm around her shoulders.

"Stop that," she said in a loud voice. Glaring at him, she pushed his arm off and tried to get away. "You're a bad boy!"

The alluring dialects of Tokyo and Osaka, as well as her beauty, reminded Sada of his older sister. Even she would act the same way if a man joked around with her. The thought suddenly made him feel brighter—as if he needn't feel bad about his own hidden desires.

Matsu looked back at him. "Hey, Rich Boy, feeling okay?"

"I'll make it." Sada showed them he could laugh.

"You look a little better. Hey, Shige, let's drink up."

"Did you think I wasn't planning to?"

Matsu put his arm around Chō. "Hey, I won the pool game, right? So no matter what the Rich Boy says, we're not listening to him. Isn't that right, Shige?"

"Absolutely."

"What do you say, Rich Boy? That's the way it goes, right?"

Sada could only force a smile.

"You said you were doing all right, Rich Boy." Matsu retraced his steps and gave Sada a thump on the shoulder. "Hang in there. I might look drunk, but I'm not. There's still a lot of drinking ahead of us tonight."

Sada didn't comment.

"What do you say? Are we good?"

"Yeah, sure. I'll drink, too."

"That's it! That a boy!" Matsu led the way, swaggering forward.

When Chō and Shige got their second wind, they let Sada go. He gathered his energy and, smiling through the pain, followed them down the hall.

Okiku could see something was wrong, though, and stopped him. "Are you all right? You're as white as a ghost."

Sada wanted to say something and blend into the crowd, but it was all he could do to keep smiling.

Matsu came back for him. "He hit his head on one of the power poles along the tracks."

"Oh, my. That's dangerous."

"But it's nothing to worry about." Chō looked back and said in a flippant tone.

"Are you okay?" Okiku inquired.

Sada nodded. Even that made him feel dizzy.

"Shall I call a doctor?"

"That won't be necessary." Matsu again took the lead. "When the geisha come, he'll feel better."

That's when Sada's nose caught the penetrating smell of a woman, coming from behind him. It was probably the scent of hair oil.

PART 6

They brought Sada to the place below a ceiling light with a huge diamond pattern in the middle of it. He immediately lay on the tatami and held his head with both hands.

"Hang in there, Rich Boy." Matsu straddled him and pressed Sada's shoulders down with both hands.

"Ouch. That hurts." Sada let go of his head; and while pressing down on the tatami with his arms, he drew his body up, and tried to wiggle free from the weight on top of him.

"You're a weak one, aren't you." Matsu got off. He went over to the other two. They were sitting cross-legged near the banister, where they could see the road to the hot springs and a line of pine trees moving slightly

in the breeze. Having loosened the upper part of their kimono, the three lit cigarettes and fanned themselves. By and by, they took their kimonos off completely. "What do you think? If the Rich Boy's not doing so well, we should have him rest somewhere quiet."

"That might be a good idea," Shige replied, cooling himself noisily with his fan.

"Maybe we should have a doctor take a look at him. Let's hope there's nothing wrong." Chō looked over at Sada and seemed anxious to do it right away.

"Yeah, but if the doctor keeps him here, he'll be the only one who doesn't get to see the geisha." Matsu went over to where Sada was resting.

Sada was pretending not to listen. He couldn't understand why the three of them were trying to leave him out.

The money for the call from Umeda had come out of his pocket. And the round trip tickets for the train did, too. And yet, even though he might have just broken his skull, they just kept enjoying themselves and showed him little sympathy. Matsu and the others acted as if they were pooling their own money and showing their influence by letting him "see the geisha." Who the hell do they think they are? Weren't they just leeching off him? It occurred to him they were actually feeling lucky that their sponsor had met with misfortune, because now they could use it all for themselves.

"Those small-minded bastards. I'm not independent yet, but I *am* the son of a successful businessman. Once I make up my mind to pay, I don't hold back. But in return, I expect them to let me into their group." He was indignant. If they decided things by age, his geisha should be the youngest one. Thinking that made him feel happy. He opened his eyes to see Matsu sitting beside him, smiling.

"Hey. Rich Boy." Matsu pushed Sada's hand away and started rubbing his head this way and that. "How you feeling? Does it still hurt?"

Sada didn't answer, even though he appreciated Matsu's effort. Tears welled up in his eyes. All he could do was shake his head.

"What about calling a doctor?"

Again, he could only move his head.

"Let him rest." Matsu turned to Chō, who was watching them closely.

"You sure he doesn't need a doctor?" Chō got to his feet. He seemed worried.

"He says he doesn't need one, right?"

"Yeah, but it might be bad." Chō sat down and put his hand on Sada's forehead. He touched the artery in his neck and checked Sada's pulse, which was racing with expectation about the geisha who were to come at any moment.

Sada felt Chō's attentiveness was forced. It bothered him. He had his lingering doubts about Chō and the others. Even more than Matsu, they were going out of their way to exclude him from their group.

"Does it hurt, Rich Boy?" Sada didn't bother to answer Shige, whose voice came to him from over by the veranda.

Okiku brought tea. She came first to Sada's group and set the cups out, then went over to Shige. Then she came back and sat down by Sada, still curled up on the floor. To Sada's irritable nerves, her presence was like a fragrant breeze. But that breeze made his body recoil automatically.

"He's in pain."

"He said it didn't hurt."

"Yes, but—"

"I'm sure it hurts." Chō stared at Sada's eyes, which were looking at nothing in particular, and added, "But more than a doctor, I think he wants a geisha."

"That's not true." Sada blushed and disagreed frankly. He turned away from Chō so that he was now face-to-face with Okiku. He hurriedly closed his eyes. Still holding his head with both hands, he quickly covered his face with his elbows.

"Once he sees a geisha, he'll feel better." Matsu spoke nonsense. Sada's eyes followed him as he moved toward the veranda. Matsu wanted to order him to call the geisha in quickly if he was going to do it at all.

And then—

"Hey, are you really okay?" Chō showed his concern by putting his hand on Sada's back. But Sada only wished Chō would leave him alone. If he was going to be nursed by anybody, he wanted it to be the "young lady," not these poisonous men. If he had Okiku, he wouldn't even mind if the geisha didn't come.

No one moved him more than she did when Okiku put her hand on his shoulder and said, "Rich Boy, shall I go call a doctor?"

"He said he was fine, you know." Matsu spoke in a scolding tone. Fanning himself vigorously, he said, "Bring some sake. O-sake."

PART 7

The novelty and fun of changing into the informal kimono restored Sada's spirits. While the others were all making a tasteless fuss about the geisha they were about to meet, he showed them that he was different. To make up for his previous embarrassment, he announced that he wanted to take a dip in the hot springs even though Matsu thought it was a waste of their time.

After a quick bath, dinner was served. Because the weather was hot, everybody sat along the veranda. There on the wooden floor, Chō sat next to the pillar closest to the stand of pine trees outside the room. Matsu was to his right. On the left was Shige and then Sada. Set into the tatami room wall opposite from where Sada and Shige sat, was an alcove containing a three-paneled landscape painting and a miniature pine tree.

"Good evening." The sliding doors opened, and in came the geisha, who expressed their surprise at where they were sitting. One deliberately dragged the skirt of her kimono and said, "You're all so far away." Another stopped in the middle of the room, saying, "You're so high and mighty, we can't get close to you." All this amused Sada. The youngest one, Kanshichi, wore a blue kimono with turtle shell patterns. She went over and sat down by Matsu and started talking to him. She said things like, "Mr. Matsu, what happened to the man who was with you last time?" and "That naked dance was a lot of fun, wasn't it?"

"I'll dance for you again tonight." Matsu got himself in the mood by sticking out his arms and pretending to roll up his sleeves.

"So you two know each other?" Shige asked.

"That's right." Matsu grabbed her with both arms and pulled her over to him. "We're made for each other. Isn't that right?"

"Of course." She squirmed free from Matsu's embrace. Laughing, she arranged her legs and sat up like she had before.

"We're going to be friends, too, right?" Chō gave the geisha next to him a lecherous look.

She replied with a look of irritation. "Everything going as planned?" Then she gave what seemed to Sada to be an almost puppy-like look and said, "My name's Shimeko. Glad to meet you."

"You aren't about to give in already, are you?" Shige asked, hoping for a challenge. The geisha sitting next to him said coolly, "That's right. For you, no tickles, just pickles."

"You've got me there!" Shige picked up a pickled scallion with his chopsticks and held it suspended in midair.

As before, Matsu continued to monopolize Kanshichi. The two of them bad-mouthed each other in a flirting squabble.

Aisuke, an older woman with a wrinkled face, came into the room late and sat next to Sada. He failed to come up with any clever repartee. He could only hold his head, blink his eyes, and frown. Aisuke was at a loss as to how to connect with him. All she could do was fill his sake cup once or twice and join in the others' conversation.

Sada compared the wrinkled face of the old woman with the pink color showing through the kimono around the knee of Matsu's companion. He couldn't help but feel out of his element.

"If you go by age, there's no way Matsu should have the youngest one. It's my money. I should decide who gets who."

Kanshichi was the one Sada really wanted. She danced "My Hometown" and another number he didn't know. Then she was called out to perform for another group. He thought she was leaving for just a minute and would be right back. But the way she addressed them when she made her exit made him start to lose hope. He wanted to ask someone if she would be back, but he didn't have the nerve to say anything.

The energy Sada had mustered now flagged, and the pain in his head came storming back. He couldn't take it anymore. Pretending he was drunk, he stood up.

Along with everyone else, Matsu looked over at Sada and asked, "Where you going, Rich Boy?"

"Nowhere," he replied. He lay down in front of the alcove and used the lip of its raised sandalwood floor for his pillow.

That was when he lost his composure and blurted out, "Shall I just go home?"

PART 8

"You're a weak one," Aisuke said in a calm voice as she brought him a pillow. Then she immediately went over to the others, and started strumming her *shamisen.*

"Let's sing." Matsu sang two or three Edo love songs in a row. Then Shige said he would sing a ballad—"On the Banks of the Sumida River" or some such thing.

"Should I do something, too?" Chō also contributed. When Matsu started in again, Shige and the geisha sitting next to him started some kind of rock-paper-scissors game. Shige lost two or three times.

"Hey, Kyōhachi. Come over here!" Matsu had been cheering them on in his vulgar manner but then suddenly stopped. He made a loud sniffing noise. "What stinks. Is that iodine? Do you have syphilis or something?"

"Idiot." Kyōhachi spoke in a cold tone. She was angry.

"But can't you smell something?"

"Just because you smell something, doesn't mean that I have syphilis."

"You, go over there. Let the sick take care of the sick."

"Why? You think she's a nurse or something?" Aisuke made a joke.

"He lost, so that's why he said something so nasty. Isn't that right, Aisuke?" Laughing, Kyōhachi stood up. "Me. I'm just a girl. But I have principles, you know."

"You tell him." Shimeko looked up at her.

"You don't have to get so mad." Matsu sipped sake from his cup.

"I'm not mad."

"You should be." Aisuke encouraged her.

"Is something wrong with the Rich Boy?" Kyōhachi moved closer to Sada.

"Yeah," Matsu replied. "Poor guy bumped his noggin on a railroad pole."

"Really?" Kyōhachi looked back at Matsu. "A floggin' to the noggin?"

"Lay off the stupid jokes." In a voice loud enough for Aisuke to hear, Matsu started to explain Sada's predicament. His words were cruel.

Resting on the pillow, Sada kept both hands on his head and turned to the livelier side of the room. He smirked, and kept opening and closing his eyes.

When he heard someone say "Rich Boy," he opened his eyes. He caught a quick glimpse of someone's red undergarment and then the chubby knee of the person who sat down next to him. It was the woman who had been sitting next to Shige, the one who spoke in a high, clear voice and made the joke about pickled scallions. She was also the only one who wasn't wearing a kimono with trailing skirts. She had her hair done in the latest Western style, and, for some reason, wore a plain, conservative kimono. She looked like a proper housewife. She spoke in a voice loud enough for all to hear. "I put some iodine on a scrape of mine. I went to the family-style hot springs and rubbed my hip raw with a towel."

"Sounds pretty suspicious to me. A family tub in the new-style hot springs?" Matsu sought for an explanation.

Sharing his tone, Aisuke added, "There are a lot of ways to get a scrape, you know."

"That's right. That's right." Shimeko seemed to be in full agreement.

"Your boyfriend must have wanted a clean piece." Chō also added his two bits.

"That's a good one." Kyōhachi made a point of clapping her hands happily.

Just then, the maid who was waiting just outside the room spoke up, as if summoned by Kyōhachi's clap.

"No, not you, it has to do with our conversation." Aisuke addressed the maid, then turned back to the others. She hid her smile behind her hand.

Kyōhachi shrugged her shoulders and smiled at Sada. Sada managed a pained smile. He too smelled the biting scent of iodine. But, far from being bothered by it, he found it to be a gentle perfume. Anyone who smelled that way could share his pain and die with him, he thought.

"Does it hurt?"

He felt her gentle hand on his shoulder and looked up at her face. She seemed more beautiful than his sister. With tears welling up in his eyes, he managed to shake his head.

PART 9

The sounds of singing and *shamisen* music came from the other rooms. A refreshing breeze moved through the large sitting room.

"Oh, that feels good." Kyōhachi stood by Sada's side, and another round of singing began. Inspired by Matsu's nonsensical dancing, even Sada's favorite girl got caught up in the moment and sang, "Though the Seas Be Dark, Come" and so on.

A feeling of loneliness swept over Sada again. He took his hand off his head and tried to get up. But his head was as heavy as a rock, and he cradled it in the crook of his arm with the pillow beneath.

"What's happening? Am I dying? If I'm dying, shouldn't I have someone from home here to scold me? Or should I just have as much fun as I can, and leave them the bill?"

He considered these options. But his idea of fun wasn't singing. Or drinking.

Matsu and his noisy merriments seemed to fade into the distance, as Sada imagined his final moment—being cared for by a woman he liked, resting on her lap in a small room with a bright lamp. It would be a quiet, safe room, where his mother and sister would immediately come upon being called.

But his dream was short lived. He realized his eyes were tightly closed in order to keep out the pain, and he heard Matsu's voice close by. "Hey, Rich Boy. Things are getting a little dull, aren't they? Come with me. We need to talk."

He trembled as he followed Matsu's lead. They left the room and ended up standing in the hallway near the restroom.

"What do you think you're doing, sleeping like that!"

Sada didn't answer. Pale-faced, he pursed his closed lips and stared at Matsu's red, besotted face.

"You know, we can't go home now. There aren't any more trains."

"Did I say I wanted to go home?" Sada didn't hide his sense of being unfairly treated.

"Good. Great." Matsu chuckled to himself. He continued in a lower voice. "So, what shall we do about girls?"

"Now you're talking," Sada said to himself. He was elated. It was his understanding that he could pick the girl of his choice. In a very low voice, he managed to say, "The one I want is—you know, the one who left a while ago."

"What?" Matsu took a step back in surprise. "I wasn't asking about that. Should I send the musicians away? Should we all sleep together or pair off with the ones here and the ones we order? That's what I wanted to ask."

"You're asking me? I don't know anything about such things."

Matsu couldn't hold back his laughter any longer. He went to the entrance of the sitting room, stuck his head in, and blurted out, "Hey, the Rich Boy has a thing for Kanshichi."

"Liar! You lie!" Sada instinctively moved to the doorway. He straightened his tall body. Feeling the effects of the wine, he held his pounding head with both hands and tried to disguise his embarrassment with a serious look. "I didn't say that."

Aisuke and Shimeko exchanged glances and laughed at him.

"Well, come along." This time Matsu grabbed Sada by the hand and led him back into the room.

"The popular girls get everything!" Shimeko didn't care if they heard her envy their absent colleague.

Aisuke laughed and said loudly, "How about me? I'll give you a suck on my teats."

Shige laughed. "Oh, Mama!"

"Yeah, your mama and your papa, too." Kyōhachi joined in, and shrugged her shoulders. "What about me?"

"So he's paying for you all? Is that it?" Aisuke looked at Chō with a serious expression on her face.

"The Rich Boy lost at pool. That's why."

"So he not only lost there, but he has to pay here, too. Is that it? He's such a nice boy."

Sada pretended not to hear them. He knew he had said something stupid and he regretted it. He opened his eyes wide and stared at Matsu.

"I hear that girl has a patron who comes every night, so she's not available." Matsu spoke in all seriousness.

"Fine, then." Feeling as if he had recovered from his mistake, he went back to where he had been and threw himself down on the floor with a thud. It bothered him to think that Matsu and the others had sent Kanshichi away without telling him. If she wasn't going to work out, there was still Kyōhachi. That was his only wish, to have her nurse him and make his pain go away. He was afraid he would only make matters worse by saying something else, so he didn't let them know about the pain in his head and how he wanted them to carry him to his deathbed. A new wave of throbbing came, and he turned to face the alcove. In his mind he fretted, "Those shits. I'll die right here, just like this." That was his wordless cry.

PART 10

"So what should we do? Go home?" Chō spoke as if he was ready to give up. It seemed like Sada no longer cared to put up with them.

"You think the trains are still running?" Shige seemed disinclined.

"There won't be any to Osaka." To hide her loss of composure, Aisuke lit the tobacco in her slender silver pipe.

"What's going on? I don't get it." Matsu, too, was dragged down by their disappointment. "The Rich Boy's a man, right? He promised to treat us . . ."

"I'm paying plenty already." Sada, with his back to them, spoke in a pouting way. "But I'm seriously injured."

"An injured man wouldn't be asking for Kanshichi, would he? You're only thinking about yourself, Rich Boy. If she can't come, then she can't come."

Sada quickly sat up and turned toward them. "So Matsu, are you saying you can take care of a wounded person?"

"Hey, I'm no nurse."

The men and women all started laughing together, which prompted Sada to lie down again and turn away. "If you want to laugh, go ahead. Laugh all you want."

"Hey, now." Speaking gently, Matsu tried to humor Sada. "So what should we do?"

"You do what you want. Just call a doctor for me."

"A doctor?" Matsu said it as though it had been a surprise. He turned to his friends to propose what they didn't want to hear. "So we call a doctor. And the rest of us, should we just sleep where we can?"

"Well." Chō seemed hesitant to reply.

"Let's not worry about the money. Rich Boy's paying no matter what."

"I guess that's all right." Shige seemed noncommittal.

"You don't have to worry about paying either."

"Yeah," Chō replied. "But if we don't know how he's feeling . . ."

"That's why I said we should call a doctor, right?"

"How about talking things over once the doctor gets here." Chō was still reluctant about the plan.

"It wouldn't be fair to these people," said Matsu as he looked over at the geisha. "How are you, time-wise? What if we go past midnight? We'll pay the overnight fee, so you won't lose out."

"How thoughtful of you!" Aisuke parried his joke and looked at the other girls. For a while they just exchanged looks. No one had anything to say, so she answered as if representing them all. "Only the girls who aren't busy."

"Well, there's nothing we can do about that. How about you, Kyōhachi?"

"Well . . ."

"Well . . ." Matsu copied her reply. Trying to save the day, he asked Shimeko. "How about you?"

"Well . . ."

"This isn't looking good." As if to hide his embarrassment, Matsu held his head. As soon as he did, Aisuke asked, "Are you pretending to be Rich Boy?"

The men in the room laughed halfheartedly.

At this point, Okiku entered the room. She was supposed to take Kyōhachi back with her. Seeming glad to be rescued, Kyōhachi straightened herself and bowed to everyone, then went over to where Sada was lying. She kneeled down and looked him in the eyes. "See you later, Rich Boy."

Sada didn't respond.

"Good-bye. Are you mad?"

"I'm not mad. I just wanted you to stay." That was what Sada was thinking, but he couldn't say it. If he died like this, he would never have to meet them again—not her or anybody. His heart was filled with the plea, "Stay with me."

"I'm going to die tonight. I know it. The least you can do is wait until I die!" The words came up to his throat and stopped there. He felt as if his body had been crushed by a sad darkness, forcing tears to well up and flow from his eyes.

As the smell of iodine penetrated to the core of his heart, and as he strained to hear the cool sound of Okiku's footsteps, he felt true despair because, at a time like this, these women didn't realize that he came from a great family of merchants who wanted for nothing.

Why couldn't Matsu and the others tell them? Why didn't they just whisper a word or two in their ears? "Getting the money is not going to be a problem, so put him up for the night. In one night, the fellow will be dead."

What heartless friends he had! They promised right from the start that they'd get him a girl. But that was a lie. For the sake of a night of endless eating and drinking, he'd been dragged there. And he'd gotten injured in the process. Inside his heart, a sense of resentment and hopelessness raised its swollen head.

At the same time, he came to harbor a new doubt. Was it as people said, that geisha sold their bodies out of desire? From what he saw tonight, it didn't seem that way. Was that because he had come with an undesirable scum like Matsu?

"They first appeared like a lively dream, then one by one they disappeared—and the most beautiful one left first." Thinking this, he couldn't remain silent any longer.

"Good-bye." He could hear the same woman's cool voice echoing in the distance. Suddenly, Sada remembered the scene of the Hishitomi's entrance when they first arrived. He remembered the one geisha who looked like somebody's wife; the men who were there to clean and to

guard the entrance; the many maids; the one named Okiku who smelled so nice; the first geisha who left, whose undergarment showed pink through her kimono; the color red; the smell of iodine; the words "Good-bye. Are you mad?"

These images, colors, and words assaulted Sada all at once. They excited his nerves. His whole body, along with the pain in his head, throbbed. Some unknown force was overpowering the pain in his head. From his bowels came a slightly emboldened voice, "Any girl will do."

Aisuke pretended to be nonchalant, "Look, it's already twelve. What are we going to do?"

"Well," Matsu responded, "Rich Boy, what do you say?"

Sada couldn't respond. The one thing he did know, though, was that he didn't want the geisha to leave. He became flustered. He took his hands off his head, and made the effort to turn toward them. Matsu was sitting cross-legged on the tatami next to Aisuke. Sada looked his way and inquired, "What do you mean, sleep together?"

Shige and Chō were still over by the veranda, sitting at their serving tables. They both laughed at the same time. Still holding their chopsticks in their hands, they looked over at Sada.

"What's so funny? What a vulgar lot they are!" Sada didn't say it, but he did send a disapproving look their way.

Smiling, Matsu explained in a schoolmaster's tone, "It means we all sleep together with the girls, but there will be no touching of any sort."

"Should we tie up our arms and legs?" Aisuke put in her two bits.

Shimeko started laughing. "Tie us up, and that'll be the end of us."

"Forget that."

Everybody started laughing together.

PART 11

Sada thought they were laughing at him, and it made him angry. But he could hardly dwell upon the thought because the pain in his head had become unbearable. Even if he was just imagining things, or even if it was a lie, as long as his hidden desires were being addressed by these things sparkling before his eyes, they somehow served as a pillar to lean against, something to help him forget his pain. But they were the very pillar that had struck him on the head. It couldn't be a more regrettable situation.

"Two blows to the head!" When he came to think of it that way, his desire for women transformed itself completely into the pain in his head, which now reached the bottom of his bowels and boiled throughout his body. In the quiet large room where no one had anything left to say, Sada

held his head with both hands. He yelled. He sobbed and writhed on the floor, "Get a doctor! Call a doctor!"

Matsu and the others tried to settle him down. Their drunkenness cleared. The geisha were startled. Everyone moved away.

The people in the shop finally brought in a doctor. To this man who had been out playing chess, they conveyed Sada's complaints about the swelling in his head. Then they had the doctor take a look.

When he left the small room where they had placed the pale-faced Sada, the doctor said, as if talking to himself, "There's nothing I can do for him at this point."

Even so, everyone thought he had gone out to get something for Sada. His friends, the lady of the house, Okiku, some other maids, everyone in the room was silent with worry.

All Sada could do was groan.

By and by, the doctor had Sada drink something from a cup in his hand. He drank half of it, then gave the cup back. In a strained voice he said, "Don't give me water. I need medicine."

The doctor shuddered when he heard these words. But he hid his fears behind the smile he stretched across his scowling face. He looked up at the lady of the house. She leaned forward to look at Sada. When her worried look and the doctor's forced smile came together, the doctor assumed a pleading tone. "I'm afraid his skull is cracked, and his brains are coming out. Just as the patient said."

"What?" The proprietress suddenly sat back and stared at the doctor as if she couldn't believe the news.

"So, just as I thought." Sada's imaginings had become his reality. Keeping his eyes tightly shut, he thought for the first time that he actually was on the brink of death. He couldn't help regret that the game of pool he had lost by a mere thirty points had led to his death. At the same time, he also wanted to think that the second-rate doctor, who didn't do anything but give him a cup of water, didn't know what he was talking about.

Sada barely heard him say, "It's a wonder he can stand the pain." The doctor was trying to hide his embarrassment by praising his patient.

Then he heard Okiku's voice. "What a courageous boy he is!"

"Of course. I'm a man!" Sada wanted to say this, but not a word passed his lips. Tears streamed onto his pillow. He no longer had the strength to hide them. He tried to think of the color red and to remember the lingering smells of just moments ago.

"Rich Boy," Matsu called to him, "hang in there. We've sent a telegram to your family in Osaka. We asked them to send a good doctor."

By the time Sada heard these words of encouragement, the local do-nothing doctor had already left. Most of the maids were also gone. Sada

blamed himself for his foolishness. Writhing with pain and regret, no longer able to see the faces of his friends and of the lady of the house, he said over and over again, "I don't want to die. I don't want to die."

He remembered the train they had taken earlier that evening, and the man with the Tokyo accent who had said, "What a fool." He was oppressed by the hopeless thought that it was now too late to ask anybody for help.

He ignored the people around him, those who were trying to soothe his pain. He waited for those he called over and over again. "Sister, Mother, Father. Come quickly."

TRANSLATED BY CHARLES SHIRŌ INOUYE

Source Texts

Abbreviations of the Titles of Series or Anthologies
GNBT = Gendai Nihon Bungaku Taikei (Chikuma Shobō)
GNBZ = Gendai Nihon Bungaku Zenshū (Chikuma Shobō)
SNKBTM = Shin Nihon Koten Bungaku Taikei Meijihen (Iwanami Shoten)
NGBZ = Nihon Gendai Bungaku Zenshū (Kōdansha)
NKBT = Nihon Kindai Bungaku Taikei (Kadokawa Shoten)
MBZ = Meiji Bungaku Zenshū (Chikuma Shobō)

All above books were published in Tokyo. The names of the libraries or archives
that hold some of the rare materials are listed in parentheses.

I. RESPONSES TO THE AGE OF ENLIGHTENMENT

Kanagaki Robun, *Things Heard around a Pot of Beef,* three volumes (*Ushiya Zōdan Aguranabe,* Seishidō, 1871–1872). And ed. Okitsu Kaname, *MBZ* 1 (1966): pp. 156–166.

"Catfish, Prostitutes, and Politicians: Satirical Cartoons": (1) Cover of the *Nipponchi,* no. 1 (1874), (Archives of Meiji Newspapers and Journals, University of Tokyo); (2) *Nipponchi,* no. 2 (1874), (Archives of Meiji Newspapers and Journals, University of Tokyo); (3) Cover of the *Marumaru Chinbun,* no. 1 (March 14, 1877). And *Marumaru Chinbun,* vol. 1 (Honpo Shoseki, 1981–1985), p. 1; (4) "The Lion Dance," *Marumaru Chinbun,* no. 137 (December 6, 1879), (AMNJ, University of Tokyo). And *Marumaru Chinbun,* vol. 5 (Honpo Shoseki, 1981–1985), p. 244; (5) "The Great Official Salary Lottery," *Marumaru Chinbun,* no. 143 (January 17, 1880), (AMNJ, University of Tokyo). And *Marumaru Chinbun,* vol. 5 (Honpo Shoseki, 1981–1985), p. 344; (6) "Momotarō Returning from the Isle of Ogres," *Marumaru Chinbun,* no. 362 (August 22, 1883), (AMNJ, University of Tokyo). And *Marumaru Chinbun,* vol. 11 (Honpo Shoseki, 1981–1985), p. 484; (7) "Everybody, Awake!" *Marumaru Chinbun,* no. 685 (January 26, 1889). (AMNJ, University of Tokyo).

And *Marumaru Chinbun*, vol. 22 (Honpo Shoseki, 1981–1985), p. 290; (8) A Plank Caught between Planks," *Marumaru Chinbun*, no. 1068 (July 11, 1896). (Waseda University Library). And *Marumaru Chinbun*, vol. 33 (Honpo Shoseki, 1981–1985), p. 233; (9) "Correcting the Textbook Review," *Marumaru Chinbun*, no. 1370 (May 3, 1902). (Waseda University Library). And *Marumaru Chinbun*, vol. 41 (Honpo Shoseki, 1981–1985), p. 891; (10) " Hypnotism," *Tokyo Pakku*, vol. 1, no. 8 (April 15, 1905). (AMNJ, University of Tokyo). And *Tokyo Pakku*, vol. 1 (Ryukeisha, 1985–2000), p. 86; (11) "Katsura Tarō Wrestling an Eel," *Tokyo Pakku*, vol. 1, no. 8 (April 15, 1905). (AMNJ University of Tokyo). And *Tokyo Pakku*, vol. 1 (Ryukeisha, 1985–2000), p. 86; (12) Cover of *Tokyo Pakku* (July 10, 1907). (Saitama Manga Museum). And *Tokyo Pakku*, vol. 3 (Ryukeisha, 1985–2000).

Mantei Ōga, *Toad Fed Up with Modernity* (*Kinsei Akire-Kaeru,* 1874). Published by Hoshino Matsuzō, (1874). (C.V. Star East Asian Library, University of California, Berkeley). And MBZ 1 (1966), pp. 197–199.

"Monsters! Monsters! Read All about It!": (1) "The Cave of the Generous *Tanuki*," an untitled item in "Zappō" section, *Akebono*, no. 470 (May 13, 1875). Reprinted as "Niigata no Sara Kashi Tanuki," in Yumoto Goichi, *Meiji Yōkai Shinbun* (Kashiwa Shobō, 1999), p. 60; (2) "The Hairdresser and the Drumming *Tanuki*," an untitled item in "Zappō/Hanashi" section, *Tōkyō Hiragana Eiri Shinbun*, no. 135 (November 27, 1875). (Kyoto University Library). Reprinted as "Yukashita de Ponpoko," in Yumoto, pp. 60–61; (3) "A Wedding Ceremony at the Inari Shrine,": untitled item in "Zappō/Hanashi" section, *Tōkyō Hiragana Eiri Shinbun*, no. 206 (February 28, 1876). (Kyoto University Library). Reprinted as "Kekkon Shitai Megitsune," in Yumoto, pp. 62–63; (4) "A Marriage at the Storehouse," an untitled item, *Tōkyō Eiri Shinbun* no. 1767 (May 8, 1881). Reprinted as "Dozō Kara Yomeiri," in Yumoto, pp. 77–79; (5) "The Fox's Obstetrician," an untitled item, *Tōkyō Eiri Shinbun*, no. 1792 (June 7, 1881). (AMNJ, University of Tokyo). Reprinted as "Inari no Sanfujinka" in Yumoto, pp. 79–81; (6) "The Haunted House of Musashi," an untitled item in *Yomiuri Shinbun*, no. 1256 (March 28, 1879). (AMNJ, University of Tokyo). Reprinted as "Korogaru Namakubi no Ie," in Yumoto, pp. 94–95; (7) "Yoshiwara Ghost Story," "Bakemonobanashi," in "Zappō" section of *Eiri Jiyū Shinbun*, no. 998 (April 14, 1886). (Library of Congress). Reprinted as "Yoshiwara no Yōkai Fūzoku-ten," in Yumoto, pp. 97–98; (8) "The Mysterious Dancing Cat," "Neko no Kai," in the "Zappō" section of *Kaishin Shinbun*, no. 799 (November 11, 1885). (Sophia University). Reprinted as "Odoru Kaibyō o Oe," in Yumoto, pp. 141–144; (9) "The Strange Creature of Monkey Island," an untitled item in "Shinbun" sectn, *Kanayomi Shinbun*, no. 472 (September 19, 1877). (Akashi Shoten). Reprinted as "Sarushima no Suiko," in Yumoto, pp. 155–156; (10) "The Birdkeeper and the Snake of Ten'ōji," an untitled item in "Shinbun" section, *Kaika Shinbun*, no. 47 (May 5, 1883). (Hitotsubashi University). Reprinted as "Hakuja Ga Akuri o Kokuhatsu," in Yumoto, pp. 188–190.

II. CRIME AND PUNISHMENT, EDO AND TOKYO

Shunkintei Ryūō, *The Bad Girl Prefers Black and Yellow Plaid* (*Adamusume Konomi no Hachijō*), performed 1873, published in *Yamato Shinbun* from July 14 to November 22, 1889. Dai 13 seki and dai 14-seki. (Collection of Shinji Nobuhiro and Mita Media Center, Keio University). And *SNKBTM* 7 (2008): pp. 371–404.

Kanagaki Robun, *Takahashi Oden, Devil Woman* (*Takahashi Oden, Yasha Monogatari*), illustrated by Morikawa Chikashige and published in 8 parts by Kinshōdō Tsujioka Bunsuke, 1879. IV-hen ge-nomaki, Dai 11-kai; V-hen jō-nomaki, Dai 12-kai. (National Institute of Japanese Literature). And *SNKBTM* 9 (2010): pp. 186–215.

Shōrin Hakuen, *Rat Boy* (*Nezumikozō*), published in 2 volumes by Shūeidō Ōkawaya Shoten, 1897, 1913. (Collection of J. Scott Miller)

Kuroiwa Ruikō, "Wedlock" (Kon'in) and "Electricity" (Denki), both published in *Miyako Shinbun*, 1890, and in the anthology *Ruikō-Shū* (Fusōdō, 1890). And *Kuroiwa Ruikō Tantei Shōsetsu-sen*, vol. 1 (Sōgensha, 2006), pp. 77–86, 97–118. (National Diet Library, Tokyo).

III. THE HIGH AND LOW OF CAPITALISM

Kawatake Mokuami, *Money Is All That Matters in This World* (*Ningen Banji Kane no Yo no Naka*), first anthologized in Yoshimura Shinshichi, *Engeki Kyakuhon*, vol. 6 (Yoshimura Ito, 1897). (National Theater Library, Tokyo). And Kawatake Ito and Kawatake Shigetoshi, eds., *Mokuami Zenshū*, vol. 13 (Shun'yōdō, 1924). And *SNKBTM* 8: pp. 57–71.

Kawakami Otojirō, "Oppekepe Rap" (Oppekepe-Bushi). A song embedded in a *surimono* print, published by Kodama Yakichi, 1891. (National Theater Library, Tokyo). And *SNKBTM* 4: pp. 357–359.

Matsubara Iwagorō, *In Darkest Tokyo* (*Saiankoku no Tokyo*), sections on "Hingai no Kagyō," "Hiyatoi Shūsen," and "Zanpan'ya," published in *Kokumin Shinbun*, 1892. (Collection of Yasunori Tan-o). Published with additions by Min'yūsha, 1893. And Iwanami Bunko, 1988, 2009, pp. 33–45.

Tanizaki Jun'ichirō, "The Jester" (Hōkan), published in *Subaru*, September 1911. And *Tanizaki Junichirō Zenshū* (Chūōkōronsha, 1966), vol. 1, pp. 187–208.

IV. MODERNITY AND INDIVIDUALISM

Nakajima Shōen, *To My Fellow Sisters* (*Dōhōshimai ni Tsugu*). Serialized in *Jiyū no Tomoshibi*, May 18–June 22, 1884. And *SNKBTM* 23: pp. 3–31.

Futabatei Shimei, "The Origins of My Colloquial Style" (Yo ga Genbun Itchi no Yurai). *Bunshō Sekai*, vol. 1, no. 5, May 1906. And *MBZ* 17: pp. 110–111.

Futabatei Shimei, "Confessions of Half a Lifetime" (Yo ga Hansen no Zange). *Bunshō Sekai*, vol. 3, no. 6, June 1908. And *MBZ* 17: pp. 112–116.

Ishikawa Takuboku, "The Impasse of Our Age" (Jidai Heisoku no Genjō). Published posthumously in Toki Zanmaro, ed., *Takuboku Ikō* (Tokyo: Shinonomedō, 1913). *MBZ* 52: pp. 259–264. And Kindaiichi Kyōsuke et al., eds., *Ishikawa Takuboku Zenshū*, vol. 4 (Chikuma Shobō, 1980), pp. 262–271.

V. A SENSE OF THE REAL AND UNREAL

Tayama Katai, "Raw Depiction" (Rokotsunaru Byōsha), published in *Taiyō*, February 1904. And *MBZ* 67: pp. 201–203.

Tayama Katai, "In the Next Room" (Rinshitsu), published in *Shinkobunrin*, January 1906, collected in *Katai Shū* (Ekifūsha, 1907). And *MBZ* 67: pp. 57–63.

Izumi Kyōka, "Messenger from the Sea" (Umi no Shisha). *Bunshō Sekai*, July 1909. And *Kyōka Zenshū*, vol. 12 (Iwanami, 1942, 1974), pp. 211–222.

VI. ROMANCE AND EROS

Kitamura Tōkoku, "Pessimist Poets and Women" (Enseishika to Josei), published in *Jogaku Zasshi*, February 1892. And *MBZ* 29: pp. 64–68.

Tokutomi Roka, *The Cuckoo* (*Hototogisu*). Serialized in *Kokumin Shinbun*, November 29, 1898–May 24, 1899. Published as a book by Min'yūsha, 1900. And *NKBT* 9: pp. 313–324.

Yosano Akiko, *Tangled Hair* (*Midaregami*), published in *Myōjō*, April 1900–August 1901. Published as a book by Tokyo Shinshisha and Itō Fumitomokan, 1901. (The Museum of Modern Japanese Literature). And Kimata Osamu, ed. *Teihon Yosano Akiko Zenshu*, vol. 1 (Kodansha, 1980).

Izumi Kyōka, "At Yushima Shrine" (Yushima no Keidai). Written in 1916 as a scene added to Yanagawa Shun'yo's dramatization of Kyōka's novel *Onna Keizu*, which had been serialized in the *Yamato Shinbun*, 1907. And *Kyōka Zenshū*, vol. 26 (Iwanami Shoten, 1942), pp. 214–234.

VII. THE CITY DREAMS OF THE COUNTRY

San'yūtei Enchō, *A True View of Kasane Precipice* (*Shinkei Kasanegafuchi*), first performed 1873. Serialized in *Yamato Shinbun*, June 26, 1887–September 7, 1888, transcribed by Koai Eitarō and, later, Sakai Shōzō, illustrated by Taiso (Tsukioka) Yoshitoshi. Dai 1-seki opening, dai 21 seki, dai 22 seki, and dai 23 seki. (Collection of Shinji Nobuhiro and Mita Media Center, Keio University). And *Enchō Zenshū*, vol. 5 (Iwanami, 2013), pp. 185–187, 249–256.

Ozaki Kōyō, "A Woodcutter Falls in Love" ("Koi no Yamagatsu"). *Jogaku Zasshi*, November 1889. (AMNJ, University of Tokyo). And *SNKBTM* 19: pp. 106–119.

"Maidens, Stars, and Dreams: Poems by Shimazaki Tōson and Kanbara Ariake": (1) Shimazaki Tōson, "A Drinking Song" (Suika) and "I'll Spend Time with You" (Kimi to Asoban), published in *Wakanashū* (Shun'yōdō, 1897). And

Tōson Shishō (Iwanami Bunko), Iwanami Shoten, 1957, pp. 50–51, 90; (2) Kanbara Ariake, "Soul's Night" (Tama no Yoru) and "Grass on the Roofs" (Yane no Kusa), from his *Shunchōshū* (Hongō Shoin, 1905). "Soul's Eclipse" (Rei no Hi no Shoku), "Daylight Thoughts" (Hiru no Omoi), and "A Wise Diviner Looking at Me" (Chie no Sōja Ware wo Mite) from *Ariakeshū* (Ekifūsha, 1908). And *Kambara Ariake Shishū* (Gendaishi Bunko, Shichosha, 1976), pp. 57, 59, 71, 72, 75.

VIII. INTERIORITY AND EXTERIORITY

Wakamatsu Shizuko, "My Grandmother's Cottage" (Omukō no Hanare), published in *Jogaku Zasshi*, 1889. (C.V. Starr East Asian Library, University of California, Berkeley). And *GNBT* 5 (1972): pp. 145–147.

Nagai Kafū, "Hilltop" (Oka no Ue), published in *Bungei Kurabu*, June 1905; later added to his *Amerika Monogatari*, Hakubunkan, 1908. (AMNJ, University of Tokyo). And *Kafū Zenshū*, vol. 4 (Iwanami, 1992), pp. 27–45.

Natsume Sōseki, *Short Pieces from Long Spring Days* (*Eijitsu Shōhin*), serialized in *Asahi Shinbun*, January 1–March 12, 1909. Collected in *Yonhen, Shunyōdō*, 1910. And *Natsume Sōseki Zenshū*, vol. 12 (Iwanami Shoten, 1994), pp. 63–144.

Iwano Hōmei, "Rich Boy" (Bonchi), *Chūōkōron*, April 1913.

Contributors

ANTHONY H. CHAMBERS, professor emeritus of Japanese at Arizona State University, is the author of *The Secret Window: Ideal Worlds in Tanizaki's Fiction* (1994). His study and translation of *Tales of Moonlight and Rain*, by Ueda Akinari, won the Japan-U.S. Friendship Commission Prize for translation of classical literature in 2007. He has taught at Wesleyan University, the Associated Kyoto Program, and the Kyoto Center for Japanese Studies.

JOEL COHN, a former associate professor of Japanese Literature at the University of Hawai'i at Mānoa, has also taught at Harvard University, Konan University, and J. F. Oberlin University in Japan. Among his other translations are Shiba Zenkō's *kibyōshi, In the Soup, Hand Made: The Thousand Sliced Arms of the Bodhisattva of Mercy* (2003), and Natsume Sōseki's *Botchan* (2005), which received a Japan-U.S. Friendship Commission Prize for translation.

REBECCA COPELAND is professor of Japanese Literature at Washington University in St. Louis. Her published works include *The Modern Murasaki: Writing by Women of Meiji Japan* (2006), coedited with Melek Ortabasi; *Woman Critiqued: Translated Essays on Japanese Women's Writing* (2006); and *Lost Leaves: Women Writers of Meiji Japan* (2000). She has also translated works by Uno Chiyo, Miyake Kaho, Kirino Natsuo, and others.

ALAN CUMMINGS is a teaching fellow in Japanese at the School of Oriental and African Studies, University of London. He has also taught as a guest lecturer at the University of Iceland. His research is in early modern Japanese literature and theater, particularly kabuki. He has published several translations in the *Kabuki*

Plays on Stage series (2002–2003). He is currently working on a monograph on Kawatake Mokuami.

JAMES DORSEY is associate professor of Japanese and chair of the Department of Asian and Middle Eastern Languages and Literature at Dartmouth College. Author of *Critical Aesthetics: Kobayashi Hideo, Modernity, and Wartime Japan* (2009), he has coedited *Literary Mischief: Sakaguchi Ango, Culture, and the War* (2010). His current research focuses on wartime representations of military heroes and the political folk-song movement of Japan's 1960s.

PETER DUUS is professor emeritus of history at Stanford. He has also taught Japanese and East Asian history at Harvard University, Washington University, the Claremont Graduate School, Waseda University, and the University of Hawai'i. His works include *The Abacus and the Sword* (1995), *The Japanese Discovery of America* (1997), and *Rediscovering America: Japanese Perspectives on the American Century* (2011).

MATTHEW FRALEIGH is associate professor of Japanese at Brandeis University. His translations of works by Narushima Ryūhoku have won awards: *New Chronicles of Yanagibashi* (2011 Japan-U.S. Friendship Commission Prize) and *Super Secret Tales from the Slammer* (2012 William F. Sibley Memorial Prize). His book *Plucking Chrysanthemums: Narushima Ryūhoku and Sinitic Literary Traditions in Modern Japan* will be published by Harvard in 2016. He has held research positions at Harvard University and Kyoto University.

HOWARD HIBBETT is professor emeritus of Japanese literature at Harvard University. He taught earlier at UCLA and has conducted research at the University of Tokyo and the University of Kyoto. A specialist in Edo and modern Japanese literature, he has edited *Contemporary Japanese Literature* (1977) and translated many works by Tanizaki Jun'ichirō, including *The Key* (1961), *Seven Japanese Tales* (1963), *Diary of a Mad Old Man* (1965), and *Quicksand* (1994).

CHARLES SHIRŌ INOUYE, professor of Japanese and former dean of Undergraduate Studies at Tufts University, has held teaching and research positions at Harvard University, Wesleyan University, Wellesley College, the International Research Center for Japanese Studies, and Kanazawa University. His translations of Izumi Kyōka's works have won him the Japan-U.S. Friendship Commission Prize, for which he presently chairs the selection committee. His research work includes *Evanescence and Form: An Introduction to Japanese Culture* (2008), and *The End of the World, Plan B* (2016).

KEN K. ITO is professor of Japanese literature at the University of Hawai'i at Mānoa. He is the author of *Visions of Desire: Tanizaki's Fictional Worlds* (1991) and *An Age of Melodrama: Family, Gender, and Social Hierarchy in the Turn-of-the-Century Japanese Novel* (2008). The latter book received the Association for Asian Studies

John W. Hall Prize. His articles include "The Family and the Nation in Tokutomi Roka's *Hototogisu*" (2000).

SUMIE JONES is professor emerita of Japanese and comparative literature and residential fellow of the Institute for Advanced Study, Indiana University, Bloomington. She has held visiting positions at Harvard University, the University of Tokyo, International Research Center for Japanese Studies, and Rikkyo University. She is author and translator of *Shirokoya Scandal* (2010) and chief editor of *An Edo Anthology: Literature from Japan's Mega City, 1750–1850* (2013).

MATTHEW KOENIGSBERG is professor of Japanese literature and instructor of Japanese language at the Free University of Berlin. He studied in Hamburg and Tübingen and has held teaching positions in Hamburg and Frankfurt. He was visiting professor of Japanese literature at Washington University in St. Louis from 2002 to 2004. His monograph in German on the work of Ozaki Kōyō was published in 2008.

DYLAN MCGEE, associate professor in the Graduate School of Languages and Cultures at Nagoya University, Japan, specializes in early modern Japanese literature, with comparative references to late imperial Chinese fiction, and in translation theory and practice. Ueda Akinari's work and early modern Japanese farce are among the topics of his recent publications. Currently, he is preparing translations of Akinari's and Tsuga Teishō's works.

JOHN PIERRE MERTZ, associate professor of Japanese at North Carolina State University, is the author of *Novel Japan: Spaces of Nationhood in Early Meiji Narrative, 1870–1888* (2003). His recent research centers on mid-Meiji overseas adventure literature, particularly concerning the literary appropriations of science and the development of ideas of primitivity. His translation of Yano Ryūkei's *Floating Fortress* (1890) is forthcoming.

J. SCOTT MILLER, professor of Japanese and comparative literature and dean of the College of Humanities at Brigham Young University, has authored *Adaptations of Western Literature in Meiji Japan* (2001) and *The Historical Dictionary of Modern Japanese Literature and Theater* (2009). His expertise is in translation theory and nineteenth-century and modern Japanese narrative, including those orally delivered and recorded.

SHINJI NOBUHIRO is professor emeritus of the University of Tokyo. He has also taught at Teikyo University and held visiting professorships at Chulalongkorn University, Thailand; Korean Institute of Foreign Languages; and Beijing Institute of Foreign Languages. He has recently edited a volume of comical and horror stories and another of orally delivered narratives in *Shin Nihon Koten Bungaku Taikei* (2006 and 2008) as well as *Three Kichizas Go Pleasure Hunting* (2008).

AIKO OKAMOTO-MACPHAIL is adjunct assistant professor in the Department of French and Italian at Indiana University, Bloomington. Her most recent publications include "The Vision of Poetry, *Un Coup de Dés* by Stéphane Mallarmé" (2009). She is currently finishing a book manuscript on *Igitur* by Stéphane Mallarmé. Her specialties in Japanese literature include Edo fiction, especially of Kyokutei Bakin, and women writers in the Heian period.

M. CODY POULTON is professor of Japanese literature and theatre at the University of Victoria, Canada. Author of *Spirits of Another Sort: The Plays of Izumi Kyōka* (2001) and *A Beggar's Art: Scripting Modernity in Japanese Drama, 1900–1930* (2010), he has translated kabuki and contemporary Japanese plays for *Kabuki Plays on Stage* (2002–2003) and other anthologies. He is also coeditor of *Columbia Anthology of Modern Japanese Drama* (2014).

LAUREL R. RODD is professor of Japanese at the University of Colorado. A specialist of Japanese poetry, women's literature, Buddhist literature, and language-and-literature pedagogy, she has been awarded a Japan-U.S. Friendship Commission Prize for her translation of *Kokinshū* and a Japanese Foreign Minister's Commendation for 2014 for her contribution to Japan studies. In addition, she recently published a full translation of *Shinkokinshū* (2015).

EIJI SEKINE is associate professor of Japanese at Purdue University and visiting professor of comparative literature at Josai International University, Japan. Author of a book in Japanese on Yoshiyuki Junnosuke and modern Japanese literature (1994) and many articles in Japanese and in English, he has authored and edited English and Japanese versions of *Echo of Poems, Desire for Narrative: Reading Japanese Literature from America* (1996).

STEPHEN SNYDER, professor of Japanese language and literature and dean of Language Schools at Middlebury College, has translated works by Ogawa Yoko, Kirino Natsuo, Yu Miri, Murakami Ryu, Oe Kenzaburo, and Nagai Kafū, among others. His translation of Isaka Kotaro's *Remote Control* was published in 2011. He is currently studying the effects of translation and globalization on Japanese fiction and is translating a novel by Maijo Otaro.

TAKASHI WAKUI, poet and professor at Nagoya University, teaches English as a foreign language, translation, and intercultural communication. His research interests are in modern Japanese poetry, animated films, and amateur astronomy. His articles in English include "The Vernacular (Genbun-Itchi) Movement in Japan and the Formation of Selfhood" (1994). He has also written articles in Japanese, including one on Shimazaki Tōson (2008).

Permissions

Akashi Shoten

Archives of Meiji Newspapers and Journals, the University of Tokyo

Collection of J. Scott Miller

Collection of Shinji Nobuhiro

Collection of Yasunori Tan-o

C.V. Starr East Asian Library, University of California, Berkeley

Ekingura Museum, Konan, Kochi Prefecture

Hitotsubashi University Library, Tokyo

The Humanities Institute Library, Kyoto University

Kitano Museum, Nagano, Nagano Prefecture

Mita Media Center, Keio University, Tokyo

Museum Meiji-Mura, Inuyama, Aichi Prefecture

The Museum of Modern Japanese Literature, Tokyo

The National Diet Library, Tokyo

National Institute for Japanese Literature, Tachikawa, Tokyo Prefecture

National Theater, Japan Arts Council, Tokyo

Sophia University Library, Tokyo

Tokutomi Roka Memorial Museum of Literature, Tokyo

Tsubouchi Memorial Theater Museum, Waseda University, Tokyo

Index